Reframing Photography: Theory and Practice

To fully understand photography, it is essential to study both the theoretical and the technical.

In an accessible yet complex way, Rebekah Modrak and Bill Anthes explore photographic theory, history, and technique to bring photographic education up to date with contemporary photographic practice. *Reframing Photography* is a broad and inclusive rethinking of photography that will inspire students to think about the medium across time periods, across traditional themes, and through varied materials. Intended for both beginning and advanced students, for art and non-art majors, and for practicing artists, *Reframing Photography* compellingly represents four concerns common to all photographic practice:

- Vision
- Light/Shadow
- Reproductive Processes
- Editing/Presentation/Evaluation.

Each part includes an extensive and thoughtful essay, providing a broad cultural context for each topic, alongside discussion of photographic examples. Essays introduce the work of artists who use a diverse range of subject matter and a variety of processes (straight photography, social documentary, digital, mixed media, conceptual work, etc.), examine artists' conceptual and technical choices, describe cultural implications and artistic influences, and analyze how these concerns interrelate. Following each essay, the part continues with a "how-to" chapter that describes a fascinating range of related photographic equipment, materials, and methods through concise explanations and clear diagrams.

Key features:

- Case studies featuring profiles of contemporary and historical artists.
- Glossary definitions of critical and technical vocabulary to aid learning.
- "How-to" chapters provide students with illustrated, step-by-step guides to different photographic methods, alongside related theory.
- Fully up to date, with both high- and low-tech suggestions for activities.
- Online resources at **www.routledge.com/textbooks/reframingphotography** will update information on equipment and provide further activities, information, and links to related sites.

- Lavishly illustrated, with over 750 images, including artists' work and examples of photographic processes.

Rebekah Modrak is a studio artist whose work has been shown at The Sculpture Center, Carnegie Museum of Art, and Kenyon College. She is an Associate Professor in the School of Art & Design at the University of Michigan, and has also taught courses involving photography, animation, mixed media, and photographic history as an Associate Professor in the Department of Art at The Ohio State University.

Bill Anthes is Associate Professor of Art History at Pitzer College. He has received awards from the Georgia O'Keeffe Museum Research Center, the Center for the Arts in Society at Carnegie Mellon University, the Smithsonian Center for Folklife and Cultural Heritage, and the Creative Capital/Warhol Foundation Art Writers Grant Program.

Reframing Photography

Theory and Practice

Rebekah Modrak with Bill Anthes

Routledge
Taylor & Francis Group

LONDON AND NEW YORK

First published 2011
by Routledge
2 Park Square, Milton Park, Abingdon, Oxfordshire OX14 4RN, UK

Simultaneously published in the USA and Canada
by Routledge
270 Madison Ave, New York, NY 10016

Routledge is an imprint of the Taylor & Francis Group, an informa business
© 2011 Rebekah Modrak with Bill Anthes

Typeset in Helvetica Neue by Fakenham Photosetting Ltd
Printed and bound by Bell & Bain Ltd, Glasgow

British Library Cataloguing in Publication Data
A catalogue record for this book is available from the British Library

Library of Congress Cataloging-in-Publication Data
A catalog record for this book has been requested

ISBN13: 978–0–415–77919–7 (hbk)
ISBN13: 978–0–415–77920–3 (pbk)
ISBN13: 978–0–203–84759–6 (ebk)

Contents

Figures

The images listed below have been reproduced with kind permission. Whilst every effort has been made to trace copyright holders of the images below, and to obtain permission for reproduction, this has not been possible in all cases. Any omissions brought to our attention will be remedied in future editions.

THEORY 1: SEEING, PERCEIVING, AND MEDIATING VISION

PRACTICE 2: LIGHT AND SHADOW TOOLS, MATERIALS, AND PROCESSES

THEORY 3: COPYING, CAPTURING, AND REPRODUCING

THEORY 4A: SERIES AND SEQUENCE

PRACTICE 4: EDITING, PRESENTATION, AND EVALUATION: TOOLS, MATERIALS, AND PROCESSES:

KEY TO SYMBOLS USED IN MARGINS

 – see further reading and/or stockists, at back of chapter

 – web resources available online at
www.routledge.com/textbooks/reframingphotography

Preface

This book came into being to address a need. When the idea formed, I was teaching in the photography area of the Department of Art at Ohio State University. My colleague Garth Amundson, Professor of Photography at Western Washington University, and I were lamenting the strange lapse between the real world and the academic world. While the contemporary artworld freely moved between media, existing academic texts still taught a form of photography from the mid-20th century.

If your knowledge of photography started with a textbook, you would learn to operate a camera, and would ascertain that the only resulting artifact could be a digital or darkroom print. If you were introduced to photography via the real world, you would see artists working with photography in all kinds of ways—projecting images to accompany spoken narrative, staining photos, cutting them apart and taping the pieces back together again, using computer drawing tools to draw reduced versions of photographs, photocopying images to produce zines, as well as printing images digitally or in a darkroom. Additionally, photography textbooks were separated into practical and theoretical or historical texts. Garth and I tried to teach our students that theory and practice are inseparable, but, by assigning students two texts (one for process, one for theory/history), we undermined our appeal that ideas and form are joined at the hip.

We fantasized about our ideal book. It would integrate theory, history, and practice. And it would reveal a broader range of possibilities in the meaning of the word "photographic." After all, what's so exciting about photography is its omnipresence. Photography isn't just Adobe Photoshop or a print. It's about actions involving looking. It's the act of reproducing an image an endless number of times. It's about questions of truth and authenticity. It's about pausing something that has life and movement so that we can watch it when it's still. It's about creating movement through fixed images. It's about the play of light and shadow. It's about finding photography in architecture and landscape, in design, in science, in everyday acts, and in making connections with the larger world.

Garth and I proposed such a text, and Bill Anthes and I went on to write it. This book is written for "photoartists," a term used by Joshua P. Smith in "The Photography of Invention: American Pictures of the 1980s," his introduction to the exhibition of the same name, to characterize artists working with photography, which may include photographers trained in the medium who identify themselves as part of a particular tradition, but which also includes artists who may not know the medium's history, who define themselves more broadly, or who do not always make photographic works.

We worked hard to represent work from a broad range of approaches, to consider diversity in terms of personal identity, aesthetics, historic context, and artistic goals. There are hundreds of artists I wish we could have included and I hope to include them in future editions. We tried to create a reading experience that encourages readers to investigate (by using the margins to note suggested resources and readings, and bibliographic notes that reveal primary sources). We hope the range of ideas inspires a sense of invention and encourages readers to make up their own rules.

Rebekah Modrak

For this topic, we also recommend Rebecca Cummins's *Rebecca Cummins: Another Light*, Martina Geccelli's *A Still Life*, Scott F. Hall's *Anadigicapping: Hybrid Analog/Digital Photography*, Jenny Hyde's *Potential Problems*, Steven H. Silberg's *Pixel-Lapse Photo Booth*, Marc Tasman's *About Polaroids*, and Ryan Thompson's *Glacial Erratic Monuments*.

Artists whose work is especially relevant for concerns about **PART 2: Light and Shadow** include:

Vesna Pavlovic, *Display, Desire*
Vesna Pavlovic's projected images of elaborate American model homes create cinematic installations that recall film sets.

Artie Vierkant,
Photographic Work
In works such as the one imaged (a histogram crafted of styrofoam), Artie Vierkant represents visual imagery according to physical qualities of light and shadow.

Owen Mundy, *You Never Close Your Eyes Anymore*
Former U.S. Naval photographer Owen Mundy draws on his experiences with surveillance film to build hand-made projection devices.

C. Thomas Lewis; Arcanum Research Documentarian, *Arcanum Research: Behind the Scenes*
In the glow of dusk, C. Thomas Lewis documents strange shapes printed in grass and other mysterious occurrences.

For this topic, we also recommend Nikki Johnson's *David, Amputation Fetishist*, Haley Morris-Cafiero's *Willpower*, Anna G. Norton's *About Light and Sound*, Lindsay Page's *Building / Unbuilding Machine* and *Force Field*, Naomi Shersty's *The Understanding*, and ssmidd's *THE MOMENT magic theatre*.

Artists whose works are especially relevant for concerns about **PART 3: Reproductive Processes** include:

Ryan Thompson, *Burden of Proof*
Ryan Thompson experiments with our expectations of truth by using digital and analog processes to present images of mythological or nonexistent animals.

Haley Morris-Cafiero,
Shape to Fit
In this series of daguerreotypes, Haley Morris-Cafiero shows her struggle to fit into a public bathroom stall.

Shannon Lee Castleman,
Jurong West Street 81
Shannon Lee Castleman introduced residents in opposing apartment buildings by inviting them to film one another.

Alex M. Lee, *Machinic Vision, Selected Works: 2008–2010*
Alex M. Lee emancipates the image from real-world capture by rendering digital images exclusively with computer technology.

For this topic, we also recommend Julie Cassels's *'Travelling Light': Reconstructing Nellie Bly's Travelling Bag*, Anna Helgeson's *The Lady Vanishes*, J. Thomas Pallas's *Installation of "Madam C.J. Walker" at Indianapolis Art Center*, Margaret Inga Wiatrowski's *Vanitas*, and Nicholas Wright's *Old Media*.

Artists whose works are especially relevant for concerns about **PART 4: Editing, Presentation, and Evaluation** include:

Roger Colombik, *Public Interventions in the Post-Soviet World*
Roger Colombik examines loss of tradition in Romanian village life and ideals of revolution in the Republic of Georgia by presenting portraits as large public art.

Antoine L'Heureux, *S.5#18S.5#31*
Antoine L'Heureux works with multiple images to create a kind of collage that presents chaotic and ordered views of the world.

Kate Pollard, *Passing*
In this series, Kate Pollard used her camera as a witness to her family's confrontations with grief over an unexpected death.

Cristobal Mendoza, *Taking a Query="line" for a Walk*
Cristobal Mendoza renders Flickr.com images tagged with the word "line" into a continuous line of lines.

Gerald Hushlak, *BreederArt: Reclaiming Wastelands*
Gerald Hushlak uses evolutionary computer processes to create fictional landscapes from digital photographs.

Ian Clothier, *Interrogating the Invisible*
For the featured project, Ian Clothier surveyed participants about their cultural identity via a project website. Responses generated the images.

Ellen Garvens, *Prosthesis*
Ellen Garvens shows her photographs of found objects, prototypes for human prosthesis and recorded stories for an online book.

Michael Filimowicz, Andres Wanner, Melanie Cassidy, *Cursor Caressor Eraser* documentation
This Internet artwork transforms the computer touchscreen tablet/mouse into a device that sensually manipulates the bodyscapes of digital photographs.

For these topics, we also recommend Ingrid Berthon-Moine's *Red is the Colour*, Robert Ladislas Derr's *In Play*, Varvara Guljajeva's *Augmented Photography*, Maria Niro's *Findings (Part 4)*, Tracee Pickett's *Modern Marriage Excerpt Film*, Bruno Ramos's *Fact and Fiction*, Louise Short's *Circa 1960*, Fred Skupenski's *TRACKS*, Matthew Slaats's *Hyde Park Visual History Project*, Sarah L. Soriano's *56 Days: I'm Still Here*, and Chris Twomey's *ASTRAL FLUFF: Carnal Bodies in Celestial Orbit*.

INTRODUCTION

Most sighted artists who perceive and record the visual world rely upon their eyes every day, yet cannot describe and do not consider the operation of these most fundamental visual tools and their many ways of looking, from smooth scanning to rapid jumps. When we overlook the opportunities of the eyes as tools of visual creation, we also tend to underutilize other optical devices. For example, we start to think a camera can only record one way, such as sharply focused images. But what if a camera was used to make rapid jumps or to record the transitions between glances? Being aware of these processes is the difference between *consciously* viewing and passively consuming. *Part 1: Vision* takes an expansive look at diverse optical devices, from the operation of the eye and brain, to other tools, such as linear perspective, camera obscuras, optical toys, and the functions of analog and digital cameras. Part 1 contains two chapters, the essay "Seeing, Perceiving, and Mediating Vision" followed by the how-to chapter, "Vision: Tools, Materials, and Processes," and draws upon the work of historical and contemporary artists to examine these various ideas and processes.

Open your eyes and look around. "Seeing, Perceiving, and Mediating Vision" offers a comprehensive understanding of the interlocking physical and cerebral actions this seemingly simple act entails. The essay takes an expansive view of vision, beginning with primary sensory portal, the eye, and dissecting its form and function, and continuing with an exploration of how physical vision is affected by cultural perception. We will explore how this neural phenomenon has parallels in visual culture, and how shifts in pictorial convention—from emphasis on sharp focus, through linear perspective, challenges to rules of proportion, assumptions of the role of symmetry—are connected to cultural and physical preferences. We analyze visual decisions in respect of the cause and effect relationships they have in forming the world around us—from landscapes that guide and shape vision to artists who reveal and document these physical manipulations.

Following these two primary stages, seeing and perception, we come to the prosthetics that frame and capture these actions. The essay follows these manipulations of vision through the creation and use of tools to manipulate vision—including eyeglasses, camera obscuras, optical devices such as zoetropes and stereoscopes, and digital technologies. Mechanical eyes produce images at continuously faster speeds. Although contemporary viewers absorb masses of images in streams of information via television and the Internet, this myriad of vantage points and viewpoints is not a new

visual phenomenon. This essay looks at how, historically, visual devices have often extended the bounds of our innate human capacity, providing ever lighter and more portable mechanical eyes. Each revolution in technology has been accompanied by a revelation in vision. For example, the ability to scale new heights at the Eiffel Tower enabled humans to take a new perspective. Armed with the information that follows, the acts of vision and the process of perceiving, capturing, and editing can be informed and dynamic.

The how-to chapter, "Vision: Tools, Materials, and Processes," promotes practical ways of putting vision into effect, through altering human vision, using viewfinders and other frames to direct perception, and by understanding how diverse photographic equipment differs in its capture of visual information. This processes chapter aims to provide a guide for various methods of recording images, from the panoramic eye of a pinhole camera, to the sharpness of an SLR lens, the directness of the digital scanner or photocopier, to the mobility of a cellphone camera image. For additional description of this section, refer to the introduction of "Vision: Tools, Materials, and Processes."

Theory: Seeing, Perceiving, and Mediating Vision

Rebekah Modrak

PHOTOGRAPHY AND THE ANATOMY OF SIGHT

Through much of modern history, the act of seeing was considered to be purely mechanical and the eye was understood as a passive vehicle of image production. Experiments by Enlightenment philosopher René Descartes (1596–1650) further demonstrated that even an eye detached from the rest of the body will form images. Descartes removed an eye from a human corpse. When holding an object in front of the eyeball, an inverted and reversed image of the object appeared on a sheet of paper held behind the eye. This discovery—that an eye unattached to the human body and brain can project an image—reinforced the notion that seeing is a purely physical act. In the late 1830s, William Henry Fox Talbot (1800–1877), inventor of the **calotype**, the first paper **negative** process, defined photography as the **pencil of nature**, because he understood the camera to be that disembodied eye, mechanically reproducing whatever fell before its lens.

Seeing photographically is still often considered in these passive terms. Some photographers wait for an event to occur, for the "right" moment to photograph. In the 1970s, Susan Sontag, author of the influential book *On Photography*, described the act of photographing as "essentially an act of non-intervention."[1] She stated:

Part of the horror of such memorable coups of contemporary **photojournalism** as the pictures of a Vietnamese bonze reaching for the gasoline can, of a Bengali guerrilla in the act of bayoneting a trussed-up collaborator, comes from the awareness of how plausible it has become, in situations where the photographer has the choice between a photograph and a life, to choose the photograph.[2]

calotype
An early photographic process, made public by William Henry Fox Talbot in 1841. The process was the first negative–positive one in which endless reproductions could be made from an original negative.

negative
An image in which the tones are the opposite of those of the subject. In traditional photography, the image is on film. Light passes through the negative onto photographic printing paper to produce a positive print.

The Pencil of Nature
The title of William Henry Fox Talbot's book, published in 1844 and the first to be illustrated with photographic prints tacked in place. Fox Talbot published the book in order to publicize the advantages of the calotype process and to inspire and instruct photographic hobbyists and budding professionals with a range of compositions and subjects. The term "the pencil of nature" references Fox Talbot's belief in the objective nature of photography, in which the sun produced the images, not the artist.

1 Susan Sontag, *On Photography* (New York: Doubleday, 1977), 11.

2 Sontag, *On Photography*, 11.

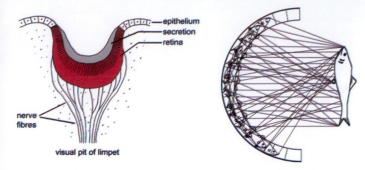

1.1 Visual pit of limpet and "fish projection." Photosensitive cells are densely clustered in the visual pit of the limpet, but the opening of this eye is so large that many light rays enter at once, bouncing everywhere and flooding the eye with light. As a result, the limpet eye discerns broad changes in light but cannot form images

photo
From the Greek *photos* meaning light.

3 Robert L. Solso, *Cognition and the Visual Arts* (Cambridge, MA: MIT Press, 1994), 16.

1.2 The nautilus's pinhole eye

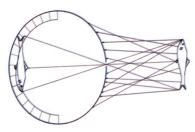

4 R.L. Gregory, *Eye and Brain: The Psychology of Seeing* (New York: McGraw Hill, 1966), 26.

photojournalism
Journalism that uses images to tell a story.

1.3 Light rays are more focused in the nautilus's pinhole eye

Though opting to take the photograph could be considered an active choice, a conscious act, Sontag observed that people simply snap pictures without thinking about their responsibility to a situation. We often view the world as a series of fixed images, rather than as a series of dynamic unfolding events of our own making.

These centripetal theories, wherein images advanced toward the eye, had an early centrifugal counterpart, in which radiance flew from the eye. Early Greek philosophers such as Plato and Euclid believed that, in order to see, light particles were projected out of the eyes onto objects. The eye actively creates the image. Despite the fantastic pyrotechnics implied in this proposal, Plato's active theory of vision is close to our contemporary understanding in which seeing is a matter of choice, of actively seeking images with our eyes and brain.

Living eyes: the photosensitive cell

The human eye can be traced back to primitive organisms whose eyes consist of a cluster of light-responsive cells connected to the creature's motor controls. Animals with this kind of basic visual mechanism still exist today. Like the retina in the human eye, their light responders are **photo**sensitive. These creatures cannot detect shapes or details, but they can perceive shifts in light or heat and respond by moving toward or away from the stimulus.

Eventually, this arrangement of photosensitive cells became more densely clustered in an indentation on the organism's surface, as in the visual pit of the limpet, a shellfish similar to a scallop (Figure 1.1).[3] One basic eye continues to exist today in the nautilus, a shelled mollusk related to the octopus and squid (Figure 1.2). The nautilus's pinhole allows a selective group of light rays to enter, forming images that are more focused than an eye pit's (Figure 1.3). The nautilus eye is easily cleaned, as the sea washes out the inside of the eye. R.L. Gregory, author of *Eye and Brain: The Psychology of Seeing*, suggests that human eyes evolved with special saline fluids that replaced the sea. Our tears are "a re-creation of the primordial ocean, which bathed the first eyes."[4]

The human eye (Figure 1.4) incorporates many of the same features, including an aperture and a light-sensitive retina. Anatomically more complex than the primitive visual structure described above, the human eye focuses light through the cornea, iris, pupil, and lens. The transparent membrane of the cornea not only protects the eye, but also helps to refract the light. The light then passes through the pupil of the iris, a muscle in the shape of a ring. The pupil at its center appears solid, but it is a black hole formed by the iris. It is through this aperture that light passes. In dim light, the iris muscle expands to widen the aperture and increase the amount of light; in bright light, the muscle contracts to reduce the amount of light (Figure 1.5).

On a camera, the **aperture** operates in much the same way as the iris (Figure 1.6). The

diaphragm has a ring of overlapping metal leaves inside the **lens**, which can be adjusted by turning the band on the outside of the lens. You can turn the band to predetermined aperture settings, each referred to as an **f/stop** with a corresponding number. For example, aperture setting f/2 lets in more light; setting f/16 admits less light (Figure 1.7).

In her *Face to Face* and *portal* **series**, Ann Hamilton (b. 1956) uses her mouth as both aperture and **shutter** to determine the passage of light. In the dark, she places a small **pinhole camera** into the cavity behind her lips and teeth. She must close her mouth before entering the light. After positioning herself 2 to 4 feet from another person, she is ready to make the **exposure** and opens her mouth for an interval of 10 to 20 seconds—a long time, considering Hamilton's close proximity to her subject. This intimacy is unusual in photography, where conventional camera lenses allow the photographer to remain some distance from their subject. Once the film is exposed, Hamilton closes her lips to protect the film from additional light.

In Hamilton's work, the blinks and tears of the eye are translated into the tremors and salivations of the mouth. Self-portraits, made in a mirror, show Hamilton contemplating herself, through her eyes and from her mouth. She marvels: "we as bodies inherit ourselves as both containers and as being contained."[5] We tend to forget about the complex physical and cultural dynamics caught up in the act of looking. When these actions become habitualized, relocating the eye as the mouth recalls our attention to the processes involved.

1.8 Ann Hamilton, *portal 19*, 1999. Black and white photograph

aperture
An opening in a device or structure; may be fixed or adjustable. In a camera, the aperture is the adjustable diaphragm that widens or contracts to let in more or less light.

f-stop or f-number
A numerical designation (f/2, f/2.8, etc.) indicating the size of the camera's aperture.

5 "Program 2 – Spirituality," *Art: 21*, 2001.

lens
One or more pieces of optical glass used to focus light rays to form an image. There are several types of camera lenses: a normal lens approximates human vision; a wide-angle lens shows a wider angle of view; a telephoto lens captures a smaller field of view and makes the object/scene appear to be closer.

series
A group of images that are meant to be seen collectively, though not necessarily in a particular order.

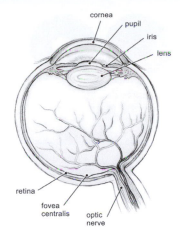

1.4 Human eye

1.5 Left: contracted iris/small aperture. Right: iris expands to let in more light

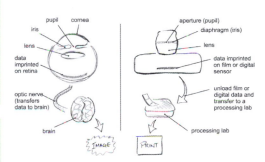

1.6 Eye/camera comparison

1.7 Left: small aperture: f/16. Right: aperture open to f/2 to let in more light

shutter
A mechanism in a camera that opens and closes to allow light to pass from the aperture to the film or digital sensor.

6 Gregory, *Eye and Brain*, 43.

exposure
The total amount of light that falls on the film or sensor in the camera to produce a latent or digital image; in darkroom printing, the exposure is the total amount of light exposed on photographic printing paper. Exposure time is the amount of time that light is permitted to fall onto the digital sensor or light-sensitive film or paper.

7 Jonathan Green, *American Photography: A Critical History, 1945 to the Present* (New York: Harry N. Abrams, 1984), 56.

pinhole camera
A basic camera with no lens or viewfinder, whose aperture is a tiny opening directly in the camera body.

Active vision: eye movements and still photography

While we are awake, our eyes are continuously moving, rapidly recording detailed and peripheral information from our environment. When *searching* for a specific object, our eyes move in a series of small rapid jerks. When *following* a moving object, they move smoothly. Apart from these two types of movement, there is also a constant small, high-frequency *tremor*.[6] All movements are integral to vision, which fades without motion from the eye. Try to fix your eyes by looking at something in front of you without blinking. After a few seconds, your vision will blur as clarity of form begins to fade. These small jerking (saccadic) movements are in fact the jolts that the eye receptor sends as a continual string of information to the brain. Consider a computer screensaver as a contemporary technological analogy: When a computer ceases to detect movement from the keyboard or the cursor, it falls asleep. Similarly, when the eye fixates on an object, the receptors cease to signal to the brain the presence of the image in the eye. While eye movements are usually overlooked in the process of seeing, we are acutely aware of their presence, or absence, when driving. Learning to drive may constitute one of the few times in life that we are given instructions on how to see. Drivers' education directs us to "scan constantly": advice based on our natural vision.

Some photographers advocate this hyper-conscious active mode of being in the world. Minor White (1908–1976), photographing in the late 1940s through the 1960s, described seeing as an intense experience. He searched the landscape for symbolic form and predicted that a photographer walking an average block in a "state of sensitized sympathy to everything to be seen … would be exhausted before the block was up and out of film long before that."[7] White understood photographic seeing as a means of transformation, of revealing an object's inner subject or its archetypal base.

The constant fluctuation of the eyes as they scan, seek, and trail after visual phenomena is quite different from the experience of seeing through a photographic camera, and vastly different from the representation of that vision in a flat, still photographic image. These differences have led many artists to invent photo-based techniques that reveal the intricacy of our natural vision. David Hockney (b. 1937) began taking photographs to use for reference when painting. He felt disappointed in single photographic images because they lacked the complexity of his experience within the original scene. Conversely, a completed painting, with its layers of paint, revealed the time involved.

In the 1980s, Hockney challenged himself to use a camera to produce images more like our dynamic, movement-based, binocular sight. His experiments involved taking multiple **Polaroid 600** photographs of a scene from different angles, then placing the pictures together to form one image. *Nathan Swimming, March 11, 1982* shows light reflecting on water during a swimmer's slow crawl; this *joiner*, as Hockney called his **collages**, is typical of his works from this period, in which moving subjects are represented via this animated process. Hockney discovered that:

The camera is … neither an art, a technique, a craft, nor a hobby—it's a tool. It's an extraordinary drawing tool. It's as if I, like most ordinary photographers, had previously been taking part in some long-established culture in which pencils were only used for making dots—there's an obvious sense of liberation that comes when you realize you can make lines![8]

As Hockney's work evolved, he began to use **35mm single-lens reflex** cameras in order to depart from the rigidity of the Polaroid square with its white border. After switching cameras, the photographic prints without borders could be overlapped so that one image blended into another in web-like paths. In this way, Hockney worked as a painter, using each image as a brush-stroke within the larger tableau. In an interview with Lawrence Weschler, Hockney explains the danger of too easily accepting the rectangle as the natural container of the photograph, lamenting "how deeply imprinted we are with these damn rectangles. Everything in our culture seems to reinforce the instinct to see rectangularly—books, streets, buildings, rooms, windows."[9]

Hockney's interest in breaking out of Western conventions led to his study of Eastern representations that allow viewers to see from multiple points rather than from a single vantage. Though *Walking in the Zen Garden at the Ryoanji Temple, Kyoto, Feb. 1983* is

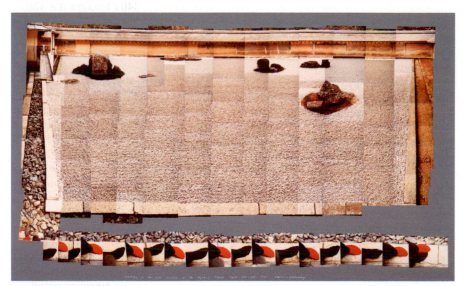

1.9 David Hockney, *Walking in the Zen Garden at the Ryoanji Temple, Kyoto, Feb 1983*, 1983. Photographic collage, Edition: 20, 40 × 62½in

Polaroid 600
A type of instant film used with a Polaroid camera; the film produces positive images within a few seconds of taking the picture.

8 Lawrence Weschler, "True to Life," in *David Hockney: Cameraworks*, ed. Raymond Foye (London: Thames and Hudson, 1984), 13.

9 Weschler, "True to Life," 21.

collage
An image made from combinations of photographs, graphics, type, and/or other two-dimensional materials, often pasted onto a backing sheet. Digital collage involves using computer tools to combine imagery from varying sources.

35mm
A small-format film; each frame (single image) is 24 × 36mm in size (about 1 × 1½in.).

single-lens reflex (SLR) camera
A camera with a mirror inside. The mirror bounces light coming through the lens into the viewfinder. The image seen in the viewfinder is approximately what the camera sees through its lens.

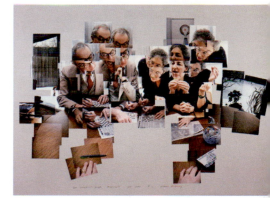

1.10 David Hockney, *The Crossword Puzzle, Minneapolis, Jan 1983*, 1983. Photographic collage, Edition: 10, 33 × 46in

1.11 Joyce Neimanas, *Maureen and Maureen*, 1984. Polaroid collage, 32 × 40cm

1.12 Joyce Neimanas, *#2 (Lautrec)*, 1981. Polaroid collage, 32 × 40cm

zoom lens
A lens adjustable to a range of focal lengths, from wide to normal to telephoto.

decisive moment
Phrase coined by photographer Henri Cartier-Bresson in 1952 to describe the photographer's goal of catching the fragment of a second in which the elements of a scene—the significance/meaning of the event and the formal, geometrical forms—come together.

10 Weschler, "True to Life," 21.

rods and cones
The two types of photoreceptors in the eye's retina. The rods are more numerous and more sensitive than the cones, though only the cones are color sensitive.

11 Sarah J. Moore, *Joyce Neimanas* (Arizona: Center for Creative Photography, University of Arizona, 1984), 15.

presented as a rectangle, the perspective is constructed from many angles. To view the top portion of the image, we quietly float above the 15th-century Zen gravel garden in which five groups of stones are placed so that one is always out of view, a riddle with an elusive meaning. At the same time, Hockney's feet steadily advance along the lower path, recalling the Japanese practice of focused, steady walks that allowed philosophers to fall into a state of contemplation. Hockney's small journey along the rock groupings also brings to mind Japanese stroll-gardens, meant to be experienced while traveling by foot or boat rather than from a fixed point of view.

When photographing two friends engaged in *The Crossword Puzzle, Minneapolis, Jan., 1983*, Hockney used the **zoom lens** to quickly move from detail to detail, from one perplexed expression to another as expressed by people's hands and faces. We read Hockney's image as we would assemble the actual event: by sweeping our eyes back and forth, from the newspaper to the players and back again. As with our peripheral vision, some of the details on the sides are out of focus or blurry. Within this scene, the fuzziness of the walls in the background keeps our attention on the main event, while still providing information about the room and a frame for the action. Says Hockney:

I take dozens of pictures at any given site and then I just take the exposed rolls down to one of the local places here to have them developed—usually I go to Benny's Speed Cleaning and One-Hour Processing. It took me a long time to convince them that I truly wanted them to "print regardless" and I still get these wonderful standardized notices back with my batches of prints, patiently explaining what I am doing wrong, how I should try to center the camera on the subject, focus on the foreground, and so forth.[10]

Like Hockney, Joyce Neimanas (b. 1944) also used groupings of photographs to represent her experience over time and from varied perspectives. In Neimanas's images, time shifts gently and invisibly. Unlike Hockney, who built an existing space from fragments of that same place, Neimanas constructs a scene out of pictures taken from varied sources and different angles over a period of days. Flowers wilt, people shift and resettle, and Neimanas uses her camera to steal their textures, edges, and lines for her own construction.

Sarah J. Moore compares Neimanas's extended span of time with the conventional notion of a photographer as someone who responds to a situation instantaneously. Popular photography—tabloid, wildlife, and journalistic photography—shows ephemeral actions suspended as image. The **decisive moment**, a term defined and advocated by photographer Henri Cartier Bresson (1908–2004), has reinforced this sense of speed: the camera captures (quickly) a "single definitive image."[11] In Neimanas's constructions, viewers suspend time by bridging the gaps between the white borders that shield one Polaroid from the next. Shifts in material and lighting are explained by our brain, which

seeks to unite all disparity, or are forgotten by our eye as it leaps to the next picture. Ultimately, with Neimanas's guidance, we form a space that could have plausibly existed but never did. The elusive nature of time as it shifts within the images corresponds to the subject of the scene. In her portrait of Maureen, for example, Neimanas constructs two versions of the woman. Side by side, the multiples allude to a psychological split similar to the fragmentary nature of vision and time.

Fovea and focus

Hockney's and Neimanas's collages demonstrate how our eyes make sense of visual phenomena by jumping from detail to detail to register one piece of information after another; our brain "sews" the pieces together to form the complete picture. We view their photographs in stages rather than all at once. The capacity of the eye to focus lies in the *fovea centralis*, a small depression in the retina of the eye (Figure 1.13). To see any object clearly, we automatically turn our eye so that the retinal image falls in the center of the fovea. While most of the retina contains **rods and cones**, the center of the fovea is the only part that is completely made up of cone receptor cells. M.H. Pirenne describes these cells as "so connected to optic nerve fibers that they work as if they had a 'single line' to the brain."[12]

This sense of focus is a feature of human vision. While many other animals have two foveae, or a "strip" fovea in which objects are seen clearly through a wide band of the visual field, human eyes are not as complicated as, say, the eyes of insects, because we have more complex brains—our simpler optical sensors let in an unfiltered stream of information that the brain must edit.[13] It is this freedom to make new inferences from sensory data that allows humans to discover and contemplate.[14]

The predilection for sharp focus has fluctuated through various movements within the history of photography and according to specific photographers' and artists' goals. From the 1850s to the early years of the 20th century, many art photographers such as Julia Margaret Cameron, Clarence White, F. Holland Day and P.H. Emerson preferred soft-focus images of romantic scenes: peasants in the field, portraiture, and pastoral landscapes. The fuzziness emulated the subject matter and hazy quality of **genre painting** then in vogue, thereby granting art photography legitimacy at a time when the medium was seen as more scientific than creative.

During the second decade of the 20th century, Alfred Stieglitz (1864–1946), an early champion of **Pictorialist** photography, radically shifted his views and joined other artists in recognizing **Modernism** and the **machine aesthetic**. He abandoned Pictorialism in favor of sharpness and precision. Purist photographers identified these characteristics as the inherent qualities of photography, which would distinguish the medium from painting, drawing, and printmaking. Stieglitz's change of heart was especially significant because

genre painting
A style of painting that depicts scenes from everyday life.

Pictorialism
Photographers working in the Pictorialist tradition, from 1890 to 1917, wanted to establish photography as an artform. Composition, subject matter and soft-focus aesthetic were typically used to make the photo look painterly.

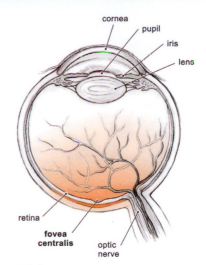

1.13 Human eye

12 M.H. Pirenne, *Optics, Painting and Photography* (Cambridge: Cambridge University Press, 1970), 26.
13 Solso, *Cognition*, 132.
14 Gregory, *Eye and Brain*, 221.

Modernism
An art movement that embraced innovative media and forms of visual expression, and which rejected traditional forms of representation. In photography, Modernism refers to a period from the end of World War One to the early 1950s.

1.14 Paul Strand, *Akeley Motion Picture Camera*, 1922. Gelatin-silver print, 24.5 × 19.5cm

avant-garde
An individual or group with ideas that seek innovation, often with the goal of advancing or challenging mainstream artistic and societal practice. Avant-garde comes from the French term "avant" (fore) and "garde" (guard), referring to the soldiers who went first in battle.

15 Sheryl Conkelton, *Uta Barth: In Between Places* (Washington: Henry Gallery Association, 2000), 20.

machine aesthetic
Popular aesthetic that came about during the industrialization of the early 20th century. Art and design celebrated the appearance of machines, i.e. the look of shiny metals, mirrored glass, etc.

depth of field
In a photographic print, the depth of field is the distance between the nearest and farthest points that appear to be in sharp focus.

grain
Silver particles that make up a photographic print.

he used his Gallery 291 to promote both European and American **avant-garde** paintings and sculptures, and Paul Strand's photographs of mechanical and precision forms. The new modernist photography eventually influenced West Coast photographers such as **Edward Weston**, Imogen Cunningham, and Ansel Adams, who founded the f/64 Group in 1932. The group advocated strict use of particular qualities: **depth of field**, through use of a small aperture (as is f/64), and sharp, small **grain**, through the use of large-format **view cameras** whose substantial negatives could be **contact printed** on glossy paper.

While our eyes may be drawn to hard edges, the idea that clarity is a photographic necessity continues to be questioned by a number of artists and photographers. In making the photographs for her *Ground* series, Uta Barth (b. 1958) *did* focus her camera lens on someone in the foreground of the scene. Once focused, Barth asked the person to step outside the frame before making the actual exposure. The resulting images show the blurred periphery as the only subject. Barth describes this hazy scene as the stereotypical version of a picturesque background: pastoral, soft pastel colored, seemingly from nature, and often based on the backdrop conventions of portrait studios.[15] For portraitists, studio backdrops provide an unobtrusive setting for the subject. In Barth's work (Figure 1.15), this abstracted, idealized picture of nature becomes the main event; yet, without a smiling face, there is no obvious focal point. Barth says:

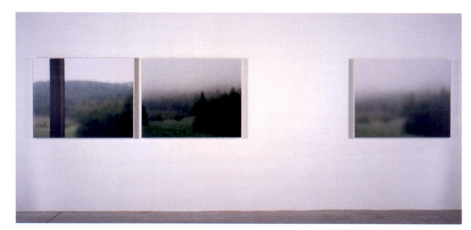

1.15 Uta Barth, *Untitled (98.5),* 1998. Color photographs. Overall: 38 × 197½in.; Triptych 38 × 48in. each

we all expect photographs to be pictures *of* something. We assume that the photographer observed a place, a person, an event in the world and wanted to record *it*, point at *it*. There is always something that motivated the taking of a photograph. The problem with my work is that these images are really

not *of* anything in that sense, they register only that which is incidental and peripheral to the implied *it*.[16]

Barth believes that blur, or out-of-focusness, is an "inherent optical condition" that is part of "our everyday vision and perception." We are not aware of these processes, however, because "our eyes are constantly moving and shifting their point of scrutiny."[17] Therefore, Barth defines photography's inherent quality not as sharpness or precision, but as its unique capacity to allow us to focus indefinitely on a cloudy image, thereby overcoming the eyes' aversion to suspended animation. Barth says: "The camera can 'lock-in' this condition [of blurriness] and give us a picture which allows us to look at (and focus on) out-of-focusness."[18] And while her work has the softness of Pictorialist photography, Barth refutes interpretations of the blur as being "painterly."[19] For example, although the *Ground* and *Field* series shift one's attention to an unoccupied background, Barth hopes that each image will hint at its lost subject and the perimeters or outskirts of vision.

In Barth's work, we view an atmosphere of hard-to-gauge depth and unknown dimensions, and we recognize how much we usually privilege recognizable form. The eye and brain are accustomed to using contours as a way to understand the environment. When these cues are withdrawn from sight, most seers cannot orient themselves. While navigating through space, the loss of contours can be dangerous—without sufficient information to see the limits of the land, one could easily wander off a cliff. Though the cliff, or anything else in nature, is not actually made up of lines and edges, the eye and brain have evolved systems that encode these differentiating signals and process the information in such a deceptively casual manner that we start to believe that edges and lines are visible components of the "real world."[20]

Some climates or landforms do not present enough clues to develop a clear-cut contour. The pale Eskimo environment, as described by Yi-Fu Tuan in his book *Space and Place: The Perspective of Experience*, contains few clues for "normal" perceptual differentiation. There is little to distinguish between earth and sky and land and water. "Moss and lichen in summer give the land a uniform gray-brown cast; snow and ice in winter paint the scene in monotone. When fog or blizzard appears, land, water, and sky lose all differentiation."[21] Humans learn to make sense of nature—to recalibrate their visual sensors—when their survival is at stake.[22] In order to survive, Eskimos have refined their perceptual and spatial skills. Under the cloak of a constant mist and without the beacon of a visible landmark, they can still navigate by observing relationships between the lay of the land, types of snow and ice crack, the quality of the air (fresh and salt), and wind direction.

Eskimos live in the fog of an Uta Barth photograph, a Ganzfeld. From the German for *whole field*, Ganzfelds are visual fields that have no contours. To experience a Ganzfeld,

16 Conkelton, *Uta Barth*, 14.

17 Conkelton, *Uta Barth*, 18.

18 Conkelton, *Uta Barth*, 18.
19 Conkelton, *Uta Barth*, 18.

Edward Weston (1886–1958)
Photographer working in the early 20th century who strived to reveal the essence of objects by using the "inherent qualities of photography," i.e. maximum detail from foreground to background, and precise lighting.

20 Solso, *Cognition*, 53.

21 Yi-Fu Tuan, *Space and Place: The Perspective of Experience* (Minneapolis: University of Minnesota Press, 1977), 78.
22 Tuan, *Space*, 79.

@ ONLINE RESOURCE **1.1** Refer to our web resources for descriptions of how to simulate the effect of a Ganzfeld.

1.16 Uta Barth, *Field #9*, 1995. Color photograph on panel. Edition of 8, 23 × 28¾in

1.17 Ralph Eugene Meatyard, *No Focus,* 1959. Gelatin-silver print

1.18 Ralph Eugene Meatyard, *Untitled*, 1962. Gelatin-silver print

view camera
A camera in which the lens projects an image directly onto a ground-glass viewing screen, for the purpose of composition. The front and back of the camera can be set at various angles to change focus and perspective. Typically, view camera sizes accept 4×5-inch or 8×10-inch sheets of film.

contact print
Process of placing a negative against sensitized material, usually paper, and passing light through the negative onto the material. The resulting image is the same size as the negative.

23 Barbara Tannenbaum, ed., *Ralph Eugene Meatyard: An American Visionary* (New York: Rizzoli, 1991), 31.

24 Tannenbaum, *Ralph Eugene Meatyard*, 30.

25 Tannenbaum, *Ralph Eugene Meatyard*, 31.

26 Tannenbaum, *Ralph Eugene Meatyard*, 76.

27 Aldous Huxley, *The Art of Seeing* (New York: Harper and Brothers Publishers, 1942), 42.

use the Ping-Pong Ball method described on our website. Proceed with caution, for you may undergo a sense of blindness. In experiments, subjects usually report a complete—albeit temporary—loss of vision after 15 minutes and then may be unclear as to whether their eyes are open or closed.

Ralph Eugene Meatyard (1925–1972) spent three months looking through an unfocused camera (Figure 1.17) in order to "learn to see No-Focus."[23] Working roughly 30 years before Uta Barth, Meatyard, an optician who practiced photography, began the project because of his initial attraction to the out-of-focus backgrounds in some of his images. Through his association with the local camera club and his connections at the university in Lexington, Kentucky, Meatyard was in contact with many other photographers, such as Van Deren Coke, whose condition for making a photograph was to find an appropriate background and put something in front of it.[24] Like Barth, Meatyard eliminated the "thing" and looked only for the background, which he would then throw out of focus. Eventually, feeling that the background was still too recognizable, he abandoned this practice and began to contemplate his surroundings through an unfocused lens. Barbara Tannenbaum describes the process in her essay, "Fiction as a Higher Truth: The Photography of Ralph Eugene Meatyard":

He would then wait two or three months before developing them [the negatives]. After that interval, he was no longer able to identify the scenes or objects; he had succeeded, at least for himself, in detaching the images from a bit of reality on which they had been based.[25]

Like many Western artists at the time, Meatyard had become fascinated with the Eastern philosophy of Zen Buddhism, in which objects have meaning beyond their physical attributes. Meatyard was influenced by photographer Minor White's belief that photography (through abstraction, sequencing, and close-up details) could be used to liberate objects from their everyday reality. The *No-Focus* series and Meatyard's later *Zen Twig* images (Figure 1.18) adhere to the minimalist tendencies articulated by the writer Suzuki: "Japanese artists … influenced by the way of Zen tend to use the fewest words or strokes of brush to express their feelings. … suggestibility is the secret of the Japanese arts."[26] Meatyard, White, and other artists working in the Expressionist style felt that their works would contain universal or personal meanings that could be openly interpreted by a viewer.

Hockney, Neimanas, Barth, and Meatyard help us to identify the intricate steps involved in seeing that we perform unconsciously everyday. Aldous Huxley analyzed the complete process of seeing into three subsidiary processes: *sensing*, *selecting*, and *perceiving*.[27] Initially, the eye absorbs the visual field: light, movement, and color all mixed up in a meaningless blur. The eye detects the *sensum*, the colored patches of light that form the raw material of seeing, and passes these initial sensations of light

on to the optic cortex, the outer layer of the brain, for processing into lines, edges, contrasts and the like. Neural impulses are then sent on to other parts of the cortex for higher-order processing, including cognition and thought, which redirects attention to featural processing and activates the eye for the following stage.[28] In the next series of movements, the eye begins to *discriminate*, using the fovea centralis to select one detail from the rest within its range of sight. The final process, *perceiving*, entails the recognition of the sensed and selected *sensum* as the appearance of a physical object existing in the external world.[29] In this overall process, we do not see a dog, we see a colored patch which our brain interprets as the appearance of a dog.

The neurologist Oliver Sacks writes that "most of us have no sense of the immensity of this construction [our visual construction of the world], for we perform it seamlessly, unconsciously, thousands of times every day, at a glance."[30] The complexity of this process becomes dauntingly apparent within Sacks's account of Virgil, a blind man in his fifties, who, following cataract surgery, regained the use of his eyes. When the bandages were removed, Virgil experienced a world of *sensa* for the first time since childhood. However, Virgil still depended upon his prior faculties as a blind man (sound, touch, taste, smell) to understand the *sensa*. For example, he recognized that a bright colored blur comprised a man only upon hearing the man's voice. He could experience the phenomena of light and color, but could not process them into the appearances of objects. His need to relearn the world according to the codes of a sighted person illustrates that seeing is a *learned* experience, based on memory and accumulated encounters in a visual world. Like Virgil, a photographic camera cannot distinguish a person from a bicycle and does not know that one is alive and the other inanimate. The eye of the camera is directed by an operator who selects, remembers, and perceives.

CONVENTIONS OF SEEING

Vision, memory, and experience

Each set of new eyes enters the world capable of sensing only a mass of vague, indeterminate *sensa*, the patches of light that make up the raw data of vision. A newborn child cannot focus enough to select and does not have the background to perceive that these visual stimuli represent physical objects. The facility for interpreting *sensa* requires accumulated experiences and a memory capable of retaining these experiences. Once the mind interprets them successfully and can reference these successful applications, the interpretation of *sensa* into images and physical objects becomes automatic.[31]

The interpretation of *sensa*, however, is not merely biological. Human optics are informed by everyday encounters. These experiences are layered and depend upon

28 Solso, *Cognition*, 31.

29 Huxley, *Art of Seeing*, 43.

30 Oliver Sacks, *An Anthropologist on Mars: Seven Paradoxical Tales* (New York: Vintage Books, 1995), 127.

31 Huxley, *Art of Seeing*, 45.

1.19 William Henry Fox Talbot, *The Open Door*, in *Pencil of Nature*, Plate VI, April 1844. Salt print from a calotype negative. 14.4 × 19.5cm

1.20 Robert Adamson and David Octavius Hill, *Agnes* and *Ellen Milne*, c. 1845. Gelatin silver print, 21.3 × 15.9cm. Modern print by A.L. Coburn

32 Sacks, *Anthropologist*, 140.

33 Sacks, *Anthropologist*, 124.

34 Gregory, *Eye and Brain*, 222.

35 William Henry Fox Talbot, *The Pencil of Nature*. Facsimile ed. (New York: Da Capo Press, 1969), section on "Queen's College, Oxford."

36 Larry J. Schaaf, *Out of the Shadows: Herschel, Talbot and the Invention of Photography* (New Haven: Yale University Press, 1992), 142.

37 Talbot, *Pencil*, text accompanying Plate VI, *The Open Door*.

surrounding cultural structures, familial belief systems, and academic instruction. Artists (and others) sometimes assert that they want to look at the world as if "seeing it for the first time," in order to achieve an unbiased view, a fresh vision. But adults (or children) cannot possibly "see as a newborn" because our neurological impulses continually mine our memory bank, sifting through past encounters to categorize the *sensa* before us. Oliver Sacks explains that even those who regain sight after a long period of blindness are not on the same starting line, neurologically speaking, as a baby. A baby's cerebral cortex is equipotential—equally ready to adapt to any form of perception. The cortex of someone blinded at birth or in early childhood becomes adapted to organizing perceptions in time and not in space.[32] The blind live in a world of time—their survey of the world is based on a series of sequential encounters and occurrences. For example, the opening of a door may take place at the end of a sequence that involves a series of unobstructed steps, followed by a stair, and then the presence of a doorknob.[33] The newly sighted adult has the more difficult undertaking of adapting from years of sequential understanding to a visual–spatial mode. A sighted infant, on the other hand, learns how to synthesize a new world of sensations with no previous experience to assist or *conflict* with this task.

Throughout our lives, we often attempt to see the world anew. Tourists visit exotic locales in an attempt to experience the world anew. Like an infant, a tourist who travels to a new setting must see and think without the rich perspective of known sights, sounds, and smells. However, even in unfamiliar territory, the tourist is not a newborn, and always measures current experience against stored memory. We never look at just one thing in isolation; like our physiological vision that is continually active and constantly scanning, our mental vision continually compares what is happening against what once happened. Rather than merely perceiving the world from the sensory information available at any given time, we use this information to test hypotheses of what lies before us.[34] Unfamiliar sensations find their way into our collection of experiences, a coalescence of past and present and an anticipation of future.

Existing images, conventional aesthetic preferences, and scenic rest stops, among other influences, teach us to perceive and visually construct the world. When William Henry Fox Talbot surprised himself with his first images, he wrote excitedly about the "multitude of minute details" that he had not noticed while making the exposure, but observed later when examining the print: "inscriptions and dates are found upon the buildings, or printed placards most irrelevant, are discovered upon their walls: sometimes a distant dial-plate is seen, and upon it—unconsciously recorded—the hour of the day at which the view was taken."[35] Gradually, Talbot began to take notice of these details and to render the scene with more premeditation. For example, he began to photograph buildings from an elevated vantage point rather than from street level to show them in "correct" perspective without the effect of **keystoning**.[36] He drew upon

his knowledge of painting by using artistic devices that focused the viewer's attention: "A casual gleam of sunshine, or a shadow thrown across his path … may awaken a train of thoughts and feelings, and picturesque imaginings."[37] As Talbot became more aware of each object's placement within the scene and his position behind the **viewfinder**, he began to purposely compose images, such as *The Open Door* (Figure 1.19). Talbot's images begin to reveal his assessment or personal vision based on his private fascinations, his general knowledge of aesthetics, and his experiences with other artistic images. Similarly, the Scottish duo, painter David O. Hill (1802–1870) and chemist Robert Adamson (1821–1848), relied upon their knowledge of commemorative painting when they joined up to make photographic portraits.

Psychologists and neuroscientists have studied how people process visual information. Gestalt theory, the study of how people perceive elements within a frame, suggests that viewers take in all elements of a scene at once. In their book *Photographic Composition*, Tom Grill and Mark Scanlon write that a "weak frame" (Figure 1.21) is one "composed of two disjointed elements."[38] Rules of composition such as these often reveal insights into how we interpret compositions (and the subject represented) as weak, strong, balanced, etc. Grill's observation of the "weak frame" is based on Gestalt theory's principle of proximity, in which elements that are further apart are less likely to be seen as a group. Having an understanding of Gestalt theory and how composition affects interpretation enables one to make informed choices when organizing the visual field. However, these should not be qualitative judgments. A "weak frame" may make for a successful or problematic image depending upon the artist's goals. For example, a photographer who aspires to present the subject as a commanding presence will want to order elements cohesively. Those interested in making an image that seems disjointed may prefer to have random elements poke into the scene.

John Baldessari's (b. 1931) photograph *Wrong* (1967) plays with the canons of acceptable composition—in this case the dogma that one should never photograph someone in front of a tree because it will appear that the tree is growing out of the person's head. The original snapshot, taken by Baldessari's wife, shows the artist standing in front of a palm tree. By wilfully disobeying the " 'rule', Baldessari questioned the validity of the accepted bromides of art education, showing that they had nothing to do with 'good' or 'bad' art."[39] Baldessari's ideas concern restrictive art theories and the larger tension between perfection and imperfection in relation to art and everyday life.

The composition for another picture, *The Spectator is Compelled to Look Directly Down the Road and Into the Middle of the Picture*, is taken from a manual by Ernest R. Norling, *Perspective Made Easy*, which illustrates the pictorial convention of establishing eye level. In his recreation of that image, Baldessari can be seen from behind, purposefully ignoring the didactic warnings. "Why not just stare directly down the road into the middle for no reason at all," says Baldessari.[40] "My work comes from trying to see the

keystoning
A distortion resulting when a rectangular plane is photographed at an angle not perpendicular to the axis of the lens. The result is that the rectangle appears to have the shape of the keystone of an arch.

38 Tom Grill and Mark Scanlon, *Photographic Composition* (New York: Amphoto Books, 1990), 33.

1.21 Tom Grill, *Weak Frames*, 1990

viewfinder
The window in a camera. This frame shows an approximation of the picture the camera will photograph.

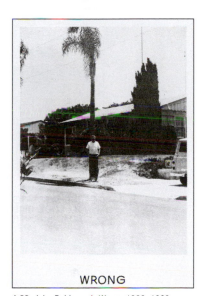

WRONG

39 Coosje van Bruggen, *John Baldessari* (New York: Rizzoli International Publications, 1990), 30.

1.22 John Baldessari, *Wrong*, 1966–1968. Acrylic and photo-emulsion on canvas, 59 × 45in

40 Van Bruggen, *John Baldessari*, 33.

41 Liam Gillick, "I Will Not Make Any More Boring Art: Interview with John Baldessari," *Art Monthly*, June 1995, 7.

42 Max Kozloff, *New York: Capital of Photography* (Connecticut: Yale University Press, 2002), 72.

43 Charles Hagen, "An Interview with Garry Winogrand," *Afterimage*, December 1977, 14.

world differently because I am tired of seeing the world the way it is presented. Our environment doesn't come to us with instructions."[41]

Likewise, in *Presidential Candidates' Rally* (Figure 1.24), Garry Winogrand (1928–1984) deliberately offsets the horizon line of the picture field, throwing its contents into an unstable seesaw. Our attention, which should be held by the political official, slips across the scene. The pillared building that should command our respect and order our attention seems to topple and pitch like a wayward ship. Winogrand used the tilting effect to picture democracy as "volatile, in a state of creation," but also to play with the rule of composition that advises that rectilinear boundaries of the viewfinder correspond to the conventions of parallel and perpendicular lines.[42] Winogrand said that "if somebody says to me, why'd you tilt the picture, I say, it isn't tilted. It's only tilted if you insist on the horizontal edge being the point of reference. That's just arbitrary."[43] This way of seeing had been demonstrated by another photographer, Robert Frank (b. 1924), a self-described outsider who published a materialistic, barren view of American culture in his 1959 monograph, *The Americans*, and set in motion the photographic fusion of the abstract expressionist style and the objective documentary.

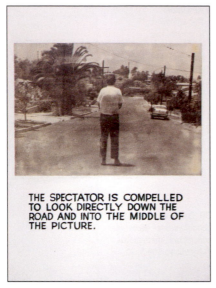

THE SPECTATOR IS COMPELLED TO LOOK DIRECTLY DOWN THE ROAD AND INTO THE MIDDLE OF THE PICTURE.

1.23 John Baldessari, *The Spectator Is Compelled …*, 1966–1968. Acrylic and photo-emulsion on canvas, 59 × 45in

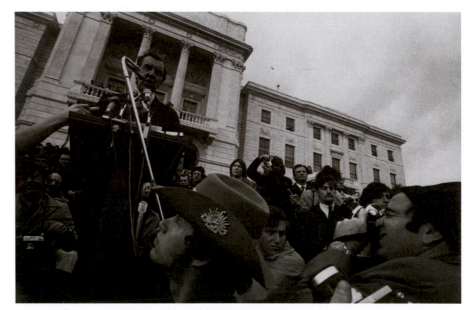

1.24 Garry Winogrand, *Presidential Candidates' Rally, Statehouse, Providence, R.I.*, 1971. Gelatin-silver print

Linear perspective and sight

A little cultural conditioning goes a long way. Pictorial conventions and modes of representation, largely derived from a history of draftsmanship and painting, continually reinforce principles of linear perspective, proportion, and symmetry. For centuries, artists and image-makers have faithfully employed these pictorial principles in their work, and they now represent a significant influence on vision.

We have come to rely on linear perspective as a known set of rules that articulate space on an illusory or two-dimensional surface. While Renaissance artists did not invent perspective, they developed a linear perspective based on geometry and standardized a system of picture-making in which all points in space recede toward one point in the distance. What was a radical proposition in the 15th century has been so absorbed and internalized that linear perspective is now a given—easily legible and assumed to represent natural vision. This is one example of how individual systems can quickly become absorbed as common knowledge. Another example is the collage technique used by David Hockney and Joyce Neimanas, which radicalizes photographic vision. However, as this system becomes accepted by many artists and audiences, the process could easily lapse into being another unconsidered convention.

The evolution of what we know as linear perspective is older than the Renaissance. Cave paintings, like those in Lascaux, France, from c. 16,000 to 14,000 BC, used a type of linear perspective in which closer objects are larger than distant objects. In order to define space and the relationships between entities, distant objects are partially obstructed and described with less clarity. Centuries later, Egyptian and Asian artists used their own rules to describe space by placing closer objects at the bottom of their pictures and distant ones higher up. Evidence that the Egyptians knew of linear perspective but chose not to use it indicates that the so-called discoveries during the Renaissance were not newly invented, but rather newly privileged. Early Greek art (from c. 500 BC) borrowed Egyptian conventions but also departed from them, so that by the 2nd century BC objects were foreshortened, faces shown in three-quarter perspective, and parallel lines of buildings converged—the conventions of **Renaissance perspective**.[44]

During the Renaissance, philosophies that valued reason and logic saw parallels to these beliefs within the consistency of geometry. The trend toward rational thought elevated the status of linear perspective. This perspective system claimed the existence of a vanishing point along the horizon. What had previously been "a confusing jumble of receding lines fell into place and became fixed at one point on the horizon."[45] In his provocative chapter "The Origins of the **Panorama**," Stephan Oettermann writes:

With the introduction of the horizon in their perceptual world, Europeans could not only embark on their voyages of discovery to the unknown lands beyond the horizon; they could also investigate the world within the horizon in a different way, using the new tool of perspective.[46]

Renaissance perspective
A method (aka one-point perspective or linear perspective) of creating the illusion of distance in a picture based on mathematical calculations. Developed in the early 15th century, Renaissance perspective shows depth by converging all lines on a central point in the distance.

panorama
A 360° unbroken view. Created in the late 18th century, the panorama was a popular tourist attraction; audiences viewed panoramas of pastoral, urban, and exotic landscapes and historic scenes painted on large cylinders that surrounded the viewers.

44 Solso, *Cognition*, 193.

45 Stephan Oettermann, *The Panorama: History of a Mass Medium* (New York: Zone Books, 1997), 8.
46 Oettermann, *Panorama*, 8.

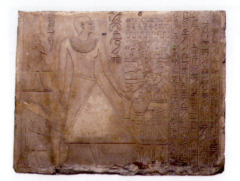

1.25 *Limestone stela of Tjetji* (detail: lower half). Egyptian limestone bas-relief of the XIth Dynasty, *c.* 2100 BC. From the tomb of Tjetji, in Thebes, showing a man and a woman carrying food for the dead man

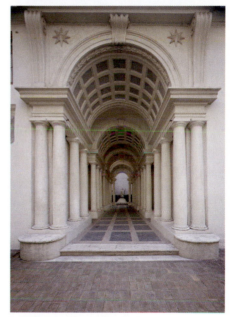

1.26 Francesco Borromini (1599–1667), *Perspective Gallery* or *Galleria Prospettica*, Palazzo Spada, Rome, Italy

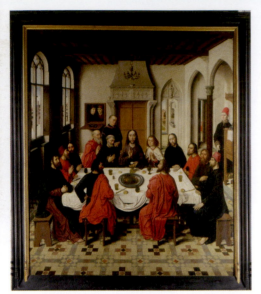

1.27 Dirk Bouts, *(central panel) Triptych of the Last Supper*, 1464–1468. Oil on oak panel, 1.8 × 1.51m

gaze
The idea of the gaze is a formal term within film theory and feminist film theory. It involves more than just looking. People always look in films, but the "gaze" refers to looks with specific meanings: usually the act of consumption, appropriation, control; and often the desire for a woman by a man who is looking at her. Jacques Lacan's use of the word "gaze" is more abstract and psychological, describing the fact that individuals are caught up in the scopic field of others.

foreshortening
A way of representing a subject or an object so that it conveys the illusion of depth – so that it seems to go back into space. Foreshortening's success often depends upon a point of view or perspective in which the sizes of the near and far parts of a subject contrast greatly.

47 Gregory, *Eye and Brain*, 164.

48 Solso, *Cognition*, 189.

The first pictorial depiction occurred in 1465, when Dirk Bouts (c. 1420–1475) painted his *Last Supper*.

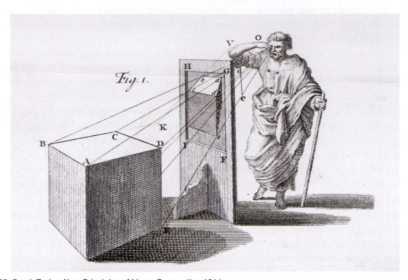

1.28 Brook Taylor, *New Principles of Linear Perspective*, 1811

The opportunity to use a singular tool to describe a complex world sounds miraculous. Procedurally, Leonardo da Vinci (1452–1519) summarized that perspective is "the seeing of a plane behind a sheet of glass, smooth and quite transparent on the surface of which all the things approach the point of the eye in pyramids and these pyramids are intersected on the glass plane."[47] Leonardo's pane of glass is analogous to another common symbol of the Renaissance system of seeing, a window. Seeing the world through this metaphoric window establishes a "perspectival" view of space. When we stand in front of a picture with linear perspective, we are meant to believe we are gazing through a window into another space. Prior to linear perspective, isolated objects may have been represented through **foreshortening**, but the space around them was not. In order to construct the illusion of looking through a window, early Renaissance artists devised methods and tools for drawing objects in perfect linear perspective. Albrecht Dürer (1471–1528) developed one device consisting of a "frame with vertical and horizontal wires strung across its opening to form a grid."[48] Artists used the frame as a transitional device that measured three-dimensional objects in space against the two-dimensional form of a grid.

A contemporary variation on the Renaissance window, John Pfahl's (b. 1939) series *Picture Windows*, is photographed through large windows. He "set the focus so that everything from inside the window-sill to infinity would be sharp and permitted stains, condensation, spots of dirt, and other marks to remain on the glass."[49] The window loses its transparency and becomes part of the scene. In her essay for Pfahl's monograph, *A Distanced Land: The Photographs of John Pfahl*, Estelle Jussim notes that the Renaissance window was possible because window glass had become "popular and cheap enough for the bourgeoisie to enjoy."[50] The type of window and its view are culturally specific; Yi-Fu Tuan writes that:

[in] many American homes are large picture windows. A guest, upon entering his host's home, may go straight to the picture window and admire what lies far beyond the house. … A traditional Oriental home, in contrast, has no picture windows; the rooms look inward to the interior courtyard, and the only expanse of nature visible to the inhabitants is the overarching sky. The vertical axis, rather than the open horizontal space, is the symbol of hope.[51]

However, Pfahl's pictures replicate the way many Americans experience nature: from the indoors.

Contemporary artist John Baldessari considers television to be the new Renaissance window on the world.[52] Television presents the world neatly flattened on a screen. Baldessari scavenges this collection of visual images for his work. Treating television's offerings like a library, he borrows images by photographing the screens of multiple sets. The recorded stills show actors from various late-night movies: frozen in positions, gestures, and stares. In *Two Opponents (Blue and Yellow)* (Figure 1.30), Baldessari emphasizes the line of sight between two men by placing dots on the end points of this **gaze**. In his article, "Pointing, Hybrids, and Romanticism: John Baldessari," James Collins describes the significance of the gaze: " 'Looking' is another way of pointing."[53]

A standardized form such as linear perspective concisely sums up the terrain. In doing so, complex dynamics are forced to fit the needs of the convention. Ernst Cassirer describes this evolution from observation to mediation:

Physical reality seems to recede in proportion as man's symbolic activity advances. Instead of dealing with things themselves, man is in a sense constantly conversing with himself. He has so enveloped himself in linguistic forms, in artistic images, in mythical symbols, or religious rites that he cannot see or know anything except by the interposition of [an] artificial medium.[54]

In *Techniques of the Observer*, Jonathan Crary applies this dynamic to the human eye when he writes that the "functions of the human eye are being supplanted by practices in which visual images no longer have any reference to the position of an observer in a 'real,' optically perceived world."[55]

49 Estelle Jussim, "Passionate Observer: The Art of John Pfahl," in *A Distanced Land: The Photographs of John Pfahl*, ed. Mary Cochrane and Dana Ashbury (New Mexico: The University of New Mexico Press, 1990), 12.
50 Jussim, "Passionate Observer," 11.

51 Tuan, *Space and Place*, 124.

52 James Collins, "Pointing, Hybrids, and Romanticism: John Baldessari," *Artforum*, October 1973, 56.

53 Collins, "Pointing," 56.

54 Neil Postman, *Amusing Ourselves to Death* (New York: Penguin Group, 1985), 10.
55 Jonathan Crary, *Techniques of the Observer: On Vision and Modernity in the Nineteenth Century* (Cambridge, MA: MIT Press, 1990), 2.

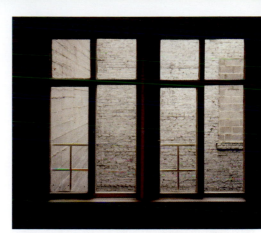

1.29 John Pfahl, *228 Grant Avenue, San Francisco, California* (December 1980) from the series: *Picture Windows*, 1978–1981

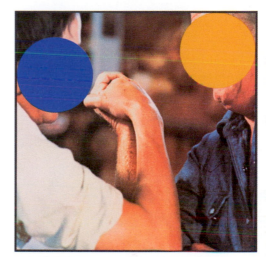

1.30 John Baldessari, *Two Opponents (Blue and Yellow)*, 2004

The window effectively severs the body from space, separating the mind and eye from the physical environment that surrounds vision. For theorists such as Martin Jay, the author of "Scopic Regimes of Modernity," the distance of Renaissance perspective "meant the withdrawal of painters' emotional entanglement" from the objects they depicted in geometrized space. Telling stories became less important than the technical virtuosity shown in depicting a scenario.[56] Theorists writing about diverse technologies that mediate seeing, from the Renaissance grid to a 21st-century photographic camera, often suggest that the devices set up a "chronic voyeuristic relation to the world that levels the meaning of all events."[57] Following the economic, social, and visual chaos of the Middle Ages, it is easy to understand why geometrized perspective appealed to Renaissance society. Linear perspective supplied a fixed relationship between viewer and world, one in which "depictions of visual space acquired a new solidity."[58] The need for quantitative and discrete experiences applies to contemporary observers as well. In the early 1970s, Susan Sontag conjectured that viewers positioned themselves behind a photographic camera in order to feel more empowered and more willing to inhabit unfamiliar spaces.[59] The viewfinder mediates a situation by allowing the user to address a subject behind the known entity of the frame, protecting against the uncertainties of physical interaction.

The protective frame, which separates the internal me from the external you, is often explicit in contemporary images, such as Shizuka Yokomizo's (b. 1966) *Dear Stranger* series (described later in "Copying, Capturing, and Reproducing") or American journalists Chris Hondros's (b. 1970) and Andrew Craft's images of daily life in Baghdad.[60,61] During the Iraq War, these embedded photojournalists accompanied soldiers patrolling the country and used the frame of the Humvee window to enclose their viewpoint. In the ongoing *Window Standpoint Series*, a group of French artists extend an open invitation to artists around the world to submit a photographic view and soundclip from their window. By clicking on red dots scattered throughout a map of the world, viewers gain access to the personal, everyday vantages of other artists. This series of structured views—breathtaking, desolate, banal, and often familiar scenes—offers glimpses into and from the private lives of artists. Anders Östberg's window looks out onto a parking lot and other units in the apartment complex, contesting the idea of the unique artist's vision. The *Window Standpoint Series'* founders claim the Internet as the new model of vision: "The window, just as the browser's window, becomes the access onto other dimensions (space, time, sound), and proposes as a new platform. At that very, fixed, moment, the frozen picture becomes one object of sharing."[62]

Though we have internalized the conventions of linear perspective, actually seeing in perspective is a strenuous, if not impossible, artifice. To see, our two eyes continually scan. Our head, neck, and spine twist and maneuver to assist this scanning so that our body can assemble images of the world. Renaissance perspective, like the photographic

1.31 Anders Östberg, *Window Standpoint, Eskilstuna, Sweden*, February 13, 2005. Digital photograph

56 Martin Jay, "Scopic Regimes of Modernity," in *Vision and Visuality*, ed. Hal Foster (New York: The New Press, 1988), 8.
57 Sontag, *On Photography*, 11.
58 Oettermann, *Panorama*, 8.
59 Sontag, *On Photography*, 9.

60 Chris Hondros, *Chris Hondros: A Window on Baghdad*, 2007 (http://www.chrishondros.com/images.htm) (25 August 2009).
61 Andrew Craft, *Andrew Craft: Humvee TV*, 2007–2008 (http://www.humveetv.com/) (25 August 2009).

62 L'appareil, *Window Standpoint Series*, n.d. (http://www.lappareil.com/window/) (25 August 2009).

camera, reduces this activity to one unblinking eye, fixed on a singular vanishing point along a continuous horizon. This single, all-encompassing vantage is often referred to as coming from the eye of God, the "Eye/I," a fixed, distant, and all-knowing observer.

The Renaissance window's flat pane of glass is different than the concave surface of our retina. In *Perspective as Symbolic Form*, Erwin Panofsky notes that even the German astronomer Johannes Kepler (1571–1630) recognized that:

he had originally overlooked or even denied these illusory curves only because he had been schooled in linear perspective. He had been led by the rules of painterly perspective to believe that straight is always seen as straight, without stopping to consider that the eye in fact projects not onto a *plana tabella* [a flat surface] but onto the inner surface of a sphere. And, if even today only a very few of us have perceived these curvatures, that too is in part due to our habituation—further reinforced by looking at photographs—to linear perspectival construction.[63]

A world composed solely of straight lines and mathematical structure also overlooks the atmospheric phenomena that mists and softens our vision. Artists such as Leonardo da Vinci understood the potency of air quality and the effects of weather on a scene, and used techniques to temper the pure geometry of perspective. For example, in his renderings, Leonardo suggested distance by drawing with increased haze and blueness. He clarified the orientation of objects using shadows and shading. Over time, linear perspective evolved beyond the generic and ambiguous articulation of receding lines.[64]

Is it possible to counter the mind–body split emphasized by the Renaissance distinction? In an attempt to enter physically the world on the other side of the Renaissance window, philosopher Ernst Mach (1838–1916) drew portions of his body as part of his visual field. An image from Mach's *Analysis of Sensations* (Figure 1.32), published in 1885, contains as much of himself as he could see from one eye—nose, moustache, eyelashes, and lower body. Mach makes the point that "in ordinary visual experience, one is seldom conscious of the ways in which the body is continually present but effectively deleted out of one's visual perceptions." His image questions the visual logic that separates "inner" and "outer."[65]

Contemporary artist Tim Hawkinson (b. 1960) goes one step further, by focusing on the parts of his body that are not self-visible and, therefore, usually unable to be accounted. We humans can see only about three-fourths of our body. Though we can touch all areas, our visual experience of the top and back of our head, our forehead and the tip of our chin, among other places, is always a mediated visual experience— through reflections in mirrors, and shots from video and still images. Hawkinson uses the camera as a floating third eye that can view parts of himself not accessible through his own vision. He marks off the boundaries between the visible and invisible areas of his anatomy and has someone photograph all the parts he cannot see. By piecing

63 Erwin Panofsky, *Perspective as Symbolic Form* (New York: Zone Books, 1991), 34.

1.32 Ernst Mach, *Inner Perspective*, 1885, illustration from *The Analysis of Sensations*, 1885

64 Gregory, *Eye and Brain*, 168.

65 Jonathan Crary, *Suspensions of Perception: Attention, Spectacle and Modern Culture* (Cambridge, MA: MIT Press, 1999), 220.

1.33 Tim Hawkinson, *Blindspot*, 1991, Photomontage, 22 × 16 × ¾in

66 Michael Duncan, "Tim Hawkinson at Ace Contemporary Exhibitions," *Art Issues*, September–October, 1993, 44.

67 Charles Desmarais, *Humongolous: Sculptures and Other Works by Tim Hawkinson* (Cincinnati: The Contemporary Arts Center, 1996), 10.

68 Catherine M. Howett, "Where the One-Eyed Man is King: The Tyranny of the Visual and Formalist Values in Evaluating Landscapes," in *Understanding Ordinary Landscapes*, ed. Paul Groth and Todd W. Bressi (New Haven: Yale University Press, 1997), 87.

69 Howett, "One-Eyed Man," 95.

70 Allen S. Weiss, *Mirrors of Infinity: The French Formal Garden and 17th-Century Metaphysics* (New York: Princeton Architectural Press, 1995), 13.

71 William Howard Adams, *Nature Perfected: Gardens Through History* (New York: Abbeville Press, 1991), 93.

72 Adams, *Nature Perfected*, 109.

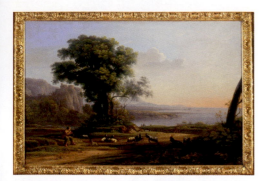

1.34 Claude Lorrain, *Pastoral Landscape (Sunset)*, 1645–1650. Oil on canvas, 74 × 110cm

1.35 *Middle distance garden*, 2009, Chelsea, MI

> **formal**
> Relating to the form and structure of the work of art, i.e. visual elements such as shapes, lines, color, and texture.

the photographs together into a kind of skin, he constructs "a self-portrait of his unknown self."[66] The final body map, *Blindspot*, 1991 (Figure 1.33), allows Hawkinson to contemplate "aspects of his self from different perspectives than would ordinarily be possible."[67]

Framing our environment

Perspectival paintings originated as artistic representations of the everyday world. Eventually, these depictions conditioned expectations of what the *actual* world should look like. Inspired by the idealized visions in the Renaissance pictures, landscape gardeners designed and constructed existing spaces to conform to the formal order of an intellectualized linear vision. Geometry served to mitigate the apparent disorder or chaos of an environment previously left to organic evolution.[68] In her essay, "Where the One-Eyed Man is King," Catherine M. Howett writes that artistic and scientific developments from the Renaissance to the present have predisposed Western societies to "experience the world in particular ways, and with particular expectations."[69] The carefully constructed landscape, carved to facilitate specific views of nature, would ultimately influence most of the landscape photography in the 19th and 20th centuries.

The crowning triumph of logic and geometry over disorder and chaos can be found in the Italian Renaissance garden. Following consistent **formal** traits, Italian Renaissance gardens (archetypal examples include the Villa Medici, *c.* 1544, and the Villa d'Este, *c.* 1550) were typically constructed on sloping terrain. The villa of the estate sat at the summit, providing an optimal view of the garden below as well as a vista of the landscape and the cityscape beyond. Geometric principles in laying out the garden resulted in regular and symmetrical placement of trees, fountains, flower beds, and statues.[70] From his garden in Villa at Poggio a Caiano (*c.* 1480), Lorenzo de' Medici could assume the eye of God. His survey of terraces, vineyards, and the open Tuscan countryside just north of Florence provided a showcase of his property, an overlook for the estate's cheese- and wine-making, and a retreat from the city filled with disease.[71]

Trees, shrubs, and planting beds are not inclined to stay in line, requiring continual maintenance in order to preserve their geometric exactitude. By the end of the 17th century, the natural growth and the neglect of planting were beginning to engulf the Italian gardens. The unpredictable growth transformed the strict linearity "into romantic picturesque landscapes that would make a deep and lasting impression on French and English travelers and artists."[72] Claude Lorrain (1600–1682), Nicolas Poussin (1594–1665), and others painted the worn Italian landscape.

Europeans believed these images to show how the classical countryside and garden must have once appeared and 18th-century English landscape architects designed the "wild" English garden based on a comprehensible visual order and a unified whole. For

example, one of the period's foremost designers, "Capability" Brown, advocated devices for landscaping that are now common in photographic composition, such as devising an appealing tension between the rustic and the cultivated and using a middle-distance feature as a visual resting point. A consistent feature in Brown's work was the use of round clumps of trees. Casually positioned as "middle-distance gardens," the clusters allowed a kind of wild garden to be enjoyed and contemplated somewhere between the vast beyond and the domestic scale (Figure 1.35).[73] The strong middle ground fills the emptiness and directs our vision on toward the horizon. This and other landscaping techniques, such as shrubbery enframing the sides of the view, are compositional devices that would influence most landscape photography in the coming centuries.

Like Claude Lorrain and Nicolas Poussin in Europe, 19th-century painters of the American **Hudson River School**, such as Thomas Cole (1801–1848) and Frederick Church (1826–1900), composed landscape scenes that framed America as pastoral or picturesque. Views painted by the Hudson River artists became popularized at exhibitions in museums and world's fairs. Through their pictorial conventions, "Americans began to see their native landscape as an object of aesthetic value."[74] In the late 19th century, American photographers such as Carleton Watkins (1829–1916), Timothy O'Sullivan, Eadweard Muybridge, and William Henry Jackson looked at works by Cole, Lorrain, and Turner. They consulted landscape paintings to learn the methods for depicting an aesthetically pleasing East Coast and a Western landscape of grandeur and isolation. Photographers who sold photographs and stereocartes of scenic views hired guides to shepherd them to famous spots along Niagara Falls and the Yosemite Valley. In his biography of Watkins, Peter Palmquist tells the story of the photographer's tenuous trips to Yosemite, escorted by pack animals carrying more than 100 glass negatives.

Interests and outcomes were usually financially motivated. Surveyors who needed evidence of a site's commercial possibilities, or documentation of property boundaries in court disputes, commissioned much of Watkins's early work. Sold or shown to the public, the photographs popularized previously unknown sites, and the sweeping stereo views of Yosemite were partly responsible for Congress's 1864 Bill preserving the lands as a national park.[75] Not until the 1960s and the New Topographic style would photographers reject the heroic in favor of the banal.

The American landscape was profoundly shaped by another, earlier, governmental effort. As part of the westward expansion of United States territory, the Land Ordinance Survey of 1840 effectively laid a grid over half of the continental US. Led by Thomas Jefferson as chief surveyor, vast areas of land were sectioned into geometric form. The rectilinear forms that became Kansas, Nebraska, and Oklahoma, among other states, are easy to recognize from the air or on a map. Jefferson's grid platted land into consistent parcels of 640 square acres. Long, straight, east–west roads define these vast agricultural tracts, occasionally punctuated by north–south routes. Efficiency dictates the form.

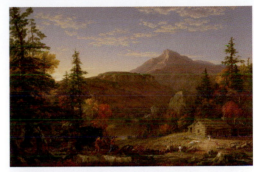

73 Adams, *Nature Perfected*, 174.

1.36 Thomas Cole, *The Hunter's Return*, 1845, Oil on canvas, 40⅛ × 60¼in

74 Howett, "One-Eyed Man," 92.

Hudson River School
Style of painting that originated in the area along the Hudson River north of New York City to Albany. Artists were interested in landscape and the quality of light given off by the river.

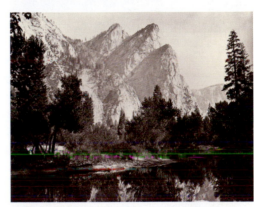

1.37 Carleton E. Watkins, *Three Brothers, 4480 ft.*, Yosemite, *c.* 1865–1866. Albumen print

75 Peter E. Palmquist, *Carleton E. Watkins: Photographer of the American West* (Albuquerque: University of New Mexico Press, 1983), 14–18.

1.38 Robert Irwin, *Black Plane, Fifth Avenue and 42nd Street, New York*, 1977

76 Lawrence Weschler, *Seeing is Forgetting the Name of the Thing One Sees: A Life of Contemporary Artist, Robert Irwin* (Berkeley and Los Angeles: University of California Press, 1982), 186.

77 Anthony Bannon, "John Pfahl's Picturesque Paradoxes," *Afterimage*, February 1979, 10.

78 Adams, *Nature Perfected*, 183. John James's 1712 translation of Dezallier d'Argenville's text.

1.39 John Pfahl, *Pink Rock Rectangle, Artpark, Lewiston, New York*, August 1975. From the series: *Altered Landscapes, 1974–1978*. Ektacolor print

Easily divisible by whole numbers, the conformance to **Euclidean geometry** reinforced a Western culture visually beholden to Renaissance linear perspective.

As reductive and restrictive as this geometry sounds, the ideals that inspired the Land Ordinance Act held higher aspirations than efficiency alone. Inspired by the rational thought of the Renaissance that championed elegant proportional relationships, and of the Enlightenment that articulated a balance between collective good and individual goals, the grid promised a great deal. Visible structure was thought to symbolize a transparent democracy, a radical break from the hierarchical royal and feudal societies of preceding centuries. Similarly, offering everyone an equal portion, so to speak, promised an egalitarian distribution of land and resources, as did the modular grid system that carries with it the possibility of endless and regular extension.

West Coast artist Robert Irwin's (b. 1928) aerial photographs capture the hypnotic, similar reliance on linear logic of Manhattan, which in 1811 imposed a regular arrangement of streets and avenues intersecting at right angles on undeveloped portions of the island. Irwin's photographs also include his own addition to the gridwork—the black paint he spread over the square defined by the crosswalks at the intersection of Manhattan's Fifth Avenue and 42nd Street (Figure 1.38).[76] Like a spotlight, Irwin's black square brings attention to already-existing but often unseen structures—buildings, streets, sidewalks—that inform the way we live and move through space.

Playing with perspective

In his *Altered Landscapes* series (1974–1978), John Pfahl used tape, chalk, and other materials to create a frame or other symbols over pastoral scenes. Close inspection of the color photographs reveals the marks to be placed within the actual landscape, rather than on the surface of the image. To create the work, Pfahl selected a scene and point of view, then traced simple drawings on the glass viewfinder of a 4×5-inch view camera. He meticulously attached tape and other materials to columns, rocks, trees, and shrubbery to mimic his drawings. Pfahl adjusted the materials and took Polaroid snapshots to test the illusion until the markings appear to be sitting on the surface of the image on the viewfinder. The illusion can only be viewed "by the camera situated at that one crucial point in space."[77]

Pfahl's marks within a space reference the mark-making devices used by gardeners. In his 1712 *La Théorie et la practique du jardinage* (*Theory and practice of gardening*), Dezallier d'Argenville advises "ruling out [on paper] a general plan" of geometric patterns for the land. The detailed paper drawings are then transferred by an assistant to the ground, using string and stakes.[78] Once Pfahl had a printable negative, he removed any traces of his intervention from the land. His work exists only as a photograph of a single perspective of that experience. As an ephemeral act, his work belongs to the realm of

Earthworks, in which artists engage with concepts of nature by acting as gardeners in site-specific locations.

Additionally, Pfahl's site-specific constructions explore "problems of perception," specifically, anamorphic art. In **anamorphic art**, as in Figure 1.40, distorted or stretched versions of images are corrected when viewed from a specific angle or as a reflection. Anamorphic art provides guidelines for viewing in the same way as other everyday devices: the blue dotted lines of grammar school paper, the camera's viewfinder, and the focus and target guides of a rifle. Pfahl simulates these types of indicators with tape and string. The rock formations in Pfahl's *Pink Rock Rectangle* are imprinted with a box that could reference the rectangle of a standard photographic print, the camera's viewfinder, or a car's windshield. Lest we forget that we view according to the conventions of one-point perspective, *Red Arrow* reminds us of photography's linear agenda; the shaft leads our eye in what Yi-Fu Tuan called the directional image of time as an arrow.[79]

Absorbed in space

Theoretically, open space is a common symbol of freedom in the Western world that implies possibility. In practice, openness often makes us feel vulnerable.[80] From the orderly development of Manhattan in 1811, to the settling of the Western frontier in the 1840s, and to suburban developments from the 1930s to the present day, Americans have organized empty or under-populated places into quantifiable systems. By continually inserting marks of human order and habitation into or onto the world, we reveal a tendency to occupy space rather than simply letting it be. This culturally specific way of dealing with open space could be explained as a form of "horror vacuii", or fear of empty space. In this excerpt from Wallace Stevens's poem, "Anecdote of the Jar,"[81] the object operates as organizer:

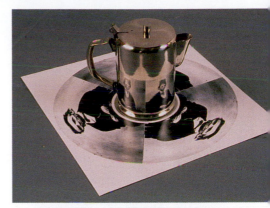

1.40 Paul Ramirez-Jonas, *Untitled (anamorph)*, 1991, 14 × 14 × 12in. Two images of Lincoln and one of Jefferson Davies are printed as an anamorph. The image can be seen undistorted as a reflection on the pitcher

79 Tuan, *Space and Place*, 179.

80 Tuan, *Space and Place*, 54.

81 Wallace Stevens, *Wallace Stevens: Collected Poetry and Prose* (New York: The Library of America, 1997), 60.

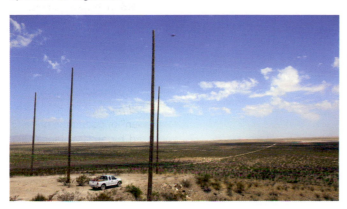

1.42 Chris Taylor, *Twin Buttes*, May 15, 2009. Digital photograph. Looking northwest from Twin Buttes towards White Sands National Monument and missile test range

1.41 John Pfahl, *Red Arrow, Roan Mountain, North Carolina*, June 1975. From the series: *Altered Landscapes*, 1974–1978. Ektacolor print

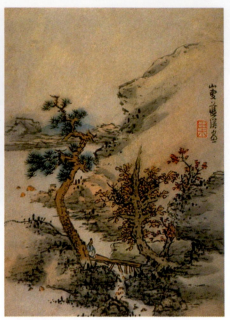

1.43 Lan Ying, *Scholar in a Landscape*. China, Ming Period (1368–1644). Album leaf, ink and color on paper, 12⅝₁₆ × 8¾in

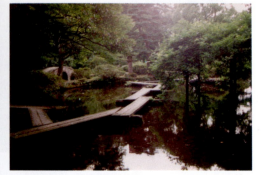

1.44 Central Park, Kanazawa, Japan

82 Naomi Rosenblum, *A World History of Photography* (New York: Abbeville Press, 1984), 133.

83 Rosalind Krauss, *The Originality of the Avant-Garde and Other Modernist Myths* (Cambridge, MA: MIT Press, 1985), 106.

84 Tuan, *Space and Place*, 16.

I placed a jar in Tennessee,
And round it was, upon a hill.
It made the slovenly wilderness
Surround that hill.

The wilderness rose up to it,
And sprawled around, no longer wild.

Vision, unable to cope with open space, looks for a focal point.

Space can resound with the same tension in photographic images. When confronted with the vast skies of the American wilderness, photographers such as Eadweard Muybridge (1830–1904) "at times printed in the clouds from separate negatives to satisfy critics who found the contrast between foreground and sky too great."[82] Conversely, **Dadaist** collage of the 1920s used expanses of white page or halos of space around images to bear the psychological weight of images. As the viewer's eye travels from one reality to another, the "fluid matrix" of the blank space combines and separates diverse depictions in one place.[83]

Differences between Western/Renaissance and Eastern attitudes toward space are palpable. Chinese scrolls were meant to be slowly unrolled, revealing their depicted scenes one after another rather than all at once. Likewise, East Asian gardens are constructed to be experienced gradually and are characterized by winding curves. One comes upon objects of contemplation, framed views, or particular garden elements sequentially while passing along a rambling path; no place, object, or viewpoint takes precedence over another. This is in stark contrast to the linear insistence of Western gardens, which present landscape from a fixed point of view and tend to feature one element (a tree, fountain, or castle) as a beacon or monument. Non-Western cultures often rely on circular features rather than linear or grid-like structures. Traditional Zulu culture, for example, plows land in curves. The Ethiopian home shown in Figure 1.45 is a round hut. Geographer Yi-Fu Tuan notes that "Dakota Indians find evidence of circular forms in nature nearly everywhere, from the shape of birds' nests to the course of the stars. In contrast, the Pueblo Indians of the American Southwest tend to see spaces of rectangular geometry."[84]

People living in dense forest do not experience distant objects. Because the Congo Pygmies are:

enveloped in the dense forest, the distinction between "land" and "sky" lacks perceptual support for them. The sky is seldom visible. … Vegetation camouflages all landmarks. A Pygmy cannot stand on a prominence and survey space before him; he cannot peer into the horizon where events occurring then may affect him later. He does not learn to translate spontaneously the apparent size of an object

into distance. For example, he tends to see a distant buffalo as a very small animal. Distance, unlike length, is not a pure spatial concept; it implies time.[85]

Someone who has lived only in dense forest may never see farther than a few feet away. If he or she is brought into a wide, empty landscape, they "may reach out and try to touch the mountaintops with their hands; they have no concept of how far the mountains are."[86] Size and distance have to be learned on the basis of experience. In National Public Radio's *This American Life* episode on "Kid Logic," the broadcast began with the story of a small child about to embark on her first plane ride. Sitting on the plane before takeoff, she turned to her companion and asked, "When do we get smaller?"[87]

MEDIATED VISION: PHOTOGRAPHY AND OPTICAL DEVICES

Our inattention to the influences of tools such as the eye and brain, visual conventions such as perspective, and our constructed environment is somewhat understandable. More surprising, perhaps, are the ways we use visual technologies daily, yet rarely notice how these devices organize our world. We arrange friends within the camera's viewfinder and consume TV narratives without actually regarding the technology that constructs the images. Just as we see without recognizing the process of seeing, we bypass the technology that mediates visual encounters and go straight to the picture. When the tools that produce the images are taken for granted, we become less aware of the photographic way of seeing. In *The Reconfigured Eye*, William J. Mitchell explains that while we may think we control the mechanics of photographic construction—cameras, lenses, and other paraphernalia—it is actually these devices that determine the way we "see the world": "While we have been using the tools, operations, and media of photography to serve our pictorial ends, these instruments and techniques have simultaneously been constructing us as perceiving subjects."[88]

Optical devices, often contrived to augment or amplify the function of the human eye, have implications far broader than the intended function of the device. Eyeglasses are an example of this broader phenomenon. Hunter-gatherers from the Paleolithic period never needed eyeglasses, points out Edward Tenner in his fascinating analysis of human performance interfaces, "Second Sight: Eyeglasses."[89] Early humans exercised the full range of their eyes by searching for distant prey and scrutinizing details of edible plants. As humans became literate we overstimulated those parts of the eye that focus on close objects. Our newly trained eyes could not see distanced objects clearly without corrective lenses. Tenner calls attention to three simultaneous expansions in the 15th century: growing literacy rates, the development of printing presses churning out more books (with smaller print), and the birth of the eyeglass industry.

85 Tuan, *Space and Place*, 119.

86 Sacks, *Anthropologist*, 119.

87 "Kid Logic," Narr. Ira Glass. *This American Life*. Chicago Public Radio. NPR. 22 June 2006.

88 William J. Mitchell, *The Reconfigured Eye: Visual Truth in the Post-Photographic Era* (Cambridge, MA: MIT Press, 1992), 59.
89 Edward Tenner, *Our Own Devices* (New York, Alfred A. Knopf, 2003).

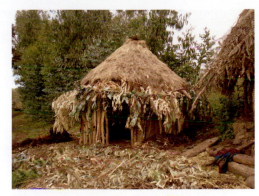

1.45 *Home, Simien Mountains, Ethiopia*, 2001

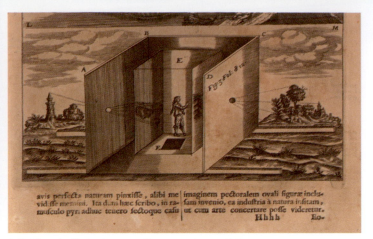

1.46 Athanasius Kircher, Large portable camera obscura, 1646

90 John H. Hammond, *The Camera Obscura: A Chronicle* (Bristol: Adam Hilger, 1981), 1.

91 Helmut Gernsheim and Alison Gernsheim, *The History of Photography: From the Camera Obscura to the Beginning of the Modern Era* (New York: McGraw-Hill, 1969), Part I.

In general use by the 17th century, spectacles had the practical function of restoring weakened eyesight. Vision resigned to shadow and obscurity regained vitality and distinctions. However, eyeglasses had another, broader outcome. If one's eyesight could be improved, then why not other deficiencies? Corrective lenses introduced the notion that individuals need not make do with their natural bodies, their human imperfections. Most tools operate this way: while correcting an immediate problem, they also instigate profound shifts in how we experience our bodies, our culture, or our environment.

THE VIEWER AS DISTANT OR ENMESHED OBSERVER: THE CAMERA OBSCURA

The camera obscura is a key visual tool that provides a model for understanding vision during the 17th and 18th centuries. In the 5th century BC, the Chinese philosopher Mo-Ti (470–390 BC) described the basic principle at work in the camera obscura: that light, traveling through a pinhole into a darkened room, would project an inverted image of the scene outside that chamber. He referred to this darkened room as a "collecting place" or the "locked treasure room."[90] Both terms emphasize what was assuredly a magical display of lights—in color, upside down, reversed from left to right, twinkling and ephemeral from motion—and downplay the images' connection to the outside world. Mo-Ti's "treasure room" appeared to offer a wondrous miracle. His description of these phenomena would be redefined in future centuries as the camera obscura, a dark room widely used by scientists, magicians, and artists.

Most histories of photography begin with the camera obscura. They record, chronologically, descriptions by Mo-Ti and other scholars. In one of the earliest written accounts, the Greek philosopher Aristotle (384–322 BC) observed the optical principles of the camera obscura at work in nature. He viewed the crescent shape of a partially eclipsed sun projected on the ground through the gaps between the leaves of a tree. Alhazen of Basra (AD 965–1040), an Arabian scholar, wrote of these principles and noted that the size of the aperture affected the image's clarity. Helmut and Alison Gernsheim's *The History of Photography* details the technical evolution of the camera obscura as a "prehistory" to modern photography.[91] This history attempts to establish a lineage of optical devices, all invented in order to record reality more realistically and with greater accuracy. The histories typically begin with the camera obscura and Renaissance perspective, and culminate in 1839 with the **daguerreotype** and calotype, inventions that captured and fixed a photographic image. However, alternative theories of this progression do exist. Jonathan Crary's *Techniques of the Observer* and Geoffrey Batchen's *Burning with Desire* have proposed that the camera obscura shares only

technical similarities with the photographic camera. Moreover, philosophically the two instruments differ greatly. Within the darkened rooms of the camera obscura, 17th- and 18th-century observers operated under a radically different model of vision.

Beginning in 1342, the principal documented use of the camera obscura was as a kind of observatory, useful for observing the sky, particularly during eclipses. These large darkened rooms allowed astronomers to record changes in the moon indirectly and safely without being obscured or blinded by the rays of the sun. In his book *Magia naturalis* (1558), the scientist Giovanni Battista della Porta explained the process by which "one can see in the dark all things on which the sun shines outside, and with their colours."[92] In a later edition (1559), he introduced two notable discoveries that sharpened the patterns of light: first, that a convex lens, placed in the aperture, produced a clearer projected image; second, that the addition of a concave mirror, placed at an angle of 45 degrees, would flip the upside-down image to right-side up on the viewing wall. These technical modifications, a lens and a mirror, extended the possible uses for the instrument and served as the technical basis for the modern single-lens reflex camera.

Those who observed the moving spectacle in the darkened chambers frequently "spoke with astonishment of the flickering images … of pedestrians in motion or branches moving in the wind as being more life-like than the original objects."[93] The dancing mirage of light and shadow is essential to the experience of the camera obscura. This is why Jonathan Crary cautions against reducing the camera obscura to "an inadequate substitute for what they [artists] really wanted … a photographic camera. Such an emphasis imposes a set of twentieth-century assumptions … onto a device whose primary function was not to generate [still] pictures."[94] Both devices use a camera body, aperture, lens, and mirror. Each views the world from the fixed, static position of the Renaissance monocular eye. However, the camera obscura retains the vitality of movement within this illusory depiction. Diderot's *Encyclopédie ou dictionnaire raisonné des sciences, des arts et des métiers* of 1753 values the camera obscura as a way to witness the world as an orderly projection, at a distance from the real thing:

[The camera obscura] throws great light on the nature of vision; it provides a very diverting spectacle, in that it presents images perfectly resembling their objects; it represents the colors and movements of objects better than any other sort of representation is able to do.[95]

In "Revealing Technologies/Magical Domains," Barbara Maria Stafford challenges Crary's notion that the camera obscura offers viewers a "space of reason." Stafford suggests that someone inside a camera obscura would more likely misinterpret visual information by projecting their fantastical imaginings onto the illusions of lights, images, and sounds being tunneled in from the outside:

daguerreotype
One of the first processes of fixing a photographic image. Invented by Louis J.M. Daguerre in 1839, the process produced a one-of-a-kind (non-reproducible) positive image formed by mercury vapor on a light-sensitized copper plate. The delicate daguerreotype images, most of which were portraits, were often set inside ornate cases and required viewing from a certain angle because of their highly polished surface.

92 Gernsheim and Gernsheim, *History of Photography*, 20.

93 Crary, *Techniques*, Cambridge, MA ,34.

94 Crary, *Techniques*, 32.

95 Crary, *Techniques*, 32.

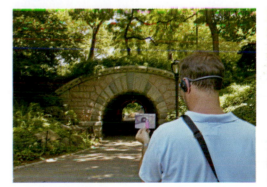

1.47 Janet Cardiff, *Her Long Black Hair*, 2004, Audio walk with photographs, 46 minutes. Curated by Tom Eccles for the Public Art Fund. Central Park, New York. (June 17–Sept 13, 2004)

1.48 Janet Cardiff, *In Real Time*, 1999, Video walk, 18 minutes. Curated by Madeleine Grynsztejn for the 53rd Carnegie International at Carnegie Library, Carnegie Museum of Art, Pittsburgh (November 6, 1999–March 26, 2000)

1.49 Janet Cardiff, *In Real Time*, 1999, Video walk, 18 minutes. Curated by Madeleine Grynsztejn for the 53rd Carnegie International at Carnegie Library, Carnegie Museum of Art, Pittsburgh (November 6, 1999–March 26, 2000)

tween
A term used in animation to refer to frames interpolated between the key frames; these in-between frames help to morph one shape into another.

96 Barbara Maria Stafford, "Revealing Technologies/Magical Domains," in *Devices of Wonder: From the World in a Box to Images on a Screen*, ed. Barbara Maria Stafford and Frances Terpak (California: Getty Publications, 2001), 81.

97 Carolyn Christov-Bakargiev, "Janet Cardiff," from *CI:99/00, Volume 2 Carnegie International 1999/2000* (Pittsburgh: Carnegie Museum of Art, 2000), 124.

98 Christov-Bakargiev, "Janet Cardiff," 124.

When individuals isolated themselves from any context by retreating into a black box pierced only by a light-channeling hole, they could no longer see the source of the scintillating apparitions appearing before them. Mesmerizingly alive with sparkling spots and flashing highlights, the camera obscura's fanciful hyperimages revealed what was "occulted," or invisible, to the unaided senses—including the bizarre contents of the onlooker's imagination. Dreamy images—that are false in spite of their magical vividness—blended with the watery substance of the beholder's reveries. The effect was akin to *tweening* in computer animation, where a fluid motion is automatically created between two separate frames.[96]

Without being able to see what is occurring outside the box, the viewer became a participant in, a creator of, the vision, rather than a reserved and objective mind.

Contemporary artist Janet Cardiff (b. 1957) creates situations in which individuals are simultaneously distant observers and invested participants. In early pieces such as *Her Long Black Hair* (Figure 1.47), "viewers" listen to Cardiff's voice on a CD and follow her instructions on a walk through New York's Central Park. The CD includes Cardiff's instructions of where to walk, accounts of events that occurred during her own stroll, and other bits of narration. Included in the packet with the CD are a few photographs that she calls upon during the walk. These images provide visual access into the story, but also ground the site in another time—when the images were taken. Cardiff's taped observations and background noises (bicycle bells, others' voices, etc.) merge and contradict with sounds experienced by the person experiencing the CD and the street in real time. A wedding party congregates for photographs by the fountain just as Cardiff describes a similar group during her narration.

Some of Cardiff's walks combine her recording with the viewer's immediate experience; others include a video component. *In Real Time* leads viewers through Pittsburgh's Carnegie Library using a portable DVD player. Viewers follow the author's path, recorded earlier. The journey, through the library's network of reading rooms, grand halls and storage niches, serves as a metaphor for "the larger complex of collective human knowledge, itself a labyrinth of stories and recollections."[97]

The tour begins at a desk within the main reading room of the Neoclassical structure; donning an individual set of headphones attached to a digital video camera, the participant hears Cardiff's voice: "Try to synchronize your movements with mine … perhaps, if I show you what I've seen, you can help me understand … I don't know why they've sent me."[98] As the video shows the passage through corridors, the real-time participant follows along, walking through the actual corridors, down winding stairs, and into the bookstacks. The hand in the video reaches for the red book, third from the left. The participant does the same, but it's missing. The screen images conflict with or are supported by events in real time. A man walks toward the viewer on the screen and the participant needlessly moves aside to let him pass. The quick speed of the tour's

pace does not allow time to consider any gaps between what is happening on the video and what occurs on the edges of our vision in the space itself. The experiences tween, blending themselves into a single amalgamation of fiction and fact, past and present. Like the sounds outside the camera obscura, Cardiff's murmuring blends with our own thoughts and influences our interpretations. In her introduction to *Janet Cardiff: The Walk Book*, Cardiff writes that, in creating these walks accompanied by **binaural recordings**, she opens up a "porthole" that enables people to escape into other worlds: "I had found a way to be in two different places at once. I was able to simulate space and time travel in a very simple way."[99]

Without isolating people in the darkened room of a camera obscura, Cardiff allows viewers to inspect images of their immediate world. Participants come to understand the library through the viewfinder's rectangular stream of images, rather than through their immediate experience of the place. The tour on video offers a more manageable focus than the **blooming, buzzing confusion** of an unsorted world. In this sense, Cardiff's tours offer a similar service as audio tours of museums or cities. Sightseers can download these recorded narratives to an MP3 player before venturing out into Philadelphia, Las Vegas, or San Francisco. Like these guides, Cardiff simultaneously simplifies and intensifies our ordinary sensory process. The removal from the world inherent in wearing an MP3 player or other headset mimics the bubble of a camera obscura. It is easy to become absorbed in the music and images and almost possible to forget the awkwardness of the headset. Our willingness to slip into images and our sophistication at consuming images may allow us to be bewitched.

Many contemporary artists and photographers build a camera obscura as a screen for contemplating images. The projected images serve not as an aid in drawing, but as a kind of wallpaper, constantly in the process of being formed. Traditionally, scenic wallpaper depicts exotic scenes and lush gardens meant to transport a room's occupants to an idyllic locale. Because a camera obscura projects what is happening immediately outside onto the inside, its walls "wear" its actual location, be it a street, park, city, or suburb. Rebecca Cummins converts mobile homes, trucks, and buses into camera obscuras. As the vehicles move and change position, so do the inverted images within. Cummins, who studied in Australia, is particularly interested in this inversion in relation to the Australian landscape and culture. She relates the upside-down projections made within her converted bus in Tamworth, New South Wales, to Eurocentric perceptions of the Land Down Under as a continent contained within the southern hemisphere where summer occurs during European winter and where fantastical accounts describe residents who walk on their heads and act as if unleashing the restrained British psyche.[100]

Early camera obscuras framed scenes of land. Their views influenced perception of the world. As the camera obscura taught occupants to appreciate orderly cuts within the

binaural recording
Sound recording using two microphones that are placed at a distance from one another to simulate human hearing. The resulting recording fully uses the capabilities of the human ears in that the sound seems to be 360°, coming from behind, ahead, above, or from other directions.

99 Janet Cardiff, "The First Page," in *Janet Cardiff: The Walk Book*, by Mirjam Schaub, ed. Thyssen-Bornemisza (Vienna: Thyssen-Bornemisza Art Contemporary, 2005), 4–5.

blooming, buzzing confusion
Phrase coined by American philosopher-psychologist William James (1842–1910), in his essay "Percept and Concept: The Import of Concepts." The term describes the inner world of babies.

100 Rebecca Cummins, "Necro-Techno: Examples from an Archaeology of Media" (PhD diss., University of Technology, Sydney, 2002), Vol. 2, 21–24.

1.50 Rebecca Cummins, *Tamworth by Bus* (bus camera obscura), 1996

1.51 Rebecca Cummins, *Tamworth by Bus: Road*, 1996. C print, 16 × 20in. Image taken by a bus converted into a camera obscura

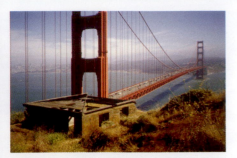

1.52 Franz John, *Golden Gate Bridge*, 1996. Color photograph

1.53 Franz John, *Roaming Through Bunkers*, 1996. Color photograph

1.54 Franz John, *Battery Cranston*, 1996. Camera obscura, light on concrete

101 Frances Terpak, "Objects and Contexts," in *Devices of Wonder: From the World in a Box to Images on a Screen*, ed. Barbara Maria Stafford and Frances Terpak (California: Getty Publications, 2001), 313.

102 Udo Thiedeke, "The Light Machine," in *Franz John: Military Eyes*, by Franz John (Herausgeber: Galerie Schüppenhauer, 1999), 38.

103 Kathryn Reasoner, "Military Eyes," in *Franz John: Military Eyes*, by Franz John (Herausgeber: Galerie Schüppenhauer, 1999), 10.

104 Reasoner, "Military Eyes," 10.

105 Franz John, email message to author, April 11, 2003.

106 Franz John, email message to author, April 11, 2003.

6×6cm
A common image size for medium-format cameras. 6×6 yields a square negative. Medium-format cameras are also available in the smaller, rectangular size of 6×4.5 and the larger sizes of 6×7, 6×8, and 6×9cm.

long exposure
Allowing photosensitive material to receive light for an extended period of time.

field of vision, observers subsequently imagined or actually constructed similar views in the outside world. In a letter written in 1767, an English aristocrat, Arthur Young, described his land by comparing the break in shrubbery with the delineation from a camera obscura: "The next opening in the hedge … gives you at one small view, all the picturesque beauties of a natural camera obscura."[101] Berlin-based artist Franz John (b. 1960) recognized that the observation windows of military bunkers frame the surrounding land in order to provide specific surveillance points; with slight modification to the bunkers, he could project these views inward.

In his project *Military Eyes* (1996), John converted deserted military bunkers near San Francisco into camera obscuras. The former army fort, located on the westernmost point of land near the entry to the San Francisco Bay, consisted of batteries armed with missiles ready to fire on enemy warships before they could attack the city. The compound, today the site of the Marin Center for the Arts and Headlands' Institute, operated during the 19th and 20th centuries. Bunkers provided a means of surveillance and were staffed with soldiers who "kept watch through the bunker's slits and San Francisco Bay's notorious fog. The soldiers were required to calculate ideal vantage and firing points."[102] The soldiers who occupied the bunkers saw from a "point of view … standardized by the restrictive views from the observation slits."[103] John recalls that, while working in the shelters, he thought "about the boredom of the soldiers who spent hour after hour in the bunkers doing tedious 'militärfremde' [busywork] jobs such as plotting wind direction, the humidity of the air and even the rotation of the earth."[104]

John transformed the bunkers into camera obscuras by partially covering the observation slits. The new apertures projected the military's outlook into the concrete interior: On the cement wall, waves crashed ashore, boats floated upside-down within the bay. This movement is why John describes the camera obscura as a medium "closer to film than photography" that should be experienced live.[105] In person, vision shifts between the graffiti on the surface of the bunker and the projected scene. To record the view, John used a **6×6cm** camera to photograph the quivering images as they stained the cracking, spraypainted wall. The **long exposure** time cannot record motion, so images show an empty harbor and a vacant Golden Gate Bridge. In the book *Military Eyes*, John rotates this frozen image so that the wilderness and bay appear right side up in order to focus our attention on "the soldiers' perspectives."[106]

John works as a kind of archeologist of perception, combing and recording a site for days. In another exploratory work, *The Copied Gallery*, he methodically copied every inch of a gallery using a common form of photographic technology—a hand-held photocopier. John wallpapered the gallery with the paper copy of itself, a reproduction that noted the bumps, ridges, and scars from previous shows. Intrigued by John's tedious reproduction, the Karl-Ernst-Osthaus Museum in Germany proposed the Herculean task of copying their enormous space. John offered instead to scan the sky above

their museum for 24 hours, from midnight to midnight. Seated officiously at his desk, equipped with a **flatbed scanner**, John provided a seemingly utilitarian service: a photographic archive of the heavens. The flatbed scanner made four passes: one for each of four colors—cyan, magenta, yellow, and black. Newer, one-pass scanners will not allow enough time to make a scan of the sky. John's cosmic audit left that particular zone of sky thoroughly inspected. In the catalogue for *Military Eyes*, Kathryn Reasoner compares John's fascination with these traces of our reality to the mirage of Plato's cave, in which cave dwellers mistake shadows cast on the walls for "the realities of the light of day."[106]

THE NATURAL EYE: DIRECT EXPERIENCE AND PHOTOGRAPHY

According to Jonathan Crary, the camera obscura's status as the prevailing model of vision was eventually usurped by new theories that were less suspicious of the human senses.[108] Physiologists such as Gustav Fechner (1801–1887), Sir David Brewster (1781–1868), Joseph Plateau (1801–1883), and Johann Wolfgang von Goethe (1749–1832) observed and studied the retina in order to understand the peculiarities of the eye, such as peripheral and binocular vision. Using themselves as subjects, they stared directly into the sun in order to test **retinal afterimages**. Experiments often resulted in permanent damage to their eyesight and even, in the case of Plateau, blindness.

In his *Theory of Colours* (1810), Goethe describes watching the projected images inside the camera obscura, then abruptly darkening the room by covering the aperture. He continued to gaze fixedly, but now at the "coloured visionary circle floating before me. After thirteen seconds it was altogether red; twenty-nine seconds next elapsed till the whole was blue, and forty-eight seconds till it appeared colourless."[109] Without the camera obscura's projected imagery, the eye saw visual apparitions. The body emerged as the creator of vision, "abruptly and stunningly abandon[ing] the order of the camera obscura."[110]

The **Cartesian model of vision** had ignored or eliminated the body in favor of a clear mental survey. However, by the early 19th century, the eyes were being recognized as a credible source of information about the world. Contemporaries of Goethe studied how the body processes shifts in light and color. By 1828, Plateau had "demonstrated that the duration and quality of retinal afterimages varied with the intensity, color, time and direction of the stimulus."[111] His theory on the **persistence of vision** affirmed that, to an extent, our eye and brain create motion by blending static objects viewed in sequence. François-Pierre Maine de Biran showed that our perception of color shifts as our body becomes fatigued. These phenomena (the appearance of afterimages, floating red blood cells, retinal veins, etc.) were previously considered deceptions that obscured "true

flatbed scanner
An optical scanner in which the scanning head/camera moves across a stationary bed.

107 Reasoner, "Military Eyes," 11.

retinal afterimage
An optical illusion that occurs when a person stares at an image or color for several seconds. After looking away, he/she will continue to see the image/color. Afterimages can be positive (the person sees the original color in the afterimage) or negative (the afterimage is the complementary color).

108 Terpak, "Objects and Contexts," 313.

109 Johann Wolfgang von Goethe, *The Theory of Colours* (Cambridge, MA: MIT Press, 2002), first published 1840, 17.

110 Crary, *Techniques*, 68.

111 Crary, *Techniques*, 107.

1.55 Franz John, *The Copied Gallery*, 1987. Portable photocopier, thermography. Franz John in process of copying the gallery

1.56 Left: Franz John, *Sky Nude*, 1992. Flatbed scanner, computer, light from the sky. Franz John scanning the sky. Right: Franz John, *Sky Nude*, 1992. Flatbed scanner, computer, light from the sky

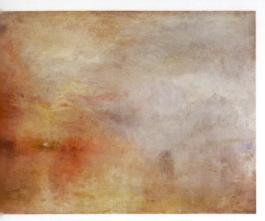

1.57 Joseph Mallord William Turner, *Sun Setting over a Lake*, c. 1840–1845. Oil on canvas, 36 × 48in

Cartesian model of vision
French philosopher René Descartes's (1596–1650) assertion that the body and mind were separate, and the body had no part in perception. Rather, vision was a result of the mind's detached appraisal of representations as they passed before a kind of Inner Eye.

112 Crary, *Techniques*, 139.

persistence of vision
The brain's ability to retain an image for a short time after the image is no longer in front of the eye. This principle creates the illusion of movement, which makes animation possible.

113 Crary, *Techniques*, 10.

sequence
A linear arrangement in which one image must be read after the next in a particular order.

1.58 Jan Dibbets, *Shortest Day at the Guggenheim Museum New York*, 1970, Color photograph, 94½ × 55⅛in

perception." In the emerging model of vision, however, they proved that vision is in flux and that the body is a source of truth and knowledge.

As discoveries about the eye became known, artists such as the painter J.M.W. Turner (1775–1851) looked into the brilliance of the sun to understand how this force affected vision. While physicists and astronomers from Kepler to Newton used the camera obscura "precisely to avoid looking directly into the sun while seeking to gain knowledge of it," Turner tackled the dangerous intensity straight on.[112] In his early-to-mid-19th-century paintings, Turner's light is direct; sun blazes over the horizon, glares across a river's surface, or diffuses a snowstorm. His preoccupation with light was more than just a fascination with its physical effects upon the body or land, but also signified goodness and evil.

In *Shortest Day at the Guggenheim Museum New York* (1970), Jan Dibbets (b. 1941) captures the glare of the sun on film. Like Turner, he stares directly into the beam, though he substitutes his naked eye with the mechanical eye of a camera lens. Changes in light experienced by the painter are now shifts recorded by the camera. Every ten minutes for the entire day, Dibbets recorded light streaming through the window of the Guggenheim Museum. Fluctuations in intensity and color, not noticeable in real time or in the actual space, are striking within the **sequence** of 80 images. As with Goethe's two-minute experiment with afterimages, the color of light varies. Dibbets provides a framework for understanding the passage of time during 13 hours.

The studies undertaken by Goethe, Plateau, and other scientists coincided with manufacturing methods rapidly developing in the early 19th century. Industry searched for clues about how their new assembly lines and other forms of mechanized production would affect humans in factories (Figure 1.59). Information about attentiveness, reaction times, thresholds of stimulation, and on-the-job fatigue could be used to adapt workers' bodies to the tasks of production. Individuals also struggled to see anew within unfamiliar and rapidly changing urban spaces. The jarring new speeds of railroad travel (and the dizzying views that flew past) and the continual flow of information offered by telegraphy created a new breed of viewer, accustomed to change, adaptable, mobile, and no longer fixed within the contemplative space of the camera obscura.[113]

Vision in flux: Impressionism and photography

The **Impressionist** style of painting (1860s–1890s), with its dabs of paint and unmixed colors simulating reflected light, conveys an immediate response to the landscape and an attempt to forget learned habits of seeing. While, in part, the responsiveness to immediate visual phenomena came from the new custom of painting from direct observation outdoors, the style signals a wider societal shift in how people saw. Viewers developed a heightened physical sensitivity to phenomena as a response to

shifts in urban scale and industrial speed. Painters, newly liberated by inventions such as tin tubes that would keep oil paints fresh for days, traveled outside their studio and embraced new subjects—trains, landscapes, and crowds. Impressionist painters turned their attention to sensations of color, flux, and the fleeting moment, properties that were imperceptible to photographers with their heavy, **large-format cameras**, slow-speed **emulsions**, and long exposure times.

Impressionist painters Paul Cézanne, Claude Monet, Vincent Van Gogh, and Camille Pissarro describe "a common dream of losing their adult sight in order to have the pristine vision of childhood miraculously restored."[114] Each believed that it was possible to cast away learned conventions in order to respond to the world with a pure innocence. In his 1885 essay on Impressionism, Jules Laforgue, the French poet and art critic, says that:

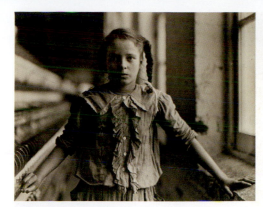

1.59 Lewis W. Hine, *Doffer Girl in New England Mill, 1909*, 1909. Gelatin silver print, 5×7in

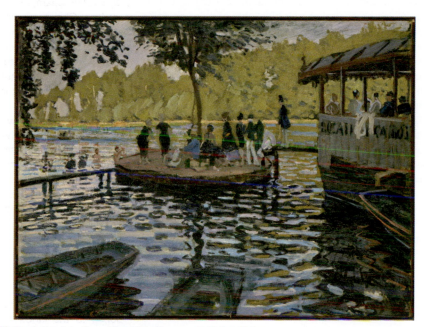

1.60 Claude Monet, *La Grenouillère*, 1869. Oil on canvas, 74.6 × 99.7cm

The Impressionist painter accomplishes this [pure seeing] by forgetting all the paintings stockpiled in museums … and the curriculum of optical education (of drawing, perspective, and coloration), and abandoning … **studio lighting**, to live and see in an honest and unfiltered fashion … in plein air …

Impressionism
A movement within painting of the mid-to-late 19th century whose artists used short brushstrokes and pure, unmixed colors in order to reveal fluctuations in light and color.

114 Simon Watney, "Making Strange: The Shattered Mirror," in *Thinking Photography*, ed. Victor Burgin (London: Macmillan Press, 1982), 156.

large-format camera
A camera which uses 4×5-inch or 8×10-inch sheets of film. Typically the camera's lens forms an image directly on a ground-glass viewing screen to enable composition.

emulsion
Any light-sensitive coating applied to films, papers, printmaking plates, or other materials to record an image. Traditional emulsions consist of silver-halide crystals and other chemicals suspended in gelatin. Slow emulsions require more light than fast emulsions. Therefore, with slow emulsions, the shutter must be open longer or the aperture must be wider.

1.61 Alfred Stieglitz, *Equivalent*, 1929. Gelatin silver print, 11.8 × 9.3cm

115 Richard R. Brettell, *Impression: Painting Quickly in France, 1860–1890* (New Haven: Yale University Press, 2000), 233.

116 Brettell, *Impression*, 233.

studio lighting
The use of artificial light sources to illuminate a scene or people. The lights and their housings are used in a controlled environment (usually a room) that is shielded from natural light. The lights can be manipulated (to intensify, diffuse, focus the beam of light, etc.).

117 Weschler, *Seeing is Forgetting*, 129.

abstraction
Removing or simplifying visual information; abstraction can be minor, with the reduced form still resembling that which it initially represented (e.g. a chair that becomes less detailed, but still chair-like), or can be completely abstract, with no connection with the world of recognizable objects.

The natural eye [an eye that has renounced learned art conventions such as perspective] succeeds in seeing reality within the living, atmosphere of forms, differentiated, refracted, reflected by beings and objects in constant variation.[115]

According to Laforgue, within the 15 minutes he estimated it took to make an Impressionist painting,

the lighting of the landscape has varied infinitely … Just one example out of millions: I see a certain violet and lower my eyes toward my palette to mix it, and the eye is involuntarily attracted to the whiteness of the shirt-sleeve. My eye has changed and my violet will reveal the consequences.[116]

As artists began to see in an Impressionist style—to be aware of reflective surfaces, to sense how colors influenced one another—they developed their own kinds of conventions. Quick brushstrokes and highlights of color could be replicated in the studio from memory rather than direct observation. Instead of recording the effects upon their eyes and bodies, the painters invested images with thought and planning.

However, the urge to perceive a world in flux continued. Eighty-three years after Laforgue's essay, Robert Irwin experienced the undulating physical world after emerging from the anechoic chamber, a room devoid of light or sound. After spending 6 or 8 hours with no visual or auditory stimuli, Irwin said that:

For a few hours after you came out … everything has a kind of aura, that nothing is wholly static, that color itself emanates a kind of energy. You noted each individual leaf … So that what the anechoic chamber was helping us to see was the extreme complexity and richness of our sense mechanism and how little of it we use most of the time.[117]

Photographers, too, often attempt to see with an innocent eye. In this case, an innocent eye suggests the ability to look at recognizable imagery (a tree, a doorframe, etc.), but to see more significant forms. Image-makers in the 19th and early 20th centuries had reveled in their ability to capture realistic imagery. But, in the 1940s, photographers such as Minor White, Harry Callahan (1912–1999), and Aaron Siskind (1903–1991) started to discover **abstract** natural and architectural forms in order to express deeper emotions or sensory response. This belief had some precedents within photography's history in the sensual forms found by Edward Weston (1886–1958), and in Alfred Stieglitz's 1920s and 1930s images of clouds and sky that he called *Equivalents*, claiming that they operated as metaphors for emotions.

As with Impressionism, the Expressionist photographic work of the early 1940s through the 1950s found form through an inventive and considered response to the environment. Siskind, White, and Callahan, pioneers of this approach, all believed that

the photographer could aim his artificial eye at details of objects—frost on windows, rock forms, strands of rope, weeds and strands of grass—and compose a picture that would transform that material into significant forms. These "forms, totems, masks, figures, shapes and images," as described by Siskind, consisted of simple gestures and marks discovered in close-up views.[118] Siskind describes the goal of these abstracted images:

For the first time in my life, subject matter, as such, has ceased to be of primary importance. Instead, I found myself involved in the relationships of these objects, so much so that these pictures turned out to be deeply moving and personal experiences. … Essentially then, these photographs are psychological in character. … The interior drama is the meaning of the exterior event.[119]

Before the emergence of these works in the 1940s, photography depended upon its ability to depict recognizable imagery. During the Great Depression of the 1930s and World War Two, photographers focused their attentions on social conditions. Art that pursued personal expression and individual growth may have seemed frivolous, selfish, or unpatriotic. After the war, the need for photographers showcasing governmental programs dissipated, and they were free to explore new ways of working. But, as some governmental pressures eased, others grew. In postwar America, the race for and build-up of atomic weapons, and Senator Joe McCarthy's pronouncement that communists had infiltrated America's borders, led to extreme fear. In 1947, the politically left-wing New York Photo League, a group that promoted photography as a tool of political change, was added to the Attorney General's list of subversive organizations. Helen Gee, owner of the Limelight Gallery, an exhibition space that provided support and community for photographers in the 1950s, describes the effect of this persecution on artists: "The climate of McCarthyism undoubtedly affected the diminished output of many photographers and, for some, influenced a change of direction."[120] Many artists and photographers who had been interested in social issues or who merely presented images of everyday life shifted to a more abstract and personal approach (as if photographs of recognizable objects do not convey personal feelings) in hopes of avoiding suspicion. In addition to the fear of being politically persecuted, the surge in artistic expression could be explained by the influx of European abstract and **Expressionist** artists to the United States before and during World War Two, and by the flood of students entering colleges and universities in the 1940s. Supported by the GI Bill, increased enrollment meant the development of new courses. Photography was taught in more universities; popularizing the medium produced a larger audience who could discuss and encourage photography as a fine art.

Aaron Siskind wrote that, after years of working in the **social documentary** style, "there was in me the desire to see the world clean and fresh and alive."[121] His sense of visual discovery was aroused during a summer in Gloucester, Massachusetts. While he

118 Aaron Siskind, "Credo (1950)," in *Aaron Siskind: Toward a Personal Vision, 1935–1955*, ed. Deborah Martin Kao and Charles A. Meyer (Boston: Boston College Museum of Art, 1994), 57.

119 Aaron Siskind, "The Drama of Objects (1945)," in *Aaron Siskind: Toward a Personal Vision, 1935–1955*, ed. Deborah Martin Kao and Charles A. Meyer (Boston: Boston College Museum of Art, 1994), 51–53.

Expressionism
An art movement of the early twentieth-century in which many European artists became interested in portraying emotions rather than realistic observations.

120 Helen Gee, "Photography of the Fifties," in *Photography of the Fifties: An American Perspective* (Tucson: University of Arizona, 1980), 4.

social documentary
A sub-genre of documentary photography, in which the emphasis is placed on people as they live, work, etc., often with the goal of effecting reform.

121 Siskind, "Drama of Objects," 51–53.

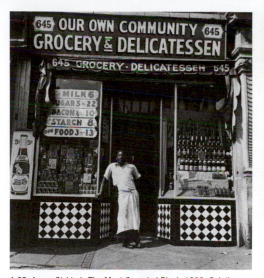

1.62 Aaron Siskind, *The Most Crowded Block*, 1939. Gelatin silver print

1.63 Aaron Siskind, *San Luis Potosi 16*, 1961

1.64 Kurt Schwitters, *Untitled (Ebing)*, 1920. Collage, 15 ×
12cm

122 Nathan Lyons, ed., *Aaron Siskind: Photographer* (Rochester: George Eastman House, 1965), 8.
123 Thomas B. Hess, "Aesthetic in Camera," in *Aaron Siskind: Photographer*, ed. Nathan Lyons (Rochester: George Eastman House, 1965), 12.

124 Arthur Koestler, *The Act of Creation* (New York: The Macmillan Company, 1964), 366.

125 *Photoprofiles: Aaron Siskind* (videorecording), produced by Thomas R. Schiff, edited by Ed L.G. Neal (Images Productions, 1985).

126 Aaron Siskind, "The Essential Photographic Act," *Art News*, 54, no. 8 (December 1955), p. 37.

> **thaumatrope**
> An optical toy, invented in 1825, which consists of a paper disk with an image on either side; when the card is flipped, the images appear to merge.

had spent the previous summer lying around on the rocks, this time "the rocks began to seem so animate that I could hardly bear to walk over them."[122] Like the Impressionists, Siskind returned to the same rocks again and again, finding in the forms sources of personal insight. As Thomas B. Hess asserts in his essay "Aesthetics in Camera," Siskind's picture-plane "is a place (an arena) where things happen—decomposition, recrudescence, melting, congealing, pushing, slipping, fighting, mumbling … The question: 'What was really there?' becomes as irrelevant as what Monet's lily pond really looked like."[123]

Art critic Arthur Koestler writes that the notion of the "innocent eye" is "a fiction, based on the absurd notion that what we perceive in the present can be isolated in the mind from the influence of past perception."[124] Later, Siskind acknowledged experiences that affected his visual aesthetic; he recognized the similarities between his initial fascination with ornate architectural woodwork, his interest in the terse language of poetry, and his later use of abstract forms. The illusion of flatness in his photographs of torn and defaced posters is similar to modernist painting's use of abstract pattern; Siskind achieved this effect by positioning the camera perpendicular to the subject, at a very short distance. When asked in a 1985 interview to reminisce on his visual influences, Siskind recalled an exhibition of Kurt Schwitters's (1887–1948) collages. "I could understand Schwitters because I think I was already involved in collage. I was photographing stuff that was like collage, but it helped me see more."[125] Siskind's conflict between recognizing these influences and his desire for innocence plays out among the forms within his photographs: "Strong tensions are inevitable, pleasurable and disturbing. Is not the esthetic optimum, order with the tensions continuing?"[126]

NINETEENTH-CENTURY VIEWING DEVICES AND THEIR OPTICAL LEGACY

Nineteenth-century research on the eye (i.e. afterimages and the persistence of vision) and simple observations of new machines (such as the movement of train wheels) revealed that perception was not instantaneous. These discoveries led to the invention of a number of optical devices. Initially constructed as scientific experiments, the **thaumatrope** (1825), **zoetrope** (before 1867), and **stereoscope** (1838) eventually became popular as toys.

The thaumatrope and zoetrope (*tropeō* meaning "to turn") rely on the brain's ability to store a visual image momentarily. The thaumatrope (Figure 1.65) consists of a card with a partial image printed on each side; for example, a house on one side and a tornado on the other. When flipped back and forth, the viewer sees not two distinct images, but an impending disaster. The zoetrope (Figure 1.66) presents images (for instance, ten images

of a horse in various stages of a canter), arranged along a strip, placed within a cylinder. When spun, the viewer watches through the slots as the images speed past, animating the horse into motion.

The stereoscope, invented by the English physicist Charles Wheatstone (1802–1875), was meant to prove that our sense of depth, when viewing objects, occurs because of the disjunction between the two eyes in binocular vision. The stereoscope relies upon the principle that each eye sees a slightly different view and that these two dissimilar pictures are united by the brain. Pictures used in stereoscopic imagery are almost identical, save for a slight difference in the amount of the view from either side (the left or right). Viewed through the stereoscope, the flat images seemed to become one picture with three-dimensional depth. Wheatstone's model recognized a physical disparity previously ignored by inventors of the camera obscura, who had eschewed the irregularity of the eyes in favor of the more rational, single stream of light.

Like the *Magic Eye* illustrations of the 1990s in which three-dimensional images emerged from patterned fields if viewers took effort to see in a new way, the pleasure of the stereoscope and other 19th-century optical toys often lay more in the effort of achieving the illusion of deep space on a flat plane than in the actual picture. The zoetrope demanded that an observer spin its wheel; the thaumatrope compelled a user to flip its card; the stereoscope forced eyes in and out of focus. Viewers started to understand image production in terms of manipulation. The effort and work involved in creating the optical magic was culturally specific to the time in which these machines were invented. During massive industrialization, humans reemerged as workers, part of the assembly line wherein "the nature of man is to be a tool … and to be set to work."[127] This work ethic has endured, and even extended to recreational activities. Susan Sontag, writing in 1977, saw this notion of work as hardwired into our species. The act of taking pictures allows us to fulfill this ethic. When we go on vacation, our aimless days regain purpose with a camera in hand. Sontag writes that the compulsion to snap pictures when in an unfamiliar place:

gives shape to experience: stop, take a photograph, and move on. The method especially appeals to people handicapped by a ruthless work ethic—Germans, Japanese and Americans. Using a camera appeases the anxiety which the work driven feel about not working when they are on vacation and supposed to be having fun.[128]

Liza McConnell's (b. 1973) *Diorama Obscura: Wind Machines* requires viewers to participate in constructing the image and the environment. Pedaling the stationary bike powers the lights inside a kind of reverse camera obscura situated beside the vehicle. The drum diorama obscura contains halogen lights (and fans that cool these lights), and a miniature landscape constructed of foam sealant, steel wool, insulation fluff, and one 6-inch model

zoetrope
An optical toy first popularized in the 1860s, which presents a series of images along a strip; images show a figure at various stages of motion. The strip is placed within a cylinder which is then spun. The viewer watches through slots in the cylinder as the images speed past, giving the illusion of a single figure in motion.

127 Crary, *Techniques*, 131.

stereoscopy
The technique (aka stereography) of capturing two images of the same scene, from slightly different positions. When viewed in a stereoviewer (aka a stereoscope), the scene appears three-dimensional. The card with the two pictures may be referred to as a stereocard, a stereocarte, a stereogram, or stereoscope.

128 Sontag, *On Photography*, 10.

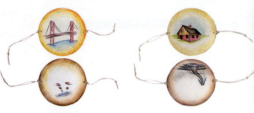

1.65 Ashley Elander, *Destruction Series*, 2009. Thaumatropes, watercolor

1.66 Lauren Nordhougen, *Reliving the News*. Zoetrope with image strips, 2009

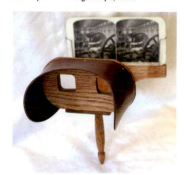

1.67 Holmes stereoscope. Digital photo, 2006

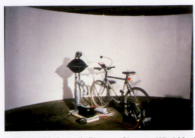

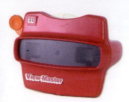

1.70 View-Master

1.68 Liza McConnell, *Diorama Obscura: Wind Machines*, 2001. View of bike, generator, projection and curved wall in lit room

1.69 Liza McConnell, *Diorama Obscura: Wind Machines*, 2001. View in operation in dark room with rider

narrative
A coherent story or chain of events related in a linear fashion.

1.71 Matt McCormick, *Vladmaster Performance at the 2005 Portland Documentary and Experimental Film Festival*, April 2005. Digital photo

129 Liza McConnell, "Pictures and Projects: A Text Supporting the Exhibition" (MFA thesis, Ohio State University, 2001), 14.

130 Vladimir, email message to author, June 28, 2005.

131 *William Kentridge: Drawing the Passing* (videorecording), directed by Maria Anna Tappeiner and Reinhard Wulf (David Krut Publishing, 1999).

132 *Kentridge: Drawing the Passing* (videorecording).

133 Linda Williams, "Corporealized Observers: Visual Pornographies and the Carnal Density of Vision," in *Fugitive Images: From Photography to Video*, ed. Patrice Petro (Bloomington: Indiana University Press, 1995), 11.

of a wind turbine. McConnell refers to her contraptions as pinhole projectors, "which eliminated digital technology from the process of fabricating a projected image."[129] The lights project images of the tiny environment through three apertures onto the walls surrounding the bicycle. The viewer's whole body is put into the service of activating the machine and the hard work is rewarded by the appearance of awe-inspiring, ethereal scenery. The landscape, like the process of viewing, is utilitarian rather than scenic, and the wind turbines turn sympathetically with the rotation of the pedals, inspiring the rider to work harder.

The control involved in creating images and in transforming the miniature to the monumental is also involved in Vladimir's performances. She creates viewing events using *View-Masters*, the 20th-century version of the stereoscope. At each performance, every attendee receives a viewer and a packet of Vladmaster disks. A narrator on a recorded soundtrack leads the audience through the images, describing events sequentially and prompting viewers to advance to the next frame. Vladimir notes that at every performance there is "an instantaneous and audible joyous response from the audience as … everyone is treated to their own personal private viewing room."[130] For *The Public Life of Jeremiah Barnes* sequence, Vladimir constructed the images from small, hand-made dioramas and tiny human figures meant for model trains.

The work of a traditional stereoscope involves combining two slightly disparate images into one whole illusion. In his film *Stereoscope*, William Kentridge (b. 1955) divides a single image into two corresponding images "as a way of talking about the way in which we are split up into different kinds of selves."[131] Growing up in South Africa, Kentridge became aware of the "unnatural" conditions of apartheid from his parents, attorneys who were involved in civil rights cases.[132] Unlike most of the other white boys at his school, Kentridge was aware of civil rights and sensitive to the difference between life in the leafy, tranquil suburbs and the struggling city of Johannesburg. In *Stereoscope*, these tensions play out via two characters, Soho Eckstein and Felix Teitlebaum. Although they share physical resemblances their responses to mounting political and personal conflict and their acknowledgment, or lack, of personal responsibility create more complex, less holistic images.

Victorian leisure-class viewers amused themselves with stereocartes of people occupied with daily tasks, romantic or humorous **narratives** of everyday life, and risqué; or erotic situations. In his writings on French society, essayist and poet Charles Baudelaire deplored the apparatus as a "machinery of looking" and as a seductive technology. In "Corporealized Observers," Linda Williams writes that Baudelaire's objection to the masses of "greedy eyes … glued to the peephole of the stereoscope" providing viewers with a "glorious satisfaction" was not based on the specific content of the imagery (erotic nudes for example), but on the inherent condition of stereo viewing, in which observers' bodies generate the sensations in a kind of masturbatory act.[133]

Williams notes that the stereoscope allowed those cloistered within their plush, private homes, especially women with limited mobility and restricted access to the public domain, the opportunity for virtual travel.[134] Stereoscopes transported viewers from one culture or location to another.

1.72 Vladimir, *Still from The Public Life of Jeremiah Barnes*, November 2004. 16mm still

134 Williams, "Corporealized Observers," 20.

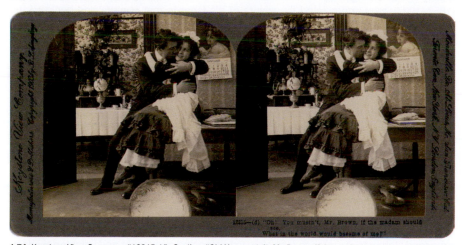

1.74 Keystone View Company, #12315-(d). Caption: "Oh! You mustn't, Mr. Brown, If the madam should see, What in the world would become of me?" *c.* 1903

135 Merry Alpern, *Dirty Windows* (Zurich and New York: Scalo, *c.* 1995), second page of artist statement, at back of book.

1.73 William Kentridge, Drawing for the film *Stereoscope*, 1999. Charcoal and pastel on paper, 47¼ × 63in

One century later, photographer Merry Alpern (b. 1955) spent several evenings each week camped out at a friend's apartment in Manhattan, peering through his window into the bathroom window of an illegal sex club. Like the Victorian ladies who viewed exotic locales and sensational conduct from the sheltered enclave of their parlors, Alpern used her camera to access drug transactions and sexual encounters between businessmen and prostitutes from the safety of afar. Isolated in the dark, her separation from the thing she viewed also brings to mind the distance inherent in the dynamics of the camera obscura. Alpern describes being fascinated by "even the most mundane of anthropological details like … the procedures of the sexual transactions: when the condom came out, when the money was handed over, how long it took, did they kiss goodbye."[135]

THE CAMERA AS MECHANICAL EYE

Today's cameras are relatively fast and facile. See something that captures your attention and you can arrest the vision with an array of ready devices, from disposable to digital. This was hardly the experience of early practitioners, whose large-format cameras

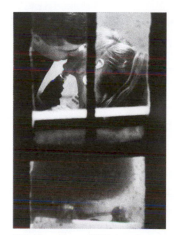

1.75 Merry Alpern, *#2 Windows Series*, 1994

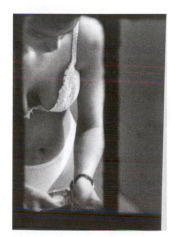

1.76 Merry Alpern, *#23 Windows Series*, 1994

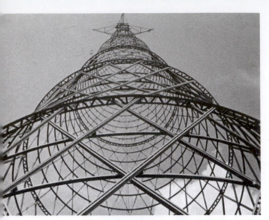

1.77 Alexander Rodchenko, *Suchov-Sendeturm* (Shuchov transmission tower), 1929. Gelatin silver print, 5¹³⁄₁₆ × 8⅞in

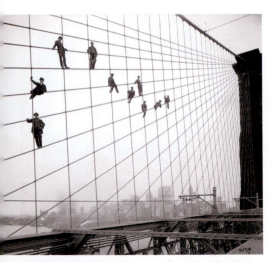

1.78 Eugene de Salignac, *Painters on Suspenders, Brooklyn Bridge*, 1914. Gelatin silver print

tripod
A three-legged stand used to steady a camera that is too heavy to be handheld or to prevent movement during a long exposure. The three legs are hinged to a plate; the camera attaches to this plate.

bellows
A collapsible, usually accordion-folded, tube on a view camera. The bellows moves the lens board closer to or farther from the film plane.

136 Liz Wells, ed., *Photography: A Critical Introduction* (New York: Routledge, 2000), 240.

shutter release
The button that you press on the camera to take the picture.

137 Viktor Shklovsky, "Art as Technique," in *Modernism: An Anthology of Sources and Documents*, ed. Vassiliki Kolocotroni, Jane Goldman, and Olga Taxidou (Chicago: University of Chicago Press, 1998), 217–221.
138 Alexander Rodchenko, "Downright Ignorance or Mean Trick?," in *Photography in the Modern Era: European Documents and Critical Writings, 1913–1940*, ed. Christopher Phillips (New York: Aperture, 1982), 246.
139 Rodchenko, "Downright Ignorance," 246.

required so much time and effort to transport, assemble, and compose that location and point of view were rarely unintentional. Without bulky apparatus or cumbersome **tripods**, hand-held 35mm and other small-format cameras inaugurated a new, faster way of seeing and acquiring images. Their ease and speed alarmed photographer Eugene Atgèt (1857–1927), who appreciated the leisure of his large-format camera and declined the use of handheld cameras, saying that they operated faster than he could think.

Freed of **bellows** and tripod, the portable 35mm camera more easily displaced the human eye. The experience of holding the camera up to one's face, looking through the viewfinder, and pressing the **shutter release** deceived operators into thinking of the camera as an extension of their own vision. In this respect, the camera is comparable to other technologies such as telephones and computers, which also serve as prosthetic devices and alter the ways we physically interact with the world.[136] With the advent of the cellphone camera, picture-taking requires users to assume a new posture. Cellphone cameras are not held to the eye. The operator extends their arm and hand. The camera, like a satellite, roams in search of an image.

Many practitioners of photography consciously used the camera to extend their sight. From roughly 1914 to the early 1930s, many artists, writers, and designers feared that, if unconsidered, vision would fall into patterns of habitual identification, rather than really seeing. In 1916, Russian critic and novelist Viktor Shklovsky developed the concept of *ostranenie*—the making strange of the familiar. In his essay "Art as Technique," he proposed literary techniques to reawaken language and rejuvenate and heighten readers' perception.[137] Visual artists adopted these initiatives with similar goals of using unconventional photographic ways of seeing to awaken viewers to their surroundings. The Berlin Dadaists, a group that included Hannah Höch (1889–1978), George Grosz (1893–1959), and John Heartfield (1891–1958), felt that images within journals and newspapers no longer communicated successfully because readers were overly accustomed to standard pictorial conventions. To reawaken readers, Dada artists **appropriated** existing images from print media and montaged them in jarring and unexpected ways.

Artists such as Alexander Rodchenko (1891–1956) in Moscow and László Moholy-Nagy (1895–1946) in Berlin looked to photography as a tool that would challenge viewers' complacency, and cultivate and expand their powers of observation. Rodchenko championed the merits of the camera as an eye that could respond to modern conditions and eliminate "old points-of-view," especially the point of view of a person "looking straight ahead."[138] He proposed that photographers pursue the enormous potential offered by the "most interesting viewpoints," those "from below up" and "from above down."[139] In Rodchenko's photographs, transmission towers soar into the sky from a worm's-eye point of view, horns trumpet directly overhead, and we float over crowds and stairways as though seeing with a bird's eye.

Rodchenko, Moholy-Nagy, and others chose as their subject the conditions rising up around inhabitants of the modern city. Pedestrians and streetcar passengers experienced a daily kaleidoscope of soaring and receding mirrored surfaces. For Rodchenko, "only the camera was capable of reflecting contemporary life."[140] Not only did the camera mirror actual encounters, but its vision made this bewildering environment more manageable. For German philosopher Walter Benjamin (1892–1940), photography and film slowed down the accelerated pace of daily existence so that city-dwellers could contemplate details, observe frozen motion, or simplify multiple frames into one clear narrative.[141]

Extreme angles also overtly affirmed the existence of a director behind the reins of the camera. Conventional, straightforward vantage points present their subject without dramatic angles and, therefore, downplay the photographer's presence. Though this alleged neutrality is as weighted with pictorial codes as any alternative strategy, the straight-on point of view suggests that the image came naturally, without influence from the image-maker's agenda.

In a series of editorials published in 1928 in the Russian avant-garde journal *Novyi lef*, Rodchenko defended the merits of his vision to several critics, chiefly Boris Kushner. Kushner asserted that Rodchenko was aesthetically motivated and that his "photographic sleight of hand" distorted reality.[142] For Kushner, the capacity for change lay in *what* was photographed, rather than *how* the subject was depicted. For example, before the Russian Revolution, only generals were photographed. Afterwards, there were images of proletarian leaders. This new visibility demonstrated the shift in political formations. Formal decisions of *how* to compose the image were secondary. Rodchenko argued back: "When I present a tree taken from below, like an industrial object—such as a chimney—this creates a revolution in the eyes of the philistine and the old-style connoisseur of landscapes. In this way I am expanding our conception of the ordinary, everyday object."[143]

Moholy-Nagy defined the new style as the "**New Vision**" and used these defamiliarizing techniques in his own work and within assignments for students at the **Bauhaus**, the influential art and design school that operated in Germany from 1919 to 1933. He believed human eyesight to be defective and weak but improved by the lens of the camera, with its faster, sharper, microscopic, and x-ray vision. His eight varieties of photographic seeing, listed in his 1936 essay "From Pigment to Light," include "abstract seeing," in which images were made without negatives by projecting light directly onto photographic paper (as with a **photogram**). He and his wife Lucia (1894–1989) experimented with the photogram, attempting to filter light past objects without revealing their identities. Moholy-Nagy's "rapid seeing" captures action immediately (as in a snapshot); his "penetrative seeing" reveals inner structures through use of x-rays; and "simultaneous seeing" projects and prints several images on top of one another.[144]

140 Alexander Rodchenko, "The Paths of Modern Photography," in *Photography in the Modern Era: European Documents and Critical Writings, 1913–1940*, ed. Christopher Phillips (New York: Aperture, 1982), 259.

141 Wells, *Photography*, 319.

142 Boris Kushner, "Open Letter to Rodchenko," in *Photography in the Modern Era: European Documents and Critical Writings, 1913–1940*, ed. Christopher Phillips (New York: Aperture, 1982), 250.

appropriate
To adopt another's material, often without permission, reusing it in a context that differs from its original context.

143 Rodchenko, "Downright Ignorance," 247.

144 Alexander Rodchenko, "From Pigment to Light (1936)," in *Photography in Print and Writings from 1816 to the Present*, ed. Vicki Goldberg (Albuquerque: University of New Mexico Press, 1981), 346.

1.79 László Moholy-Nagy, *Untitled*, 1923, gelatin silver photogram, 18.9 × 13.9cm

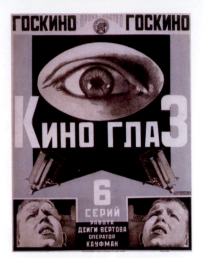

1.80 Alexander Rodchenko, *Kino-Glaz*, poster for the film *Cine-Eye* by Dziga Vertov, 1924, lithograph on paper, 90.8 × 67.9cm

145 G.D. Chichagova, "Vkhutemas," in *Alexander Rodchenko*, ed. David Elliot (Oxford: Museum of Modern Art, 1979), 106.

Bauhaus
A school of art and design in Germany, in operation from 1919 to 1933. The school was progressive in breaking down distinctions between practical crafts and the fine arts, and in its endorsement that art should respond to everyday life and society.

146 Abigail Solomon-Godeau, "The Armed Vision Disarmed: Radical Formalism from Weapon to Style," in *The Contest of Meaning*, ed. Richard Bolton (Cambridge, MA: MIT Press, 1992), 91.

147 Watney, "Making Strange," 170.

photogram
An image formed by placing material directly onto a sheet of sensitized film or paper and then exposing the sheet to light.

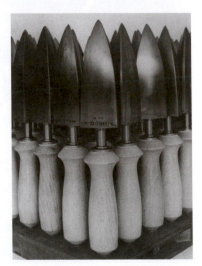

1.81 Albert Renger-Patzsch, *Shoemaking Irons, Fagus Works*, Alfeld, 1928

Dazzled by innovation and newness, these avant-garde photographers saw themselves as revolutionaries of the future. A reorganization of vision carried broad implications; if one could discover new ways of seeing aesthetically, then one would realize and implement new systems elsewhere, within ideas, politics, and social intercourse. Rodchenko's philosophies were evident in the uniform he wore to work. "He looked … like a combination of pilot and motorist," described one of his students.[145] The suit reflected his artistic stance: as visionary, on one hand, and as worker, on the other. If artists were workers, artmaking would no longer be an elitist practice, separate from other kinds of production, but would join industry to drive change from within the products of mass-marketing. Rodchenko and Moholy-Nagy did not define themselves as photographers and did not distinguish between photography's use as a fine or an applied art. By integrating alternative photographic perspectives into illustration, product design, and manufacturing, images would be seen by more people and could act as a catalyst for social change. Ardent about promoting or situating art and design within the public eye, Bauhaus students were required to document their work for publication in art and trade magazines. These images of modern design, employing the formal innovations and hard geometry of Russian and German photographers, influenced the developing advertising industry.

Art historian Herbert Molderings describes how advertising co-opted the defamiliarizing techniques, but without political intent:

The development of *Sachfotographie*—the photographing of individual objects—is recognized as an important achievement of photography in the twenties … Objects hitherto regarded as without significance are made "interesting" and surprising by multiple exploitation of the camera's technical possibilities, unusual perspectives, close-ups and deceptive partial views.[146]

Photographers such as Albert Renger-Patzsch (1897–1966) presented elegant rows of metal spoons, irons, and headlights. Standing at attention, the functional objects were rendered useless. Renger-Patzsch emphasized the symmetry and precision epitomizing the age of modern industry. In "Making Strange: The Shattered Mirror," Simon Watney describes how *ostranenie* "dissolved into the general Modernist need for constant stylistic innovation, seen as an end in itself. It became aestheticised."[147]

The New Vision rippled into an international style, utilized by photographers from the 1930s to the present day. During America's Great Depression, social documentary photographer Dorothea Lange framed sharecroppers from low angles so they would soar heroically into the sky. These shots dignified the American laborer and endorsed the myth of American individual liberty and opportunity in order to establish faith in the New Deal programs. In her essay "The Armed Vision Disarmed: Radical Formalism from Weapon to Style," Abigail Solomon-Godeau traces the evolution, and the diminution, of

the New Vision. Beginning with the Bauhaus, the style moves to the Institute of Design in Chicago to influence the next generation of photographers, such as Aaron Siskind and Harry Callahan.[148] Detailed, abstracted shots and radical angles are inherently interesting and can aestheticize any subject, from poor farm laborers to expensive Italian sunglasses.

NEW VIEWS: EXPERIMENTS IN SPACE AND TIME

Rodchenko and Moholy-Nagy were not the first to seek extreme or elevated views. Explorers, scientists, artists, and adventurers discovered and subsequently rediscovered the horizon from the 15th through the 19th centuries. In his introductory chapter of *The Panorama: History of a Mass Medium*, Stephan Oettermann explains how the ability to sight the horizon provided a symbol of physical and psychological limitations. The unvarying distant line comforted sailors and eventually came to symbolize real or imagined boundaries: that which the horizon encircles is safe, while that which lies beyond is a risk to be avoided or an obstacle to be overcome.[149]

In search of new vantage points, we can fly to exotic places or at least view them on television. The 18th-century viewer's outlook was much more restricted, so Europeans in search of distant views ascended mountains in search of unsettling vantage points. At 15,000 feet, the world presents itself anew. Overcome by these new visual sensations, climbers reported feelings of seasickness. Those who couldn't travel took part in the trend by visiting the tallest structures within a town, the cathedral towers. "Church spires no longer directed the gaze of the faithful heavenward; instead of looking up, human beings, themselves become godlike, now looked down from towers that served their need to see."[150] Eventually, architectural feats such as the Eiffel Tower (built between 1887 and 1889) replaced mountains and churches and were erected solely to satisfy the crave for distant horizons.

Not all those who ascended remained on firm ground; Oettermann points out that the surge of interest in the horizon and the invention of hot-air balloon flight occurred simultaneously. The first unmanned balloon lifted off from France on June 5, 1783. Six years before the French Revolution, Pilâtre de Rozier became the first person to take flight, inspiring throngs of people who followed the trip from the ground. These middle-class onlookers equated the balloon's boundless views with their own new powers of social navigation. By 1860, as surveyors and photographers took advantage of the balloon's panoramic view for surveillance purposes, the public began to see the floating vessel more as a threat than as a symbol of independence.[151]

The views afforded by hot-air balloons, the Eiffel Tower and early 19th-century skyscrapers were not to be outdone until 1968, when space travel expanded the view

148 Solomon-Godeau, "Armed Vision."

New Vision
Phrase coined by László Moholy-Nagy (1895–1946) to describe photography's ability to exceed human vision with radical points of view achieved by cameras, and with experimental processes using light and photographic chemistry.

149 Oettermann, *Panorama*, 8.

150 Oettermann, *Panorama*, 11.

151 Oettermann, *Panorama*, 13.

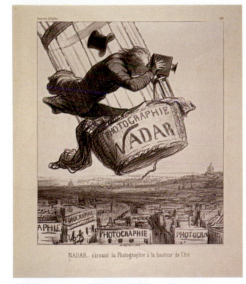

1.82 Honoré Daumier, *Nadar Elevating Photography to the Height of Art*, 1862, lithograph, 36.5 × 29.9cm. Originally from the journal *Boulevard*, May 25, 1862

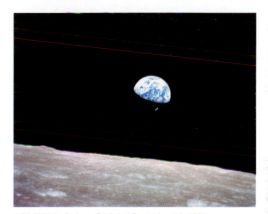

1.83 William Anders, *Earthrise*, December 24, 1968

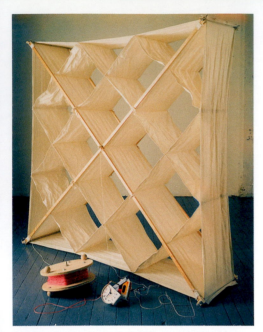

1.84 Paul Ramirez-Jonas, *Multicell Square Box Kite, after Joseph Lecornu*, 1994. 62 × 18 × 62in. Kite made after pre-existing original, photograph, alarm clock triggering device, and spool with line

152 For more background on the Whole Earth image, see "The Eye of Discovery," in Vicki Goldberg's *The Power of Photography* (New York: Abbeville, 1993).

153 Jerome Yaakov Garb, "The Use and Misuse of the Whole Earth Image", *Whole Earth Review*, 1985, p. 19.

154 Garb, "The Use and Misuse," 20.

155 Suzanne Seed, "The Viewless Womb: A Hidden Agenda," in *Multiple Views: Logan Grant Essays on Photography*, ed. Daniel P. Younger (Albuquerque: University of New Mexico Press, 1991), 398. [Originally quoted in Lacan's *Four Fundamental Concepts of Psychoanalysis*.]

156 Seed, "Viewless Womb," 392.

157 Seed, "Viewless Womb," 398.

Hasselblad
Medium-format Swedish camera design, originally modeled on a German surveillance camera from World War Two.

158 Paul Ramirez-Jonas, email message to author, November 20, 2002.

from the whole city to the whole planet. Taken 25,000 miles from Earth, the "Whole Earth" image of a small sphere hanging in a vast atmosphere is said to have initiated the environmental movement of the 1970s. Since national boundaries were indiscernible from outer space, the environmental movement saw the Whole Earth image as capable of uniting a global community that would care for their shared planet.[152]

In his 1985 essay "The Use and Misuse of the Whole Earth Image," Yaakov Jerome Garb criticizes the Whole Earth image for representing a limited view. Rather than enabling us to see the planet comprehensively and with more sympathy, Garb warns that distance will lead to a kind of "psychic aloofness." According to Garb, the metaphysical separation between humans and their surroundings began when Judeo-Christian monotheistic religions of a God who existed "out there" replaced religions in which local pagan spirits inhabited all living matter.[153] Says Garb: "Though the whole Earth image emphasizes the unity and interconnectedness of all places on the distant Earth, it homogenizes all specific places, and de-emphasizes the importance of having an intimate knowledge, bonding, and loyalty to a specific locality."[154]

Suzanne Seed contends that what Garb finds problematic is the nature of sight itself: vision inherently separates you from the thing you see. In her essay "The Viewless Womb: A Hidden Agenda," Seed searches for the source of this sentiment and locates it within **Lacan's** assertion of the eye as evil. Because "You never look at me from the place from which I see you," looking implies a relationship fraught with dominance and subservience.[155] Seed argues that Garb is fearful of the implications of looking. His desire to lose distinct perspective and to have direct experiences is an unrealistic whim to be newborn, to be without preconceptions, "the fantasy of a viewless womb."[156] Instead, she maintains, mediated experiences are human experiences. It is necessary and "healthy" to hold an opinion and to have "the power to focus and separate."[157]

On a 1966 NASA space flight, one astronaut lost his grasp on his personal **Hasselblad** camera, allowing it to bob off into the cosmos where it may continue orbiting to this day. This poetic image of a mechanical eye constantly in a state of surveillance but unable to take a photograph parodies human attempts to get a picture from every possible vantage point. Like the astronaut, artist Paul Ramirez Jonas (b. 1965) sent his own low-tech satellite into the sky. Ramirez Jonas attached a disposable camera to a box kite, a replication of a flying machine invented during the early 20th-century race for air flight. After successive attempts to become airborne, each of his kites recorded its first successful flight with a single photograph triggered by a wind-up clock timer. The free-floating eye of the kite, aimed toward the tether that led back to Ramirez Jonas, documented the kite's transcendence of space and the artist's earthbound status. Ramirez Jonas says that the initial photographic attempts did not include his distant figure, and thus looked like common "pictures from high up."[158] The feat of achieving extreme angles provided only a novel thrill. Ramirez Jonas addressed the problem by rigging the camera to show

the relationship between himself and the kite. The kite climbs to the fanciful heights imagined by Alpine climbers and "see-sickness" seekers, and to the radical positions demanded by the Russian proletariat and the French revolutionary.[159] Ramirez Jonas shows up as a small speck at the end of the rope. Not discernible as human, his face can show neither the euphoria of flight, nor the sadness of being left behind. Ramirez Jonas exhibits the actual box kites alongside their ensuing photographs, thereby providing a record of the performance and the successful outcome of the endeavor.

Modern devices, such as satellites and surveillance cameras, satiate the public's continually growing expectations for boundless views. Sites such as Google Earth allow those with access to a computer to explore the Earth, Mars, and the moon via photographs and satellite imagery. Public access to these distant views can be educational, thrilling, and sometimes extremely useful. In the aftermath of Hurricane Katrina in 2005, many New Orleans refugees sought views of their homes by zooming in on aerial views in Google Earth. Twenty-four hours after the levees broke, people could scrutinize the condition of their home by comparing recent images taken from a jet with older satellite images.[160]

Twentieth-century citizens became increasingly reliant upon the faster speeds of the mechanical eye. Now, 21st-century observers quickly record hundreds of digital images and reorient their eyes with the moving images of television, video, and the Internet. The wave of screen events asks only that the spectator sit back and receive the deluge, without contributing to its construction. This hyperactive movement—the average shot on television changes every 3.5 seconds—requires the eye to continually readjust.[161] The eye becomes accustomed to rapid transitions and viewers quickly learn to surf through channels and scan through pop-up windows on the Internet. News networks such as CNN have absorbed Internet design strategies that showcase the user's multiple boxes: search engines and mailboxes appear alongside credit card advertisements, dream vacation sweepstakes, and weight-loss trials. CNN's screen also offers several options at once: a newscaster, an additional picture box, story headlines, the stock report, and a scrolling text box reeling off excerpts of unrelated stories. In an attempt to appear innovative, accommodating, and technologically efficient, the composite of visual data divides viewers' attention with a choice of simplistic stories. Viewers learn to navigate multiple and diverse sources, but sacrifice substance for distraction.

A viewing environment that accommodates several stimuli at the same time is a pre-World War Two invention. It is no coincidence that the American **picture magazine** and interstate highways developed at the same time. When motorists read billboards while driving on the highway, they employ the same attention it takes to read magazine stories peppered with advertisements. The eye's/mind's ability to subconsciously register stimuli has been documented in studies about "highway hypnosis." In one study, a driver reported that, while driving at night, he approached the glow of a town

159 Oettermann, *Panorama*, 12.

Jacques Lacan (1901–1981)
French psychoanalyst who supported the idea of the unconscious mind as espoused by Sigmund Freud, and whose ideas influenced linguistics, film, and literary theory.

160 Katie Hafner, "For Victims, News About Home Can Come from Strangers Online," *New York Times*, September 5, 2005, Business Day, C1.

161 Postman, *Amusing*, 86.

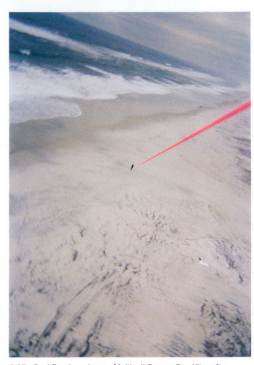

1.85 Paul Ramirez-Jonas, *Multicell Square Box Kite, after Joseph Lecornu*, 1994. 24 × 36in. Photo

picture magazine
A type of print magazine that emerged in the 1930s. The picture magazine (examples are *LIFE, Look*, and *Picture Post*) presented news and entertainment in mainly photographic form, and with dynamic layouts and captions.

1.86 Surveillance camera

162 Tuan, *Space and Place*, 70.

163 Sally Stein, "The Graphic Ordering of Desire: Modernization of a Middle-Class Woman's Magazine, 1914–1939," in *The Contest of Meaning*, ed. Richard Bolton (Cambridge, MA: MIT Press, 1992), 142.

164 Stein, "Graphic Ordering," 166.

165 Crary, introduction to *Suspensions*, 1.

166 Crary, *Suspensions*, 367.

magic lantern
A type of slide projector used for entertainment from the end of the 17th century to the early 19th century. Traveling lanternists would project light through images hand-painted on glass slides. "Magic" refers to the tendency of the imagery to be of creepy, supernatural subjects.

and realized that he had been "in an almost asleep condition for about 25 miles."[162] For 30 minutes, his eyes navigated curves on the highway without retaining any memory of the experience. Advertisers hope you will remember more. Magazine layouts set up highway viewing conditions: stories trail off and re-commence later in the journal, guiding us through the real point of the magazine—the advertisements. Text intermingles with imagery, advertisements with editorials. In her analysis of typical women's magazines from the 1940s, Sally Stein discovers that the layout is "not organized along a single continuum."[163] Editors expect viewers to sustain interest in the articles while simultaneously browsing product endorsements. Picture magazines such as *Ladies Home Journal* and *Life* prepared viewers "for the distinctive flow of messages delivered by television."[164] Television adopted the techniques that proved successful in previous media.

In *Suspensions of Perception*, Jonathan Crary notes that viewers adapt to the influx of information by learning to "cancel out or exclude from consciousness much of our immediate environment."[165] In his speculations on human attention, Sigmund Freud wrote that viewers of the 20th-century technological age must assume an attentiveness in which everything is regarded but nothing is focused upon. He called the ability to evenly suspend attention *gleichschwebende Aufmerksamkeit*. His letter, written from a cafe in Rome, describes the frenetic activities surrounding his table: **magic lantern** slides and cinematic projections, electrically lit flashing advertisements, newspaper boys announcing headlines, and bustling crowds. By allotting a minimum amount of thought to each competing stimulus, Freud could ration his energies and reserve his focus for the letter. He compares the stream of information encountered by the 20th-century observer with his own methods of analyzing the accounts of eight patients a day without straining himself.[166]

In absorbing the familiarity of the snapshot, the pace of television, film, or video, and the omnipresence of Internet images, the 21st-century spectator continues to process at high velocity and regularly assumes a photographic way of seeing. The next chapter, "Vision: Tools, Materials, and Processes," takes a parallel approach by exploring the possibilities and limitations of various viewing devices, from the human eye to the camera obscura, to digital scanners, and to other types of camera. Discussion of camera features describes how various technologies enable particular acts of vision and the capture of visual phenomena.

Vision
Tools, Materials, and Processes

Rebekah Modrak

We begin by looking at how *human vision* operates in order to understand our eyes as the primary tool of photography. Not only do our eyes work in particular ways to focus and frame our visual world, but all optical devices (cameras, scanners, etc.) depend upon or extend our visual acuity and limitations. An understanding of how you use your eyes, and their capabilities, helps you to make choices with other technologies. This chapter describes the basic anatomy of the eye–brain visual system, but also begins to look at how visual aids extend our biological tools.

"The camera as viewer" describes how camera viewfinders, viewing systems, and lenses enable us to see. Beginning with the camera obscura, a darkened room that allows one to visualize the exterior world, we then continue with handheld cameras. Here, our focus is on how the camera can be used to orient the visual world vertically or horizontally; how the lens affects how much we can see and how much is in focus, and the scale or proximity of objects in relation to one another.

The final section, "The camera as recorder," describes different camera formats that record visual data, from small, medium, and large digital and film-based cameras, to instant and cellphone cameras, photocopiers, and scanners. In this section, we describe the available options, such as size of the film or sensor, storage ability, and processing capabilities, how to operate each camera body, and how to control components such as aperture and shutter.

EXPLORING HUMAN VISION

Many visual aids and devices, such as photographic cameras, are based on human optics. So close is the relationship between human vision and photographic seeing

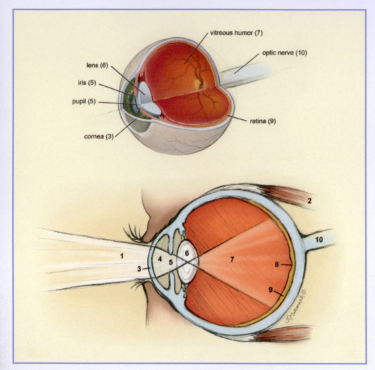

1.87 Passage of light

that we tend to forget there is a difference. However, the constant fluctuation of the eyes as they scan, seek, and trail after visual phenomena is quite different from the experience of seeing through a photographic camera, and vastly different from the representation of that vision in a flat, still, photographic image. Recognizing the complex physical and cultural dynamics caught up in the act of looking allows us to recognize the eyes and brain as the primary tools of vision and to be more aware of the peculiarities of camera-based vision.

The eye and the brain

1 With the eyelid raised, **light** enters the eye and brings with it the information picked up by reflecting from or passing through objects in its path. These light patterns travel past the eyelashes that keep out dust, and through the cornea that is kept moist and clean by a continual flow of tears.

2 Muscles attached to the eyeballs move them in harmony with one another. The eyes move continuously: slowly, from side to side and up and down, when following a moving object; rapidly, when searching for something; and in a constant tremor to keep vision from fading. If the retina receives no data, the optic nerve stops sending images to the brain.

3 The **cornea** is the window to the eye, a clear tissue that protrudes from the opaque white of the eye. The cornea causes the first and greatest light refraction, or bending of the light, for focusing. Light passing through the cornea is bent sharply toward the center of the eye.

4 Light exits the cornea as tightly clustered rays. These enter the **aqueous humor**, a clear fluid behind the cornea that continues to bend the light to the same degree as the cornea. In addition to its role in focusing light, the aqueous humor also nourishes the front part of the eye.

5 Next, light encounters the **iris**, a colored, doughnut-shaped muscle whose hole is the **pupil**. The iris increases or decreases the size of the pupil's opening in order to let more or less light in. Dark-colored irises, brown or hazel, have more pigment than blue or green.

6 Behind the iris/pupil, the **lens** does fine focusing for near or distant objects. Though very small, the lens consists of about 2200 infinitely fine layers. These layers lie on top of each other like the layers of an onion and alter their shape, becoming curved or flat, to accommodate for seeing different distances. Each layer of the lens bends the light slightly so that the effect is a smooth focusing.

7 The **vitreous humor**, a clear gel, fills the space between the lens and the retina, giving the eye its shape. It has the same refractive index as the lens, so that the rays continue on the course set by the lens.

8 Next, the light patterns reach the eye's **retina**. The retina lines the inside the posterior wall of the eye. It has three layers: (1) photoreceptors that convert the light into electrical and chemical signals. There are two types of receptors: rods (able to discern black and white values in low light) and cones (meant for detail and color in bright light); (2) bipolar cells that pick up electrical signals from the photoreceptors; and (3) ganglion cells that transmit the messages to the brain by the optic nerve. Contrary to what you might expect, the rods and cones are in the last layer of the retina. Light first passes through the nerve fibers, the ganglion and bipolar cells before reaching the receptors.

In the middle of the retina is a tiny area called the macula, responsible for the eye's sharpest vision. And at the center of the macula is the **fovea centralis**, which sees fine detail. Because the fovea contains only cones and no nerve fibers, light reaches the receptors unobstructed. The eyeball moves continuously to keep the image focused on the fovea, which makes up only 5% of the retina but is a huge part of acute vision.

9 The retina's **nerve fibers** come together at one location, the optic nerve head, in order to exit the eye. The nerve bundles from both eyes come together at an intersection called the optic chiasma. They separate into two branches and continue on to the left and right lateral geniculate bodies, located just beyond the brain's midsection, and then to the fourth layer of the visual cortex, where visual perception takes place. In the cortex, different nerve cells react to different sets of signals from the retina. For example, one cell reacts if the stimulus is a certain color or moving horizontally, but shows no response at all when the stimulus moves vertically. These cells combine, exchange data, and create perception—a picture in the mind.

From the visual cortex, signals are also disseminated to other regions of the cortex. Because vision involves memory and association, signals are sent to other areas of the brain that store the data of experience.

Altering human vision

Human vision is continually mediated. Corrective lenses and sunglasses alter all visual data. Windows and doorways frame and restrict our view, lighting amplifies focus, and city or rural plans order all visual elements. These devices operate as photographic viewfinders, designating importance through visual hierarchies and simplifying our visual world. Some of these tools are manufactured: the size and

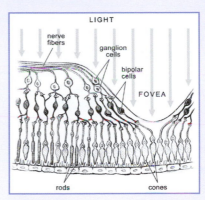

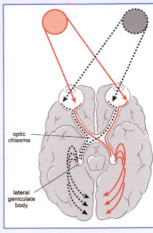

1.88 Retina wall **1.89** Signals to brain

 1.2 Refer to our web resources for additional descriptions of how the eye and brain operate, including binocular vision, and for instruction on how to simulate a Ganzfeld effect.

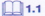 **1.1**

1.90 *Personal Horizon Lines*, Wearable Tension Fabric, 2005, 2006. Jessica Frelinghuysen writes: "*Personal Horizon Lines* remedies displacement and the tension some might feel from their urban surroundings. These wearable horizons provide city dwellers with a horizontal plane on which to rest their eyes after being blocked in by verticals on a regular basis."

1.91 Exterior view of refrigerator box camera obscura

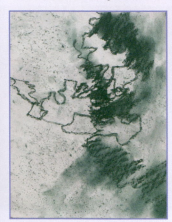

1.92 Caitlin Costello, *Backyard View*, 2005. Chalk pastel drawing of camera obscura image

1.93 Digital photograph of projection inside box camera obscura, recorded with video camera. Dimension of box approx 18 × 18 × 18in

@ **1.3** Refer to our web resources for information about altering human vision via corrective lenses, binoculars, camera-binoculars, Night Vision devices, and telescopes.

shape of a television screen, the shape of a camera's viewfinder, the span of a pair of spectacles, the conventions of landscaping that dictate intervals for spacing views—all are determined for us. Some viewing devices are invented by artists in order to reframe the visual world in idiosyncratic and site-specific ways.

THE CAMERA AS VIEWER

The camera obscura
Constructing a room-sized camera obscura

A camera obscura is a light-tight chamber with a small hole in the middle of one wall. Light enters through this hole, projecting a moving image of events occurring directly outside the room. The camera obscura can be made by modifying an existing enclosed space, or by building a new room in any location.

The space/room must have two necessary conditions: (1) The chamber must be light-tight (windows must be blacked out, cracks in doors sealed, etc.) and (2) there must be an aperture that allows controlled amounts of light to enter. The aperture can be 2–3 inches in diameter. The image will be projected on the surface directly opposite the aperture.

To operate the camera obscura: Open the aperture. Watch the wall opposite the aperture and wait until your eyes adjust. Eventually, you will see an upside-down image of the view outside the aperture.

Constructing a portable camera obscura

Small or portable camera obscuras can be made out of any light-tight container: wooden boxes, books, tents, etc. The following directions explain how to elaborate upon the design of the room-sized camera obscura by turning a cardboard box into a portable camera obscura.

For a basic portable camera obscura, find a box that can be closed on all sides and that, when fitted over your head, has at least 5 inches of room to spare from the top of your head to the top of the box, and at least 12 inches between your eyes and the front of the box (the image plane).

Interior of box The image will project into your box. You can allow the box's corrugated texture to be the surface of the viewing screen or, since images are easier to see on a white surface, you can tape white paper onto the viewing plane.

Seal the box Tape over all seams and corners (electrical and duct tape work well).

Make a hole for your head

Option 1: cover all of your head If you have a large box, you may want to place your head completely inside the camera obscura. In this case, cut a hole large enough to fit your head though the open side of the box (the side with flaps).

Option 2: cover part of your head If your box is smaller, you may want to fit the box partly over your head, rather than covering it entirely. This design also allows more room for the aperture. Rather than cutting a hole for the box to fit over your entire head, custom-fit the hole so that the box fits over the top of your head and rests on the bridge of your nose. In our example, we cut half a circle at the bottom of the box (on the same side as the aperture); and continued this hole-circle on the bottom of the box, pointing out in the shape of a nose.

Make an aperture: Place the box on your head. Measure the gap between the top of your head and the top of the box. In the center of this space, on the back wall of the box, cut a 2-inch square hole. The hole must be high enough so that light entering the aperture will pass by your head, and low enough that light entering will not strike too close to the top of the box. Cut a piece of aluminum (metal from a beverage can works well) into a 2.5-inch square. Using a small drill-bit or a large pin, poke a hole into the middle of the metal piece. Smooth the aluminum with sandpaper so that the hole has no rough edges. Center the aluminum across the box's 2-inch hole and tape into place.

Operating the box camera obscura

The camera works best in bright light. Place the box over your head, with the aperture at the back. When the box is sitting on your head/nose, the insides will need to be light-tight. Wrap a towel around your neck to keep light from entering the box from below. Watch the wall opposite the aperture and wait until your eyes adjust. You will see an upside-down image of the view behind your head.

The viewfinder

A viewfinder that allows the user to see the scene being photographed is not essential to a camera. Pinhole cameras do not have a viewfinder, and therefore do not allow the operator to see an approximation of the final image before it is made. Part of the intrigue of pinhole photography is that the user cannot see a final image until it is processed. On the other end of the spectrum, a room-sized camera obscura allows the viewer to watch every aspect of the scene in all its large-scale projected splendor. There is no grid or window to hold up to your eye; by standing inside the room, the viewer is positioned inside the belly of the camera.

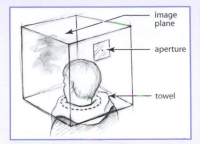
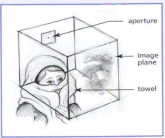

1.94 Portable box camera obscura over entire head, with towel wrapped around to prevent light leaks

1.95 Portable box camera obscura fitted onto the bridge of the nose, with towel as hood

1.96 Viewing with box camera obscuras

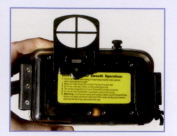

1.97 This 35mm underwater camera has both an optical viewfinder and a pop-up frame viewfinder

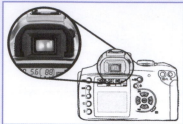

1.98 Optical viewfinder on a digital SLR camera

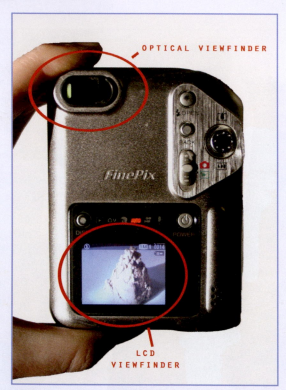

OPTICAL VIEWFINDER

LCD VIEWFINDER

1.99 This point-and-shoot digital camera has both an optical viewfinder and an LCD display for pre- and post-viewing images

Digital and 35mm cameras are equipped with some form of viewfinder, from a basic wire frame to an optical viewfinder or an LCD screen. The viewfinder defines the rectangular image in order to frame the scene before you. The following section describes various types of viewfinders, and how they may be used to compose the subject.

Optical viewfinders

An optical viewfinder is a glass or plastic "window" that allows you to see and compose an approximation of the final image. Single-lens reflex cameras have optical viewfinders. Some digital point-and-shoot cameras have an optical viewfinder, though most have only an LCD screen. While the optical viewfinder is primarily used to compose the image, it may also contain other information:

1 some kind of focusing tool(s), such as crosshairs and lights that indicate when the image is in focus
2 parallax guides to indicate the actual edges of the image compared with what the viewfinder shows
3 status indicators that light up when the flash is ready
4 light meter readings
5 aperture and/or shutter speed settings.

The quality of the viewfinder will determine whether its image is bright and clear, and the amount of **parallax** error. Some optical viewfinders have a *diopter control*, a small wheel that adjusts the viewfinder to fit your vision. In Figure 1.98, part of the diopter control wheel is visible at the top right corner of the viewfinder.

LCD viewfinders

Most digital cameras have an LCD (Liquid Crystal Display) that can be used as a viewfinder. This monitor gives a larger window with which to compose the image, view and edit menu options, and review and delete pictures already captured. Window sizes vary, with some screens having a diagonal dimension as large as 3.5 inches. A big display can make a marked difference in the ease of viewing images. There may be some differences between the image viewed in the LCD and the final image, depending upon the quality of the LCD. Additionally, after pressing the shutter release button, the camera's computer may adjust image color, sharpness, and other characteristics.

The downside of using the LCD is that it may be difficult to read in direct sunlight or in low light conditions, though some cameras offer a screen brightness control and some LCDs have an anti-reflective coating. Some cameras allow you

to adjust the position of the LCD by swinging it out and tilting it away from the camera. Be careful when using the LCD, as it eats up a lot of battery power (the larger the screen, the more the drain on battery power).

Optical and LCD viewfinders and parallax error

Parallax error is the difference between the view you see in the viewfinder and the view the camera actually records. The kind of camera you are using and the quality of the viewfinder will determine whether there is parallax error. Rangefinder cameras with optical viewfinders have some parallax error: the recorded image will have a slightly different perspective or will include more of the scene than you see in the viewfinder. SLR camera viewfinders see TTL (through the lens); the viewfinder shows exactly what the lens sees, so there is no parallax error. LCD viewfinders also have no parallax error, showing 95–98% of the final image.

Viewing systems

A camera's viewing system allows the user to see an estimate of the "picture" before pressing the shutter release button. The viewing system is also the means by which the camera's digital sensor or film "sees" the image in order to record it. Usually, a camera's viewing system includes the viewfinder, the lens, and the film plane or digital sensor. There are several different viewing systems in today's cameras. Small- and medium-format cameras are usually equipped with either an *SLR*, *Rangefinder*, *Viewfinder*, or *LCD* screen (live view) viewing system. Large-format cameras have a direct view from the subject to the back of the camera, using the Ground Glass viewing system. Each system has its advantages and disadvantages, which change according to the goals of a specific project. Digital cameras have introduced a post-exposure viewing system, via the *LCD monitor*, which allows you to immediately review the image after pressing the shutter release button. Each system has its advantages and disadvantages, which change according to the goals of a specific project.

Single-Lens Reflex (SLR)

The single-lens reflex system is used for both film and digital cameras. In the SLR system, a viewer sees almost exactly what the lens sees. Light enters the lens, hits a mirror which is positioned at a 45-degree angle, and is reflected through the focusing screen into the pentaprism. The pentaprism reverses the mirrored image back to its original view so that it can be seen correctly in the viewfinder. A viewer looking through the viewfinder sees the scene from the same vantage point as the lens. There is no parallax error. While making the actual exposure, the viewer

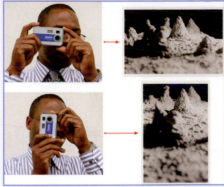

1.100 The same subject can appear vastly different, depending upon how we order it through the viewfinder. In this group of images, the horizontal orientation (top) allows the viewer to see a wider vista and presents the tableau as an irregular series of peaks and statuary. In contrast, the vertical orientation (bottom) emphasizes the foreground and confines the landscape to an orderly series of receding peaks

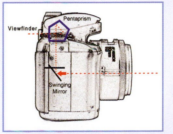

1.103 Single-lens reflex viewing system

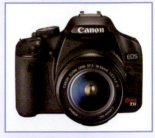

1.104 Single-lens reflex camera. Small-format. DSLR camera

1.101 and 1.102 Here, the photographer used vantage point as an opportunity to underscore particular aspects of the scene. The eye-level view of the lockers allows the viewer to see the entire row, emphasizes its ordered framework, and limits information about materials. The worm's eye view gives partial, but more detailed, information. While the eye-level view seems impartial, the image taken from the perspective of someone lurking on the floor seems more opinionated

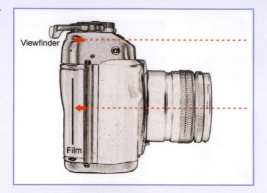

1.105 Rangefinder and viewfinder viewing systems

Viewfinder

Film

1.106 Parallax error. The black outline shows what the viewfinder sees. The red outline shows what the lens sees

1.107 Medium-format 6×7cm camera. Rangefinder viewing system

1.108 Small-format disposable 35mm camera. Viewfinder viewing system

will not be able to see through the viewfinder, as the mirror blocks the view to the subject.

Some SLR cameras allow the operator to see the aperture and shutter speed settings without removing the camera from the eye. The SLR also gives you the ability to see the focus and exposure controls, located on the viewing screen. A built-in exposure meter measures the amount of light passing through the lens. Lenses can be interchangeable: one can be replaced with another, from wide angle to telephoto.

Because an SLR has a more elaborate viewing system than rangefinder or viewfinder cameras, SLRs generally give more manual control of the shutter and aperture, allowing you to freeze or blur motion, to photograph at night, and to have shallower depth of field, with some areas in sharp focus and other areas blurred. The downside: they will be heavier, larger and more conspicuous. In addition, digital SLRs (DSLR) will not have some of the features of their smaller counterparts. For example, they may not be able to shoot digital movies. Most DSLRs only allow you to use the optical viewfinder to compose shots; the LCD screen only controls menu options and allows image preview.

Rangefinder and viewfinder viewing systems

Rangefinder and viewfinder cameras use a double-lens system. You view through one lens (the *optical viewfinder*) and the camera takes a picture through the second (we'll call that the camera lens). The view seen through the optical viewfinder is slightly different than the view seen through the lens because the eyepiece is usually positioned higher and to the side of the lens. This discrepancy causes the recorded image to be from a slightly different perspective than the one seen through the viewfinder, an effect known as *parallax error*.

Rangefinder cameras have a viewfinder and a rangefinder focusing mechanism. Some rangefinder cameras allow the operator to see the aperture and shutter speed settings displayed within the optical viewfinder. Focusing controls are variable, with some having set focusing zones, and some having adjustable focusing. Because a rangefinder camera does not have a pentaprism and reflex mirror, these cameras tend to be lightweight and small.

LCD screens

Most digital cameras have an LCD (liquid-crystal display) on the back of the camera. With a diagonal measurement of from 1.8 inch to 3.5 inch, the LCD screen on compact digital cameras—and a few digital SLRs—can be used to preview images in the making. While an optical viewfinder requires users to put their eye to the viewer, the LCD screen is viewed at a distance from the eye. In the interest of making digital point-and-shoot cameras smaller and increasing the LCD screen size, most manufacturers have removed the optical viewfinder and provide only

the LCD screen. In this and some other instances, this "live view" seen on the LCD screen is similar to that of an SLR system, in that the image comes through the lens and there is no parallax error.

One of the main advantages of working with a digital camera is the ability to see the results immediately. LCD monitors allow you to review images after they have been recorded. Evaluating the photographs at the time of exposure allows you to know whether the focus, lighting, and composition are correct, and, if they are not, to adjust the exposure and framing of successive shots. You can also review images in order to decide which ones to save, print, or delete. Be careful, because the LCD image preview takes a lot of battery power to operate.

The ground-glass viewing system

The ground-glass viewing system is generally only available in large-format film cameras. In this system, the image you see on the ground glass will be the same size as the image exposed on the film. The large-format camera is comprised of front and rear boards (standards) connected by an accordion-like light-tight bellows. The lens is fitted onto a lens board, which attaches to the front standard. The image comes directly through the lens and is projected on the ground glass, which is housed on the back standard. This type of viewing system is often used for photographing architecture because you can correct for converging lines by setting the front standard and then making fine adjustments to the back standard. While the large size of the ground glass (4 × 5 inch, 8 × 10 inch, or larger) makes it easy to focus, composition with the ground-glass viewing system can be tricky. Unlike the SLR, which uses a mirror to reorient the image to be right-side up, the operator sees an upside-down and backwards image on the ground-glass viewing screen.

The lens

The camera body is simply a black box for recording images, while the lens and film, or digital sensor, are responsible for image clarity. The sharpness with which a lens "sees" varies greatly, depending upon whether it is built of glass or plastic, and how it is engineered. If you want the romantic look of a slightly hazy scene, you may prefer a plastic lens, or a pinhole camera with no lens at all. If you want to take reasonably clear images, the zoom lens on most point-and-shoot film and digital cameras will suffice. For sharp, detailed images, a high-quality lens is necessary.

Imagemakers use clarity to direct the viewer's attention to a specific part of the scene. Clarity denotes importance. Sharpness is not essential, as demonstrated in images by artists such as Ralph Eugene Meatyard and Uta Barth. Meatyard

1.109 This point-and-shoot digital camera has an LCD display for pre- and post-viewing images

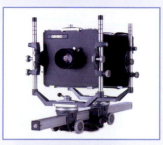

1.110 Large-format camera with ground-glass viewing system

film plane (focal plane)
Flat surface on which the image is formed inside the camera.

digital sensor
Digital cameras use a small light-sensitive sensor called a charge-coupled device or CCD to gather the light information in what are known as pixels. To render color, small translucent filter elements in red, green, and blue overlay the CCD.

depth of field
The sum distance in front and behind the (photographic) subject that appears to be in focus. Since there is only one distance at which the subject is in absolute focus, the depth of field is the range through which the blurriness is not apparent to the viewer.

image plane (aka the projection surface and the film plane)
The plane, in the camera apparatus, onto which an image is projected. The image plane is a more general term for the film plane in film cameras or the CCD sensor plane in digital cameras.

viewfinder
Window that shows the viewer an approximation of the image that will be recorded.

lens
One or more pieces of optical glass used to focus light rays to form an image.

focal point
the point where light rays originating from a single point on the subject converge behind the camera lens. Here, the point on the subject appears in absolute focus on an image plane in the camera.

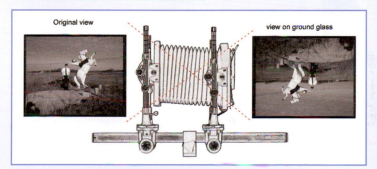

1.111 Large-format viewing system

1.112 No focus (f/2.8 at ⅛ second)

1.113 Focus on the foreground (f/2.8 at ⅛ second)

1.114 Mid-ground in focus (f/2.8 at ⅛ second)

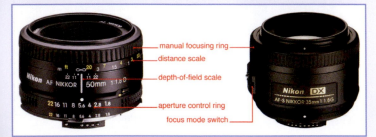

manual focusing ring
distance scale
depth-of-field scale
aperture control ring
focus mode switch

1.115 SLR lens (left) and DSLR lens (right)

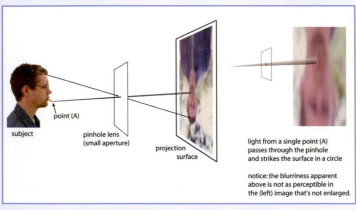

subject

point (A)

pinhole lens (small aperture)

projection surface

light from a single point (A) passes through the pinhole and strikes the surface in a circle

notice: the blurriness apparent above is not as perceptible in the (left) image that's not enlarged.

1.116 Pinhole lens

purposefully used haziness to sever the images from reality and Barth intentionally creates blurred images to question the notion of subject and to direct the viewer's attention outside the borders of the photograph.

Caring for the lens

When the lens is moved from cold to warm temperatures, condensation may appear. You can minimize this problem by allowing the camera to warm up slowly in a bag.

Clean the lens surfaces by brushing away dust with a soft brush or blowing away particles with a rubber blower. Then, crumple a clean piece of lens tissue into a ball, moisten it with a small amount of lens cleaning fluid, and wipe the lens gently in a circular motion. Use a second piece of tissue to dry the lens.

If your lens has threading on the front end of the barrel, you can screw on a clear glass filter to protect the lens. If the camera is an automatic one, the lens may retract for protection when not in use. Otherwise, cap the lens and store it in a cool, dry area.

The lens and focus

The sharpness of an image—its clarity or fuzziness of detail—is determined by several factors that involve the lens. Primary among these is the ability to focus the lens, either automatically or manually. The material and shape of a lens can also affect the sharpness of an image. Certain lenses are designed for maximum clarity, others are designed to minimize distortion or maximize speed, while other lenses intentionally do the opposite: cheap cameras with plastic lenses (such as the Holga) are popular precisely because they distort perspective and produce romantically hazy images. Likewise, pinholes produce idiosyncratically hazy images in a camera, although without the use of a lens. Regardless of the qualities of a particular lens or pinhole, the variables of focus, aperture, depth of field, and distance from the subject all interact with each other to alter the sharpness of an image.

The pinhole as lens

A pinhole functions much like a lens: it projects an image of a three-dimensional scene into a camera and onto a flat surface. Light reflected from one part of the subject passes through the pinhole and strikes a corresponding area on the image plane. Since light travels in a straight line, each point of the three-dimensional subject will be projected directly onto the projection surface on the opposite side of the pinhole.

As a general rule, a small round pinhole provides the sharpest focus because

light reflected from each point on the subject will be more precisely constrained during the projection (Figure 1.116). A larger pinhole produces a fuzzier image because light from each point on the subject will be more dispersed as it strikes the projection surface (Figure 1.117).

Regardless of the pinhole size, the light rays—as they travel from a particular point on the subject, pass through the pinhole, and project onto the image plane—can be described as a cone (Figure 1.118). Light from a point on the subject (the tip of the cone) travels in straight lines through the pinhole, producing a corresponding circle (the cone's base) on the image plane in the camera. Circles from every point on the subject overlap to produce a continuous field of color. Although the image produced may appear relatively clear, closer examination shows it to be consistently out of focus (see inset, Figure 1.116). Technically, a pinhole never produces sharp images; only a lens can really focus the photographic subject.

Focus and circles of confusion

A lens allows more light to pass through than a large pinhole, while sharply focusing beyond the resolution of a small pinhole. Figure 1.118 illustrates how light reflected from a single point of the subject (*point A*) travels to and through the photographic lens. Notice how the light entering the lens from a single reflective point can be described as a cone with its tip at the point and its base at the lens —this conical shape is made up of individual rays of light, each traveling straight from *point A* to a different point on the lens surface. There the lens glass bends the light, projecting it to converge at *point P*—the *point of focus* or *focal point*—behind the lens. This projection and convergence of light can also be described in terms of a cone: here individual rays travel from the lens surface to a convergence point—the tip of the cone—where light from a single point on the subject will appear perfectly focused at *point P* in the camera.

If the image plane is at the point of focus (*point P* in Figure 1.118), *point A* of the subject will be in focus on the photograph. If no film plane or digital sensor blocks the light at or before the point of focus, the light will continue traveling, forming an inverse cone on the other side (Figure 1.119). At each distance before and after *P*, the light rays from *A* form a circle. This circle, which can be isolated as a slice of the cone of light, is often called a *circle of confusion*. Therefore, if the image plane is before or after *point P*, the light rays from the subject's *point A* are not convergent on a single point and will not be in focus.

When a camera is out of focus (as in Figure 1.119's *image planes A and C*), the light rays from each point on the subject exist as circles of confusion, rather than as points, on the projection plane. These circles combine and overlap with nearby circles so the out-of-focus subject appears as a continuous fuzzy field of

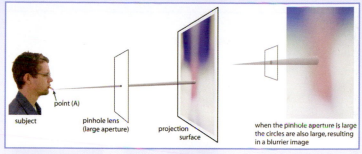

when the pinhole aperture is large the circles are also large, resulting in a blurrier image

1.117 Pinhole lens

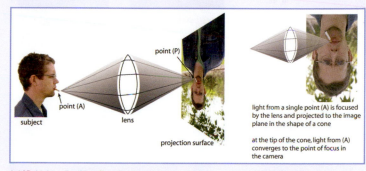

light from a single point (A) is focused by the lens and projected to the image plane in the shape of a cone

at the tip of the cone, light from (A) converges to the point of focus in the camera

1.118 Light reflecting off a single point

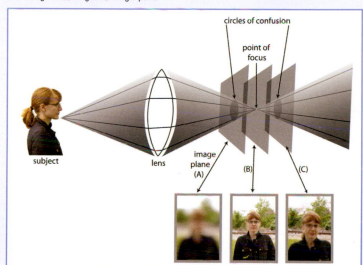

1.119 Point of focus

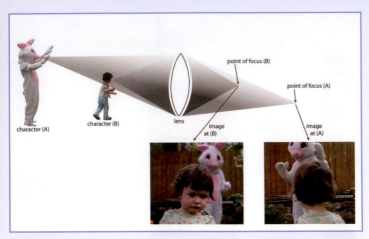

1.120 Subjects of different distance to the camera lens

1.121 Seven autofocus (AF) points are visible as white boxes. Here, the camera focuses the lens using the center point

1.122 To shift the focus, we locked the central autofocus (AF) point on the sand-dog in the bottom-left of the foreground, recomposed the image, and took the exposure

light and color. This is the same pattern projected by a pinhole lens: circles of light overlapping to create a blurry visual field (Figure 1.117). A pinhole image differs from a lens image, however, in that the entire scene is composed of like circles, causing near and far objects to be equally focused. A lens focuses its image differentially according to distance.

Distance, depth of field, and focus

As we have seen (and as illustrated in Figure 1.119), the light from a single point on the subject expands in the shape of a cone before passing through the lens and then converging, in the shape of another cone, to a tip—the point of focus. A second subject at a different distance from the front of the lens will have its own point of focus that lies at a different distance behind the lens (Figure 1.120). When a scene includes subjects at different distances from the camera lens, only one of these subjects can be absolutely in focus—i.e. the image plane can be at either *point A* or *point B*. However, it is possible for both subjects to *appear* focused on the photograph if the depth of field is large enough.

Since focus results from the spatial relationships between the subjects, the lens, and the image plane, changes in their relative distances will affect image focus. For Figure 1.120, the subjects could move relative to each other or to the camera, *or* the image plane could move toward or away from the lens, to alter the scene's focus. In practice, however, most cameras do not allow the distance between lens and film/digital sensor to be adjusted. Most cameras use a lens apparatus that adjusts focus internally through manual or automatic focus controls.

Manual focus

On manual cameras, or automatic cameras with manual focus, focus is controlled by rotating the *focusing ring* on the lens, located at the front of the lens. The *focusing screen*, seen through the camera's viewfinder, may provide some pattern or shape as an aid to help you focus. Single-lens reflex cameras with automatic functions usually provide a toggle on the lens that switches focusing control from manual to automatic.

Automatic focus

Point-and-shoot and single-lens reflex cameras with automatic focus adjust the lens to focus the image. (Most single-lens reflex cameras with automatic focus also allow manual focusing.) To focus automatically, press the shutter release button halfway down. Press the rest of the way to take the exposure. Automatic focusing is fast and can be helpful if your own vision is blurry.

The camera's viewing screen will show one or more focus (AF) points. These are

areas of the screen on which the lens can focus automatically; they are indicated on the screen by some sort of box, circle, or bracket. If the camera has only one focus point, it will be in the center of the viewing screen. If a camera has several focus points, it will attempt to use the correct one, although this may result in unpredictable focus, against the wishes of the photographer. Cameras with more than one focus point usually give the user the option of selecting which point is used. Check the camera's manual.

Although cameras automatically focus with the central focus point, your subject may not be in the middle of the field. To focus on a subject that is not in the center, you can reconfigure the camera to select a focus point that is by that subject, or you can use the central focus point to lock the focus before taking the image. Be aware that, when using automatic focusing, your camera will meter the exposure in the same part of the frame that it focuses. If you want to meter the scene from a different part of the frame than this focus point, many cameras offer an automatic exposure lock (AE).

Pre-focusing

While looking through the viewfinder, aim the focus point at the main subject and press the shutter release button halfway to activate the focus. Maintain pressure on the shutter button (this locks the focus into place) and recompose the image as you want it, with the main subject off-center. Press the shutter button all the way down to take the image.

Pre-focusing also helps in situations where the subject is moving. You can focus on a stand-in object or person at the distance at which the subject will be, and then wait for the moving subject to reach that point before taking the picture.

Lenses with selective focus

Garth Amundson stitches together his own lenses out of recycled water bottles. The elaborate, multi-faceted, clear, sparkling lenses create a reverential passageway for light to enter. At the same time, the exaggerated length of these forms plays with the phallic nature of photographic equipment, and the length of one's lens as a point of pride. The architectural emphasis of the construction is apparent in the resulting images as well, as they distort the outer edges of the subject, and fixedly focus our attention on the center.

Focus and digital images

Because of their small sensors and the short focal length of their lenses, most point-and-shoot digital cameras produce clear images with wide depth of field, even when using a wider aperture. When all areas of an image are sharp, all contents may seem to be equally important. In order to impart significance to one

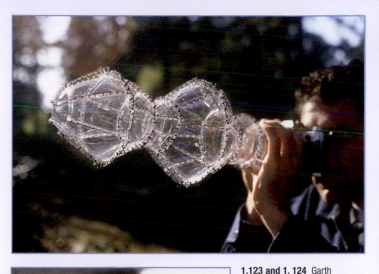

1.123 and 1.124 Garth Amundson, *Objective Distortion – Large Lens*, Recycled plastic and thread, 2000–2009

1.4 Refer to our web resources for a description of the LensBaby™, which attaches to any camera body to allow for more dramatic selective focus.

STEP 1

1.125

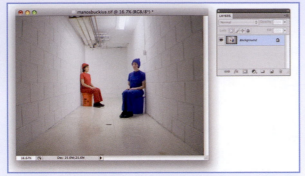

STEP 2

1.126

STEP 3

1.127

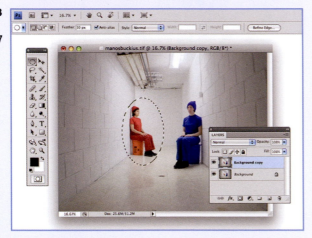

area, make that area the clear focal point of the image. If your camera cannot or did not produce an image with an out-of-focus area, you can soften that area in a digital editing program, such as Adobe Photoshop. Use one of the many Blur options under the Filter menu to defocus less important areas.

In the following example, we create blur using the Gaussian Blur filter and a Layer Mask. Blur filters locate significant color or value transitions in an image, then create intermediate colors or values to soften the edges. The Gaussian Blur filter uses a mathematical formula to create the effect of looking through an out-of-focus lens: it locates a pixel and averages the values of surrounding pixels into that pixel. We can control the amount of blur by adjusting the "radius" to determine how many of the surrounding pixels are affected. In this example we add the blur selectively using a Layer Mask.

The image used in this demonstration is by The ManosBuckius Cooperative, including Melanie Manos and Sarah Buckius. The MBC, *The MBC in The Basement*, digital photograph, 8×10in., 2007.

STEP 1
Open the image. Make your Layers panel visible by choosing *Windows > Layers*.

STEP 2
Create a duplicate copy of the Background image in your Layers panel by selecting *Layer > Duplicate Layer*, or by selecting *Duplicate Layer* under the pop-up menu at the top right of the Layers panel. Once you have a copy of the Background layer in your Layers panel, click inside the copied layer to make it active.

STEP 3
Determine how gradual the transition from focus to non-focus will be using Feathering. In the Options Bar, enter a Feather Radius. The lower the radius of pixels, the sharper the transition.

Next, select the part of the image that you want to remain in focus. To make our selection, we used the Elliptical Marquee tool. Next, invert the selection by choosing *Select > Inverse*.

STEP 4
Convert this layer to a Smart Object by choosing *Filter > Convert for Smart Filters*. This makes the filter editable and allows you to apply a mask to it.

STEP 5

Add a blurry filter to this layer by choosing *Filter > Blur > Gaussian Blur*. Increase the Radius to increase the softness. Click *OK* when you are satisfied with the amount of blur. The blur effect is applied to the selected area.

In your Layers panel, you will see the Smart Filter mask, which protects the clear areas, on the Smart Object layer. You can double-click on the Gaussian Blur filter to adjust the blur.

Focal length

Focal length is the distance from the rear of the lens to the image it forms on the focal plane when the lens is focused at infinity. Focal length determines the lens's angle of view and its magnification; it is measured in millimeters, and can be divided into three main categories: normal, wide, and long.

Focal lengths for film-camera lenses A film-camera's *normal* lens has a focal length that is approximately equal to the diagonal measurement of the image area it covers. The normal focal length for a 35mm film camera is 50mm. (The "35mm" in "a 35mm camera" refers to the size of the film, not to the focal length.) The normal focal length for a medium-format camera is 80mm, and that for a large-format camera is 150mm.

Focal lengths for digital-camera lenses The focal lengths of all digital point-and-shoot cameras and many digital SLRs (DSLRs) are different from those of 35mm film cameras because their sensors are usually smaller than one frame of 35mm film. It is harder to specify standard focal lengths for normal, wide, and long digital lenses because they are dependent on the size of the sensors, which vary with camera type.

　To ease the transition from film to digital, digital-camera manufacturers often provide a 35mm "equivalency," "focal length multiplier," or "crop factor" for the digital lens's focal length. For example, Nikon's focal length multiplier, given as 1.5, can be used to determine that when a 50mm film lens is placed on a Nikon DSLR body the resulting focal length would be 75mm (50 × 1.5). Or conversely, a digital lens with a focal length that is similar to Nikon's 50mm film lens would have a focal length of 75mm. This convention allows photographers to use regular film focal length numbers to understand the focal length of a camera lens or digital lens on a digital camera.

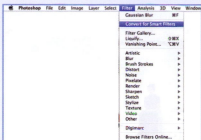

STEP 4

1.128

STEP 5

1.129

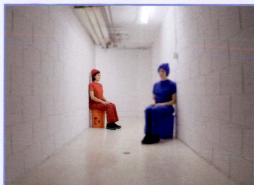

1.130

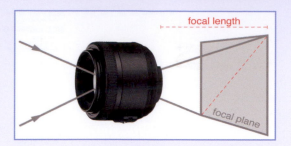

1.131 A camera's normal lens has a focal length that is approximately equal to the diagonal measurement of the image area

Dedicated and interchangeable lenses

If a camera has a dedicated lens, that lens cannot be removed from the camera body and replaced with another. Most point-and-shoot cameras have dedicated lenses. Film and digital SLR cameras are designed for *interchangeable* lenses that can be removed from the camera body, and another lens (often made by the same manufacturer) can be put in its place. Interchangeable lenses are either of fixed focal length or zoom lenses with the ability to change focal length. Be careful, because removing the lens from a camera exposes the interior to dust particles. This is especially difficult with a digital camera, whose electrically charged sensor attracts dust. If you store a camera without a lens, use a cap to seal the opening.

Many DSLR cameras are designed to accept both lenses made for film cameras and lenses made specifically for digital cameras. Keep in mind that using film-type lenses on DSLRs can cause vignetting, lower sharpness, chromatic aberration, and loss of some lens functions. In addition, because of the smaller sensor, they have a narrower field of view and an increased focal length. The narrowing field of view is especially noticeable when a wide-angle film-type lens is used with a DSLR body. Lenses made specifically for DSLRs are advantageous because the smaller sensor size results in smaller, lighter, and cheaper lenses. If you are choosing to attach film lenses to your DSLR, you may want to research potential compatibility issues.

Fixed lenses

Lenses of fixed focal length (for example, 50mm) are also referred to as single focal length lenses or prime lenses. Until recently, fixed lenses were constructed of higher-quality glass and optics than lenses that vary in focal length (zoom lenses). Thanks to improvements in design and construction, the gap in quality between the two types of lenses has narrowed. Fixed lenses are available with a larger selection of wide apertures, which make it easier to shoot in low-light conditions. However, a fixed lens gives limited options in terms of angle of view and magnification.

Zoom lenses

Zoom lenses provide a range of compositional options without having to alter the camera's position. Users can choose from a variety of focal lengths by rotating the zoom ring on the lens barrel, or by pressing a zoom button on the camera. This range of focal lengths allows you to magnify objects in a scene, or to increase or decrease your angle of view without repositioning the camera. Most cameras have zoom lenses or the capacity to accept a zoom lens. Some automatic cameras with a fixed zoom lens provide limited fixed zoom ratios rather than a continuous range of zooming.

1.132 Zoom lens

There are some drawbacks to a zoom lens. Because they must accommodate multiple focal lengths, the optical quality is usually not as good as fixed lenses. However, quality varies greatly between models and brands. A zoom lens will also allow for a smaller range of apertures than a fixed lens, which offers larger maximum apertures.

Digital cameras with zoom lenses allow you to magnify areas of a scene, with either optical and/or digital zoom. For digital point-and-shoot cameras, zoom values are given as a multiplication factor, such as 3×. This means that, from its widest point, the lens will zoom in 3 times. *Optical zoom* has a series of lens elements that lengthen the focal length to magnify the scene. As this is done optically, the quality of the image is still sharp. Digital SLR cameras only zoom optically. *Digital zoom* gives a zoom effect by cropping into the image and then magnifying that portion of the image to appear zoomed. Because the pixels are enlarged and fewer make up the image, image quality decreases. If you have imaging editing software, such as Photoshop, you will get sharper images if you do not use your camera's digital zoom, but instead magnify the image in Photoshop.

Panoramic lenses

Some panoramic cameras take a regular 46° angle of view and then crop the top and bottom to give a panoramic format. Others, such as the Lomography Society's Horizon Kompakt, take a 120° field of view.

Supplementary magnification lenses

Supplementary magnification lenses are small filter-like lenses that screw onto the front of an SLR camera's lens and magnify a scene. They come in different magnification powers, such as +1, +2, and +4 (sold separately or as a group) and can be screwed on individually or in combinations of two or more. Check your lens to make sure it is threaded to accept filters, and read the filter thread diameter so that you buy a supplementary lens that will fit.

Effect of focal length on angle of view and magnification

The *angle of view* is the amount of a scene that the lens is able to capture. If you make a circle with your thumb and forefinger and hold this makeshift viewfinder close to your eye, you will see most of the scene in front of you, as with a short focal length lens. When you move the circle a few inches from your eye, the view diminishes, approximating the angle of view of a normal focal length. By moving the circle further away, you reduce the angle of view even more, resembling the view of a long focal length. *Magnification* refers to the size an object appears to

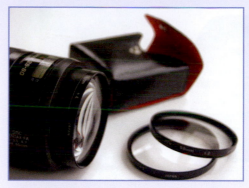

1.133 Supplementary magnification lenses. The +4 lens is screwed onto the camera lens. Also included in this pack are a +2 and a +1

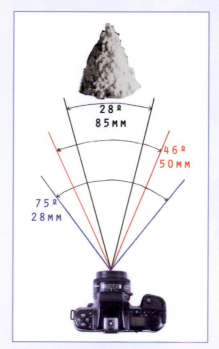

1.134 Angle of view

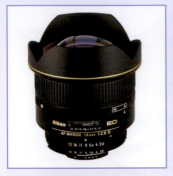

1.135 Wide-angle lens (14mm)

1.136 Wide-angle lens (28mm)

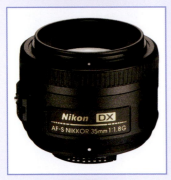

1.137 Normal focal length

1.138 Normal lens (50mm)

1.139 Long focal length

1.140 Long lens (85mm)

be in an image as compared with its actual size. A normal focal length lens makes objects seem their actual size. A wide-angle lens makes objects appear smaller. A long lens makes the subject appear bigger.

Wide-angle lens (short focal length)

The wide-angle lens in Figure 1.135 has a 75° angle of view, about 50% more than the human eye or a normal lens could see clearly if focused on the same subject. In Figure 1.136 the wide-angle lens takes in so much of the setup that the lighting stand is visible. A wide-angle lens will make it possible to capture a scene without backing up. While the angle of view is wider, the objects in the scene appear smaller than they would if shot with a normal focal length lens.

Normal lens (normal focal length)

This normal lens provides an angle of view of 46°, which approximates to the angle of view and magnification of human vision.

Long lens (long focal length)

This long lens has an angle of view of 28°. The long lens magnifies the middle peak, but in doing so, shows less of the scape around it. Long lenses make it possible to get an enlarged view of something that you cannot get close to.

Effect of focal length on depth of field and perspective

Focal length affects the relationship between the foreground and the background of an image. This section describes two effects of focal length: on *depth of field* (the area within a photograph, from near to far, that is sharp), and on perspective. Figures 1.141–1.145 demonstrate how the portrayal of a subject changes with varying depths of field and perspectives.

The wider the lens, the greater the depth of field. The longer the lens, the shallower the depth of field. Figures 1.141 and 1.142 show artist Megan Hildebrandt poised to begin a game of croquet through the campus of the University of Michigan. Her croquet route and Victorian uniform call attention to the history of female students' access to athletics and academia within the university. Each of the images was shot from the same distance (4 feet from the subject), with the same small aperture (f/16). Yet, because they each have a different focal length lens, the depth of field varies: The *wide-angle* lens yields clarity from foreground to background, a good effect if the photographer wants to emphasize all elements of the scene. The *long lens* yields shallow depth of field, a good effect if the image-maker wants the croquet player to be distinguished from the background. Note

also that the long lens compresses perspective, making distant objects appear closer to the foreground. Long focal length lenses are often used for portraiture as their compression of facial features is seen as more flattering.

Focal length and perspective

To make these images, the subject stayed in place. The photographer changed the camera focal length with each shot, and moved the camera back or forth to ensure that the croquet player remained the same size throughout all images.

The stereoscopic camera

A stereoscopic image consists of two photos, side by side, each showing the same scene from a slightly different perspective. When viewed with a special viewer, stereoscopic images give the illusion of viewing one three-dimensional space, giving the viewer the sensation of being able to look around the space of the picture. Victorians with the time and income for leisure kept a stereo-viewer and stereocartes in their parlor. The device has continued to entertain contemporary audiences in the form of the *View-Master*, a toy depicting three-dimensional cartoons, film stills and tourist sites. A special stereographic camera with two lenses is generally used to make stereographic images. The following instructions explain how to make stereoscopic images using a camera with a single lens.

Choosing a subject Stereographic images are most effective when the scene has a strong foreground, middle-ground, and background. That is, each section consists of distinct objects separated by a field of empty space. However, too prominent an object in the foreground could overwhelm the image.

Photographing images for stereo viewing After taking the first photograph, move the camera 2.75 inches to one side before taking the next picture. This is roughly the distance between your eyes. When moving the camera, make sure the distance between you and the subject remains the same: the images must be exactly the same size in order to view them stereographically.

Aligning the images Each image in a stereocarte is usually between 2 and 3 inches wide. You can print and align the images with or without a computer. In either case, align the photos by choosing one main item in the images and using this to align the pictures on a horizontal axis. For example, in Figure 1.147, we have chosen the closest vessel and aligned the images so that the vessel stands just underneath the guideline in both pictures. The amount of space between the photographs depends on the size of the prints. Move them back and forth until you find a distance that allows you to comfortably view the pictures in 3D. Crop the images so that they are the same size. Mount the images on heavier board, such as cardstock.

1.141 Wide-angle lens **1.142** Long lens

1.143 Wide-angle lens (short focal length); distance from subject: 4 feet
A wide-angle lens produces a steep perspective so that more elements of the background are visible, yet they appear smaller than in real life. Here, most of the building is visible, a good view if the artist wanted to reveal the precise location of the croquet game. The wide perspective exaggerates proportions: the croquet player looms out of her surroundings, almost as monumental as the hall behind her. The lawn seems to recede into the distance

1.144 Normal lens (normal focal length); distance from subject: 12 feet
A normal lens approximates the spatial and size relationships between objects as they are seen by human eyes. Here, the perspective makes the building seem closer to the croquet player. Unfortunately, the dark rectangular windows distract from the foreground event without providing any significant information to understand the context

1.145 Long lens (long focal length); distance from subject: 22 feet
A long lens compresses perspective, making elements appear closer to the foreground. Note that the building appears much closer, with details of the façade more visible. Likewise, the space of the steps and lawn is compressed, with the edge of the lawn seeming closer. This would be a good perspective if the artist wanted to emphasize the contrast between the whimsy of her uniform and the stability of the academic building

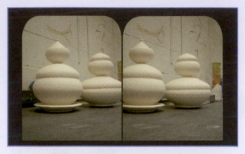

1.146 Sarah V. Cocina, *Two Pots*, 2002. Stereographic image. Each frame within the card is 3 x 3in

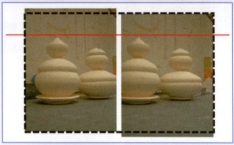

1.147 Aligning images

1.148 Viewing stereocard with toilet paper stereoviewer

1.149 Toilet paper stereoviewer. Here, two tubes are connected with a third so the device can be held with one hand. The tubes are painted black to keep light from entering through the sides

Viewing the image with a handmade viewer If you are unable to see the illusion using your naked eye, you can build a viewer. Two cardboard tubes, about 1.5 inches in diameter and 4 inches long (the size of a toilet paper tube), can serve as a viewing device. The two tubes are easier to hold if attached to each other. Hold them in front of your eyes as though you are looking through binoculars. Hold the stereoscopic images in front of the tubes so that the left eye sees only the left image and the right eye sees only the right image. Relax your eyes and merge the two images together into one three-dimensional photograph.

THE CAMERA AS RECORDER

Camera formats

The following section discusses different *formats* of camera that record information. *Camera format* refers to the area of information a camera will record. For example, a small-format film camera uses 35mm film. For digital cameras, the small-format section in the book includes point-and-shoot cameras and digital SLRs (DSLRs), which have sensors similar in size to a frame of 35mm film. The medium-format section includes film cameras that produce images typically about 6cm square, digital backs attached to medium-format film cameras, and DSLRs with sensors larger than 35mm. Large-format refers to view cameras using sheet film (or with digital backs) of at least 4×5 inches.

In addition to these small-, medium-, and large-format cameras, this section describes instant and cellphone cameras, photocopiers, and digital scanners. Each camera format may offer certain options, such as digital sensor and film size, type of viewing system, image storage, ability to record in b&w or color and as negative or positive, and various processing or output needs. This section describes these features and their availability. No features are inherently better than others, but should be chosen according to each specific project.

Small-format cameras

Portable cameras first appeared during the period 1880–1890. Popular among these were miniature spy cameras, discreet, quiet models such as the "photo-cravate" that tucked under a man's tie, or the "vest camera" that hid in a coat with the lens peeking out from a buttonhole. For everyday middle-class use, Kodak introduced the No. 1 Kodak in 1888. Fabricated with a fixed focus, the camera did not offer the photographer the ability to adjust the focus or to look through a viewfinder. A well-crafted version of today's disposable cameras, the No. 1 Kodak came already loaded with 100 exposures. Publicized as easy to use: "You press the button—We do the rest," users shot the pictures and then mailed the camera back for processing and reloading. In 1924, the Leica camera was invented in response to the need for a portable camera

1.150 Medium format. 6 × 7cm negative

1.151 Small format. 35mm negative

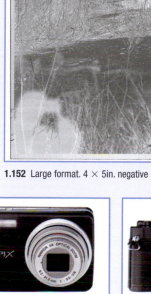

1.152 Large format. 4 × 5in. negative

1.153 Small format, disposable 35mm film camera. Viewfinder viewing system

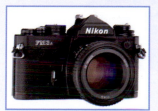

1.154 Nikon's S550 Coolpix. Small format. LCD screen

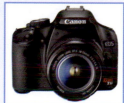

1.155 Nikon's FM3A. Small format. SLR 35mm film camera

1.156 Canon's Rebel T1i. Small format. DSLR camera

1.157 Lomographic Society's Zero Pinhole 35. Small format, 35mm film. No viewfinder. 25° angle of view

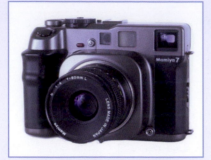

1.160 Medium-format 6×7cm camera. Rangefinder viewing system

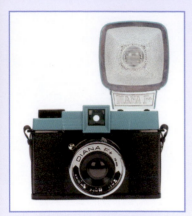

1.159 Medium format. Plastic Diana F+ camera. Viewfinder viewing system. The original plastic Diana camera was manufactured in Hong Kong in the 1960s. The camera became popular among art photographers for its saturated colors and soft focus. Manufacturers ceased production in the 1970s, but the Lomographic Society recently began producing a new version, the Diana F+, with pinhole and panorama features

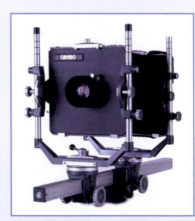

1.163 Large-format 4×5in. camera

1.161 Medium-format Zero pinhole camera. No viewfinder

	small-format camera: film	small-format camera: digital
available viewing systems	SLR, Rangefinder, or Viewfinder.	SLR, Rangefinder, Viewfinder, or LCD Screen.
film size/sensor	*Film size* refers to the dimensions of a negative in film cameras. In a digital camera, the film is replaced by an electronic sensor. This sensor records the image by translating the light into pixels. A larger film size or a larger number of pixels allows you to enlarge an image without losing detail. Whereas film size refers only to the dimensions of the negative, sensor size refers to the dimensions of the sensor and also to the sensor's quality.	
	The most popular small-format negative uses 135 (35mm) film, and produces an image that is 24x36mm in size (about 1 x 1.5in.) Sprocket holes on the film's edges help to secure the film inside a 35mm camera. Small negatives may show grain when enlarged beyond 8x10in. Film speed and processing factors also determine image resolution.	The amount of information a camera can record is referred to in megapixels. More megapixels does not mean higher-quality images, just that the image can be printed larger without losing image quality. Lenses and circuitry also affect image quality. Most digital sensors are not as big as one frame of 35mm film. Those that are the size of a 35mm film frame are "full-frame 35mm sensors" with high resolution. Besides size, the quality of different sensors varies greatly, with each being able to capture different amounts of information within the same dimensions.
number of exposures per roll of film / per storage card	35mm films are rolled in metal cassettes that hold 12, 24 or 36 exposures per roll. Some 35mm films can be purchased in 50- or 100-foot rolls, then bulk loaded onto cassettes.	Images are stored on removable memory cards rather than on film. The size of the card determines how many images can be stored. The number of images that can be stored also depends on the battery charge and the size of each image. Image size depends on camera settings used, for example resolution, compression, file format, and bit depth.
image type/file type	Each 35mm analog film has different qualities, ISO values, saturations, and proficiencies.	The file type or format is the way that the camera records information. Each format records data differently. The most common file formats for image capture, JPEG and RAW, have corresponding bit depths that affect the image quality and the amount of memory it takes to store an image. Shooting in RAW format provides the most information per image; shooting in JPEG provides less, but will yield a smaller file size.
grain/noise	As 35mm is a relatively small film size, recording less information during the exposure, images will show more grain with greater enlargement. Grain also increases as the ISO increases.	Digital noise results when the sensor captures random electrostatic charges along with the true light particles in a scene. Digital SLRs, with larger sensors and more noise filtration capabilities, produce less noise than most point-and-shoot cameras. However, noise is rarely a problem with any camera when shooting with a low (100 or below) ISO.
images are color or b/w?	Film for 35mm cameras comes in a wide variety of b/w and color. Each brand of film records color slightly differently.	All digital cameras produce RGB files that can be converted to B&W in the computer. Some cameras give you the option of photographing and reviewing in B&W. Like film, each brand of digital sensors records color differently. Most sensors render dark greens, blues and fluorescent colors more accurately than film.
images are negative or positive?	A wide variety of films for making negative or positive images.	Produces positive image that can be converted to negative in the computer.
camera lens options	Each camera body is simply a black box for recording images. The lens and film or digital sensor are responsible for image clarity. If you want the romantic look of a slightly hazy scene, you may prefer a plastic lens or a pinhole camera. If you want to take reasonably clear images, the lens on most point-and-shoot cameras will suffice. SLR and medium-format cameras have higher-quality lenses.	
	Standard lens is 50mm. Lenses can be inexpensive ones to specialty, wide-angle & telephoto. SLR lenses are interchangeable and can give a wide range of apertures, from f/1.8 to f/22. Zoom lenses (that have a range of focal lengths) are usually of lower quality, whether on a point-and-shoot or SLR camera.	Manufacturers now make lenses specially designed for digital cameras: their focal length matches the digital focal length and gives full coverage of the sensor area. Digital point-and-shoot cameras have a fixed zoom lens whose glass is nowhere near the quality of an SLRs lens.
available as manual or automatic	Some SLR cameras are completely manual, while others have some automatic controls. Conversely, most point-and-shoot cameras are fully automatic, though some may have manual controls.	None is solely manual. Digital cameras are either fully automatic or allow for both manual and automatic control.
aperture	A camera's *aperture* controls the amount of light that reaches the film or digital sensor by controlling the size of the beam of light. The choice of aperture setting affects depth-of-field (how much of an image is in sharp focus).	
	Point-and-shoot cameras have a more limited range of aperture settings than SLR cameras.	Point-and-shoot cameras have a more limited range of aperture settings than SLR cameras. SLR cameras are equipped with a range of apertures, usually from f/2.8 to f/32.
shutter	A camera's *shutter* controls the amount of light that reaches the film or digital sensor by controlling the duration of the beam of light. The choice of shutter speed affects motion and stillness in the recorded image.	
	Point-and-shoot cameras have a more limited range of shutter settings than SLR cameras.	Point-and-shoot cameras have a more limited range of shutter settings than SLR cameras. Lower-end point-and-shoot digital cameras have a lag time (a pause) between the time the shutter release button is pressed and the image is written to the card. This can make capturing motion difficult. Digital SLRs provide the same shutter settings as film SLRs.
expense	Cameras range from cheap to expensive. Film and print processing are additional expenses.	Point-and-shoot cameras range from cheap to expensive, especially now that disposable varieties are available. DSLRs are relatively expensive, especially if the camera body is a separate purchase from the lens. Larger storage cards are expensive. Digital eliminates cost of film & allows you to print only the images you want. Printers and ink cartridges can range from relatively inexpensive to high-end professional grade at high costs.
user operation considerations	These factors have to do with the camera's design, or how to process exposed film and digital images.	
	Commercial labs can turn negatives into prints or digital files. A darkroom or scanner and computer is needed to modify images. Compact cameras can be so small that they are difficult to hold or operate.	Storage cards can be given to labs for printing or the images can be directly downloaded from the camera to a computer or printer. To download, use a card reader, USB cord, or wireless connection. Digital cameras often use rechargeable batteries with varying battery life. Some camera batteries can be used hundreds of times, while the life of others is nearly endless. The dimensions and weight of compact digital cameras varies. While the small size of some make them easy to slip into a pocket, the tiny buttons may be difficult to operate. The camera interface also impacts ease of navigation through camera functions, making camera settings more or less accessible.

1.158 Table of small-format film and digital cameras

that could make test exposures for cinematography. By the early 1940s, the photographer Henri Cartier Bresson had adopted the Leica to quickly record fleeting scenes without being noticed. The quiet and lightweight camera allowed him to capture what he called the "decisive moment," that instant when the geometry and intensity of a scene reached its peak. This ability to react immediately to a situation led to the aesthetic of the snapshot.

Today, small-format cameras are the most common size of camera, with the most variation in features and cost. The main differences between small-format cameras is whether the viewing system is single-lens reflex (SLR), rangefinder/viewfinder, or LCD screen, and whether the camera is analog or digital. Cameras with automatic systems enable quick shots without the need to fuss with camera controls. Manual cameras, or cameras with a manual mode, allow you to selectively focus and/or choose aperture and shutter speed.

Medium-format cameras

Medium-format cameras are mid-range-size cameras often used for studio work, involving subjects without a lot of movement. They usually offer a wider range of apertures (f/2.8 to f/64) and a smaller range of shutter speeds (the fastest is usually 1/1000). The film's larger negative size is four times the size of a small-format image, allowing for far finer detail in prints. Most medium-format digital cameras have sensors sized proportionally with the standard film size ("120"). However, older or less expensive medium-format digital cameras have sensors just larger than 35mm. Most medium-format digital cameras are cross-platform in that they accept film or compatible digital backs.

Large-format cameras

Large-format cameras, also known as view cameras, are one of the most basic types of camera, used since the beginning of photography. They consist of a light-tight box with a lens board on one end and a ground-glass viewing screen on the other. After focusing your image on the glass, you drop a film holder containing one or two sheets of film into a slot in front of the viewing screen. Large-format cameras accommodate film in sheets the same size as the ground-glass screen—at least 4×5 inches, but potentially up to 20×24 inches. This large size makes large-format cameras ideal for images that need fine detail. The other advantage of large-format cameras is that the lens and film planes can be shifted in order to correct or distort perspective. These shifts are called "movements." Large-format cameras are big and bulky, must be placed on a tripod, and take time to set up. There are two variants: monorail and "field." Monorail versions have larger bellows and are typically used in studios. Field cameras do not have the same range of movements, but are lighter in weight and collapse to a size that is easier to carry. They are primarily film cameras, though expensive digital backs are available.

	medium-format camera: film	medium-format camera: digital
available viewing systems	Rangefinder, SLR or Twin Lens Reflex (TLR). A TLR system uses two lenses. One takes the picture and the other is used for the waist-level viewfinder.	Available in SLR. Digital cameras have LCD displays for post-exposure reviewing.
film size/sensor	Film size refers to the dimensions of a negative in film cameras. In a digital camera, the film is replaced by an electronic sensor. This sensor records the image by translating the light into pixels. A larger film size or a larger number of pixels allows you to enlarge an image without losing detail. Whereas film size refers only to the dimensions of the negative, sensor size refers to the dimensions of the sensor and also to the sensor's quality.	
	Film produces image sizes of 6cm. (about 2.25in.) or various widths: 6x4.5, 6x6, 6x7, 6x8, or 6x9 depending on the camera model. Film comes on plastic spools taped with lightproof paper backing. Because the negative is relatively large, the image will have fine detail when enlarging prints. Graininess or sharpness of print is also affected by the film's speed and processing.	The amount of information a camera can record is referred to in megapixels. More megapixels does not mean higher quality images, just that the image can be printed larger without losing image quality because lenses and circuitry also affect image quality. Medium-format digital sensors are bigger than one frame of 35mm film, but smaller than 4x5". Images have so much information that they can be printed very large without losing detail.
number of exposures per roll of film / per storage card	Depending on the camera, a 120 roll makes 12 6x6cm square exposures or 8, 10, or 16 rectangular ones. A 220 roll film has twice as much film.	Images are stored on removable memory cards rather than on film. The size of the card determines how many images can be stored. The number of images that can be stored also depends on the battery charge and the size of each image. Image size depends on camera settings used, for example resolution, compression, file format, and bit depth.
image type/file type	Medium-format films are made by different manufactures, each with different qualities, ISO values, saturations, and proficiencies.	Medium-format digital cameras use RAW file compression; many offer other formats, such as JPEG, TIFF, or DNG.
grain/noise	Images show little or no grain with greater enlargement. Grain also increases as the ISO increases.	Digital noise results when the sensor captures random electrostatic charges along with the true light particles in a scene. Medium-format digital cameras with larger sensors produce lower noise than small-format DSLRs.
images are color or b/w?	Film for 35mm cameras comes in a wide variety of b/w and color. Each brand of film records color slightly differently.	All digital cameras produce RGB files that can be converted to B&W in the computer. Like film, each brand of digital sensors records color differently. Sensors render dark greens, blues and fluorescent colors more accurately than film. Medium-format digital cameras have greater color depth than small format DSLRs.
images are negative or positive?	A wide variety of films for making negative or positive images.	Produces positive image that can be converted to negative in the computer.
camera lens options	Each camera body is simply a black box for recording images. The lens and film or digital sensor are responsible for image clarity. If you want the romantic look of a slightly hazy scene, you may prefer a plastic lens (such as a Holga), which creates images that are only sharp in the middle. High-end medium-format cameras have high quality lenses.	
	Standard lens is 80mm. Wide range available, from fixed lenses to specialty, wide-angle & telephoto. Plastic lenses (for plastic cameras) have limited aperture settings, usually only f/8. Plastic lenses are not very sharp and tend to leak light.	Medium-format digital cameras use the standard lens that fits on the analog camera body, though coverage will not be the same if the sensor is smaller than standard medium-format size. This will change the effective focal length. Manufacturers also make lenses specially designed for digital cameras that give full coverage and the correct focal length. Lenses are interchangeable, as long as they are produced by the same manufacturer as the camera body.
available as manual or automatic	Some SLR and Twin-Lens Reflex cameras are completely manual; some SLRs and Rangefinders have automatic controls and autofocus.	None is solely manual. Most provide both manual and automatic controls.
aperture	A camera's aperture controls the amount of light that reaches the film or digital sensor by controlling the size of the beam of light. The choice of aperture setting affects depth-of-field (how much of an image is in sharp focus).	
	Except for plastic varieties, they have a range of apertures, usually from f/2.8 to f/64.	Equipped with a wide range of apertures, usually from f/2.8 to f/64.
shutter	A camera's shutter controls the amount of light that reaches the film or digital sensor by controlling the duration of the beam of light. The choice of shutter speed affects motion and stillness in the recorded image.	
	Not designed for high speed. Fastest shutter speed is often 1/1000.	Not designed for high speed. Fastest shutter speed is often 1/1000.
expense	Except for the Holga and Diana (plastic cameras), most cameras are fairly expensive. Used twin lens reflex cameras may be relatively inexpensive, at $100-200.	Medium-format digital cameras are expensive. Digital eliminates cost of film & allows you to print only the images you want. Printers and ink cartridges can range from relatively inexpensive to high-end professional grade at high costs.
user operation considerations	These factors have to do with the equipment's design or processing of exposed film and digital images.	
	With the exception of the plastic cameras or some digital versions, medium-format cameras are heavier than small-format, but still portable. Commercial labs can turn negatives into prints or digital files. A darkroom or scanner and computer are needed to modify images.	Storage cards can be given to labs for printing or the images can be directly downloaded from the camera to a computer or printer. To download, use a card reader, USB cord or wireless connection. Digital cameras often use rechargeable batteries with varying battery life. Cameras tend to use a great deal of battery power and battery drain can be a problem. Medium-format cameras may be heavier and larger than small-format, but are still portable. Test out the camera interface to determine how easy it is to navigate through camera functions.

1.162 Table of medium-format film and digital cameras

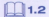 1.2

Pinhole cameras

Pinhole cameras are lensless cameras, constructed and used as early as the 1850s. The camera body has a small hole in one side, through which light passes and forms an image inside the camera. Because there is no lens to sharpen the image, pinhole images are fairly soft, which gives them a romantic quality. This is why they were popular in the 1890s with Pictorialist photographers who wanted photographic images with the hazy look of paintings. Interest in pinhole photography faded for many decades, and then revived in the 1970s when the first histories of photography were published and artists began to look at older processes.

1.165 Lomographic Society pinhole camera. Available in 35mm or medium-format sizes. No viewfinder

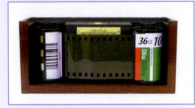

1.166 Lomographic Society 35mm pinhole camera. View from open back

![Lomographic Society Paper pinhole camera]

1.167 Lomographic Society Paper pinhole camera. 35mm. Viewfinder viewing system. 25° angle of view

large-format camera (aka view camera)	
available viewing systems	Ground Glass Viewing System
film size/sensor size	Film is available in 4x5in., 8x10in. and larger sizes. Large-format film is only available as single sheets, not in rolls. Digital backs are available with sensors that scan across a film plane that is almost 4x5in. The large film negative or digital image has the ability to retain detail while making large prints.
number of exposures per roll of film	Large-format cameras generally only accept film in single sheets. Each sheet is placed in a black light-tight film holder which can carry two sheets of film, one on each side. Each film type has a special "notch" to identify its type. The notch location also indicates the emulsion side of the film.
images are color or b/w?	Film selection is very limited. Digital images are color with great color depth.
images are negative or positive?	Film selection is very limited. Digital images are positive.
camera lens options	Standard lens is 135mm. Most lenses are high quality. They are available as fixed focal length lenses to specialty, wide-angle & telephoto. They are available in focal length from 35 to 700mm. Lenses can correct for converging lines in architecture.
available as manual or automatic?	Manual only.
aperture	Has the smallest possible aperture, so gives the greatest depth of field.
shutter	Has a leaf shutter that can flash sync at any shutter speed.
expense	Expensive. A used large-format camera costs about $500. Instructions for building your own view camera are available on the internet.
user operation considerations	Large-format cameras are heavy, require a tripod, and time to set up. If you scan the negatives and burn the images to CD, a photo lab can turn negatives into prints or digital files. A darkroom or scanner and computer are needed to modify images.

1.164 Table of large-format cameras

pinhole camera	
available viewing systems	Most do not have a viewing system because the camera body does not have a viewfinder.
film or paper size	Size is variable as most pinhole cameras are homemade. Size of image depends upon the size of the film plane. Purchaseable pinhole cameras, such as the Polaroid pinhole or wood cameras, range in size from 3 1/4 x 4 1/4 in. to 11x14 in..
number of exposures per roll of film	Most pinhole cameras accept a single sheet of film or paper at a time, though you can build or purchase a pinhole camera that will accept roll film. For example, the Polaroid pinhole camera will accept packs of film.
images are color or b/w?	Color or black and white. If the camera takes sheet film, there is a limited selection of films available. If the camera takes sheets of photographic paper or roll film, there are more varieties.
negative or positive images?	Negative or positive. Whether using sheet film, photographic paper, or roll film, it is easy to produce a negative. A wide variety of films and papers are available. A paper negative will yield a softer image because light will be projected through the paper when making the positive. A positive can only be produced using film (not paper) and there are only a few varieties of positive sheet or roll film available.
camera lens options	Pinhole cameras have no lens. The size of the pinhole aperture will affect exposure times and image sharpness.
manual or automatic?	Manual only.
aperture	If pinhole camera is homemade, aperture can be any size. Size of aperture will affect image clarity and exposure.
shutter	Shutter is usually rudimentary: a piece of tape covering the aperture. Therefore, shutter speed depends upon speed with which the user removes and reapplies the tape.
expense	Homemade cameras are very inexpensive. Commercial cameras average around $100.
user operation considerations	Paper negatives must be processed in a darkroom – cannot be given to a photo lab.

1.168 Table of pinhole cameras

Commercial pinhole cameras are available for purchase, or conventional camera bodies can be converted into pinhole cameras with a custom lens cap fitted with a pinhole. Pinhole cameras are also easy to make. You can use any light-tight container as long as you have access to the inside of the container (for loading and unloading paper or film), and can pierce a hole through the side. Lunch pails, watermelons, trashcans, buses, seashells, and discarded refrigerators are among the objects that have been transformed into pinhole cameras. Camera features that will affect the final image include: distance from the image plane to the pinhole, size of the film plane, whether the film plane is flat or curved, pinhole diameter, and number of pinholes.

Instant cameras

The instant picture process exposes and develops a photograph on the spot. Instant images offer an immediacy for artists who need to take and produce images without delay. Photographers often use instant film to take test shots before making a final exposure with another camera. Digital cameras with LCD post-exposure viewing offer an alternative method of viewing shots instantaneously, but instant photography still offers the only inexpensive means of producing an actual print immediately. This directness lends an authenticity to the photograph: the instant image may seem more truthful because there is no opportunity for manipulation in the darkroom or computer. Maybe for this reason, instant pictures are often used by construction and health industries that need evidence of a work site or a patient's condition.

1.169 Fujifilm Instax 200 camera and Instax 200 instant color film

1.170 Polaroid PoGo Instant Digital Camera. Digital camera with built-in printer

	instant picture camera
available viewing systems	Viewfinder viewing system. Instant camera backs can be attached to small, medium, and large cameras with other viewing systems.
film size	Film is available as small as 1.8 x 2.5in. and as large as 4x5in.
number of exposures per roll of film	Single sheets and 8- or 10-frame packs.
images are color or b/w?	Most films are available in color; some are available in black and white.
negative or positive images?	When pulled from the camera, the film is already developed into a positive image.
camera lens options	Most lenses are relatively low quality. The standard camera lens has a fixed focal length that focuses automatically between 3ft and infinity.
manual or automatic?	Automatic only.
aperture	Fixed.
shutter	Fixed.
expense	As of this writing, a moderately priced camera is about $50. Film is more expensive than other films, but processing expense is included in the price.
user operation considerations	Most cameras have built-in flash.

1.171 Table of instant photo cameras

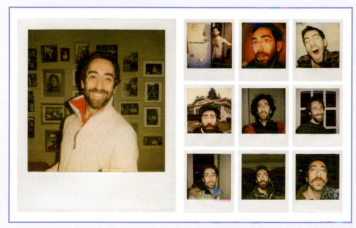

1.172 Marc Tasman, *Every New Year's Day* from the *Ten Year Polaroid Project*, 2000–2009, Polaroid SX-70 camera and Polaroid 600 film. Tasman photographed himself every day for ten years, from July 24, 1999 to July 23, 2009. The images here present a selective look at ten New Year's Days and offer one of many smaller ways of sorting and understanding the larger archive. http://www.youtube.com/user/marctasman/

1.173 Nokia N86 8MP small-format cellphone digital camera

 1.3

Instant photography is synonymous with the Polaroid brand name, although, in 2009, Polaroid discontinued all of its instant photography film products. The company now makes an instant digital camera with built-in printer that prints an image in 40 seconds. One or two other manufacturers currently make instant cameras. Fuji currently produces the most instant products, and these are available through www.lomography.com.

Cellphone cameras

The cellphone camera is changing the process of taking photographic images. At the time of this writing, cellphone cameras outsell digital cameras 4 to 1. Cellphone images change the way people stay connected and the way this communication is mediated. The digital images in the phone are meant to be transported and distributed. While they can be printed, the stable life of paper is not for them. Instead, the phone image is destined to be passed on, down- and up-loaded, shared and trashed. With mobile blogging (aka *moblogging*), users can capture and send digital images over wireless phone networks to a web page. Cellphone cameras can capture intimate or mundane moments of daily life.

The experience of taking images with a cellphone camera differs from that with conventional digital cameras. The cellphone camera is meant to be an amusing device used for phone conversations and emails, and thus has minimal features compared with standard cameras. However, cellphone cameras are increasingly being used for everything from work-related documentary applications to quasi-journalism, and are developing into more sophisticated machines. Artists may appreciate the more rudimentary aspects of the technology or the evolving features.

Cellphone viewfinder/display

Instead of a conventional viewfinder, the cellphone user views the image on an LCD screen. The screen fulfills multiple roles, from serving as the camera's viewfinder to showing various camera features and telephone menus and options. Composing an image on the screen usually involves holding the camera at a distance. The process of taking a photo has an almost video game-like dynamic of watching the action on the screen and maneuvering the phone to capture the desired shot. Different makes of cellphone have screens of different resolution. Screens with higher resolution give a better idea of how the image will look when uploaded online, emailed, or printed later.

Cellphone accessibility and shutter lag

While cellphone cameras are easily accessible, speed of use is not necessarily their strength. If the subject is fleeting, take into account that the phone must first

be turned on. Once on, it may take another 1–4 seconds for the camera feature to turn on, followed by an additional few seconds of "shutter lag." Shutter lag is the delay between when the camera shutter release is triggered and the photo is exposed. Recent models have less lag.

The cellphone lens

The lens is usually located on the back of the cellphone, though a flip-phone's lens can sometimes be found on the flip-top so that, when open, it faces away from the user. Kept in pockets and flung in bags, cellphones take such abuse that scratches and dust may affect lens clarity. Some phones have a sliding cover to protect the lens.

Due to the compact size of cellphones, cellphone camera lenses do not have space for variable focus or optical zoom. To take a sharp photo with the fixed focus lens, the subject must be at the perfect distance. Newer models have autofocus, and the quality of cellphone camera lenses will undoubtedly improve. For example, Varioptics is making liquid lenses, consisting of drops of water and oil sandwiched between glass or plastic. Many cellphone camera lenses have digital zoom (though remember that digital zoom gives the effect of a zoom only by cropping into the image, which will result in grainy images). Available as separate accessories, filters can enlarge, soften, or distort objects seen through the lens.

Lighting conditions

Many cellphone cameras have an automatic light sensor that measures the available light and adjusts the exposure in order to get accurate image brightness. Most cameras do not allow the user to control or direct the sensor and, in situations with varying intensities of light, the sensor reads only one area, often resulting in under- or overexposure. A few newer models feature *photometry*, which provides a choice between spot metering (metering a small part of the scene) and taking an average reading of the scene. Some cellphone cameras provide a few exposure and lighting options, such as adjusting image brightness before taking the picture, or setting the white balance by selecting between sunny, cloudy, tungsten, fluorescent, or nighttime lighting conditions. Some cameras are equipped with flash for low-light situations. Many manufacturers respond to the playful nature of popular photographs by creating features such as color effects, which tint images any color of the spectrum.

Image resolution

Resolutions for cellphone images can be fairly high. Many phones also offer three resolutions in varying bit depths: for example, 24-bit, 16-bit, and 256-color. Watch for camera overrides: some cameras have a default setting that automatically uses

1.174 Osman Khan and Omar Khan. *SEEN: Fruits of our Labor*, August 08, 2006. Acrylic, Infrared LEDs, Custom Electronics, Computer, Wire

The SEEN creators write: "*The project asks members of three communities that make up San Jose's labor needs – Silicon Valley's tech workers, undocumented service workers and outsourced call center workers – one question: What is the fruit of your labor? Their responses are displayed back to the general public on a 4×8ft. infrared LED screen whose content is visible only through the audience's personal digital capture devices (cellphone cameras, digital cameras and DV cams etc.). By creating this hidden/mediated spectacle, we knew we could generate the right amount of curiosity and reward … [to encourage the crowd] to partake in its 'viewing'. Part of the consequence of this engagement was that some people could completely view the work, while others shared or looked over shoulders in efforts to understand what all the fuss was about. Interestingly, the groups we had surveyed we felt were arguably well equipped to view the work: high tech workers for obvious reasons, and undocumented workers who prefer using mobile phones allowing them the ability to communicate while staying off the grid.*"

a lower resolution when images are taken with the flip handset open. This is based on the assumption that users will want to email those shots.

In addition, image quality is determined by the recording file format. Some phones allow users to save files in a range of formats, including JPEG, GIF, PNG, and TIFF. Check the phone camera manual for the size of each format.

Image capture review

When photographing with your cellphone camera, consider the features described above. In brief, choose the highest possible resolution and do not use digital zoom features. Clean the lens before use. Make sure the subject is fairly close to the lens, and is well lit. Hold the camera still when making the exposure.

Storage space

Some cellphone cameras have internal memory. Others have a side slot for removable memory that can be read with a card reader. These cards normally ship with the phone and vary in size. Storage space is not dedicated to images but must also accommodate other features such as contact information, calendar, and messages. The resolution setting and the recording file format determine how many images will fit in the memory space. Higher resolution and uncompressed images take up more space. Lower resolution and compressed images take up less.

Image viewing

Once captured, images can be viewed in the camera's image gallery. Images are usually recorded with the date and time they were saved. The gallery allows you to scroll through, erase, and edit captions, for all saved images. A handful of cellphone cameras even provide image-editing options, such as cropping, rotating, and resizing. For best image quality, it's usually better to edit photos with Photoshop rather than using the camera software.

Image sending

The real specialty of the cellphone camera is the ease with which images can be sent. However, some cellular service plans charge extra to send images.

To an email account If the cellphone is equipped with email messaging capabilities, the image can be emailed to your own or another account. Unfortunately, this process resizes photos and diminishes print quality.

To another phone The cellphone photograph can be sent to another cellphone user if they have the same cellular carrier or if their carrier accepts images from

other carriers. The final image's quality, however, may be determined by the image quality acceptable by the recipient's phone or server. Many servers limit the message to about 100K, so even if you are using a high megapixel camera, there may be a size limit when sending the image over the wireless network. Some servers handle larger file sizes, but the ultimate quality is still dependent on the technology used by the receiving phone.

To an image server Many cellular service carriers allow you to set up an image server, which is a space online to store or share images. In addition, websites such as www.snapfish.com offer free accounts for the same purpose. You can set up a photo album as a kind of home base. The album can be used to store and share photos and to order prints. Images can be uploaded to a server using the upload command on the cellphone.

Download to a computer or memory card Most camera phones support USB connections that allow the user to download full resolution images from their phone to a computer. This is one way to ensure you retain the original image quality.

Using Bluetooth If the cellphone supports Bluetooth technology, images can be sent wirelessly to a nearby electronic device, such as another phone, a Personal Digital Assistant (PDA) or a computer. The receiving device must be located within about 30 feet of the cellphone and must also support Bluetooth technology. The advantage of a Bluetooth transfer is that you do not need to connect your phone to the device using a cable.

Scanners and photocopiers

Unlike cameras, scanners operate by passing the lens or sensor over the image or object. Toner-based copiers are one of the most instantaneous, available, and inexpensive means of making an image. They spit out an image in seconds for a few cents. For this reason, photocopiers are often used to manufacture zines, fliers, and other mass-produced articles, but could also be used to generate original images. The process of making photocopies and using them within various transfer techniques is discussed in greater detail later in this book.

Digital scanners produce a digital memory of the image or object they record by converting tones and colors into digital information. There are essentially three different types: film, flatbed, and drum. A flatbed scanner is similar to a copy machine. A *linear sensor* makes one or three passes under the print, transparency, or object, which rests on a glass plate. *Film scanners* convert transparencies or negatives into digital files by projecting them onto a linear sensor that moves across the image area. The sensor samples points from the image or object being

1.175 Epson Perfection V500 flatbed scanner

1.176 Film scanner

1.177 Photocopier. Hewlett Packard LaserJet 9065 multi-functional printer prints up to 64 pages per minute

1.178 Epson Workforce 600. Print, photocopy, scan, or fax

scanners: digital	
types of scanners	Film, flatbed, and drum scanners; pens meant for scanning handwriting. Portable digital copiers. Multi-functional or all-in-one printers can scan, copy, and print images.
size	Film scanners range in size from 35mm scanners to drum scanners that scan large sheets of film. Flatbed scanners typically come in either letter or legal sizes, though larger beds are available.
image quality	Image quality depends upon the lens quality, resolution, dynamic range, and bit depth. The condition of the image or object being scanned is also a factor. The larger the original source material, the sharper the final copy will be reproduced. Resolution is described below. The "how to scan" section describes other controls that affect image quality. (See pp.89–92.)
resolution	A scanner is capable of optically capturing information up to a certain clarity. The optical resolution refers to the number of pixels per inch or samples recorded along the full width of the image. Optical resolution for film scanners is described by one number, for example, 4000 ppi. Flatbed scanners describe their optical resolution with two numbers, for example, 3200 x 6400 (width by length) ppi. The smaller number is the scanner's maximum optical resolution. However, the maximum resolution of that same scanner could be 12,800 x 12,800 ppi. After 3200 ppi, the software for this example would simply start making up, or interpolating, data based on the information from surrounding pixels.
optical density / dynamic range	A scanner's Dynamic Range, aka its Optical Density, is a measure of the range of densities and the deepest shadow density that the scanner can discern and record. When measured, scanner image density ranges from a 0 (pure white) to a 4 (very black). The scale is logrithmic. The larger the number, the better the scanner can see into the shadows.
bit depth	A scanner's bit depth is the accuracy with which it interprets color and tone. A higher bit depth, for example 24, captures a greater range of color than a bit depth of 8.
Digital ICE	Some scanners have this software, which removes dust and scratches.
scanning speed	Depends on scanning resolution, amount of scaling, bit depth, and size of original image. Generally, speed ranges from a few seconds to under several minutes.
negative or positive images?	Film scanners will scan either negatives or positives. Flatbed scanners usually work with reflective (opaque) surfaces, but most can be converted to scan transparencies or slides by removing the document mat from inside the scanner cover, connecting a different cable, and placing film or slides in a holder.
expense	Wide range, from relatively inexpensive to expensive depending upon type of scanner, the options, and features. Drum scanners are very expensive.

1.179 Table of scanners

scanned. The number of samples taken is described in ppi/pixels per inch (though many manufacturers refer to the sampling in dpi/dots per inch). *Drum scanners* offer the highest resolution; the print or transparency is attached to a cylinder that rotates at high speed while the sensor passes across its surface. As with any digitized image, scanned images can be viewed on monitors, projected, posted through the Internet, or printed.

BASIC CAMERA BODIES AND CONTROLS

The following sections will introduce you to the features, controls, and operation of basic camera bodies, including the basic flatbed scanner, pinhole camera, film and SLR cameras, and digital point-and-shoot and DSLR cameras.

Cleaning and maintenance of all cameras

Most camera bodies are fairly fragile. They should be handled carefully and protected from excessive heat, dust, and moisture. If you travel with your camera, store it in a padded bag. If you store the camera for long periods, some manufacturers recommend removing the batteries.

A camera body is a light-tight, closed receptacle. Opening the camera provides an opportunity for dust to enter the camera's interior. Digital cameras are especially vulnerable to dust because their operation relies so much upon electronics, which produce electrostatic charges that attract dust. Only open the camera body to install or remove film, memory cards, or batteries, or to change lenses.

Once dust gets inside a camera body, it is hard to eliminate. To clean the interior of your SLR, remove the lens, and gently blow air with a bulb blower. Never touch the fragile mirror itself. Some DSLRs have anti-dust filters built into the camera body. Others have a setting that allows you to open the shutter so that you can use a blower to carefully blow dust away from the surface of the sensor. However, this is a risky practice and is best done by a professional technician.

If your exposed image has dust spots, you can remove them from the digital image in Photoshop, or correct the image by spotting the print.

The basic pinhole camera

All devices that record images digitally or on film—pinhole, point-and-shoot, single-lens reflex, large-format, instant and cellphone cameras—have in common a few features. They share: a light-tight body, a hole to receive a stream of light, a way to prohibit light from entering, and an interior plane upon which to place and focus the image. The most basic image recording device, a pinhole camera, has only these four features. Figure 1.183 shows a basic pinhole camera, constructed from a cylindrical oatmeal box.

1.180–1.182 Jonathan B. Duke, detail of *The Big Game*, 2005, silver gelatin prints from pinhole camera negatives, each image is 5 × 10in

Basic pinhole camera parts

1 *Camera lid*: allows the container to be easily loaded with light-sensitive film or paper. Must close tightly to prevent light leaks.

2 *Camera body*: can be any light-tight receptacle, from a shoebox to a garbage can to a mobile vehicle. The depth of the container (distance from pinhole to film plane) determines whether the camera's focal length is wide, normal, or telephoto.

3 *Film plane*: the surface against which the photographic material is placed and where the image is projected within the camera. The size of the film plane determines how big the photosensitive material can be. Cylindrical pinhole cameras have curved film planes for greater image distortion. The paper or film curls inside the camera, and is easily secured against the film plane. For flat film planes, you may need to insert a lip to secure the paper or film to the plane.

4 *Pinhole aperture*: a hole drilled through a metal plate (the aperture plate) and smoothed down to eliminate rough edges. Smaller holes produce sharper images but require longer exposures.

5 *Aperture plate*: a small sheet of metal (here, a soda can) into which the aperture can be drilled.

6 *Shutter*: covers or uncovers the aperture to prevent or permit light entering the camera. The shutter of this pinhole camera consists of a piece of black electrical tape.

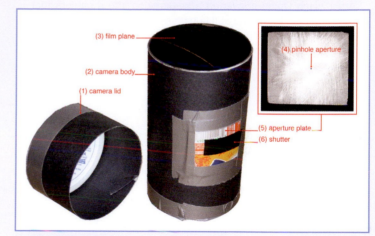

(3) film plane
(2) camera body
(1) camera lid
(4) pinhole aperture
(5) aperture plate
(6) shutter

1.183 Pinhole camera diagram

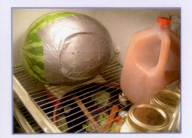

1.184 Watermelon pinhole camera

1.185 Image from watermelon camera

Lens-to-subject distance: 8 inches
Focal length (distance from the aperture to the film plane): 5 inches (short/wide)
Exposure time: 2 minutes
Artist Alana Quinn converted a watermelon into a camera that approximates the shape of a human eye. She took this exposure inside a lighted refrigerator (the melon's "natural" habitat). The wide aperture, pierced with a wooden skewer, yields a fuzzy image. This softness is accentuated by the paper negative that absorbed the melon's juice.

1.188 12-inch box pinhole camera

1.189 Image from 12-inch box camera

Lens-to-subject distance: 10 inches
Focal length (distance from the aperture to the film plane): 12 inches (long)
Exposure time: 10 minutes
This image was taken on an overcast December day in midday light.

Focal length and the film plane

The size of the film plane and the distance from the pinhole to the film plane—the camera's focal length—determine whether the angle of view is telephoto, normal, or wide. If the pinhole-to-film distance is shorter than the film plane's diagonal distance, the camera is wide-angle. If the focal length is longer than the film plane's diagonal distance, the camera will be telephoto. In addition, a curved film plane (as in the watermelon camera and image in Figures 1.184 and 1.185) creates more distortion in the final image.

1.186 6-inch box pinhole camera

1.187 Image from 6-inch box camera

Lens-to-subject distance: 10 inches
Focal length (distance from the aperture to the film plane): 6 inches (normal)
Exposure time: 3.5 minutes
This image was taken on an overcast December day in midday light.

Constructing a pinhole camera

Pinhole photography is a low-tech and inexpensive way to make negatives. Any light-tight vessel can be a pinhole camera and, with minimal modifications, can generate pictures. Artists have transformed oatmeal boxes, soda cans, and the human mouth into cameras that make photographs. Often, the object that captures the image is as compelling as the resulting picture. You may want to consider how the camera/vessel relate to the subject.

Make a container light-tight When choosing the container, bear in mind that the shape and size of the receptacle will affect the image. The container must be light-

tight. Reinforce thin areas with black cardboard or another material. There must be a lid or opening that allows you easy access to the interior in order to place light-sensitive paper or film inside. If the interior of the camera is not already black, spray it with flat black paint. An exception: a red interior (such as a watermelon or a red bell pepper) functions like a darkroom safelight and is safe for black and white papers. Seal the edges of the container (especially around the lid) with black electrical or duct tape.

Choose your film plane The film plane is where the photographic paper or film rests. Some vessels naturally provide a secure place to hold film or paper: For example, paper curls inside a cylindrical oatmeal box. Other containers will need specially built slots or lips to hold the light-sensitive sheet in place during the exposure time. You can also use a piece of tape to hold the film or paper in place.

Make an aperture plate and a shutter Cut a 2-inch square from a piece of metal shim (aluminum from a beverage can works well). Using a standard sewing needle, drill a hole into the center of this metal square. The smaller the hole, the sharper the image and the longer the exposure time. Turn the metal over and sand the aperture hole with fine-grain sandpaper to remove rough metal edges.

Cut a 1-inch hole in the middle of the wall opposite the film plane. Center the aluminum plate *outside* this 1-inch hole and tape it into place on all sides. Make a shutter by covering the hole with a 2-inch piece of black electrical tape.

Test the camera for light leaks In complete darkness, position a sheet of photographic paper or film on the camera's film plane, with the emulsion side (the side coated with light-sensitive chemicals) facing the aperture. Close the camera and make sure the aperture is covered by the shutter. Place the camera outside in the sun for 2 minutes. Return to the darkroom and process the paper. (See *printing images: traditional processes*.) If the paper turns gray, you have a light leak. Reinforce the camera.

Exposing a paper negative Load the camera with another sheet of photographic paper or film. When you're ready to take the picture, start with a trial exposure: If outdoors, open the shutter (uncover the aperture) for an exposure time of 30 seconds; indoors, try a longer exposure time of 2 minutes. At the end of the exposure, cover the aperture. Return to the darkroom and process the paper. If the image is too light, repeat the process with a new sheet of paper, and *double* your exposure time; if the image is too dark, repeat the process and *halve* your exposure time.

1.190 Rectangular box pinhole cameras have flat film planes. The ones shown here are made with black foam core, duct tape, and aluminum plate

1.191 Film-camera diagram

The 35mm SLR camera body

Figure 1.191 shows a 35mm camera, a light-tight receptacle with basic components for controlling exposure and the passage of film through the camera. The particular model shown is a single-lens reflex (SLR) camera. SLRs are bigger and heavier than rangefinder and viewfinder 35mm cameras because their optics are more complicated. They allow a lot of manual control; the operator can set the film speed, advance the film, meter the light, and focus the lens. Some SLRs can perform these actions automatically. Automatic cameras may or may not have manual or semi-manual modes that allow differing amounts of control.

Parts of the 35mm camera

These are the basic parts of a 35mm camera and lens (Figure 1.191). The precise location of the camera parts varies depending upon the model. Here, most of the controls appear as dials or rings. Cameras with more automatic features tend to control settings with a dial on the camera body. The settings for that dial are usually viewed through the camera viewfinder or on a small LCD screen.

1 *Film advance lever*: advances the film after an exposure has been made. If the lever is unable to advance, this may indicate that all exposures have been made. On some cameras, the lever must be partially engaged (pulled out from the camera) in order to press the shutter release button.
2 *Shutter release button*: controls the shutter by initiating the exposure. On an automatic camera, pushing the shutter release button halfway down automatically focuses the lens; pushing all the way takes the picture.
3 *ISO dial*: should be set to the film's speed (ISO number) so that the camera's built-in light meter can measure the amount of light specifically needed by that film.
4 *Hotshoe bracket*: allows accessories (e.g. an external flash) to be attached to the camera.
5 *Film rewind knob*: once all exposures have been made, the knob can be flipped out to make a crank handle. The crank handle, in conjunction with the rewind button on the bottom of the camera, winds the film back into the cassette. Automatic cameras will rewind the film automatically at the end of the roll. Pulling up on the rewind knob opens up the back of the camera for loading and unloading the film.
6 *Shutter speed dial*: is turned to regulate the shutter speed.
7 *Aperture control ring*: is rotated to choose an aperture setting.
8 *Manual focusing ring*: is rotated to manually adjust image focus.
9 *Viewfinder*: (on the back of the camera) shows the view seen through the lens (and projected onto the film).

Preparing the camera, taking exposures, and rewinding film

Install the battery Most film cameras use disposable batteries that require infrequent replacement. Make sure that the camera battery is charged. Automatic cameras usually have either an indicator light (that blinks or changes color when the battery is charged or low) or an LCD screen with a battery icon (that shows how much power is left). Fully manual cameras can take photographs even when the battery is depleted, although you will not be able to use the built-in light meter.

To install the battery, locate the battery compartment, usually on the bottom of the camera. Cameras use different types of batteries; automatic cameras will usually rely upon lithium or AA batteries while manual cameras usually use a button cell. Note any instructions inscribed within the battery chamber, such as a plus or minus symbol meant to correspond with the polarity of the installed battery.

Turn the camera on If the camera has any automatic features, there will be an on/off switch or lever.

Set the film speed The camera must know the film speed (**ISO** number) in order to measure light for that particular sensitivity of film. Some automatic cameras read and register the film speed automatically by reading a DX code printed on the side of the 35mm cassette. Manual cameras will have a dial that must be turned to set the speed to that of the film you are shooting.

Load the film Before opening the back of the camera to load the film, make sure there is no film currently in the camera. You can confirm this by peeking through the window on the back of the camera, which shows a strip of information from the film cassette. If there is no window, check the frame counter for "0" or "Empty."

Open the camera back If there is no film in the camera, open the back. Some camera backs unlock through a release button or switch; most manual cameras open by pulling up on the film rewind knob.

Place film in the camera Place the film cassette inside the large empty cavity to one side of the film plane (the flat stretch where the exposure takes place). In some cameras, the cassette inserts right into place; other cameras have spindles that must locate with the cassette. Once the cassette has been positioned, push the rewind knob back (if applicable). Check your camera's manual for more detailed instruction.

Pull the tapered film leader to release enough film to reach the take-up spool on the opposite side of the film back. Make sure that the film's sprocket holes line up with the teeth on the sprocket wheels. With automatic cameras, lay the film leader over the take-up spool, close the back, and the camera will advance the

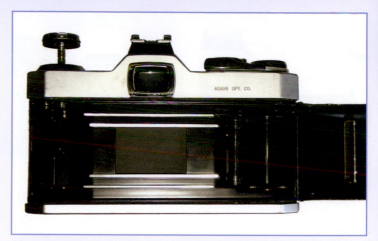

1.192 Loading film into a camera

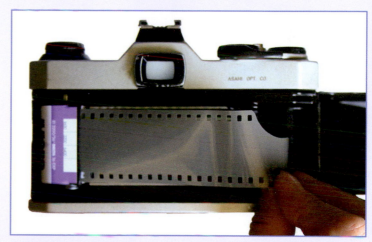

1.193 Loading film into a camera

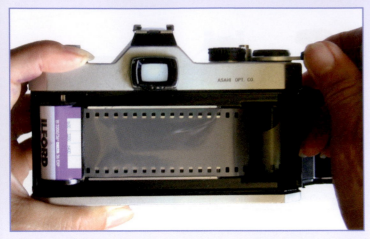

1.194 Loading film into a camera

film automatically. With manual cameras, the leader must be inserted into a slot or beneath a tab on the take-up spool.

Advance the film Make sure the leader is securely inserted, then alternately press the shutter release button and advance the film advance lever until the film winds itself once or twice around the take-up spool. Close the camera back until it clicks and locks shut. Advance the camera two more times to ensure that there is unexposed film on the film plane. If the camera is manual, make sure that the film rewind knob turns as you advance the film. The knob not turning indicates that the film is not properly loaded. If the camera is automatic, make sure that the frame counter or LCD panel shows a number "1," indicating that film is loaded and ready for exposure. If you need to reload film, the cassette can be rewound slightly by turning the hub located on one end of its spool. Do not rewind so much that the leader disappears into the cassette.

Take the pictures and rewind the film Use the viewfinder to compose and focus the scene. Record the image by pressing on the shutter release button. If the camera does not have automatic advance, wind the film with the film advance lever. Once all the exposures have been shot, you will see "24" or "36" on the frame counter and the film will no longer advance. The film must be rewound back into the light-tight cassette before it is safe to open the camera back. Automatic cameras usually rewind after the last frame on the roll has been shot. There is usually a rewind button in case you want to rewind a partly exposed roll. To rewind film in a manual camera, flip out the crank handle from the film rewind knob. (Do NOT pull up on the rewind knob or the camera back will open.) Press the rewind button, located on the bottom of the camera, while cranking the handle. You will know that the film is rewound when (1) the crank becomes easier to turn, indicating that the leader has been released from the take-up spool, and (2) the leader makes a "click" sound as it enters the cassette.

The digital camera body: Point-and-shoot and DSLR cameras

Unlike film photography, in which the pictures exist as latent images on photo-sensitive material until processed, digital photographs are visible immediately. This means that you can view an image on the camera's LCD screen, determine whether it fulfills your criteria, and take more pictures if necessary. Unwanted images can be deleted from the camera's memory so that the camera only stores those pictures that you want to keep.

Figure 1.195 shows digital single-lens reflex (DSLR) and digital point-and-shoot cameras. Both are light-tight receptacles with basic components to control

exposure and record the light digitally on light-sensitive chips. Compact cameras rely upon one or hybrid viewing systems, which may include viewfinder, range-finder, or LCD screen systems. DSLR cameras use a single-lens-reflex viewing system, and allow the operator to set the ISO number, meter the light, and focus the lens manually. Compact cameras will be smaller and lighter than DSLR cameras because their optics are simpler.

If you are considering buying a camera, www.dpreview.com and www.dcresource.com offer reviews of digital cameras.

Basic DSLR and point-and-shoot camera parts

These are the basic parts of a digital camera and lens (Figure 1.195). The precise location of the camera parts varies depending upon the camera model. The controls for most digital cameras, whether point-and-shoot or DSLR, are found either on dials and buttons on the top or back of the camera, or within a series of menus accessed by buttons on the back of the camera and viewed on an LCD screen. Detailed descriptions of these parts, as they relate to your image-taking, can be found in your camera's manual. Camera manuals are usually available online at manufacturer websites.

1 *Flash*: can be built-in or pop-up. Compact cameras often have a built-in flash and DSLRs have a pop-up flash.
2 *Flash button*: Most cameras have a flash button or dial option that tells the camera when to use flash.
3 *Lens release button*: can be pressed to remove the DSLR lens.
4 *Terminal cover*: located on the side of most cameras, providing sockets for attaching USB cables, AV cables, and remote controls. Such connectors transfer data from the camera to other devices.
5 *Shutter release button*: controls the shutter by initiating exposure. Pushing the shutter release button halfway down automatically focuses the lens and activates auto exposure metering to set the aperture and shutter speed. Pushing the button all the way takes the picture.
6 *ISO button*: allows you to specify the sensitivity of the camera's sensor to light (some cameras have a dial or menu option rather than a button).
7 *Power switch or button*: turns the camera on.
8 *Shooting mode dial or toggle button*: allows you to select Automatic, Semi-automatic, Manual, and sometimes Movie shooting modes. Many digital cameras also provide other modes, such as Portrait, Landscape, Close-up, and Night Portrait.
9 *Hotshoe bracket*: allows accessories (e.g. an external flash) to be attached to the camera.

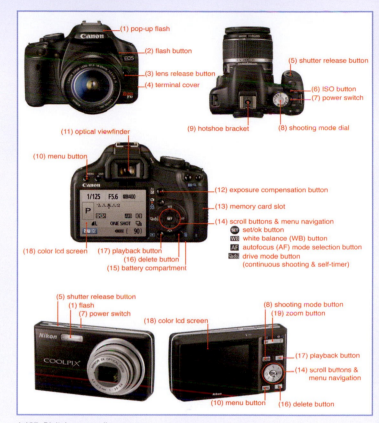

1.195 Digital-camera diagram

10 *Menu button*: provides access to options and settings in the menu, via the LCD screen.
11 *Optical viewfinder*: shows the view seen by the lens (and by the digital sensor).
12 *Exposure compensation button*: allows you to decrease or increase exposure.
13 *Memory card slot*: houses the memory card beneath a protective cover.
14 *Scroll buttons* and *Menu navigation*: allow you to move up, down, into, and out of menu folders. These buttons also provide other controls, such as:
 Set/OK button: confirms a selection when browsing in the menu.
 White balance (WB) button: allows you to choose a color temperature for the exposure based on the light in the scene.
 Autofocus (AF) mode selection button: allows you to choose which part of the image is being focused.
 Drive mode button (including *self-timer function* and *continuous shooting mode dial*): Self-timer function can be accessed by a dial, a button, or as a selection embedded in menus. This function provides a delay between the moment when the button is pressed and the moment when the picture is taken. The continuous shooting option tells the camera to take several shots continuously while you hold down the shutter button.
15 *Battery compartment*: houses the batteries.
16 *Delete button*: allows you to remove one or more images from the memory card.
17 *Playback button*: allows you to view and scroll through images captured on the memory card.
18 *Color LCD screen*: has many functions. It can be used: (1) to compose images while shooting when using a compact camera (and some DSLRs); (2) to view images after they have been taken; and (3) to view and adjust camera controls embedded in menus.
19 *Zoom button*: tells the motorized lens on a compact camera to move towards and away from a subject to zoom in and out on the scene.

Operating a digital camera

Install the battery Digital cameras use rechargeable batteries that gradually lose their charge, even when not in use. The charge may provide anywhere from 200 to 2500 shots, depending upon the size and type of battery and the temperature (cold temperature reduces the number of available shots).

Batteries are not shipped with a charge and must be charged before using. Follow manufacturer instructions to install the battery and charge it. Most cameras come with an AC power adapter for charging and recharging. Maximize the charge potential by turning the camera off when not in use. If storing the camera for a long period, run the battery out before removing it from the camera. Store the battery inside a soft case in a cool location.

Install the memory card A memory (aka storage) card is a small, rewritable chip that, like film, records the digital image data. Follow the manufacturer instructions to insert the storage card into the back or side of the digital camera.

Storage cards come in various formats and sizes. Most cameras come with a low-capacity memory card, such as 16 MB, which will fill up after only a dozen or so exposures. Your storage capacity needs will depend upon the size of your images (higher megapixel files require more storage space) and how many exposures you want to make before transferring the files to another storage device. It's usually helpful to keep the small card as an emergency backup and to purchase a larger memory card to use on a daily basis. You can download data from your storage card by attaching a cable from the camera to another device, such as a computer. Memory-card slots built into laptops, card readers, cellphones, printers, photo-printing kiosks, and other devices also allow you to transfer data from the storage card. A card reader is useful because it offers several slots, for varying storage card formats. This comes in especially handy if you have several digital cameras or want to download photos from a friend's camera.

Turn on the camera The start-up time, the amount of time it takes for a camera to power up and be ready to shoot, can vary from a fraction of a second to several seconds.

Set the image resolution and compression Cameras may offer different image file formats, for example JPEG and/or RAW. The file format will determine compression and bit depth (the number of bits each pixel contains). The greater the bit depth, the smoother the transition from tone to tone, the more accurate the color representation, and the greater the capacity for editing in Photoshop without affecting image quality.

- **JPEG** The JPEG format compresses the file by discarding subtle shifts of color, or other information that seems too subtle for the human eye to detect. Throwing out information yields smaller files but also tends to degrade image quality. Most digital cameras allow you to choose between several levels of compression, and thereby to control (to some degree) how much information gets lost. Many point-and-shoot digital cameras only record JPEG images.
- **RAW** RAW images are unprocessed files. The camera saves the actual pixel data that the lens and sensor see, without correcting tone, color, sharpness, or white balance. RAW files are ideal if you want higher bit depth or prefer to edit color space and white balance after the capture, in Photoshop. RAW format is rarely available in point-and-shoot digital cameras and is more commonly offered in DSLRs.

For more detailed information about camera file formats, resolution, and compression, see *Digital sensors* on page 233.

Set the ISO number You should set the ISO number according to how much light there is in your scene (more light requires a lower ISO number, while less light demands a higher ISO number). Digital "**noise**" increases as the ISO value increases.

Set the shooting mode Basic shooting modes rely upon fully automatic settings, in which the camera chooses the shutter speed and aperture setting. You might choose a fully automatic mode in situations in which you need to capture images quickly. Semi-automatic modes, such as *Shutter-priority* or *Aperture-priority*, allow you to choose some settings. The *Manual* mode requires that the user pick the shutter and aperture values.

Set the white balance Though our brain tricks us into believing that light is white, light varies in color depending upon the color temperature. For example, daylight is bluer, while tungsten (for example, from household light bulbs) is more yellow. The *White Balance* (WB) setting helps to compensate for the color temperature by making image colors look more accurate. Most white balance features allow you to select from such settings as Auto White Balance (the sensor determines the balance), Daylight, Shade, Cloudy, Tungsten, Fluorescent, or Flash. The White Balance settings can usually be found by pressing a WB button or by searching through the Menu settings.

Take the pictures Press the shutter release button halfway to focus the camera. Press it all the way to record the image.

View the images Digital cameras have an LCD screen that may be used to view images before or after their capture. Many DSLR cameras provide the ability to see the image's histogram on the screen alongside the image preview. This chart reveals the tonal values present in the image. The histogram reveals if there are blown-out highlights or clipped shadows. The photographer can immediately determine if the values are within the desirable range and can change exposure settings to adjust the tonal values.

Download images Give the storage card to a commercial lab for printing, or download the images directly from the camera to a computer, printer, or television via card reader, USB cord, or wireless networking. Some cameras can send

photos by email to photo-sharing webpages. Once you have downloaded and saved your images onto a storage device, you can erase the camera storage card.

Storing digital files Images downloaded to a computer can take up a lot of space. If you create a lot of images that you want to save, consider purchasing a portable hard drive. Portable hard drives have a high capacity (dozens of gigabytes) and can be connected to any computer via a USB or Firewire cord so that images can be transferred back and forth. For minimal storage capacity, use a flash drive (a small drive that plugs into the computer's USB port), a CD, or a DVD.

Organizing digital files Maintaining hundreds, if not thousands, of files can be challenging, especially since cameras initially label images with a somewhat random numerical title. Many tools and resources are available to help create an efficient digital archive. Adobe Bridge, accessible with Photoshop, and Adobe Lightroom are helpful browser applications for cataloging and managing files. See *Processing Digital Images: Digital Workflow* for descriptions of various systems for sorting, archiving, and locating images using keywords, file numbering, and embedded metadata in conjunction with either Adobe Bridge or Adobe Lightroom.

The Digital flatbed scanner

Scanning can be used as a means of digitizing images or materials for further manipulation within image-editing programs. The following passage describes tools and techniques for scanning on a flatbed scanner, although many of these features would be the same if using another type of scanner.

Scanner software

There are essentially two types of software. Many scanners come equipped with both of these.

Scanner software that exists independently of image-editing software Using this type of scanner software involves opening the software, scanning the image (which could simply mean pressing the Start button), and saving the file to be edited or printed through image-editing software. This type of software may not offer as many options for image adjustment (the ability to change the color balance, contrast, etc.).

Software that uses image-editing software (such as Adobe Photoshop) as a host These "plug-ins" are accessed by choosing *File > Import* and then selecting

the appropriate option (for example, *Epson Twain*). After scanning the image, the software closes and the image appears as a Photoshop file.

Scanner software provides a choice of Auto or Manual modes

Scanner software is similar to image-editing software in that it offers basic options for image correction, such as cropping, and adjustments to color, contrast, and brightness. Full Auto makes all of these decisions, while Manual provides greater control over the scan with more options, such as determining image resolution or choosing to record in color or black and white.

If you do not have time to edit your image in Photoshop, then make some corrections with the scanner software. If you plan to use Photoshop to edit the image, we recommend making only basic corrections with the scanner's histogram, then making the majority of your changes in Photoshop.

Operating a scanner

Before beginning any scan, make sure the software is installed, all cables are connected, the power is switched on, and the scanner is on an even surface. Clean the scanner glass or transparency window with a soft cloth. Some computers will not recognize the scanner software unless the scanner is turned on before connecting it to the computer.

Make sure the image or object to be scanned is free of dust or dirt and place it face down on the scanner bed. If scanning a document or photograph, make sure it is flat against the glass. Ideally, the entire bed of a flatbed scanner should yield the same tonal and optical results, with no hotspots, unevenness, or imperfections. However, distortions are more likely to occur at the edges; the document should be centered within the bed. If the object or document to be scanned is particularly large, check to see if the scanner cover is removable.

The following steps introduce you to the settings you may find when scanning in Manual mode. See your software's manual for detailed instructions. The choices you make will vary depending upon the original image (size and quality) and how you plan to use the scanned data (posted on the Internet, printed as a poster, etc.). In this example, we use the flatbed scanner to scan part of a sketchbook page, which the user intends to print at twice the size of the original.

Begin by opening the scanner software (if using a Photoshop plug-in, go to *File > Import > Scanning Software*). Locate the Manual mode. As soon as the software opens, it will automatically preview the image—it will provide a quick scan of the image for reference when making your selections. If the image is not previewed automatically, it means that this option is deselected in your scanning preferences. You can also obtain a preview by clicking on the preview button (in our software, preview is the page icon above the big blue Scan button).

Step 1: Specify the image type In the Document Source area, tell the scanner the type of document you are scanning (*flatbed*, *positive* or *negative transparency*, etc.) and identify whether the document should be scanned as *color* or *black and white*, a *photograph*, *document* or *line art*. Indicate the *bit depth*. The bit depth, or the number of bits a pixel contains, determines the tones and colors of an image. A pixel can have anywhere from 1 bit black and white to 64 bit RGB (18.4 quintillion colors). The greater the bit depth, the smoother the transition in tones, the more accurate the color representation, and the greater the color range. Each scanner, monitor, and printer is capable of attaining a certain level of color and grayscale bit depth. All scanners are at least 36-bit now, and most are 48-bit. Be aware that higher bit depths take longer to scan, yield larger image files, demand more computer memory, and offer fewer filter options in Photoshop. Some applications do not support more than 24-bit color or 8-bit gray. Which bit depth you choose should be determined by your intended output. We suggest scanning at a high bit depth if your ultimate output requires continuous tone.

Step 2: Crop the image With the pointer hovering in the previewed image, hold down the mouse button and drag the cross-hairs over the part of the image that you want to scan. The tool forms a dotted line, a "marquee," around the area that you wish to keep. Release the mouse button. Once made, the marquee can be dragged to another part of the screen or resized.

Step 3: Specify resolution Scanners capture pixels of varying brightness and color. The more pixels recorded, the more detailed the scanned image. The amount of resolution needed depends upon the size of the original image and the final use of the file. Final use means what you will do with the digitized information: for example, post the photo on the Internet or print it out as a poster. On average, 72 dpi is a reasonable resolution for images that will be posted on the Internet or sent and viewed on email. The average resolution for images to be printed is 300 dpi. These are settings that would be correct if you did NOT enlarge the image after scanning. Any enlargement to the original image should take place while scanning (see step 4).

Step 4: Specify final size Once you have designated the scan area, notice that the dimensions of this area appear in the Source box as either pixels, cm, inches, or mm. Areas outside the marquee will be cropped during the scan.

If you want the digitized image to be larger than its original size, you should now upscale the image. Under Target, change one measurement (the width or height) to the desired size. The other measurement will change proportionally. For example, we started out with a source width of 4.11 inches and a height of 4.50 inches. When we changed the target width to 8.22 inches, the target height changed to

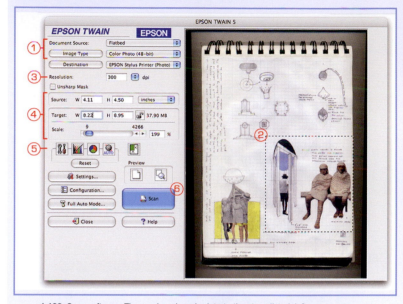

1.196 Scan software. The numbers in red relate to the steps listed, left

8.95 inches. (Note that the Scale automatically changed to reflect the percentage of up- or downsizing; in this case, our scale changed from 100% to 200%.) At the far-right side of the Target line, note the file size. In this case, it is 37.90 MB. If your computer or storage device has limited memory for storage, the file size will be an important number to watch.

Step 5: Make image adjustments Most software with manual controls provides some means of changing image brightness, contrast, and color, and of determining both ends of the tonal range in the image. We recommend using only the histogram option, because it makes such precise changes. The histogram can affect density, color, and contrast on each color channel. For example, you could remove a magenta color cast in the highlights by selecting the green channel and highlight tonal portion, then dragging the curve until the cast is eliminated.

The process of scanning decreases image clarity, so most scanners offer an unsharp mask tool to sharpen the image. As it's best to sharpen images after making all other adjustments, do not use the scanner sharpening option if you plan to make adjustments in Photoshop.

Step 6: Perform the scan After making all the necessary corrections, click the button to begin the scan.

Step 7: Save the file Save the scanned image in the desired file format.

Straightening digital images

If you placed scanned material crookedly on the scanning bed, your scanned image will be askew; and even images taken with a digital camera may have undesirable tilted horizons. There are several ways to straighten images. The method you use will depend on whether you open your image in Photoshop or Adobe Camera Raw, and the nature of the image. You can use either method below with raw files, JPEGs, and TIFFs.

The Ruler tool in Adobe Photoshop

Step 1 Select the Ruler tool from the Tools panel. (If the Ruler tool is not visible, click and hold on the arrowhead by the Eyedropper tool; they're in the same menu.) Find a line or edge within the image that should be vertical or horizontal. With the Ruler tool selected, hover the tool above one side of that line. Click and drag the tool to the end of the line. Release the mouse. You can see our Ruler tool line circled in red in our demonstration image.

Step 1

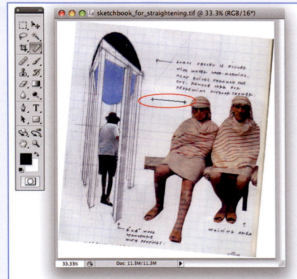

1.197 The Ruler tool

Step 2 Select *Image > Image Rotation > Arbitrary*. When the dialog box opens, the angle and direction of the correction will already be typed in. This measurement is based on the Ruler tool's line. Click *OK*.

Step 3 Use the Crop tool to get rid of any unwanted image area.

Step 2

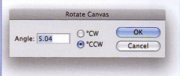

1.198 The Ruler tool

Step 3

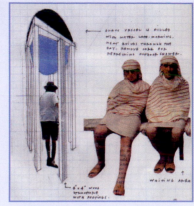

1.199 The Ruler tool

The Straighten tool in Adobe Camera Raw

Step 1 Open Adobe Bridge. Choose *File > Open In Camera Raw*, or press Command+R to open your image in Camera Raw.
 Select the Straighten tool, or press A.

Step 2 Find a line or edge within the image that should be vertical or horizontal. With the Straighten tool selected, hover the tool above one side of that line. Click and drag the tool to the end of the line. Release the mouse.

Step 3 A crop marquee will appear showing the new outer edges of the rotated image. Double-click the Hand tool or open the image in Photoshop to view the adjustment.

Step 1

1.200 The Straighten tool

Step 2

1.201 The Straighten tool

Step 3

1.202 The Straighten tool

1.203 Ann Chwatsky, *Lace Planets*, August 2008. Scan, camera-less print
When understood spatially, rather than two-dimensionally, the small bed of a flatbed scanner can take on grand gestures. Here, Ann Chwatsky transforms this area into the solar system. The scanogram produces images that are both fantastical and precise. The fine detail is a result of the direct translation of the scanning process – more accurate and less distorted than other forms of representation

The scanogram

The term scanogram is often used by photographers to describe the process of using a flatbed scanner to scan objects or environments rather than images. The creation of this term suggests an association with the *photogram*, the traditional photographic practice of placing photographic printing paper under a sheet of glass with two- or three-dimensional objects on top, and exposing the paper to light. The comparison between the two processes seems to hang on the presence of the sheet of glass, the objects, the projection of light, and the fact that information is recorded over a period of time. However, a photogram is a camera-less photographic image while a scanner is a recording device, able to capture detailed images that can be edited and reproduced. A scanogram captures images with far greater clarity and realism than a photogram and, in this way, is more like a camera.

A scanner differs from a camera in that its image is not made by a single-point perspective lens, but by a row of sensors that travel across a field. As the scanner arm moves across the bed, every point on the object is captured by a sensor directly across from it. The result is an extremely detailed image with a more direct spatial relationship between the object and its representation: the image will not betray the distortion seen in lens-based images (most obvious in pictures made with a wide-angle lens).

Playing with light, time, and focus

Once you know how to operate your scanner, making a scanogram is a simple extension. Objects pressed directly against the flatbed glass will appear sharpest in the captured image; soft objects may also be slightly distorted from pressing against the hard surface.

Because scanner sensors need lots of light to produce an image, the scanner arm is designed to throw a bright band of light onto the scanned object while it scans. As with a camera flash, you can augment or alter this light by opening the scanner lid by varying amounts. The scanning time could range from a few seconds to a few minutes and is determined by several factors, including bit depth, resolution, image mode (grayscale or color), and size of the scanned area. Your composition can be static throughout the process or you could see the time as an opportunity to move, alter, or play with objects and the environment.

CAMERA CONTROLS

The aperture

The aperture refers to the part of the camera's lens that widens and contracts to control the amount of light reaching the film or digital sensor. Like the iris of your eye, the aperture widens and contracts to let in more or less light.

Aperture settings or f-stops

Each aperture setting is referred to as an *f-stop*. The standard sequence of f-stops, from wider openings to smaller ones, is: f/1, f/1.4, f/2, f/2.8, f/4, f/5.6, f/8, f/11, f/16, f/22, f/32, f/45, and f/64. The aperture scale on the lens in Figure 1.204 shows f-stops ranging from f/2.8 to f/22.

Changing aperture settings

On a single-lens-reflex film camera, the diaphragm, a ring of overlapping metal leaves inside the lens, can be adjusted from stop to stop by turning the band on the outside of the lens. SLR cameras with automatic features, including DSLRs, have a dial to adjust the aperture settings. These options can be seen while looking through the viewfinder window or on an LCD screen. In *Automatic Mode*, a digital camera will choose the aperture. Some digital point-and-shoot cameras provide menu options for changing the aperture. Automatic cameras (digital or film) usually have an *Aperture Priority Mode*; you select an f-stop and the camera chooses a corresponding shutter speed in order to get the correct exposure.

The aperture and light

With aperture settings, *smaller* numbers (e.g. f/2) have *wider* openings, thereby letting in more light; *larger* numbers (e.g. f/16) have *narrower* openings, thereby letting in less light. The change from one aperture to the next is referred to as a stop. For example: to change from f/5.6 to f/8 would result in *one stop less* exposure or *one stop down*. Each time you give one stop less exposure, or "stop down," you *halve* the amount of light reaching the film. When you give *one stop more* exposure, or "stop up," you *double* the amount of light reaching the film. An example of giving one stop more exposure would be a change from f/5.6 to f/4.

Depth of field

Why would you want to stop the aperture up or down? One reason would be to change the image's *depth of field*. Depth of field is the area within a photograph, from near to far, that is sharp.

Depth of field is partly determined by the aperture setting. Light rays expand as they pass from the actual object, through the aperture of the lens, and to the film plane. When recorded close to the focal point, the light appears as a point that is in focus. When recorded further away from the plane of focus, the light appears as circles (called *circles of confusion*) and thus seems out of focus.

The size of the aperture affects the amount of variation in this focus. When using a wide aperture (such as f/2.8), the part of the scene that you focus the lens on will be sharp, but the rest of the scene will be out of focus. For example, in Figure 1.206, taken with a wide aperture (f/2.8), the middle mountain is the only area in the picture that is sharp. In this case, depth of field would be described as

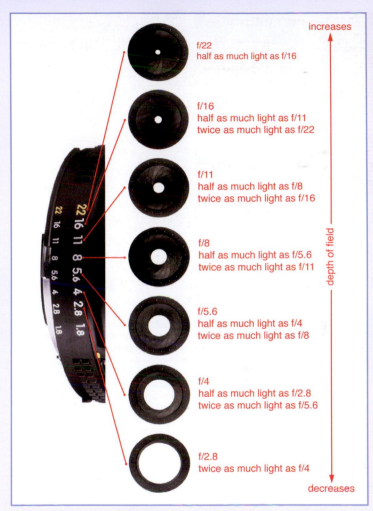

increases

f/22
half as much light as f/16

f/16
half as much light as f/11
twice as much light as f/22

f/11
half as much light as f/8
twice as much light as f/16

f/8
half as much light as f/5.6
twice as much light as f/11

f/5.6
half as much light as f/4
twice as much light as f/8

f/4
half as much light as f/2.8
twice as much light as f/5.6

f/2.8
twice as much light as f/4

depth of field

decreases

1.204 Lens showing aperture settings

1.205 Guide for scene
In this lunar-like landscape, figure (a) is approximately two feet away from the camera; figure (b) is four feet from the camera; figure (c) is six feet from the camera. Forms have been built up slowly from drippings of sand, water, and glue. The piles appear sharp or soft, depending upon the aperture used to take the picture

1.206 Wide aperture (f/2.8) at 1/8 second
In this photograph, the lens was focused on figure (b), four feet away from the camera. By opening the diaphragm to a wide aperture, f/2.8, the image shows a shallow depth of field: only figure (b) is sharp, while figures (a) and (c) are out of focus. With this shallow depth of field, the central stalagmite is the focal point and all other mountains are merely vague, ominous forms

shallow, with only a small area of the scene appearing sharp. In Figure 1.207, taken with a small aperture (f/22), depth of field becomes *deeper* as everything from the foreground to infinity is in focus.

Depth of field is controlled or affected by several factors:

1 Size of the aperture. The smaller the aperture, the greater the depth of field.
2 Distance from camera to subject. The closer the subject is to the camera's lens, the shallower the depth of field. The further the subject is from the camera's lens, the greater the depth of field.
3 Focal length of the lens. The *focal length* is the distance from the rear of the lens to the image it forms on the focal plane, when the lens is focused at infinity. Lenses with a short focal length, also called wide-angle lenses, have a relatively large depth of field. Lenses with a long focal length, or telephoto lenses, have a shallower depth of field.
4 Size of the imaging sensor on a digital camera. It is very difficult to take a picture with shallow depth of field using a point-and-shoot digital camera with a built-in lens. Even at wide apertures and with the subject close to the lens, the camera's small imaging sensor and short focal length lens combine to create a greater depth of field. It is often easier to create shallow depth of field *after* taking the picture, with imaging software such as Photoshop.
5 Degree of enlargement. While enlargement does not affect the recorded clarity and depth of field of the image, larger photos can make circles of confusion more noticeable.

The aperture, depth of field, and circles of confusion
As we have seen, if a scene includes subjects at differing distances from the lens, only one of those subjects may be absolutely in focus at a time. However, subjects that aren't exactly focused on the projection plane may appear to be in focus if the depth of field is sufficiently large. This is possible for two reasons: because image focus is partly a matter of scale, and because circles of confusion vary according to aperture size.

Human vision is limited in what it can distinguish; from a distance of 25cm the eye can discern about five lines per millimeter, therefore anything less than 0.2mm across is indistinguishable and any shape at that scale may pass for another. This means that, in a photograph, circles of confusion that size or smaller appear to be perfectly focused points. In terms of our own vision, depth of field is described as the area in a photograph where circles of confusion are smaller than our vision threshold of 0.2mm. Thus, whereas areas of a photograph may appear in focus

when the image is small, enlargements of the same picture will magnify the circles of confusion beyond our vision threshold, and reveal parts of the scene to be unfocused.

When taking a photograph, one can control the size of circles of confusion by adjusting the aperture, as illustrated in Figures 1.208 and 1.209. A wide aperture (such as f/4 in Figure 1.208) produces large circles of confusion (shallow depth of field), while a small aperture (such as f/22 in Figure 1.209) produces narrow circles of confusion (and a wider depth of field). Previous examples (in *Lens and focus*, p.58) have shown how a cone of light, projected by the lens into the camera, is useful to diagram and determine the point of focus and circles of confusion. Since the light of the cone passes through the aperture before converging on the point of focus, the base of the cone is synonymous with the aperture. Therefore, a smaller aperture (as in Figure 1.209) yields a narrower cone, which results in circles of confusion that are proportionally smaller—and less distinguishable—for every distance. This is why aperture is the best way to control depth of field and overall focus.

Creating shallow depth of field in a digital image

Most digital point-and-shoot cameras produce images with wide depth of field, even when using a wider aperture. Because the entire field of a digital photograph is usually sharp, the images may lack a focal point. Rather than attempting to produce shallow depth of field with a compact digital camera's lens, you can

1.207 Small aperture (f/22) at 4 seconds
In this photograph, the lens was focused on figure (b), 4 feet away from the camera. By closing the diaphragm to a small aperture, f/22, the image shows a great depth of field: figures (a), (b), and (c) are all in focus. With this deep depth of field, the central stalagmite is one of many peaks, and the pile in the foreground reveals itself to be the distinct shape of a dog

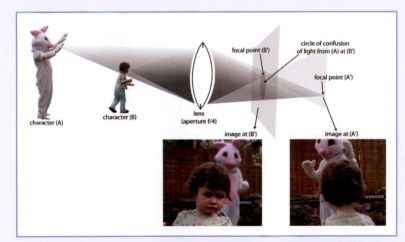

1.208 A wide aperture (here f/4) produces large circles of confusion (shallow depth of field)

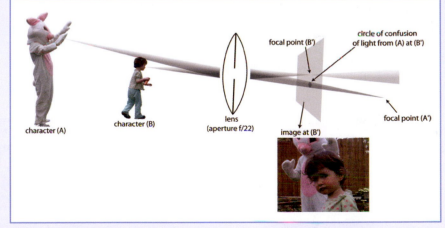

1.209 Although the camera lens is focused only on character *A*, character *B* also appears to be in focus because the camera's small aperture (f/22) produces circles of confusion (at focal point B¹) that are imperceptibly small

Step 1

1.210

alter the depth of field in Photoshop. In the following technique, we designate one part of the image to be clear, while making the rest progressively blurrier. This progression is realistic, as traditional photography's shallow depth of field is a gradual blur created by the optics of the lens.

Step 1: Copy background layer Open the image. Make your Layers panel visible by choosing *Windows > Layers*.

Create one duplicate copy of the Background image in your Layers panel either by choosing *Layer > Duplicate Layer*, or by selecting *Duplicate Layer* under the pop-up menu at the top right of the Layers panel. Once you have one copy of the Background layer in your Layers panel, click inside the copied layer to make it active.

Step 2: Activate Quick Mask mode Double-click on the Quick Mask mode icon (the button under the Color Swatches). When the dialog box appears, select Masked Areas under Color Indicates. Click *OK* and make sure that Quick Mask mode is still selected (if not, click on the icon to select).

Step 3: Set up the Gradient tool Select the Gradient tool from the Tools panel and press the Return key to open the Gradient palette. Double-click on the third gradient from the left (the Black to White).

Step 2

1.211

Step 3

1.212

1.213

Step 4

1.214

Step 4: Drag the Gradient tool Begin by clicking the Gradient tool in the area of the image that you want to remain sharp, and then drag the cursor into the area that you want to become out of focus. In this example, we clicked on the figure's head and dragged back into the stairway. If you want a more extreme shift from clarity to blur, use a shorter line.

Step 5: Red overlay appears Because you are in Quick Mask mode, a red-to-transparent gradient will appear on the image.

Step 6: Exit Quick Mask mode Press the "q" to leave Quick Mask mode. The selection you just made will appear, indicating the area whose depth of field will now be changed.

Step 7: Convert to Smart Object Convert the duplicate layer to a Smart Object by choosing *Filter > Convert for Smart Filters*. Converting the layer to a Smart Object makes the filter editable. You can now see the Smart Object's thumbnail on your Background copy layer.

Step 8: Apply blur Choose *Filter > Blur > Gaussian Blur*. In the Gaussian Blur dialog box, enter the Radius value. This will determine the most extreme blur in the farthest point of your selection. Click *OK*. The blur effect is applied to the selected

Step 7

1.217

Step 8

1.218

Step 5

1.215

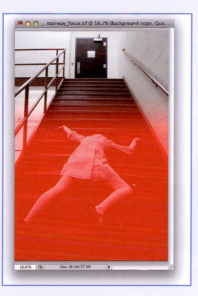

Step 6

1.216

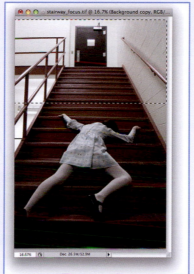

Step 9

1.219

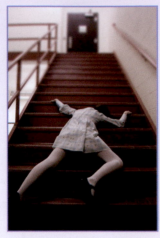

1.220 Focal plane shutter completely closed. Here, the camera is not loaded with film. If loaded, the film would stretch from the left spool to the right. With the shutter in this position and the camera back closed, the film is protected from light

1.221 Focal plane shutter completely open

area. You can see the Smart Filter mask, which protects the clear areas, on the Smart Object layer of your Layers panel. You can double-click on the Gaussian Blur filter to adjust the blur or click once on the Smart Filter mask to adjust the gradient.

Step 9: Final image View your changes to the depth of field. In our example, the fallen figure in the foreground becomes more prominent now that the distant stairs and door have softened.

The shutter

The shutter regulates the amount of light that enters the camera during an exposure. The shutter lies inside the camera body, just in front of the film plane or digital sensor. The shutter opens and closes to let light reach the film or digital sensor. The longer the shutter stays open, the more light enters. The faster the shutter closes, the less light enters.

Most cameras with a mechanical shutter have a focal plane shutter, which is rectangular and made of narrow blinds or curtains that move along, exposing the film surface to light sequentially (Figures 1.220–1.222). Some cameras have a leaf shutter, within the lens itself. Some digital cameras have a mechanical shutter to control exposure; others have an electronic shutter that controls the duration of exposure by turning the sensor on and off for periods similar to those of a film camera's shutter speeds.

Shutter speed

Shutter speed is indicated in fractions of a second. For example, "60" means 1/60th of a second. "1" means the shutter opens for one full second. Most cameras offer the following standard shutter speed settings in fractions of a second: 1/2000, 1/1000, 1/500, 1/250, 1/125, 1/60, 1/30, 1/16, 1/8, 1/4, and 1/2—plus 1

1.222 Focal plane shutter as it moves from side to side. The shutter's window moves across the film, exposing as it moves

and 2 whole seconds. The faster shutter speeds (such as 1/2000) yield shorter exposures. Some digital and automatic film cameras have shutter speeds as fast as 1/8000 of a second. Slower shutter speeds (e.g. 1/2) allow longer exposures. Many cameras also offer a "B" or *bulb* setting, which allows you to keep the shutter open for as long as you want.

Changing the shutter speed

Any camera with some manual features will allow you to select a shutter speed for a particular situation. SLR film cameras have a dial engraved with the shutter settings. Each number sets the length of time the shutter will remain open during an exposure. The dial can be manually turned to the chosen speed. SLR cameras with automatic features, including DSLRs, have a dial or a wheel to adjust the shutter settings. These options are read while looking through the viewfinder window or on an LCD screen. In *Automatic Mode*, a digital camera will choose the shutter speed. Some digital point-and-shoot cameras provide menu options for changing the shutter. Automatic cameras (digital or film) usually have a *Shutter Priority Mode*; you select a shutter speed and the camera chooses a corresponding aperture in order to get the correct exposure.

Firing the shutter

On any camera, the *shutter release button* controls the shutter and/or initiates the exposure. On a digital camera, pushing the button initiates a series of actions, including calculating exposure, activating the sensor to receive light, and preparing the memory card to receive data. For this reason, there may be a slight delay, called *shutter lag*, with some pocketsize cameras. To counter shutter lag, try pressing the shutter release button halfway down to focus the camera on the subject. Keep it halfway down until you're ready to take the exposure, and then press all the way. Be aware that processing large file formats or high resolutions can also slow down the shooting speed.

If you cannot press the shutter release button yourself (because this motion may cause the camera to vibrate or because you want to be in the picture), there are several other options. Many automatic cameras have a self-timer feature that can be programmed to trigger the shutter release button after a given amount of time. You can also use a cable release. One end of the cable screws into a socket on or near the shutter release; the other end has a plunger that can be pressed to trigger the shutter from a distance (cables range in length up to 12 feet or more) without holding the camera.

1.223 The Split Cam camera has a dual blind lens system with two shutters. Each covers half the lens and can be controlled separately. You can make an exposure on one half of the frame of film, then expose the other half at a later time

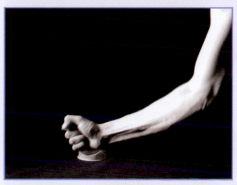

1.224 With shutter lag, the camera does not respond quickly enough and misses the desired moment. Here, the arm's swing was too fast for the shutter, which recorded only its weighty landing

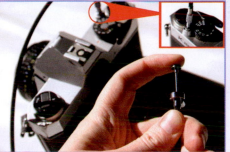

1.225 A cable release allows you to shoot from afar and to prevent handheld camera shake. In the main photo, a hand holds the plunger. The inset photo shows the release screwed into the camera's shutter release

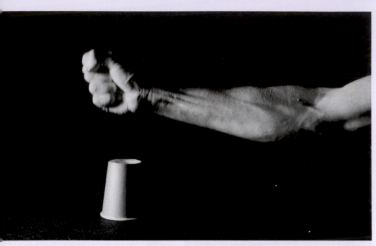

1.226 Sven Kahns, *A Study of Motion: White Arm*, 2003. Digital photograph. Shutter speed set at 1/500 of a second. Aperture set at f/4
Here, a fast shutter speed catches the fist in mid-blow. The clenched fist seems to hover over the flimsy paper cup, freezing details like the arm's tensed muscles

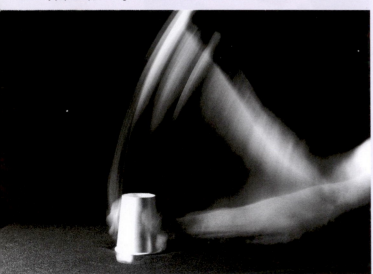

1.227 Sven Kahns, *A Study of Motion: White Arm*, 2003. Digital photograph. Shutter speed set at 1/15 of a second. Aperture set at f/22
Here, a slow shutter speed shows the force of the fist through its entire rotation

The shutter and continuous shooting

If you are attempting to capture many still images within a short amount of time, be aware that cameras can shoot a series of frames at different rates. Manual film cameras are ready to take another shot as soon as the film lever is rewound. Automatic cameras may be ready quickly, depending upon whether the flash needs to be recharged. Most digital cameras have a *Continuous Shooting Mode*; while holding the shutter button down, the camera shoots continuously. The speed of "continuously" is different for every camera, and is described in frames per second (fps).

Shutter speed and exposure

Like aperture settings, each standard shutter speed is referred to as a *stop*. Moving from one stop to the next will increase or decrease the amount of time the shutter is open, and therefore the amount of light that is allowed to register on the film or sensor. Each shutter speed lets in half or double the amount of light as the setting before or after. For example, a 1/125 second shutter speed lets in half as much light as 1/60, but twice the amount of light as 1/250.

Shutter speed and motion

Generally, a fast shutter speed can freeze motion while a slow shutter speed will show it as a blur. Freezing or showing motion also depends upon:

1 How fast the subject is moving;
2 The direction of the movement. A subject moving toward the camera lens can be frozen with a relatively slow shutter speed. If the same subject were to move horizontally across the image (parallel to the film plane), you would need a faster shutter speed to capture them, even if they were moving at the same speed;
3 Focal length of the camera's lens. The longer the lens, the greater the apparent motion;
4 The quality of the shutter (with digital cameras). As we have seen, some low-end cameras suffer from *shutter lag*, a short pause between when the shutter release button is pressed and when the camera actually takes the picture;
5 The image processing and storing time of each image. Image processing time is dependant on the speed of the sensor, the speed of the memory buffer, the size of the image file, and the image type. It takes longer for the camera to process and store RAW files than JPEGs.

Panning the camera

Motion can be suggested by a blurred subject *or* a blurred background. If you want the moving subject to be in focus, you can swing the camera to follow the subject during exposure. This technique, called *panning*, keeps the subject in the same position in the viewfinder, and on the film or sensor, so that the subject is relatively clear. The background will be blurred.

To achieve this effect, follow the subject with the camera for the entire time that the shutter is open. With an SLR or DSLR camera, this is somewhat difficult because you will not be able to see the subject through the viewfinder during the exposure. It may be helpful to start panning even before you press the shutter release.

In his series *A Study of Motion: Black Arm*, Sven Kahns can emphasize either the foreground fist or the background wall of cups by holding the camera still or by panning.

Aperture and shutter working together

The aperture and shutter determine the amount of light that will reach the film or digital sensor. The *aperture* is like the eye's iris, widening or contracting to allow more or less light. The *shutter* is like the eyelid, controlling the amount of time the light is allowed to enter. Another analogy compares the camera's aperture and shutter with a faucet. The aperture is the intensity of the water stream: from a drip to a downpour. The shutter is the opening and closing of the tap: the duration that the water is allowed to flow.

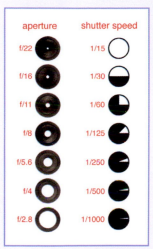

1.229 This diagram shows a series of equivalent exposures. Each aperture / shutter speed pairing produces the same exposure as the combination below or above. When reading the pairs from the top, note that as the amount of light – indicated by white – decreases (by half) within each shutter speed, the amount of light increases (is doubled) through the aperture

aperture	shutter speed
f/22	1/15
f/16	1/30
f/11	1/60
f/8	1/125
f/5.6	1/250
f/4	1/500
f/2.8	1/1000

1.228 Not panned. Shutter speed of 1/15. Aperture f/22
For this image, the artist photographed with the camera secured on a tripod. Because the camera was held camera steady, the background is sharp while the arm is in motion

Panning the camera. Shutter speed of 1/15. Aperture f/22
For this image, the artist followed, or panned, the movement of the fist with the camera. Because the lens followed the fist's motion, the fist appears frozen and the still background is transformed into a sea of blurry stars

If your camera allows you to choose the shutter speed and aperture, meter the light within the scene in order to determine what combination of shutter speed and aperture will give the correct exposure. You can use those settings to determine other equivalent exposures for the same scene and lighting conditions. For example, if you get an initial exposure reading of f/8 at 1/125, you then know that f/5.6 at 1/250 will also provide the correct exposure. This is because each time you open your aperture or shutter one stop, you double the amount of light and each time you close one stop, you halve the amount of light. By opening your aperture one stop to f/5.6 and closing your shutter one stop to 1/250, the amount of light entering the camera is the same as f/8 at 1/125 even though the settings have changed.

How, then, do you know which combination to use? Decide which feature—depth of field or freezing/showing motion—is most important for the particular scene. For example, in Figures 1.230 and 1.231, the two equivalent exposures were both focused in the foreground, yet each has a drastically different aesthetic and emphasis.

1.230 and 1.231 In Figure 1.230, the fast shutter speed (1/2000) captures the jumper in mid-air while the shallow depth of field (from the wide aperture of f/2) yields only a narrow band of focus in the photograph: most of the hallway is a hazy blur. Figure 1.231 was shot with a small aperture of f/22 resulting in clear focus throughout the photograph; this size aperture demanded a slow shutter speed (1/15), which rendered the jumper blurry beyond recognition and she blends into the white of the corridor

SUGGESTED FURTHER READINGS AND ONLINE RESOURCES

1.1 SUGGESTED READINGS ABOUT THE OPERATION OF EYE AND BRAIN

Donald D. Hoffman, *Visual Intelligence: How We Create What We See* (New York: W.W. Norton, 2000).

Richard L. Gregory, *Eye and Brain: The Psychology of Seeing* (Princeton: Princeton University Press, 5th edition, 1997).

Conrad G. Mueller and Mae Rudolph, *Life Science Library: Light and Vision* (New York: Time-Life Books, 1969). [This is an older source, but a concise and comprehensive presentation of vision that incorporates both the operation and the psychology of the eye and cameras. In addition, the text presents unusual examples, such as a gallery of various animal eyes.]

1.2 PINHOLE RESOURCES

Pinhole Resource. http://www.pinholeresource.com/shop/home/

Eric Renner, *Pinhole Photography: Rediscovering a Historic Technique* (Newton, MA: Focal Press, 1994).

1.3 CELLPHONE CAMERA RESOURCE

Howard Chui: reviews and information about cellphones. http://www.howardchui.com/

INTRODUCTION

To perceive form we need contrast. While the physiology of seeing is addressed in *Part 1: Vision*, in *Part 2: Light and Shadow* we consider light and shadow as materials in themselves. A photograph, whether we can recognize an image or not, is simply a pattern of light and shadow—a modulation of value or energy permanently fixed on a surface. Light and shadow are materials with particular cultural associations, symbolisms, and physical powers or qualities. We consider these attributes when exploring how light and shadow appear when they are captured in an image, leave their trace upon a photographic emulsion, or are captured as data by a scanner or digital camera. *Part 2: Light and Shadow* includes an essay and a how-to section that together explore the work of artists who manipulate and record light, a range of cultural phenomena that inform our understanding of illumination and darkness, and practical information for working with light.

The essay "Light and Shadow" begins with a discussion of the void, or the total absence of form. After considering Plato's theories of the shadow as an illusory representation, we turn to the notion that photography enables the presence of objects to be written or recorded in light. The section "Writing with light" looks at pioneering photographic experiments of the 19th century, as well as the work of contemporary photographers and artists. The counter to this view of light as benign inscription is the idea of radiation powerful enough to burn and destroy. Works by contemporary political activists and by the Danish-Icelandic installation artist Olafur Eliasson engage with issues of the embodied perception of light. In architecture and urban planning, the physical forces of light and shadow affect our bodies and shape cities.

Photographers and filmmakers employ and manipulate qualities of light to direct our understanding of morality or atmosphere. A dark, foreboding sky triggers alarm. A sterile room is usually bright. Popular culture, movies, psychology, and religion reinforce the symbolism of light and dark as well as longstanding stereotypical notions of racial difference. Indonesian puppet theater, European "magic lantern" presentations, early technologies for creating moving images, such as the zoetrope and the kinetoscope, and contemporary advertising and graphic design incorporate these traits when using projected light and cast shadows.

The how-to section, "Light and Shadow: Tools, Materials, and Processes," describes practical ways of utilizing light as a source material whose natural or artificial illumination lends brightness or casts imagery. This processes section describes ways of controlling, measuring, and coloring light. The final discussion looks at how the resting point—the surfaces onto which light is cast—affects the illumination or the projected image.

Theory: Light and Shadow

Bill Anthes

INTRODUCTION

From the expressive, soft-focus images of Pictorialists such as Henry Peach Robinson and Gertrude Käsebier, to the clear and sharp "straight" style of Paul Strand and the modernist photographers of f/64 in the 20th century, to the invented worlds of Anna Gaskell or Gregory Crewdson, photographers use the basic elements of light and shadow to create and reinforce sense of time, place, and mood. Other artists address light as a subject in its own right, such as Alvin Langdon Coburn or Christopher Bucklow. Filmmakers Stan Brakhage and Paul Sharits have produced "flicker films," in which individual frames in solid colors, or hand-painted segments of film, appear to pulse and vibrate, testing the perceptual limits of the eye and mind. In all these examples, light and shadow also carry profound cultural associations, which will also be discussed in this essay.

In his *Republic*, written between 338 and 367 BC, Plato relates the famous allegory of the cave. He describes a group of prisoners shackled for their entire lives so that their only view was of the daily procession of shadows cast on a wall directly in front of them. Having only ever experienced these shadows, Plato argues, the prisoners would assume that what they were seeing was, in fact, reality—flat, colorless, and without weight or dimension. If (Plato argued) a prisoner was freed and left the cave to experience daylight and the world of color and form, he would recognize how limited his view of reality had been. Those who have never experienced the truth will ridicule the freed prisoner, who grasps at last the incomplete nature of his vision, much like the philosopher who attempts to discover and explain truth to an ignorant public.

For Plato, the shadow was a metaphor for the incomplete, and therefore flawed, nature of human knowledge. He argued that, like his imaginary prisoners, we are

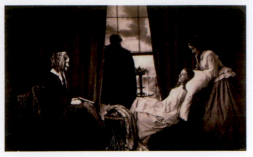

2.1 Henry Peach Robinson, *Fading Away*, 1858. Albumen print, combination print from five negatives, 24.4 × 39.3cm

1 Victor I. Stoichita, *A Short History of the Shadow* (London: Reaktion Books, 1997), 25.

2 John Bloom, *Photography at Bay* (Albuquerque: University of New Mexico Press, 1993), 47.

3 A. Roger Ekirch, *At Day's Close: Night in Times Past* (New York: W.W. Norton, 2005), 3.

4 Stoichita, *Short History*, 188.

prevented from understanding the true nature of reality, limited as we are to experiencing only our immediate world of imperfect forms. For Plato, as Victor Stoichita in his book *A Short History of the Shadow* writes, "The shadow represents the stage that is furthest away from the truth."[1] While shadows provide us with important information about the world (or, rather, they allow us to infer important information about the world), they are nevertheless suspicious entities; shadows keep us at a remove from truth, and thus foster ignorance and fear. As John Bloom writes, "Plato's parable continues to inform human consciousness in its struggle with objectivity—in discriminating between appearance and significance."[2]

Moreover, if light is associated with knowledge in many world traditions, shadow is often linked to death and loss. This idea seems to be embodied in a photograph by British photographer and founder of Pictorialism Henry Peach Robinson (1830–1901). Robinson's most famous works were combination prints, made by joining several negatives to create a single image. *Fading Away* (1858) is composed of multiple exposures, which allowed the artist to precisely control the value of each individual element, such as the brightly lit woman in the foreground, who contrasts with the background's shadowed figure staring out of the window as if into the unknown of death itself. For the final print, Robinson combined the negatives to produce a convincing, naturalistic, and picturesque scene, based on sentimental, 19th-century genre paintings. Philosopher Edmund Burke, author of *A Philosophical Enquiry into the Origins of Our Ideas of the Sublime and the Beautiful* (1757), noted that shadows were inherently fearsome. Burke wrote that darkness was "terrible in its own nature"—that instinctively we fear the dark.[3] Robinson's complex image seems to invoke similar thoughts.

THE VOID

Without contrast, pure light or pure dark are perceived as an absence or a void. Artists have experimented with this phenomenon, producing photographs, films, paintings, sculptures, and musical compositions that offer the experience of total absence, even as that absence seemed to promise to deliver absolute presence. In four versions of his famous *Black Square* produced between 1915 and 1930, Russian avant-garde painter Kasimir Malevich (1878–1935) attempted to reduce art to its most basic elements. With no color, form, or internal contrast, Malevich reduced representation to a near-zero degree. Victor Stoichita notes that Malevich's *Black Square* was first conceived as a stage curtain for the theater. "For the curtain is not a 'representation' but what covers it," Stoichita explains, "or, by raising it, what makes representation possible." As Stoichita describes, the *Black Square* was, like the curtain that appears at the beginning of a theatrical production, the "embryo of infinite possibilities."[4]

Tony Conrad (b. 1940) has also made art from nothingness. Conrad's *World Premiere Exhibition of 20 New Movies* (also known as the *Yellow Movies*), shown at the Millennium Film Workshop in New York in 1973, shared with John Cage's *4:33* (in which a performer sat silently before a piano for the specified amount of time), Robert Rauschenberg's early all-white paintings, and Nam Jun Paik's *Zen for Film* (clear film stock run through a projector), an expression of absence. For his exhibition, or "screening," Conrad produced a series of paintings in which the outline of a screen was painted with an "emulsion" (actually, varying shades of white and yellow house paint), making what Conrad referred to as "movies" that could be "projected" indefinitely, without film or a projector. Each "movie" was identified by the date when the "movie" started "running." Over time, each "movie" would yellow, inviting a viewer to experience the transformation in real time. Film critic Jonas Mekas described the exhibition: "[T]he change of 'image' on each canvas or 'movie' is very, very slow. The action is still slower, Conrad stated, when the canvases or 'movies' are rolled into rolls. When unrolled, they are going faster."[5]

Importantly, the voids of Malevich, Conrad, et al., were not meant as idle provocations, or mere pranks. Throughout the 20th century, avant-garde artists have offered absence as a path toward a more direct relationship with the viewer—a relationship with clear political implications. In this sense, what appears to be absence is a strategy to achieve greater agency and action—an attempt to break down the hierarchy between active artist and passive audience, by creating works that were fundamentally collaborative, that could only be activated or completed by an engaged viewer. As such, the *Yellow Movies* were intended as a radical gesture at a politically charged moment for the New York art world in the era of the Vietnam War.

WRITING WITH LIGHT

From its beginning, photography has been closely linked to the often mysterious experience of light and shadow. Shadows were authorless images, with some causal relation to the physical world of people and objects, but things of wonder none the less. As photography historian John Bloom writes:

Shadows were probably the earliest form of observed projection, and belief in their magical powers was connected to their sun-origin and their ability to evoke significant form. The shadows, dancing on the cave walls, had a life of their own. They fascinated because they engaged the imagination in an auto-constructed believable world.[6]

Early efforts to make photographs—to capture a fleeting image in permanent form—were to many practitioners a kind of magic. William Henry Fox Talbot referred to photography as

5 Jonas Mekas, "Movie Journal," *The Village Voice*, March 22, 1973.

6 Bloom, *Photography*, 47.

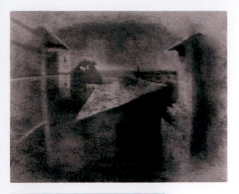

7 Patrick Maynard, *The Engine of Visualization* (Ithaca: Cornell University Press, 1997), 149.

lithography
A printing method in which a drawing is applied to and printed from a stone, metal, or plastic plate.

2.2 Joseph Nicéphore Niépce, *View from the Window at Le Gras*, 1826. First Photograph, heliograph, 1826 and Helmut Gernsheim and Kodak Research Laboratory's retouched print of the First Photograph, gelatin silver print with applied watercolour reproduction, 1952. The most commonly reproduced image of Niépce's famous photograph was created by the Research Laboratory of the Eastman Kodak Company in 1952. The image was painstakingly restored (some would say over-restored) by Helmut Gernsheim, who rediscovered the lost original. Gernsheim spent over 11 hours working with watercolors to create the "pointillistic" effect, which is not present in the original but which Gernsheim felt represented Niépce's intentions. While this is the most accepted and familiar version of Niépce's image, it is not accurate. In 2002, the original was carefully examined and conserved at the Getty Conservation Institute in California. The second image reproduced here is a new, unretouched photograph, which more accurately depicts Niépce's original photograph. More information can be found at the website of the Harry Ransom Center at the University of Texas at Austin: http://www.hrc.utexas.edu/exhibitions/permanent/wfp/

Louis Jacques Mandé Daguerre (1787–1851)
Inventor of one of the earliest photographic processes, the daguerreotype.

"faery magic." Although Fox Talbot was a man of science, he had no problem reveling in the mysteries of light and shadow, permanently fixed by this new alchemy. But if photography was not magic, it was, as Patrick Maynard has written, a clever and economical invention—using abundant, free light to capture and permanently fix still images.[7]

The first successful effort to capture an image permanently came in 1824, when Joseph Nicéphore Niépce (1765–1833), a gentleman-scientist who had dabbled in printmaking (in particular the newly invented medium of **lithography**), and developed a process to copy engravings with a light-sensitive varnish and pewter plates. In 1826, Niépce set up a camera obscura—a device heretofore used as a drawing aid—in the upper-story room of his country home in Burgundy. Niépce placed within his camera obscura a polished pewter plate coated with a light-sensitive petroleum derivative— bitumen of Judea—which hardened upon exposure to light. After exposing the plate for eight hours, Niépce removed the plate and bathed it in a mixture of lavender oil and white petroleum, which dissolved the bits of bitumen that had not been hardened by exposure to the light, leaving a single, positive image on the surface of the pewter plate. Niépce called the resulting image a "heliograph" or "sun drawing." Details in Niépce's original are faint, but not due to fading; the materials and process are in fact quite permanent. Rather, even after eight hours, the plate was still underexposed due to the slowness of the emulsion.

The required eight-hour exposure produced a visual paradox: sunlight and shadow can be seen on two sides of structures at left and right—the "pigeon house" or upper loft of Niépce's home, and the sloped roof of a barn with a bakehouse in the rear. As such, Niépce's landmark image presages something that will be true of all the photographs produced in the centuries following his invention: the camera has recorded a view that, for all its apparent veracity, is a scene which the human eye would never see.

Niépce's invention is recognized today as the first photographic image. Niépce went on to form a partnership with Louis Jacques Mandé **Daguerre**, another widely credited "inventor" of photography, in 1829, but he died suddenly in 1833 before making any additional contributions to the new field of photography.

In 1834–1835, Talbot (1800–1877), an Englishman whose various interests included mathematics, physics, and philology, hit upon his own unique process whereby paper treated with a light-sensitive solution of table salt and silver nitrate allowed him to capture the silhouettes of cast shadows and the fleeting images cast by a camera obscura. Talbot, on honeymoon in Lake Como, Italy, and frustrated by his inability to draw, wrote:

[T]his led me to reflect on the beauty of the pictures of nature's paintings which the glass lens of the Camera throws upon the paper in its focus—fairy pictures, creations of the moment, and destined as rapidly to fade away … It was during these thoughts that the idea occurred to me … how charming it

would be if it were possible to cause these natural images to imprint themselves durably and remain fixed on the paper.[8]

Talbot's invention, which he called "photogenic drawing," did not produce the clear, sharp focus of the images produced after 1837 by the French artist and chemist Daguerre (1787–1851), but his process pointed toward modern photography. Whereas Niépce and Daguerre had managed to capture a single, unreproducible image, Fox Talbot produced photograms—negative images—which, he discovered, could be turned into positive images by printing them in contact with a second sheet of treated paper. Fox Talbot's first exhibition in 1839 at the Royal Institution included silhouette images of botanical specimens, negatives made from contact prints with engravings, camera negatives of buildings, and a few images made with a microscope.

By 1840, Fox Talbot had refined his process, which he now named the calotype—from the Greek *kalos* and *typos*, meaning "beautiful print." Talbot's calotypes were produced on paper treated with potassium iodide and silver nitrate and brushed with a solution of silver nitrate, acetic, and gallic acids—which Talbot called "gallo-nitrate of silver"—which could then be exposed to produce a negative from which multiple positive prints could be produced. Because Talbot used paper negatives, the resulting prints have a soft and painterly quality when compared to the nearly infinite focus of the daguerreotype, owing to the diffusion of light through the fibers of the paper, further emphasizing their affinity with drawing and graphic arts. A collection of Talbot's images was published as *The Pencil of Nature* (1844). However, his were not the first photographs to be published. Anna Atkins (née Children) (1799–1871) was an English botanist, photographer, and the first to publish a book illustrated exclusively with photographic images. Her *British Algae: Cyanotype Impressions* was published in 1843.

Photograms—the general term for images produced without a camera or lens, such as the cyanotype or the blueprint—have been used by numerous artists throughout the 20th century, including Dada artists such as Man Ray and Christian Schad.[9] In photograms, areas that are exposed to the light darken; those areas that are not exposed remain light in color, producing a negative image that is at once luminous and shadowlike. Critic Barbara Tannenbaum describes the photogram as a "conveyor of literal fact; the actual physical presence of the object or the light is recorded directly onto the paper."[10]

For his evocative photograms, Adam Fuss (b. 1961) returned to the technique pioneered by Talbot and Atkins. While what we see in camera-less images is the "literal fact" of light and chemistry, in Fuss's art it functions as a metaphor for spiritual content. This may be because of the mystical connotations of light, as well as the lingering sense that photography is somehow a magical, alchemical process. For his series entitled *Love*, Fuss laid out disemboweled rabbits symmetrically on a large sheet of **Cibachrome** paper, then exposed the arrangement to the light. The resulting strange colors result

8 Joel Snyder, *On the Art of Fixing a Shadow* (Washington, DC: National Gallery, 1989).

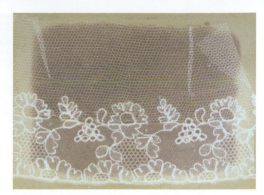

2.3 William Henry Fox Talbot, *Lace* (Plate XX in *The Pencil of Nature*), 1844–1846, Calotype

cyanotype
A low-cost permanent print made by exposing a matrix in contact with paper impregnated with iron salts and potassium ferricyanide, which darkens when exposed to light. The image is usually white on a blue ground.

9 Floris M. Neusüss, "From Beyond Vision," in *Experimental Vision: The Evolution of the Photogram Since 1919* (Denver: Denver Art Museum, 1994), 7–14.

10 Barbara Tannenbaum, *Adam Fuss: Photograms* (Akron, OH: Akron Art Museum, 1992), n.p.

Cibachrome
A process for printing vivid color prints from transparencies.

2.4 Adam Fuss, *Love*, 1992. Cibachrome photogram

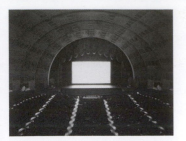

2.5 Hiroshi Sugimoto, *Radio City Music Hall, New York*, 1978. Gelatin-silver print

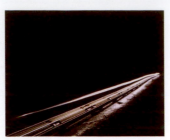

2.6 Paul Ramirez-Jonas, *Model 3: Wake*. 1998. Cibachrome, 20 × 30in

11 Adam Fuss interviewed by Ross Bleckner, *Bomb* magazine (Spring 1992); quoted in *Under the Sun: Photographs by Christopher Bucklow, Susan Derges, Garry Fabian Miller, and Adam Fuss* (San Francisco: Fraenkel Gallery, 1996), 90.

12 Hiroshi Sugimoto, quoted in Kerry Brougher and David Elliott, *Hiroshi Sugimoto* (Washington, DC and Tokyo: Hirshhorn Museum and Sculpture Garden and Mori Art Museum, 2006), 77.

13 Diana Friis-Hansen, "Towards a New Methodology in Art," in Dana Friis-Hansen, et al., *Cai Guo-Qiang* (London: Phaidon, 2002), 43.

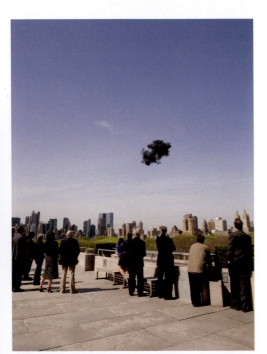

2.7 Cai Guo-Qiang, *Clear Sky Black Cloud (edition)*, 2006. Digital reproduction

from the light that passed through areas of lesser and greater translucency. In addition, acids from the intestines etched the photographic paper itself, producing psychedelic rainbow effects. The transcendent quality of the light and color are seemingly at odds with the source of the image. Fuss explained his metaphysical interests in an interview with painter Ross Bleckner:

This making of art is really but a shadow of the real yearning … [for] … the light … Light provides an understanding. Not physical light, but understanding the questions is like light. I have this dark space in me, and when I ask a question, there is a desire for light, and perhaps the light will come.[11]

For Niépce, as for many early photographers, even a day-long exposure produced an image that was dim and lacked sharp detail. Long exposure times fail to capture movement, as revealed by the evocative photographs of grand movie palaces and drive-in theaters photographed by Hiroshi Sugimoto (b. 1948) between 1975 and 2001, a period when many such theaters were being permanently shuttered due to the decline of urban neighborhoods or competition from the home-video market. Sugimoto left his camera's shutter open to capture "the sum total of light projected during a feature-length film."[12] A two-hour feature film is compressed, and registers as a luminous rectangle—a zen-like void that is neither presence nor absence.

Sugimoto's use of limited available light and a long exposure is comparable to *Wake* (1998), a series of seven, 20x30-inch Cibachrome photographs by Paul Ramirez-Jonas. The only light in Ramirez-Jones's photographs came from a single head lamp on a toy train; over the course of a 30-minute exposure, Ramirez-Jonas ran the train back and forth, allowing an adequate amount of light to accumulate to expose the film and form an image.

The multimedia art of Chinese-born Cai Guo-Qiang (b. 1957), best known for artworks using gunpowder and fireworks, can be compared to photography in that it is literally produced with light and darkness. Around 1984, Cai began making crude drawings with firecrackers on paper. Later, he learned to control the explosions more precisely, and made a large series of gunpowder drawings, many of which reference in their horizontal orientation the Chinese tradition of painting on silk scrolls.[13] For the series *The Century with Mushroom Clouds: Project for the 20th Century* (1996), Cai created small mushroom clouds—miniature versions of the iconic plume associated with a nuclear blast—at sites including a former nuclear test site in Nevada, earthworks by artists Michael Heizer and Robert Smithson, and the Manhattan skyline. The explosions, which feature prominently in his work, appear as either pure light, or smoky darkness, depending on whether they are seen during the day or at night. *Project for Extraterrestrials*, which Cai produced in 1989 and meant to be viewed from outer space, utilized gunpowder, fuses, and fireworks, to produce spectacular effects that would, according to the artist, "reconfirm

the connections between the heavens and the earth."[14] For *Clear Sky Black Cloud*, Cai created a small, dense cloud of black smoke above the Metropolitan Museum of Art roof garden. The cloud, appearing with a "boom," was the product of black smoke shells, which burst "like an inkblot" against the blue sky above Central Park, then slowly dissipated.[15]

"LIGHT IS RADIATION"

Our bodies note and respond to the effects of light and shadow—from the uplifting feeling of sunlight on our faces (which triggers the body's production of Vitamin D, an important nutrient), to the cooling effect of shadow on a warm summer day. (Interestingly, in a photograph, color temperature has to do with the actual temperature of the physical process taking place, although the results are the opposite of what we might expect: higher temperatures produce a more intense light, with more of a blue cast, while a weaker, cooler light has a reddish cast.) Indeed, the natural patterns of light and dark drive the circadian rhythms (or "biological clock") of humans and other animals. Winifred Gallagher writes that the "origins of the influences of light on our activity are rooted far back in the evolutionary past … [the] very survival of our species has depended on matching the workings of our bodies and minds to the demands of the day and night."[16]

Artist James Turrell has been interested in the physical effects of light throughout his career. "Light is radiation," he explained to an interviewer. "I've had melanoma, so I know."[17]

The physical power of light was also demonstrated, with gruesome effect, by the shadows of passersby etched permanently into the granite of buildings near the hypocenter of the blast when the United States detonated an atomic bomb over the Japanese city of Hiroshima during World War Two; the blast of light imprinted permanent photograms of passersby onto the buildings and pavements. Every year, on August 6th, participants in the *International Shadow Project* draw chalk shadows on streets and sidewalks to remember the human shadows burnt into the streets of Hiroshima and Nagasaki. The project is part memorial, part activism, as they hope that individuals will see the chalk outlines and resolve to never again cast nuclear shadows on the Earth.

Installation artist Olafur Eliasson (b. 1967) creates environments in which light is carefully manipulated to be experienced physically as well as visually. *The Weather Project*, installed in the Turbine Hall at the Tate Modern Gallery in London in 2003, used few elements to create a powerful perceptual experience in the cavernous space of the former power plant. The only light in the exhibition came from a semicircular disk made up of hundreds of yellow single-frequency bulb lights behind a diffuser, and reflected on

14 Friis-Hansen, "Methodology," 55.

15 Jan Garden Castro, "Cai Guo-Qiang: Metropolitan Museum of Art," *Sculpture*, v. 25, n. 9 (November 2006): 74–75.

16 Winifred Gallagher, *The Power of Place: How Our Surroundings Shape Our Thoughts, Emotions, and Actions* (New York: Harper Perennial, 2007), 29.

17 Quoted in Vicki Lindner, "Interview: James Turrell," *Omni*, v. 17, n. 9 (Winter 1995), 108.

installation
A work of art that integrates indoor or outdoor architecture with objects/ constructions made specifically for that space.

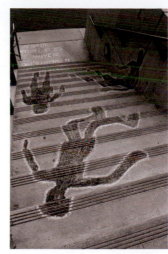

2.8 *International Shadow Project*, August 6, 2009, Ann Arbor, Michigan

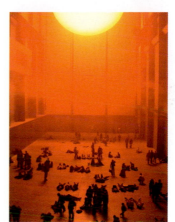

2.9 Olafur Eliasson, *The Weather Project*, 2003. Monofrequency lights, projection foil, haze machine, mirror foil, aluminum, and scaffolding. Dimensions variable. Installation view at the Tate Modern, London, 2003

the mirrored ceiling to form a complete circle—a massive indoor sun. Eliasson further transformed the space by installing humidifiers to create a fine mist in the atmosphere. Viewers responded to *The Weather Project* by lingering and basking in the warmth and light—a welcome respite from a winter in rainy, gray London. They lay on their backs on the floor and watched themselves on the mirrored ceiling, in a scene reminiscent of a holiday weekend at the beach.[18]

Light and shadow have also shaped the physical fabric of the modern city. In Japan, zoning regulations require that builders of high-rise towers must compensate neighbors who would be thrown into shadow by their buildings, effectively halting building projects in many cities and preventing Japan from solving its urban housing shortage.[19] New York City skyscrapers must conform with "setback laws" passed in 1916 in response to the proliferation of the massive office blocks that were made possible by new technologies such as the elevator and electric lights in the early 20th century.[20] After 1916, buildings were designed to step back from the property line as they reach upward, allowing air to circulate and light to reach the streets below. Architects have created innovative responses to the setback law. In the mid-20th century, Ernest Flagg, Buchman and Kahn, Emery Roth and Sons, and Sylvan Bien responded to the new regulations by designing buildings that looked like Mesoamerican ruins or wedding cakes. Ludwig Mies van der Rohe reinvented the formula for New York skyscrapers with his Seagram Building, begun in 1954 and completed in 1958. Instead of building to the lot line as previous architects had done, Mies created a plaza at street level, building the tower on a footprint that occupied just one quarter of the block. As a result, the curtain wall of Mies's sleek steel and glass box rose uninterrupted to a height of 38 stories, or 525 feet. Mies's innovation transformed the look of the city once again, giving rise to a new generation of slender, glass boxes that have defined the postwar "International Style" of architecture, favored by American corporations from the 1960s to the 1980s. In 1999, faced with a very narrow lot on which to build, Christian de Portzamparc, architect of the Louis Vuitton-Moët Hennessy Tower in New York, designed the building to curve backward on itself to meet the city's zoning requirements. As befits the headquarters of a Parisian manufacturer of perfume and champagne, the resulting sleek, steel and glass tower resembles an arrangement of glass bottles.

QUALITIES OF LIGHT

Lighting, whether from available or artificial sources, and whether naturalistic or expressionistic, can be described in terms of *contrast* and *directionality*. Range of contrast has to do with the intensity of the light, relative to the entire scene, but is also a factor of reflection. *High-key* lighting produces a photo without strong shadows, as in the

18 Olafur Eliasson, *Minding the World* (Arhus: Arhus Kunstmuseum, 2004).

19 Robert Casati, *Shadows: Unlocking Their Secrets from Plato to Our Time* (New York: Vintage, 2004), 16.

20 For histories of skyscraper building, see: Carol Willis, *Form Follows Finance: Skyscrapers and Skylines in New York and Chicago* (Princeton: Princeton Architectural Press, 1995), and Benjamin Flowers, *Skyscraper: The Politics and Power of Building New York City in the Twentieth Century* (Philadelphia: University of Pennsylvania Press, 2009).

film noir
A genre of American films made in the aftermath of World War Two, which reflected the anxieties of the postwar and dawning Cold War period through crime stories cast with desperate characters, and set in shadowy, low-key lighting.

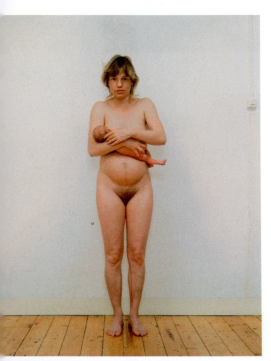

2.10 Rineke Dijkstra, *Tecla, Amsterdam, Netherlands.* Chromogenic color print, 60¼ × 50¾in. 1994

even-toned portraits of Rineke Dijkstra. *Low-key* lighting, such as night scenes rich with pools of light from street lamps and silhouetted forms, is reminiscent of classic **film noir**, such as *Double Indemnity* or much of the work of director Alfred Hitchcock.

If the initial goal of early photographers was the objective recording of visible reality, an image such as the first photograph by Niépce, which presents an ambiguous and otherworldly pattern of light and shadow, presented a challenge to early practitioners. As such, an early goal of controlling the light in photographs was the elimination of shadow. To this end, photographers have developed an array of mechanical technologies, from techniques that work with available light (natural and other incidental light), to myriad sources of artificial light, including spot- and floodlights, which can be controlled, directed, reflected, or otherwise manipulated to achieve a range of effects. Photographers have learned to control light to produce the desired exposure—the amount of light required to activate the photosensitive chemicals on the plate, film stock, or emulsion. This can be measured with a light meter, and regulated by adjusting the camera's f-stop or aperture in combination with varying film speeds and filters.

Metaphorically, light has a "texture." A light source is often described as soft or hard.[21] Moreover, distinctions can be made between "naturalistic" and "expressionistic" lighting, in relation to the attempt to reproduce the look of natural/available light, or to create an altogether abstract visual environment, depending on the effect that is desired by the photographer.

In more concrete terms, photographic lighting can be described as "high contrast" (showing few middle tones) or "low contrast" (showing a limited range of **middle tones**). We can distinguish between "base lighting" (overall illumination, with little modeling); "key lighting" (strong modeling and prominent shadows, as in the bold **chiaroscuro** of a Renaissance painting); "practical light" (i.e. incidental); "fill light" (diffuse illumination, which softens the harsh shadows resulting from key lighting); and "backlight" (which produces a halo effect or a silhouette, creating the effect that a subject is separated from the background).

Often photographers will use a strong light source such as a flashbulb or a bank of spotlights to illuminate a scene, as in the images captured by Jacob Riis and Weegee, which depict the seedy underbelly of city life, or the vividly colored architectural scenes photographed by Barbara Kasten. Diane Arbus's photographs of social outcasts often feature their subjects as if illuminated by a blinding flashbulb, which casts strong shadows, throwing the sitter into high relief. The lurid light and strong shadow remind viewers of the photographer's presence—we are not invisible voyeurs, but are privileged to be able to witness this individual because Arbus has formed a relationship with them and they have allowed themselves to be photographed in an intimate setting. Similarly, Adrienne Salinger's series of photographs, *Teenagers in their Rooms*, features a high-intensity, "spotlight" effect that reminds the viewer of the photographer's presence and

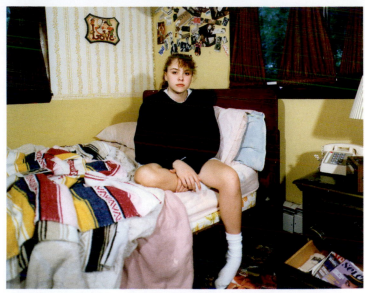

middle tones
Values midway between light and dark or highlights and shadows.

chiaroscuro
Using light and shadow in a drawing or picture to give two-dimensional objects the illusion of shape.

21 Robert S. Withers, *Introduction to Film* (New York: Barnes and Noble Books, 1983), 115–124.

2.11 Adrienne Salinger, *Bridget B*, 1993. Type C photograph
Yesterday was my Junior Prom which I did not attend. Ever since I was in the 9th grade, I've been thinking about the Junior Prom. What if I don't get asked? And in the end I didn't get asked. So I decided I was going to go anyway. Lots of people go without dates. I made myself believe I didn't want a date. I had my dress, I had everything all ready to go and the second I woke up, I started crying. I cried all day. I was too humiliated to go by myself. My mom said I can take the dress back. Most of my friends went. I'm waiting for them to call and tell me how it was. The thing is I did have someone I could have asked but my parents wouldn't let me because he's black. My parents say I don't need that kind of date. He's just a friend but I talk to him every night. He's the only black kid in his school and he hangs around all white people, so he's just like me except for his color. I get so frustrated. I wish I could explain to my parents that despite what they believe – I believe something different. And I couldn't tell him that my parents are prejudiced. He would have felt like crap. Because it isn't his fault. So I just told him that I didn't feel like going

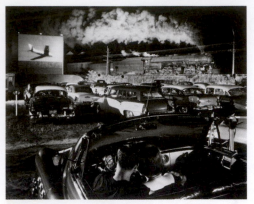

22 O. Winston Link, *The Last Steam Railroad in America* (New York: Harry N. Abrams, 1995), 20.

2.12 O. Winston Link, *Hot Shot Eastbound at Iaeger, West Virginia (August 2, 1956)*, 1956. Gelatin silver print

23 See J.C. Cooper, *An Illustrated Encyclopaedia of Traditional Symbols* (London: Thames and Hudson, 1987).

24 Andrew Tudor, "Genre," in *The Film Genre Reader II*, ed. Barry Keith Grant (Austin: University of Texas Press, 1995), 5.

control of the scene, even as the subject of the photograph describes the setting in her own words.

Photographer and train enthusiast O. Winston Link (1914–2001) photographed at night so that he could completely control the light in his carefully posed compositions. "I can't move the sun—and it's always in the wrong place—and I can't even move the tracks," Link explained, "so I had to create my own environment through lighting."[22] For example, Link's famous photograph *Hot Shot Eastbound at Iaeger, West Virginia* from 1956 was illuminated with 43 flashbulbs (the backs of four lights lining the railway embankment are visible in the photograph) wired together by Link and an assistant, and fired simultaneously while the shutter of his 4×5 Graphic View camera was open. Because Link couldn't control which scene from the film (a Korean War picture movie *Battle Taxi*) would appear at the exact moment that the Norfolk and Western train came barreling down the tracks, Link cut and pasted the desired image onto the drive-in theater's screen.

THE SYMBOLISM OF LIGHT AND DARK

In many world cultures, light has been associated with life, divinity, the primordial intellect, the supernatural, the transcendent, and the incorporeal. Conversely, darkness is often associated with a negative principle—a lack, the primordial darkness of the void, evil, death, shame, despair, destruction, corruption, and ignorance.[23] The symbolism of light and dark has been plumbed by cinema since its earliest invention. In the Western (one of the earliest popular movie genres), heroes and villains are identified by the color of their costumes and horses; we can always recognize the good guys in their white hats. Characters are "typed" as value becomes a convenient shorthand for moral character. In *Shane* (1953), as film scholar Andrew Tudor writes, the film "plays on ... stereotyped imagery, contrasting the stooping, black-clad, sallow, gloved [Jack] Palance with the tall (by dint of careful camera angles), straight, white-buckskinned, fair, white-horsed [Alan] Ladd."[24] Examples abound in all genres: in countless science-fiction and fantasy films, "white" magic is a force for good; "black" magic or the "dark side" is irredeemably evil.

Patterns of darkness and light are powerful metaphors for human existence. Swiss psychoanalyst Carl Jung (1875–1961), in *Modern Man in Search of a Soul* (1933), compared the arc of a human life with the path of the sun across the sky. The sun, he wrote,

rises from the nocturnal sea of consciousness and looks upon the wide, bright world which lies before it in an expanse that steadily widens the higher it climbs in the firmament. In this extension of its field of action caused by its own rising, the sun will discover its significance; it will see the attainment of the greatest possible height—the widest possible dissemination of its blessings—as its goal. In this conviction the sun pursues its unforeseen course to the zenith; unforeseen, because its

career is unique and individual, and its culminating point could not be calculated in advance. At the stroke of noon, the descent begins. And the descent means the reversal of all the ideals and values that were cherished in the morning. The sun falls into contradiction with itself. It is as though it should draw in its rays instead of emitting them. Light and warmth decline and are at last extinguished.[25]

Light and darkness provide a central organizing metaphor for a dualistic world. Indeed, in many spiritual traditions a fundamental system of binary oppositions is mapped onto the division between night and day—the apparently irreconcilable division between darkness and light. Perceptual psychologist and theorist of art and film Rudolph Arnheim writes:

Here also we meet darkness as the great antagonist of light. There can be no light without darkness, but the relationship between them makes for two mutually exclusive conceptions. To the physicist, darkness is nothing but the absence of light, and shadow falls where light is missing. To the eye, however, darkness is the active counterpower, from which light is born and which is combated by light. Hence, in religion the world is either the monopoly of God with darkness as a mere remnant of evil, whose presence is not easily justified; or in a religious philosophy, such as that of the Gnostics, the world is ruled by two coordinating agencies, the power of light and the power of darkness. The two fight against each other in the battle of good against evil, or they complement each other, as in the Eastern image of yin and yang.[26]

We should keep in mind, however, that such a **Manichaean** conception of a world defined by a conflict between light and darkness is often mapped onto notions of racial difference. As the African American philosopher and historian W.E.B. DuBois wrote presciently in his 1903 book *The Souls of Black Folk*, "The problem of the twentieth century is the problem of the color-line—the relation of the darker to the lighter races of men in Asia and Africa, in America and the islands of the sea."[27] The once benevolent-seeming notion that it was the "white man's burden" to "uplift" the "darker races" through the institutions of colonialism, education, and Christianity is a product of just such a dualistic view of the world, and one that has come gradually to be seen as outdated, ill-informed, and dangerous.

In the Western, Judeo-Christian theological tradition, darkness is cast as the antithesis of light, which is a symbol of God's divinity and power. Indeed, in the book of Genesis, the moment of creation begins with the separation of light and dark. In the Christian New Testament, Jesus is identified as the "light of the world," and, as the apostle John writes, "Again, a new commandment I write unto you, which thing is true in him and in you; because the darkness is past, and the true light now shineth."[28] The paintings of the Italian Baroque artist Caravaggio (Michelangelo Merisi da Caravaggio, 1571–1610), for example *The Calling of Saint Matthew* or *The Conversion of Saint Paul*, depict intense beams of light as they invade otherwise dark, squalid spaces, representing the sudden

25 Carl Jung, *Modern Man in Search of a Soul*, trans W.S. Dell and Cary F. Baynes (London, K. Paul, Trench, Trubner, 1933), 106–107.

Manichaean
Adjective derived from a religion that originated in Persia in the 3rd century with the basic doctrine of a division between light, which was good, and dark, which was evil.

26 Rudolph Arnheim, *The Split and the Structure* (Berkeley: University of California Press, 1996), 80–81.

27 W.E.B. DuBois, *The Souls of Black Folk* (New York: New American Library, 1903), 19. See also the Menil Foundation 4-volume series, *The Image of the Black in Western Art*, an ongoing research project motivated by founders John and Dominique de Menil's commitment to Civil Rights for African Americans.

28 1 John 2:8.

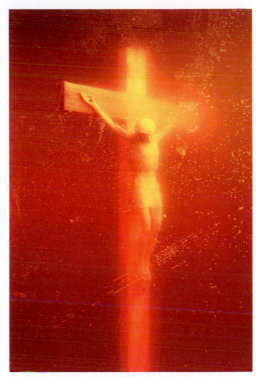

2.13 Andres Serrano, *Immersions (Piss Christ)*, 1987. Cibachrome, plexiglas, wood frame. 32¾ × 45in. (83.2 × 114.3cm) frame

German Expressionism
Around 1905, many European artists became interested in portraying emotions rather than realistic observations. German Expressionism was part of this larger movement, though tended toward the portrayal of more ominous aspects of the human consciousness. Imagery tended toward distorted lines, dramatic lighting, vibrant color, and flattened perspective. German Expressionist films also emphasized sinister emotional content, with tilted camera angles, strong shadows, and harsh contrasts between dark and light.

Gothic
A literary style that emerged at the end of the 18th century and featured romantic and mysterious occurrences set in gloomy or bleak settings. Gothic dramas took their influence from medieval Gothic architecture's towering structures with gables, arches, and ornamentation.

realism
Any form of representation that attempts to show the physical world as accurately as possible, without distortion or emotion.

29 See E.H. Gombrich, *Shadows: The Depiction of Cast Shadows in Western Art* (London: National Gallery Publications, 1995).

30 Arnheim, *The Split and the Structure*, 80.

31 See Warren Susman, "Did Success Spoil the United States? Dual Representations in Postwar America," in *Recasting America: Culture and Politics in the Age of Cold War*, ed. Lary May (Chicago: University of Chicago Press, 1989), 19–37; Paul Schrader, "Notes on Film Noir," in *The Film Genre Reader II* ed. Barry Keith Grant (Austin: University of Texas Press, 1995), 218.

32 Nicholas Christopher, *Somewhere in the Night: Film Noir and the American City* (New York: The Free Press, 1997), 14.

flash of divine knowledge and the viscerally felt experience of spiritual conversion.[29] Caravaggio's widely influential *tenebroso* (or "dark style") has been linked by art historians to the Neoplatonic doctrine of divine light penetrating the darkness of the physical world.[30] This theme—of divine light permeating the base nature of physical reality—might also be seen embodied in the controversial photograph entitled *Piss Christ* (1987) by Andres Serrano (b. 1950), in which a plastic crucifix appears submerged in a quantity of the artist's own urine, suffused in resplendent light.

In American *film noir* of the Cold War era, light and shadow function as characters, embodying a view of a hostile world, torn between the warring of equally matched, counterbalanced forces. Set in American cities—particularly in New York and Los Angeles—in the early post-World War Two era, *film noir* was influenced heavily by **German Expressionist** films, owing to the emigration of German directors and **cinematographers** to the United States on the eve of the War. Fusing a German symbolic tradition that dated back to **Gothic** stage plays and an American taste for **realism**, *film noir* came to embody a particular "anxiety of affluence," as Americans struggled to come to terms with the precariousness of the United States' newfound global dominance, in what cultural historian Warren Susman describes as an ambivalent "dual representation" of the sunny postwar American Dream and its "dark side."[31]

Classic *film noir* includes use of "low-key" lighting, wherein scenes are lit for night; shades are closed and lights are turned off, except for low floor and table lamps, creating pools of light and shadowed and silhouetted figures. Sight lines and camera angles are oblique or vertical—as opposed to the insistent horizontality of the classic Western and frontier epics (referencing the wide-open, available landscape) and appropriate to the claustrophobic and fragmented spaces of the city. As Nicholas Christopher writes,

When Abraham Polonsky, director of *Force of Evil*, was dissatisfied with the look his cinematographer, George Barnes, was getting, he took him to an exhibition of American painter Edward Hopper's paintings and said, "this is how I want the picture to look." And it did: full of black windows, looming shadows, and rich pools of light pouring from recessed doorways and steep stairwells.[32]

While the lighting in *film noir* appears naturalistic—that is, it appears to emanate from available sources—it is used expressionistically. Changes in lighting signify important truths about character and plot, and establish and reinforce mood and tone. This has its impact on the psychological space of the film, and on character development. As film scholar Paul Schrader notes, "No characters can speak authoritatively from a space that is continually being cut into ribbons of light." Even in parodies, such as Woody Allen's *Play it Again, Sam*, or in the radio adventures of Garrison Keillor's private detective, Guy Noir (a classic, down-on-his-luck *noir* character, whiling away "a dark night in the city that knows how to keep its secrets"), the classic *film noir* protagonist is an anti-hero at best,

often hidden in shadow. Such a style tends to equalize actors and their environment, with the effect that the city often becomes a key character in the film. "When the environment is given equal or greater weight than the actor, it, of course, creates a fatalistic, hopeless mood," Schrader notes. "There is nothing the protagonists can do; the city will outlast and negate even their best efforts. This visual tension often supplants any overt physical action, most action is purely psychological."[33]

The aesthetic of *film noir* may be seem to contrast with the theories of Plato, who associated shadows with deception. In *film noir*, shadows do not hide the truth, but reveal it. As Nicholas Christopher writes, "[I]n many noir films, it is the mundane, daylit world that seems unreal, while the night, complex, frictionally, sensorially explosive, stimulating in its contrasts, envelops us with an exotic, often erotic pleasure."[34] And, according to French cinematographer Allen Daviau, "Darkness is not a negative space. Darkness is the most important element in the scene. *The most important lights are the ones you don't turn on.*"[35]

Paula Rabinowitz suggests that Esther Bubley (1921–1998) anticipated much of the *film noir* aesthetic in the photographs she took for the Office of War Information, created in 1942 with many of the same personnel as the Farm Security Administration, including Roy Stryker, who had headed the famous photo division during the Depression. Bubley's photographs documented the uprooted lives of working women, living newly autonomous lives as they worked in government offices and factories on the home front during World War Two. Her striking series of the temporary domestic spaces created by young, single women living together in shared apartments and rooming houses are notable for their dramatic shadows and oblique angles—as in Bubley's melancholy image of an Office of Price Administration stenographer and her roommate from 1943, in which the scene, illuminated by a single bare light bulb, seems to present more questions than answers. As Rabinowitz writes, these photographs "define a sense of enclosure and desperation, even as they portray daily mundane spaces and activities."[36] Compared to her better-known peers working for the FSA and OWI, Bubley's images were rarely published; her photographs revealed sexual tensions that would not find expression until the following decade, in the **femme fatale** characters of classic *film noir*. Indeed, Bubley's compositions create a sense of "the nondomestic domicile, the house that is not a home, the uncanny"—a space of female agency, if transient, with a hint of lesbian desire.[37]

A decade earlier, associations between shadows, death, violence, and abject horror were the subject of an extended series of photographs by **Surrealist** Hans Bellmer (1902–1975). For his book *The Doll* (*Die Puppe*), published anonymously in Germany in 1934, and a subsequent series of more than 100 black and white and handcolored photographs, Bellmer created a movable sculpture of wire and *papier-mâché*. Bellmer than arranged the doll as a still-life prop in various **tableaux** and photographed it in low-key *chiaroscuro* lighting, creating a strikingly eerie, terrifying effect. Like other

femme fatale
A seductive female who lures men into dangerous situations.

33 Schrader, "Notes on Film Noir," 219.

34 Christopher, *Somewhere*, 4.

35 Quoted in Christopher, *Somewhere*, 231.

Surrealism
A movement that began in the early 1920s, which placed importance on gaining access to understandings outside of rational thought, for example dreams and the subconscious mind. Artists, musicians, and writers attempted to cultivate repressed thoughts or visual imagery. Though many of the visual works seem dreamlike or absurd, they often have some basis in each artist's personal experiences, and in the devastation of World War One.

36 Paula Rabinowitz, *Black & White & Noir: America's Pulp Modernism* (New York: Columbia University Press, 2002), 36.

37 Rabinowitz, *Black & White*, 38.

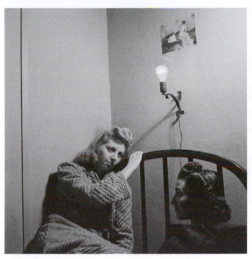

2.14 Esther Bubley, *Office of Price Administration Stenographer and a Friend in their Boardinghouse*, 1943. Gelatin silver print

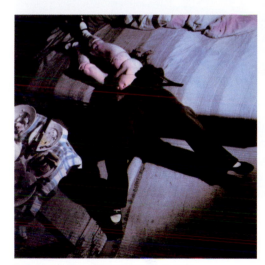

2.15 Hans Bellmer, *Second Doll (on Bed)*, 1935

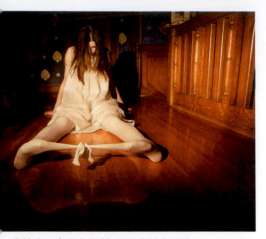

2.16 Anna Gaskell, *Untitled #35 ("Hide")*, 1998

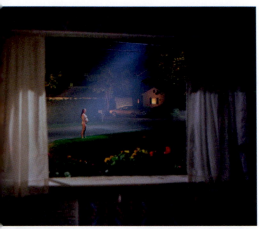

2.17 Gregory Crewdson, *Untitled* from *Twilight* series, 1999. Laser-direct C-print

38 Sue Taylor, *Hans Bellmer: The Anatomy of Anxiety* (Cambridge, MA: MIT Press, 2000) 58–60.

39 Theresa Lichtenstein, *Behind Closed Doors: The Art of Hans Bellmer* (Berkeley: University of California Press, 2001), 13.

tableau
An artistic arrangement, often of still objects.

Weimar period
Period in Germany from 1919 to 1933, which began with the Treaty of Versailles that ended World War One, and which ended when Adolf Hitler came to power. The arts and sciences thrived during these years of the Weimar Republic.

40 Matthew Drutt, "Anna Gaskell: half life," in *Anna Gaskell: Half Life*, by Drutt et al. (Houston: Menil Foundation, 2002), 14–15.

41 Gaskell, quoted in Joy Press, "Girl Crazy," *Vogue* (September 2002), 488; in Drutt, "Anna Gaskell," 15.

42 Sigmund Freud, *The Uncanny*, trans. David McLintock (New York: Penguin, 2003), 10.

modernist dolls by Max Ernst, Raoul Haussmann, Francis Picabia, Marcel Duchamp, and Giorgio de Chirico, Bellmer's dolls "conflated the human body and the machine," to produce uncanny images.[38]

Bellmer's work has been interpreted in light of themes of violence and sadomasochism—especially vis-à-vis issues of voyeurism and pornography, male domination and control.[39] However, Bellmer was also very interested in Christian images of martyrdom and the Crucifixion—which are often painted with a dramatic *chiaroscuro* technique. However, art historian Sidra Stich has noted that Bellmer's horrifying photographs also have an analogue in the ubiquity of amputees with stumps and prosthetic limbs in Europe between the wars. This theme was also treated by a number of artists in **Weimar-period** Germany. Moreover, Bellmer's work, like that of many modernist artists in Germany in the 1930s, was labeled "degenerate" by the Nazis, forcing him to flee to France in 1938. As such, Bellmer, who refused to make any work of art that would glorify the Reich, should also be interpreted in terms of his resistance to Nazi ideologies of racial purity. And whereas the academic tradition (in painting) had employed shadows primarily for their descriptive expediency (i.e. *chiaroscuro* modeling), the Surrealists—from painters such as Giorgio de Chirico to photographers such as Lee Miller and Hans Bellmer—employed shadows to create moods of mystery and dreamlike intensity.

Inspired by Surrealism, the photographs of Anna Gaskell (b. 1969) also visualize themes of good and evil vis-à-vis light and shadow. Drawing from cinematic sources such as the films of Alfred Hitchcock, and literary sources ranging from Lewis Carroll's *Alice's Adventures in Wonderland* to Mary Shelley's *Frankenstein*, Gaskell's staged tableaux create a fictional world populated by eerie young girls—a third-wave feminist version of *Lord of the Flies*. Purity and innocence are signaled by white and lightness—e.g. a pair of upended legs in brightly lit white stockings and Victorian nightgowns—and contrasted with settings cast in foreboding darkness. As Matthew Drutt has written, Gaskell's signature motif comprises "a young woman caught between the purity of youth and the gradual loss of innocence that comes with maturity."[40] Gaskell has explained that she is interested in the dark side of this transitional moment: "under-the-radar competition and manipulativeness."[41]

Light continues to carry otherworldy connotations in contemporary popular culture. In films such as *Close Encounters of the Third Kind* (1977) or *Poltergeist* (1982), or television series such as *The X-Files* (1993–2002), intense light does not represent divine insight, but the appearance of an extraterrestrial or supernatural presence. This quality of light is suggested in the color photographs of Gregory Crewdson (b. 1962). Influenced by television and cinema, and in particular by films such as Alfred Hitchcock's *Vertigo* (1958), Crewdson's photographs are produced with an elaborate support crew much like a **motion picture**, and might best be described in terms of Sigmund Freud's notion of the uncanny, in which "something which ought to have remained hidden … has come to light."[42]

As Crewdson explained, "My pictures are about everyday life combined with theatrical effect … I want them to feel outside of time, to take something routine and make it irrational. I am always looking for a small moment that is a revelation."[43] Such small moments of revelation were a staple of the popular cult television show, *The Twilight Zone* (1959–1964), created by writer and producer Rod Serling, which captured the creeping paranoia of the United States during the Cold War era. In his spoken introduction to the series, Serling linked such moments of mystery to a particular time of day and quality of light. "You're traveling through another dimension," Serling intoned, "a dimension not only of sight and sound but of mind. A journey into a wondrous land whose boundaries are that of imagination. That's a signpost up ahead: your next stop: the Twilight Zone!"

Twilight is a subject that Crewdson has addressed in a series of photographs, shot in western Massachusetts, and representing a series of otherworldly occurrences in a rural small town where shafts of light enter living rooms and backyards. Crewdson's photos deliberately do not cohere into a clear narrative sequence, and we are left to wonder about the causal relationship between the mysterious light and the strange behaviors of the town's residents. Novelist Rick Moody describes the otherwordly twilight in Crewdson's photographs:

Photons can collide with electrons and other subatomics, dusk comes in waves, like the tides, dusk is the separation of all into spectral wavelengths, it is nature at its most artificial, ambient light at its most perfect, such that film directors have always favored it with their attentions, waited for it, waited for *the magic hour*, but also because the poetry of retrospection always adheres to the dusk, to the gloaming, to the time when night becomes a thing to be survived.[44]

MODERN LIGHT AND SHADOW

The spiritual strivings and moralizing imperatives of Neoplatonism and the Judeo-Christian tradition find a modern echo in the technologies of artificial light developed in the 19th century. From its invention, artificial light was associated not only with modernity, but with hygiene and reform. Between 1820 and 1880 (the period associated with the apex of the Industrial Revolution in Western Europe and North America) numerous new forms of artificial light were invented. Previously, olive oil, whale oil, tallow, and wax provided illumination, albeit smoky, inconsistent, and unreliable to the point of being dangerous. By the beginning of the 19th century, gas lamps were introduced and soon lined the streets of middle- and upper-class neighborhoods in major cities. Poor, slum neighborhoods remained dark and dangerous, sheltering a hidden world of illicit goings-on, often patronized by the residents of the clean, well-lighted places mere blocks away. The crusading photojournalist Jacob Riis used a **flashgun** to

motion picture
A movie.

43 Quoted in Annette Grant, "Lights, Camera, Stand Really Still: On the Set with Gregory Crewdson," *The New York Times* (Sunday, May 30, 2004): Arts section, 20.

44 Rick Moody, "On Gregory Crewdson," in *Twilight: Photographs by Gregory Crewdson* (New York: Harry N. Abrams, 2002), 10.

flashgun
A lamp that emits a brief flash so that a camera has enough light to make an exposure. When first invented, the device resembled a gun.

illuminate the seedy underbelly of Manhattan for the photographs in his influential book, *How the Other Half Lives*, often imperiling the very subjects he sought to uplift. Electricity was harnessed first in the form of an open arc between carbon filaments, and later in the vacuum-sealed filament bulb perfected by Thomas Alva Edison (1847–1931). By 1880, electricity—cheap, safe, and transportable—would replace gaslight entirely.

The new electric lights were more luminous than the open flame of a gas lamp. As Roberto Casati writes, the new electric lights were also different from their gas predecessors because they were stable:

> They no longer depended on a flame exposed to air currents, and they didn't flutter ... As is by magic, shadows too stopped flickering along the streets and within the houses ... The nineteenth century didn't just vanquish shadows, it created new ones ... Static shadows had never existed in nature.[45]

45 Casati, *Shadows*, 13–14.

Twentieth-century modernist photographers such as Ansel Adams and other members of the **Group f/64** sought to master every aspect of light and shadow in their painstakingly exposed and developed prints. The modernists recognized that structure and composition could be beautiful, as in the late photographs by Alfred Stieglitz and early work of Paul Strand. Whereas the previous Pictorialists had focused on photographing beautiful subject matter (i.e. borrowed from the *beaux-arts* tradition of 19th-century academic painting) and crafting a beautiful surface (through the use of matte-finish papers, and **gum bichromate** and other printing techniques that mimicked drawing and printmaking), modernist photographers argued that anything could be beautiful if it was well-composed and executed.

Named for the smallest aperture on the lens of a large-format camera, which provides the greatest depth of field, Group f/64 was organized in 1932 by Ansel Adams, Edward Weston, Imogen Cunningham, and others, to promote their "purist" version of **fine art photography**—carefully composed, sharply focused images with a depth of field greater than that discernible by the unaided human eye, printed on smooth glossy paper that emphasized sharp value contrasts and the unique qualities of photographic seeing and the photographic process.

Much of the new look of the photography of Group f/64 was influenced by economic and technical changes taking place in the early 20th century. In the aftermath of World War One, the prices for platinum and palladium skyrocketed compared to silver; platinum and palladium papers were priced out of the market and silver rose to prominence. Whereas a gum bichromate, platinum, or palladium print by a Pictorialist photographer such as P.H. Emerson might exhibit a rich range of tonalities in the shadows due to greater sensitivity to low light levels, a silver gelatin print by Adams, Weston, or Cunningham will show higher contrast. This sharpness was also a factor of new develop-

Group f/64
A group of West Coast American photographers, including Edward Weston, Imogen Cunningham, and Ansel Adams, founded Group f/64 in 1932. The group advocated particular qualities of photography: clearness and definition. They achieved these with the use of small apertures (such as f/64) to obtain a wide depth of field, and large-format view cameras whose substantial negatives created sharp, grain-free images.

gum bichromate
An early photographic process in which an image is formed by exposing a negative to a surface coated with an emulsion of gum arabic, potassium bichromate, and pigment. The emulsion hardens in relation to the amount of light it receives through the negative. Unexposed emulsion is washed away.

fine-art photography
Photography with art or creative expression as its purpose. This term is often used to distinguish the work from imagery that is in the service of business or public interests, such as commercial or documentary photography.

ments in the manufacturing of large-aperture or "fast" lenses, and to the f/64 members' penchant for printing their negatives at a 1/1 ratio—as opposed to earlier generations who enlarged their photographs to the scale of drawings and fine-art prints. Additionally, Adams developed what he referred to as the "Zone System," which allowed him to control the range of tones in a photograph from darkest black to whitest white in order to achieve perfect clarity. Adams also researched the technologies of photographic reproduction in **halftone** printing, ensuring that the quality of any reproduced work would as closely as possible match the standard of his original darkroom print. All of f/64's innovations led to an entirely new, modern tonality in photographic prints, and established a benchmark for quality and craftsmanship, as well as a set of aesthetic strictures that survived late into the 20th century.

The strictures of f/64's aesthetic, however, ensured that some subjects and some individuals would remain largely invisible in the world of fine-art photography. African American photographer Roy DeCarava (1919–2009) worked throughout his career to develop an aesthetic appropriate to his subject matter—as he described it: "the strength, the wisdom, the dignity of the Negro people. Not the famous and the well known, but the unknown and the unnamed, revealing the roots from which spring the greatness of all human beings."[46] DeCarava is best known for his 1955 collaboration with writer Langston Hughes, *The Sweet Flypaper of Life*, a book about everyday life in Harlem featuring 140 photographs and a fictionalized portrait of a black Harlem family. He is also known as the first African American photographer to receive a **Guggenheim Fellowship**, in 1952. In 1955, DeCarava's photography also appeared in the exhibition *The Family of Man*, curated by Edward Steichen at the Museum of Modern Art.

Born and raised in Harlem, New York City's historic and predominantly African American neighborhood, DeCarava began his artistic career as a painter and a graphic artist. As a high school student, he worked for the Poster Division of the Works Progress Administration. He first began to use photography to capture images for use in printmaking, but by the end of the 1940s, DeCarava had begun to pursue photography as an artistic medium in its own right.

Historian of photography Maren Stange notes that "eye-catching tonal contrast, scaled and balanced to emphasize shadow, recurs often enough in DeCarava's work to register as a trope."[47] Because of his interest in the expressive potential of light and shadow, DeCarava came to prefer photography to traditional printmaking. In printmaking, gradations of value must be built up from individual marks. But DeCarava appreciated photography's continuous tone and far more subtle range of values. "It's just one seamless integration from black to white," he said. "And for me, the beauty, the distinctive quality of photography, is this seamless movement from black to white."[48]

DeCarava's art, and in particular his aesthetic of light and shadow, is closely linked to his sense of responsibility to African Americans. His goal was to make visible a

halftone
A process that enables continuous tone images to be printed in ink on paper. When projected onto a printing plate, the image is broken into a regular array of microscopic dots that vary in size according to how dark the image is at that point. The larger dots transfer more ink to the paper, the smaller dots less, reproducing the tones of the original image.

Guggenheim Fellowship
A prestigious annual award from the Guggenheim Foundation to artists who are judged to have produced exceptional creative works.

46 DeCarava's 1952 Guggenheim Fellowship application essay, quoted in Peter Monaghan, "Perseverance and Elegance in Photography," *The Chronicle of Higher Education*, v. 44, n. 16 (December 12, 1997): 44.

47 Maren Stange, "Shadow and Substance," *Art in America*, v. 84, n. 3 (March 1996): 35.

48 Quoted in Monaghan, "Perseverance," B10.

49 Monaghan, "Perseverance," B10.

street photography
A genre practiced by photographers who make their primary subject modern urban life.

50 Stange, "Shadow and Substance," 35.

Black America that was not represented sympathetically elsewhere. As DeCarava has explained, "It was unjust that they should go through life unseen."[49] Inspired by the 1954 Supreme Court decision in *Brown* v. *Board of Education*, which declared school segregation to be unconstitutional, and the subsequent Civil Rights Movement, DeCarava's entire oeuvre is focused on Black America. DeCarava, however, is not strictly speaking a social documentarian. African Americans in his work are not represented in the familiar terms of violence and trauma, but in terms of aesthetic and philosophical themes. Moreover, his sense of social responsibility is connected to his style; his signature dark tonality is calibrated to represent blacks with a subtlety and intimacy that white photographers had never attempted. Using small cameras in the manner of a documentary **street photographer**, DeCarava shot exclusively with available light, capturing images that are rich in subtle, dark tonalities.

DeCarava's 1952 photograph *Sun and Shade* was made during his Guggenheim Fellowship. It features an overhead view of two boys playing on a sidewalk. His theme of duality and opposition is figured/embodied in light–dark contrasts. Stange describes the image:

[W]e must read the shadow to see the child on the shady side; the direction pointed by the "sunny" boy's gun leads our eyes to the other figure almost hidden in the shadow. In the darker portion, which is not solid black, we see that this boy, too, points a gun at his counterpart. Twinned by their identically combative stances across the division that defines them, the figures read as two opposing, even warring, halves of a whole.[50]

REFLECTION, SHADOW, AND THE SELF

According to some theories of child development, children's understanding of shadows has to do with how they understand the way the world works. Children develop an elementary grasp of the physical properties of objects in the world as a fundamental step toward maturity and self-awareness. Swiss developmental psychologist Jean Piaget (1896–1980) conducted a series of experiments in the 1920s aimed at exploring the reasoning and worldview of children. Piaget's conclusions—for example, the assertion that children believe that everything has a soul—have been controversial, but his observations and interviews yielded some fascinating data about how children study and absorb information about the physical world, and come to develop a mature understanding of their environment.

The children interviewed by Piaget and by other researchers passed through several stages in their understanding of the nature of shadow. At first, the children believed shadows to be material objects—emanations from the objects that cast them. Although

the children intuited some relationship between object and cast shadow, they failed to grasp the precise nature of the relationship. Later, when children came to understand that light plays a role in the creation of shadows, they wrestled with the paradox of how light can create darkness. Other researchers have asked children whether shadows are material or immaterial—children, from as early as four years, identify shadows as immaterial, along with echoes, dreams, and electricity. A mature understanding of the physical world is achieved only when the child develops a geometrical understanding of the relation between a shadow, and object, and a light source.[51]

51 Casati, *Shadows*, 30.

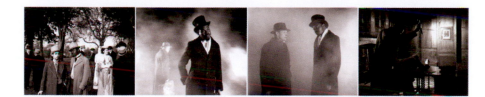

2.18 Yinka Shonibare, *Dorian Gray*, 2001. Eleven black and white resin prints, one digital lambda print. Each print 30 × 37½in.; overall 130 × 175in

Notions of a shadow or mirror self—of opposite reflection and binary opposition—are also embodied in images of the double—or *doppelgänger*—such as the series of photographs by Yinka Shonibare MBE based on the character of the vain, wealthy aesthete Dorian Gray. Born in London in 1962, Shonibare grew up in Lagos, Nigeria, the capital of one of the wealthiest nations in the Third World. In cosmopolitan Lagos during the 1970s, Shonibare was exposed to a range of global popular culture and was raised without a

52 Olu Oguibe, "'Double Dutch' and the Culture Game," in *Yinka Shonibare: Be-Muse*, by Elena di Majo and Christina Perrella (Rome: Museo Hendrik Christian Andersen, 2002), 35.

53 Quoted in Cristiana Perrella, "Be-Muse, Between Mimesis and Alterity," in *Yinka Shonibare: Be-Muse*, by Elena di Majo and Christina Perrella (Rome: Museo Hendrik Christian Andersen, 2002), 16.

54 See Nancy Hynes, "Re-Dressing History (Yinka Shonibare)," *African Arts*, v. 34, n. 3 (2001): 60–68.

55 Rank quoted in Lichtenstein, *Behind Closed Doors*, 64.

56 Benedetta Bini, "In Exile from Here: the Dandy's Latest Metamorphosis," in *Yinka Shonibare: Be-Muse*, by Elena di Majo and Christina Perrella (Rome: Museo Hendrik Christian Andersen, 2002), 59.

sense of himself as a marginal person.[52] Returning to London at age 17 to study art at Goldsmith's College, Shonibare found himself at home moving between cultures, calling himself a "postcolonial hybrid."[53] Much of Shonibare's work references the history of European colonialism in Africa and calls attention to issues of race and representation.[54]

Shonibare often appears as a character in his own photographs, such as *Diary of a Victorian Dandy* (1998), in which he plays the central figure in a photographic series that self-consciously recalls English painter William Hogarth's 1732–1733 series, *A Rake's Progress*. For his 2001 series of 11 black and white and one color photograph, *Dorian Gray*, Shonibare plays the role of the famously vain title character from Oscar Wilde's 1890 novel, *The Picture of Dorian Gray*, and in particular from the 1945 film adaptation directed by Albert Lewin. Each of Shonibare's 12 photographs recreates a scene from Lewin's film. As Gray, Shonibare, who cuts a dashing figure as he moves like a gadfly through London's high society, is to contemporary viewers conspicuous as the only black figure in an otherwise all-white cast of characters. However, the white characters do not seem to notice Gray's blackness. Perhaps, like the original Dorian Gray, the truth of Gray/Shonibare's identity is protected by a painting which appears in the first photograph in the series. In Wilde's novel and Lewin's film, Gray remains young and vital, while only his painted portrait registers the passing of time and the inevitable processes of aging, as well as the shame of Gray's increasing cruelty and heartlessness. When, in a key image in the series, Gray/Shonibare murders the artist who painted the portrait, we begin to witness Gray/Shonibare's downfall. In the one full-color photograph in the series, Gray/Shonibare gazes into an ornate, gilt mirror and sees for the first time his ravaged face. In the next photograph, Gray/Shonibare lies dead on the floor, and in the final photograph in the series we witness the horrified reactions of Gray/Shonibare's servants as they discover his wasted body.

According to Theresa Lichtenstein, the double, or the *doppelgänger*, was described by the psychoanalyst Otto Rank, who saw the double as the threatening other or shadow side of the self, as in the story of Dr. Jekyll and Mr. Hyde, or the "evil twin" plotline familiar from daytime TV dramas. Rank describes the double as a recurrent theme in modern Western literature: "[T]he hero's consciousness of his guilt causes him to transfer the responsibility for certain deeds of the self to another self—the double." According to Rank the theme of the double reemerges at moments of profound social crisis, and is possibly linked to a desire for a broader, social reimagining or rebirth.[55]

Additionally, we can understand Shonibare's photographic series as a kind of shadow, or double, of Wilde's original story (which was already mirrored in Lewin's film). As critic Benedetta Bini notes, Shonibare's photograph of Gray/Shonibare studying his double in the mirror places the two texts—Wilde's and Shonibare's—in a direct dialogue in which they "write themselves one upon the other."[56] As such, the two artworks—Wilde's

novel and Shonibare's photographic series—have become mirror images, Shonibare's contemporary version recasting and revising Wilde's 19th-century original.

Shadows (or perhaps more accurately, our understanding of them) have also been interpreted as having a relation to the unconscious. In the German Expressionist film *The Cabinet of Dr. Caligari* (1920), characters are sometimes paired with oversized shadows, which, as Victor Stoichita writes, can be seen as "the externalization of the person's inner self."[57] The Jungian psychoanalytical tradition has particular significance. Marie-Louise von Franz wrote in *Shadow and Evil in Fairytales*:

In Jungian psychology, we generally define the shadow as the personification of certain aspects of the unconscious personality, which could be added to the ego complex but which, for various reasons, are not … [we] might therefore say that the shadow is the dark, unlived, and repressed side of the ego complex.[58]

To be sure, however we interpret the shadow (as a manifestation of the soul, or a symbol of the unconscious), it is a **sign** (or rather an index) of presence. Lee Friedlander's (b. 1934) shadow in his photographs is a stand-in for his presence as a photographer on the scene, thus invalidating any claims that his images might be taken for a purely mechanical and objective recording of the world—thus, a sign of Friedlander's personality, his person, his biases and interests as an artist, which intrudes into the frame, rather than remaining hidden.

PROJECTED LIGHT

Artist Krzysztof Wodiczko (b. 1943) stages temporary projections on building façades. In locations such as New York City, Hiroshima, and Tijuana, Wodiczko has created temporary public artworks in which museums, monuments, and corporate headquarters become projection screens for still and moving images—most recently from live-feed video cameras trained on participants' faces and hands as they recount personal traumas. Wodiczko's goal is to revitalize the contemporary public sphere as a democratic space. He explains his tactics:

The attack must be unexpected, frontal, and must come with the night when the building, undisturbed by its daily functions, is asleep and when its body dreams of itself, when the architecture has its nightmares. This will be a symbol-attack, a public psychoanalytical séance, unmasking and revealing the unconscious of the building, its body, the "medium" of power. By introducing the technique of an outdoor slide montage and the immediately recognizable language of popular imagery, the Public Projection can become a communal, aesthetic counter-ritual. It can become an

57 Stoichita, *Short History*, 150.

58 Marie-Louise von Franz, *Shadow and Evil in Fairytales* (Boston: Shambala Publications, 1995).

signs (theory of)
According to semiotician C.S. Peirce, a "sign" is something that stands for something else. For example, red lights at intersections indicate a social convention of movement; the word "tree" stands for a physical object; for James Dean, blue jeans may have been a "sign" of rebellion.

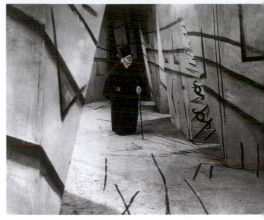

2.19 Still from *The Cabinet of Dr. Caligari*, 1920. Directed by Robert Wiene from a screenplay by Hans Janowitz and Carl Mayer

59 Krzysztof Wodiczko, "Public Projection," *Canadian Journal of Political and Social Theory*, v. 7 (Winter–Spring, 1983), quoted in *Public Address: Krzysztof Wodiczko* (Minneapolis: Walker Art Center, 1993), 107.

urban night festival, an architectural "epic theater," inviting both reflection and relaxation, where the street public follows the narrative forms with an emotional engagement and a critical detachment.[59]

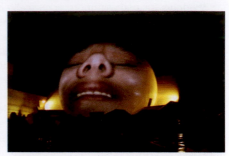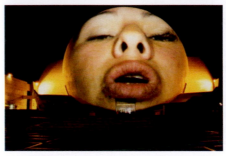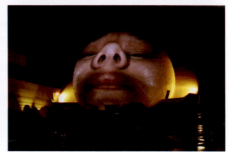

2.20 Krzysztof Wodiczko, *Tijuana Projection*, 2001

high-speed photograph
The act of photographing fast-moving subjects with a camera capable of capturing multiple frames per second.

60 John Bloom, *Photography at Bay* (Albuquerque: University of New Mexico Press, 1993), 47.

Photography theorist John Bloom notes: "In its rudimentary state, projection is interrupted light; its presence is, in a sense, *in absentia*."[60] As such, Wodiczko's use of projection to assert the presence of voices that are normally silenced or absent is particularly poignant.

Other artists and organizations also use projected images in public spaces. Advertisers often project messages onto darkened buildings. An Evangelical Christian congregation in Columbus, Ohio, has made a practice of projecting an image of Jesus onto its church to make a public statement of faith. When the Corcoran Gallery of Art in Washington, DC, canceled the retrospective exhibition of Robert Mapplethorpe in 1989, fearing a loss of federal funds due to the controversial nature of the openly gay artist, protesters responded by projecting images of Mapplethorpe's photographs onto the façade of the building. And in a public artwork by artist and graffiti researcher fi5e, New York City graffiti artists (or "writers") have temporarily "tagged" buildings using a high-intensity projector.

SHADOW PLAYS

On the Indonesia island of Java, where shadow plays have evolved into an elaborate form of ritual performance, the word *wajang*—"shadow"—is also the word for "theater" and actors are called *wajang wong*—"shadow men." Javanese "actors," however, are not humans, but intricately carved silhouettes of translucent leather, which are manipulated by a shadow artist or *dalang*—who sits cross-legged behind a taught linen screen and speaks and sings to the accompaniment of a traditional Gamelan orchestra. The *dalang* operates as many as 60 different puppets—illuminated by an oil lamp, or more recently by an electric light. The *Wajang Kulit* ("shadow play"—translates as "leather puppet") of Indonesia features performances that are based on Indian epics, the Mahabharata and the Ramayana, as well as on Indonesian folktales, and feature complex love stories, tragedies, chase scenes, and battles. Staged to invite blessing and to teach moral lessons, as well as to entertain, performances often last for many hours.

Shadow theater once thrived in many regions. Shadows plays existed in India and China as early as AD 1000. Bali and Sumatra have traditions that probably evolved from older practices in Java. In Turkey, the *Karagoz Oyunlari* (or Karagoz plays, named for the main character, Karagoz) evolved from the *Hadar Hayal*, which was transmitted to Central Asia by way of China.

In Western Europe—where it was always more of a secular entertainment than a religious or educational experience—shadow theater was made obsolete by the new technology of film, which better satisfied audiences' desire to see moving images. The term "magic lantern" describes a rudimentary device that used a light source—a candle or an oil lamp—and a lens to project hand-drawn images onto a wall, perfected by the Dutch physicist Christian Huygens around 1662. The first magic lanterns served educational uses, but soon were used primarily by artists and entertainers. The device proved most useful for projecting ghost-like apparitions to frighten and delight audiences who had little experience of the new technology. By the 1850s, lantern slides were produced photographically on glass plates. The new technology accompanied itinerant lecturers on the Chautauqua circuit, or social reformers such as Jacob Riis, and, when synchronized with music, could be used to create elaborate presentations, such as Philadelphian Henry Heyl's use of multiple slides in sequence, which created the illusion of a waltzing couple.[61] The famous Parisian shadow theater, *Le Chat Noir*, closed in 1895, the same year that cinematic pioneers Auguste and Louis Lumière screened their first film. The ability to regulate and control light also made possible the motion pictures developed by Thomas Edison and the Lumières, as well as the new technologies of **high-speed photography**, as in the motion study photographs of Eadweard Muybridge, and the remarkable photographs taken with a high-speed strobe by Harold Edgerton.

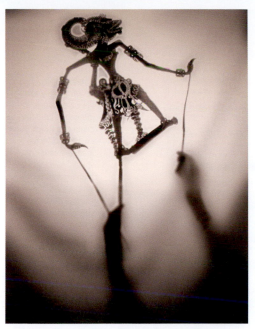

2.21 Bapak Gogon Margono, Sanggar Wayang Gogon puppet production studio. *Javanese Shadow Puppet of Hanuman.* 2008

61 Bloom, *Photography at Bay*, 49–50; Joseph Maria Eder, *The History of Photography* (New York: Dover, 1978), 46–55; Robert Taft, *Photography and the American Scene: A Social History, 1839–1889* (New York: Dover, 1964), 408–409.

2.22 Gregory Barsamian, *Postcards from the Fringe*, 2002

armature
A framework that supports other materials.

kinetoscope
An early cinematic device produced at the end of the 19th century in which an 18mm film ran around a series of spools. As each frame ran under the lens, a flash of light allowed the individual viewer, peering through a peephole, to see what appeared to be a moving image.

62 Stoichita, *Short History*, 200.

flipbook
A book with a series of pictures that change slightly from one page to the next. When flipped, the pictures appear to be animated.

63 Mary Jane Jacob, "Introduction," in *Christian Boltanski: Lessons of Darkness* (Chicago: Museum of Contemporary Art, 1988), 11.

64 Stoichita, *Short History*, 200.

Postcards from the Fringe (2002), a kinetic sculpture by artist Gregory Barsamian (b. 1953), makes use of this same technology of precisely timed strobe lights to create the illusion of motion. Barsamian's kinetic sculptures comprise series of objects and images mounted onto rotating **armatures** and illuminated by synchronized strobe lights. They recall 19th-century devices such as the zoetrope and the **kinetoscope**. Using the principle of the persistence of vision, in which the viewer's brain fills in the gaps between still images, as in a **flipbook** or motion picture, Barsamian creates animations that plumb the depth of his unconscious. (The imagery is based on Barsamian's dreams, which the artist recounts into a tape recorder that he keeps by his bedside. Freud called dreams "the royal road to the unconscious." Similarly, Barsamian is interested in intuitive, unconscious and preconscious states, rife with fragmentary images and associations, which the waking mind filters and rationalizes, but which, Barsamian believes, speak to universal human emotions and perceptions.) For *Postcards from the Fringe* Barsamian arranged six tiers of postcards on a rotating construction which resembles a sales rack at a typical tourist trap. A viewer, standing in one spot, focuses on what appears to be a single image, brought to life by the action of the spinning rack and the strobe light.

The work of French artist Christian Boltanski uses cast shadows to involve the viewer in a theatrical experience. Boltanski's work is often concerned with the memory of the Holocaust. In his installations involving **found photographs**, newspaper clippings, and lost clothing, Boltanski draws on the deep-seated sense of dread evoked by darkness. "I relate many things to shadows. First of all because they remind us of death."[62] An artist who has worked with performance, installation, and photography, Boltanski recalls this tradition in his sculptural installations such as *Les Ombres* (1984) and *Les Bougies* (1986–1987). As Mary Jane Jacob describes the artist's sculptural installations such as *Les Bougies*, they "do not present his handmade puppets as sculptural objects in themselves, but offer instead their distanced reflections, their shadows projected onto the wall."[63] Modest arrangements involving a single candle and a cut-paper silhouette, these artworks flicker, grow, and shrink in response to a viewer's motion. Boltanski compares these works to photography. He reminds us that:

In Greek the word [photography] means writing with light. The shadow is therefore an early photograph … I wanted to work with things that were lighter, things I could put in my pocket. I realized that just by projecting a microscopic puppet I could obtain a large shadow … What appeals to me so much about shadows is that they are ephemeral. They can disappear in a flash: as soon as the reflector is turned off or the candle extinguished there is nothing there any longer.[64]

Artist Kara Walker (b. 1969) produces installations of large-scale silhouettes cut from black paper and adhered directly to the gallery wall. Walker's artworks recall the cut-paper images produced by the proprietors of silhouette machines throughout

the 18th and 19th centuries. Installed in complicated, narrative tableaux, Walker's artworks comprise fictionalized scenes of interracial sex, white-on-black violence, and slave rebellion. Walker's cutouts are flat—monochromatic, blank. As Walker explains, "It's a blank space, but it is not at all a blank space, it is both there and not there."[65] Moreover, Walker's art makes extensive use of stereotypes of black slaves and white aristocrats in the antebellum American South. To be sure, through the device of the cutout silhouette (which derives from a middle-class tradition of making family pictures as well as 19th-century scientific racist theories of physiognomy), Walker deliberately engages ugly stereotypes. This latter point has caused Walker's work to be criticized by an older generation of African American artists and feminists, including Betye Saar and Howardina Pindell, who protested at Walker's pandering of "negative images" of African Americans for the benefit of a mostly white community of contemporary art dealers, critics, and curators. But, as art historian David Joselit argues, Walker's use of stereotypical silhouettes is central to her "anti-racist, anti-homophobic and feminist politics."[66] Joselit continues:

65 Quoted in Jerry Saltz, "Kara Walker: Ill-Will and Desire," (interview) *Flash Art*, v. 29, n. 191 (December 1996): 86.

66 David Joselit, "Notes on Surface: Toward a Genealogy of Flatness," *Art History*, v. 23, n. 1 (March 2000): 29–30.

found photograph
A photographic image made by another person for another purpose. Examples could be a school portrait, family snapshot, or a police record.

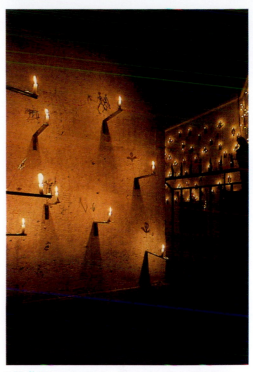

2.23 Christian Boltanski, *Les Bougies* (Candles), 1986. Copper figurines, tin shelves, candles. Installation view, Chapelle de la Salpêtrière, Festival d'automne, Paris, 1986

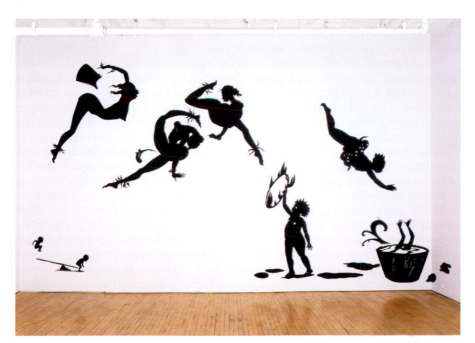

2.24 Kara Walker, *Danse de la Nubienne Nouveaux*, 1998, paper silhouette installation, 120 × 240in. overall

67 Joselit, "Notes on Surface," 30–31.

This formal oscillation between positive and negative, body and shadow, black and white, captures the insidious nature of the stereotype. Stereotypes, like Walker's silhouettes, are always "both there and not there"; they are blank in their generality, and yet powerfully present in their introjection by the stereotyped subjects and their racial others.[67]

Walker's art draws from a long history of using silhouettes—or the cast shadow—as the basis of representation. According to the 1st-century AD Greek philosopher Pliny the Elder, the origin of art can be traced back to the shadow. In Pliny's history a young woman, faced with the grief of her lover's departure, sought to capture a lasting image. She traced the silhouette of the shadow of his profile, cast by a lamplight on the wall. Afterwards, her father, the potter Boutades, filled in the outline and made a clay model. As Victor Stoichita notes, this first artwork was not a result of direct observation of the human form. Rather, it was a transcription of an image already produced by the body itself—an image produced without the direct intervention of the artist. It was thus a copy of a copy, very much like a photograph, which is produced without the direct, physical intervention of an artist. Moreover, Stoichita suggests that the shadow and its descendent the photograph are closely linked in their attempts to circumvent loss and death. In capturing permanently an image fleetingly cast onto a wall, Boutades' daughter fixed a lasting, "upright" image of her absent lover.[68]

> **pantograph**
> An arm-like instrument for copying drawings or pictures.

68 Stoichita, *Short History*, 11–16.

The first artwork described by Pliny stands at the beginning of a long line of mechanically produced images. As art historian Wendy Bellion notes, by the 18th century the notion that a client might want a convincing likeness of a loved one, or of him or herself, had been thoroughly democratized. Whereas in previous periods the ability to commission a painted or sculpted portrait was limited to patrons of a certain class and means, Bellion writes that a range of devices made possible the "mechanization of likeness."[69] The famous Philadelphia museum founded by painter and naturalist Charles Wilson Peale (1741–1827) featured a physiognotrace, a device which used a mechanical arm, similar to a **pantograph**, to trace the sitter's profile. Peale used the device to cut likenesses of individuals for whom a painted portrait would have been prohibitively expensive. Such technologies had a broad appeal in North America and Europe. Peale claimed to have cut more than 8,800 such silhouettes in the first year of operating the device.[70] Other proprietors of the "profile machines" which became popular in American cities during the 1790s added details such as eyes, nostrils, ears, and hair to complete the likeness.[71] Entrepreneurs and their clients were interested in capturing a likeness as faithfully as possible, leading many commentators to describe Peale's device as a precursor to photography.

69 Wendy Bellion, "The Mechanization of Likeness in Jeffersonian America," *MIT Communications Forum*, http://web.mit.edu/comm-forum/papers/bellion.html/

70 Edward Schwarzschild, "From the Physiognotrace to the Kinematoscope: Visual Technology and the Preservation of the Peale Family," *The Yale Journal of Criticism*, v. 12, n. 1 (1999): 60, 62.

71 Bellion, "Mechanization."

Swiss poet and minister Johann Caspar Lavater (1741–1801) developed his own technique for making precise tracings of silhouettes, which he referred to as "shades." Lavater's method involved a shadow of the sitter's profile thrown onto a screen by a

candle. As the sitter sat perfectly still close to the screen, a person on the other side of the screen would carefully trace the projected image—producing a copy after an image—much as Boutades' daughter had done in Pliny's tale. But more than mere mechanical transcription, Lavater's innovation relates back to an ancient tradition of physiognomic studies—the belief that a person's face was the outward expression of their inner soul. Lavater believed that his accurate profiles were useful in this research. He wrote:

I have collected more physiognomic knowledge from shades [silhouettes] alone than from every other kind of portrait, have improved physiognomic sensation more by the sight of them, than by the contemplation of ever mutable nature ... Shades collect the distracted attention, confine it to an outline, and thus render the observation more simple, easy and precise.[72]

Lavater's method was widely practiced around 1800, although it is not clear whether it was understood as a scientific undertaking, or merely as a diverting parlor game. In response to charges that physiognomy was a way of dividing humanity, Lavater responded that he was driven by a fervent religious devotion, believing that his physiognomic studies offered a path to, as Stoichita writes, "understand man as a moral being, through his shadow ... Lavater maintained that the practice of physiognomic development was an act of love, committed to searching out the divine in a human being."[73] For Lavater, the practice of physiognomy afforded a glimpse of another's soul, and, as such, "unites hearts, and forms the most durable, the most divine friendships; nor can friendship discover a more solid foundation than in the fair outlines and noble features of certain forewarn—when to excite; when to console—when to reprehend."[74]

As the publishers of an English-language version of Lavater's physiognomic principles described the value of the physiognotrace:

NOTHING is more common than to hear the study of Physiognomy condemned as being calculated to mislead men in their judgments of each other, and because of the impossibility of its being reduced to a science; yet, nothing is more prevalent, in all classes of society, than the formation of judgments from the appearances of the face. How often do we hear these observations—"He has an open countenance"—"His countenance is forbidding"—"That man has an honest face"—"His looks are enough for me"—"Rogue is depicted in his countenance"—"That bewitching eye"—"That stupid face," and many other expressions of the kind. This proves that, although differences of opinion be entertained respecting Physiognomy, all men are, in the true signification of the term, physiognomists.[75]

Lavater's "research" was pseudoscience. His early innovations and grandiose goals for his "shades" paved the way for the later photographic work of Francis Galton,

72 Quoted in Stoichita, *Short History*, 157.

73 Stoichita, *Short History*, 160.

74 *The Physiognomist's Own Book: An Introduction to Physiognomy Drawn from the Writings of Lavater* (Philadelphia: James Kay Jun., & Brother/Pittsburg: C.H. Kay, 1841), 5. http://www.newcastle.edu.au/school/fine-art/publications/lavater/pop-phys.htm/. See also: Ellis Shookman, ed., *The Faces of Physiognomy: Interdisciplinary Approaches to Johann Caspar Lavater* Columbia, SC: Camden House, 1993).

75 "Preface," in *The Physiognomist's Own Book*, 5.

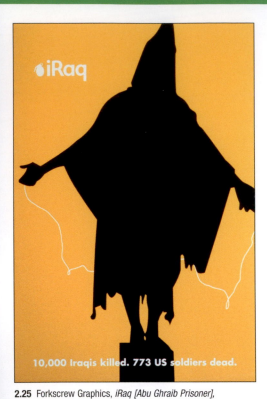

2.25 Forkscrew Graphics, *iRaq [Abu Ghraib Prisoner]*, silkscreen, 2004, Los Angeles, CA

76 Dora Apel, "Torture Culture: Lynching Photographs and the Images of Abu Ghraib," *Art Journal*, v. 64, n. 2 (Summer 2005): 97.

Alphonse Bertillon, and August Sander, who believed that, aided by the objective eye of the camera, the great variety of human phenotypes could be scientifically studied and rationalized to produce comprehensive racial, ethnic, or class types.

Silhouettes continue to be used in commercials for coveted consumer goods, from De Beers diamonds to Apple's popular iPod music player. Silhouettes offer a graphically strong, quick read in multiple contexts, whether seen in a poster on a cluttered street corner, or in an animated graphic on a webpage. Moreover, advertisers favor silhouettes because they allow the potential consumer to project themselves into the imaginary world constructed by the advertisement. In 2004, Forkscrew Graphics, a Los Angeles design collective, parodied Apple's well-known iPod advertising campaign which featured silhouetted, dancing figures against brightly colored backgrounds. Forkscrew placed posters of silhouetted coalition soldiers brandishing automatic weapons and rocket launchers, Iraqi insurgents hurling rocks, and the infamous 2003 photograph of a hooded torture victim from Abu Ghraib prison, which had been leaked to the press earlier that year.[76]

In this essay we have considered light and shadow as visual elements in photography; but as we have seen, light and shadow also carry deep cultural associations, and manifest themselves as powerful physical forces. We explored notions of the void, or the absence of representation where there is no contrast; the idea of "writing with light"; the physical properties of light, which is, in fact, a form of radiation; qualities of light; the symbolism of light and dark; cultural and psychological notions of reflection, shadow, and the self; projected light; and shadow plays and uses of the silhouette. The next chapter, "Light and Shadow: Tools, Materials, and Processes," describes practical issues related to light and shadow, including potential sources of light, qualities such as light intensity, direction, and color, methods of evaluating exposure, and the use of filters and gels. We also consider issues such as reflectivity, projection, and working with silhouettes and cast shadows.

Light and Shadow
Tools, Materials, and Processes

Rebekah Modrak

The physical basis of photography is the transformation of light into image. In *The Allegory of the Cave*, an early account of light as image, Plato describes how prisoners chained inside the cave mistook shadows cast by events outside the cave for the events themselves. The flickering shadows served as a substitute for reality. Later, the magical, changing lights projected inside the camera obscura provided viewers with an alternative, enchanted view of the world. In these examples, light and image were fluid, fluctuating forms. Images can also be fixed, as with a photograph. According to Pliny, painting originated when a woman drew an outline around her lover's shadow. This act—the fixing of light into image— could also serve as a metaphor for the origin of photography.

This chapter on "light and shadow" explores processes that use light as a malleable material *and* as a means of casting images. In other words, lighting can be used as a means to an end (as a means of lighting objects and scenes to be filmed or photographed), as a way to project images, or as the goal in itself (as a sculptural material in installation and performance). *Light and Shadow: Tools, Materials, and Processes* is divided into three sections: the source, the path, and the terminal point.

The *source of light* shapes the implied narrative of an image. For example, a scene where the main light seems to radiate from a car's ceiling lamp may help to convey the intimacy of the automobile's interior space and the vulnerability of that space next to the vast darkness of the outside world. The kind of lighting equipment used has specific connotations. For example, we usually think of the sun as a "natural" light, as grand, warm, or romantic. If sunlight seems to suggest a

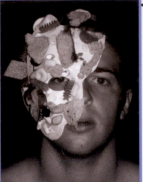
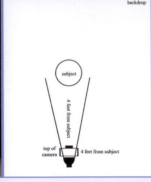

2.26 Direction of light: front 90°

2.27 *Front lighting* creates few shadows, so the subject seems flatter. Flash photography is the most common form of front lighting and is traditionally used for portraits that emphasize information over personality, such as drivers' licenses and mugshots. Here, front lighting is the only direction that allows us to see both of the man's eyes. He seems exposed, as if caught in headlights

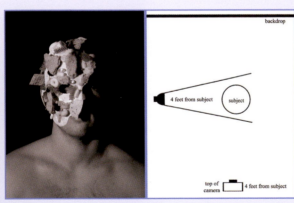

2.28 Direction of light: left 90°

2.29 *Side lighting* creates drama, with one side in shadow and the other in light. This type of lighting emphasizes dimensionality. In this image, the lighting emphasizes the food's texture. Side lighting is traditionally used for studio portraits, though usually with a fill light or reflector to slightly brighten the darker side

spontaneous or genuine world, artificial light often refers to that which is human or industrial. Fluorescent light is often used to convey a dreary, clinical, bureaucratic space. In Woody Allen's film *Sleeper*, his character wakes up in a future lit with radiant whiteness, a spare efficiency designed to suggest a new, highly developed world with ultramodern technology.

The *path of light* involves choices of level and direction. Light can be manipulated to shape or flatten objects and actors in order to make them more or less visible, to focus or distract the viewer's attention, to give a sense of the time of day, season, and era, and to influence the mood of a scene. Light and shadow hide or reveal (suggesting knowledge, ignorance, secrecy, or revelation, etc.); convey style (realism, abstraction, etc.); determine composition (symmetry, balance, fragmentation, horizontality, verticality, etc.); and reinforce psychological conditions (jubilance, eeriness, boredom, etc.).

In addition, objects and elements that are hit by light within the scene are also implicated. Each of these *terminal points*, walls, and other surfaces, provides a palette that merges with the color of light. Their texture and placement facilitates or impedes reflection and the bouncing of light. Objects within a scene are opportunities to cast shadow, to mirror or to merge with their surroundings. Each of these actions depends upon the level and direction of the lighting.

THE SOURCE OF LIGHT

Qualities of light
Intensity, contrast, and distribution
The light source itself affects the scene. The power, voltage, or size determines its *intensity*, that is, whether the light radiates as a bright glare or as a faint glow. A light meter can be used to measure how much light is falling on an object or how much light energy is reflected from the object itself. The strength of the light also determines *contrast*, the difference between bright areas and shadow areas. Higher contrast lighting is extreme, with dark and light areas but little range in between. Flat lighting has a narrow spectrum of light, without much distinction between values.

The number of light sources and their housing affect light's distribution, whether the beam is diffuse or hard. Light from large, close sources (sun filtered through clouds, shade, artificial light bouncing off reflectors or diffused through scrims) creates *diffuse* light that is hazy with few or no shadows. More coherent light sources (the sun on a clear day, a flash unit, a spotlight, or a photoflood, a slide, or LCD projector) have strong parallel rays that produce hard or *specular* lighting with strong, dramatic highlights and shadows, and sharply defined edges. In addition, diffusion and specularity are determined by the direction of light: light emanating

from multiple directions, such as an overcast sky, is diffuse; light striking a subject from one direction, such as the sun in the early morning, at midday, and in the evening, casts harsh shadows.

Direction of light

The same light source can have strikingly different effects depending upon how it is directed at the subject, and the location of the viewer or camera watching the scene. The angle of light affects contrast and texture. Cinematographers of the 1940s learned to glamorize starlets by practicing their craft on oranges. Comparable to human skin, an orange's surface could appear to be extremely porous or as smooth as satin, depending upon whether the frontal light came from high up or from eye level.

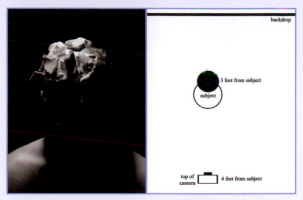

2.34 Direction of light: overhead

2.35 *Overhead lighting* creates harsh shadows. Used here, the top lighting melds together the food and the facial features

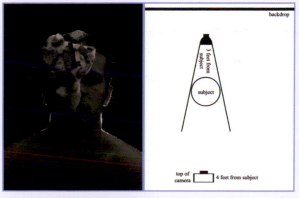

2.31 *Back lighting* silhouettes the head in shadow, outlined by a halo of light. This accent or rim lighting helps to separate the subject from the background

2.30 Direction of light: back

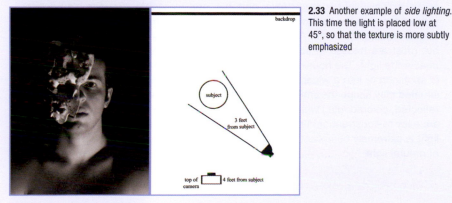

2.33 Another example of *side lighting*. This time the light is placed low at 45°, so that the texture is more subtly emphasized

2.32 Direction of light: lower right

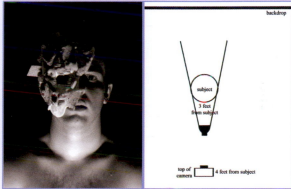

2.36 Direction of light: bottom

2.37 Also referred to as "ghoul" lighting, *bottom lighting* creates the ominous shadows we are familiar with from holding a flashlight under our chins. This position (from below) is one that the sun never takes, and, as such, is always associated with artificial light. In this image, the light accentuates the subject's neck

The direction of light also determines the existence of shadows and how they fall. A subject can be concealed in darkness, cast in blinding light, or hovering between radiance and shade. Lighting allows you to both visually and conceptually separate one object from another, or to bind items together in brightness or shadow.

In the images on pp. 138–139, Michael Tanzillo combines the traditional headshot with a still life of food that shapes the outside of the body. He used one light source (a 90-watt floodlight found at a garage sale) throughout the series. For each shot, the viewer's point of view, the subject, and the black background remain the same. The subject was 5 feet in front of the backdrop and the camera was 4 feet in front of the subject. Only the light's position changes.

Natural and artificial light

These two categories of light offer different aesthetic and practical possibilities.

Natural light comes from such a distance that its beam passes through and bounces off infinite surfaces around us. This pervasiveness gives sunlight and its many reflections, colors, and shadows a spontaneous quality. While we can be reasonably assured that the sun will be present each day, it is often difficult to forecast what form the light will take. Depending upon the time of day, the season, and atmospheric conditions, the sun assumes a range of contrasts, intensities, and colors. Though you may want the bluish-gray diffusion of overcast light, the sky could produce hard, dramatic light and shadow. Sunlight can be controlled to an extent by channeling and reflecting it off and through other surfaces.

Anyone who has ever experienced a blackout knows how much we rely upon artificial light. From traffic lights to street lamps to household bulbs, artificial light extends visibility and casts beams into quiet, moonlit nights. While natural light is free of charge, artificial light will cost a bit more, especially if you need to light large areas. Artificial light is predictable, portable, and malleable. You can plan ahead without fear that the light will change, and can control the light by easily changing and redirecting its beam. Artificial lamps can be used in the form of bare bulbs, but most are housed in some sort of fixture, which both protects the bulb and directs the light. The housing can project the light into a specific, focusable beam (a spotlight) or into a wider light (floodlights). While the housing in which a bulb is situated may shape the emitted light, light can also be altered (softened, hardened, reflected, colored, etc.) with other equipment. These devices can be purchased or are easy to construct or improvise from found materials. However, though artificial light is extremely compliant, it is difficult to make it take on the softness and color of natural light.

Natural light

The sun can be a wonderful light source if you learn to take advantage of its properties and to understand and control its effects on your subjects. The sun's natural light appears to possess a white quality that is the combination of an equal balance between all wavelengths of light. Bluer at noon, yellower at sunrise and sunset, daylight will affect your subject differently depending on the time of day, season, and atmospheric conditions. In Figures 2.38 through 2.41, the subject performs a series of activities for the camera, each event accentuated and complemented by a particular type of natural lighting.

Direct sunlight

Direct sunlight is sunlight that falls directly onto a subject without passing through natural filters or encountering objects that create shadows (such as buildings or trees). Direct sunlight will hit a subject in the same ways discussed in the "Direction of light" section, as front-, side-, back-, bottom-, or top-lighting. Each direction creates different types of shadowing and emphasizes or de-emphasizes the texture and three-dimensionality of a subject. Because direct sunlight lacks diffusers, it will create areas of intense highlights and shadows. This can pose exposure problems, as metering properly for one side of the subject may result in a loss of detail on the other side. In this case you can experiment by making several exposures based on both the dark and the light areas to see which gives the amount of detail you want. You can also make an average exposure of several meter readings. Figure 2.38 shows direct front-lighting. In this case, the light strikes the subject from a low angle so the object lacks visual contours created by shadows. This lighting gives the appearance of compressed perspective. In our image, the artist wanted to flatten her subject in order to expose the monotony one may feel as a corporate employee.

Open shade

When you photograph under a large tree or in the shadow of a building, you are probably in open shade. Open shade refers to a scene that is lighted only by natural light, but not direct sunlight. In these situations, the light is soft and even. Exposure readings of light and dark areas in the scene are usually similar. In open shade, the light is often reflected from the surroundings, as in Figure 2.39. Often in this type of lighting, the subject reflects fill light bounced from neighboring objects. This bounced or reflected light brings with it the color of those objects. For example, in our open-shade photograph, the subject received bounced green hues. The picnicker, therefore, is visually integrated into nature as part of the pleasant and calm park environment.

2.38 Direct sun

2.39 Open shade

2.40 Mixed light

2.41 Overcast

A mixture of light and shade

Sometimes a subject lies under a patchwork of light and shade. This patchwork is created by the contrast of light trickling through or being blocked by trees, windows, or other translucent or patterned objects. Metering for such scenes is similar to that for direct sunlight, as you must consider whether the image should have detail in the lights or darks and expose for that part of the scene, *or* shoot an exposure based on an average reading. If you have to choose to expose for either the light or the dark areas, the image will often have high contrast. In our mixed-light photograph, Figure 2.40, light streaming through an open window casts a rosy glow onto the aproned figure baking in her home. The smiling head, however, falls into shadow.

Overcast weather

On rainy and cloudy days the lighting on a subject may be without shadows, thus lacking the three-dimensional effect of the sun's direct light. Puddles and wet pavements can reflect colors onto the subject, which could create interesting color patterns or could be distracting. An overcast lighting situation may be useful for flat lighting needs or for bringing out the range of colors in a color photograph, but may be less appropriate if contrast is desirable. Our overcast photograph, Figure 2.41, shows the subject shopping and waiting for the bus on a rainy day. The head now seems cloudlike against the dreary gray sky and dampened pavement.

Reflected colors

In natural light, a subject also feels the effects of bounced light from surrounding objects. When you look at the head of the subject in the photographs here, you will see green light reflected off green leaves, brown light reflected off amber wood grain, and gray-blue light reflected by cement. At times, you might not want these color casts in your images. Filters, fill-light reflected off white reflectors, or alternative lighting sources will reduce their effect.

Artificial light

Continuous light

Continuous light refers to the light emitted by the types of lamp that provide a steady stream of light: floodlights, spotlights, and projectors. These lights usually plug into an electric outlet. One advantage of their constancy is that you can see the effect of the illumination (the direction, shape, intensity, and shadows) while you're arranging the light. Continuous bulbs are most readily available in tungsten color temperatures, but are also available in daylight, fluorescent, and other tints. Most continuous light bulbs tend to be less expensive than the other source of

artificial light, flash units. However, continuous lights have a shorter life than flash (momentary) lights.

Momentary light (flash)

Momentary light is brief, but powerful, light from flash or strobe equipment. A strobe light is an electronic flash; some units are triggered to flash one time and some will continue to flash over and over. Electronic flash is at daylight temperature, 5500K (degrees Kelvin, see Figure 2.54). The burst of light is so powerful that the equipment can be very small and portable, as with the flash units that are built into cameras; and so brief (a few ten-thousandths of a second) that you cannot see its effect at the time of use. Therefore, most studio flashlights are equipped with a tungsten *modeling light* to help provide a visual estimation of the way the light will fall. If your goal is to freeze motion, the brief duration of the flash will produce sharp-focus images. Because flash is a cooler or "whiter" light than the yellowish tungsten, it is often described as producing a "cleaner" light. Flash units can be powered by batteries or an electrical outlet, and can be used many times before burning out. Flash heads are more expensive than continuous light bulbs.

Built-in flash units on cameras

Cameras with built-in flash units come with their own light source. This can be a blessing in situations where there is not enough light in the scene. However, when subtlety is called for, built-in flash can overpower a scene, creating overexposed highlights (white areas with no detail) and strong shadows. Conversely, a flash can also underexpose when it is not powerful enough to reach very far. In these instances, it helps to be able to control the light.

Usually, cameras with built-in flash give the option of having the flash on or off. Many give further options. Most common are choices between automatic flash (the flash is triggered when the camera's meter senses that there is not enough existing light to obtain a good exposure), no flash, or flash with *red-eye reduction* (a pre-flash fires first to cause the subject's pupils to contract: the smaller the pupil, the less chance of red-eye). More elaborate cameras may offer *flash exposure control* in which the user can alter the power of the flash when it seems too strong or weak. Flashlight can also be altered using softboxes, diffusers, and reflectors.

The projector

While projectors are meant for enlarging images to screen-size proportions, they are also a good source of light for sets, installations, and other needs. Their strong beam produces hard-edged lighting that can be thrown out of focus for softer light. The projector and lens work as a team. The projector provides the power and light and channels the image. The lens directs and focuses the image and light. The

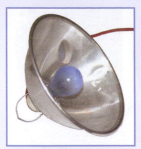

2.42 Daylight-tinted bulb screwed into an inexpensive reflector meant for chicken hatching; these are available in hardware or farm supply stores

2.44 Flashlight with tungsten bulb

2.43 Professional tungsten light that can be modulated from a tight spot to a wide flood. Here, with barndoors that help direct the beam, and clamped on a light stand

2.45 Slide projector with halide lamp. While projectors are usually used to project slides, when fit with a blank slide mount they are also a good source of a strong beam of light

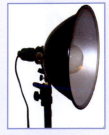

2.46 Tungsten bulb screwed into a reflector, and clamped on a light stand

2.47 Built-in electronic flash. An automatic electronic flash unit is built into this disposable camera

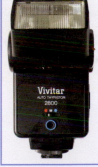

2.48 External flash unit. This small portable unit has a synchronization contact that fits into the hot shoe of a camera. When the hot shoe flash is mounted on a camera, it fires when the shutter release button is pressed. This flash has a movable head that can be angled in different positions for bouncing the light

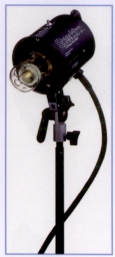

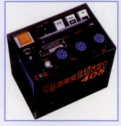

2.50 Power pack. An electrical supply for electronic flash heads. This pack has multiple sockets for several heads and allows you to vary the wattage from head to head

2.51 Synchronization cord (sync cord)
One end of the cord connects to the camera (as seen here); the other end connects to a flash unit. When connected, the flash fires when you press the camera's shutter release button

2.49 Studio flash head. Studio flashlight that can be mounted onto light stands. They get their power through a cord connected to a power pack

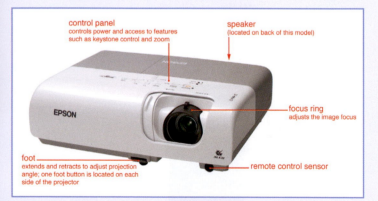

control panel
controls power and access to features such as keystone control and zoom

speaker
(located on back of this model)

focus ring
adjusts the image focus

EPSON

foot
extends and retracts to adjust projection angle; one foot button is located on each side of the projector

remote control sensor

2.52 Digital (LCD) projector

distance from machine to wall determines the image's magnification. This system of lens and projector exists in several types of machines.

Overhead projector

An overhead projector allows the presenter to make modifications to the transparency while the audience watches. For example, Paul Zaloom spills liquids and moves objects onto an overhead projector to simulate the creation of the world. Artist Kara Walker uses overhead projectors to paint with shadows. This type of projector consists of a large box containing a very bright lamp and a fan to cool the light. On top of this sits a lens that directs the light upwards, through the transparency film, which rests on the flat staging area. On average, staging areas are about 10x10 inches across. Light travels through the transparency into a mirror situated above the box at the end of a long arm. The mirror redirects the light and image forward onto a screen for enlarged display.

Opaque projector

An opaque projector is a modified version of the overhead projector. This machine projects opaque materials by shining light down onto the surface from above. Artists and set designers often use opaque projectors to transfer an image from a small source to a larger field. For example, an image can be projected onto a new surface where it can be traced to provide an outline for a larger work.

Slide projector

The most common type of slide projector is for 35mm slides, though lantern projectors, which take larger transparencies, also fall into this category. In addition to projecting images, 35mm projectors can be loaded with an empty slide mount to produce a sharp, rectangular beam: this is a great source of strong lighting. Kodak stopped manufacturing 35mm slide projectors in 2004, and most other companies will probably follow suit in the near future as digital images and multimedia projectors become less expensive. Yet, 35mm slide projectors and lantern projectors can easily be found in second-hand stores and through Internet auction sites.

Digital (LCD or DLP) projector

A digital projector has multiple inputs to connect to computer, video, and audio equipment. LCD projectors use a lamp, a prism, and filters to project an image onto a screen. DLP projectors use a newer technology based upon a system of tiny mirrors; these use reflection to produce a higher output of light with a lower source of power. As a result, the machines run cooler because they don't need as bright a lamp.

Mini-projectors

Mini-projectors are handheld projectors, about the size of a camera, lit with lasers or LEDs (light-emitting diodes). The mini-projector can project images from a cellphone, camera, television, laptop, or organizer.

Optical and physical aspects of projection
Keystone correction

A beam of light will be symmetrical if it hits a surface from straight on. For example, if you pointed a flashlight directly in front of you, the beam that hits the wall will be circular. As you lift the flashlight over your head, angling the light at the same point on the wall, the beam will take on an oval shape. This is the phenomenon of keystoning.

When projecting light, you can optically correct a keystoning problem by changing the relationship between the projector, lens, and terminal point, that is, by angling the projector and the lens, or the terminal point, so that the beam is hitting all surfaces from the same distance. The problem can also be corrected electronically. Most digital projectors are equipped to correct keystoning through the control panel, up to a certain degree (for example, up to a ±20° tilt). This correction shrinks the longer side of the keystone so that all sides of the image are parallel. Be aware that when you use electronic correction, the image's aspect ratio will be maintained, but the image will become smaller.

Brightness

A projector's brightness is measured in lumens. Levels range from hundreds to tens of thousands of lumens, depending on the model you choose. For example, the *Epson PowerLite S5* LCD projector (Figure 2.52) has 2000 lumens of brightness. For most applications, a projector of this brightness is a reasonable starting point. Lumens are but one aspect that affects the perceived image brightness. Others include:

- **Size** of the projected image: bigger images will be dimmer; smaller will be brighter.
- **Density** of the projected image: a black image will be darker than a white image.
- **Conditions** of the space: the ambient lighting of the location will affect image brightness. Images appear brighter in darker spaces.
- **Type** of projector: overhead, slide, computer, or video.

Another consideration of image brightness is the uniformity of the screen's illumination. The illumination ratio measures the difference between the darkest spot

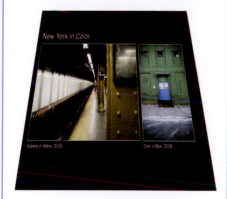

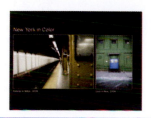

2.53 Perspective and keystoning: *top:* Image projected at straight angles with no keystoning; *middle:* Image projected at angle shows keystoning; *bottom:* Image with keystoning corrected electronically. Image shrinks because keystone correction reduces wider side until sides are perpendicular. Image may be slightly squeezed horizontally in the process, but generally this is not a problem

(usually the corner) and the brightest spot (usually the center) on the screen. The higher the ratio, the more uniform the brightness. For example, the *Epson PowerLite S5* screen has a brightness uniformity of 90%, which will seem completely uniform in most applications.

Sharpness and contrast

The sharpness of the image quality depends on the lens. As the lens quality increases, the image projected will be sharper. With projection, the *contrast ratio* measures the difference between the light intensity of the brightest and the darkest areas of the image. The greater the difference (and higher the ratio) the sharper and more colorful the images will appear and the more shadow detail will be visible. For example, the *Epson PowerLite S5* LCD projector has a contrast ratio of 400:1. There are 400 steps between white and black. If a projector had a contrast ratio of 90:1 there would only be 90 steps between white and black, and thus far fewer subtleties of color or value. High-end projectors have contrast ratios of 10,000:1 or more. The contrast ratio is a fixed specification of a projector and cannot be altered. To some extent, the contrast ratio also affects the projector's ability to reproduce image color, though, even with a high contrast ratio, it can be challenging to get a digital projector to reproduce the quality of image you see on your computer. A green image on your computer monitor may appear green-blue when projected. You may need to edit the image color and contrast to the point where it may not look correct on the computer monitor, but does so when projected.

Image resolution

Digital projectors have a *native resolution* that determines the level of detail at which the projector can present images. The resolution consists of so many pixels by width and so many by height. For example, many high-end digital projectors offer a resolution of 1024×768 pixels (XGA). Lower-end models offer a resolution of 800×600 pixels (SVGA). If you are projecting a 10-foot image, a resolution of 1024 pixels across that span will create smaller pixels (and therefore finer detail) than will a resolution of 800 pixels. The native resolution is fixed and cannot be changed.

Projectors offer best quality when their native resolution matches the resolution of the input device—say, a computer monitor. Fortunately, the resolution of most computer display screens can be changed to match the projector's native resolution. The computer screen's resolution can be adjusted under System Preferences or *Control Panel > Display* or *Monitor Settings*. If the display's resolution matches the projector's resolution, say 1024×768 pixels, the image will fit the screen.

@ **2.1** Refer to our web resources for additional information about projectors, including installation, altering image size, aspect ratio, projector noise, and image quality and resolution.

THE PATH OF LIGHT

Color of light

Objects appear to be certain colors because of their own coloring and because of the *color* of the light falling upon them. Light varies in color depending on the light source and the colors the light strikes or passes through. The color temperature of light is measured using the K (Kelvin) scale. Temperatures range drastically. Candlelight is an extremely warm, reddish light with a low color temperature of 1900K. The warm yellow of household bulbs, photofloods and other artificial tungsten lights measure around 3200K. Standard daylight refers to the sun at noon, a cool blue light that measures around 5500K. However, daylight temperatures vary from a warm 3100K at sunrise/sunset to the 1800K of the open blue sky, and vary even more according to the season, with winter light becoming extremely blue. Unlike daylight and tungsten light, fluorescent light is not a stable wavelength, so the light emitted by fluorescent tubes fluctuates between yellow-green and blue-green and can be difficult to measure.

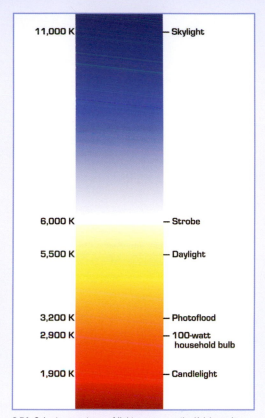

2.54 Color temperatures of light sources on the Kelvin scale

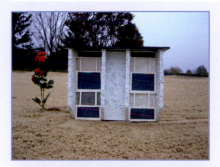

2.55 Color of light: morning light, 8:00am, late October

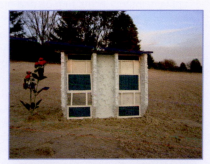

2.57 Color of light: evening light, 6:30pm, late October

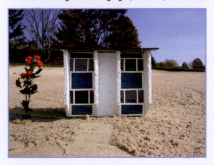

2.56 Color of light: afternoon light, 12:30pm, late October

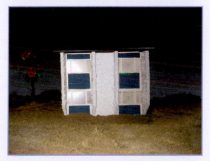

2.58 Color of light: night light, 10:00pm, late October (tungsten photoflood aimed at house and two handheld fluorescent flashlights in the background)

Artists working with light must be aware of color casts. When used well, casts emphasize the psychology of a scene (e.g. a reddish cast can convey a sense of danger). When not used well, a color cast just seems unrelated to the scene or sickly. The color of light can be neutralized to appear white, or filters and gels can be placed on lights to alter their color, to warm or cool the temperature, and to change the mood of a scene. For more information about film, digital sensors, and color casts, see *color* in the index.

Movement of light

The way a light moves—either by streaking across a space, creating a haze of luminance, or rapidly turning on and off—can initiate action, create suspense, and set up conditions for a scene. Natural light sources involve movement. The sun does not stay still and, as it moves, it changes in intensity and color, and recasts the outline of all objects. A household settling down for the night can be understood in terms of sequences of movements with light: sunlight dims, curtains are drawn over downstairs interior lights, streetlights and porch lights flutter on, upstairs interior lights turn on and gradually peter out. Recreating these effects in artworks involves consideration of *time* and *manipulation*. When light is used within time-based works, such as installation, performance, and video/film, its intensity, color, and distribution can be visibly altered over time. Shifts in contrast, angle, or diffusion can occur gradually or quickly. Though the light source may provide one type of beam, such as an acute spotlight, artists may need to manipulate that source or simulate other characteristics in order to achieve certain effects. In *Painting with Light*, cinematographer John Alton describes how to create a staged effect of dim, flickering light with two sources, one symbolic and one practical. For example, the audience thinks the character is lit by a flame from a candle wick, when he/she is actually illuminated by a more powerful lamp hidden in the hollowed-out candlestick. The following pages describe ways to redirect and alter the movement of light.

Manipulating the intensity and contrast of light: Focusing, filling, diffusing, and reflecting

Main light or direct light

When working with lights, the brightest light is referred to as the "main" or "key" light. The intensity and distribution of this bulb or tube determine the overall lighting for the scene or location—the flatness or dimensionality of objects and the density and contrast of shadows and highlights.

Fill light or indirect light

When lighting a scene, a main light may not be enough to place the highlights and shadows where you want them. In that case, you can use *fill light*, a less intense light than the main light; its role is to soften or brighten existing shadow and highlight areas in order to show more detail in areas. Fill light may involve techniques such as adding an additional light bulb, using reflectors to bounce artificial or natural light back into the scene, or supplementing sunlight with flashlight, etc. Whatever the form, fill light should be less intense than the main light, either of less voltage, diffused, or placed at a distance. Fill light is often used to light highly reflective surfaces that produce glare if lit directly.

Focusing light

This involves narrowing the spread of light and controlling light from spilling into other areas. A beam can be narrowed into a spotlight by attaching a *snoot* or *barndoors* to the lamp housing. A snoot is a tube positioned in front of the light to project a circular beam. Barndoors are a pair (or two pairs) of adjustable panels that shape the beam of light and prevent light from reaching particular areas of the scene. You can also make the light harder and more focused by attaching a *grid*, a honeycomb-pattern screen, over the light.

Reflecting light

Reflectors direct the main light, or redirect spill-over light that has missed the subject. For example, if you point a large lamp at a subject, some of the beams might spill over the sides. These can be reflected back. Reflectors can be screwed onto the light socket or placed directly around the bulb or flash tube to concentrate all the illumination in the same direction. They can also be placed at a distance from the bulb, flash tube, or sun to redirect the light.

Reflectors include metal bowl-shaped reflectors (that screw onto the bulb to direct the light), reflector flats, cardboard or foil panels (used to aim light back into underlit areas), and umbrellas (curved white or metal reflectors that may be used to direct light back to the subject).

Bouncing light

This is a way of creating softer light than a lamp could produce directly. In this technique, the light bounces off a reflective surface before hitting the subject. The light source points away from the subject, directed toward a reflector panel, a piece of foam core, an umbrella, or the wall or ceiling, etc. This softer fill light is reflected back to the subject. Some flash units mounted on cameras can be turned at various degrees, so that their light bounces off the ceiling or walls. To ensure

2.59 Snoot

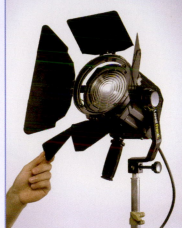

2.60 Barndoors

2.61 Grid. Helps control the beam angle and hardness of light

2.62 Reflector. Narrows the beam of light

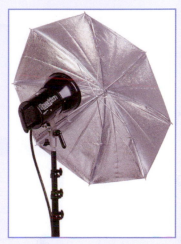

2.63 Umbrella reflecting light. The light is pointed toward the underside of the umbrella and away from the subject and camera

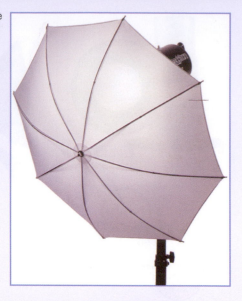

2.64 Umbrella diffusing light. The light and umbrella are facing the subject

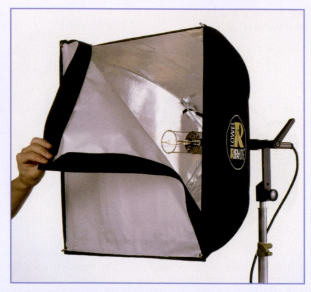

2.65 Softbox

that you always have a white surface for bouncing light, you can attach a note card to the flash unit with a rubber band.

Diffusers

These are used to soften light, to lessen the intensity of the light, and to spread the light over a wider area. You can diffuse the light by reflecting it with a matte surface, or by bouncing the light off another surface. You can also aim the light through a translucent material such as a cloth sheet, a white umbrella, or a softbox. Small flash units are easy to diffuse with a white handkerchief. *Softboxes* are fabric boxes that completely enclose a light bulb or tube; the front of the box has a scrim that diffuses or softens the light.

When choosing or constructing a reflector or diffuser, consider:

- The **color** of the reflecting material, which will alter the color of the light.
- The **texture** of the surface; some materials, such as thin cotton, soften light, while polished surfaces, such as mirrors or tinfoil, create stronger, harder reflections).
- The **shape**; from flat boards to curved umbrellas.
- The **size**; from small note cards attached to an on-camera flash to large sheets of newspaper and aluminized "space-blankets."
- The **proximity** of the reflector to the light.
- The **angle** at which the reflector is held.
- The **direction**; whether the light is facing toward or away from the reflector and the subject.

Stands and clamps

Studio lighting stands are tripods on which to mount lamps and reflectors. Hardware stores have inexpensive clamps that can be used to secure lamps and reflectors in place.

Inexpensive ways to alter light

Many manufactured products will focus, reflect, and diffuse light. However, it is just as easy to construct these devices by hand. Homemade versions can be made for a fraction of the cost and can be designed to suit a specific situation. You can reflect or bounce light with foam core, tinfoil, or other reflective boards. Using mylar, kleenex, and semi-transparent fabric or other materials, you can make tiny or room-sized softboxes and diffusers. The following examples describe just a few of the ways you can alter lights to better serve your needs.

Small on-camera softboxes

When taking photographs in lighting situations that require a flash, you may sometimes want to soften the glaring effect of flash on a subject. On-camera softboxes solve this problem by filtering the flash's light and spreading the luminance over a wider surface. The filtration and diffusion eliminate the harsh brightness created by flash, lessen the intensity of the light, and decrease glare when photographing reflective surfaces. Making your own filter gives you the versatility to experiment and customize the intensity of your flash.

To be used quickly, the homemade filter should easily attach to a built-in camera flash. Construct this homemade softbox by taping a small overlay of translucent material over the flash. Muslin curtains, tracing paper, tissues, or several layers of other translucent draping material work well. Determine the appropriate thickness of the material with trial and error. The number of layers will depend on your choice of material and the level of filtration that you need. Make sure that the material is spread evenly over the flash. Attach with tape or a rubber band. Be aware that, by softening and filtering the light, the softbox will lessen the amount of exposure to light, thereby darkening the image slightly. Slight exposure differences can be corrected through digital editing or printing.

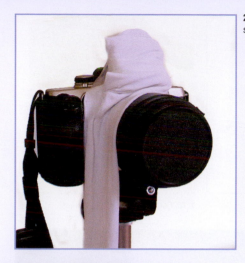

2.66 Flash covered with layers of sheer white fabric

2.67 Version 1 (shot with straight-on flash)

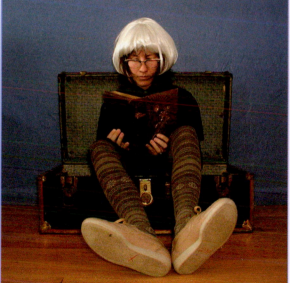

2.68 Version 2 (shot with diffused flash). While photographing Figure 2.67, the flash produced harsh lighting and glare on the wig, floor, and trunk. To correct this, the artist covered the flash with six layers of the stretch material from a pair of pantyhose

2.69 Aluminum bounce

2.70 Corrugated aluminum bounce

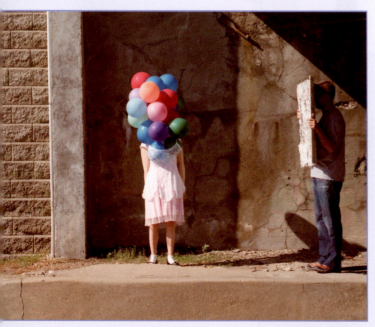

2.71 Using an aluminum reflector to cast fill light on the subject

Bouncing, reflecting, and diffusing light from large light sources

These methods are helpful for altering the light from large light sources, such as sunlight or photofloods. Light bouncers and filters can be created out of basic household and craft materials.

Reflecting and bouncing light If you need softer light than your lamp can produce directly, or if you need to direct additional light onto an area of a subject, you can use a sheet of foam core to bounce the light. Curving the foam core helps direct the light to a particular section of the scene. To curve the board, vertically score the panel in areas that you want to bend. Bow the foam core at these slits in order to curve the board. Place this device in a location that catches the light, and angle it to bounce the rays back to the subject. For greater reflectivity, crinkle aluminum foil evenly and fully, and attach it to the foam core. Heavyweight foil is easiest to work with as it has less chance of ripping than lightweight versions. Be aware that, while the bounced light will be relatively soft, reflecting light onto glossy or shiny surfaces may produce an image of the reflector on that surface. To create a more diffuse light, cut the slits in the foam core on alternating sides to create an accordion-type bounce. Cover with aluminum foil, if desired.

Diffusing light A frame and translucent material can be used as a light diffuser to soften light. Use any translucent material that allows some light to pass. Heavier fabrics may prevent too much light from passing through; extremely light fabrics may allow too much light to pass. The frame can be made of any materials—wire or foam core are inexpensive and readily available—and can be circular or rectangular, depending on your needs. The dimensions of the diffuser will determine the field of softened light; a larger frame diffuses light over a wider area than a smaller frame. Staple or tape the material around the frame. To use, hold the frame between the light source and the subject.

Evaluating exposure: light meters

A light meter measures the amount of light needed to make a correct exposure on film or digital recorder, and provides this measurement in aperture and shutter speed settings. Light meters may be built into cameras or separate handheld units. There are two types of meters: reflected-light and incident-light. Reflected-light meters measure the light reflecting *from* the subject. Incident-light meters measure the amount of light falling *on* the subject. Remember that an underexposed image will have little shadow detail, but an image overexposed by one or two stops may

still be acceptable. When in doubt and shooting with film, overexpose. When in doubt and shooting with digital, underexpose.

Reflected-light meters

Reflected-light meters measure the intensity of light reflected from the subject. To use a reflected-light meter, aim the meter at the subject. All meters built into cameras are of the reflected-light type. Most handheld meters measure both reflected and incident light.

Reflected-light meters in manual cameras or manual modes

To use the reflected-light meter built into a manual camera, or a camera in manual mode:

1 If you are using a film-based camera, set the film speed on the camera's ISO dial.
2 Set your aperture or your shutter speed, depending upon the effects you are hoping to achieve (see *Camera Controls: Aperture*, p. 94, and *Camera Controls: Shutter Speed* p. 100). For this example, let's say that freezing motion is more important to you, so you choose a shutter speed of 1/125 of a second.
3 Look at the exposure readout in your viewfinder or LCD display. The way this is displayed varies according to the camera. In some cameras, the exposure readout will be a needle that falls in the middle of a scale when the exposure is "correct"; in other cameras, it will be a "+" or "−," a moving green light, or some other sort of indicator.
4 Keeping an eye on this readout, change the aperture until the readout indicates that you have the correct amount of exposure.

With digital or automatic cameras, check the camera manual for variations on these instructions.

Exposure meters and automatic modes

Automatic film and digital cameras have built-in (reflected-light) meters with several options. One (sometimes called *Program* or *Automatic Mode*) measures the light and chooses shutter speed and aperture settings that will give the right amount of exposure. Other options offer a combination of manual and automatic: the *Shutter-Priority Mode* allows you to choose the shutter speed; then the camera chooses an aperture based on the exposure reading. *Aperture-Priority Mode* lets you choose the aperture and the camera chooses the shutter speed. Many cameras also offer an automatic exposure lock (AE) feature that allows you to

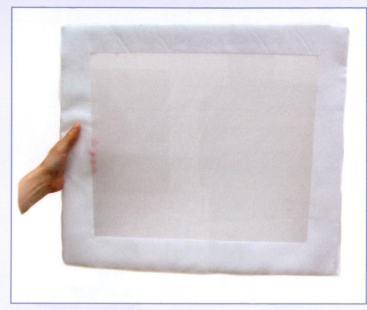

2.72 Foam core frame and translucent fabric diffuser

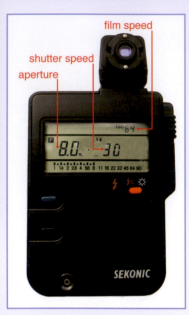

2.73 Handheld reflected-light meter

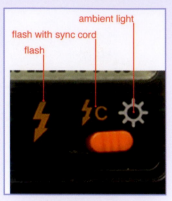

2.74 Options for reflected-light meter

2.75 Photoelectric cell in reflected-light meter

take an exposure reading from a different part of the scene than the focus point. You can meter anywhere in the scene and lock in that reading. When you take the actual picture, the camera will use the original exposure reading. This feature is helpful for situations where you want to expose for a small piece of the scene that is lit differently than the main scene. Sometimes these features are options on the Mode Dial, and other times they can be located under *Automatic Mode*.

Using a handheld reflected-light meter

To use a handheld reflected-light meter:

1 Set the film speed into the meter.
2 Point the meter's photoelectric cell at the subject from the same angle as the camera.
3 Trigger the meter.

Check the meter's manual for variations in instructions. Remember that, because the meter is separate from the camera, it will not account for any filters or attachments on your camera's lens. You will need to adjust the meter's reading to accommodate for these.

Reflected-light meters and middle gray

Exposure meters assume that the highlights, middle values, and shadows of most scenes reflect 18% of the light that hits it; in other words, the scene's values average out to middle gray. Reflected-light meters are calibrated to give you a thumb's up when the light reflected off the scene reads middle gray on the meter's photoelectric cell. This works well with scenes that do average out to middle gray. In situations that are lighter or darker than 18% gray, the meter will still give you an exposure reading that turns the scene middle gray. For example, if you are photographing marshmallows on the tundra, and use the light meter's calculations, you will end up with a picture showing grayish marshmallows in dreary snow. To capture the actual dazzling white scene, you need to trick the camera's meter by filling the viewfinder with an 18% gray card, taking the reading from this card, extracting the card from the scene and taking the exposure. When you remove the card, the camera's meter will indicate that you are overexposing by one or two stops. Ignore the meter—remember that the meter's goal is middle gray, not white.

Gray cards can be purchased from photographic supply stores (usually overpriced), are sometimes available in technical books, and can be bought most economically as a piece of matte board (there is an 18% gray matte board titled "photo gray"). If you are in a bind and have any sort of lawn available, green grass is the equivalent of about 18% gray and can substitute.

When metering a scene using a gray card, make sure that you hold the gray card in the part of the scene whose exposure is most important to the image. If the scene has varied values and you want all parts of the scene to be exposed correctly, you can meter several spots and then calculate average settings. When taking the reading, the gray card should fill the viewfinder. Hold the card perpendicular to the ground—if the card tilts up or down, it will not reflect the light correctly.

Incident-light meters

Incident-light meters measure the intensity of light falling onto the subject. To use an incident-light meter, hold the meter in front of the subject, but facing the camera. The white diffusing cover in front of the meter's photoelectric cell collects light coming toward the subject from all directions. Most handheld exposure meters have this diffusing cover, which can be removed to convert the meter into a reflected-light meter.

To use a handheld incident-light meter, check the meter's instructions. Remember that, because the meter is separate from the camera, it will not account for any filters or attachments on your camera's lens. You will need to adjust the meter's reading to accommodate for these.

To use a handheld incident-light meter:

1 Set the film speed into the meter.
2 Point the meter's white diffusing cover and cell at the camera from the subject.
3 Trigger the meter.

Evaluating exposure: Histograms

Your digital camera may have an in-camera histogram display to assess the exposure of each shot. A histogram is a chart showing the image's overall tonal range and/or the brightness distribution for individual color channels. This information immediately tells you if you need to reshoot the image due to over- or underexposure, or if you need to adjust the setup of the scene or lighting conditions. Figures 2.81, 2.82, and 2.83 show views of an in-camera histogram visible immediately after taking a photograph. This particular camera provides a histogram for overall tonal values on the bottom left and histograms for each of the color channels, red, green, and blue, on the right. Pure black is represented by the left end of the graph and pure white by the right end. For each color channel histogram, the ends represent the brightest and darkest values of that color. The height of each bar represents the number of pixels in the image with that tone.

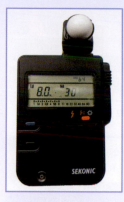

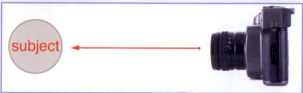

2.77 White diffusing cover of incident-light meter

2.76 Incident-light meter

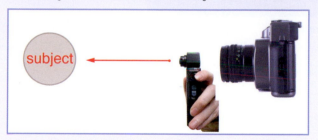

2.78 Metering with the camera's built-in reflected-light meter

2.79 Metering with a handheld reflected-light meter

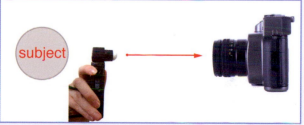

2.80 Metering with a handheld incident-light meter

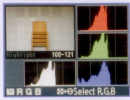

2.82 Detail of histogram

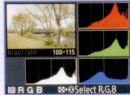

2.83 Detail of histogram

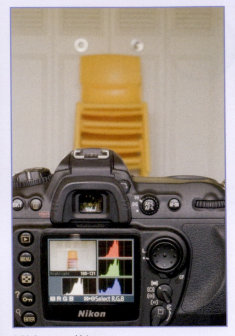

2.81 In-camera histogram

Reading the histogram immediately after taking a picture will reveal whether the shot is well exposed, underexposed (tonal values touching the left end of the graph), or overexposed (tonal values touching the right end of the graph). If there are values that extend to either end of the graph, the shadows or highlights are considered to be *clipped*. Those image details that are clipped are lost. As shown in Figure 2.83, clipping in the highlights often occurs in scenes that include bright skies and dark foliage. This is because digital-camera sensors are very sensitive to extreme lights and darks in an image.

Try to avoid clipping or eliminating visual information by making sure that the tonal values remain between the two ends of the graph, and do not extend off the ends. Pay particular attention to ensuring that information is not clipped on the highlight end of the graph (Figure 2.83 shows this type of clipping), because loss of information in the lights can be particularly visually problematic in the final image. While it is preferable to have NO clipping, if you must over- or underexpose, choose to slightly underexpose images to avoid blowing out the highlights. This will allow you to correct your image further in the computer without loss of information in the highlights. Bear in mind that this strategy is meant for digital images; with film images, overexposure is usually more preferable than underexposure.

Cameras that provide both a single histogram and all three color-channel histograms are useful because the individual color channels tell you whether one color is over- or underexposed. After viewing the histogram, you may reshoot the image with exposure compensation, stop up or down, add or remove light sources, or change the composition in order to make sure that tonal values fall between the two ends of the histogram graph.

Metering techniques: bracketing

If you are unsure whether you are getting a good exposure, bracket. *Bracketing* involves taking several identical images of the same scene, at different exposures. Situations that call for bracketing include: photographing a scene with drastic differences between highlight and shadow areas; using a camera for the first time when you are not sure if it works properly; using a reflected-light meter without a gray card; photographing at night or without a light meter; capturing multiple exposures to be merged for High Dynamic Range Imaging.

Ideally, one of your bracketed exposures will have the correct density throughout all areas. If all areas of a single exposure are not of the correct density, bracketing will give you several exposures to play with and the correctly exposed parts of each can be merged together digitally or in the darkroom. Processes such as

High Dynamic Range Imaging (HDR or HDRI) uses bracketing to create multiple exposures of the same scene, exposing for deep shadows and bright highlights. These various exposures are composited together to create a final single image with a larger range of luminance than any of the original images alone. Although this process can be achieved in the darkroom using negatives, digital photography provides new tools and technologies for artists to explore.

Manual bracketing

1 Set your aperture *or* shutter speed to the desired setting.
2 Use the camera's reflected-light meter to get an initial reading. For this example, let's say that you initially chose a shutter speed of 1/30 second and then changed the aperture until the meter indicated that f/16 would give the correct exposure. Take a picture at these settings.
3 *Increase* your exposure settings by one stop (by two stops if working with RAW images) and take another shot of the exact same scene. (You can choose to open either the aperture or the shutter, but your choice must remain consistent throughout the entire bracketed series.) For example, we could continue by opening the aperture; our second exposure would be f/11 at 1/30.
4 Now take a third exposure of the same scene, but *decrease* the exposure by one stop (from your original exposure). In our case, the third exposure would be f/22 at 1/30.

Auto exposure bracketing (or Auto bracketing)

This allows you to program the camera to automatically bracket three shots. You determine the amount of over- and/or underexposure by presetting the bracketing mechanism. For example, you may bracket by half a stop, a full stop, or two stops at a time. When you press the shutter release button, the camera takes all three pictures in succession. Having three different exposures can be helpful, both in selecting a final image and in editing: if each of the three images has some good areas of exposure, they can be merged in imaging software.

Exposure Compensation is a feature that allows you to intentionally over- or underexpose the image by a specific number of stops (or fractions of stops). Moving the dial +1 or +2 makes the image look lighter. Moving the dial –1 or –2 darkens the picture.

Some cameras have a *Backlit Button*; pressing this will add a fixed amount (1 to 1.5 stops) of exposure to the image. This feature cannot be used to decrease exposure.

@ONLINE RESOURCES 2.2 Refer to our web resources for instruction on reading and calculating flashlight for adequate exposure.

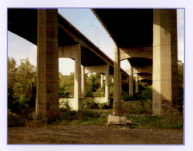

2.84 One-stop underexposure: f/22 at 1/30

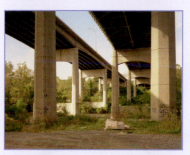

2.85 initial exposure: f/16 at 1/30

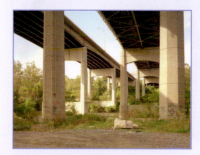

2.86 One-stop overexposure: f/11 at 1/30

This scene presents an exposure challenge as many elements are lit differently: the underside of the bypass is in shadow, while the columns are in strong sunlight. Making three or more bracketed exposures increases the chance of getting a correct exposure and gives options for image manipulation. From the three images above, you could choose a single image with the correct overall exposure. In this case, one artist may look for good detail in both shadows and highlights and would therefore choose the initial exposure, while another artist may want to obscure the details of the bypass in favor of emphasizing the larger geometric shape. You can also merge several sections together digitally or in the darkroom. For example, you could digitally select the overexposed bypass and move this section to the underexposed image

Bracketing at night

Photographing at night or in dark locations calls for exposures of anywhere from 1 second to many minutes, depending upon available light and how much detail you want to see in the final image. To be safe, you may want to do a long series of exposures in which you double your shutter speed:

- Initial exposure: f/8 at 1 second
- One-stop overexposure: f/8 at 2 seconds (with shutter speed on "Time" or "Bulb" from here on)
- Two-stop overexposure: f/8 at 4 seconds
- Three-stop overexposure: f/8 at 8 seconds
- And so on …

Bracketing by ISO number

If you can manually set the film speed (ISO) on your camera, you can also use this setting to bracket. Instead of changing the shutter speed or aperture, you would set your film speed higher or lower than it really is. For example, halving the film speed (from ISO 200 to ISO 100) tells your camera that the film or sensor is less sensitive to light and overexposes the film or sensor (lightens the picture) by one stop. Doubling the film speed (from ISO 200 to ISO 400) underexposes the film or sensor (darkens the picture) by one stop. If using film, it is not possible (because film speed affects processing) to change the film speed of every exposure, so film speed must be applied to the entire roll (for example, overexpose the entire roll by one stop). Bear in mind that noise or grain may be a problem at high ISO settings.

Altering the color of light: filters and gels

Filters can be attached to artificial lights to create interesting illumination effects. The same color filters used by theater, lighting, and cinematography designers can also be used when constructing photographic images. When working with colored light, be aware of the intensity and direction of the lighting sources and how multiple colors affect one another. Warm hues, such as red and yellow, tend to wash out colder hues, such as blue, purple, and green. Overall, cool colors tend to recede while warm ones overwhelm. Keep in mind the various symbolic connotations associated with different colors, such as red with anger, blood, and war, orange with sunlight, warmth, and insanity, blue with coolness and sky, and green with nature, restfulness, or seasickness.

 2.1

2.87 Gel and diffuser. For coloring and softening light

Commercial filters

Professional-quality filters come in a variety of materials, including gelatin, mylar, acetate, polyester, polycarbonate, and glass. Gelatin is the least expensive and may be an option for short usage, but fades over time with the heat of modern light sources, becomes brittle with age, and loses its form when dampened. Gelatin filters come in a wide variety of color choices and patterns. Both acetate and mylar are waterproof and more durable than gelatin. Acetate, while less expensive than mylar, will also fade and change color over time. Mylar is extremely durable and can be reused. Glass is the most expensive and, though heavy and bulky, is heat resistant and can be molded into markings and prismatic lines that will spread light. These filters may be attached to lights using specifically designed mounting holders or ordinary wooden clothespins.

Making your own filters

You can make your own light "filters" using transparent colored plastic gift-wrap, often found at hobby stores, or translucent colored fabrics. Plastic wrap can be attached to a circular wireframe used for making wreaths or to a bent wire that can then be held in front of the lights. Layer pieces of wrap on top of one another to create stronger color intensity or to mix shades and create colors not available commercially (e.g. use blue and yellow to make green). These homemade filters work fine for color intensity, but might melt onto hot lights unless held or attached at a distance from the light source.

2.88 One layer of yellow cellophane gift-wrap taped onto a wreath wire

2.89 One layer of blue cellophane gift-wrap taped onto a wreath wire

2.92 Rosco gel filter used to light wall

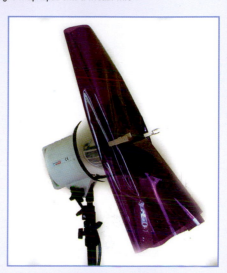

2.93 Rosco gel filter used to light closet

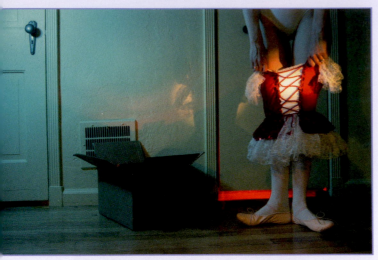

2.90 Sarah Buckius, *Reentering My Past*. Color photograph, 8 x 10in., 2006

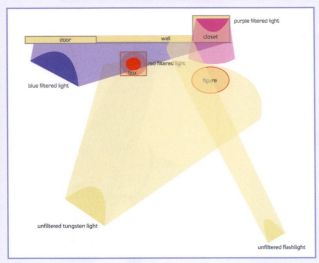

purple filtered light

closet

door wall

red filtered light

box

blue filtered light

figure

unfiltered tungsten light

unfiltered flashlight

2.91 Plan for lighting room for Sarah Buckius's *Reentering My Past*

Using color gels to alter the color of light: Case study

In Figure 2.90, the artist used filters to transform her bedroom into a theatrical stage for dressing up in childhood costumes. She cast a blue hue onto the yellow wall to offset the figure, to create a sense of a moonlit night, and to accentuate the red of the dress. A purple-filtered light radiating from within the closet indicates that this space is magical and possibly associated with memories or fantasy. A red-colored filter produces a faint light from within the cardboard box, giving the unceremonious storage container ambitions of becoming a theater itself. She lit the central figure, the dress, and its occupant with an unfiltered flashlight. This use of "realistic color"—pink flesh and vibrant red velvet—reminds the viewer of the actual event behind the fantasy. The spotlight indicates a moment of performance. The Rosco gelatin filters used here are relatively inexpensive ($6 per 20×24-inch sheet) and easily attach to light sources with clothespins and without fear of melting.

Creating a filtered light effect digitally

If you are working in RGB mode, you can create colored light effects digitally using the Photoshop Render Filter called Lighting Effects. The filter allows you to specify color, focus, position, and intensity of lighting effects, thereby heightening the drama of a scene and drawing attention to certain areas. Digital lighting effects allow you to simulate lighting on small regions of a scene that would be hard to single out with studio lighting, and to customize how light reflects off surfaces within the image. Access the Lighting Effects dialog box through *Filter > Render > Lighting Effects*. The dialog box will open with one default light that you can modify. Options allow you to add lights, to select from a range of lighting styles, to move lights around, and to change the circumference, color, angle, brightness, intensity, and focus of the light. Be aware that Lighting Effects does not create the shadows that would be cast on a subject if working with actual lights. To develop a more realistic play of light, you can digitally add these shadows with tools such as the History Brush, or create shadows from inverted images.

You can apply the lighting effects to a layer, as a smart filter to a layer, to multiple layers, or to a selection within a layer. If there are areas of the image that you wish to light differently, select those areas beforehand and apply the effects to each area within a different layer. This will preserve the file's original pixels and will allow you to move, blend, or change the opacity of the filter within the layer. To simulate studio lighting, apply a different light source to each part of the image. For example, you could light a background wall differently than the subject in the foreground. In such cases, experiment by applying varying lighting effects to different layers.

The following describes basic options and controls within the *Lighting Effects* dialog box. Numbers in the text correspond with items numbered in red on the diagram, Figure 2.94.

Lighting effects controls
Adding, repositioning, and deleting lights

- To add additional lights, drag the light icon (19) into the preview area (20).
- To reposition lights, drag the light by its center circle (16) to a different location within the preview area.
- To delete a light, drag the light by its center circle to the trash icon (18).

Light style (4)
Provides different options for color, intensity, and focus. You can use the default style or start with other styles in this palette.

Light type (5)
Allows you to choose between three types of light source and then to control the intensity (6) and/or focus (8) of that beam.

If you want to color the light, click in the light color swatch (7) and select a color from the Color Picker. To make the light softer, drag the angle endpoint (17) out from the center circle. To narrow or widen a light, drag the side handles (15).

- *Directional* (2) produces a light similar to that of the sun. Adjust the direction of the light by dragging the handle at the end of the line to rotate the light's angle. Change the brightness by shortening or lengthening the length of the light. A very short line yields pure white light; a very long line produces no light.
- *Omni* (1) shines light evenly in all directions, like a light bulb hanging over the image. Drag one of the handles to increase or decrease the size and intensity of the light (the light becomes more intense as it gets bigger).
- *Spotlight* (3) projects a ray of light whose brightness is strongest at the center of the source and then gradually reduces intensity as it moves outward. Increase or decrease the light angle by dragging the handle at the end of the line to shorten or lengthen the ray. You can also drag a handle to stretch the ellipse or rotate the light. You can adjust the focus slider (8) to alter the width of the beam inside the ellipse of light.

Properties
These control the way light reflects off a surface.

- *Gloss slider* (9) defines how a surface reflects light, as either shiny or dull.

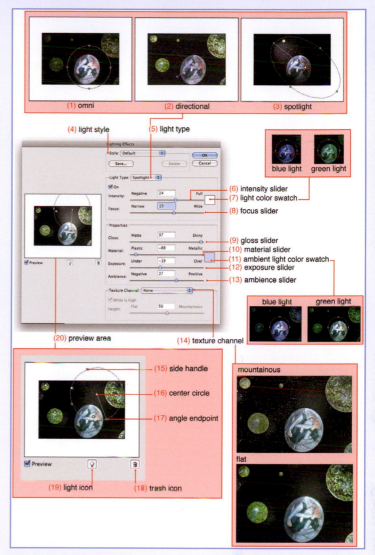

2.94 Digital lighting effects

- *Material slider* (10) establishes whether the light or the object being lit is more reflective. Plastic reflects the light's color and Metallic reflects the color of the object in the image.
- *Exposure slider* (12) controls the brightness or darkness of all lights (unlike the intensity slider, that defines the light intensity of individual lights). Use the slider bar to under- or overexpose.
- *Ambience slider* (13) controls the overall amount of light on a layer and, if a color is selected in the color palette, tints the light. Click on the ambient light color swatch (11) to adjust the ambient color light around the spotlight.

Texture channel (14)

Allows you to create a texture using the color channels of your image or another grayscale image of your choice. The applied texture makes the white parts of the texture appear raised, an effect that increases as you move the slider from flat to mountainous.

LIGHT'S TERMINAL POINT

Reflectivity in the scene or space

In a scene, surfaces hit by light rays are the terminal points for the light. Walls, furniture, or other objects have a role in the illumination of a scene. Whether you are setting up a scene to be photographed or creating an installation for projection, you will need to choose qualities of light (how much light is needed, the temperature of the light, etc.) based on the reflective properties, color, and contrast of objects within the scene. For best results, match your lighting source or projector output with the reflectivity of your space and the ambient light conditions. For example, a set with an image subtly projected into the background, behind the main event, would need a strong projector bulb, a minimally reflective background surface, and could have some degree of ambient or other lights. However, a scene in which the image is the central focus would demand a strong projector bulb, a highly reflective terminal point, and no ambient light.

The following considerations should help to organize your thoughts when creating a staged tableau that will be photographed, when designing an installation that involves projection, or when simply projecting an image onto a surface.

1 **Lighting sources or projection method** The brightness of your light source or projector will affect how close this source must be to the terminal point to yield a sufficiently bright image. Are there appropriate places to situate

the lights or the projector? If using multiple sources, how will they affect one another? How does the contrast and color of the lighting source impact the scene?

2 **Configuration and reflectivity of space** Consider beforehand which surfaces should accept light or projection and which should not be reflective. What are the surfaces like in this space? Are they smooth or textured? Do their textures need to be altered to better project or dim the light? In the early days of cinema, cinematographers dulled shiny props by spraying with a solution of chalk and water. Gradually, polished props such as mirrors and glazed china were seen as an asset to the life of a set. Extreme reflectivity can be found in the nighttime city sets of *film noir*. Sprayed with water, the wet pavement reflected all light sources and the drama of the city at night: dark and suspenseful, but sparkling and alive.

Will objects or surfaces within the space cast their own colors? How do the colors and tones support the psychology, time of day, or presumed location of the scene? How do they help to contrast or subdue elements within the scene?

3 **Ambient light** Stray light makes lighting hard to control. Ambient light falling on objects or projected images may cause them to appear washed out or may change their color. How much are you able to control the lighting conditions? What kind of ambient light will there be? What is its intensity? Where is the ambient light in relation to your controlled lighting, your imagery, and any three-dimensional objects?

Projection screens and reflectivity

Any surface can be projected upon, but all surfaces reflect light differently depending on their texture and color. For example, if you plan to bounce light off, or project images onto, a wall painted with white paint, the whiter the paint and the smoother the surface, the more reflective the wall will be and the brighter your image. A black wall will reflect no light at all. Black and dark tones can be used to minimize light reflection. For example, a black fabric or painted border around a screen minimizes the amount of reflected light that bounces off room surfaces back to the screen.

Screens made for projection have optical coatings that improve reflective properties. The image will be sharper, highlights will be more radiant, and contrast and color saturation will be more intense than with the white wall. There are four categories of screen surfaces, from least to most reflective, they are: matte white (less than 5% reflectivity), pearlescent (15% reflectivity), silver (30% reflectivity), and glass bead (40% reflectivity).

ONLINE RESOURCES **@ 2.3** Refer to our web resources for discussion of how black levels affect projection and reflectivity.

Gain and the viewing angle

When selecting a projection surface—say, between, a latex-painted white wall, a low-end projection screen, or a high-end projection screen—consider the *gain* of each surface. Gain is a measurement of a screen's ability to reflect light. Some are low-gain with a rating in the range of 0.8 to 2; others are high-gain, with a rating around 6.

To achieve high gain, screenmakers embed small lenses in the screen surface to confine the light rays to a narrower angle of travel. Because the image is brighter, the projector can be further away from the screen than would be possible with a white wall (painted with household latex paint) or with a low-gain projection screen. The drawbacks of high gain are: (1) the screen is so reflective that it is hard to produce a dark black image; and (2) light rays travel back to the viewers' eyes at excessively narrow angles, resulting in hot spots and a smaller viewing angle (viewers can only see the image when situated directly in front of the screen). This is why a highly reflective screen is not as desirable as a lower-gain screen with a stronger light source.

When the projector is more powerful with more lumens, a low-gain screen can be used. The pearlescent or matte finish does little to redirect light rays into a particular path, hence the viewing angle is wider and hot spots are not a problem, blacks are projected as dark gray (there is no true black in projection), and the image is bright with good contrast.

It is important to match the screen gain with the projector output level, screen size, ambient light, and viewer placement.

Projection screen materials and formats

Fiberglass, pvc, vinyl, and polyester projection screens

Projection fabrics can be purchased by the yard from companies such as Dazian. These fabrics allow artists to design and install their own screen according to specific dimensions. Fabrics vary in width (from roughly 54 inches to 110 inches) and gain (from 1 to 1.6). They can be stretched across a frame, or simply tacked to a wall. Fabrics do not need to be stretched tightly to be reflective.

Screen paint

All projection screens start out as a liquid that is applied to cloth or cured into a vinyl. Some manufacturers sell the liquid as screen paint, highly reflective acrylic paints designed for front and rear projection. Paints such as *Screen Goo* claim to offer exceptional color fidelity and excellent gain, with minimal hot spotting. For front projection, the paint is meant to be applied to the smooth surfaces of materials such as sheet rock, MDF, or acrylic sheet. However, we have found that even rough surfaces, such as brick, could be transformed into projection screens.

For rear projection, any rigid transparent surface can become a double-sided projection screen. Two coats of base and topcoat, enough to paint a typical home-entertainment-size wall, costs around $175.

Standard vinyl screen sizes do not always match the dimensions of the projected image size, leaving an awkward amount of empty white screen. The freedom to paint a projection surface frees the screen from necessarily being a fixed flat rectangle on a wall, allowing artists to integrate the projection surface into the set by painting objects or surfaces, movable or fixed, in any shape. Liquid screens can be painted to fill the screen completely and, over time, will not shrink or get sticky.

Screen paint and site-specific projection

Daniela Kostova created her site-specific video projection *Billie Jean Performance* in order to connect the informal street culture of downtown Ann Arbor, Michigan, with the institutional culture of the historic Michigan Theater. The installation involved video projection onto a circular screen, painted on the side wall of the Theater. A 4-minute video loop featured Brian Wooldridge, a local street performer known as "Michael Jackson," dancing to Jackson hits in one of his regular venues, the alley next to the theater. By projecting *Billie Jean Performance* back into the alley during the first night of the Ann Arbor Film Festival, Kostova made the oft-shadowed dancer visible from a distance.

The screen paint made possible the circular projection screen, which created the effect of a spotlight showcasing the dancer, attracted a large crowd, and created a festive atmosphere that paid homage to the street performer. After recording and editing the video and audio, and obtaining permission to use the site, Kostova needed to identify an appropriate product for the outside projection screen. She plugged relevant information, such as the ambient lighting, projector model, aspect ratio and resolution, screen dimensions, and application method into GooSystem's calculator, located on the GooSystem website (http://www.goosystems.com), to determine the type of screen paint that would provide the appropriate balance of contrast and brightness for those particular conditions. The calculator recommended Digital Gray Basecoat and Topcoat to create the 7-foot-wide screen.

Silhouettes and Shadow Play

In the 18th and 19th centuries, silhouettes, traced from shadows cast by a lamp, satisfied the demand for inexpensive portraits. Prior to this technology, only those wealthy enough to afford painters' fees could possess accurate representations of themselves. With the *silhouette*, the middle classes could preserve their likenesses

2.95 Seven-foot screen made of screen-goo painted on brick wall, 2006

2.96 Daniela Kostova, still from *Billie Jean Performance*, 2006

2.97 Daniela Kostova, *Billie Jean Performance*, 2006, site-specific projection with screen paint

as well. Though inexpensive, the contours had to be drawn or cut out individually. They included no details within the solid black outline. The *physionotrace* (or *physiognotrace*) provided a mechanical system for producing multiple copies of objects that revealed details. The technique combined two inexpensive methods of portraiture: the cutout silhouette and the engraving. The operator used a lamp to cast a profile onto a glass plate, and then traced the shadow. The tracing stylus was connected to an engraving tool by a system of levers. The engraving tool duplicated the gestures of the stylus onto a copper plate at a reduced scale. Like photography, this process used mechanical operations to output multiple reproductions of realistic likenesses of sitters. Showcased within a home, the engraving also revealed the sitter as worthy of rendering. In this way, the physionotrace preserved both image and social status

As a precursor to photography, silhouettes and physionotraces allowed operators to create multiple and fairly accurate images using light and shadow. Like photographs, shadows are one-dimensional representations of three-dimensional objects. Like photographic negatives, shadows and silhouettes show the inverse of what we see—they show the absence of light. Shadows represent the space occupied by an object.

Working with shadows

Working with shadows to make images, performances, or installations involves dealing with issues of scale, angle, intensity, focus, color, and value distinctions. In any type of work, regardless of materials, equipment, or setup, you will need to consider:

- Scale. The *scale* of shadows produced is determined by the distance of the light source to the subject and of the subject to the projection screen. The closer the object to the light source and the further the object from the projection surface, the larger the shadow.
- Direction. The *direction* (location and angle) of the light source, in relation to the object, affects the object's shape. Directly lighting the object from behind creates less distortion in the silhouette than a light source that hits the subject from the side, above, or below. Distortion can also be created by using multiple lights shining from different directions.
- Intensity. The *intensity* or wattage of the light source affects the degree of lightness surrounding the shadow. Thus, more powerful lights create images with greater contrast. Color filters will change the color of the areas around the shadow.

- ■ Acutance. The distance of the light to the object and the object to the screen also determines the *acutance* or sharpness of the shadow. The closer the object is to the screen, the more distinct the shadows; the further the object is from the screen, the more blurred the silhouette. In addition, moving the object close to the light source diffuses the shadow so it will appear less sharp.

If the work is to be performed, consider whether performers, objects, and lights should be visible to the audience or hidden from view. If you want the projection screen to be between the artist and the audience (so that the objects are visible only as shadow), experiment with materials such as white muslin, broadcloth, and bed-sheets. Almost any white material that allows some light to pass through it will work. The more translucent the material, the more it will reveal details of objects and people behind the curtain. Materials with a brighter white produce images of higher contrast, and more discernible shadows, because the light surrounding the shadow contrasts more with the shadow.

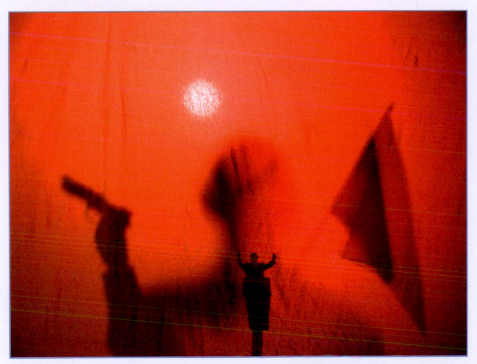

2.98 Sarah Buckius, *The MAN Behind the Curtain*. Color photograph, 8 × 10in., 2006

SUGGESTED ONLINE RESOURCES AND STOCKISTS

2.1 MANUFACTURERS OF FILTERS AND GELS

Apollo Design Technology, Inc. Produces gelatin filters, filters with patterns and even text cutouts. http://www.internetapollo.com/

Gam Products, Inc. Sells filters composed of deep dyed polyester. http://www.gamonline.com/

Lee Filters USA. Produces mylar filters. http://www.leefiltersusa.com/

Rosco International. Produces gelatin, acetate (called Roscolene), and mylar filters. Rosco's filter swatchbook labeling system is the most convenient. http://www.rosco.com/

INTRODUCTION

The reproductive relationship in photography is greater than the interaction between a negative and a print—it includes, for example, an impression and its afterimage, a force of nature and a trace it leaves behind. Through the development of these relationships, *Part 3: Reproductive Processes* incorporates a range of diverse disciplines—from the recording processes of digital sensors and film through image transfer, printing processes, and genetic cloning that can help us understand the nuanced nature and potential of reproduction from a range of perspectives. Each of these disciplines effectively poses questions for artists using photography to consider: How is information captured? How does the recording device affect the information? How does an artist make visible the captured information? How does the output method affect how the information is understood? Part 3 contains two chapters, the essay "Copying, Capturing and Reproducing" followed by the how-to chapter, "Reproductive Processes: Tools, Materials, and Processes," and draws upon the work of historical and contemporary artists to examine these various ideas and processes.

Which is more valuable, the original or its copy? The essay "Copying, Capturing, and Reproducing" begins by considering some of the earliest negative impressions, fossils, and then continues to mine the historical and contemporary questions surrounding the value(s) of reproduction. This distance between the original and its afterimage is described by analogies from genetics, in which the variance from offspring to offspring resembles the variations from copy to copy, while still bearing clear resemblances to the source (the original). We also consider the position of photography as a singular object or a tool of mass reproduction. Whereas the value of an autonomous object lies in its rarity, photography is a medium defined by reproduction, which posits much of its value in copies. The ubiquity of reproductions, from *cartes-de-visite* to digital files, has enabled political campaigns, the culture of celebrity, social revolutions, and Facebook.

As reproductive speed has increased, so has the chance for rapid diffusion through mass media—witness the development of picture essays, text and image photo lithography, and halftone printing. All of these advents have collectively prepared us, on one hand, for television and, on the other, for activism. The essay looks at how artists respond to imagery from the press and the social politics of images. Photographs of the bombed Hiroshima or of a fictionalized Native American population raise the challenges of reproduction: What are the ethical dimensions of reproduction and diffusion?

Finally, we ask: What does it mean to redo something? We consider reproduction in terms of reenactment, of performing an action more than once. How does the duplicate action describe the original? We examine historic reenactors, rephotographic survey projects, and reenactments of earlier photographs in order to understand how revisiting the past enables cathartic, empathetic, or educational possibilities.

The how-to chapter, "Reproductive Processes: Tools, Materials, and Processes," involves looking at various ways of recording, processing, and printing (or output). Recording could involve low-tech methods, such as rubbings or image transfer, or film and digital media. We describe how to process film chemically and to manage digital files through applications such as Adobe Bridge. You will learn to print and evaluate black and white chemical, liquid emulsion, screen, and digital prints, to make contact prints, and about commercial methods of printing. This practical chapter encourages a network of cause and effect possibilities wherein one process may lead to countless others. For example, an image may be transferred, then digitally scanned and projected. The projection could then be recorded and a new course could develop. For additional description of this chapter, refer to the introduction to "Reproductive Processes: Tools, Materials, and Processes," pp. 217–218.

Theory: Copying, Capturing, and Reproducing

Rebekah Modrak

POSSESSING THE SUBJECT: THE PHOTOGRAPHIC COPY

Photography involves different stages of reproduction—from capturing the original subject, to the production of a negative, to the printing of a positive image. André Bazin described the psychology of these relationships in his essay "The Ontology of the Photographic Image" (1945). He compares a photograph to relics such as a death mask or the Holy Shroud of Turin that use what he calls an objective process of embalming, of molding light or earth to transfer the physical body of the original, through time and space, to the image.[1]

Author Susan Sontag agrees that photographic images possess the presence of the original subject. In her essay "The Image-World," she notes that past societies saw an object and its image as having different physical characteristics, but a similar "energy or spirit."[2] While paintings may provide an image that is merely an appearance of the thing painted, "a photograph is not only an image (as a painting is an image), an interpretation of the real; it is also a trace, something directly stenciled off the real, like a footprint or a death mask."[3] Like a fossil, a photograph offers a trace of an object now resigned to the past. As physical imprints, fossils and photographs hold significant power; while we know they are not identical to their pre-fossilized selves, we understand that they are powerful replacements. As their referent disappears, the remnants become as important as the original. In doing so, they essentially become similar to the source itself. Since my grandparents' deaths, the few photographs I have of them have become increasingly valuable, to the point where, when I see them, I almost feel as though I am visiting them.

1 André Bazin, "The Ontology of the Photographic Image" (1945), in *Classic Essays on Photography*, ed. Alan Trachtenberg (New Haven: Leete's Island Books, 1980), 237–244.

2 Susan Sontag, *On Photography* (New York: Anchor Books, Doubleday, 1989), 155, originally published in 1977.

3 Sontag, *On Photography*, 154.

In his essay, "Photography: The Emergence of a Keyword," Alan Trachtenberg describes how mid-19th-century literature and illustrations transformed popular understanding of photography. Essays such as Oliver Wendell Holmes's 1859 articles about stereography described the act of experiencing the contents of a photograph as if they were the real thing. Holmes describes scenes from stereoscopes as if he is experiencing the actual landscapes: "The scraggy branches of a tree in the foreground run out at us as if they would scratch our eyes out."[4] Trachtenberg notes that, in the shift from the unique, object-based daguerreotype to the printed image, the meaning of the photographic image changed from an understanding of the image as a one-of-a-kind object, "another instance of the same thing," to a belief that the image was a way of owning and supplanting the original object.[5] Trachtenberg warns that when the viewer consumes these views as if he is in the location itself (hovering above Jerusalem, strolling through the temples of the Acropolis), he unconsciously assumes the perspective of the photographer and his or her cultural, economic, and political biases.[6]

Photographic reproductions liberated from ritual

In his seminal essay "The Work of Art in the Age of Mechanical Reproduction" (1936), German Marxist philosopher and literary critic Walter Benjamin describes the impact of photographic reproductions, both for duplicating and for creating artworks. Benjamin predicted that the ability to make multiple reproductions would profoundly change the relationship between pre-existing works (painting and sculpture) and their (mass) audience by abolishing the *aura* of the work of art. The aura is the authority of an object as one-of-a-kind and treasured:

An ancient statue of Venus, for example, stood in a different traditional context with the Greeks, who made it an object of veneration, than with the clerics of the Middle Ages, who viewed it as an ominous idol. Both of them, however, were equally confronted with its uniqueness, that is, its aura. … We know that the earliest art works originated in the service of a ritual—first the magical, then the religious kind. … In other words, the unique value of the "authentic" work of art has its basis in ritual, the location of its original use value.[7]

Whether ritual implies religious or secular reverence, it suggests a unique presence that is upheld by the object's sense of permanence, sense of place, or by the fact that it is the only one in existence. For Benjamin, reproductive technologies promised to liberate the work of art from ritual:

4 Oliver Wendell Holmes, "The Stereoscope and the Stereograph" (1859), in *Photography in Print*, ed. Vicki Goldberg (Albuquerque: University of New Mexico Press, 1981), 107.

5 Alan Trachtenberg, "Photography: The Emergence of a Keyword," in *Photography in Nineteenth-Century America*, ed. Martha A. Sandweiss (New York: Abrams, 1991), 17–18.

6 Trachtenberg, "Photography: The Emergence," 42.

7 Walter Benjamin, "The Work of Art in the Age of Mechanical Reproduction," in *Illuminations*, ed. Hannah Arendt (New York: Schocken Books, 1969), 223. [Originally published in *Zeitschrift für Sozialforschung* 5(1), 1936.]

From a photographic negative, for example, one can make any number of prints; to ask for the "authentic" print makes no sense. But the instant the criterion of authenticity ceases to be applicable to artistic production, the total function of art is reversed. Instead of being based on ritual, it begins to be based on another practice—politics.[8]

Benjamin writes that "technical reproduction can put the copy of the original into situations which would be out of reach for the original itself. Above all, it enables the original to meet the beholder halfway, be it in the form of a photograph or a phonograph record. The cathedral leaves its locale to be received in the studio of a lover of art; the choral production, performed in an auditorium or in the open air, resounds in the drawing room."[9] The loss of the aura would make works of art accessible to a wider and less privileged audience.

Writing in 1972, John Berger held similar political views about the economic and aura-laden differences between reproductive and non-reproductive media. In his view, museums, which function like "homes of the nobility," possess artworks to the exclusion of the public (who are occasionally, and on prescribed schedules, allowed to visit these venerable objects).[10] For Berger, singular and unique objects are more valuable as property, but this value inevitably results in the death of the artwork. Berger writes that "Painting and sculpture … are dying because, in the world as it is, no work of art can survive and not become a valuable property. … People believe in property, but in essence they only believe in the illusion of protection which property gives."[11]

While Berger feels that unique art objects can only function as material goods that symbolically preserve the status quo or represent traditional values, photographs operate according to another system:

By their nature, photographs have little or no property value because they have no rarity value. The very principle of photography is that the resulting image is not unique, but on the contrary infinitely reproducible. Thus, in twentieth-century terms, photographs are records of things seen. Let us consider them no closer to works of art than cardiograms.[12]

The social function of the photograph is not to signify property, but to reference the external world, to "bear witness to a human choice being exercised in a given situation," to declare: *I have decided that seeing this is worth recording*."[13]

Otsuka Museum of Art

The collection at the Otsuka Museum of Art offers viewers full-size photographic reproductions of art masterpieces. If you can't travel to Madrid to see Picasso's *Guernica*, visit the replica in Naruto City, Tokushima Prefecture, Japan. If the Vatican limits visitors to

8 Benjamin, "The Work of Art," 224.

9 Benjamin, "The Work of Art," 220.

10 John Berger, "Understanding a Photograph," in *Classic Essays on Photography*, ed. Alan Trachtenberg (New Haven: Leete's Island Books, 1980), 291. [Originally published in Berger's *The Look of Things*, 1974.]

11 Berger, "Understanding a Photograph," 291.

12 Berger, "Understanding a Photograph," 291–292.

13 Berger, "Understanding a Photograph," 292.

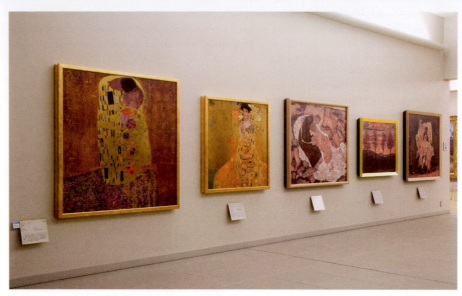

3.1 Reproductions of Western masterpieces in the Otsuka Museum of Art, Naruto City, Tokushima Prefecture, Japan

Michelangelo's Sistine Chapel, you can experience the ceiling painting in Naruto City. At the Otsuka Museum of Art in Naruto City, a committee of six art historians determined the most important works of art in the Western world. The Otsuka Pharmaceutical Group funded the ambitious project of photographically replicating more than 1,000 works on ceramic board, in the original size, orientation, and installation position. Museum directors, curators, and artists' descendents authenticated the works as exceptional reproductions. The museum calls attention to the authentic nature of the works with words such as "real" and "exact," and by making little distinction between copy and original, claiming that the image-replications allow visitors "to appreciate the true artistic value of the original works."[14] The introductory text reassures guests that, if the original works eventually perish in a natural disaster or expire from conservation problems, the reproductions are guaranteed to keep their "shape and color" for 2000 years.

The Otsuka Museum of Art's directors see the exhibition as a valuable substitute, more real than experiencing the artwork as an image in a book, without any particular loss to the authenticity of the experience. This construct may be the motivating force behind such artifices as Paris, Las Vegas. The real—the authentic experience—is not only unimportant, it is inconvenient, often dirty and volatile. Like indoor natural theme

14 *Otsuka Museum of Art*, http://www.o-museum.or.jp/english/, 2004, August 24, 2009.

parks, the Otsuka Museum offers a predictable experience—all of the works of art you've ever wanted to see, in pristine condition. In her essay "The Image-World," Susan Sontag argues that, as we come to understand experiences, events, and, even, ourselves as a series of appearances, reality takes on the character of images. If photographic works contain some essence of their reference, if they appear somewhat like that *real* object, then Sontag argues that *reality* itself becomes more image-like.[15] The Otsuka Museum of Art was not constructed to emulate the experience of viewing actual works of art, but to permit the experience of browsing through an art history survey book, such as *Gardner's Art Through the Ages*. If this seems a radical shift away from a preference for authentic experiences, William M. Ivins reminds us in *Prints and Visual Communication* that art historians regularly base their observations and analysis on reproduced images rather than on first-hand observation, yet rarely acknowledge the "extent to which their own thinking and theorizing have been shaped by the limitations imposed on those statements by the graphic techniques."[16]

Photography and genetics: Error and accuracy in replicating DNA and prints

Comparable notions of original and reproduction can be found in genetics. On average, your genes are 99.9% the same as those of any other human. Bill Bryson describes the human reproductive process in *A Short History of Nearly Everything*:

> Most of the time our DNA replicates with dutiful accuracy, but just occasionally—about one time in a million—a letter gets into the wrong place. This is known as a single nucleotide polymorphism, or SNP, familiarly known to biochemists as a "Snip." Generally, these Snips are buried in stretches of noncoding DNA and have no detectable consequence for the body. But occasionally they make a difference. They might leave you predisposed to some disease, but equally they might confer some slight advantage—more protective pigmentation, for instance, or increased production of red blood cells for someone living at altitude.[17]

Snips represent the 0.1% difference between any two humans and, as we each have a different set of Snips, our "instructions" and inaccuracies vary to the same degree (0.1%) from those of any other human.

Likewise, most photographic reproductions vary from copy to copy. Enlarger bulbs and filters age, chemistry weakens, printing inks diminish, and digital printer heads clog. Mechanical and human errors and chance occurrences often create subtle differences between multiples. In the first photographic duplication process, William Henry Fox Talbot noted variations in the tint of reproductions, resulting from varying exposure times and paper quality. Before attempting to standardize the process to achieve one tint,

15 Sontag, *On Photography*.

16 William Mills Ivins, *Prints and Visual Communication* (New York: Da Capo Press, 1969), 2.

17 Bill Bryson, *A Short History of Nearly Everything* (New York: Broadway Books, 2005), 409.

3.2 Sigmar Polke, *Salamander Stone*, 1998. Mixed media on fabric

3.3 Sherrie Levine, *Sherrie Levine: After Walker Evans: 2* (Burroughs family portrait), 1981. Gelatin silver print; 3¾ × 5¹⁄₁₆in

3.4 Walker Evans, *Burroughs Family, Hale County, Alabama*, 1936. Gelatin silver print, 19.1 × 24.1cm

18 William Henry Fox Talbot, "Brief Historical Sketch of the Invention of the Art," in *The Pencil of Nature* (1844–1846), by William Henry Fox Talbot (New York: Da Capo Press, 1969).

19 John R. Lane and Charles Wylie, eds, *Sigmar Polke: History of Everything, Paintings and Drawings 1998–2003* (New Haven and London: Yale University Press, 2003).

postmodernism
A cultural and artistic movement that questioned the assertions of modern arts and conventions, such as medium specificity and formal purity. Postmodernism is characterized by the juxtaposition of multiple styles, the rejection of assertions of truth or originality, and the blending of high and low culture.

he informally surveyed colleagues on their aesthetic preferences and noted that each seemed to favor a different shade.[18]

Anomalies in the duplication process take center stage in German artist Sigmar Polke's (b. 1941) series *Druckfehler* or *Printing Mistakes*. This work considers the language of print images—the dot matrix pattern, a pattern of small dots—black and white for grayscale images and cyan, magenta, yellow, and black for color images. Look closely at a newspaper and you will notice the dot pattern; then you may notice the errors—smudges, gaps, streaks, or overlaps that come from off-registration, over-inking, a bubble in the ink, or a strand of hair on the plate. Attracted to the disparity between the original image and the blotched reproduction, Polke collected, enlarged, and projected each error onto a polyester surface, where he painted the mistake and the surrounding dots. The dot pattern (which formed the paper's image) now serves only as a backdrop to a glitch that should have been overlooked, but which has become the image itself. Polke's intervention reveals that, when inspected closely, mistakes and Snips cause every copy to be an individual.[19]

A family of originals and reproductions

Like our genetic partners, reproductions tend to look similar from a distance and different from up close. But while a purist might disavow a relative or photographic print that seems dissimilar, others might have more flexible definitions of who belongs in the family. **Postmodernism** is famously willing to acknowledge distant cousins. Sherrie Levine's (b. 1947) rephotographed photographs of Walker Evans (1903–1975) and Edward Weston (1886–1958), among others, explore this issue. Levine photographed reproductions of their prints from magazines and printed them as her own works. To look at Levine's *Sherrie Levine: After Walker Evans: 2* (1981) in a book is to look at a reproduction of Levine's original print, which was printed from a negative, which was shot from an Evans reproduction in a magazine, which was reproduced from Evans's original print, which was made from a negative shot by Evans. To follow the genetic history of the print further, we could ask "How did the sharecropper and his family, imaged here, know to face forward, to stand close together, and to compose themselves in this manner?" We could trace the conventions of their group portrait back through earlier instances of photographic history, and then back to pictorial customs of painting. (See Figures 3.5 and 3.6.)

Historians and theorists such as Abigail Solomon-Godeau, Douglas Crimp, Rosalind E. Krauss, and others have followed a different line when they tracked Levine's rephotograph of Weston's image of his nude son. In *The Originality of the Avant-Garde*, Krauss writes:

Levine's medium is the pirated print, as in the series of photographs she made by taking images by Edward Weston of his young son Neil and simply rephotographing them, in violation of Weston's copyright. But as has been pointed out about Weston's "originals," these are already taken from models provided by others; they are given in that long series of Greek *kouroi* by which the nude male torso has long ago been processed and multiplied within our culture. Levine's act of theft … opens the print from behind to the series of models from which it, in turn, has stolen, of which it is itself the reproduction.[20]

In the titles of these works, Levine's use of the word "After" in the titles pays tribute to these renowned artists. While Levine explicitly references the source of her work, Weston and Evans did not. They worked within a modernist mode in which master photographers possessed a unique and inspired vision. By questioning the notion of originality, Levine takes a postmodern stance.

Postmodernism proposed that, in a field of reproductions, the source is elusive. In "Winning the Game When the Rules Have Been Changed: Art Photography and Postmodernism," Solomon-Godeau reminds us of the subject, Weston's son Neil, himself and asks:

And does not this final acknowledgment that this originary point must be—as it is for all photography—the living world which has been imprinted on paper further problematize the search for the real thing? Sherrie Levine in fact remarked that when she showed her photographs to a friend he said that they only made him want to see the originals. "Of course," she replied, "and the originals make you want to see that little boy, when you see the boy, the art is gone."[21]

Making and valuing the perfect copy

While contemporary notions of cloning may still bring up science-fiction-like fantasies of extraterrestrials taking over the identities of individuals, cloning originated through benign practices in agriculture. Asexual plants, such as strawberries and spider plants, regularly send out runners that grow into exact copies of the parent plant: clones. Until the 1950s, when Robert Briggs and Thomas King cloned frogs, the term "clone" was used exclusively to describe the genetic duplication of plants. The harmless act of copying a houseplant has evolved to cloned and genetically engineered crops, the duplication of mammals, and the possibility of creating "designer cows" for milk and meat production. These reproductive exploits bring up ethical, medical, and legal issues, such as whether genetically engineered food should be labeled differently in groceries, how a shrinking gene pool will affect genetic diversity, whether someone has the "right" to own genes of the original plant or animal, or whether an outside party can own or control personal genetic information. Comparable issues exist with photographic reproduction,

20 Rosalind Krauss, *The Originality of the Avant-Garde and Other Modernist Myths* (Cambridge, MA: MIT Press, 1999), 168. [originally published 1985.]

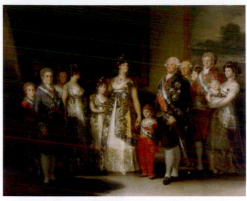

3.5 Francisco de Goya, *King Charles IV of Spain and his Family*, 1800, oil on canvas, 280 × 336cm

21 Abigail Solomon-Godeau (1985), "Winning the Game When the Rules Have Been Changed: Art Photography and Postmodernism," in *Illuminations*, ed. Liz Heron and Val Williams (Durham: Duke University Press, 1996), 308. [First published in *New Mexico Studies in the Fine Arts*, reprinted in *Exposure 231*, Spring 1985.]

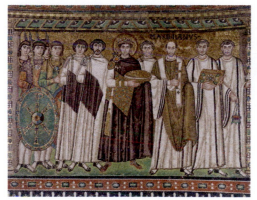

3.6 *Justinian and his Court*, apse, north wall, Church of San Vitale, Ravenna, Italy, *c.* 546–548, mosaic

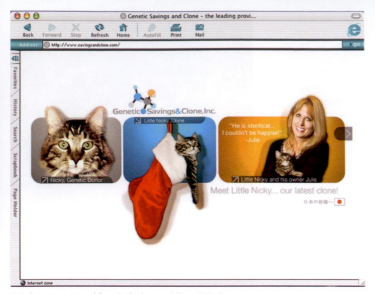

3.7 Screen capture of Genetic Savings and Clone Website (2005)

22 Anne-Marie Willis, "Digitisation and the Living Death of Photography," in *Culture, Technology and Creativity in the Late Twentieth Century*, ed. Philip Hayward (London: John Libbey, 1990).

23 Anne Eisenberg, "Hello Kitty, Hello Clone," *The New York Times*, May 28, 2005, Section C: Business/Financial, 5.

24 Trachtenberg, "Photography: The Emergence," 22.

with ongoing problems such as whether estates, organizations, or individuals have the right to continue printing negatives after an artist has died, or more recent issues such as whether artists and technicians can digitally alter a negative's DNA, the pixels that form the image, and how or whether to inform the public if manipulation occurs. More fundamentally, some, such as Anne-Marie Willis, suggest that digital photography may have silently killed photography and inhabited its corpse—now creating images that look photographic, but are produced by a radically different kind of imaging technology that creates a duplicate reality rather than mirrors an actual one.[22]

The implications of cloning as a kind of reproduction are great, including the possibility that the copy is genetically older than their physical age, and the possibility that the clone may not be like the original, either in physical appearance or in temperament. Researchers invested in the business of reproducing guaranteed facsimiles must be able to ensure that the duplicate will be an exact copy of the original. Genetic Savings and Clone funded the birth of CC (Copy Cat), the first feline to be cloned. They offered a money-back guarantee that all breeds of cat (save Calicos) and of dogs would produce a clone, with the identical physical colorings and marks of the original. However, as personality is a construct of environment and genetics, it is still unclear whether clones will have the personality of their original. In her article "Personal Business; Hello Kitty, Hello Clone," Anne Eisenberg interviewed David Cheng, a technology auditor who had his cat Shadow's cells saved, cultured, and frozen after learning that it had a tumor. Mr. Cheng planned to store the cells at Genetic Savings and Clone until the death of his second cat, Nana. "After she passes away, I may start all over again with one new Shadow and one new Nana."[23]

What is particularly interesting about this statement is Mr. Cheng's willingness, after experiencing the original Shadow and Nana, to extend the *same* enthusiasm to the cloned versions, the reproductions, as though they were identical to the first. In photography and art, the more traditional valuation is the one that prioritizes the authentic original. For early art photographers who struggled to convince art institutions that the medium was artistic rather than mimetic and mechanical, repeatability was a flaw. These practitioners overcame photography's exacting rendition of detail by suggesting that a photographer, in a state of sympathy, would "release symbolic resonances and implications," projecting inward feelings to create "an original, and originating, experience."[24]

In addition to using the power of metaphor to release a duplicate from the offense of imitation, photographers have refuted reproducibility by purposefully limiting the number of prints. The pretension of presenting a duplicable image as a singular work of art is described by Abigail Solomon-Godeau in her essay "Photography After Art Photography," when she detects "the ultimate denial of photography as a mechanically reproducible technology in such phenomena as Emmet Gowin's production of

'monoprints,' editions of a single print from a negative."[25] Though popular and mass photography rely upon the process's endless production of multiple prints, art photographers often distinguish their offspring by underscoring the preciousness of an authentic image. This distinction is considered to have initially been made in the late 1880s when Kodak's introduction of "you-press-the-button, we-do-the-rest" technology initiated the ubiquitous use of photography by the untrained, across class, gender, age, and culture. Art photographers distanced themselves from this crowd with stylistic devices (Pictorialism in the 1880s through 1910s, and **straight photography**, beginning in the early 1910s), but also by making a distinction between the unique fine-art print and the coarse mass-produced copy. In the next few sections, we will look at how artists and institutions—galleries and museums—frame the notions of property and value that exist with reproductive technologies.

How precious is this photograph?

In his essay "The Judgment Seat of Photography," Christopher Phillips recognizes the significant role played by various directors within the Museum of Modern Art's Department of Photography in laying claim for the preciousness of the artistic photographic print. For example, Beaumont Newhall began his tenure at MoMA (as a librarian) with a curatorial vision that included a range of photographic works, including press, scientific, and creative. By 1940, when Newhall became MoMA's first Curator of Photography, the museum chose to focus on photography's aesthetic prowess as a fine art. Newhall and his colleagues made this shift by presenting photographic prints with the same conventions and language as engravings or drawings, with an emphasis on "rarity, authenticity, and personal expression—already the vocabulary of print connoisseurship."[26] In *60 Photographs: A Survey of Camera Esthetics* (1940), the first exhibition presented by Newhall and Ansel Adams (Vice-Chairman of the new department), Phillips notes that,

Typically the photographs were presented in precisely the same manner as other prints or drawings—carefully matted, framed, and placed behind glass, and hung at eye level; they were given precisely the same status: that of objects of authorized admiration and delectation.[27]

In 1947, MoMA's trustees determined that denying reproducibility in favor of an authentic one-of-a-kind experience had failed to attract significant crowds. Newhall resigned and they hired Edward Steichen, a founder of the Photo-Secession who had long since renounced Impressionist photography in favor of photography's abilities as a communication tool. Steichen was best known for his commercial work (including fashion photographs published in *Vogue* and *Vanity Fair*), and portraits of celebrities

25 Abigail Solomon-Godeau, *Photography at the Dock: Essays on Photographic History, Institutions, and Practices* (Minneapolis: University of Minnesota Press, 1991), 106.

straight photograph
A photograph made with a camera, without any post-exposure manipulation (i.e. cropping the image or compositing images).

26 Christopher Phillips "The Judgment Seat of Photography" (1982), in *The Contest of Meaning*, ed. Richard Bolton (Cambridge, MA: MIT Press, 1992), 21.

27 Phillips, "The Judgment Seat," 23.

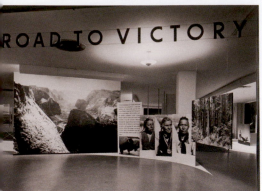

3.8 Albert Fenn, Installation view of the exhibition *Road to Victory*, MoMA, New York, May 21–October 4, 1942. Photograph, 7 × 10½in

28 Phillips, "The Judgment Seat," 23.

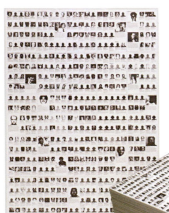

3.9 Felix Gonzalez-Torres, *Untitled (Death by Gun)*, 1990. New York, Museum of Modern Art (MoMA). Stack of photolithographs, offset printed in black, composition: 44½ × 32½in. (113 x 82.5cm)

and politicians. Hiring Steichen effectively served as a warning that the Department of Photography would expand its reception of the photographic from the creative field to the commercial and **documentary** realms with their mass appeal. The willingness to acknowledge photography's reproductive status was in part a response to what Christopher Phillips describes as a failure "to retrieve photography from its marginal status among the fine arts and to attract what the museum could consider a substantial popular following," and equally an acknowledgment of photography's potential as a mass medium, used to decipher world events in picture magazines and newsreels for just over a decade.[28]

As a guest director at MoMA in 1942, Steichen had staged *Road to Victory*, a collection of images showing the country at war. The power of the show came from the compelling installation, designed by Herbert Bayer, in which enlarged photographs, some wall-sized, created a maze-like path for the viewer. The experience, akin to falling down the rabbit hole only to find oneself within a human-scale three-dimensional layout of *LIFE* magazine, communicated the same romantic, dramatic, simplified versions of events as the picture magazines. Whereas Newhall had treated each print as a sacred object, carefully enshrined as a unique print within a white matte halo and behind glass, Steichen made the most of the print's reproducibility.

Felix Gonzalez-Torres: ultimate availability

Five decades after *Road to Victory*, artist Felix Gonzalez-Torres (1957–1996) used the duplication process, not as a means to an end, but as the conceptual foundation of the work itself. Gonzalez-Torres's stacks must be maintained through constant reproduction. A "stack" work consists of so many copies of a print, piled to a particular height as determined by Gonzalez-Torres. For example, *Untitled (Death by Gun)*, 1990, photolithographs, is 9 × 44$^{15}$⁄$_{16}$ × 32$^{15}$⁄$_{16}$ inches at ideal height. Visitors to the piece are allowed to take one or several prints away. In purchasing the piece, the owner agrees to replenish the stack to the correct height, which was often determined by Gonzalez-Torres's sense of the shape in the installation space, often based on **minimalist** sculpture, rectangular and cube-like masses that defined themselves as being about pure form. Gonzalez-Torres's stacks take on these forms, though they do not deny meaning or politics. Allowing visitors to take prints disturbs the shape of the mass and the usual ritual of looking at art as sacred and separate. Touching the work, picking it up, rolling up the print and placing it in the available bag may cause viewers to look uneasily over their shoulder, ready to be apprehended by the museum guard.

While a museum or collector is invested in the notion of permanence, i.e., property, Gonzalez-Torres wanted the work to disappear in an attempt to "be a threat to the

art-marketing system," out of generosity, and to come to terms with the death of his partner from AIDS. In an interview with Tim Rollins, Gonzalez-Torres described his decision to allow the prints to be taken:

Freud said that we rehearse our fears in order to lessen them. In a way, this "letting go" of the work—this refusal to make a static form, a monolithic sculpture, in favor of a disappearing, changing, unstable, and fragile form—was an attempt on my part to rehearse my fears of having Ross disappear day by day right in front of my eyes.[29]

While a particular group of sheets in a stack may be transient, theoretically, the stack itself is extremely permanent. As the stack slowly fades away, its caretaker reproduces the prints and brings it back to completeness.

This shifting nature of the stacks, from rare and fleeting to infinite and unending, affects how viewers value each sheet. In the museum, visitors admire the beauty of the stacks and may be swept up in the excitement of taking a photograph. Outside the museum, the large, rolled-up sheet of paper may or may not retain its value. In "Exchange Rate: On Obligation and Reciprocity in Some Art of the 1960s and After," Miwon Kwon describes leaving Gonzalez-Torres's 1995 Guggenheim Museum retrospective only to see

overstuffed garbage cans in the lobby, jammed with rolled and scrunched sheets of paper from Gonzalez-Torres's stacks. Outside the museum, too, Fifth Avenue waste bins were filled to capacity with what were, only a few yards away inside the museum, "works of art."[30]

Conversely, my own experience of the work is of having carried my two prints home, stored them in a tube and then, over the next decade, transported them through three moves. Each time I pack up my belongings, I reevaluate my decision to keep the prints. Are they worth money? Probably not. Are they useful to show to students? Probably. But, ultimately, the reproductions have survived my residential purges because the prints have taken on the kind of corporal existence that Gonzalez-Torres sought. Discarding them would be a sign of disrespect. Does this mean these mass-produced sheets are endowed with an aura? Gonzalez-Torres's stacks simultaneously produce democratic victory (reproductions in the hands of everyone, information fully distributed), science-fiction nightmare (endless clones without an original), and institutional authenticity (ownership and monetary value of the reproductive rights to a stack).

minimalism
A 20th-century art movement and style stressing the idea of reducing a work of art to the minimum number of colors, values, shapes, lines, and textures.

29 Tim Rollins, "Interview: Felix Gonzalez-Torres (1993)," in *Between Artists: Twelve Contemporary American Artists Interview Twelve Contemporary Artists*, (Los Angeles: A•R•T• Press, 1996), 88.

30 Miwon Kwon, "Exchange Rate: On Obligation and Reciprocity in Some Art of the 1960s and After," in *Work Ethic*, ed. Helen Molesworth (University Park: Pennsylvania State University Press, 2003), 93.

31 Marvin Heiferman, "Everywhere, All the Time, for Everybody," in *Image world: Art and Media Culture*, ed. Marvin Heiferman and Lisa Phillips (New York: Whitney Museum of American Art, 1989), 20.

32 Fox Talbot, *The Pencil of Nature*, text accompanying Plate XI.

carte-de-visite
(aka CDV) A small photograph mounted on heavy cardstock the size of a calling card.

wet-plate collodion
Wet-plate collodion, aka "wet collodion," "collodion," and "wet-plate process," is a photographic process invented in 1851 that uses light-sensitive silver nitrate as an emulsion on glass plates to produce a negative. The emulsion was much faster than its precursor, the calotype, and shortened exposure times considerably.

33 Heiferman, "Everywhere," 22.

34 Naomi Rosenblum, *A World History of Photography* (New York: Abbeville Press, 3rd edition 1997), 62.

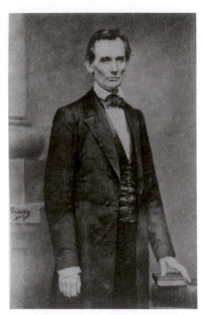

3.10 Matthew B. Brady, *Abraham Lincoln (the "Cooper Union Portrait")*, 1860. Albumen print from wet collodion negative

MASS MEDIA AND REPRODUCTION

Vast quantities of photographic reproductions that have appeared in newspapers and magazines, on billboards, on packaging, in motion pictures, on television, and on videotape form a wrap-around picture environment, an Image World.[31]

In 1990, when Marvin Heiferman described the Image World in the catalog introduction to the Whitney Museum of Art's exhibition of the same name, a century and a half had elapsed since the dawn of a world of reproduced images and our arrival in an environment saturated with photographs. As far back as 1844, William Henry Fox Talbot had suggested possible uses of photography as a means of reproducing botanical forms, and of copying engravings and drawings. Talbot himself produced the first book with photographic plates, *The Pencil of Nature*. Unfortunately, the expense of printing each plate by hand prohibited large runs of the book; Talbot reproduced *The Pencil of Nature* in limited quantities for limited audiences. Though an expensive and lengthy process, the project heralded a future for reproductive works. Plate XI, *Copy of a Lithographic Print*, illustrates his confidence that the negative/positive process would facilitate the reproduction of works of art, and would allow printers to "alter the scale, and to make the copies as much larger or smaller than the originals as we may desire."[32]

The crave to collect: From *cartes-de-visite* to Facebook

The mid-19th century's first widely distributed photographic phenomenon was the **carte-de-visite**. With the invention of the **wet collodion plate**, French studio portrait photographer André Adolphe Disderi (1819–1889) saw a way to join the calling card, a strictly typographic way for the middle and upper classes to introduce their name and address, with a pocket-sized paper portrait. In 1854, Disderi patented and standardized the process and the term, *carte-de-visite*. His innovations yielded eight small (3.5 × 2.5 inch) vertical portraits exposed on a single plate; the printed photographs were cut and mounted individually on a slightly larger card. Standardizing the process of cutting and mounting allowed photographers to sell the images inexpensively. Social classes that did not previously have access to self-portraits could now own a lasting image and send photos of themselves to friends and family. Low-cost reproductions led to the printing and distribution of a new genre of collectibles in the form of *cartes* of public figures. As the images became sought-after commodities, *cartes-de-visite* of Civil War heroes, celebrities, entertainers, and political leaders were marketed, collected, and traded.[33] Portraits of Queen Victoria and the Royal Family sold over 100,000 copies.[34]

This fascination with imagery anticipated the Image World a 150 years later. The aura of reproductive imagery encouraged the fantasy of having direct contact with public figures, opening society up into an organism susceptible to the influence of images.

In the 1860s and 1870s, aspiring political candidates such as Abraham Lincoln cast themselves into the public eye through *carte-de-visite* images. *Cartes-de-visite* and wood engravings in illustrated newspapers turned Lincoln from an unknown man into the most recognizable face in the United States. Additionally, these mass-produced images presented a more palatable version of Lincoln. To allay rumors and popular songs that ridiculed Lincoln's features, Mathew Brady's studio used clever posing, lighting, editing, and printing to shorten Lincoln's gangly neck and minimize his large hands, and to present him in the image of a dignified statesman. Upon winning the election, Lincoln announced that "Brady and the Cooper Union speech made me president of the United States."[35] Mass reproduction's ability to influence public opinion by appealing to voters' preconceptions of the ideal physical attributes of a politician would continue in the television era. Viewers of the first-ever televised presidential debates, beginning on September 26, 1960, relied upon images to confirm their impressions. Vice-President Richard Nixon, recovering from a recent illness and still underweight, turned down makeup that might have covered up his 5 o'clock shadow and colored his peaked skin. While radio listeners declared Nixon the winner of the debate, the majority of the 70 million television viewers pronounced the tan and fit Senator John Kennedy as the victor.

Today, the craving created by the *carte-de-visite* for collectible images is satisfied via the Internet, where personal profiles continue the earlier practice of social networking, promotion, and photo-sharing. Facebook, the most popular social-networking site as of this writing, has grown into a site where millions maintain home pages, often decorated with intimate snapshots and revealing commentary on their lives. Members illustrate their profiles with pictures of themselves, their friends, and their favorite celebrities, the digital analog to the *cartes-de-visite*. Just as collecting *cartes-de-visite* in the 19th century demonstrated familiarity or intimacy, the passion for collecting "friends" is validated by numbers, and breeds the thrill of building a big "friend list."

Within this extensive network of "friends" and visibility, social-networking Internet sites create celebrity within their own universe and assemble the famous in your own entourage. One year before the 2008 presidential election, 18 candidates had posted personal pages on MySpace and Facebook, including 2008 Democratic presidential candidate Barack Obama. Bannered in red, white, and blue (as are most political profiles), Democratic candidate Hillary Clinton's profile reveals her favorite reality TV program (*American Idol*) and worst habit (chocolate), and features a poster/hyperlink announcing "I AM NOT ONLY VOTING FOR HILLARY, SHE'S MY FRIEND! ADD HILLARY AS YOUR FRIEND!"

35 Lorraine Monk, *Photographs That Changed the World* (New York: Doubleday, 1989), 6.

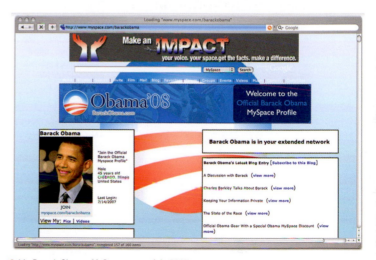

3.11 *Barack Obama*, MySpace page, July 2007

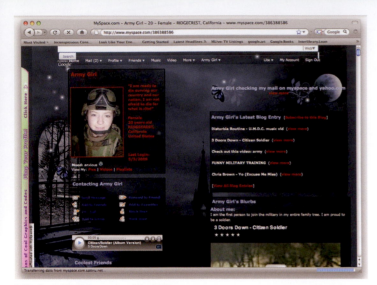

3.12 *Army Girl*, MySpace page, May 2009

36 Mike Nizza, "Pentagon Blocks MySpace and YouTube," The Lede, *The New York Times News Blog*, May 14, 2007. http://thelede.blogs.nytimes.com/2007/05/14/pentagon-blocks-myspace-and-youtube/?apage=5&scp=1–b&sq=Pentagon+Blocks+MySpace+and+YouTube&st=nyt

Just as Civil War-era *cartes-de-visite* recorded soldiers and military heroes, Facebook and MySpace profiles document soldiers during the Iraq War. Active-duty soldiers post photographs of their (usually leisure) activities and communicate with friends daily through these pages. If a soldier is killed, his or her MySpace profile often remains as a memorial where friends can post tributes. While the range of tools available on the site allows "subjects" to editorialize through imagery and text, the amount of information available on a profile and its potential open-access to audiences was grounds for concern among the U.S. military. In 2007, the Defense Department blocked access to 13 "recreational websites" for US soldiers serving in Iraq. According to Mike Nizza of the *New York Times*, a spokeswoman for the United States Strategic Command cited an overburden on the government servers as the reason for the ban.[36]

The Industrial Revolution and reproductive technologies

Mass reproduction, from *cartes-de-visite* to MySpace pages, has brought wider and wider access to information and images, enabling individuals to create and share images, and, subsequently, to affect public perception of social and political events. Some of the quantum leaps of these technologies and their uses in advertising and journalism came hand in hand with the Industrial Revolution, a period of such rapid growth matched by the speed of information.

The emergence of new technologies during the Industrial Revolution brought on cultural changes as inhabitants responded to shifting notions of time and space surrounding automation. Beginning in Britain in the early 18th century with the invention of labor-saving devices for farming and textile work, the Industrial Revolution would transform the modern reader. In 1839, Daguerre announced his invention for organizing and capturing vision in the daguerreotype. Five years later, Samuel Morse transmitted the first telegraph message over wire. As the camera and photographic processes provided a means to organize visual perception and to describe and display data, electricity and steam supplied the means to transmit information. Transportation technologies promised to collapse distances by easing travel to remote parts of the world. The world was opening up to citizens of the 19th century and, if still physically confined to a local region for economic or other reasons, trains could now carry newspapers and journals across the country and new photographic technologies could release views of the world via visual reproduction. Manufacturing processes sped up production time. Eli Whitney recognized that using interchangeable parts would allow equipment to be easily replaced, a critical step toward mass reproduction and the assembly line, introduced by Henry Ford in 1913. Daguerreotype and paper-printing

studios already made use of assembly lines to produce portraits, the processing often done by women.

By the 19th century, in theory, a photographic negative could serve as the original for an unlimited number of images. However, in practice, until the early 20th century, photography (costly, time-consuming, and liable to fade) lagged behind all manner of printed illustrations as the infinitely repeatable picture technology. When images graced the pages of 19th-century newspapers and other publications, these were dominated by (in chronological order of prominence) woodcuts, engravings, and **photogravure**. In most pre-photographic instances, images performed support roles—decorative marginalia whose role was illustrative, evocative, or atmospheric.[37] Up until the late 19th century, the illustrated press had an editorial relationship between text and image wherein substantive content was left entirely to words. Though halftone printing processes were first developed in the late 1870s, improvements in the technology in the 1890s finally made the process easier, faster, and cheaper than engraving. On January 21, 1897, the first daily paper, the *New York Tribune*, printed the first halftone picture on newsprint. While a number of papers redesigned their layouts to accommodate illustrations in the 1880s and 1890s, reservations about using images with news prohibited many companies from investing in the technology until the 1920s.

Mass reproduction and advertising

The consuming culture of the Industrial Revolution, with its growing population, increased literacy rates, keen attention to transportation, and fascination with change would shape photography's procession from illustration to information. The mass production of consumer goods would bring about an increased need to market products.[38]

Before the late 19th century, print advertising essentially served to translate the face-to-face sales pitch into printed text. Rarely did advertisers use illustrations. As manufacturing shifted in the 1880s from small quantities of regional products to mass production of standardized goods, companies needed a way to seek out and convince a proportionate mass of buyers to embrace their products. Emergent department stores and mail-order catalogs hired advertising agencies to persuade buyers that products were legitimate and valuable. The modern publicity age realized marketing strategies in which mass production and the consumption of goods and images went hand in hand. In 1896, HO Oatmeal became the first company to use a photographic illustration by attempting to persuade mothers that any child who consumed their cereal would look as happy and healthy as the baby printed on the box. The appeal to mothers' emotions foreshadowed the future of marketing as the presentation of a series of images

photogravure
A photomechanical process in which a photographic image is transferred to a printing plate. When etched, the plate is capable of reproducing the continuous tones of the photograph on paper.

37 Pierre Albert and Gilles Feyel, "Photography and the Media: Changes in the Illustrated Press," in *A New History of Photography*, ed. Michel Frizot (Cologne: Könemann, 1998), 359.

38 John Tagg, *The Burden of Representation: Essays on Photographies and Histories* (Minneapolis: University of Minnesota Press, 1995), second printing, 64.

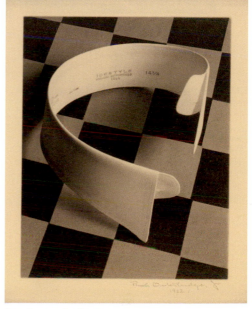

3.13 Paul Outerbridge, Jr., *Ide Collar*, 1922. Gelatin silver print

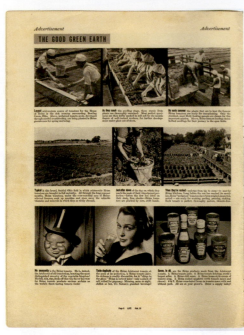

3.14 The Good Green Earth (advertisement for Heinz products), from *LIFE* magazine, February 15, 1937

stock photography
Pre-existing, professional photographs of objects, places, or people that can be used for commercial purposes. Collections of such photographs are available in image banks, where buyers can purchase a license to use the image once or multiple times.

39 Thomas Michael Gunther, "The Spread of Photography: Commissions, Advertising, Publishing," in *A New History of Photography*, ed. Michel Frizot (Cologne: Könemann, 1998), 557.

Cubism
An art movement of the early 20th century whose artists reduced objects to geometric forms and rejected traditional techniques of perspective in favor of multiple vantage points.

Constructivism
An art movement that began in Russia around 1913 and that was influenced by Cubism and Futurism. It is characterized by an interest in the modern, in machines, and in geometric forms determined by industrial materials, such as metals, wood, and glass.

40 Gunther, "Spread of Photography," 561.

projecting our desires. The authority held by photography, in its relationship with the real and the factual, confirms the deal—that what is promised can come true.

After World War One, tastes shifted from the romantic Victorian imagery to a seemingly objective machine-made aesthetic. Postwar advertising employed legions of photographers to showcase products by photographing them analytically—emphasizing detail, form, material—but seductively.[39] Beginning in the 1930s, a number of early avant-garde practitioners carefully controlled lighting, staging, and composition of the image. Among them, European-based, Bauhaus-affiliated artists such as László Moholy-Nagy and Herbert Bayer, as well as Americans Edward Steichen and Paul Outerbridge, used the camera as an industrial tool to create images that reflected the mechanical aesthetic of industrial technology—abstract and modern forms that exemplified techno-logical advancement. Outerbridge's (1896–1958) *Ide Collar*, 1922, one of the icons of early commercial photographic work, transformed an ordinary detachable collar into a sculptural form. In the 1920s, Steichen used a reflective black background and sophisticated lighting techniques to transform a pile of Camel cigarettes into a **Cubist** construction.

Through their work, early 20th-century advertising images create carefully controlled profiles of consumer goods, frequently isolated from context and with an emphasis on their machined material surface. Tilted camera angles, photomontage, streamlined rows of identical objects, all hallmarks of **Constructivist**, Surrealist, or Bauhaus compositions, made their way into print ads, in a confluence of the avant-garde and commerce. By the early 1930s, however, marketing supplanted avant-garde decision-making. Art directors and editors took control of image-making, using **stock photography** to sell a product or hiring camera operators for their technical expertise rather than their aesthetic vision.[40] Picture magazines such as *LIFE* magazine used full-page ads that relied on the same devices as the editorial content. Just as feature stories might give a tour of a slaugh-terhouse, advertisements used mini-picture essays to show the full life of a product by walking the reader through, for example, the process of making ketchup, from field to bottle. Advertisements displayed testimonials by individuals, consumers like you, just as feature stories presented a "Day in the Life of …" to suggest an intimacy between subject and reader.

Reproduction of images in print: Photojournalism

While typography predominated through the 19th century, the rise in image-rich war reporting through engravings of the Crimean War (1853–1856) and the American Civil War (1861–1865) gave way to mutually dependent relationships between text and image. By the 1890s, the halftone screen process made it possible to reproduce photographs, and tabloids and dailies made a habit of communicating news with pictures, though

usually presenting images as minor rectangles of information within the narrow, static columns of earlier layouts. By the early 20th century, papers such as the New York *World* had begun to reorganize page spreads with photographs of varying sizes and more dynamic relationship between image and text. On July 4, 1897, the *New York Times* dedicated entire pages (though not the cover) to photographs of Queen Victoria's procession during her Jubilee celebration.[41]

The early 20th century's technological potential of improved paper and plate-making facilities for halftone printing, and faster films, flashbulbs, and the 35mm camera, bred and fed an ever-increasing desire to be kept up-to-the-minute through rapid dissemination of first-hand images connected to new stories. At this point, the time between event and publication was impeded primarily by the speed of the plane, train, or boat that transported the image from the field to an editor. During the delay, publishers printed stock photographs of people implicated in the story. Between 1902 and 1912, inventions by Arthur Korn and Édouard Belin contributed to photo-telegraphy, the transmission of photographs by electrical signals. During 4 minutes on May 12, 1914, a photograph of President Poincaré opening the Lyons fair crossed the wires to become the first telegraphic image printed in a newspaper, in this case by *Le Journal*.[42] In 1935, the Associated Pres (AP) launched Wirephoto, the first service for transmitting photographs over wires. Newspapers could now receive photographs on the same day as the event took place. Further improvements to printing presses, faster cameras and film, the increased speed of production, and the decreased cost of distribution meant that photojournalism could capture all types of event. The combination of these technical factors and the increased readership—due to increased earnings and added leisure time—ushered in newspaper layouts whose dependence upon photography promised to appeal to the curiosity and efficiency of a modern reader.

In 1919, the New York *Daily News* (initially *Illustrated Daily News*) saved readers time with their novel format of beginning and completing each story on one single page, and by using the ultimate time saver, the photograph. A landmark episode for news photography, the 1937 in-air disaster of the *Hindenburg* airship captivated the world. The widespread coverage of the *Hindenburg* disaster, with pictures of the enormous gas-filled dirigible bursting into flames as 33 of the 95 passengers aboard died, marked a turning point for daily papers whose widespread and rapid coverage allowed thousands around the world to view the events soon after they occurred. Events photographed over this New Jersey landing field in 1937 served as the visual analog to radio broadcasts made on the scene, the two forms in tandem priming the world for television.

While the telegraph and halftone printing promised instantaneous access to information and wide-ranging communication, media critic Neil Postman laments this shift from a typographic (or written) culture to a televisual culture in his book *Amusing*

41 Other examples of how individual publications gradually incorporated photo-mechanical processes into mass reproduction can be found in Albert and Feyel's essay, "Photography and the Media," one of the most thorough accounts of the history of photography in newspapers and magazines.

42 Albert and Feyel, "Photography and the Media," 362.

Ourselves to Death. In the print culture of colonial to mid-19th-century America, readers had the stamina to follow and analyze lengthy, complex arguments, whether verbal debates and speeches or text-based information. Though access to cross-continental information should have allowed us more profound connections and understanding, Postman argues that the telegraph, and subsequent innovations from faxes to the Internet to cellphones, only allowed for more data. "For the first time," he writes, "we were sent information which answered no question we had asked, and which, in any case, did not permit the right of reply."[43]

The picture magazine

As the use of halftone images grew to a point of eclipsing the text, the advent of periodicals such as *LIFE* magazine was inevitable. Publications such as the French *VU* (1928), the American *LIFE* (1936) and *LOOK* (1937), and the British *Picture Post* (1938) pioneered the **photo essay** as a persistent visual form in which pictures formed stories, with little or no text. "To see life … to see the world … to see and be instructed; Thus to see, and to be shown, is now the will and new expectancy of half mankind," wrote Henry Luce.[44] As publisher for one of the emerging picture magazines that form the basis for much of our contemporary culture of mass reproduction, Luce intoned this prophecy in 1936 to promote the then upcoming appearance of his new publication, *LIFE* magazine. Long before the emergence of *USA Today* or *Flickr*, Luce's magazine harnessed the early 20th century's appetite for a diet of images. *LIFE* and its counterparts succeeded in distributing images to thousands of viewers.

Weekly tabloid papers had been running articles filled with photographs since the 1910s, and these were followed by periodicals such as *VU*, *LIFE*, *LOOK*, *Picture Post*, and *Paris Match*. The popular 1930s weeklies became part of visual culture by presenting picture stories as a series of sequential boxes, the print form of popular cinema newsreels that showed the world quickly passing by. Their influence in an increasingly fast-paced world was challenged by the daily papers, whose production methods—halftone printing and cheaper papers, and correspondents in many cities—began to catch up to the weekly photo-based press. The once popular and influential picture magazine, a way to see the world from home, was on the wane by the 1960s. The availability of television and cheap air travel supplanted the role of the picture magazine to make the unreachable and exotic familiar. In 1972, *LIFE* ended production.

If the picture magazine became too over-managed by editors and disengaged with the psychology of current events, contemporary technologies have developed to explain large public issues through more democratic channels. Currently, individuals armed with a camera and access to the Internet have supplanted many editorial print directives. On blogs and photo-sharing websites, and messaging services (such as Twitter: "Share and

43 Neil Postman, *Amusing Ourselves to Death: Public Discourse in the Age of Show Business* (New York: Penguin Books, 1985), page 69.

> **photo essay**
> A series of photographs that tell a story, usually printed in a periodical or book.

44 Vicki Goldberg, *The Power of Photography: How Photographs Changed Our Lives* (New York: Abbeville Publishing Group, 1993), 192.

discover what's happening right now, anywhere in the world"), legions of self-appointed freelance photographers replace official staff.[45] The widening access to images has made us all the agents of our own world of picture stories. If photography's use in mass reproduction was initially part of what John Tagg called the state apparatus of top-down control, in which governments or captains of industry could carefully manage the public image of an ideology, the Internet now provides the means to build a more thorough story, with access to international sites (corporate and amateur) that might include imagery, text, and streaming audio.[46] In his book, *We the Media: Grassroots Journalism By the People, For the People*, Dan Gillmor describes how

The tools of grassroots journalism run the gamut from the simplest email list … to weblogs … to sophisticated content-management systems used for publishing content to the Web; and to syndication tools that allow anyone to subscribe to anyone else's content … What they have in common is a reliance on the contributions of individuals to a larger whole, rising from the bottom up.[47]

The cellphone: Mass distribution and civilian journalists

As most cellphones come equipped with cameras, people find themselves outfitted to take photographs with a device they commonly tote around. Before a news team can arrive, onlookers quickly capture and transmit newsworthy public images through mobile phone or email. The stranded subway riders and fleeing commuters who used their cellphone cameras to make images of bombing sites in the London subways on Thursday July 7, 2005, ultimately shaped the way the world perceived the devastation and terror of the first suicide bombs in London's history. In June 2009, activists turned to Twitter when the Iranian government stifled the use of online sites during Iran's civil resistance movement. Citizen journalists posted photographs, organized rallies, and reported conditions on the street.[48]

While cellphone photography enables a kind of grassroots journalism, top-down control still exists through the editorial control of news, media, and brokerage agencies. Companies such as Scoopt serve as brokerage agencies for news organizations. Join the agency, send them a photo, and (for a fee) Scoopt will try to sell the image to the media. News agencies usually don't pay for civilian photos, though many do solicit images from ordinary cellphone users on their websites. In 2003, the BBC added the *In Pictures* page to its website. *In Pictures* catalogues and publicizes photos or videos emailed by viewers and observers across the globe. Harnessing a world of snap-shooters, the site states: "News can happen anywhere at any time and we want you to be our eyes."[49] Whether interested in obtaining intimate first-hand visual accounts, or hoping to exploit

45 *Twitter*, http://twitter.com//, 2009, December 21, 2009.

46 Tagg, *Burden of Representation*, 64.

47 Dan Gillmor, *We the Media: Grassroots Journalism By the People, For the People* (Sebastopol, CA: O'Reilly Media, 2004), 25.

48 Yigal Schleifer, "Why Iran's Twitter Revolution is Unique," *The Christian Science Monitor*, June 19, 2009. http://www.csmonitor.com/2009/0619/p06s08–wome.html

49 *BBC*, "Have Your Say," http://news.bbc.co.uk/2/hi/talking_point/2780295.stm, August 24, 2009.

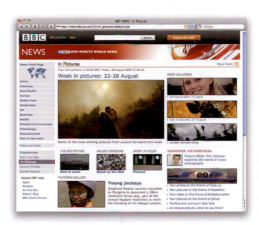

3.15 Screen shot of BBC, *In Pictures*, August 28, 2009

free content by not paying copyright fees, these calls for submissions have become very popular.

The technology and open call for submissions allows for imagery that may be more immediate, less artfully composed, and more particular to local or personal moments. Interestingly though, the BBC *In Pictures* page offers some training in image-making. Its guide suggests that camera users think through the topic as a series, photograph detailed shots for context, and orient objects in the foreground for "impact."[50] While the composition or immediacy of a particular image may be enticing, emailed photographs can raise ethical problems. There are fewer safeguards to ensure that images are not faked or staged, and it may be difficult to track down the origin of the image to verify its authenticity. So while the BBC *In Pictures* and other sites may try to impart a code of conduct by requesting that image-makers "not endanger yourself or others, [or] take any unnecessary risks or infringe any laws," it's hard to verify observance of these ethics.[51]

MASS REPRODUCTION AND ARTWORKS

Mass production and collage: Waste, critique, and reverie

In his 1939 essay, "Avant-Garde and Kitsch," Clement Greenberg forecast that kitsch, easily digestible, mass-produced artifacts and imagery that require little effort to understand, would displace avant-garde works.[52] However, by the time Greenberg wrote his essay, artists were already eroding the distinctions between high and low culture. In the early 19th century, artists used collage as a response to the material excesses of mass reproduction, to the surge of printed information from advertisers, government war machines, and news journals, and to shifting ideas about the role of the artist as a contributor of rarefied objects or critic of information and economic systems.

The **Futurists** recognized the dizzying shifts in time and space brought on by the newspaper; as Filippo Tommaso Marinetti (1876–1944) wrote in his 1913 manifesto, "Destruction of Syntax—Imagination Without Strings—Words-in-Freedom": "By reading a newspaper the inhabitant of a mountain village can tremble with anxiety every day, following insurrection in China, the London and New York suffragettes, Doctor Carrel, and the heroic dog-sleds of the polar explorers."[53] Excited by the effects that the Industrial Revolution's new technology had on consciousness, Umberto Boccioni (1882–1916), Marinetti, Carlo Carrà (1881–1966), and Gino Severini (1883–1966) assembled pieces of newspaper, type, ticket stubs, and photographs in dizzying, fractured compositions that celebrated the machine age.

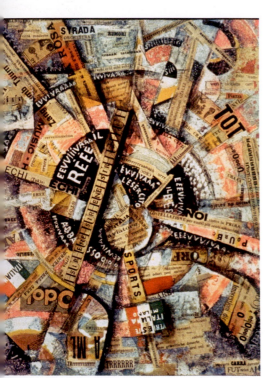

3.16 Carlo Carrà, *Manifestation Interventionniste*, 1914. Collage, 1914, 38.5 × 30cm

50 *BBC*, "Have Your Say."

51 *BBC*, "Have Your Say."

52 Clement Greenberg, "Avant-Garde and Kitsch," in *Art in Theory 1900–2000: An Anthology of Changing Ideas*, ed. Charles Harrison and Paul Wood (Malden, MA: Blackwell, 2003), 539–549.

53 Filippo Tommaso Marinetti, "Destruction of Syntax – Imagination Without Strings – Words-in-Freedom (1913)," in *Futurism and Futurisms*, ed. Pontus Hulten (New York: Abbeville Press, 1986), 516.

Futurism
An art movement founded in Italy in 1909 that revered the new traits of industrial and mechanized life – speed, pollution, noise, and machinery – and that exalted the merits of war and fascism.

The Berlin Dadaists are best known for their use of collage during the Weimar Republic, which began in 1918 with the defeat of Germany in World War One and ended in 1933 with the election of Hitler as Chancellor. **Dada** collagists such as Raoul Hausmann (1886–1971), Hannah Höch (1889–1978), George Grosz (1893–1959), and John Heartfield (1891–1958) created photomontages in order to present commonplace reading materials in unsettling compositions that would force readers to confront the reality behind the slick media images. While the Futurists used reproduced images to better convey the speed of modern progress, Höch's imagery commonly critiqued overdependence upon technology or responded to the myth of the "new woman," a favorite media image that arose after German women gained the right to vote and hold office in 1918; the German media celebrated the birth of a sexually liberated, economically and socially independent woman. Using contemporary magazines, Höch collaged puppet-like women to suggest the complex realities—the lower-paying jobs, inability to gain admittance to political parties, and ongoing expectations of traditional homemaker duties— behind the myth of the carefree, liberated female. Photomontage techniques were also popular with Surrealists, Constructivists, and Bauhaus artists, who broke down distinctions between art media, and maintained that citizens could be radicalized to better critique politics and society through exposure to more radical design and extreme vantage points.

The legacy of collage developed further in the 1960s as Romare Bearden (1911–1988) used cut and torn photographs from illustrated magazines to piece together narrative-based images depicting a "Negro experience."[54] In *The Jazz Cadence of American Culture*, Richard J. Powell describes this sensibility as a kind of "excavation" of previous uses of patchwork collage in African American tradition.[55] Bearden's use of magazines such as *Ebony* and the *Saturday Evening Post*, and his arrangement of the cuttings echoes back to the early 20th-century practice of papering the insides of homes with a patchwork of magazines, catalogs, and newspapers. This earliest manipulation of mass-produced media can be attributed, not to modernist artists, but to **folk artists** or just plain folk in poor communities, especially during the Depression. A thrifty substitute for commercial wallpaper, the printed material kept out the wind and insects and also embellished the home with color, imagery, and patterning. Writing of homes in rural Appalachia, Charles E. Martin describes that "the application of printed pages was quite orderly and upheld the longstanding Appalachian custom of recycling nonfunctioning machine-made objects."[56] Using the newspaper type to orient the paper, women hung the sheets vertically, horizontally, or in checkerboard patterns, and sometimes with decorative folds. Cartoons and Sunday funnies could be placed strategically along the bottom of the wall so that children could see them at eye level. Other imagery was placed in content-appropriate rooms (for example, toys and furniture near children's beds, and recipes by the stove). In *Log Cabin Pioneers: Stories, Songs and Sayings*, Wayne Erbsen describes one girl's memories of her mother papering the walls with pages from a Sears

Dada
An artistic movement following World War One. Dada artists blamed rational institutions of science and government for the destruction caused by the war. They advocated art that was irrational, absurd, and provocative, and which used unconventional forms and methods.

54 Richard J. Powell, "Art History and Black Memory: Towards a 'Blues Aesthetic'," in Robert G. O'Meally, ed., *The Jazz Cadence of American Culture* (New York: Columbia University Press, 1998), 190.

55 Powell, 190.

folk art
Usually refers to art made by someone who is self-taught as an artist; may also refer to art that is created by (and which often reflects the traditions of) people of a particular culture or region.

56 Charles E. Martin, "Appalachian House Beautiful," *Natural History*, February 1982, 6.

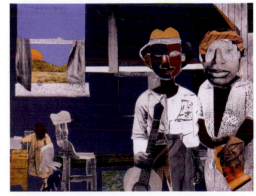

3.17 Romare Bearden, *Farm Couple*, c. 1965. Collage of various papers with paint, ink, and graphite on cardboard, 23.2 × 29.9cm

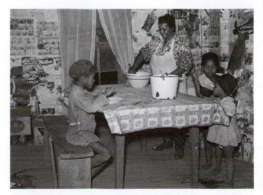

3.18 Marion Post Wolcott, *Kitchen in Negro Tenant Home on Marcella Plantation, Mileston, Mississippi Delta, Mississippi*, November 1939. Gelatin silver print

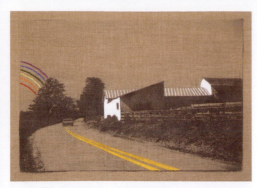

3.19 Betty Hahn, *Road and Rainbow*, 1971. Gum bichromate on fabric with stitching

57 Wayne Erbsen, *Log Cabin Pioneers: Stories, Songs and Sayings* (Asheville, NC: Native Ground Music, 2001), 45.

58 Steve Yates, *Betty Hahn: Photography or Maybe Not* (Albuquerque: University of New Mexico Press, 1995), 30–31.

59 Yates, *Betty Hahn*, 30.

Zone System
A technique to plan negative exposure and development to achieve precise control of the darkness or lightness of various areas in a print. Developed by the American Ansel Adams (1902–1984).

& Roebuck catalog, a "wish book" whose images of unattainable treasures provided a fantasy not unlike commercial wallpapers' scenes of exotic landscapes.[57]

The use of narrative collage continues with Betty Hahn's (b. 1940) use of older photographic processes, such as gum bichromate, to print photographic imagery on cloth. In addition, Hahn sewed parts of the images that "resembled stitching" in order to invigorate what she called "the vacancies" of a picture or to "perform surgery on ailing photographs."[58] The use of thread, a traditional tool of women's work, calls attention to a portion of the image:

The fabric photographs allude to another photographic tradition of the turn of the century wherein family photographs and other images of sentimental value were printed in cyanotype and other processes on silk, cotton, and linen for application to decorative, utilitarian objects.[59]

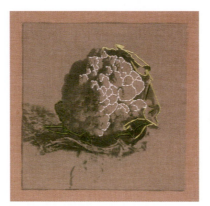

3.20 Betty Hahn, *Cauliflower*, 1972. Gum bichromate on fabric with stitching

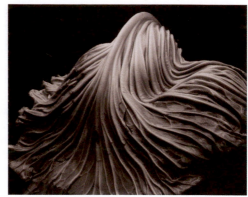

3.21 Edward Weston, *Cabbage Leaf*, 1931. Gelatin silver photograph, 19.2 × 24.0cm

3.22 Betty Hahn, *Soft Daguerreotype*, 1973. Xerox on synthetic silver fabric

In 1971, Hahn printed images of broccoli and cabbages, a reference to the black and white photographs Edward Weston (1886–1958) made in the late 1920s through 1930s. Hahn's depiction of vegetables paid homage to Weston's influence, while her lavish embroidery and colorful gum bichromate printing poked fun at his rigid pronouncement of the **Zone System** as the only way to print a photographic image.

While Hahn's imagery varied, her subject was almost always photography. Her *Soft Daguerreotype* refers back to early photography when daguerreotypes were lovingly presented entombed in velvet cases. Hahn's reproduction is an inexpensive Xerox,

fetishized in a soft, plush encasement of silk and velvet. Her resurrection of older photographic processes, such as **Van Dyke Brown printing** and gum bichromate in *Road and Rainbow* (Figure 3.19), should be considered in the context of the 1960s and 1970s, when photography made advances in its struggle to be accepted as a fine art.

Joanne Leonard's collage works incorporate both mass-media clippings and personal photographs. In *Twins: Conjoined and Separated*, Leonard responds to the endlessly replayed loop of the Twin Towers, from attack to collapse, from the knowledge of being a twin herself. A historical image of conjoined twins uncomfortably extending their arms upward is set against a ghostly image of the towers snuggled close together, the twin structures whose reliance upon one another made them seem imperishable.

While Futurist and Dada artists and individuals such as Bearden and Leonard used collage in order to shatter myths, cinema editors often use digital collage techniques to generate fantasy. In "How Digital Animation Conquered Hollywood," Matt Brady describes the significance of postproduction effects in the making of movies such as *Jarhead*, the 2005 film from director Sam Mendes that follows a Marine from boot camp through active duty in Iraq. Pablo Helman, who created effects for the film, described shooting the oil inferno scene. He says: "I would go around the fire to film at different distances, different lighting conditions, different angles, so I could create a library of fires. In postproduction, I replaced all the horizon lines, filled everything with the fires."[60] In animation, all elements and textures are reduced to pixels that can be blended with other pixels. A skilled technician can smoothly combine disparate imagery and, by flattening layers in Photoshop, permanently hide all signs that there were multiple sources.

Artists and mass production: Records of daily life and consumption

After World War Two, the industrial sites and scientific innovations that had worked in the service of the machinery of war could be refocused toward the desires of peacetime consumption. The postwar boom in manufacturing and the Cold War race for technological advance met with a baby boom and prosperity among the general public. The result — a demand for automobiles, refrigerators, TVs, Tupperware, and Coca-Cola — promised to improve buyers' lives. An explosion of glossy print ads, billboard posters, and television commercials convinced the public to consume. Consumers and academics, museums and historians celebrated popular culture by embracing kitsch— comic books, mass magazines, calendar art, popular music, and Hollywood movies. By the early 1950s, a group of British artists began to respond to the flurry of postwar consumption by appropriating the imagery of advertising and media. British art critic

Van Dyke Brown printing
A photographic process that originated around 1840. The process involves a ferric ammonium citrate sensitizer mixed with a silver nitrate solution. When the two chemicals are coated on paper and exposed to sunlight under a negative, the ferric compound turns ferrous, producing a quite visible image in iron. In brown printing, water is used not only to develop the brown print image but also to fix it and wash away the non-image-forming chemicals.

60 Matt Brady, "How Digital Animation Conquered Hollywood," *WIRED*, March 2006, 127.

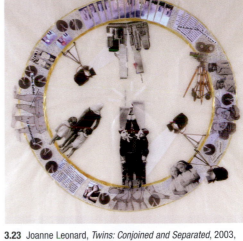

3.23 Joanne Leonard, *Twins: Conjoined and Separated*, 2003, glassine with gold paint, watercolor, scanned photographs, constellation map of Gemini, newspaper clippings. 17in. diameter circle on 22in. square glassine sheet

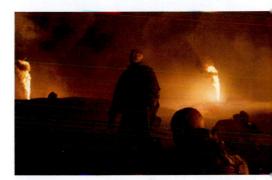

3.24 Still from *Jarhead*, 2005. Directed by Sam Mendes, Universal Studios

61 G.R. Swenson, "Interview with Andy Warhol: What is Pop Art? Answers from 8 Painters, Part I," in *I'll be Your Mirror: The Selected Andy Warhol Interviews: 1962–1987*, ed. Kenneth Goldsmith (New York: Carroll & Graf, 2004), 18. [originally published in *ARTnews*, November 1963.]

62 Swenson, "Interview with Andy Warhol," 17.

63 Klaus Honnef, *Andy Warhol 1928–1987: Commerce Into Art* (Cologne: Benedikt Taschen, 1990), 55.

64 Hans Belting, *The Invisible Masterpiece* (Chicago: University of Chicago Press, 2001), 383.

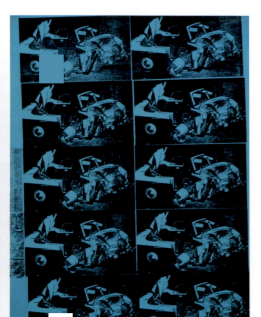

3.25 Andy Warhol, *Green Disaster Ten Times*, 1963

Lawrence Alloway referred to the movement as **Pop Art**, short for popular art, and a reference to the use of everyday imagery and objects as well as to the accessibility of the work by the general public. In the United States, rampant consumption and growth of the advertising agencies provided both source material and an audience for artists such as Andy Warhol, Jim Dine, Robert Rauschenberg, Alex Katz, Edward Ruscha, Claes Oldenburg, Roy Lichtenstein, and James Rosenquist.

Andy Warhol (1928–1987), one of the best known Pop artists, who adopted the illusions and realities of consumer culture, began work in New York as an illustrator for several magazines such as *Glamour* and *Vogue*. Warhol said that the process of doing commercial work was machine-like.[61] After ten years as a commercial artist, he saw little distinction between low and high art. In his fine-art studio, Warhol made use of mass media and popular culture imagery, and the automatic process of photo **silkscreen**, to print single or multiple images of Campbell's Soup cans, celebrities, Coca-Cola bottles, and newspaper photographs of car crashes and other disasters on canvas. Warhol's use of serial reproductive processes, from 1962 to 1965, allowed him to work exclusively from found photographs, which became more real than the objects themselves.

Mechanical reproduction processes such as silkscreen satisfied Warhol's desire to become a machine, to divorce himself from the conceptual and image-production processes, a philosophical approach demonstrated by the fact that his works were frequently made by assistants and his studio was named the Factory. Although the silkscreen process is based on mechanical reproduction, Warhol said that one of the reasons he used the process was because of inconsistencies from print to print. As the screen clogged with ink or colors failed to register, the variations obscured his identity as the printer. "I haven't been able to make every image clear and simple and the same as the first one. I think it would be so great if more people took up silk screens so that no one would know whether my picture was mine or somebody else's."[62] Klaus Honnef notes the subversive contradictions in Warhol's practice in using photographic reproduction to make unique prints. "[Warhol] undermines the hitherto unassailable importance of uniqueness and originality as criteria for great art ... He deceives his critics with an amazing simulation, and still contrives to retain originality as an aesthetic category."[63]

Works such as Warhol's *Last Supper* reproduce a painting that was, until the advent of photographic reproduction, an original. To create the silkscreened picture of Jesus and his Apostles, Warhol worked from "a whole range of copies—a nineteenth-century black and white reproduction, an outline drawing from a children's book, a cheap devotional sculpture."[64] He was as fascinated by the ways that Leonardo's offspring had depicted the iconic painting as he was enthralled with the original. While Warhol's play with historical paintings shed light on the different

renditions of "masterpieces" as a way of asserting one's individual identity through known cultural symbols, his silkscreens reprinting morbid scenes of car and airplane crashes, and electric chair executions, fresh out of the daily news, speak to the darker motivations of consumption. Through the repetitions of Warhol's printer, a determined viewer can identify the body of a driver thrown from his car. Warhol's reproduction of these fatalities associates them with starlets, consumables, and other products presented by the media for the momentary entertainment of the public.

Fluxus projects: Mass reproduction in the service of democracy

Fluxus, an international group of artists working primarily in New York over the period 1961–1978, "found Pop's glibness, ambivalence, and lack of critical intervention objectionable," and generally worked to subvert art's status as a luxury object.[65] Based on the philosophy of low cost and high volume, Fluxus artists, such as pioneer George Maciunas (1931–1978), used mass-culture forms—film, TV, postage stamps, newspapers, and commercial products—as vehicles for their art. Fluxus publications were inexpensively produced—either on newsprint, with photocopies or photographs, bound simply or contained by envelopes and small boxes. These had enigmatic titles, such as *Fluxus I* and *II*, *Fluxus Yearbook*, and each contained a wide selection of loosely organized materials to be interacted with—music and scores to be performed, instructions that came with photo documents of past events.[66] Fluxus artists Ray Johnson (1927–1995) and Robert Watts (1923–1988) used stamps and correspondence art to encourage these non-precious exchanges and to find an alternative display method that would undermine the exclusive gallery system trading in commodities. Viewing the existing infrastructure of the postal system as a **readymade**, and the ability to create homemade postage stamps as essentially an unlimited edition image, Fluxus correspondence allowed artists to send and display (even on a one-to-one basis) works of art.[67]

In addition to Warhol and the Fluxus artists, absorption of post-World War Two consumer culture influenced artists such as Jasper Johns, Edward and Nancy Redin Kienholz, John Baldessari, Dan Graham, Hans Haacke, Martha Rosler, and Robert Heinecken in the 1970s; and Sherrie Levine, Sarah Charlesworth, Richard Prince, Christian Boltanski, Barbara Kruger, and Mike and Doug Starn in the 1980s; and, more recently, Douglas Gordon and Paul Pfeiffer share this lineage of incorporating the reproduced image as a common language, and as a way of connecting to or critiquing popular culture.

Fluxus
An avant-garde art movement that emerged in the early 1960s. Practitioners celebrated anti-art (much in the spirit of Dada) in defiance of an established gallery system that emphasized and controlled how and which artworks were valued. Fluxus works involved a range of media, including performance, music, correspondence, and visual arts.

65 Lisa Phillips, "Art and Media Culture," in *Image World: Art and Media Culture* (New York: Whitney Museum of American Art, 1989), 63.

66 Owen Smith, *Fluxus History of an Attitude* (San Diego, CA: San Diego State University Press, 1998), 171.

67 Smith, *Fluxus History*, 174.

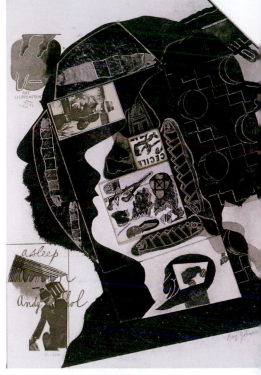

3.26 Ray Johnson, *Green Hornet with Arman and Andy*, 1976–80–81–85–86. Collage on illustration board, 15 × 11in

readymade
Something that is already manufactured. Marcel Duchamp used this term to refer to commonplace objects that he selected and deemed artworks, such as a urinal. The object became a work of art as a result of his selection, which also involved displaying, titling, and signing the item.

REPRODUCTION AND ETHICS

Legal rights of reproduction: The right to photograph

Aside from the question of whether digitally or otherwise manipulated realities (situations that never existed for the naked eye) should be reproduced as fact, a central issue of reproduction has been the question: Legally speaking, what basic rules govern who or what can or cannot be captured on camera? Attorney Bert P. Krages II has published a concise guide to American photographers' rights online at http://www.krages.com/phoright.htm. He advises that, short of there being a statute or ordinance that forbids picture-taking, anyone can take any pictures as long as they are in a public location or in a place where they have permission. Not only can photographers take pictures of people and objects on streets, sidewalks, and public parks, he or she can photograph private property from public places. In addition, Krages asserts that "Basically, anyone can be photographed without their consent except when they have secluded themselves in places where they have a reasonable expectation of privacy such as dressing rooms, restrooms, medical facilities, and inside their homes."[68]

The Photographer's Right, Bert P. Krages II, ©2003

http://www.krages.com/phoright.htm

They Have No Right to Confiscate Your Film

Sometimes agents acting for entities such as owners of industrial plants and shopping malls may ask you to hand over your film. Absent a court order, private parties have no right to confiscate your film. Taking your film directly or indirectly by threatening to use force or call a law enforcement agency can constitute criminal offenses such as theft and coercion. It can likewise constitute a civil tort such as conversion. Law enforcement officers may have the authority to seize film when making an arrest, but otherwise must obtain a court order.

How to Handle Confrontations

Most confrontations can be defused by being courteous and respectful. If the party becomes pushy, combative, or unreasonably hostile, consider calling the police. Above all, use good judgment and don't allow an event to escalate into violence.

In the event you are threatened with detention or asked to surrender your film, asking the following questions can help ensure that you will have the evidence to enforce your legal rights:

1 What is the person's name?
2 Who is their employer?

68 *Bert Krages II, Attorney At Law*, http://www.krages.com/phoright.htm/ (2006) (August 24, 2009).

3 Are you free to leave? If not, how do they intend to stop you if you decide to leave? What legal basis do they assert for the detention?

4 Likewise, if they demand your film, what legal basis do they assert for the confiscation?

Disclaimer

This is a general education guide about the right to take photographs and is necessarily limited in scope. For more information about the laws that affect photography, I refer you to the second edition of my book, *Legal Handbook for Photographers* (Amherst Media, 2006).

This guide is not intended to be legal advice nor does it create an attorney client relationship. Readers should seek the advice of a competent attorney when they need legal advice regarding a specific situation.

Captured in the public eye: Google's Street View

The same laws protect ventures such as Google's Street View, a map service, introduced in May 2007, intended to provide computer users with a preview of any street in cities such as New York, Miami, Denver, Las Vegas, and San Francisco.[69] After clicking on a particular city and street, users can see a panoramic view of all that lines the street—restaurants, residences, parks—and whoever happened to be occupying these places at the moment when the Google van cameras rolled down the road. The surreal act of sitting in one city while virtually strolling down the street in another has fascinated many and led to such projects as *Street with a View*, in which a pair of artists staged scenes for the cameras of Google Street View along Sampsonia Way, Pittsburgh, PA.[70]

Some citizens have voiced concerns about privacy infringement, such as Mary Kalin-Casey who logged onto the site from Oakland, California, looked up her own address and identified the fuzzy blur in her window as her cat, as seen through the living room window. She protested: "The next step might be seeing books on my shelf. If the government was doing this, people would be outraged."[71] Upon expressing her outrage (and providing a link to her street address) on the blog BoingBoing.com, Ms. Kalin-Casey invited a *New York Times* photographer into her apartment to take a shot of the animal and herself for reproduction in the national paper and online publication. Google does consider requests for "offensive" photographs to be removed, and seems to track Internet blogs in order to pull prurient photographs. Ms. Kalin-Casey, and a few others, requested their presence be removed from the site, a process that changes a relatively blurry, non-descript building into a black screen with a note that the "image is no longer available." While Google reminds viewers that Street View "contains imagery of public property," they did take certain actions before publishing

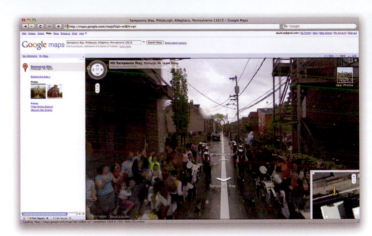

69 Google *Street View.* http://maps.google.com/ maps?tab=wl&hl=en/ 2009 (August 24, 2009).

3.27 Google *Street View* site showing participants in *Street with a View* on Sampsonia Way, Pittsburgh, PA, 15212 (website captured on August 28, 2009). Reproduced with permission

70 Robin Hewlett and Ben Kinsley, *Street with a View.* http://www. streetwithaview.com/ November 2008 (August 27, 2009).

71 Miguel Helft, "Google Zooms in Too Close for Some," *New York Times*, June 1, 2007. http://www.nytimes. com/2007/06/01/ technology/01private. html/

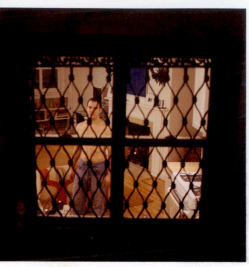

3.28 Shizuka Yokomizo, *Stranger (23)*, 2000. C-type print

72 *Google*, "Privacy and Street View," http://maps.google.com/support/bin/answer.py?hl=en&answer=70195/ 2009 (August 25, 2009).

73 Shizuka Yokomizo, *Shizuka Yokomizo: Distance* (Canton: Chapter, in collaboration with Spacex), 8.

74 Erving Goffman, *The Presentation of Self in Everyday Life* (Garden City, NY: Anchor Books, 1959), 123.

75 Paola Colombo, trans., *Shizuka Yokomizo* (Rome: MACRO; Milan: Electa, 2002), 36.

the site.[72] After considering how access to Street View's archive might prove harmful, the company worked with agencies to identify and remove particular images, such as photographs of women entering shelters for victims of domestic violence.

Between private and public: Shizuka Yokomizo requests access

While Google's roaming cameras capture views of residences legally from public property, Japanese artist Shizuka Yokomizo (b. 1966) asks occupants to decide whether to and how to present themselves before setting up her camera on the street. The letter Yokomizo delivers to the mailboxes of ground-floor apartments reads:

Dear Stranger,
I am an artist working on a photographic project which involves people I do not know … I would like to take a photograph of you standing in your front room from the street in the evening. A camera will be set outside the window on the street. If you do not mind being photographed, please stand in the room and look into the camera through the window for 10 minutes on __-__-__ (date and time) … I will take your picture and then leave … we will remain strangers to each other … If you do not want to get involved, please simply draw your curtains to show your refusal … I really hope to see you from the window.[73]

While the law recognizes the sanctity of the home as private and photographically off-limits, sociologist Erving Goffman points out that our houses are designed according to varying degrees of privacy. In *Presentation of Self in Everyday Life*, Goffman maintains that our daily actions and settings can be understood as types of performances and performative spaces, created purposefully or unintentionally for an audience. The living room is, traditionally, the most public space within our home, and the most visible to guests and from the street, while the bathroom or kitchen may be considered "backstage."[74] Directing participants to "stand in the front room" gives Yokomizo street access but also calls attention to a space that Goffman considers full of devices or props—furnishings, decoration, clothing, facial expressions—chosen in order to support a particular role, to present ourselves in a particular way, as played for a set or shifting audience. By instructing participants to "be in the room alone," to "wear something you always wear at home," to "turn all the lights on," to "keep reasonably still and calmly look into the camera" for 10 minutes, and to stand at least 3.5 feet into the room, Yokomizo ensures that the person is fully part of the space and engages only with her.[75] The appeal of Yokomizo's invitation may lie in the fact that her request provides an opportunity for an official performance. The individuals who present themselves consent to this relationship

with Yokomizo and agree to be recorded. When Yokomizo mails them a print of the image, they decide if the photograph will be made more public, reproduced, and displayed.

Ethics of reproduction: War and photography

If the examples above define the right to photograph according to legal notions of private and public, how do these concepts apply during extraordinary circumstances, such as civil protest and war? The existence of war photographs and their content depends upon a number of factors, including the capabilities of existing photographic technologies, the type of weapons used, the government, press and public's perceptions of the conflict and involvement in controlling these messages, and each photographer's ethical stance and capacity to communicate this through aesthetic and technical means. Photographs made during wars of the 19th century, such as the Mexican–American War (1846–1848), the Crimean War (1853–1856), the Civil War (1861–1865), and the Spanish–American War (April–August 1898), required lengthy exposures and awkward, heavy equipment, which prohibited action shots. Relying on the customs of prior media, photographers made heroic portraits of military leaders and soldiers, and views of battle sites, that would appeal to the public at home. Photographs were not meant to reproduce the realities of war—starvation, bloodshed, abuse of slaves—but, at the least, to entertain the public and, at most, encourage public support for the war and hatred of the perceived enemy.

In proving a point, most war photographs hide some evidence, be it the suffering of soldiers, the blockade of food and medical supplies to enemy combatants, or the condition of prisoners. In early wars, most of these omissions were due to the limitations of photographic technologies. By World War One, faster camera equipment made scenes of conflict possible, but many photographers were banned from the Western Front. If the governments did not explicitly ban images of corpses or gruesome battles, the press often chose to protect the public from such scenes. During World War Two, when sharper lenses, fast film for low-light conditions, and color film meant that any event could be reproduced, the United States continued censorship policies until the spring of 1943, when James Byrnes of the Office of War Mobilization suggested that publishing more graphic photographs might curb "public criticism of rationing and wage and manpower controls."[76] These policies continued through the Korean and Vietnam Wars, when the shift in public perception from "patriotic" battles to imperialist wars

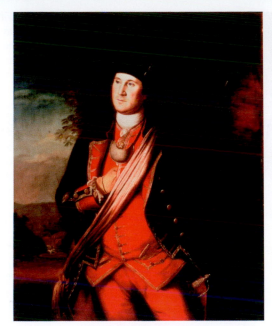

3.29 Charles Willson Peale, *George Washington*, 1772. Oil on canvas

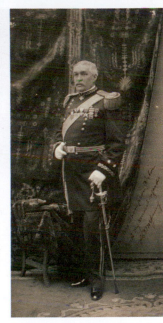

3.30 Unknown photographer, *Portrait of a man in a military uniform, including a sword, medals, and epaulets*, n.d. (*c.* 1890–1920). Photogravure, 4.0 × 7.875in

76 Susan D. Moeller, *Shooting War: Photography and the American Experience of Combat* (New York: Basic Books, 1989), 223.

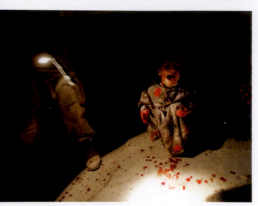

3.31 Chris Hondros, *One Night in Tal Afar*, January 2005. Color photograph

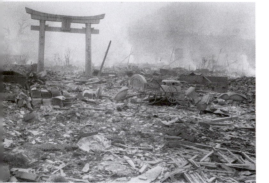

3.32A Yosuke Yamahata, *Nagasaki (Untitled, A-9-4)*, August 10, 1945

77 Elisabeth Bumiller, "Pentagon to Allow Photos of Soldiers' Coffins," *New York Times*, February 26, 2009. http://www.nytimes. com/2009/02/26/ us/26web-coffins.html/

78 David Carr, "Not to See the Fallen is No Favor," *New York Times*, May 28, 2007. http://www.nytimes. com/2007/05/28/ business/ media/28carr.html?_ r=1&scp=1&sq=Not%20 to%20see%20the%20 fallen%20is%20no%20 favor&st=cse/

79 Moeller, *Shooting War*, 9.

80 George H. Roeder Jr., "Making Things Visible: Learning from the Censors," in *Living with the Bomb: American and Japanese Cultural Conflicts in the Nuclear Age*, ed. Laura Hein and Mark Selden (Armonk, NY: M.E. Sharpe, 1997), 73.

corresponded with the shift to routinely showing photographs of horrific images of dead servicemen (Korean, Vietnamese, and American).

In the Iraq War, 2003–present (the Second Gulf War), digital cameras, computers, the Internet, and satellite communications greatly increased opportunities to communicate images of war at the moment conflict occurs. However, debates continue about whether showing casualties and violent imagery offends readers or produces a more informed public. During the Iraq War, military policy prohibited journalists from photographing coffins returning to the U.S. The Obama administration amended the ban in 2009, allowing photographs to be made with family consent.[77] Embedded photojournalists also must obtain consent from a wounded soldier before images made can be published. As David Carr reported in the *New York Times* ("Not to See the Fallen is No Favor," May 28, 2007), what the military media operations describe as an act of respect for the wounded and their families, many photographers insist is a political attempt to conceal information from the public.[78] However, the press is committed to reproducing difficult images such as Chris Hondros's (b. 1970) photos of horrified children whose parents have just been accidentally shot by a U.S. Army patrol, and James Nachtwey's (b. 1948) unsettling images of amputees at military hospitals. Even so, photojournalist Carl Mydans (1907–2004) argued that photography is only capable of reproducing a limited view of a battle: "You see only those photographs that a correspondent was able to take. You don't see all the things that were happening all around him when he couldn't raise his head."[79]

Blackout: Beyond censorship

Of all the reproductive omissions, in which images are never reproduced or shown, one of the greatest acts of suppression is not showing the effects of the atomic bombs on Hiroshima and Nagasaki, and their populations. On August 6, 1945, at 8:15am, the first bomb flattened the city, instantly vaporizing 110,000 civilians and 20,000 military personnel in Hiroshima. In Nagasaki, on August 9, 1945, at 11:02am, the second bomb demolished Nagasaki and killed 74,000 people. In successive years, thousands more would die from radiation poisoning. Yet, as George H. Roeder Jr. comments in "Making Things Visible: Learning from the Censors," "no photographs of long rows of bodies comparable to those taken by Allied liberators when they reached the death camps emerged from these atomic hells."[80] Instead, in the weeks after the bombings, U.S. newspapers and magazines reproduced aerial views of the demolished cities and photographs of the mushroom cloud, images that effectively distanced Americans from the specifics of human suffering and focused on the scientific and military victories of the bomb itself.

Ground-level images were available. Despite the enormity of the destruction, a

few photographers managed to record pictures of the bombing victims.[81] Japanese photographer Yoshito Matsushige (1913–2005) recalled the anguish of making a few photographs as people were dying around him.[82] The Hiroshima newspaper *Chugoku Shinbun* published five of these photographs. Japanese newspapers printed Yosuke Yamahata's (1917–1966) photographs, taken in Nagasaki on August 10, 1945, on behalf of the News and Information Bureau of the Japanese Western Army Corps. In the United States, *LIFE* magazine reproduced photographs of blast survivors taken by a staff photographer during a visit to Hiroshima the previous month. These instances of publication are rare; once Japan had surrendered, U.S. censors banned all "objectionable" images that might "disturb public tranquility" or "tear open war scars and rekindle animosity."[83] By concealing evidence of civilian trauma, the United States could avoid angry protest over the use of civilian targets and better control occupied Japan.

Not photographing as a form of resistance

In her essay "Victor Masayesva, Jr., and the Politics of Imagining Indians," Fatimah Tobing Rony suggests that, in particular situations, refusing to take photographs or to allow others to do so can be a form of resistance and an ethical stance.[84] Her comments frame a discussion about the complex history of photography for Native Americans and the photographic, video, and film work of Hopi artist Victor Masayesva, Jr. (b. 1951). In Native American communities, the act of capturing an individual or event on film or digital media can be a commonplace activity or a breach laden with personal or historical implications.

The technological development of photography in the mid-19th century came upon the heels of two centuries of conflict, slaughter, expulsion, and incarceration of indigenous peoples in the East and Midwest, and coincided with continued battles between Euro-American settlers and Southwestern and Northwestern tribes. As the United States asserted control over territories, government officials, ethnologists, anthropologists, and missionaries returned from trips with photographs of Native American life.

Photographs, whether taken for commercial reasons or for academic study, presented natives in several ways, each as an imagined "type." Images such as the 1910 photogravure print by Edward S. Curtis (1868–1952) portray Native Americans standing alone in a misty landscape as though a picturesque element of nature, akin to a mountain range. This portrayal, along with the belief in the doctrine of "manifest destiny," presented indigenous peoples as objects to be explored and consumed. The position was, in part, reinforced by the technical limitations of photography at the time. Because photographers needed sunlight to keep exposure-times manageably short,

81 Adam Levy, "The Ground Zero They Didn't Want Us to See," *Guardian* (London), Guardian Weekend Pages, July 16, 2005, 22.

82 Roeder, "Making Things Visible," 79.

83 Monica Braw, *The Atomic Bomb Suppressed: American Censorship in Occupied Japan* (Armonk, NY: M.E. Sharpe, 1991), 93.

84 Fatimah Tobing Rony, "Victor Masayesva, Jr., and the Politics of Imagining Indians," *Film Quarterly*, v. 48, n. 2 (Winter, 1994–1995), 20–33.

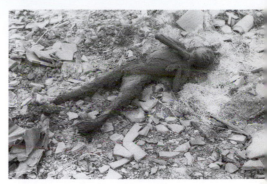

3.32B Yosuke Yamahata, *Nagasaki (Untitled, A-13-20)*, August 10, 1945

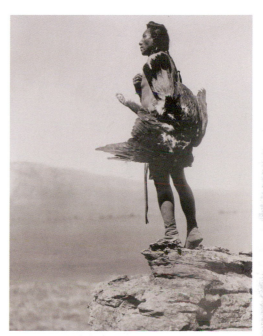

3.33 Edward S. Curtis, *The Eagle Catcher*, 1908. Photographic print

they often asked individuals engaged in domestic household activities to move outside to demonstrate their occupation, thereby creating inaccurate documents that suggested such work as cooking took place outdoors. Also popular was the representation of the Noble Savage, a primitive uncorrupted by civilized society; in this case, the subject also stood alone, often dressed in "costumes" for the fascination of the public. While the regalia of a tribe member has meaning and importance during particular ceremonies, many photographers insisted that garments be worn out of context or that sitters wear generic headdresses or buckskins supplied by the portrait studio. This image appealed to white audience's sense of the Native experience as authentic, unspoiled, and "struggling to survive in the wild," a concept that appeased their shame over imperialism and reassured them that the Indians were, in fact, disappearing, and no longer a threat to American expansion.[85]

85 Tobing Rony, "Victor Masayesva, Jr.," 20–21.

These commercial images and the construction of transcontinental railroads, such as the 1881 completion of the Atlantic and Pacific railroad through the Southwest, encouraged and spawned a tourist trade, eager to witness and photograph the "authentic" lives of native peoples. Many visitors came hoping to see dramatic and entertaining performances, without understanding the significance or holiness of the songs and ceremonies. Zeke Fletcher, an enrolled member of and Tribal Attorney for the Grand Traverse Band of Ottawa and Chippewa Indians, describes these traditions: "In a more traditional sense, in the Great Lakes Algonquin communities, honor songs and the beginning and closing ceremonies done at a *Jingtamok*, more commonly known in the non-Indian world as a Pow-Wow, are spiritual songs of solicitation and intervention dedicated to someone or something that invokes the world we used to live in and are trying to preserve. Generally pictures are not allowed as a form of respect and spiritual acknowledgment that the whole community, past, present and future is more important than the individual desire to take a picture."[86] In addition to being a sign of disrespect, taking photographs is antithetical to the spirit of the events themselves, when to photograph is to separate oneself from the ceremony and community. Many of the images taken were used for commercial purposes, with images of sacred ceremonies being sent around the country as postcards.

86 Zeke Fletcher, email message to author, August 1, 2007.

Regulating reproduction: The right to own your own image

87 Erin Younger, "Changing Images: A Century of Photography on the Hopi Reservation," in *Hopi Photographers, Hopi Images*, ed. Victor Masayesva, Jr. and Erin Younger (Tucson: University of Arizona Press, 1983), 19.

By the late 19th century, tension over the problems of reproduction had reached the point that many Native Americans resorted to breaking cameras to impede the progress of photographers.[87] One of the more inventive acts of resistance involves photographer Edward Sheriff Curtis's 1904 film of a Navajo Nightway (Yeibichi) ceremony. Participants appear to be performing a mirror-image of the actual ceremony; while some historians

explain the reversal of their actions as a technical issue, others believe that the participants intentionally performed it backwards.[88]

Beginning in the early 20th century, many tribes began to regulate picture-taking by stipulating which events could be photographed, or by banning photography altogether. Writing about tribal groups in the Southwest (New Mexico, Arizona, part of Colorado, and in Mexico, Chihuahua Sonora, and part of Sinaloa), Luke Lyon writes that many of these initial bans are still in place.[89] The prohibitions are a response to many factors, including on-site distractions and offenses, eroding the sanctity of ceremonies, inaccuracies in representation, and disagreements over control and distribution of the images. While there are those who prefer not to have their photograph taken because recording one's image possibly steals from the spiritual self, Tobing Rony believes that the "very real fear of photography 'stealing the soul' has become a clichéd Western primitivist explanation for any indigenous resistance to photography."[90] Rather, the view is based in the conditions described above and is a way to assert control over one's own image. As Zeke Fletcher writes:

To a degree, photography is a power relationship. Pictures are a statement about the photographer and the person photographed. To control the image is to control the power relationship … refusing to be photographed is a form of resistance against those that would be in control of the photograph.[91]

"Refraining from photographing certain subjects has become a kind of worship"

Although Native Americans have often been depicted as being disinterested in technology or lacking the sophistication to image themselves, by the 1940s many used photography to create snapshots of family and community life, and currently many, such as Richard Ray Whitman, Lee Marmon, Shelley Niro, Larry McNeil, and Hulleah Tshinajinie, use the medium artistically to document contemporary American life. Victor Masayesva Jr., who grew up in Hotevilla, Arizona, on the Hopi Third Mesa, has been working with photography, film, and video since the early 1970s to explore imagery of natural objects with ideas about ancestry, language, and the perception of life and culture of the Hopi. Masayesva makes works by scratching text in negatives, painting on prints, and using digital technologies. In his writings, he is always aware of his role as a photographer and of photography's potential for abuse. In "Kwikwilyaqa: Hopi Photography," he writes:

This impression of photographers and their physical behavior was forcefully brought to my attention one day when I was photographing an older man. He called me a *Kwikwilyaqa* … Later came

88 Tobing Rony, "Victor Masayesva, Jr.," 33.

89 Luke Lyon, "History of Prohibition of Photography of Southwestern Indian Ceremonies," in *Reflections: Papers on Southwestern Culture History in Honor of Charles H. Lange*, ed. Anne Van Arsdall Poore (Santa Fe, NM: Published for the Archaeological Society of New Mexico, Albuquerque, NM, by Ancient City Press, 1988), 238.

90 Tobing Rony, "Victor Masayesva, Jr.," 33.

91 Zeke Fletcher, email message to author, August 1, 2007.

the sober realization that he might have meant *Kwikwilyaqa* in the perspective of what this being does: he duplicates. When he comes into the plaza, this *Kwikwilyaqa* shadows anyone he can find, attaching himself to that person. He mimics every action and motion of the harried person he selects. In this way the *Kwikwilyaqa* rapidly becomes a nuisance.[92]

92 Victor Masayesva, Jr., "Kwikwilyaqa: Hopi Photography," in *Hopi Photographers, Hopi Images*, ed. Victor Masayesva, Jr. and Erin Younger (Tucson: University of Arizona Press, 1983), 11.

REENACTING AS A PHOTOGRAPHIC ACT

Over the past 40 years, as traditional photographic media—the camera, film, or digital memory—have become thoroughly integrated into the work of most contemporary artists, the act of recreating earlier scenes, photographs, and events has become increasingly popular. The feat of recreating can be found in rephotographic projects, in reenacting earlier works of art, and in group recreations of civil and modern war. Each method poses questions about the difference between an original and its copy, about present-day interpretations of the past, and about changeable standards of authenticity. In the following section, we look at two types of reenactments: those that recreate earlier images; and those that reproduce "actual" events (though, as many of these events were in themselves based on imagery, it is hard to pin down the origin as belonging to reality or to media).

Rephotographing photographs: rephotographic survey projects

The term *rephotography* usually refers to the act of retaking a historical photograph: locating the original vantage point, under the original lighting conditions in the present day, and taking a second photograph that reproduces the earlier shot. Nicholas Nixon (b. 1947) began his project with the Brown sisters in 1975. Every year he takes a group portrait of his wife and her three sisters, standing in the same order. In some senses, this is a rephotographic project, a photograph made to commemorate an earlier photograph; in other ways, the work speaks to the family photograph as a type of **reenactment** in which they (or we) confront the camera, and present themselves as a family, and as individuals within a family, in a particular arrangement, year after year.

The term *rephotography* is used to describe the process of rephotographing a scene that has been imaged previously. In Mark Klett's (b. 1952) *Rephotographic Survey Project* (1977–1979), Klett, JoAnn Verburg, Gordon Bushaw, and Rick Dingus worked from photographs by well-known 19th-century survey photographers, such as Timothy O'Sullivan, William Henry Jackson, and John K. Hillers. Klett's team located the original scenes and made new reproductions intended to show changes in land formation and

reenactment
To act or perform again. A historical reenactment is an event or performance in which participants attempt to recreate a historical event, such as a battle.

cultural variance. Twenty or so years after making these second views, Klett continued the project with Kyle Bajakian, Toshi Ueshina, Byron Wolfe, and Michael Marshall, this time with the goal of supplementing the rephotographs with GPS mapping of the locations, field notes, artifacts, video and sound documentation taken at the sites, and the creation of a website to display all the results.

The process of making *Third View* (1997–2000) is documented in a book called *View Finder*. Unfortunately, the author William Fox underscores the machismo of the event by writing about Klett, his crew, and the process of rephotographing, with utter reverence. His use of third-person narrative, his action-based language, and his emphasis on the pursuit (by car) and the equipment ("a formidable array of still, digital, and video cameras") suggest that this journey in search of past views is a kind of safari-hunt. For example, as Klett hones in on the vantage point of a particular "rephoto" in Texas, Fox writes,

The whole time Klett is glancing back and forth between the eight-by-ten black-and-white print in his other hand and the closest hillsides. He must be watching the road, too, because we make it to the edge of town in one piece. Without any fanfare, Klett takes turns immediately into the city park, drives by an improbably green lawn surrounded by sagebrush, parks, then walks directly to the vantage point.[93]

Fox's emphasis on the pursuit, and his dynamic language, perpetuate the romanticism of photographers such as Timothy O'Sullivan (1840–1882), who created grand views. These photographs documented the geology of the West to provide maps of unexplored territories, to help identify mineral reserves for development, and to encourage tourist trade. Many *Third View* images subvert this earlier, idealized first view by revealing the advance of human traffic or receding populations and by catching members of the photographic crew on camera, attending to distinctly non-heroic functions. In an image of Karnak Ridge, Nevada, Byron Wolfe appears to check a blister, and in a rephotograph of Timothy O'Sullivan's *Shoshone Falls, Idaho*, Wolfe checks his laptop above the Falls, seemingly enraptured by the laptop screen and oblivious to the grand scene nearby.

The desire to re-record past images is manifested in numerous other rephotographic projects, including *The Atget Rephotographic Project*, originating in 1987 to rephoto-graph scenes imaged by French photographer Eugene Atget, the Kansas Geological Survey's 3D rephotographs of Alexander Gardner's images, *Boise Then & Now*, the *Wisconsin Sesquicentennial Rephotography Project*, and Douglas Levere's rephoto-graphs of Berenice Abbott's images of New York. There often seems to be a desire in these "then and now" projects to make sure that the imaged world is still being classified, that the real world hasn't broken free during some lapse in attention. Often, words provide more context, conveying the impact of the historic images; this is the case with Bill Ganzel's 1979–1980 *Dust Bowl Descent*, in which he rephotographed and inter-viewed people pictured in the original 1930s Farm Security Administration photographs.

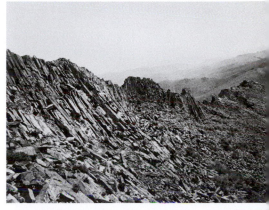

93 William L. Fox, *View Finder: Mark Klett, Photography, and the Reinvention of Landscape* (Albuquerque: University of New Mexico Press, 2001), 56.

3.34A and B The *Third View* Project, Timothy O'Sullivan, 1867, *Crab's Claw Peak, Western Nevada* (United States Geological Survey). Mark Klett and Byron Wolfe for the *Third View* Project, 1998. *Karnak Ridge, Trinity Range, NV.* Gelatin silver photographs, 1998

The postmodern phenomenon: Reenactments of unreality

Two trends in recent years have inspired artists to construct their own images of fiction-alized realities. First, media images have become more accessible and more explicit since the 1950s, from daily images of accidents and tragedy on the local news to the horror of war in Vietnam and images of the abuse and torture of prisoners at the Abu Ghraib prison in Iraq. Second, notions of truth have been broken down by lapses in critical journalism that fail to examine representations of race, gender, class, and power, and by the emergence of digital media, which cast questions of truth or fiction onto all representations. Introducing the 1989 exhibition *The Photography of Invention: American Pictures of the 1980s*, Joshua P. Smith wrote that:

The feeling of powerlessness engendered by the loss of hope for constructive social and political change and the feeling of betrayal produced by the official fabrications and cover-ups of Vietnam, Watergate, and the Iran-Contra scandal have conditioned many of us to see real life as unreal and to view official public truth as fiction. In the kind of era in which television, our dominant visual and information medium, presents fiction and truth indistinguishably—with news becoming like enter-tainment and docudrama masquerading as history—and our leaders and would-be leaders present themselves through "photo opportunities" and disinformation campaigns, the invented images in this exhibition are a forceful response, and even a useful guide, to the brave new world in which we live.[94]

Photography is a perfect tool for invention as it connotes authority and can, therefore, be put in the service of creating an "official unreality." Increasingly, images already in circulation are often the subject of this unreality. Rather than work from the "real" world, many artists, working from the 1960s to the present day, have chosen to use historical, vernacular, or media images as the point of "origin." The philosophy behind this approach is similar to photographer Ken Josephson's (b. 1932) practice of holding postcards or other images within the scenes he was photographing. Lynne Warren wonders if this was a way of making photographs that acknowledge the image as a representation that relies upon pre-existing representations. By recognizing the illusion and the fact that any photograph taken has, in some ways, already been taken, Josephsons's insertions attempt to "escape being redundant."[95] Umberto Eco describes this as the postmodern attitude:

I think of the postmodern attitude as that of a man who loves a very cultivated woman and knows he cannot say to her, "I love you madly", because he knows that she knows (and that she knows that he knows) that these words have already been written by Barbara Cartland. Still, there is a solution. He can say, "As Barbara Cartland would put it, I love you madly". At this point, having avoided false

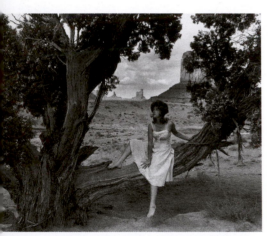

3.35 Cindy Sherman, *Untitled Film Still #43*, 1979. Black and white photograph, 8 × 10in

94 Joshua P. Smith, "The Photography of Invention: American Pictures of the 1980s," in *The Photography of Invention: American Pictures of the 1980s,* National Museum of American Art, Smithsonian Institution, Washington, D.C. (Cambridge, MA.: MIT Press, 1989), 14.

95 Lynne Warren, "Kenneth Josephson: A Philosophy of Paradox in Kenneth Josephson (Chicago: Museum of Contemporary Art, 1983), 9.

innocence, having said clearly that it is no longer possible to speak innocently, he will nevertheless have said what he wanted to say to the woman: that he loves her; but he loves her in an age of lost innocence.[96]

Likewise, artist Cindy Sherman (b. 1954) renders herself through the visual products of advertising, fashion, pornography, and movies by performing (and rephotographing herself playing) the roles implied in the pose, costuming, and attitude of their subjects. In her 1977–1980 series *Untitled Film Series*, she presented herself as 69 versions of female types, as seen in movies of the 1940s and 1950s. Alternately startled, seductive, wistful, or poised, all stills are characterized by framing that corners the female subject or by a vantage point that leers over or behind each woman.

Sherman's grainy, black and white prints captured the utilitarian spirit of film stills. Just as any film still presents a key moment in a movie, albeit an incomplete version of that character or narrative, Sherman's series of moments reenact already existing media-identities. In other series, such as *Centerfolds* (1981), *History Portraits* (1989–1990), *Sex Pictures* (1992), and *Older Women* (2002), Sherman continues to present composites of women constructed from her memories of what Merry Foresta calls "pictured experience."[97] Sherman's influence on future generations' desire to stage reenactments can be seen in Janine Antoni's (b. 1964) reenactment of herself as her parents (and they as each other), Chen Chieh-Jen's (b. 1960) digital photographs of punishment, Nikki S. Lee's (b. 1970) study and on-camera performance of groups such as Yuppies, skateboarders, and young Japanese in the East Village, and Kristan Horton's (b. 1971) obsessive recreation of stills from Stanley Kubrick's 1964 film *Dr. Strangelove*.

Yasumasa Morimura: reenacting across cultures

Yasumasa Morimura (b. 1951) played the part of women in his reenactments of female starlets in classic roles, such as Elizabeth Taylor, Liza Minelli, and Marilyn Monroe, and in masterpieces, becoming Leonardo's Mona Lisa, Manet's Olympia, Kahlo's Kahlo, and Goya's Maya. With the aid of a computer to smooth out the details, the final works, printed large, assume the monumental status of the original painting or celebrity. If Sherman's reenactments stir up vague memories of paintings or photographs, Morimura focuses on particular images and his uncanny ability to imitate gestures and facial

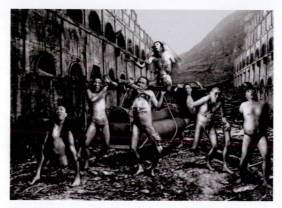

3.36 Chen Chieh-Jen, *Revolt in the Soul and Body/A Way Going to An Insane City*, 1996–1999. Digital black and white photograph, 112 × 150cm

96 Umberto Eco, *The Name of the Rose*, including the Author's Postscript, trans. William Weaver (New York: Harvest Books, 1994), 530–531.

97 Merry A. Foresta, "The Photographic Moment," in *The Photography of Invention: American Pictures of the 1980s*, National Museum of American Art, Smithsonian Institution, Washington, D.C. (Cambridge, MA.: MIT Press, 1989), 4.

3.37A Kristan Horton, *Dr Strangelove Dr Strangelove*: dr0018-s003-03, 2003-2006, archival print, Dibond, 28 × 76cm

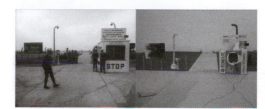

3.37B Kristan Horton, *Dr Strangelove Dr Strangelove*: dr0105-s008-05, 2003-2006, archival print, Dibond, 28 × 76cm

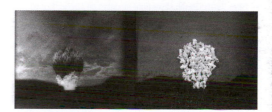

3.37C Kristan Horton, *Dr Strangelove Dr Strangelove*: dr0657-s039-02, 2003-2006, archival print, Dibond, 28 × 76cm

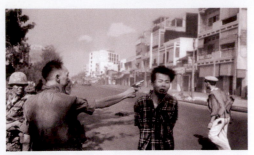

3.38 Eddie Adams, *General Nguyen Ngoc Loan executing a Vietcong prisoner, Nguyen Van Lem, on a Saigon street, February 1, 1968.* 1968. Silver print, 8 × 10in

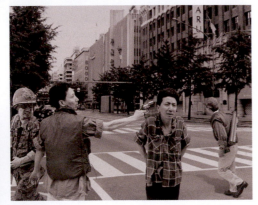

3.39 Yasumasa Morimura, *A Requiem: VIETNAM WAR 1968 – 1991*, 2001. Gelatin silver print mounted on Alpolic, 120 × 150cm, Edition 5

98 Yasumasa Morimura, "About My Work," in *Daughter of Art History: Photographs*, by Yasumasa Morimura (New York: Aperture, 2003), 114.

99 Kay Itoi, *Season of Passion* [interview with Yasumasa Morimura], *artnet magazine*, December 6, 2006, 2.

100 Goldberg, *The Power of Photography*, 228–229

expressions. Though his cross-gender reenactments originate in the Japanese tradition of Kabuki Theater, in which men played female roles, the choice to use cross-cultural works of art or identities comes from the influence of the Western world on Japanese tradition. As a child, the artists he knew and studied in school were Western masters such as Picasso. Morimura writes that, by using his "clearly Asian-looking" male face to reenact these iconic paintings, he hopes that viewers will feel estranged. "The picture of things gone amiss, imbalanced, distorted, disturbing and strange serves as a psychological portrait of myself having been strongly influenced by Western culture, despite having been born and raised as a Japanese man."[98]

More recently, Morimura chose to reenact images from popular culture and recent historic events. In his 2006 *Season of Passion/A Requiem: Chapter I*, he transforms himself into author Yukio Mishima, Lee Harvey Oswald, Jack Ruby, and the Viet Cong prisoner being executed in Eddie Adams's (1933–2004) photograph. Morimura chose to portray men as a kind of cleansing ritual to purge the history of what he perceives to be masculine values:

There are two kinds of beings in the world: ones like Amaterasu [the Sun Goddess in Japanese mythology, known for warmth and compassion] and others like Susanoo [God of Storm and Sea, known for violence]. Awful historic events in the 20th century were men's doing—I think, provoked by the Susanoo in them. For a long time, I produced works that embraced the values represented by Amaterasu, particularly with the "Actress" series. And I see that the [traditionally male-dominated] Japanese society has changed to accept and appreciate such values.[99]

Reenacting memory: Vik Muniz
The famous photograph taken by Eddie Adams of a South Vietnamese colonel executing a communist North Vietnamese Viet Cong prisoner in the street was printed on the front page of at least five major U.S. newspapers on February 2, 1968. Reproduced at a moment of public debate over whether American forces were winning the war in Vietnam, the lawlessness of the execution, along with the failure of the Tet offensive, fueled the antiwar movement.[100] Eventually reaching iconic status, Adams's photograph burned itself into the minds of citizens everywhere and continued to be reproduced in photo books such as *The Best of LIFE* and *Photographs That Changed the World*. In 1983, artist Vik Muniz (b. 1961), a Brazilian living in Chicago, purchased *The Best of LIFE* at a garage sale. Having recently arrived in the United States, with little knowledge of English and few acquaintances, Muniz says the book made him feel connected with his new home.

Losing the book gave Muniz an opportunity to check his memory to learn how much he remembered of those photographs. Every day, as he awoke, he would draw what he

could bring to mind of Adams's image and a few others, sometimes asking other people to contribute their memories to inform his drawing:

> Once I'd transformed the image-memories into drawings, I thought they should be returned to their photo state. So I photographed the drawings. When they were ready, I printed the photos with the same halftone screen the original photos were printed on. People thought they were seeing bad reproductions of photographs of famous events, but in fact they were only looking at pictures of thoughts.[101]

The process of making this work helped him to understand that our relationship with an image is more dependent upon the quasi-reproduction formed in our head. For Muniz, his memory-images lost facial detail and correct body positions but retained clothing and architectural features and point of view. Similarly, Kota Ezawa's reductive drawings of historic photographs strip away all the minutiae and lay bare flat, orderly prompts in place of the originals.[102]

Rephotography as a passage back in time

Mircea Eliade has noted that the act of traveling back in time is at the core of modern psycho-therapy: "the cure [of trauma] consists precisely in a 'return to the past'; a retracing of one's steps in order to reenact the crisis, to relive the psychic shock and bring it back into consciousness."[103] Often, rephotography is a way to cope with experience, as in Zbigniew Libera's (b. 1959) *Positives*, a series of photographs

101 Charles Ashley Stainback, "Vik Muniz and Charles Ashley Stainback: A Dialogue," in *Seeing is Believing*, (Santa Fe, NM: Arena Editions; New York, NY: Distribution by Distributed Art Publishers, 1998), 25.

102 Kota Ezawa, *The History of Photography Remix* (Tucson, AZ: Nazraeli Press, 2006).

103 Mircea Eliade, *Myths, Rites and Symbols: A Mircea Eliade Reader*, trans. Wendell C. Beane and William G. Doty (New York: Harper & Row, 1976), 85.

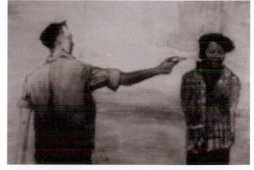

3.40 Vik Muniz, *Memory Rendering of Saigon Execution of Vietcong Suspect*, from the *Best of Life* series, 1989, photograph

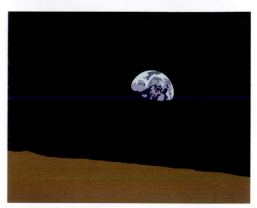

3.41 Kota Ezawa, *Earth from Moon (1969)*, 2005. Lightbox, 22 × 28in

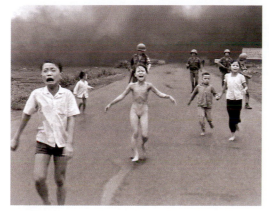

3.42 Nick Ut, *Villagers Fleeing a Napalm Strike, village of Trang Bang, Vietnam, June 8*, 1972. Gelatin silver print, 16 × 20in

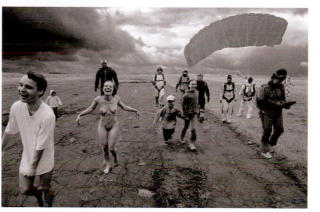

3.43 Zbigniew Libera, *Nepal*, 2003. Photograph

presenting buoyant versions of famous horrific images, such as the children burned by napalm or the moment when Martin Luther King Jr. was assassinated. Lukasz Ronduda counsels that "What is real cannot be presented directly, because the essence of trauma is that the psyche is not ready to represent it and capture it in words. Therefore, in the life of the psyche, the real can only appear in the form of unclear repetitions." In this sense, reenactments such as those made by Libera, Muniz, and John Grech are more accurate than the original photographs because they depict the true nature of trauma, as a gap between the real and the unspeakable.[104]

John Grech created the interactive web project *Sharkfeed* (1997) to "gain greater insight into" the 1960 kidnapping and death of Graeme Thorpe, an Australian boy. Using historic photographs, recordings, and his own rephotographs of significant locations in the tragedy, Grech tracks the event in a number of lines that follow the path of the boy, the response of his family, the media's coverage, and the kidnapper's background, in order to confront a moment that redefined public perceptions of trust. Descriptions from police journals, such as a report of the handkerchiefs in the dead boy's trouser pocket, still creased with the neat folds made by his mother's hands, revisit not only the site of the physical trauma, but the loss of a mother's son, and the larger cultural realization of childhood as perilous, even with parental protection.[105] Grech used rephotography to separate the divide between the viewer and our ancestors.[106]

Reenactment as a form of photography

Capturing an image does not complete the photographic act; a viewer is needed to rouse the subject through contemplation. Family photographs and historical documents each allow the observer to "return to the past." Many artists, such as Janet Cardiff, Pierre Huyghe, John Grech, Marina Abramovic, and Sophie Calle, use the photograph to stir such memories, but also thrust themselves or others into the past through conversation or reenactments. A reenactment is the ultimate photographic act, the process of reproducing a living representation. These forays enrich, question, or reconfirm present convictions and individual or collective memory. In *Other People's Feelings Are Also My Own—Soul Drawings* (2004–2006), artist Markus Hansen dresses like his subject, then attempts to assume the emotion, body language, and facial expression of that individual. Presented through video documentation, the results are somewhat startling, as Hansen's transformations are incredibly reminiscent of his partner and each presents a drastically different version of Hansen "himself." Using reenactment, the work proposes a more empathetic role for a portraitist in recording his or her subject.

The act of reproducing, of retelling, asks us to recall details all over again. Psychologists studying memory have learned that the human brain will recall facts more

104 Lukasz Ronduda, "Corrective Devices: Zbigniew Libera's Art in 1989–2004," in *Zbigniew Libera: Work from 1984–2004*, trans. Kasia Kietlilnska (Ann Arbor: The University of Michigan, School of Art & Design and Center for Russian & East European Studies, 2005), 29.

105 John Grech, *Sharkfeed*, http://www2.abc.net.au/sharkfeed/vestibule/temphome.htm, 2000 (August 24, 2009).

106 John Grech, "Living with the Dead: Sharkfeed and the Extending Ontologies of New Media," *Space and Culture*, v. 5, n. 3, 2002, 214. http://sac.sagepub.com/cgi/content/abstract/5/3/211/

3.44 Markus Hansen and Virgil de Voldere Gallery, *Philippe*, 2006. C-Type print. Markus Hansen and Guggenheim Museum, *Framboise*, 2004. Video still

precisely if they are received as a story, rather than as a list. Additionally, in "This is Your Life (and How You Tell It)," Benedict Carey writes that "the perspective people take when they revisit the scene [in memory]—whether in the first person, or in the third person, as if they were watching themselves in a movie" affects the emotional intensity of that memory at the present moment. Those who describe a past event in the third person, as though it happened to someone else, are less likely to be upset than those who become absorbed in the memory in the first person.[107]

To be effective, the third-person voice must be shaped by the individual in question. The unsettling dissonance of too many storytellers and the resulting inability to control one's own memories is at the center of artist Pierre Huyghe's (b. 1962) two-channel video, *The Third Memory*. Huyghe filmed John Wojtowicz retelling his memories of a 14-hour standoff with police in Brooklyn, New York, in 1972. During the botched robbery, Wojtowicz and his partner took hostages, who quickly became sympathetic to their lives. The crime became a media event. Sidney Lumet's 1975 film *Dog Day Afternoon* reenacted the events, with Al Pacino as Wojtowicz. Fictional liberties taken by the screenwriters have, over time, confused Wojtowicz about the actual events of the robbery. Using double-screen projection, Huyghe's *Third Memory* presents Wojtowicz in a set reenacting the day's events, alongside clips from *Dog Day Afternoon* and original television footage of the robbery. Huyghe's reenactment passes from the first memory of the actual event to the second memory of *Dog Day Afternoon*, to the *third memory*, Wojtowicz's reenactment of the day in a rudimentary version of the *Dog Day Afternoon* set. Wojtowicz's third-view account is noticeably compromised by the striking collision between the first and second views. Additionally, Wojtowicz's admission that he had studied for the crime by watching Francis Ford Coppola's *The Godfather*, starring Al Pacino, suggests that his actions were predisposed to media influence from the beginning.[108]

Historical reenactment and reproduction

Reproduction as recreation involves retelling, recollection, memory, and interpretation. Mathew Brady's team of photographers, who photographed the aftermath of battle in their images, essentially retold Civil War soldiers' stories. Depending upon the photographer and their perspective, they reproduced the horrors of war or a sense of patriotism. Timothy O'Sullivan photographed mutilated bodies in order to reproduce something of the reality of war. But Alexander Gardner felt that bloated bodies didn't tell the real story. Instead, he turned bodies around to hide evidence of decay or swelling, planted guns as props to show the corpse as a soldier, not just a body, and placed a soldier's hand on his heart to suggest that the death was valiant. Authenticity was not an issue in the late 19th-century. Mary Warner Marien writes that during the

107 Benedict Carey, "This is Your Life (and How You Tell It)," *New York Times*, May 22, 2007, Mental Health and Behavior, 1. http://www.nytimes.com/2007/05/22/health/psychology/22narr.html?pagewanted=1/

108 Jason Farago, "Reality, Narrative, and Reliability: Pierre Huyghe's *The Third Memory*," http://www.sapheneia.com/huyghe.html (June 10, 2007).

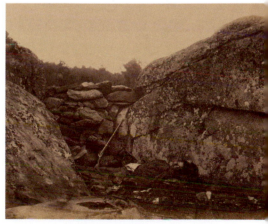

3.45 Alexander Gardner, *Dead Confederate Sharpshooter in the Devil's Den, Gettysburg, Pa*, July 1863. Albumen print

109 Mary Warner Marien, *Photography: A Cultural History* (New York: Harry N. Abrams, 2002), 48.

110 Marien, *Photography: A Cultural History*, 229.

111 *Broadcast News*. VHS. Directed by James L. Brooks. Los Angeles: 20th Century Fox Film Corp, 1987.

112 R. Lee Hadden, *Reliving the Civil War: A Reenactor's Handbook* (Mechanicsburg, PA: Stackpole Books, 1999), 19.

113 Hadden, *Reliving the Civil War*, 9.

Mexican–American War (1846–1848) an amputation scene in a "Mexican daguerreotype was probably staged for the camera,"[109] and during the Spanish–American War (1898) photographers even "faked battle scenes on the roofs of New York City buildings, using toy boats floating in bathtubs, and cigar smoke for the fumes of burning."[110] By the early 20th century, photographic documents were expected to be "truthful." In a scene from the movie *Broadcast News*, a guerrilla soldier rubs his bare feet before putting on his boots. A cameraman urges the soldier to put on his boot and his producer Jane Craig (Holly Hunter) scolds the photographer, reminding him that they are not there to stage the news. "Wait and see what he does." In a tension-filled moment, the confused soldier, now surrounded by attentive armed comrades and the news team, pauses, and then puts on his boot.[111] This concern for misrepresenting even an insignificant action is telling of late 20th-century journalism's sense of objectivity in reporting facts and concern for looming threats to these standards—digital technology, increased competition among emerging cable, and satellite stations that often encourage entertainment-type news.

The insistence on authenticity in reproduction is an essential issue for Civil War reenactors, 21st-century men, sometimes tens of thousands at a time, who don the period uniforms of 19th-century soldiers and play out the battles as described in journals. Civil War reenactors sometimes refer to reenactments as "snapshots of history," thereby implying that the simulation has become the document.[112] The main goal of the 50,000 reenactors in America is authenticity, to give a factual "impression," a portrayal of a particular solider, from a particular unit. To ensure accuracy, reenactors study primary sources of information, such as soldiers' diaries and the archive of Mathew Brady's historical photographs, and use the research to do an "impression," a portrayal of a particular soldier. In some instances, the so-called factual basis for their "impressions" was based on impression as well. For example, during the Civil War, the 17th Michigan Infantry used novels and color engravings to inform their sense of army life:

When called to combat, they changed from their usual fatigue uniforms into their dress uniforms, thinking they should meet the enemy in their best clothes. The men then went into their first battle in full dress uniform, with Hardee hats, brass scales on their shoulders, and white gloves. Because the engravings never showed the men wearing packs in battle, they left them on the road. They never went back for their knapsacks, and during the rest of the campaign they went without food, blankets, or a change of clothes.[113]

In *Reliving the Civil War: A Reenactor's Handbook*, an important guide for reenactors, R. Lee Hadden lists several levels of knowledge to achieve, including uniform and equipment; understanding of 19th-century persona, attitudes, and lifestyle; and general

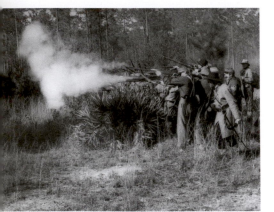

3.46 Liz Magor, *Where An Army Gave Its Own Orders*, 1991. Gelatin silver print

knowledge of the Civil War. In this third area, Hadden points out that reenactors know more than the soldier they are portraying would have known. Most significantly, they know how the war ended.[114] In all the 276 pages of his handbook on Civil War reenactment, Hadden gives such details as what kinds of snacks are authentic to eat (apples), and the type of apples that would have been available during the War (Granny Smith), but not one word alludes to slavery or other economic or political motivations for the war. The quest for authenticity is all in the details, with no care for the larger historical and social implications. In response to criticism that restaging war with all the details but none of the sacrifice trivializes the horror of war, reenactors counter that everyone—historians, journalists, reenactors, citizens—has a right to participate in interpretations of history.[115]

When captured by the lens of Liz Magor's (b. 1948) camera and printed as a black and white print, the Civil War "hobbyists" seem to become immortalized as the real thing. In her 1990–1991 images, taken at various reenactments across the United States, uniformed individuals stand by wagons, pose for the camera, or lie dead. Only slight anachronisms—the clarity of the camera lens, and the film's ability to capture smoke emanating from the muzzle of a rifle—reveal the truth. Magor's *Civil War Portfolio* reimagines the past by asking if these scenes, taken 120 years after the conflict, are a more realistic documentation of Civil War events than the technologies at the time were able to capture.

Jenny Thompson, author of *War Games: Inside the World of 20th-Century War Reenactors,* believes that reenactors do not use the hobby to relive history, but to cope with present-day issues, to use the role of soldier to act out unstated everyday ways in which they are either a hero or a pawn, or to use the hobby to fulfill the needs for camaraderie that go unmet in their everyday lives. Many reenactors are married and buried in their uniforms. By reproducing scenes of war, reenactors believe they have a legacy to leave behind.

114 Hadden, *Reliving the Civil War*, 11.

115 Jenny Thompson, *War Games: Inside the World of 20th-Century War Reenactors* (Washington, DC: Smithsonian Books, 2004), xviii.

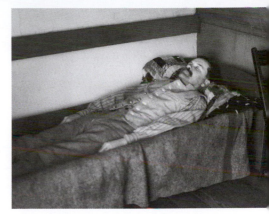

3.47 Liz Magor, *The Plans That Failed*, 1991. Gelatin silver print

3.48A, B, C, and D Jeremy Deller, *The Battle of Orgreave*, 2001. Commissioned and produced by Artangel. Photos by Martin Jenkinson

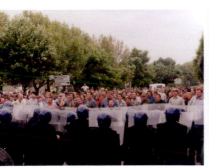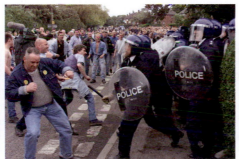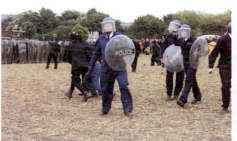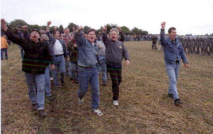

Restaging as a slow exposure: Jeremy Deller and the Battle of Orgreave

Reenactments bring up questions of how a story is retold, but also about which stories are chosen for commemoration or inquiry. In an episode of *TV Nation*, Michael Moore reenacted the LA Riots. His choice pointed to the amount of time that must pass before we are ready to turn a bloody, deadly conflict into a leisure activity, and the fact that the nostalgia of fallen soldiers isn't applied to torched neighborhoods, or to African and Korean Americans. British artist Jeremy Deller (b. 1966) felt the same distress about the violent confrontation between striking miners and the police on June 18, 1984, at Orgreave, South Yorkshire. Most media coverage of the mass picket and brutal pursuit by police provided violent images, rather than a deeper understanding of the conflict. After 15 years of contemplating the effect of those images and wondering about the realities of those involved, Deller chose to reenact the event. While Moore briefly revisited the LA Riots, Deller spent over a year reading about the Battle at Orgreave, and interviewing people involved in the strike and battle, including former miners, labor leaders, police officers, and participants in the women's support group. Additionally, he enlisted the help of reenactment expert Howard Giles to direct over 800 participants, including many miners and a few policemen from the original battle. Accompanying the "veterans" were members of more than 20 historical reenactment societies from all over the country who, Deller says, were "well trained in recreating combat and in obeying orders," and whose involvement legitimized the Battle of Orgreave as "part of the lineage of decisive battles in English History."[116]

Whereas the original event was chaotic and provided little in the way of resolution, Deller's reenactment introduced a kind of slow exposure, a thorough, thoughtful documentation of the event. Unlike Civil War reenactments that focus on logistical details, rather than socio-political significance, Deller was not interested in "a nostalgic interpretation of the strike."[117] Over time, he discovered evidence that the strike and conflict were part of a preconceived plan by the Thatcher administration to break unions in the UK using paramilitary tactics.[118]

While reenactments are often called "living histories," Deller's inclusion of former miners and policemen meant that the actors were walking in familiar and deeply personal territory. The reenactment enabled former miners, whose families had worked in the mines for generations, to commemorate the iconic moment when they lost a meaningful part of their lives. In this sense, the reenactment may be closer to medieval pageants than to contemporary historical reenactments. In "An Arena in Which to Reenact," Sven Lütticken distinguishes between the contemporary reenactments, a group of individuals reenacting, and pageants, in which a community is "presented with an image of itself through exposure to history from the podium," and also learning "by doing through the

116 Jeremy Deller, *The English Civil War Part II: Personal Accounts of the 1984–85 Miners' Strike* (Great Britain: Artangel, 2001), 7.

117 Deller, *English Civil War*, 7.

118 Deller, *English Civil War*, 67.

medium of play."[119] Deller's examination of the Battle of Orgreave allowed the miners to be recognized and gave the public access to the collective memories produced by the project.

Ideally, Lütticken writes, "reenactors want to break through the two-dimensional images into physical experience."[120] In a reenactment, one could say that the size of the reproduction, the "photograph," is based on a one-to-one scale. In this sense, the representation is similar to virtual reality (VR) technology. In *The Language of New Media*, Lev Manovich asserts that virtual reality

can be found whenever the scale of a representation is the same as the scale of our human world so that the two spaces are continuous. This is the tradition of simulation rather than that of representation bound to a screen. The simulation tradition aims to blend virtual and physical spaces rather than to separate them. Therefore the two spaces have the same scale.[121]

Reenactment provides a compromise between the unsatisfactory two-dimensional image and the invented simulation. Reenactments are related to the real, but are more immersive than a flat image.

The ability to reproduce an original is one quality that distinguishes photography from other media. One source can generate numerous negatives and positives, with varying degrees of difference from the original. The chapter *Reproductive Processes: Tools, Materials, and Processes* that follows this essay builds upon these comprehensive and expansive definitions of reproduction by providing descriptions of tools and techniques associated with low-tech duplication processes (from transfer to silkscreen and the photocopy) and film and digital recording, processing, and printing.

119 Sven Lütticken, "An Arena in Which to Reenact," in *Life, Once More: Forms of Reenactment in Contemporary Art*, ed. Sven Lütticken (Rotterdam: Witte de With, Center for Contemporary Art; New York: D.A.P./Distributed Art Publishers, 2005), 33.

120 Lütticken, "Arena in Which to Reenact," 37.

121 Lev Manovich, *The Language of New Media* (Cambridge, MA: MIT Press, 2001), 112.

Reproductive Processes
Tools, Materials, and Processes

Rebekah Modrak

Is any copy an exact match of its original? In genetics, identical twins and clone/parent are the only pairs that reproduce with the same DNA. Yet, although there may be a genetic resemblance, environmental conditions in and outside of the womb often prohibit physical resemblance. Although there are many instances of identical twins, even those raised in different environments, who have grown to have the same interests, habits, and outlooks, identical twins do not always share the same physical or character traits. Just as the environment impacts physical resemblance with siblings, photographic reproductive processes present interesting questions of duplication. The methods and tools involved in capturing the source will determine how that subject is represented, and how its image may be reproduced further. The method of duplication will impact what information is lost or retained and how existing data is presented.

Reproductive Processes: Tools, Materials, and Processes invites you to think of photography as the act of reproduction, which may involve making records on film and digital media, or generating copies of images through rubbings, needlepoint, or other materials. Images are malleable and transferrable. This chapter demonstrates some options for capturing, processing, and reproducing images, and encourages elasticity in considering how a subject's image may be rendered and duplicated through various media.

Any image or object, whether positive or negative, can be used as a matrix for making multiple copies. A charcoal rubbing of a grave headstone provides a negative of that physical surface, its texture and markings. Chemical, digital,

and transfer processes allow you to generate endless versions of an image. The techniques discussed here range from low- to high-tech, from analog to digital, from 2D to 3D, and from the handmade to the commercially reproduced. "Low-tech negatives and positives" introduces various ways of generating negatives or copies through transfer, rubbing, and painting processes. "Recording images" describes how images are captured on black and white or color film and digital sensors, and how to process that digital data or turn film-based latent images into negatives. "Processing images: developing film" describes how to develop black and white film. "Printing images: traditional processes" describes black and white papers, chemistry, and processes for wet darkroom printing, including test prints, **contact sheets**, and enlargements, as well as other processes such as liquid light and cyanotype. "Processing digital images: digital workflow" advises on a particular system for working with digital images, and describes ways to organize and format images in the Adobe software products Bridge, Lightroom, and Photoshop. "Printing images: digital printing" explains the steps involved in printing digital images. "Other printing options" highlights other available avenues, such as commercial printing or photo kiosks, and reveals other methods artists utilize to recreate images.

LOW-TECH POSITIVES AND NEGATIVES

Negatives and positives: Translating tone and color

A positive image is one in which the whites, grays, blacks, and colors correspond directly to those of the original subject. A *negative* image is one in which the tones are the opposite of the subject. In traditional photography, a positive subject is turned into a negative image, which is then printed as a positive photograph. Light passes through a negative onto photographic printing paper; the negative's tones are reversed and a positive is produced. A negative can be paper-, glass-, or plastic-based and can be made various ways: by exposing light-sensitive materials, by painting on plastic or glass, and by photocopying, transferring, or digitally printing onto a transparent sheet.

Reproductive techniques such as photocopying reproduce a positive from a positive (or a negative from a negative), with some slight differences in contrast or texture. Some photocopiers are capable of reversing the image's tones. Image transfers also reproduce a version that is tonally identical to the original image, but reversed (left to right). Rubbings produce a negative of the original subject.

When creating negatives for printing, assess the *shadow*, *midtone*, and *highlight* areas for *density* and *contrast*. On a negative, the shadow areas are white or clear;

contact sheet
In traditional photography, a contact sheet is a contact print made from an entire roll of exposed and processed film. This provides an intermediate step, enabling the photographer to determine which pictures should be enlarged. Digital photography continues the practice of making a contact sheet; for example, Adobe Bridge provides a way to place thumbnails in contact sheet format.

the highlight areas will be dark. Density refers to the thickness of the emulsion, be it silver or toner; contrast refers to the difference between the shadow and highlight areas. The negative must be dense enough to have captured details of a scene, but not so dense that light cannot pass through the negative, causing details to be over-blown or obscured.

RUBBINGS

If one's interest in working photographically comes from the desire to produce multiple copies from a single matrix, then the process of rubbing may be the solution. A rubbing is a record of a raised or textured surface made by placing paper over it and rubbing the paper with graphite or other materials. Rubbings provide two-dimensional representations of three-dimensional objects. More specifically, they produce (multiple) detailed reproductions of an object. Rubbings provide a document of a surface.

Historically, rubbings provided a way of reproducing text and commemorating the deceased. By 300 BC, the Chinese were using rubbings to accurately reproduce the written word and calligraphic styles on stone tablets. Unlike woodcarving, the process does not require reverse carving or size limitations. The Chinese rubbings constituted some of the first efforts of mass reproduction, as the emperor's literature was distributed to the outermost parts of the empire. Today, archeologists often use the technique to copy tomb carvings and gravestones. Rubbings often provide more accurate representations of three-dimensional surfaces than photographic methods because the pressure captures the texture of narrow, pitted surfaces and vessels that traditional cameras cannot enter. But the process also allows for the emotion of a drawing—while it may seem crass to photograph John Lennon's memorial or Karl Marx's grave, a rubbing generates a more gentle document.

The rubbing process

Rubbing simply involves placing paper over a surface and rubbing the paper with some sort of media. The hardness or softness of the image will depend upon the amount of pressure applied and the type of media and paper used.

Tape and fixative

To ensure that the paper does not move while rubbing, you may want to tape it in place. If so, use a tape that will not leave adhesive behind, such as drafting tape. After rubbing, use a spray fixative to secure the image—especially if rubbing with a dusty material such as chalk or charcoal.

ONLINE RESOURCES 3.1 Refer to our web resources to learn about the cliché-verre process in which a negative is drawn or painted and then printed in a wet or dry darkroom.

3.49 Here, the artist used wax rubbing to document the buildup of her hair around the bathtub drain. The image captures a portrait of the artist through a collection of strands. The drain holes, ordinarily the darkest part, do not register as a tone on paper

 3.1

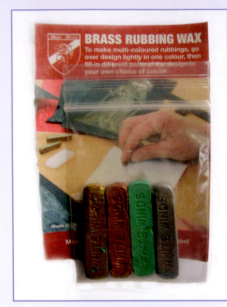

3.50 White Winds brass rubbing wax

Rubbing media

Crayons, graphite, charcoal, pencil, chalk, carpenter's crayon, rubbing wax sticks, and other drawing materials all can be used as media for rubbing. For high contrast between whites and darks that help details to be most apparent, Brass Rubbing Wax provides the best results.

Papers

Tracing paper, plain white computer paper, butcher paper, newsprint, rice paper, and rubbing paper can all be used to produce images. Translucent paper and heavyweight vellum allow you to see the object beneath the paper while making the rubbing.

INFINITE WAYS TO GENERATE IMAGES

On the following pages, all images originate from either the digital or the printed color image of Lance Loud. Lance was the oldest child of the Loud family, the first family to be the subject of "reality television" as documenters Alan and Susan Raymond followed the daily lives of his middle-class family in *An American Family* (1973). The Raymonds describe Lance as a "free spirit who dared to live his life on his own terms," the first "reality TV star" and the first openly gay person on television. As a teenager, Lance admired the artist Andy Warhol, and initiated a correspondence that continued into his adult life. Warhol elevated everyday images to iconic status by printing multiple editions. On these pages, Loud is the one replicated, in *Still of Lance Loud*, a series by artist Alana Quinn.

Reproducing Lance Loud

Alana Quinn captured the initial image, a digital still, from a video of the Raymonds' documentary, *Lance Loud! A Death in An American Family* (2002), showing Richard Noble's 1973 portrait of the Louds. Alana captured the still image using the video editing program iMovie. Once captured, the still could be opened in Photoshop. She saved one digital version as a positive image and converted another (in Photoshop) into a digital *negative*. We could then use all of these positive and negative prints to generate countless other images, using basic photographic techniques, such as photocopying and darkroom printing, or chemical, pressure, adhesive-based, and inkjet transfer methods.

Photocopier negatives and positives

A photocopier is an inexpensive, low-tech way to reproduce black and white or color images. Copiers are available as handheld devices that make one scan at

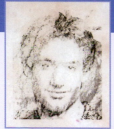

L Acetone transfer on typing paper

K Wintergreen oil transfer on typing paper

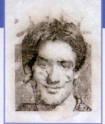

O Transfer collage

A generated all images to the right [(M), (N), (F), (B), and E)] highlighted in red, and image (P)

A Original digital capture: printed on paper with a color laser printer

M Photocopier positive: color image was photocopied as black and white image, output on paper

M was used to make (C) and transfers (L), (K), and (O)

N Photocopier negative on paper: color image was photocopied as a black and white negative image, output on paper

N was used to make negative (D)

P Contact paper lift

C Acrylic lift from positive Xerox

D Acrylic lift negative

D was used to make both the photograph (H) and the cyanotype (S)

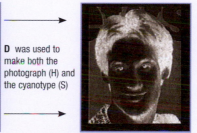

H Black and white contact print from acrylic lift

S Cyanotype from acrylic lift negative: printed on Arches watercolor paper

F Photocopier negative on transparency: the printed color image was photocopied as a black and white negative image, output on transparency

B Film negative: the digital color image was converted to grayscale black and white, inverted to negative in Photoshop, and output to halftone film

E Transparency negative: the digital color image was converted to grayscale black and white, inverted to negative in Photoshop, and output on transparency

F was used to make both the photograph (J) and the cyanotype (R)

B was used to make both the photograph (G) and the cyanotype (Q)

E was used to make the photograph (I)

J Black and white print from negative: black and white contact print made from photocopier negative

G Black and white print from negative: photographic contact print made from digital film negative

I Black and white print from negative: photographic contact print made from digital transparency negative

R Cyanotype from photocopier negative: printed on Arches watercolor paper

Q Cyanotype from digital film negative: printed on Arches watercolor paper

3.51 Alana Quinn, *Still of Lance Loud*

a time, or as large table-sized machines. Most copiers have basic options that allow you to adjust image brightness and scale. Many have different settings for *photograph/image* and *text* that automatically adjust the exposure in order to get varying amounts of detail. More advanced copiers have a *Special Features–Neg/Pos button* that will reverse an image's tones before copying the print to paper or transparency.

 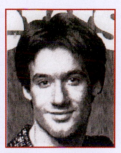

3.52 Original capture, printed digitally on paper

3.53 Black and white photocopy of original color image, printed on paper

3.54 Wintergreen oil transfer

3.55 Paper negative made using the photocopier's negative setting, which reproduces whites as blacks and blacks as whites

3.56 Acrylic lift

3.57 Negative made using the photocopier's negative setting

3.58 Silver gelatin print from photocopier negative in Figure 3.57

On this page, the images framed in red are all photocopies made from the same original, Figure 3.52. Any of these copies could be considered the final print or could be used to generate additional images, as demonstrated with Figures 3.53 and 3.54, in which the photocopy was transferred to a new sheet of paper using wintergreen oil; Figures 3.55 and 3.56, in which the negative copy's toner was lifted off using acrylic medium; and Figures 3.57 and 3.58, in which a negative copy was printed in the darkroom. Be careful about image density with this last technique. When using a photocopy as a negative, the toner may not be thick enough to prevent light from easily passing through. Remedy the problem by making two identical copies and sandwiching them together to form a denser negative.

Image transfer and rubbing techniques

With image transfers, the toner that makes up the picture is lifted from one surface and applied to another. In the process, the image is reversed horizontally. The transferring technique allows you to place all or select areas of a photograph,

3.59 Photocopier positive (black and white) on paper

3.60 Acetone transfer on typing paper

3.61 Wintergreen oil transfer on typing paper

3.62 Here, Alana Quinn portrayed Lance Loud as Andy Warhol with a wintergreen oil transfer of Loud's face and acetone transfers of Warhol's wig and a Warhol floral print

illustration, or drawing onto or next to existing images, in a seamless kind of collage.

Most printed images can be transferred to another surface by applying a medium to loosen the ink, and then pressing the ink against a new surface. Freshly printed images from copy machines and presses transfer best. Images coated with plastic, such as glossy magazine pages, will not transfer. If printing on an inkjet printer, print onto wax paper to transfer (See "Inkjet transfers" below).

A transfer can be made to look like a smudged drawing or a distinct photograph, depending upon the type of medium used, the amount of medium used, the amount of pressure applied when rubbing, and whether the ink is manipulated or brushed after being transferred.

Selecting a medium

Inkjet transfer, described on the following page, requires no liquid medium as the ink is transferred from wax paper. Oil and solvent image transfers use those liquid media to loosen the toner for transferring. *Wintergreen oil* is non-toxic and produces a dense transfer, with rich black areas. A little oil goes a long way. The more used, the more the carbon/ink will bleed when transferring and the longer it takes for the final image to dry. *Solvents*, such as acetone, paint remover, and lighter fluid, give a drier, lighter-looking transfer and have less chance of smudging. They need to be applied in larger quantities as they evaporate quickly. They are toxic and should only be used in a well-ventilated area.

Wintergreen oil or solvent image transfers

Tools and materials

- Image(s), copied on a copy machine and reduced or enlarged to the scale that fits your needs. Remember that the image or text will be reversed during the transfer, so begin with backwards text if you want it to be readable in the final work. Trim off any parts of the image that you do not want to transfer.
- Wintergreen oil (available at health food stores), or a solvent, such as acetone or silkscreen transparent base.
- A cotton swab.
- Paper or fabric to receive transfer.
- A burnisher (a spoon).
- Clear or drafting tape that can be peeled away without ripping the paper (optional).

The oil or solvent transfer process

Place the copied image face down on the receiving paper or cloth surface. Use the cotton swab to apply the oil or solvent over the back of the image. Rub with a burnisher. If you do not want the image to move while burnishing, tape it down. During the process, you may check the transfer by slightly peeling the top image back, but be careful not to shift the paper. Dry face up.

Inkjet transfers

In the inkjet transfer process, the dye-based image is printed on a sheet of wax paper so that it can be transferred to another surface or material. The transferred photographic image will have a painterly, mottled look.

Tools and materials

- Transfer material (wax paper that will hold ink, such as computer label sheets with the labels removed, or glassine).
- An inkjet printer.
- Paper or cloth to receive transfer.
- A wet sponge.
- Paper or cloth towels.
- A burnisher (a spoon).

The inkjet transfer process

Open your image in an image-editing program, such as Photoshop. If you want the final transfer to be oriented as it is on the screen, flip the image horizontally (*Image > Image Rotation > Flip Canvas Horizontal*). Place the transfer material in the printer (glossy side up). In the Print Settings directory of the print dialog box, choose the highest possible quality and choose a Glossy Paper for Print Media. Print the image. The printed image will look very dull.

Prepare the receiving paper by sponging it lightly with a wet sponge. Place the printed image face down on the paper or cloth surface. Rub gently with a burnisher. During the process, you may check the transfer by slightly peeling the top image back, but be careful not to shift the paper. Once the image has been transferred, the ink can be manipulated with a brush. Dry face up.

Woodcut image transfers

The woodcut (also known as the woodblock) is the oldest of all printmaking techniques, originating in China around the 9th century and gaining popularity in

3.63 Digital print

3.64 Inkjet transfer on cardstock

3.65 *Annual Accordion Concert* (detail), 1956. Black and white photograph, (whole image: 4 × 6in.)

3.66 Toby Millman, *Accordion*, 2005. Image-transfer woodcut, 5 × 5in

Europe around 1400. One of the major advantages of the woodcut process lies in its simplicity, with emphasis on lines, outlines, and large simple forms. The woodcut is a form of relief printing. Ink a piece of wood and press paper against the block; the flat surfaces of the wood will print, while the carved-out areas of wood will not.

There are many ways to transfer an image onto the block of wood for carving: the picture can be drawn, or transferred using the image-transfer process on the preceding pages. The woodcut image-transfer process combines the precision of a photograph with the stark lines of a woodcut. Photographs with less detail may be better suited for this process, depending on the image size and the artist's level of expertise.

Image-transfer tools

■ Laser printout or color photocopy of image (color photocopies transfer better than b/w ones. Make a color copy even if the original is b/w).
■ Brush.
■ Wintergreen oil (recommended over acetone or other solvents).
■ Tape.
■ A burnisher (metal spoon).

Carving and printing tools and materials

■ Paper (one with a smooth surface will accept the ink better).
■ Woodcarving tools (linoleum cutters can be used for soft woods).

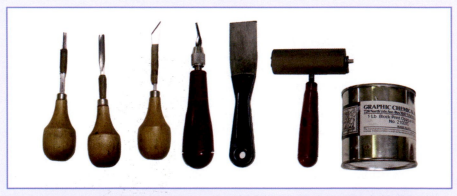

3.67 Carving and printing tools (left to right): three traditional woodcarving tools: (1) a parting tool; (2) a straight gouge; and (3) a knife; (4) linoleum cutter, works with soft woods and can be purchased with several different-sized blades for varying line weights. The blade shown here is a liner for cutting thin lines; (5) putty knife; (6) rubber brayer; (7) woodblock ink

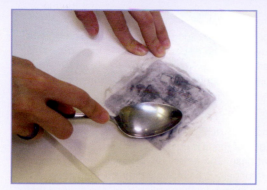

3.68 Place the print or photocopy face-down on the woodblock. Brush the back of the print with wintergreen oil until the paper is saturated. Keeping the paper secure (use tape if necessary), firmly burnish the print with the spoon. Press firmly using a circular motion. The wintergreen oil will act as a solvent, transferring the ink onto the wood. The more porous the wood, the more accurate the transfer. In our example, we used basswood. After burnishing all areas, lift the print

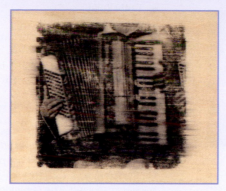

3.69 The woodblock will be printed with a mirror image of the original

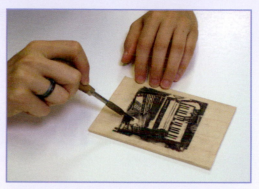

3.70 Using the photo transfer as a guide, carve out the areas that you do not want to ink. These areas will be the color of the paper. As much as possible, try to carve with the grain of the wood. Going against the grain will result in splintering. A thin sharp-edged woodcarving tool or knife helps to carve lines when scoring areas against the grain

3.71 Once the block is carved, use the putty knife to spread the ink on a sheet of glass. Use the brayer to roll out the ink until it is the right density and an even consistency. Roll the ink on the woodblock, making sure to apply it evenly

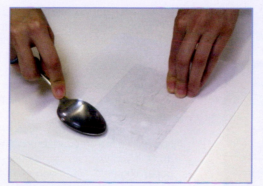

3.72 Place the printing paper down against the block, making sure to center the block with the desired borders of paper, if you plan to show the whole sheet. Firmly rub the back of the paper with the spoon. To judge whether enough pressure is being used, lift a corner of the paper while keeping the opposite corner secure

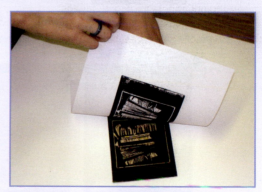

3.73 Once the entire woodblock has been rubbed, remove the paper. On the print, the mirror image of the woodblock will be reversed back to the orientation of the original photograph

3.74 Color print

3.75 Contact paper lift

3.76 Photocopier positive on paper

3.77 Acrylic lift

3.78 Photocopier negative on paper

3.79 Acrylic lift negative

- Woodblock (basswood and balsa wood are soft and easy to carve; the grain of softer woods is more pronounced and will often give added texture to the print).
- Putty knife.
- Rubber brayer.
- Woodblock ink (use other inks or paints with additives—magnesium carbonate can be added to stiffen ink, or boiled linseed oil can be added to loosen ink until the consistency is like soft butter).
- Spoon (though it is possible to print woodcuts with a press, it is not necessary).

Acrylic lifts

The following type of process includes *acrylic lifts*, *image lifts*, *gel medium transfers*, and *contact paper lifts*. Each of these methods allows you to transfer an image from a paper to a transparent base. The toner, ink, or emulsion that makes up the picture is coated with the transparent base, and then the original paper base is dissolved. The resulting image is on a leathery, pliable, plastic surface that can be presented in this form, sewn, stuck to other surfaces with a layer of gel medium, or cut and collaged in multiple applications. As a semi-transparent image, the acrylic lift is also a *negative* that can be contact printed.

Acrylic lift with acrylic medium

Tools and materials

- Image(s), copied on a copy machine and reduced or enlarged to the scale that fits your needs. The image or text will be reversed during the transfer, so begin with backwards text if you want the words to be readable in the final work. Trim off any parts of the image that you do not want to transfer.
- Matte or gloss acrylic medium.
- Paper or fabric to receive transfer.
- Wide (1–3-inch) hair or foam brush.

The area over which you brush the medium will affect the image edges. If you do not want a frayed edge, brush the medium over the entire piece of paper (Figure 3.77). If you want a ragged edge, end your brushstrokes within the border of the paper (Figure 3.79). If you want the final transfer to have a clear white plastic border, copy the image so that it is surrounded by a field of white and make sure to cover this area with the acrylic. Brush the acrylic medium over the image. Let the first coat dry (use a hair dryer to speed up the process), then brush another layer in the opposite direction. (For example, if the first layer was applied horizontally,

apply the second layer vertically.) Apply at least eight layers, more for a thicker surface.

When dry, soak the image in hot water until the paper is softened. Using your fingers or a sponge, rub the back of the image gently to remove the paper. Be careful not to rub off the toner/ink. Hang to dry. For clarity, you can apply a final coat of acrylic medium.

Acrylic lift with contact paper

Tools and materials

- Image(s), copied on a copy machine and reduced or enlarged to the scale that fits your needs.
- Clear contact paper.
- Burnisher (metal spoon).

This process is similar to the previous one, but instead of applying layers of acrylic medium, you apply the plastic all at once in the form of a sheet of clear contact paper. Adhere clear contact paper to the front of your image, being careful not to get bubbles or wrinkles in the surface. Rub the plastic very hard with a burnisher. The pressure forces the ink onto the adhesive layer of the contact paper. Soak the image in hot water. The water dissolves the paper. Using your fingers or a sponge, rub the back of the image gently to remove the paper. Be careful not to rub off the toner/ink. Hang to dry.

RECORDING IMAGES: FILM AND DIGITAL SENSORS

Film and digital reproductive technologies involve light-sensitive materials or electronics. The chemical emulsions of traditional photography and the electronic sensors of digital photography each record the light and color reflected from the environment at a given moment. Once this data has been recorded and processed, it can be reproduced through darkroom or digital printing.

Film

Photographic film consists of a clear, plastic base coated with a light-sensitive emulsion. There are many types of film, including negative, positive (reversal or

transparency), panchromatic, orthochromatic, and infrared. This book primarily addresses the makeup, processing, and printing of negative film.

Types of film

Manufacturers produce different types of film. Films vary by:

Size Film is available in different formats and packages for different types of camera. *Format* refers to the film dimensions, as film frames vary from 35mm, to medium (around 6 × 6cm) or large formats (4 × 5 inch or larger). Large-format films come as sheet film, each frame a single sheet, with many sheets in one box. Medium-format and 35mm films are packaged as roll film, with multiple frames on one roll of film, and with varying numbers of frame per roll. 35mm films can also be purchased in less expensive bulk rolls up to 100 feet in length. A bulk film loader is used to transfer the bulk film to smaller cassettes for the camera.

Black and white or color Black and white films have varying contrast levels. Color films differ primarily by color balance: daylight- or tungsten-balanced. Additionally, each color film has a different color range, intensity, and saturation level. There are some films that appear to be black and white, but are known as chromogenic films and are processed in the same way as color films. They will say C-41 process on the cassette. Do not purchase these if you want to process the film with black and white chemistry.

Positive or negative Negative films produce an image in which the tones and colors of the photographed scene are reversed. For example, a white vase will look black. On a color negative, a yellow towel will appear blue. Printing the negative on paper reverses the image back to the original tones and colors. Positive films produce a positive, transparent image. Transparencies are most commonly available as 35mm slides, in which a single positive image is framed within a plastic mount and viewed on a light box or projected from a slide projector.

Professional and consumer These designations simply refer to the film's color balance. Any film tends to have a particular color balance. A professional film is designed to have consistent color balance from roll to roll, while a consumer film's color may vary slightly from roll to roll.

Storage and handling

When purchasing film, check the expiration date—especially if the film has been discounted. Keep film away from heat, and store it in a cool location. If refrigerating

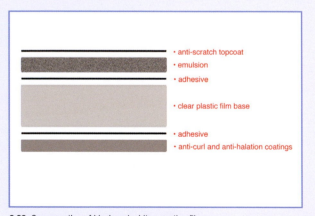

3.80 Cross-section of black and white negative film

- anti-scratch topcoat
- emulsion
- adhesive
- clear plastic film base
- adhesive
- anti-curl and anti-halation coatings

film, note that the emulsion will not respond accurately when chilled, so bring it to room temperature before use. Load film into a camera in dim light so as not to fog the emulsion.

Black and white film: How the film produces an image

When exposed to light, the silver halide emulsion undergoes a chemical change: those areas that receive the most light are most changed, those receiving the least light are least changed, with varying degrees in between. The image is now imprinted on the film as a *latent image*, not visible to the eye. The exposed film is still light-sensitive until chemically processed, at which point the positive or negative image is *developed*. In development, the silver halide crystals that received light turn to metallic silver. Parts of the original scene that were whitest had projected the most light, and so corresponding areas on the negative have the most density, or silver buildup, and will be darkest. Parts of the original scene that were blackest or darkest projected the least light and so corresponding areas on the negative form little or no density and will (later in the processing) turn clear. There will be varying degrees of density in between the black and clear areas. Once the latent image becomes visible, it is *fixed*, that is, desensitized to light.

Color film: How the film produces an image

The overall makeup of color film is similar to black and white. Color film is also made up of silver halide emulsion, a topcoat to prevent scratches and a bottom anti-halation coat. However, whereas black and white film consists of one emulsion layer, color is made up of three emulsion layers, each sensitive to a different spectrum (or color) of light. The top layer is sensitive to blue light, the middle to green light, and the bottom to red light. Blue, green, and red parts of the original scene record in separate layers of the film. Other colors record on multiple layers in varying degrees. For example, yellow light will affect the green- and red-sensitive layers.

Additionally, each emulsion contains a color chemical coupler. During development, the silver halide crystals that received light turn to metallic silver. Simultaneously, the developer combines with the color couplers to produce dyes: yellow in the blue layer, magenta in the green layer, and cyan in the red layer. The amount of dye produced is proportional to the silver buildup. Subsequent processing steps bleach the silver off the layers, leaving the dye to form the color image. The final negative shows the original image but in complementary colors: red in the original scene is registered as cyan; blue as yellow; and green as magenta. In addition, color film has an orange mask to reduce contrast.

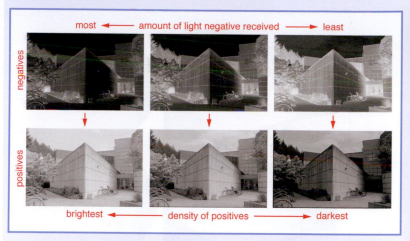

3.81 Original negative to positive. Note that the brightest area of the original scene (the sky) reflected the most light to the film, thereby creating the most silver buildup and appearing darkest in the negative. When printing that negative, light will not pass easily through this part of the film and, therefore, the area will print as white. Areas that were the darkest in the original scene (a bush to the left of the building) reflected the least light to the film and, therefore, created little silver buildup (density) on the negative. When printing the negative, light will pass easily through these semi-transparent areas of film and the bush will print as black

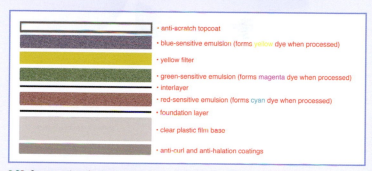

3.82 Cross-section of color negative film

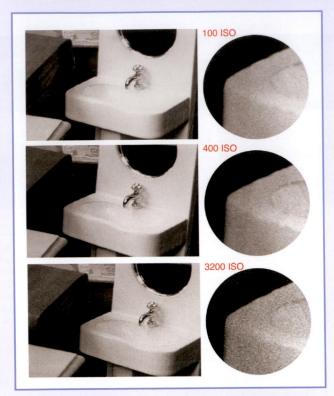

100 ISO

400 ISO

3200 ISO

3.83 Film speed and grain

	faster film speeds	slower film speeds
and light	require less light during exposure	require more light during exposure
and a subject in motion	are better at freezing motion	are better at blurring motion
and the negative's		
• grain	produce more visible grain	produce less visible grain
• sharpness (acutance)	produce less acute edges	produce sharply defined edges
• latitude	have more latitude for exposure error	have less latitude for exposure error
• contrast	produce less contrast	produce higher contrast
• color	produce less saturated, less accurate colors	produce more saturated, more accurate colors

3.84 Chart of film speeds

Film characteristics

The term *characteristics* refers to graininess, speed, saturation, sharpness, contrast, and color. These attributes vary with film type and manufacturer.

Grain size

During development, the silver crystals are transformed into particles of metallic silver. In the color process, these silver bits form color dyes. In black and white or color film, the silver particles or the color dyes that formed around those particles appear as individual specks, referred to as *grain*. The grain is not visible when looking at the negative but may be noticeable in a print. Several factors affect the print's *graininess*: the film speed (low film speeds yield smaller grain; higher film speeds yield larger grain); the type of film developer and other development conditions (e.g. overdevelopment increases graininess); the type of printing paper; the degree to which the negative is enlarged (the more the negative is enlarged, the more visible the grain); and the tonal qualities of the image (grain is less noticeable in busy, textured, patterned areas than in areas of uniform tonality). The prints and enlargements in Figure 3.83 show the differences in graininess from film of different speeds.

Film speed (ISO)

The film speed refers to how quickly the emulsion responds to light. Slower speed films (with lower ISO numbers) have finer grain crystals that respond less quickly to light than higher speed films (with higher ISO numbers), which have larger particles. If the number doubles, so does the speed. If the number is halved, so is the speed.

When selecting a film speed, consider the:

■ *lighting conditions*: If you will be shooting in low-light conditions, either without a tripod or with a fast shutter speed and/or small aperture, you will need a fast film speed to compensate.
■ *subject*: If you are working with a moving subject and want to make a quick exposure that will freeze the action, a high film speed will allow you to use a fast shutter speed and/or a small aperture.
■ *final print*: If you are making large enlargements with a lot of detail and do not want the appearance of grain, use a slow film speed. If you want to emphasize the silver particles and graininess of the film, use a fast film speed. Slower films tend to produce higher contrast than faster films. If a subject or lighting is particularly contrasty, using a higher speed film may increase your chances of getting a good exposure.

Latitude

Latitude refers to the film's ability to withstand over- and underexposure errors and still produce satisfactory results. Slower speed films have less latitude for error, while faster speeds have more. Color negative films, because of their orange mask, tend to have greater latitude for overexposure and less for underexposure. Negative films have far greater exposure latitude than positive films.

Sharpness (acutance)

The sharpness of the film, its *acutance*, is a measurement of the film's ability to form sharply defined edges between tonal areas. Usually, slow films have higher acutance. Faster films tend to be less sharp. Other factors, such as overexposure, reduce image sharpness as well.

DIGITAL SENSORS

Digital cameras use a light-sensitive electronic sensor to record information. The sensor, either a CCD (charge-coupled device) or CMOS (complementary metal oxide sensor), is a small plate located in the same location as film in a conventional camera. The sensor is covered with microscopic cells, known as photosites. Each of these sites corresponds to a pixel (short for picture element) in the final image. A camera with a rectangular arrangement of 2464 × 1632 sensor cells is referred to as a 4 megapixel camera (2464 × 1632 = 4,021,248); 4 megapixel means 4 million pixels. The term megapixel refers to a unit of 1,000,000 pixels.

Each pixel records the brightness of a part of the picture. A filter processes this light to transfer corresponding amounts of red, green, or blue colored light as an electrical charge. Using the same method as color film's emulsion layers, the sensor filters admit light of certain colors and block light from complementary colors, thereby ensuring that the underlying pixels record subject colors. The charge is then converted to a digital number representing a particular brightness and color.

The sensor records data to a removable storage card, rather than to film. The number of images (or exposures) a storage card can hold will depend on the size (in megabytes or gigabytes) of the card, and the resolution, compression, and file format of the recorded images. Once images have been recorded, you can download the information to a computer, take the card to a photo lab for downloading and printing, or print directly from the camera or storage card.

Sensor size

Whereas *film size* refers only to the dimensions of the negative, *sensor size* refers to the dimensions of the sensor and also to the sensor's quality. The size of the

image resolution: 300 ppi
pixel dimensions: 2304 x1536

image resolution: 72 ppi
pixel dimensions: 553 x 369

image resolution: 20 ppi
pixel dimensions: 154 x 103

3.85 Pixels and print size

sensor determines the number of available pixels, and the sensitivity of these pixels. Most point-and-shoot cameras have digital sensors that are not nearly as big as one frame of 35mm film. Many megapixels packed within a tiny sensor can create problems with noise. Sensors that are closer to the size of a 35mm film frame provide higher resolution and less image problems. Sensors that are the same size as a frame of 35mm film are known as "full-frame 35mm sensors." Medium-format digital sensors are bigger than one frame of 35mm film, but smaller than 4 × 5-inch sheet film. Medium-format images have so much information that they can be printed very large without losing detail.

Pixels and resolution

The number of pixels contained within a camera's sensor is often described as the resolution of that camera. The greater the number of pixels, the larger you can print the image without seeing individual pixels. As low-resolution files are printed larger, it becomes easier to discern individual pixels and the image no longer seems like a smooth transition of tones (*continuous tone*). You can see this in the comparison of three identical details, shot at varying resolutions (Figure 3.85). Here, resolution is described in pixel dimensions (e.g. 2304 × 1536) and pixels-per-inch image resolution (e.g. 300 ppi). The 2304 × 1536 (300 ppi) image has enough pixels to give the appearance of continuous tone. The 553 × 369 (72 ppi) file has fewer pixels; individual pixel cells are discernible and, therefore, the image has rough shifts in tone. The chart (Figure 3.86) provides the maximum size print (with continuous tone) you can expect from various megapixel sizes.

Image resolution is a question of how many pixels make up the image, not the "quality" of that image. Quality is determined by the combination of many factors: the lens optics, exposure to light, the number of megapixels, the resolution, compression, file format, ISO, and the size of the print. Photography books or discussions tend to refer to sharp images with no discernible pixels as "high-quality" images. Try not to equate continuous tone with high quality, as there may be instances when you want low-resolution and pixelization. For example, if you are trying to create an abstracted area, or to mimic the look of low-res graphics, you may prefer a low-resolution image.

The advantages of higher megapixel cameras/files are:

1 The image can be printed larger without pixelization.
2 The image can be cropped in the computer, while still leaving enough pixels to print the remaining image at a reasonably large size and without pixelization.
3 Cameras with eight or more megapixels tend to have better lenses and circuitry, both of which increase image quality.

number of megapixels	pixel resolution	print size @ 300ppi
<1		web (monitor)-based viewing only (72ppi)
3	2048 x 1536	6.82" x 5.12"
4	2464 x 1632	8.21" x 5.44"
6	3008 x 2000	10.02" x 6.67"
8	3264 x 2448	10.88" x 8.16"
10	3872 x 2592	12.91" x 8.64"
12	4290 x 2800	14.30" x 9.34"
16	4920 x 3264	16.40" x 10.88"
35mm film, scanned	5380 x 3620	17.93" x 12.06"

3.86 Resolution and pixels

4 If you do not know how you will use the image, higher megapixels gives you more options.

Although each digital camera is capable of achieving a certain level of image quality, this may not always be necessary. Recording images at the peak resolution takes up more memory, allows fewer images to be stored, and slows down processing time. Alter your image quality as needed through the camera's resolution and compression settings. For example, if you choose to shoot in high-res (RAW) format with a sensor size equivalent to 35mm negatives, each image will be around 20.2MB (megabytes, in other words 20,200,000 bytes) in size. If your storage card is 2GB in size (1 gigabyte is 1,000,000,000 bytes), this means you have 2,000,000,000 bytes of space available on this card. To figure out how many shots you will have on a card, calculate 2,000,000,000/20,200,000 = about 99 images. Figure 3.87 shows specifications for how resolution affects file size and storage card capacity in Canon's EOS Rebel T1i DSLR camera.

image quality (file type)	megapixels	image file size	storage card capacity for a 2GB card
low (JPEG)	3.7 M	1.7 MB	1080 shots
medium (JPEG)	8 M	3.0 MB	610 shots
high (JPEG)	15 M	5.0 MB	370 shots
high (RAW)	15 M	20.2 MB	90 shots

3.87 Digital file size and storage

Image quality: Compression and resolution
Most cameras give at least three image quality options (for example, *Small*, *Medium*, and *Large*). The quality is determined by the amount of compression. Compression creates smaller files by discarding some information. For example, the sky may have five hues of blue. An uncompressed file may record all five of those hues, while a compressed file might collapse several hues into one, recording only three distinct colors. Minor compression may not affect the way you perceive the image because many of these slight shifts in color are not visible to the human eye. Your choice depends on the size of the printed image and your desired aesthetics. If you want large, continuous-tone images, choose a Large resolution option. If you want small, continuous-tone prints, a Small resolution will be fine. Internet display only requires low-resolution files. As images have one resolution and output devices another, knowing the resolution of your output device will help you to choose the image resolution when capturing the image. To set image quality in your camera, look up *Resolution or Image-Recording Quality* in your camera manual.

Digital cameras and ISO
Most digital cameras give an ISO or film speed setting. The ISO indicates how sensitive the digital sensor is to light. While, in film photography, an entire roll of film is rated at a single ISO, a digital sensor can be reset from exposure to exposure. Changing the sensor increases or decreases its sensitivity through amplification, using electronic gain. The sensor responds to light less quickly with

a low ISO (64) and more quickly with a high ISO (400). A high ISO will allow for faster shutter speeds, suitable for freezing the motion of a moving subject. A high ISO can also be helpful in low-light conditions. The side effect of a high ISO is that the increased electronic gain causes errors or interference, referred to as noise. Digital noise shows up as graininess in digital images, most notably in shadow areas and underexposed images. An image shot at a higher ISO may have some noise. A lower ISO will contain little noise. Therefore, it is generally best to use a low ISO.

Sensor imperfections

Visible noise increases as ISO value and exposure length increase. Imperfections in sensor design can also result in digital noise. Although CMOS sensors are more susceptible to noise than CCD sensors, recent designs show improvement. Sensors can also have "hot pixels," defective pixels that consistently show up brighter or a different color than the actual scenes.

Image formats

This refers to the way that the camera records information. Each format interprets data differently. Possible formats are JPEG and RAW.

JPEG is the default format for all digital cameras, and most point-and-shoot cameras only record in JPEG. JPEG analyzes the raw information that a camera records and compresses or eliminates information that seems unnecessary in order to produce smaller files. Most cameras give several JPEG compression options, such as Large/Superfine (higher image quality, but fewer images per card), Medium/Fine (medium quality and storage capacity), and Small/Normal (lower image quality and more images per card).

The RAW format is the only format unique to cameras (not used with computers). In RAW format, the camera lens and sensor record all information, without in-camera processing (sharpening, white balance, compression, etc.). RAW provides the most information per image and takes up more file space than a high-resolution JPEG. RAW is available with higher-end digital cameras, such as DSLRs, and sometimes with point-and-shoot digital cameras.

Bit depth

A bit ("binary digit") is the smallest unit of digital data, and has a value of either "0" or "1," black or white. As one bit would only allow for either a black or a white pixel, most digital cameras create color images with 8 bits per color channel (red, green, and blue). This gives 256 possible combinations per pixel, and a larger possible range of colors.

When capturing images with digital cameras, the two common file formats each have a different bit depth. JPEG files have a bit depth of 8. RAW files usually have a bit depth of 12 or 16, and, therefore, a greater number of possible colors for each pixel, which allows for greater variation in recorded colors. 16 bits would yield 65,536 possible colors. Some high-end cameras and scanners have bit depths of 36 or 48. These higher bit depths produce more subtle gradations in tone and thus, when you manipulate the image, less data is lost during processing.

Color space

The *color space* is the number of possible colors available to an image. Every device offers different color space options, each with a different range of colors available. For example, the sRGB color space is a more limited palette of colors, and a good choice if you plan to project images or show them on a monitor, because those devices also use the limited color space of sRGB. The color space Adobe RGB has a larger number of possible colors for the image, a wider range than sRGB, and is a good choice for print purposes. DSLR cameras usually allow users to select from different color spaces for image capture, either sRGB or Adobe RGB. You can change the color space in an image-editing program.

Dynamic range

The range, from dark to light, in which the sensor can absorb and record detail is called the sensor's *dynamic range*. Each photographic device has its own dynamic range. The camera has a different dynamic range than your display device (computer monitor) and than your output (printer). The subjects you are photographing will also vary in dynamic range, from a scene with only small changes in tone to one with great difference between lights and darks. Devices with greater dynamic range allow you to capture a broader range of tones without burning out highlights or losing shadow details.

Color of light: film and digital sensors

What we see as white light is actually a blend of different colors at varying wavelengths and temperatures. Each type of film or digital sensor responds differently to the colors of the subject. Understanding a film or sensor's sensitivity and knowing how to emphasize or neutralize these tendencies will help you to control the way your film or digital camera records the color balance and contrast of a scene.

How black and white film records the color of light

Most black and white films are panchromatic. Like the human eye, they are sensitive to all visible colors of light and record them as various shades of gray. However, panchromatic films are slightly more sensitive to bluish colors than are our eyes. As a result, blues may appear lighter in the photograph than they were in the actual scene.

How film and digital sensors record the color of light

Light varies in color temperature, depending on the source and the colors it strikes or passes through. However, to our eyes, most light looks "white." This is because our brain has the capacity to correct colored light so that neutral or white objects illuminated by a colored light still appear neutral or white. Color film and digital sensors are unable to make these corrections and record the "true" color cast of light; if uncorrected by using color-balanced film, filters, or digital white balance settings, white or neutral objects will appear warm or cool, rather than white or neutral.

In order to help film and digital sensors record the way our eyes and brain perceive, the photography industry established two midpoints along the color temperature (Kelvin) scale as standard temperatures. *Daylight* films and digital settings (balanced for the blue light of 5500K) produce neutral results (no cast) when used in daylight conditions or with electronic flash. *Tungsten* films and digital settings (balanced for the orangish-red light of 3200K) produce neutral results when photographing in tungsten light.

If you want the scene's color to be represented accurately, use the film or digital camera setting that is balanced for the correct temperature of the light (see Figure 3.88 for approximate temperatures). Digital cameras offer preconfigured settings for Daylight and Tungsten (also called Incandescent or Indoors) settings, but also for Fluorescent and others. You can also fine-tune these settings to compensate for lighting conditions that vary from standard—for example, daylight that is bluer than the standard noon light.

Color casts

When using daylight film or the daylight digital setting to photograph in tungsten light, the image will have a yellow cast. When tungsten film or the tungsten digital setting is used in daylight, the image will have a blue cast. A color cast is a shift in which all areas of the picture appear too warm or cool. A cast muddies the recorded scene, reducing all elements to the same hue and importance; details that should recede or stand out are flattened.

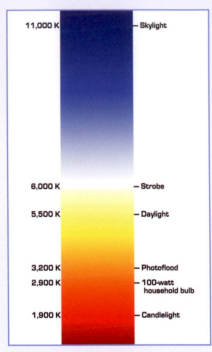

3.88 Color temperatures of light sources on the Kelvin scale

Film and color casts

If you are stuck with the wrong film for existing light conditions, use a filter on the camera lens to neutralize the color of light (see the section on "Filters" below). It is difficult, if not impossible, to correct color casts in the darkroom, because color shifts do not affect the image evenly. For example, the shadows may be more saturated with yellow than the highlights. If you are printing in the darkroom, you won't be able to correct the shift by adjusting the yellow/blue for the entire photograph.

Digital cameras and color casts

All digital cameras have an automatic white balance feature. With "white balancing," the camera's sensor looks for the brightest area of the scene, assumes this is white, and balances the rest of the scene to correspond. Unfortunately, if the brightest part of the scene is not white, the color balance could be imprecise. Higher-quality digital cameras allow you to "customize white balance," to shoot a white object that will serve as a standard for the white balance.

In mixed lighting conditions (for example, a room lit by daylight and tungsten bulbs), digital cameras have more latitude for color balance than film. However, no two cameras will interpret a color in the same way and each camera offers different options for controlling color casts. Unless using camera RAW file format, don't avoid using white balance features on your camera, assuming that you will be able to correct the image's color in the computer. The color shifts that occur will not affect the image evenly. For example, the shadows may be more saturated with yellow than the highlights, so you won't be able to correct the shift by simply adjusting the yellow/blue for the entire photograph.

If you have accidentally shot digital images in the wrong white balance mode, or find that there is still a slight cast even when using the appropriate white balance, try color correcting the cast with the technique described in the "Editing: digital color correction" section, pp. 406–409.

Helpful color casts

When used well, casts emphasize the psychology of a scene (e.g. a reddish cast that conveys a sense of danger). When not used well, a color cast just seems to give the scene a sickly or extraneous tint. If your goal is to *create* an overall or partial cast, mismatching the temperature of the film or digital white balance with the temperature of the light is not an effective method. For more control, consider creating a cast by filtering one or several light sources with colored gels, by handtoning, or by digitally coloring the image (see index for *handcoloring, lighting effects,* and *digital lighting*).

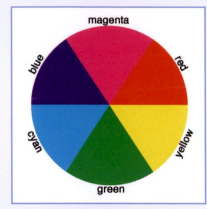

3.89 Additive/subtractive colors on the color wheel. Complementary colors are opposite one another: e.g. magenta and green

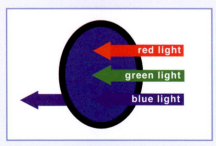

3.90 Filters transmit some colors of light and block others

FILTERS

Filters are clear or colored lenses that can be screwed onto the front of a camera lens to perform a variety of functions. Most basically, they will protect the front of the lens. In addition, filters are available that cut down on glare, color the light to affect color balance and contrast, increase saturation, or create special effects. Filters can be used on any camera with a threaded lens. They must fit the thread diameter exactly; this number is usually printed near the rim of the lens. With the exception of UV and polarizing filters, filters are usually not used on digital SLR lenses. This is because you can balance color by setting the white balance and achieve most filter effects through image manipulation in Photoshop. In order to understand how filters work and to select the appropriate one for your needs, it is important to understand basic principles of color and light.

Filters and the spectrum of light

What we see as white light is a blend of different colors of varying wavelengths. *Red*, *green*, and *blue* each represents a third of the spectrum. Because they are the basic colors and blending them together makes white, they are called *additive primaries*.

On the color wheel, adjacent additive primaries combine to form *subtractive primaries*: *cyan* (made up of blue and green), *magenta* (made up of red and blue), and *yellow* (made up of green and red). While red, green, and blue can be added together to form white light, the subtractive primaries can be combined to form black.

The subtractive and additive primary opposing one another on the color wheel are complementary colors: cyan is the complement of red; magenta is the complement of green; yellow is the complement of blue.

Filters alter color by transmitting light of a similar color and blocking (absorbing) light of complementary colors. For example, a blue filter allows blue light (magenta and cyan) to pass, but not yellow (red and green). This is because filters are dye- or pigment-based. Dyes and pigments don't have a color. They appear colored because they absorb portions of the spectrum and reflect the rest. (This is why a blue filter looks blue—because it reflects blue light.) The amounts of each hue allowed or denied passage depend upon the density and hue of the filter.

Filters for film and digital photography

Several types of filters can be used on SLR or DSLR cameras for either color or black and white film or digital photography. *Ultraviolet (UV) filters* absorb ultraviolet light to reduce haze, but otherwise have no effect on color or exposure. They do, however, protect the lens from scratches and dirt. *Polarizing filters* reduce glare when photographing surfaces such as water or glass, increase the saturation of

colors, and produce a darker blue sky in the photograph. To operate a polarizing filter, screw the filter onto the lens, and then rotate the filter while looking through the viewfinder until the glare is minimized. *Neutral density filters* are gray filters that absorb equal quantities of light from the entire spectrum, thereby reducing the amount of light entering the camera; they are used to filter light when the photographer desires a slower shutter speed or wider aperture.

Filters for black and white film

Black and white films are *panchromatic*, that is, they are sensitive to all wavelengths of light. They convert all colors to values of white, gray, or black. While in the original scene one object may stand out from the rest due to contrasting color relationships, this dynamic may be flattened in the translation from color to gray values. For example, an orange bowl may be nicely conspicuous on a blue table. However, if the bowl and the table are of equal value (reflect the same amount of light), the bowl will be less distinct when pictured in black and white. *Contrast filters* allow photographers to emphasize the difference between tones by blocking some colors of light (thereby lightening those areas in the print). In the example above, a blue filter would absorb blue light and allow yellow (red and green) to pass through to the film. In the print, the blue table would print lighter and the orange bowl darker, with greater contrast between the two.

Black and white films tend to be more sensitive to blue light. This can cause problems when photographing landscapes and outdoor scenes. When a filter is not used, the portions of film that record the sky may become overexposed, resulting in too bright a sky in the print. A number of *sky filters* are available, such as a yellow filter that helps yield a more accurate tone for the sky and a red filter that will dramatically darken the sky on the print. Some sky filters (and other types) are *graduated*, with one half clear and the other half colored. In the case of a sky filter, compose the image so that the horizon line is in the middle of the filter with the sky's light absorbed by the colored half.

Filters for color film

Color filters are designed to alter the color temperature and balance of color film. If the color temperature of your film does not match that of your lights, you can use color filters to make major or minor adjustments to the color of light entering the camera.

Filters that make large adjustments are referred to as color conversion filters. The 80 series contains *blue filters* that filter the warmish light of tungsten when photographing with daylight film in tungsten light. The 85 series contains *amber filters* that filter the cool light of daylight when photographing with tungsten film in daylight.

Other filters, called *light-balancing filters*, make slighter adjustments; say you are photographing on an especially blue winter day and want to decrease the coolness of the light by a few hundred degrees, you could use a pale-to-medium

Common Filters

Number	Color or Name of Filter	Use with this Type of Film	Effect of Filter on Light	Example of Use	Filter Factor (Increase in Exposure)
	UV	B&W or Color	Reduces atmospheric haze.	Allows clearer outdoor images. Protects lens.	None.
	Polarizing	B&W or Color	Neutralizes polarized light.	Reduces glare when photographing surfaces such as water or glass. Increases saturation of colors. Darkens blue sky.	2.5x This is one of the few filters that is adjustable and can be rotated.
	Neutral Density (ND)	B&W or Color	Reduces the amount of light entering the lens.	Increases the amount of exposure needed.	Available in 1, 2 or 4 f-stop densities.
8	Yellow	B&W	Reduces blue rays.	Darkens blue sky.	2x
25	Red	B&W	Reduces blue green rays.	Darkens blue sky and increases contrast.	8x
81 A, B, C	Pale Amber	Color (Tungsten)	Lowers the temperature of the light.	Warms image color.	Check information on filter pack.
85 series	Amber	Color (Tungsten)	Lowers the temperature of the light.	Use when photographing with tungsten film in daylight. Ex: the 85B balances tungsten film with 5500K light.	From 1.25x to 1.6x, depending upon the density of the filter. 85B is 1.6x.
82 A, B, C	Pale Blue	Color (Daylight)	Raises the temperature of the light.	Cools image color.	Check information on filter pack.
80 series	Blue	Color (Daylight)	Raises the temperature of the light.	Use when photographing with daylight film in tungsten light. Ex: the 80A filter balances daylight film with 3200K light.	From 2x to 5x, depending upon the density of the filter. 80A is 5x.
Color-Compensating (CC) Filters	Available in a variety of colors (yellow, magenta, cyan, red, green and blue) and densities.	Color	Each filter blocks its complementary color. For example, the red filter blocks cyan (blue green) light.	Can use one or several at a time to adjust the color balance of the scene.	Check information on filter pack.

3.91 Common filters

amber filter (81A, 81B, or 81C) to add varying degrees of warmth. The 82 series of *blue filters* cools the color temperature in varying increments. The chart of common filters lists some available filters and their uses.

Fluorescent filters are magenta-colored filters. The FLD filters balance fluorescent's green light so that it is the correct temperature for daylight-balanced films; FLT or FLB filters balance fluorescent light for tungsten films. Fluorescent lights can be tricky to balance as there are several types of tubes available with different wavelengths that fluctuate (as compared with the steady temperature of tungsten and daylight).

Whereas color conversion and light-balancing filters warm or cool a scene, *color compensating filters* modify the color balance. The filters are available in any of the additive or subtractive primary colors, in seven densities. For example, a magenta filter in a strength of .30 (a 30M filter) would block more green light than a magenta filter rated .10 (10M).

Filters and exposure

If you are using filters, be aware that they may affect the amount of exposure needed. Adding a filter over your camera's lens may block some light rays from entering, requiring more exposure. A through-the-lens light meter in your camera will read the actual light entering the camera and adjust the reading to compensate. A handheld meter will not. You will need to factor the adjustment yourself. Many filters come with a filter factor, which indicates how much to double the exposure to compensate for the density of the filter. A factor of 2× needs one stop additional exposure; 4× requires 2 stops; 8x requires 3 stops.

Film shot in tungsten light

3.92 Daylight film in tungsten light

3.93 Daylight film in tungsten light with an 80A filter

3.94 Tungsten film in tungsten light

Digital sensor recording in tungsten light

3.95 Digital "automatic white balance" in tungsten light

3.96 Digital "automatic white balance" in tungsten light, corrected with the Curves Adjustment Layer in Photoshop

3.97 Digital tungsten mode in tungsten light

Effect of color temperature on film and digital images

In this series, Shawn Scully photographed Lego toys, replicas of actual vessels used for various space missions, in response to the renewed interest in space travel with the Mars Rover in 2004. Shot in tungsten light, each individual shot assumes a different color cast depending upon the type of recording media—tungsten film, daylight film, or digital sensor—and the type of color correction being used. There is not one "correct" color scheme. Rather, each cast references a different period or perception about space travel. For example, the warm cast (Figure 3.95) resembles color photography of the 1960s during the height of space intrigue; the bluer light (Figure 3.96) presents a frigid version of the lunar surface.

Color cast correction for digital images

Adobe Camera Raw and Adobe Photoshop offer various ways of correcting color, including Camera Raw's White Balance tool, or Photoshop's Curves, Color Balance, Auto Color, Levels, or Variations, among others. (For an overview of digital color correction see the index for *color: digital*.) Photoshop's Photo Filter emulates traditional over-the-lens warming and cooling filters with preset colors or by customizing colors. Camera Raw's White Balance tool provides a quick way to fix a color cast in an image if it has an area that 1) contains some detail and 2) should be a neutral white, gray, or black. To fix such a cast, follow the steps overleaf.

ONLINE RESOURCES **@ 3.2** Refer to our web resources for instructions on Adobe Photoshop's Photo Filter tool for correcting color casts.

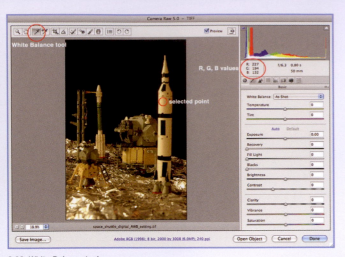

3.98 White Balance tool

3.99 Final image

@ ONLINE RESOURCES **3.3** Chemicals, times, and temperatures for the C-41 color negative development process are on our website.

STEP 1: Open the image in Camera Raw

■ In Adobe Bridge, select the image (JPEG, TIFF, or RAW) and then select *File > Open in Camera Raw* to open the image in Adobe Camera Raw.

STEP 2: Eliminate the cast with the White Balance tool

■ Select the White Balance tool in the toolbar

■ Locate an area in the image that should be neutral white, gray, or black. This area must have some detail (no specular highlights or pure blacks). In the space shuttle image, we chose a point on the body of the space shuttle because it *should* be white with detail (if there was no color cast).

■ Place the cursor over the point you selected. To eliminate your cast, click with the White Balance tool on this point and the tool will neutralize the cast by making the R, G, and B values of that point equal or nearly equal. If the color cast still exists, then you may have picked a point in the image that is not actually *supposed* to be neutral. In such a case, you may select a different point OR you may tweak the Temperature and Tint sliders after you use the White Balance tool to eradicate the cast.

PROCESSING IMAGES: DEVELOPING FILM

In your camera, light exposes the film, creating a latent image. In order to view this image, the film must be developed, fixed, and washed. If you are photographing with film, you may find that having it processed at a lab saves time and gives desirable results. You may, however, prefer to process your own film, for increased control over how your negatives look (for example, you can alter the development time to increase or decrease density and/or contrast), and for more options when photographing (for example, you can rate the film speed higher in your camera and compensate for this during processing). While many of the following sections will be helpful for both color and black and white film processing, refer to our web resources for specific information about the C-41 color negative development process.

Film processing: Work areas

There are several steps involved in processing film, each requiring attention to sequencing, temperatures, and times. Each also requires a different kind of work space. Depending upon how much space is available and how often you plan to process (or print) film, you may want to establish a dedicated room in which you can execute all of these steps, or to modify an existing bathroom, cellar, or utility room when needed.

Work area for loading film

Film is loaded onto reels for processing. This requires a light-tight changing bag, or a closet or room without ANY light, and a counter or table to assemble equipment. To make sure that the space is light-tight, spend at least 5 minutes in the dark. If you can see your hand in front of your face or detect any light seepage, especially around doors or windows, seal any leaks with lightproof material: aluminum foil, black fabric (attached with Velcro or tape), dark caulking, and weather stripping.

Work area for processing film

Once the film is safely loaded in the tank, it can be processed in the light because chemicals are poured through a light-tight hole in the tank's lid. Processing involves chemicals and water; choose a room or sink area that can accommodate spills. A faucet for running water and a drain are convenient, but not necessary. At the end of the process, you will need a dust-free location to dry your film. This can be an electric film dryer or simply a clothesline.

Wet darkroom for printing from film

If you are planning to print from the film with an enlarger (rather than scanning the negatives for digital printing), you may want to consider how a darkroom could figure into your plans for space. A darkroom should include a "wet" area (for trays to process film and/or paper) and a "dry" area (for cutting paper and for the enlarger). Running water and a drain are convenient, but not necessary. Walls do not need to be painted black: in a truly lightproof room, white walls will not be too reflective and will help reflect the indirect light of a safelight. The room should have reddish safelights (for printing negatives). You will need enough power outlets for the enlarger, safelights, and other equipment, such as a clock. Ventilation is important: you'll need an exhaust fan.

Film processing: chemicals, safety, mixing and storage

Chemical safety

Read the labels on all products Abide by any stated safety precautions. Manufacturers are required to provide Material Safety Data Sheets, which state all information about their chemicals. Request hard copies or web addresses with data.

Do not allow chemicals to touch your skin Problems may not be immediately visible, but chemicals do have an impact upon your body, especially with continued exposure. Wear rubber gloves to protect your hands, especially when

handling developer concentrates. Use tongs when handling prints in chemistry. Wash your hands after using chemicals.

Do not breathe chemicals in Avoid dry chemicals. Liquid solutions are safer. If using dry chemical powders, wear a mask. When working with any chemicals, always work in a well-ventilated area.

Check manufacturers' information to learn the proper way to dispose of chemicals Be especially careful with used fixer, which contains silver. If you are processing on a large scale, do not pour used fixer down the drain. Contact a disposal company for silver recovery.

Equipment for storing and mixing chemicals

You will need a selection of storage containers in which to keep your solutions, and graduated containers in which to measure and mix them.

Stock solutions and working solutions: Concentrates and dilutions

The terms *stock solution* and *working solution* refer to photographic chemicals' status for storage or use—whether the solution is in a concentrated or diluted form. Photographic chemicals come as a liquid or powder that is mixed with water to form a *stock solution*, a still-concentrated form of the chemical. For use, a small amount of this stock solution is diluted with water to form a *working solution*. The dilution will affect such factors as the length of time you process the film, whether you can only use the chemicals once or several times before discarding, and how long you can store the chemicals before they go off.

Always refer to the manufacturers' instructions, which come with the chemicals and can also be found on manufacturers' websites. Procedures and terms vary among instructions. For example, Kodak's black and white film developer, XTOL, comes as two packets of powder that must be mixed together with water to form a stock solution. This stock solution can form a working solution to develop film by using it full-strength, or diluted 1:1 with water. Some liquid chemicals are shipped as stock solutions. For example, Sprint Standard B&W Film Developer comes in a liquid concentrate. When ready to use, dilute the concentrate 1:9 (1 part developer/9 parts water) to make the working solution.

The following example provides a model for calculating the quantities to mix for a specific amount of solution. If making a solution that needs 1:9 dilution, start by dividing the final volume you want by 10. For example, a standard two-reel metal developing tank is 16 ounces. You would first measure out 1.6 ounces of Sprint

3.100 Water source

3.101 Thermometer

3.102 Stirring rod

3.103 Funnel

3.104 Safety equipment

3.105 Dark plastic containers

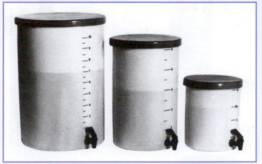

3.106 Plastic tanks for storing large quantities of chemicals; many have floating lids to prevent oxidation

3.107 and 3.108 Smaller cylinders, capable of measuring 1oz increments, may be needed if preparing chemicals from concentrate. Larger cylinders, 10–50oz, are good for mixing working solutions

developer concentrate (16 divided by 10), pour this into a larger graduate, and add water to bring the total liquid to 16oz (14.4oz of water).

Stock solutions and working solutions: Storage

The amount of time that chemistry will last, or its "shelf life," depends upon the type of chemistry, but can be predicted according to storage conditions:

- Temperature: most manufacturers recommend storing chemicals at 77°F or lower.
- Light: chemicals should be stored in dark glass or plastic bottles, away from strong light.
- Oxidation: keep air from reaching chemicals by storing full containers of solutions. If partly full, use squeezable bottles that allow you to remove air, or tanks with an extra floating lid.

■ Dilution: concentrates have a longer shelf life than diluted solutions. For example, Sprint Standard B&W Developer can be stored as a concentrate for at least one year unopened, while a full container of working solution diluted 1:9 is guaranteed to last only one month.

SMALL TANK FILM PROCESSING

Equipment to load film in small tanks

3.109 Bottle opener

3.110 Scissors



3.111 Exposed roll of film

Developing tank and spiral reels

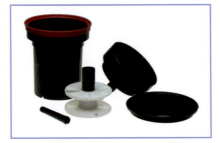

3.112 Plastic developing tank and reels/spirals
Film is loaded onto a plastic spiral that fits onto a central column. An inner funnel, with a hole that keeps light out but allows chemicals to be poured in, fits over the spiral. A lid fits over this funnel so that you can turn the tank upside down during agitation. Plastic tanks are versatile: the spiral reels expand to load 35mm or 120/220 film. It is easier to load plastic reels than metal ones, but the plastic reels are harder to clean and chemical residue may affect processing

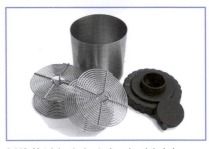

3.113 Metal developing tank and reels/spirals
The lid of a metal tank has a cap that covers a light-trapped aperture. Chemicals can be poured into and out of the tank through this hole. Each metal reel accommodates only one size of film. Reels are initially harder to load than plastic ones, but easier to clean

A developing tank consists of a lightproof cylindrical tank, a lid, and one or more "spirals" or "reels." Load film onto the reels, seal the tank, and pour chemistry through the lightproof lid and into and out of the tank. There are two types of tanks: metal or plastic.

Instructions for loading film in small tanks

WORKING IN THE DARK, you will need to be able to get the film from the cassette, load it onto the spiral and secure the reel in the lightproof tank. Before beginning, review these instructions and the ones that come with your developing tank. Lay out equipment in front of you and memorize its position. Practice loading a reel in the light (with your eyes closed) using a sacrificial roll of film.

Make sure your hands and all the equipment are bone dry—any trace of moisture will make the film stick. Even with clean hands, touching the emulsion side of the film will imprint oil and fingerprint marks. If you are only processing one reel of film in a multi-reel tank, insert the empty reels on top to fill up the tank. A single reel processed in a multi-reel tank will bump around and over-agitate the film.

Retrieving film from the cassette

If your camera has a hand-crank rewinder, consider *not* rewinding your film all the way. Instead, leave a few inches of film protruding from the cassette. This allows you to attach the end of the film to the reel in the light. If you want to use this method but have rewound your film all the way, or if your camera rewinds film automatically, a gadget called a *film picker* enables you to pull the end of the film out through the cassette lips. Pull 2 or 3 inches out, trim the end, and attach it to the reel. Then, TURN OFF THE LIGHTS before further loading the film.

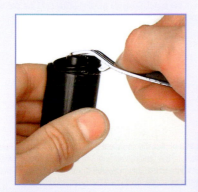 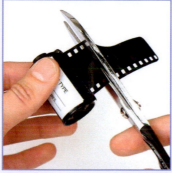

3.114 and 3.115 In total darkness, pull the flat end of the film cassette off with the opener. With the lights still off, locate your scissors and carefully cut off the tapered leader, taking care to cut between two perforations

The other method should be done in total darkness. If you have rewound your film completely into the cassette, use a bottle opener to remove the film from the cassette in order to load it onto a reel.

Loading film onto reels/tank (in the dark)
Loading onto plastic reels

3.116 1. Hold the reel in your left hand, with the lead-in-noses facing up. With your right-hand, hold the film (still rolled up) by the edges with your thumb and index finger. Pinch the film slightly to produce a gentle curvature down. Insert the end of the film into the reel until the film's sprockets are firmly engaged by the ball bearings of the spool

3.117 2. Once an inch or so of the film seems to be inserted, use the "self-loading" mechanism—twist the two halves of the spiral back and forward in opposing directions, while guiding the film with a finger. When you reach the end of the film, use scissors to cut the film end from the spool. Continue twisting spiral until the end is loaded

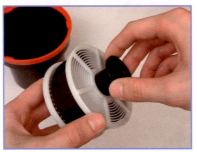

3.118 3. Put the spiral onto the center column and place them in the tank. Cover with the funnel (hub) and twist to lock into place. It is now safe to turn on the light. Cover with cap

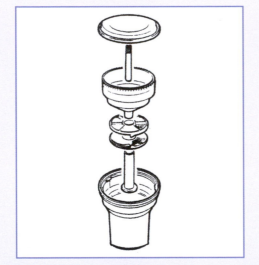

3.119 Order of parts in plastic developing tank

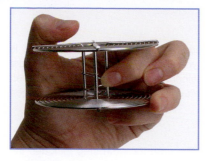

3.120 1. Hold the reel in your left hand, as shown, with the narrow end of the metal clip (in the center of the reel) pointing right. Your left index or middle finger should be on the end of this metal clip, ready to press down

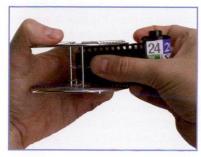

3.121 2. Press the clip end with your index finger. Use your right thumb to push the end of the film between the clip and bar, as far as possible (about ½ inch). Far enough that, when tugged gently, the film should not be released

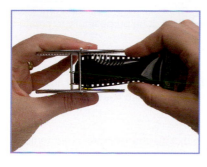

3.122 3. Pinch the film slightly to produce a gentle curvature
4. To load the film, continue to give more film with your right hand, while turning the spiral clockwise with your left hand. Rather than wrapping the film onto the spiral, the motion should be a loose back and forth motion, a give and release. If the film feels too tight or starts to buckle on one side, unwrap the reel a few inches and reload. When you get to the end of the film, use scissors to cut the film end from the spool. Place the loaded reel in the tank. Cover the reels with the lid. It is now safe to turn on the light

BLACK AND WHITE FILM PROCESSING

Equipment and instructions
Read the manufacturer's instructions thoroughly until you are familiar enough with them not to need them while processing. The process is continuous, with each

3.123 Instructions for processing times, temperatures, dilutions, and shelf life

3.124 Graduated container

3.125 Tray with chemicals in water bath. Includes developer, chemical stop (optional), fixer, washing aid (optional), and wetting agent

3.126 Timing device. Any clock or watch with a second hand; a clock with an alarm is helpful

3.127 Film clips

3.128 Drying cabinet

3.129 Negative storage page

step timed. Once you have started, you should continue through all the steps without pause.

Consistency and cleanliness

Everyone has particular ways of processing film. Whatever your quirks, it is important that they are consistent so that you can predict your results. Make sure that all equipment is clean and any containers or equipment shared between several chemicals (for example, a thermometer or a funnel) are rinsed between uses.

Timing

The timing device should be clearly visible. The time for each step includes the time it takes to pour the solution in at the beginning and out at the end. Make sure to keep in and out pouring times to a minimum and to drain the tank thoroughly between each solution. The developing time is especially crucial, as longer development produces darker, more contrasty negatives, especially in the highlight areas, and underdevelopment produces thin, flat negatives.

Temperature

The action of all chemicals is accelerated at higher temperatures, so make sure that chemistry is the correct temperature during processing. To maintain the correct temperature, use the water bath method, described in the paragraph below. At especially high temperatures, the film's emulsion will soften and wrinkle. This, known as reticulation, is also caused by extreme shifts in temperature between one solution and another and is sometimes done purposefully to create a grainy, dotted pattern in the emulsion.

Light

Pour solutions through the tank's pour spout that is designed to accept liquids but not light. Do NOT expose the film to light until after the film has been fixed.

The water bath method

During processing, the developer must be at exactly the recommended temperature and the remaining solutions should be within a certain number of degrees. The water bath method is a way of monitoring and controlling the temperatures of all your chemicals during the entire development process.

Place a tray of water in the sink. Set up a hose or faucet to run water in at the temperature of the developer. Use a clean measuring container to dilute each chemical to working strength (if necessary). Place containers of solution—developer, stop (optional), fixer, washing aid (optional), and wetting agent—in the

water tray. All chemicals should remain in the bath before and during processing. During development, set the developing tank in the water bath between agitation cycles.

Because chemistry takes a while to warm up or cool down to the correct temperature, prepare the chemistry and leave the containers in the tray while you load your film onto the spiral(s). Before beginning processing, check all solution temperatures and warm or cool the bath if needed.

Agitation

Agitation is a means of ensuring that liquids circulate throughout the tank. In processing, each step calls for a different degree of agitation. Follow these carefully, especially with the developer—too much agitation could overdevelop the negatives and leave streaks; too little could underdevelop the film.

 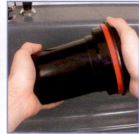 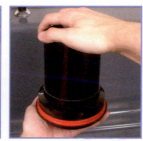

3.130 Agitation **3.131** **3.132**

To agitate, hold the tank with one hand on the top and the other on the bottom. Turn the tank upside down, twisting it slightly in the process. Hold it upside down for a second while solution flows down inside, and then turn it upright, twisting again. This is one "inversion." When agitating, repetitive movements cause chemicals to simply roll back and forth, in the same area. In order to ensure that the solution is distributed throughout the tank, the movement should be more varied—hence the twist in the inversion. After any period of agitation, tap the bottom of the tank several times against your work surface to remove any air bubbles.

Chemicals for processing black and white film
Developer

The developer makes the film's latent image into a visible image by turning exposed silver crystals into particles of metallic silver.

Some developers are intended to give finer grain, more shadow detail, greater sharpness, and varying degrees of contrast. These qualities will also be impacted by the developer dilution (for example, whether you use the developer at full strength or a 1:1 dilution), and by processing factors such as agitation and temperature. You can find suggestions and personal preferences by searching the Internet.

The instructions that came with your film will usually recommend one or more developers, with appropriate development times, dilutions, etc. Film manufacturers almost always recommend their own brand of developer. Kodak suggests their D-76 developer and Ilford advocates ID-11. These are virtually the same formulation and can be used interchangeably, using the same development times. It is not necessary to use the same brand of developer and film, although processing time/dilution information will be more available this way. Some developers can be reused a few times, others only once. The life of a developer will depend upon the type, the dilution, and the storage conditions.

Stop bath

Development continues until stopped by the introduction of the stop bath, which can simply be a water wash or can be a chemical solution of acetic acid or an odorless citric-acid solution. Some chemical stop baths should be discarded after each use. Indicator-type stop baths can be reused several times; they change color when they are exhausted. Indicator-type stop baths can be used to process both film and prints.

Fixer

The fixer, sometimes referred to as "hypo," stabilizes the now visible image by dissolving any remaining light-sensitive silver. After this step, the film can be safely exposed to light. Be careful not to overfix and bleach the image.

Fixers are available with "hardeners" that prevent scratches to film, and "non-hardeners," which are usually recommended for processing prints. Some are "rapid" fixers that cut processing times. It may be best to use a non-hardening fixer that can be used to process both film and prints.

Most fixers are meant to be reused several times. The manufacturer will give guidelines as to how many rolls of film can be processed per quantity of working solution. Keep track of how many rolls you process, or use hypo check to test the fixer's strength. A few drops of clear hypo check will turn cloudy in exhausted fixer.

Fixer remover (washing aid) / wash

After fixing, the fixer residue must be washed off the film or it will cause the film to deteriorate. The film can be washed in water for 20 to 30 minutes or can be soaked in a chemical washing aid, such as Heico Perma Wash or Kodak Hypo Clearing

Agent, before a shorter water wash. The shortened wash time lessens the chances that the emulsion will be softened and damaged.

Wetting agent
A wetting agent, such as Kodak Photo-Flo, keeps water from clinging to the surface of the film and forming water spots during drying. A small bottle of wetting agent will produce many bottles of working solution. Most working solutions of wetting agents are meant to be reused several times before discarding.

Determining development time and temperature
Film usually comes with instructions for development times and processing temperatures using developers of the same brand. Likewise, chemistry for developing film usually gives only instructions for film of the same brand. For example, Kodak's information chart for their developer XTOL lists only Kodak films. If you are crossing brands (for example, using an Ilford film with a Kodak developer), search for additional information on the manufacturer's website or use the development times from film with a similar film speed. If your searches for information puzzle you with different times for the same developer/film combination, use an average time. A few brands of developer, such as Sprint, do not manufacture film and so give developing times for a wide range of films. Over time, you may choose to adjust the development time (increase or reduce it) to produce negatives with a little more or less contrast and density.

Most manufacturers provide several options for processing temperatures, but the recommended temperature is 68°F, which is low enough to avoid softening the film's emulsion. The remaining solutions should be within ±5°F of the developer to prevent reticulation, which is the wrinkling of the film's emulsion caused by sudden temperature changes. Figure 3.133 gives an example of the kind of information available about developing times and temperatures.

Black and white film processing instructions
Pre-wet
Time: 30 seconds
Temperature: within 5°F of developer temperature
Agitation: constant

This optional short water bath softens the emulsion to make the film more receptive to the developer and to prevent air bubbles from sticking to the surface of the film.

To pre-wet, remove the cap from the tank's lid (do not expose film to light) and completely fill the tank with water that is at the same temperature as the developer. Replace the cap and tap the tank on the edge of a table or sink to

3.133 Kodak XTOL developer

dislodge air bubbles. Agitate for 30 seconds. Drain the water. It is normal for the water and subsequent solutions to show some color from dyes used in the film.

Developer
Time: see manufacturer's instructions
Temperature: see manufacturer's instructions
Agitation: first 30 seconds, then 5 seconds at 30-second intervals

When the developer temperature is correct, start the timer and quickly pour the developer into the tank. Replace the cap and tap the tank on the edge of a table or sink to dislodge air bubbles. Agitate for the first 30 seconds and then for 5 seconds at 30-second intervals until the end of the processing time. After each agitation cycle, tap the tank on the counter to dislodge air bubbles. Between agitation cycles, keep the tank in the water bath to maintain the correct temperature. When there are 10 seconds left in the developing time, begin pouring the chemistry from the tank's spout (either discard or recycle, according to manufacturer's instructions) and move immediately to the next step.

Stop bath
Time: 30 seconds
Temperature: within 5°F of developer temperature
Agitation: constant

Pour running water or a chemical stop bath into the tank to stop development. Replace lid and agitate constantly for most of the remaining 30 seconds. Empty the tank during the final few seconds.

Fixer
Time: see manufacturer's instructions (5–10 minutes)
Temperature: within 5°F of developer temperature
Agitation: first 30 seconds, then 5 seconds at 30-second intervals

Pour fixer into the tank. Replace lid and agitate for the first 30 seconds, then for 5 seconds at 30-second intervals until the end of the processing time. After each agitation cycle, tap the tank on the counter to dislodge air bubbles. Between agitation cycles, keep the tank in the water bath. When there are 10 seconds left in the fixing time, begin pouring the chemistry from your tank (either discard or recycle, according to manufacturer's instructions). At the end of the fixing time, you may inspect the negatives in the light. If you do look at a few frames of the film, make sure that the areas between the frames and around the sprocket holes are clear and there is no trace of "milkiness." If the film is not clear, refix using fresh fixer.

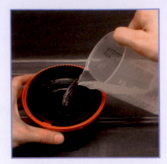

3.134 Pouring the developer

Wash / fixer remover

Time: water wash (20–30 minutes); washing aid (water for 2 minutes; washing aid for 2 minutes; water wash for 7 minutes)
Temperature: within 5°F of developer temperature
Agitation: washing aid (5 seconds at 30-second intervals)

There are two options for the final wash: washing only with water or supplementing the water wash with a washing aid.

If using only water, remove all lids from the tank. Place spirals in a film washer OR leave them in the tank with a hose or faucet running directly into the tank at the same temperature as the developer; every minute, dump the water from the tank and allow it to refill.

If using a washing aid, first do a water wash for 2 minutes. Then, pour in the washing aid. Place the lid on the tank to agitate. After the second minute, pour out the washing aid. Wash spirals in a second water wash for 7 minutes, changing the water every 30 seconds.

Wetting agent

Time: 1 minute
Temperature: within 5°F of developer temperature
Agitation: none

Pour the wetting agent into the tank. Let film soak for 1 minute.

Drying and storing negatives

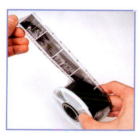

3.136 Carefully remove the film from the spiral and hang it in a dust-free place to dry

3.137 Attach a weighted film clip or clothespin to the bottom to prevent curling. The film will be dry in 1–2 hours

3.138 When dry, use scissors to cut the film into strips that can be stored in plastic negative pages. Be careful to cut the film in the space between the images. Never touch the image area of the film. Handle only by the ends or edges

3.135 Water wash

Black and White Negative Film Processing Steps

Solution or Procedure	Time in Minutes (includes a 10-second drain time)	Temperature (Fahrenheit)	Agitation in Seconds* *After agitation, rap tank on sink to dislodge bubbles		
			Initial	Reset	Agitate
1. Water Pre-wet	40 seconds	Within 5° of the developer	30		
2. Developer	See manufacturer's instructions.	Recommended is 68° (see manufacturer)	30	25 (Continue the 25 to 5-second cycle for the remainder of the development.)	5
3. Stop	40 seconds	Within 5° of the developer	30		
4. Fixer	See manufacturer's instructions. (5 to 10 minutes)	Within 5° of the developer	30	25 (Continue the 25 to 5-second cycle for the remainder of the fix.)	5
---- The remaining steps can be done in the light. ----					
5. Water Wash	2 minutes	Within 5° of the developer		Refill tank with fresh water, agitate, dump and refill.	
6. Washing Aid/Fixer Remover	2 minutes	Within 5° of the developer	30	25 (Continue the 25 to 5-second cycle for the remainder of the washing aid.)	5
7. Water Wash	2 minutes	Within 5° of the developer		Refill tank with fresh water, agitate, dump and refill.	
8. Wetting Agent	1 minute	Within 5° of the developer			
9. Dry	10 to 20	75 to 110°			

3.139 Black and white negative film processing

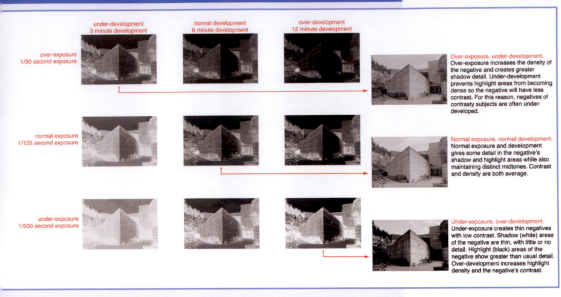

under-development
3 minute development

normal development
6 minute development

over-development
12 minute development

over-exposure
1/30 second exposure

Over-exposure, under-development.
Over-exposure increases the density of the negative and creates greater shadow detail. Under-development prevents highlight areas from becoming dense so the negative will have less contrast. For this reason, negatives of contrasty subjects are often under-developed.

normal exposure
1/125 second exposure

Normal exposure, normal development.
Normal exposure and development gives some detail in the negative's shadow and highlight areas while also maintaining distinct midtones. Contrast and density are both average.

under-exposure
1/500 second exposure

Under-exposure, over-development.
Under-exposure creates thin negatives with low contrast. Shadow (white) areas of the negative are thin, with little or no detail. Highlight (black) areas of the negative show greater than usual detail. Over-development increases highlight density and the negative's contrast.

3.140 Evaluating black and white negatives

Evaluating black and white negatives for density and contrast

The negatives in Figure 3.140 show the same scene, reproduced at different exposures and developed for different amounts of time. Look at the shadow, highlight, and midtone areas to determine negative *density* and *contrast*. Remember that the shadow and highlight areas within the original scene will be represented reversely in the negative. In the negative, shadow areas will appear white or clear (with some or no detail). Highlight areas will appear black (with some or no detail). The amount of detail in these areas depends upon the negative's *density*. Density is the buildup of silver as a result of exposure to light and development.

Contrast is the difference between shadow and highlight areas. A high-contrast negative has an extreme jump from black to white, with few midtones. A low contrast, or flat, negative has little difference between shadows and highlights—all areas are within a similar tonal range. There is no single ideal or standard for contrast; rather, contrast should be considered in terms of each particular image and how the flatness or contrast affects form and content. In a negative, contrast is determined by many factors, including the values and lighting of the original scene, the type of developer, the temperature and length of development, and the amount of agitation during processing. If you understand how exposure and development time affect the construction of the image, you can play with these factors to alter image detail, density, and contrast.

How exposure and development affect the negative

During exposure, the brightest areas of the scene (the highlights) will have the greatest and fastest chemical reaction on the film's emulsion. Midtone areas affect the film more slowly and shadow areas take the longest to reflect light on the film. Therefore, too little exposure produces thin negatives with no detail in the midtone or shadow areas. Overexposure produces greater density and more detail in the shadow areas, but also may block up highlights and obscure detail in the lightest areas of the scene. Overexposed negatives will print better than underexposed ones. A general recommendation is to expose for the shadows. Determine how much detail is needed in the darkest part of the scene and expose for this area. If in doubt, overexpose.

During processing, the developer turns exposed silver halide crystals into metallic silver. The highlight areas appear during the early stages of development, followed by midtone and then shadow areas. Under-development will prevent details from developing and the negative will have low contrast. Over-development will have little effect on the shadow areas, but great effect on the highlight areas, causing those areas of the negative to become extremely dense and increasing the image contrast.

Push processing film

Once you understand how exposure and development affect the negative density and contrast, you can purposefully adjust them to suit your needs. The most common technique is called *push processing* or *up-rating film*. To push-process, underexpose the entire roll of film by one or more stops, and then over-develop the film by 25–50% (per stop decrease). Shift the film speed for the duration of the roll. Increase development only. All other chemical steps remain the same. Many photo labs can push-process film.

Image-makers often use this technique in situations where the lighting is too dim for the film speed being used. For example, when photographing indoors with 100 ISO, you may need to use a shutter speed of 1/30 to have an aperture of f/8. Up-rating the film's speed one stop, to 200 ISO, allows you to shoot the roll at f/8 and 1/60 sec. Since the whole roll will be underexposed by one stop, over-develop to compensate.

There are aesthetic side effects: negatives will have increased graininess and image contrast and diminished shadow detail. Only push-process if these formal qualities fit the conceptual goals of your subject.

Trouble-shooting: Evaluating negatives for camera, lens, and development problems

After processing, inspect your negatives to see if any problems have occurred as a result of equipment difficulties or film development complications. Below, we describe some common problems, their probable causes, and solutions.

Clear negative

Problem: The negative is completely blank, but with visible film frame numbers and manufacturer's name.

Likely cause: The film was not exposed to light, either because the film did not advance through the camera, the lens cap was left on, the shutter did not open, or the flash did not fire.

3.141 Clear negative

3.142 Fogging

Remedy: Load the film properly in the take-up spool and, before making the first exposure, make sure to remove the camera's lens cap. If the problem persists, have the camera examined by a technician.

(*Note*: If the negative is completely blank and no film frame numbers or manufacturer's name is visible, the film was probably placed in the fixer before it was placed in the developer. Make sure to clearly label the chemical containers and to perform development in the correct order.)

Fogging

Fogging, in which the negative is unintentionally exposed to light, is a common problem that can occur in many different ways.

Problem: In its mildest form, a fogged negative appears darkened in the image area but not in the film edges.

Likely cause: Negatives received unintentional flare from light when image was recorded.

Flare can be caused by a direct light hitting the lens surface that bounces around within the lens, a light source within the image that creates glares, or scratches, dirt, dust, or finger oil on the lens.

Remedy: Use a lens shade matched to your lens's focal length to prevent light from shining directly into the lens. Change your position in relation to lights in the scene to lessen the light brightness. Make sure that the lens is clean.

Problem: In more serious instances, the negative appears darkened in the image area and/or at the film edges.

Likely cause: The film has been accidentally exposed to light. This problem may result from 1) light leaking into the camera back or film cassette, 2) a light leak in the film development tank, 3) expired film, or 4) exposure to high temperatures.

Remedy: Make sure the camera back, locking mechanisms, and hinges are working properly, and that the back does not open when the roll of film is exposed inside the camera. Load film in shaded areas so that you do not expose undeveloped film to too much light. Make sure the film cassette is not bent or damaged. Make sure the processing tank lid is properly secured and that, if using a plastic tank, the tube that runs through the center of the film reels is seated properly. Don't

unintentionally expose the negative to light, heat, or radiation (e.g. a hot car, or an airport x-ray machine). Do not use film that is past its expiration date.

Crescent shapes

Problem: The negative is imprinted with crescent shapes that are lighter or darker than the surrounding area.

Likely cause: The film was crimped or kinked while it was loaded onto the developing reel.

Remedy: Make sure the reels are completely dry so that the film does not stick while being loaded. Handle the film carefully; do not press with fingernails. If you have difficulty loading the film, unroll and reload the roll rather than forcing it onto the reel.

Large, irregular, blank patches

Problem: The negative has large, irregular, dark or creamy-colored blank patches on the emulsion surface.

Likely cause: Sections of film were stuck to each other during film processing.

Remedy: Load film smoothly onto the reel; crinkling sounds indicate that the film is bending rather than wrapping along the spiral. Do not force film onto the reel. If you feel as though the film is stuck, unwind and reroll it.

PRINTING IMAGES: TRADITIONAL PROCESSES

Printing and enlarging film

Once you have processed the negatives, they can be printed on photographic paper. A photographic print is a positive image made from a negative. During the printing process, light areas of the film are printed as dark values, dark areas become light, and colors are printed as their complements. While the following section describes traditional printing equipment and black and white printing techniques, negatives can also be scanned into digital files that can be altered and printed on a digital printer. See index for *digital scanning* and *digital printing*.

The traditional chemical process involves printing negatives on light-sensitive materials. You can take the film to be printed at a commercial lab or print it yourself in a "wet" darkroom, using an enlarger. In the darkroom process, you will shine a controlled amount of light through the negative onto light-sensitive material. There are two methods of printing: *contact printing* and *enlarging*. A *contact print*

3.143 Crescent shapes

3.144 Irregular blank patches

@ **3.4** Refer to our web resources for information about color photographic papers and for information on printing color photographs in the darkroom.

Darkroom Equipment: Exposing the Paper

Timer: digital electric or rotary dial timers control the amount of time the enlarger's light is on.

Photographic Printing Materials: usually paper, but can be any material with a light-sensitive emulsion.

Grain Magnifier: magnifies grain to make it easier to focus the enlarger's lens.

Anti-static Brush, Canned Air or Film Cleaner: are various ways to clean dust from the negative. The liquid film cleaner also helps to remove fingerprints and dirt; wet Q-tip and wipe.

Enlarger: projects light through the negative to make a positive.

Safelight: black-and-white and color paper are sensitive to different lights. For black-and-white printing use an amber light, an orange 25 watt bulb, a red bicycle light or a sodium vapor light with adjustable doors. For color, print in total darkness or with a #13 amber light.

Scissors or Paper Cutter: cut paper for test strips or smaller prints.

Dodging and Burning Tools: hand-made devices allow you to direct or block light from any part of the print. In addition, readily available objects (such as your hand) can be used to dodge some areas.

Sheet of Glass: presses the negative(s) against the paper when making contact prints; tape the edges with masking tape.

Easel: a hinged frame that keeps the photographic paper flat during exposure and creates precise borders; some easel blades are adjustable.

Darkroom Equipment: Processing the Paper

Trays: at least three trays (developer, stop bath and fixer), but possibly six (Holding Bath, Washing Aid/Fixer Remover and Final Wash). Trays should be designated for each chemical (the developer tray should nto be used for fixer, etc.). They should be large enough for the paper with some room for agitation.

Tongs: transfer prints from tray to tray without fingers touching paper or chemicals. Color-coding the tongs (blue-developer; red-stop; yellow-fixer) helps to prevent contamination.

Vertical Washer: archival washer separates prints during wash to allow fresh water to circulate. Washing time is less than a tray bath. To use, start washer. Allow water to fill. Drop print into slots.

Clock: with a second hand and glow-in-the-dark numbers will help you keep track of processing times.

Thermometer: check temperature of chemicals and water.

Darkroom Equipment: Drying the Paper

Drying Tools: Automatic processors have the drying step built in so that the paper enters the machine dry and exits dry. Tray-processed prints and fiber-based prints must be air-dried on blotting paper or screens. RC paper should be hung with clothes pegs or can be run through a heat dryer.

Squeegee: removes surface water from printing after the final wash and before drying.

3.147 Darkroom equipment

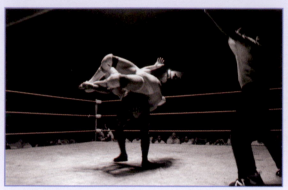

3.145 Charles Fairbanks, *Arena Isabel, Cuernavaca*, 2001. Silver gelatin print, 16 × 20in

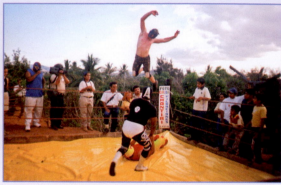

3.146 Karen del Rosario Arreola Moguel, *Documentation of the One-Eyed Cat*, 2004. Color photograph, 16 × 20in

While studying in Mexico in 2001, former wrestler Charles Fairbanks photographed the theatrical form of Mexican wrestling, La Lucha Libre. Later, he chose to return to Mexico in order to teach photography to local children while practicing La Lucha Libre with the wrestlers he had photographed years before. For the final project in their photography classes, his students photographed his Lucha debut as the One-Eyed Cat (El Gato Tuerto). Their photographs then hung alongside his own in exhibitions in Mexico and the U.S.

is made by pressing a negative directly against photographic paper, whereas an *enlargement* is made by projecting light through the negative onto the paper. Once the paper has received the latent image, the print is developed, fixed, washed, and dried (if black and white) or developed, bleached/fixed, and dried (if color).

Darkroom facilities, equipment, and materials

A darkroom includes a dry area (for cutting and exposing the paper to light), a wet area (for processing black and white paper in trays), and a dust-free area for drying prints. See "Film processing: work area," p. 244, for additional tips on outfitting and lightproofing a darkroom. Running water and a drain are convenient for tray processing, but not essential.

If printing black and white film, the room should have reddish safelights. Install safelights on the ceiling or under tables. If too bright or installed too close to the work table, they can fog the paper. Install at least 3 feet from chemical trays and paper areas. You will need enough power outlets for the enlarger, safelights, and other equipment, such as a clock. Ventilation is important: an exhaust fan is necessary to remove chemical fumes.

The enlarger

There are two types of enlargers, the diffusion enlarger and the condenser enlarger. Both distribute the light evenly across the negative. A condenser enlarger gives greater printing contrast than the diffused light type.

BLACK AND WHITE PHOTOGRAPHIC PAPERS

Photographic printing papers are coated with light-sensitive emulsion. The emulsion is sensitive to different waves of light depending upon whether the paper is meant for color or black and white printing. Black and white photographic paper is sensitive to blue or blue and green light, but not to red and orange, and so can be safely exposed to an amber or red safelight in the darkroom. All photographic papers come packaged inside a lightproof black plastic bag inside a cardboard box. Make sure to keep paper inside the sealed bag and box at all times, especially when printing in a community lab where someone might turn on the white lights without warning. Black and white paper that is accidentally exposed to light will be *fogged*. Fogged paper is unusable, as it produces a gray or colored veil in affected areas. Handle paper by the edges and corners. Do not bend (paper will crease) or touch the image area (fingerprints will be permanent). Fingerprints are more likely to show up on glossy paper. If storing unused paper for long periods, seal tightly and place the box in a refrigerator or other cool location. Allow the paper to return to room temperature before printing.

Locating the emulsion side

Photographic paper is coated with light-sensitive emulsion on one side. While exposing and processing photographic paper, it will be necessary to place the paper on the easel base or in the chemical trays so that the emulsion side faces a certain direction (up or down, depending upon the situation). A couple of clues to help figure out which side is the emulsion side:

- Papers tend to curl upward when the emulsion side faces up, and down when the emulsion side faces down.
- Papers with a glossy surface will have a slight shimmer to the emulsion side.

Paper characteristics

Black and white photographic papers are made by coating light-sensitive emulsion onto white or colored paper stock. The makeup of the emulsion varies depending upon the brand of paper, but metallic silver halides suspended in gelatin is the most common composition. Emulsions for black and white printing are also available in liquid form. Referred to as liquid light, the solution can be painted onto

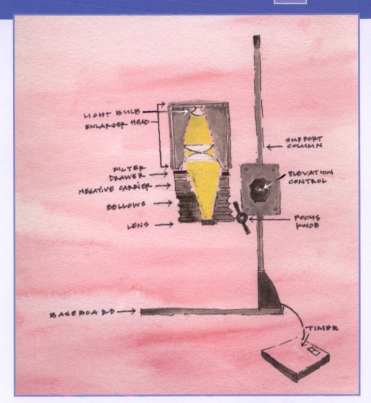

3.148 Enlarger diagram

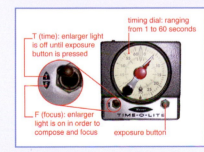

3.149 Enlarger timer

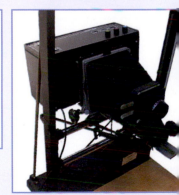

3.150 The enlarger head is turned 90° to project horizontally onto the wall of a darkroom for poster-size prints

most surfaces to turn them into light-sensitive materials able to record a photographic image. See more about *liquid emulsions* in the index.

Commercial photographic papers are pre-coated with the emulsion. There are two kinds of black and white printing papers: *fiber-based* (a wood fiber paper coated with emulsion) and *resin-coated* (the paper is laminated between plastic before being coated with emulsion). There are also specialty papers that use linen or fabric instead of paper. Fiber-based papers take longer to process but yield richer black tones, a wider tonal range, and, with archival processing, a longer lifespan (around 70 years with archival processing). Fiber-based prints are receptive to toning and are less reflective than those on resin-coated papers, which may not tone and which have a plastic look and feel. Resin-coated papers (also referred to as *RC papers*) have shorter processing times. With proper processing and storage, resin-coated papers will not fade or crack for about 30 years. Whether you choose fiber-based or resin-coated, all papers share the following characteristics:

- *Tone* refers to the paper color and image color (the color of the silver after processing). Common tones are *cold-tone papers* with a blue-black silver on a bright white paper base; *neutral papers* with a neutral black; and *warm-tone papers* with a brown- or green-black on a cream or yellow paper base. Print developer also affects image tone and, if this is a priority, use a cold-tone developer with cold-tone paper, etc.
- *Contrast*, the range of tones from light to dark, is one of the most important choices with black and white printing papers. Contrast is mainly controlled by the paper and, sometimes, with filters. Contrast is also affected by processing chemistry and procedures. Black and white papers offer two contrast options: *graded papers* and *variable contrast* (aka VC, Polycontrast, or multigrade) *papers*. *Graded papers* are set at a specific contrast rate. These range from #0 to #6, with #2 being average contrast, #0 the lowest, and #6 the highest. The box of paper is all the same grade. You can balance a contrasty negative by printing it on a low contrast (#0 or #1) paper. To switch to a different grade, you must use a different box. Investing in an entire box of one grade can be impractical; it is better to work with variable contrast papers.
 VC papers can achieve any contrast grade when used in conjunction with variable contrast filters. Contrast levels vary slightly between brands; a #2 from one manufacturer may be slightly more or less contrasty than a #2 from another company. For additional information about contrast, see the index for *contrast*.
- The paper *surface* may be a choice between glossy, semi-glossy, matte, semi-matte (also called luster, pearl, and oyster), and satin. Matte papers are less reflective and have a slight texture. Glossy papers tend to make the image seem sharper. Some manufacturers offer textured surfaces, such as silk.

- The *weight* or thickness of the paper varies from single-weight (the thickness of bond paper) to double-weight (the weight of light board). When printing large prints, use double-weight paper to avoid crinkling.
- Boxes containing sheets of paper come in the following standard *sizes*: 5×7 inch, 8×10 inch, 11×14 inch, 16×20 inch, and 20×24 inch. Some papers offer additional sizes or rolls for mural prints.

Black and white photographic printing paper: Making comparisons

3.151 Cachet Multibrom Warm **3.152** Bergger Warm Tone **3.153** Kentmere Fineprint VC **3.154** Ilford Multigrade IV

In this series of images, you see the results of Charlotte Ording's experiment with black and white photographic printing papers. She printed the same negative on four different brands of paper in order to understand how paper characteristics such as surface, tone, and contrast affect how the image is interpreted. Paper tones vary from the creamy base of the Cachet Multibrom to the bluish cast of the Kentmere Fineprint VC. Bergger WarmTone reproduced the greatest tonal range, giving weight to the stockinged leg.

BLACK AND WHITE PRINT PROCESSING

Chemicals and instructions
Chemicals for processing black and white photographic papers are essentially the same as those used to process film, with a few exceptions. The developer performs the same function in both instances, but has a different chemical makeup. The stop bath, fixer, and fixer remover are the same for film and paper, though manufacturers recommend different dilutions and times. The fixer remover (also called the *washing aid*

developer	stop bath	fixer	holding bath	washing aid / wash

The developer turns the print's latent image into a visible image by turning exposed silver crystals into particles of black metallic silver. The print developer will affect the tone of the print. Tones vary from warm brownish-black to cool bluish-black. Any developer will process any paper, regardless of the tone, though manufacturers encourage use of cold-tone papers with cold-tone developers and so on.

Development continues until stopped by the introduction of the stop bath. Use a chemical stop bath for fiber-based papers; development of RC papers can be neutralized in a chemical or water stop bath. An indicator-type stop can be reused several times and changes color when it is exhausted.

The fixer, also called "hypo", stabilizes the now visible image by dissolving any remaining light-sensitive silver. After this step, the paper can be safely exposed to light. Be careful not to overfix and bleach the image.
Fixers are available with "harden-ers" that prevent scratches to RC prints, and "non-hardeners", which are usually recommended for processing fiber-based papers. Non-hardening fixers can be used to process both film and prints. Some fixers are "rapid" fixers and cut processing times. Use hypo check to test the fixer's strength. A few drops of clear hypo check will turn cloudy in exhausted fixer.
For archival print processing (fiber-based paper only), use a two-bath fixer. Begin with two trays of fixer. Fix print for half the time in the first bath and half in the second. When the first bath becomes exhausted, promote the second bath to the first position and mix fresh solution for the second bath.

If fixer residue is not washed off with water, the print will deteriorate. Wash prints in a tray bath with a siphon and running tap or in a vertical washer. RC papers can be washed for a short amount of time. Double-weight fiber-based papers must be washed for 1 hour. To reduce this time, the print can first be bathed in a chemical Fixer Remover / Washing Aid, such as Heico Perma Wash, before a shorter (10-20 minute) water wash. The shortened wash time lessens the chance that the emulsion will be softened and damaged.
All prints must be in the wash before starting the clock. Do not add prints after the wash begins or partially washed ones will be contaminated.

The holding bath, a tray of water, puts already processed images in process-ing limbo while continuing to make additional prints. Once you have finished printing, or when the holding bath is full, all prints can be placed in the washing aid or water wash together. Replenish the holding bath with fresh water every hour or when full of prints. together.

3.155 Black and white print processing

3.156 Place paper in developer

3.157 Let print drip

or *hypo clearing bath*) is not used with RC (resin-coated) papers. The wash is the final step, as a wetting agent (used in film processing) is not used when processing paper.

Check manufacturers' recommendations for storage, shelf life, and exhaustion rate of each chemical. In general, each quart of working solution of developer, stop, and fixer can process 20–25 prints. Fixer remover can process half as many. Use enough chemistry in trays to immerse the whole print under each solution.

Safety issues when handling chemicals

Read manufacturers' literature about possible hazards and ways to handle problems. Wear gloves when handling any chemicals, safety glasses when working with solutions that could splash, and a mask when working with powders. Always use tongs to transfer prints from one bath to another. Do NOT stick your hands in the chemicals. To avoid dripping water on the floor, place a wet print in a tray to move it from one location to another. Work in a well-ventilated space and wash your hands during and after contact with materials. Dispose of all materials according to manufacturers' instructions.

Temperature

Black and white printing papers are either resin-coated or fiber-based. Processing steps and times differ for each and are described in Figure 3.160. The temperature of all chemicals should be between 65°F and 70°F. Developer is less effective at colder temperatures and more rapid at higher ones. Water washes inefficiently below 65°F and softens emulsions at high temperatures.

Agitation

Instructions include comments about agitation. There are two methods: rocking the tray, and turning the print. Each causes the chemistry to move in a different pattern, ensuring that the paper is exposed to fresh chemistry throughout the processing. Use tongs to flip the print; pinch the rubber tips to part of the paper's border to avoid scratching the image.

Avoiding contamination

The times described for all steps include a 10-second drip: use tongs to hold the print over the tray and let excess chemistry drip off. This helps to preserve chemicals and keep baths from becoming contaminated. Always use tongs to transfer the paper from one tray to the next. To prevent contamination, each chemical should have a designated, color-coded, set of tongs (developer—blue; stop—red; fixer—yellow). Do not add prints to the water wash once it has begun.

Consistency

Maintain the same processing times, temperatures, and agitation for all prints. If a test strip is developed for 2 minutes and then the total exposure is processed for 3 minutes, the image density and contrast will vary. Do not over- or under-process.

Trouble-shooting: Common black and white printing problems

After processing, inspect the print to see if any problems have occurred as a result of equipment difficulties or processing complications. Below, we describe some common problems, their probable causes and solutions.

Problem: Yellow stains on print

- *Likely cause*: Yellow stains can result from: 1) too much time in the developer; 2) exhausted developer, stop bath or fixer; 3) developer temperature too high; 4) developer contaminated by fixer; 5) the paper was exposed to too much air when agitating; or 6) insufficient washing.
- *Remedy*: Check and correct any of the above.

Problem: Brownish-purple stains on print

- *Likely cause*: Insufficient fixing.
- *Remedy*: Make sure that the fixer is not exhausted and fix print for recommended time, with the necessary agitation.

Problem: Overall gray cast in the highlights and on the margins of the paper

- *Likely cause*: 1) the printing paper may have been fogged by enlarger light or safelights during printing or processing; 2) if the paper's packaging was not closed adequately, the paper may have been fogged during storage; 3) the print may have been in the developer for too long.
- *Remedy*: Make sure that that there are no light leaks into the darkroom, no stray light from the enlarger or timer, and that the safelights are an appropriate strength and distance from the print. Keep the paper in the developer for the recommended amount of time. During fixing, do not expose the paper to light until the fixer has had enough time to desensitize the film. Store the paper properly (away from heat and light).

3.158 Squeegee

3.159 Place print on drying screen

Processing Black and White Photographic Paper

Steps	Time	Agitation	Processing Information
Developer	1 1/2 minutes for RC papers. 2 to 3 minutes for fiber-based papers.	Agitate by gently rocking tray every 30 seconds; flip print occasionally.	Slide paper into developer emulsion side up or down. Do not leave the paper in the developer for less or longer than the recommended time.
Stop Bath	10 to 15 seconds for RC papers. 30 seconds for fiber-based papers.	Agitate once or twice by tipping tray.	A chemical indicator stop bath will change from yellow to purple when exhausted.
Fixer	2 minutes for RC papers. 5 to 10 minutes for fiber-based papers.	Agitate constantly for the first minute, then every 30 seconds for the remaining time.	After 1 minute in the fixer, prints can be viewed briefly in white light. After examination, continue fixing for the required amout of time. Test fixer occasionally with hypo-check. If fixer is exhausted, hypo-check drops will turn cloudy. See index for description of *archival fixing*.
Holding Bath	Deposit prints in holding bath until ready for final wash of all prints.	Replenish constantly with fresh water.	
Washing Aid/ Fixer Remover	Do not use with RC papers. 2 to 4 minutes for fiber-based papers.	Agitate constantly.	A chemical washing aid is not necessary, but it cuts down on the prints' final water wash time.
Wash	4 minutes for RC papers. 1 hour for fiber-based papers if no washing aid was used. 15 minutes with washing aid.	Replenish constantly with fresh water.	Wash time depends on type of equipment used (tray with hose or vertical washer) and the number of prints in bath (fewer prints means water is better distributed and less time).
Dry	Varies depending on method used. Heated dryers take a minute. Air-drying can take a few hours.	N/A	Squeegee excess water off both sides of print. Dry fiber-based prints on drying screens. Hang RC prints with clothes pegs, dry on screens or run through a heated dryer. On screens: dry RC prints face up and fiber-based prints face down. (If using a communal lab, dry all prints face up to avoid contamination.) Clean screens frequently.

3.160 Processing black and white photographic paper

3.161 Cordelia McGehee, *Angelic Shrimp Ascend to Heaven*, 2006. Silver gelatin print, 8 × 10in.
In this photogram, Cordelia McGehee tested the transparency and opacity of rock salt, shrimp shells, sphagnum moss, maple seeds, cheesecloth, and rose petals. Their exposure to light reveals details such as the overlapping transparent plates of the shrimp exoskeleton. McGehee's symmetrical ordering of disembodied sea creatures and her use of texture-based patterns, heart-shapes, and a densely covered ground recall the designs of sailors' Valentines

THE PHOTOGRAM

A photogram is a camera-less photographic image. Rather than taking an image of an object with a camera, the photographer places two- or three-dimensional objects on photographic printing paper and exposes them to light. Light passes most easily through translucent objects (producing some exposure in the processed paper), and is obstructed by denser objects (creating little or no density in the print). The following text describes the basic process for making a photogram.

Materials and equipment

Photographic printing paper, sheet of glass, objects and/or images for printing, opaque board (such as a large book) to block light when making a test strip.

Creating a photogram

Step 1. In the light, turn on the enlarger and place the sheet of glass on the enlarger baseboard.

Step 2. Make sure negative tray is closed before turning on the enlarger light (focus button). Open the enlarging lens to an aperture of f/8. Raise the enlarger head so that the light covers the glass. Set the timer for 2 seconds. Turn off the light.

Step 3. Place a piece of unexposed photographic paper on the baseboard (emulsion side up) under the sheet of glass.

Step 4. Arrange the objects/images on the unexposed paper. In addition to these materials, which will be contact printed, you can also project objects from the negative carrier. For example, placing woven or mesh fabric, or transparent material, such as a leaf, in the carrier will project a pattern into the image.

Step 5. Hold a book or an opaque board a few inches over the objects/paper/glass so that all but 2 inches of the paper will be shielded from the light.

Step 6. Expose for 2 seconds.

Step 7. Move the book over another 2 inches (now 4 inches are uncovered) and expose for 2 more seconds (the original 2 inches has now been exposed for 4 seconds total). Repeat this procedure all the way until you make the last exposure with the photo paper completely uncovered. Process the paper.

Step 8. Evaluate the test strip to determine the area with the best density. If you

have objects of various materials and thicknesses, you may want to choose an exposure that produces a rich black in one area of the strip.

Step 9. Reset the timer to the chosen exposure. Place a sheet of unexposed paper on the baseboard. Rearrange objects if necessary, make the final exposure and process.

PRINTING A CONTACT SHEET IN THE DARKROOM

Contact printing is a method of printing in which the negatives are touching the photographic paper when exposed to light. As a result, the positive images are the same size as the negatives. Contact printing can be used to print either a single image or a *contact sheet*, a print of many negatives on one piece of paper. A contact sheet makes it easier to evaluate black and white or color negatives when choosing one to enlarge. These sheets can be stored alongside the negatives for future reference.

Tools and equipment

- Negatives (cut in strips).
- Photographic paper—if black and white, use variable-contrast paper.
- Clear plastic storage page (optional)—storage pages keep negatives clean, in order, and prevent them from curling; however, the plastic makes the image slightly less sharp.
- Opaque board (a book is usually handy).
- A sheet of glass works well, and is inexpensive and easy to purchase. A hinged contact frame (see Figure 3.162) keeps the negatives in order without having to use clear plastic storage pages, and is easier to manage in the dark.
- Enlarger with timer.
- Photo-processing chemistry and equipment.

Set up the enlarger

IN THE LIGHT, make sure the enlarger is plugged in and equipped with a lens. The enlarger lens is like a camera lens, with a variety of aperture settings. Make sure the lens's aperture numbers are easily visible. Set the aperture to a mid-size setting (f/8). (Mid-size and small apertures yield good edge sharpness and even illumination.) To contact-print, some enlargers need an empty negative carrier in the enlarger.

If the enlarger has a colorhead, and you are printing black and white, set the head to no filtration, the equivalent of a #2 filter (see index for *contrast* for more details). Set the enlarger's timer to 4 seconds.

3.162 Hinged contact frame

3.163 Glass being lowered onto paper and negatives

3.164 Cover paper, negatives, and glass with board

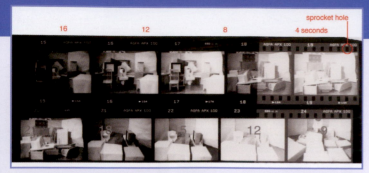

sprocket hole

16 12 8 4 seconds

3.165 Test print contact sheet

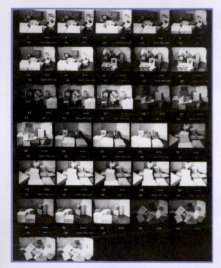

3.166 Full contact sheet

3.167 Contact sheet section

Make a test strip for the contact sheet

A test strip is a print with multiple exposures. The test strip gives a range of exposures to choose from when determining the correct printing time.

IN THE DARK, turn the enlarger light on and adjust the enlarger's height so that the beam of light is slightly larger than the sheet of negatives. Turn off the enlarger light.

Place a piece of photographic paper (a strip, roughly 3x8 inches) emulsion side up on the baseboard. Place the negatives (in the storage page or in strips) emulsion side down on top of the paper in such a way that at least two strips of negatives will be printed. This will allow you to see a range of negatives, in case the exposures range from under- to normal to overexposed. If the negatives are not in a contact sheet holder, place a sheet of glass over the negatives.

Hold the opaque board an inch above the paper/negatives/glass, shielding all but a 2-inch section. Press the timer button to trigger the enlarger light. Keep the board still while the paper is exposed for 4 seconds. When the light goes off, do NOT move the paper, but move the opaque board to reveal another two inches of the paper/negative/glass. Press the timer button again. Continue this series of actions until the entire strip of paper has been gradually exposed. If you made four 4-second exposures, the test print will have a range of exposures in 2-inch increments at: 4, 8, 12, and 16 seconds.

Process the strip using the directions for black and white print processing.

Evaluate the contact sheet test strip

Evaluate the test print. If the shortest exposure (see Figure 3.165 at 4 seconds) is too dark, the entire test print is overexposed. Close down your aperture two stops and make another test print. If the longest exposure (see Figure 3.165 at 16 seconds) is too light, the entire test print is underexposed. Open up your aperture two stops and make another test print. If the test print has some sections that are not too dark or too light, choose the section that is correctly exposed.

Evaluate the density of the images, but remember that the negatives themselves may be under- or overexposed. If printing black and white, you can use the film's sprocket holes to determine correct exposure. The sprocket holes should be indistinguishable or barely distinguishable from the surrounding film.

Make a final contact sheet

Reset the timer for the optimum exposure. Place a full sheet of paper under the negatives and glass. Expose, process, wash, and dry.

Contact sheet composites

Beyond the practical purposes of organization and reference, contact sheets can be images in their own right. Contact printing multiple images at once can be a good way to construct an image made up of multiple negatives. If you intend to print the roll in strips of images, the shots must be taken in the correct order to match up with one another when printing. Images must be shot horizontally, left to right. Before shooting, decide how long you want each strip to be (e.g. 6 frames). The length should be determined by the subject and its proximity to the camera. If contact printing the negatives, shooting vertically is possible only if you are willing to cut and arrange each frame individually.

It is also possible to assemble a contact sheet composite digitally, either by scanning the negatives and assembling them in a digital editing program (if you want the look of a film strip with sprocket holes and numbers) or by shooting digital images and stitching them together digitally.

When shooting, consider the 24 or 36 exposures as parts of the whole, details of a larger subject. Working this way has similarities with painting (many brushstrokes that make up one picture) and film direction (multiple frames or scenes shot at varying times). Before shooting, consider the following:

Continuity and fragmentation Before photographing a scene with multiple images, consider whether each part should blend seamlessly into the next, whether there should be spaces or leaps between frames, and whether there should be repetitions to extend areas. When panning the camera horizontally, keep track of the right or left edge of the preceding image so that you will know where to begin for the next shot. Depending upon the subject and your approach, you may want the next shot to begin at that edge, or you may want some overlap in order to exaggerate or extend the subject. If the subject is fairly large and close, move in close with the camera if you do not want frames to overlap.

Angle of view and perspective By building a scene with many frames, an artist can capture a wider field of view than would be possible with a single image. With a single shot, the camera is fixed in place; with multiple shots the camera is free to roam. Midway through shooting, you can move the camera to a different location. Movement often creates some disorientation. Consider whether disparate elements should have a transition or appear disjointed. Consider also how your movement affects perspective. Panning the camera (while standing in the same location) will result in a fish-eye effect. Walking the camera along the horizon line of the picture, as you shoot, will maintain the perspective of human vision. Additionally, you can change the camera's lens, zoom in and out or add magnification filters during shooting in order to capture details of areas within the larger scene.

3.168 In this image, the composite contact sheet is a way to insert detailed images of plants and a human into the larger bucolic setting of a park. The composite technique captures the path, landscaping, tree stump, and distant trees, an impossible feat for a single image. The artist also combined elements from two different locations, joining the two scenes with transitional foliage. The detailed close-up shots allowed her to display identifiable grasses and clovers that could have gotten lost in the larger landscape. In this way, the image is reminiscent of works such as *Ophelia* (1852), by the English Pre-Raphaelite painter John Everett Millais (1829–1896)

Focus Just as you would use focus and blur to direct the viewer's eye through a single photograph, use those devices here as well. Throwing entire frames or rows of frames out of focus will make focused frames stand out.

Time A composite image is constructed over time: seconds, minutes, hours—even days. During the amount of time you take to aim the camera's lens from one part of the scene to another, anything can happen. Elements of the scene can move, be altered, or disappear. Weather could change. Seasons could shift. You can move the camera to a completely different location in order to add and link other scenes.

Printing the image Print the negatives following the instructions for "Printing a contact sheet in the Darkroom," p. 269 or for "Digital printing," p. 296. Consider how the strips of negatives or frames are arranged on the photographic paper or digital canvas, their relationship to one another, to blank areas of paper (that will print black), to the digital background, and to spaces left between rows or frames of images. If printing in a darkroom, the negatives can be placed inside a clear plastic storage page if you want them to be printed in that orientation. The plastic sheet may diffuse their clarity a bit. Otherwise, arrange the individual strips or frames on top of a sheet of photographic paper and cover with a sheet of clean, unscratched glass.

MAKING AN ENLARGEMENT IN THE DARKROOM

An *enlargement* is a positive print made by projecting a negative onto photo-sensitive material. Enlarging emphasizes image details that may be overlooked when printed small. Enlarging affects image graininess (which increases with print size) and the way the image is read: intimate images must be studied up-close, while larger images may bring to mind television sets or reference the scale of paintings.

The following instructions describe how to make a straight print, wherein the entire image is printed at the same exposure time with little manipulation. Straight prints are rare, as most images need to be refined by changing contrast, adding or subtracting exposure locally (with dodging and burning), correcting color balance, and toning.

Tools and equipment

- Negatives (cut in strips of four or five).
- Film cleaner.

- Focusing magnifier.
- Photographic paper—expect to use at least 10 sheets to make one good print.
- Spare sheet of photographic paper for focusing negative—focusing on the easel yields less accurate focus because the surface is slightly lower than the paper.
- Opaque board (a book is usually handy).
- Easel, or tape if printing enlargements larger than an easel can accommodate.
- Enlarger with timer and negative carrier.
- Photo-processing chemistry and equipment.

Set up the enlarger and easel

IN THE LIGHT, make sure the enlarger is plugged in and equipped with the appropriate focal length lens (i.e. a 50mm lens for printing 35mm negatives). Make sure the lens's aperture numbers are visible. Set the enlarger aperture to a mid-size setting (f/8). Set the enlarger timer to 2 or 3 seconds for the test strip. If the enlarger has a colorhead, set it to no filtration, the equivalent of a #2 filter. If printing black and white without a colorhead, we recommend beginning with a #2 multigrade filter in the holder (see index for *contrast filters*).

Choose a negative. Clean the image with an anti-static brush, liquid cleaner, or compressed air. Place the negative in the negative carrier so the emulsion side is down when the carrier is installed in the enlarger. If necessary, you may clean the negative while it is in the carrier. Insert the carrier into the enlarger. Place the easel on the enlarger's baseboard.

IN THE DARK (with safelights on), insert a spare sheet of photographic paper into the easel, white side up. Turn on the enlarger's focus light and adjust the enlarger's height until the image is the desired size. Turn the enlarger's focusing knob to focus the image. Fine-tune the image's focus with the focusing magnifier, which examines the grain structure of the image. Move the easel and adjust its blades to securely hold the paper, to compose the image, and to get the desired margins. Remove the spare sheet of paper and set aside for future focusing. Turn off the enlarger light.

Make a test strip for the enlargement

A *test strip* is a print with multiple exposures. The test strip gives a range of exposures to choose from when determining the correct printing time.

Place a piece of photographic paper (a strip, roughly 3×8 inches) emulsion side up on the easel. Position the strip within a part of the image that has highlights, midtones, and shadows. This will allow you to determine exposure from a range of tones. If the paper curls, weight the ends with coins or by tucking two opposing corners under easel blades.

3.169 Clean the negative once it is in the carrier

3.170 Focus the image with the focusing magnifier

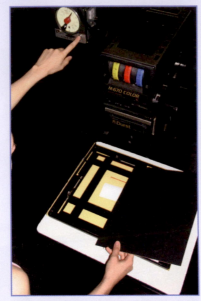

3.171 Expose a strip of paper in increments

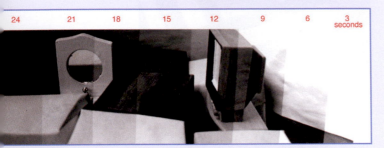

| 24 | 21 | 18 | 15 | 12 | 9 | 6 | 3 seconds |

3.172 When evaluating the test strip, we looked at the section showing the table under the TV monitor to assess density. The table has a bright highlight area but also substantial detail. We chose the 12-second exposure: shadows are dark enough to weight the image, shadow details are visible, and the screen is bright enough to appear to be glowing, yet not underexposed and lackluster (as in the 9-second highlight areas). The correct exposure could be between two bands. For example, we could print this negative at a 13-second exposure. The 15-second band shows how an area would look if burned. The 9-second band shows how an area would look if dodged

Hold an opaque board an inch above the paper, shielding all but a 2-inch section. Press the timer button to trigger the enlarger light. Keep the board still while the paper is exposed for 2 or 3 seconds. When the light goes off, do NOT remove the paper, but move the opaque board to reveal another 2 inches of the paper. Press the timer button again. Continue this series of actions until the entire strip of paper has been gradually exposed. For example, if you made eight 3-second exposures on the strip, the print will have eight areas of differing density in 2-inch increments from 3 to 24 seconds. The ideal final exposure should be between 12 and 20 seconds, as you will need a minimum of 12 seconds to dodge and burn. More than 20 seconds is unnecessarily long.

Process the strip using the processing directions.

Evaluate the enlargement test strip

Evaluate the test print for density. Look at the test print in the type of light under which it will be viewed. Bear in mind that some photographic papers dry down; that is, they become slightly darker and less contrasty after drying.

If the shortest exposure (3 seconds in the b/w test print in Figure 3.172) is too dark, the entire test print is overexposed. Close down your aperture two stops and make another test print. If the longest exposure (24 seconds in our example) is too light, the entire test print is underexposed. Open up your aperture two stops and make another test print.

When analyzing a black and white test strip, look at key highlight areas of the image and choose the exposure that shows detail in the highlights. It is not necessary to have an exposure that yields a full range—light areas, dark areas, and midtones—unless you want this range in tonal values. The tonal range of the print should correspond to the conceptual goals of that image.

Ideally, the correct exposure of your strip should be the middle band, so that the darker band shows how highlight areas of the subject would look if "burned." A lighter band shows how shadow areas will look if "dodged." The final exposure should be between 12 and 20 seconds long. The minimum time of 12 seconds gives you time to dodge and burn. More than 20 seconds would be unnecessary, as you can adjust the enlarger's lens to avoid such a lengthy exposure.

Make a final enlargement

Reset the timer for the optimum exposure. If necessary, reclean and refocus the negative. Place a full sheet of paper in the easel. Expose a full-size trial print. Process. Evaluate the highlight areas. Are they bright with some detail? Next, assess the shadow areas for blackness and detail.

If you are satisfied with the density of the print, begin to consider other qualities. Most prints are not *straight* prints (made with the same overall exposure at average

contrast). Usually, a print requires some degree of manipulation to emphasize particular aspects of the image. Ask yourself:

- Is the print *focused* correctly?
- Are there *dust particles* creating white spots on the print? If dust cannot be cleaned from the negative, see the index for *retouching techniques*.
- Are there particular areas of the print that should be *lighter* or *darker*? See the index for *burning* and *dodging*.
- Are you satisfied with the *image contrast*, the range of tones from white to black? If not, see the index for *contrast*.

Keep notes about final settings for your print: the aperture setting, print time, dodging and burning process, contrast filters used, etc. With these notes, you can, in the future, make additional copies without having to start the process from the beginning. During a second run, try to work with the same variables: for example, use the same enlarger and the same lens. The chemistry will fluctuate from day to day. Printing at the original settings will get you fairly close, but expect to make fine-tuning adjustments.

3.173 Print exposed for 12 seconds

Liquid photographic emulsion

Liquid emulsion is silver-gelatin emulsion that can be applied to any surface. The solution can be painted or sprayed onto any base—wood, glass, ceramics, plastics, chinaware, fabrics, metals, stone, canvas, and other surfaces. Liquid emulsion, or Liquid Light as one brand is called, will make any material or object light-sensitive and able to capture a photographic image. If a paper print is not the solution to your artistic goals, liquid emulsion provides a means to print images on walls, eggs, silverware, or other materials. The resulting image is permanent and archival.

Liquid light tends to take on a ghostly quality. Rather than starting each work with a new canvas, artist Pierre Gour reuses existing paintings so that their histories float beneath the surface of his paint. Into these forms, Gour works a field of color and floating heads (portraits of himself and his loved ones, animals, or iconic figures from popular culture). *Barometric Meter* was part of a larger series based on observations of weather-measuring devices. Liquid light enabled Gour to integrate a photographic image into an otherwise romantic field.

Liquid emulsion requires the same conditions and processing as a black and white print. The emulsions should be applied and processed in a darkroom. Because liquid emulsions are slow, they can tolerate great exposure to a darkroom safelight without fogging. Liquid emulsions tend to stick to surfaces better

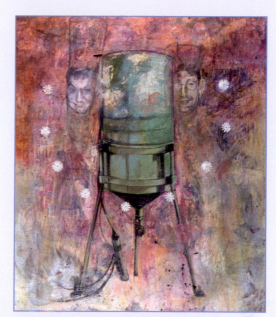

3.174 Pierre Gour, *Barometric Meter*, 2005. Mixed media, rivets, plastic flowers, and liquid light on canvas

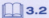 3.2

when conditions are cool. Pack the sink with ice, and place trays of processing chemicals on top of the ice to stay cool.

Tools, materials, and equipment

- A dense negative.
- Liquid emulsion (e.g. Liquid Light): each ounce covers approximately 1.5 square feet (some materials require two or three coats). A sponge brush, paint applicator or roller, for applying the emulsion to the base.
- Container for warming the liquid emulsion (while in its bottle). The container should be at least twice as big as the bottle of emulsion and able to hold water at a temperature of at least 130°F.
- Enlarger or slide projector for exposing an image onto the light-sensitive materials.
- Developer and fixer for black and white print photographic processing. Avoid rapid fixers, which do not harden the emulsion and can bleach the image. Hypo-clearing agent (optional) will help shorten the final wash time. Trays or spray bottles for chemistry. Ice (optional) for cooling chemistry.
- The base material (see below for more description) and extra pieces of this material or file cards to serve as test strips for exposure.

Base materials and surface preparation

- *Natural fiber paper and fabric*: Cottons and other natural fibers easily receive liquid emulsion. They are usually so absorbent that they often require two or more coats. Wash and dry new fabrics before coating.
- *Synthetic materials, metals, plastics, wood and canvas primed with gesso*: Liquid emulsions tend to slide off these surfaces. They must be made more receptive with a pre-coat of a transparent, glossy, oil-based polyurethane varnish (spray or liquid), an opaque oil-based or alkyd primer paint, or a gelatin precoat "subbing" solution of unflavored gelatin and powdered laundry detergent. Note that polyurethanes tend to yellow with multiple coats or as they age.
- *Vitreous materials, such as glass, glazed ceramics and rock*: These surfaces are non-porous and resist application of liquid light. They can be pre-coated with the polyurethane or alkyd primer, but a better anchor is a gelatin pre-coat "subbing" solution. The subbing helps fuse the emulsion to the glass or pottery. The process uses unflavored gelatin and powdered laundry detergent and is described on the Rockland Colloid website: www.rockaloid.com.

Printing process

Heat and prepare the liquid emulsion

At room temperature, the liquid emulsion has a gel-like consistency. Plunge the still-closed bottle of emulsion into a container of hot water, 130°F or higher, until the emulsion turns liquid. Do not shake the bottle, as bubbles will form in the emulsion. To ensure that the emulsion remains in liquid form, keep the bottle immersed in a container of hot water for the duration of the printing session.

Once heated, pour the emulsion into a glass, plastic, enamel, or stainless-steel container. Do not use other types of metal container as the emulsion may react and form black streaks. The container must be wide enough to allow you to dip the brush into the solution. The emulsion must stay warm during the entire preparation and coating process. Add a few drops of print developer to the emulsion to increase its speed.

Apply the emulsion to the base and allow to set

Using the brush, quickly spread the emulsion onto the base. Porous materials may need two or more coats. If more than one coat is necessary, alternate the stroke direction so that the second coat is brushed at a right angle to the first. Coat a few pieces of paper or file cards to serve as test strips for determining the correct exposure.

After coating, cool air will help set the emulsion. Allow the emulsion to air dry for a few minutes, or use a fan.

Expose the emulsion

Once the liquid emulsion becomes sticky or dry, make a test strip of the image. Liquid emulsions need longer exposures than conventional enlargement papers. If using an enlarger, the average exposure for an 8×10-inch image is usually 20 seconds at the largest available aperture. Larger images require more time. Slide projectors can be used for mural-size prints. Limit their light output and sharpen their projection by placing a black piece of board with a quarter-inch hole centered directly over the lens.

Process the emulsion

Develop the strip in a tray in the same way you would a conventional print, unless the material is too fragile or large. In that case, use a spray bottle to apply the developer (and separate spray bottles for the wash and fix), according to the manufacturer's instructions. Rinse the strip quickly with cool water to remove excess developer. Do not use acid stop as this will soften the emulsion. Next, fix the strip for 5–10 minutes, until the chalky white areas of the emulsion turn transparent and the emulsion becomes tough and leathery to the touch. Wash the strip

3.175 Pierre Gour, *Man Drinking Milk*, 2005. Oil and gum bichromate on canvas

for 10 minutes. You can use a hypo clearing agent to shorten the wash time. Be careful that the emulsion does not soften and slip off in the wash.

Evaluate the exposure and make a final enlargement
Evaluate the strip for the best exposure. Expose the base material for this time and process. Air dry with the emulsion side face-up.

Clean-up
Liquid emulsion washes away with hot water.

Trouble-shooting

- *Emulsion turns gray before coating*: too much developer added as sensitizer.
- *Bubbles in coating*: Loosen the cap and let the bottle stand in hot water for a few minutes. Brush slowly to prevent bubbles forming.
- *Emulsion turns gray during development*: Chemical contamination or light-fog. Test a few drops of emulsion on a test strip and develop without exposing.
- *Emulsion slides off surface of material*: Surface not prepared with the correct pre-coating, or fixer is non-hardening (should be hardening).
- *Some areas darker than others*: Uneven drying of emulsion. Needs circulating air.
- *Black, purple, or yellow stains appear over time*: Not enough fixer.
- *Fading over time*: Print not washed enough to remove all the fixer.

NON-SILVER AND HISTORIC PROCESSES

Non-silver and historic processes are general terms referring to various photographic processes that do not contain silver in their emulsion or were popular around the turn of the 20th century. Invented during the latter half of the 19th century, these older processes include collodion wet-plate, Van Dyke Brown, gum bichromate, and cyanotype, among others. Each requires mixing and coating the emulsion by hand; as a result, the images have a painterly quality, an effect often arising from the brushstrokes used in painting the emulsion, and the small inconsistencies and inaccuracies that result from hand processing.

In the 1960s and 1970s, research into antique photographic processes unearthed descriptions of these techniques, which had not been in use since silver-gelatin printing became dominant. It is unclear what led to this revival. Some accounts claim that photographers documenting Civil War reenactments wanted to subscribe to the same level of historical accuracy as the participants "fighting" the battles. Photography was also starting to gain greater acceptance as a fine-

art form during this period and many artists were attracted to the experimental nature of historic processes. Revivalist practitioners rewrote the recipes for historical formulas from the language of the 19th century for a contemporary audience. The books and online sources in our resources guide describe the processes of making Van Dyke Brown, gum bichromate, cyanotype, and other print positives.

Printing facilities and safety

Each process has specific needs and safety requirements. Chemicals, especially dry chemicals, may be toxic, cause staining or burns, and should be handled only when wearing gloves, goggles, and a respirator. Chemical toxicity information accompanies the purchase of chemistry, can be located at manufacturers' websites, or can be found by reading the recommended resources for historical processes.

Nature Print®

The commercially available *Nature Print®* paper makes prints like a cyanotype, but without having to mix chemicals or spread the emulsion. Any material can be laid upon the paper to make an image. Fix the exposed image simply by washing it in water. Exposed areas print to a deep blue color while unexposed areas remain white. The process is non-toxic. Using carefully measured exposure, you can use Nature Print® to print photographic negatives. In addition, the paper lends itself to alternative photographic processes. For example, as shown in Figures 3.177 and 3.178, it can be used to create photograms of various light-transmissible objects.

SCREENPRINTING

Screenprinting, also called silkscreening or serigraphy, is essentially a stenciling process. Selective holes of a tightly stretched mesh screen are "blocked out" or masked. While a variety of materials can be used to block the screen (paper or plastic for a hand-cut stenciled image; liquid hardeners or glue for a hand-painted image), we use photo emulsion in the following process. After blocking the screen, ink squeegeed across the mesh will pass through only the unblocked portions to print onto the printing substrate (which could be paper, fabric, glass, metal, vinyl, or plastic, among other materials). Depending on the type of ink used, almost any surface can be printed.

Screenprinting originated in Japanese stenciling, though some accounts date stenciled imagery back to the ancient Greeks and Egyptians. During World War One, the process gained popularity with American graphic artists in commercial advertising. Screenprinting's bold areas of flat color, sleek commercial look, and

 3.5 Refer to our web resources for instructions on making a black and white digital negative for printing with traditional or historical photographic processes.

📖 **3.3**

3.176 Nature Print ® paper

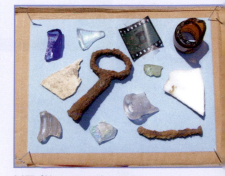

3.177 Objects arranged on paper

3.178 Processed sunprint

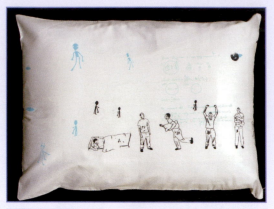

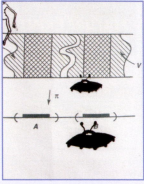

3.179, 3.180, and 3.181 Toby Millman and Kevin Wildrick, *When they come for you, be sure the information you need is close by: a mathematical guide for returning to Earth*, 2005. Glow-in-the-dark screenprinted pillowcases
Toby Millman and Kevin Wildrick's "*When they come for you …*" is a short mathematical and illustrated guide for people who wish to prepare to be abducted by extraterrestrials. Mathematical equations and diagrams, essential for calculating the distance and route back to Earth from any given space/time dimension, are printed alongside illustrations that teach how to identify aliens, flying saucers, and Earth. The images are conveniently printed on pillowcases as most abductions occur during the night while one is asleep. The most essential information is printed with glow-in-the-dark ink in order to be available in the dark as the human makes final preparations before falling asleep

ability to easily produce large editions at minimal expense led to its adoption by artists within the Pop Art movement of the 1960s.

Facilities
Emulsions should be applied in a dimly lit space and dried in a darkened room. Unhardened emulsion will need to be washed off in a sink or tub.

Tools, materials, and equipment
Silkscreen Purchase the screen and frame pre-stretched, or make the frame and stretch the screen yourself. The frame should be at least 3 inches bigger than the image at the top and sides (so that the image doesn't warp at the edges) and 5 inches bigger at the bottom (to provide room for the ink to pile up). The two main kinds of screen fabric are not silk, but *monofilament polyester* and *multifilament polyester*. Monofilaments are smooth, suited for large production runs, easy to clean, and less likely to clog during printing. Multifilaments fabrics are used in the textile industry and, while they do not wear as well as monofilaments, can be used to print on textured or curved surfaces. Emulsions and films adhere more easily to multifilaments than to monofilaments. All silkscreen fabric is woven into a grid mesh. The thickness of the threads and number of threads per inch determines the amount of ink that passes through each hole and the degree of fine detail the screen will hold. Monofilaments are measured in terms of threads per inch, and can range from 60 to 420. Multifilaments are measured by a number followed by XX, and range from 4xx to 30xx. We recommend using a screen with at least 110 threads per inch or 10xx for printing photo-based imagery.

You may want to have a smaller spare screen for exposure tests.

Photo emulsion Choose a photo emulsion that can be used with water-based inks. The photo emulsion will be made up of emulsion and sensitizer. After preparing the emulsion according to manufacturer's directions, the solution will be sensitive to light. Keep the solution within its lidded container. When not in use, store the solution in a refrigerator. When in use, handle in a dark space.

Film positive Because the printing process is a one-to-one direct print, the film positive will be the same size as the final screenprint. The positive must be black and white, without shades of gray or color. In Photoshop, begin with a Grayscale image (*Image > Mode > Grayscale*). Then convert to black and white (with no gray values) by changing the Grayscale image to Bitmap (*Image > Mode > Bitmap*), or by using a Color Halftone Filter (*Filter > Pixelate > Color Halftone*). If using the Color

Halftone Filter, use the default Screen Angle. The dot size of the halftone pattern will affect the clarity and aesthetics of the tonal areas. Additionally, the dot size must be larger than the fabric holes for the fabric to capture that pattern. Figure 3.182 shows three examples.

Paper positives must be coated with vegetable oil to become transparent. If soaking the paper positive in oil, print the image from a dry-ink printer so that the ink is non-soluble in oil. Most laser printers and photocopiers will work, but ink from inkjet prints will bleed. Let the print soak in the oil for approximately 10 minutes until saturated on both sides.

Screenprinting ink In our example we use water-based ink, though there are also oil, plastisol, vinyl, nylon, and enamel-based inks. Water-based inks are the only non-toxic inks. If using water-based ink to print on nonporous surfaces, contact a commercial ink supplier for recommendations, as there are constant developments in water-based inks. For one 11x14-inch image, you will need approximately one cup of ink. Excess ink can be reused.

Print surface/material Depending on the ink used, the image can be printed on almost any material. If printing on surfaces other than paper or natural fibers, experiment first.

Scoop coater This is a tool used to apply photo emulsion, but a thin strip of matte board can also be used.

Squeegee Used to squeeze ink through the screen. The squeegee should be wider than the image, but smaller than the screen. The harder the squeegee, the less ink will be applied; softer squeegees are usually easier to work with and tend to press a thicker coating of ink through the screen.

Light source The light source should be relatively large in order to evenly expose the screen. A homemade or professional-grade light table is ideal. A desk lamp will work for small screens.

Emulsion remover Purchase emulsion remover with the photo emulsion, as some emulsions can only be removed with the same brand of remover.

Hinge clamps Dick Blick heavy-duty screenprinting clamps work well.

Duct tape, sponge, and iron These are optional.

no filter

4 radius halftone pattern

10 radius halftone pattern

3.182 Screenprinting patterns

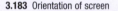

3.183 Orientation of screen

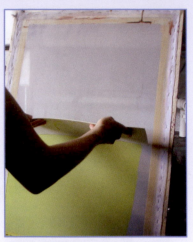

3.184 Coating the screen with emulsion

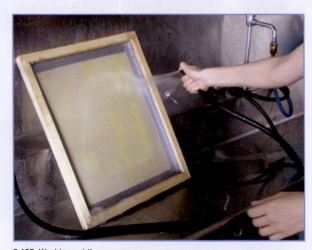

3.185 Washing out the screen

The screenprinting process

Coat the screen with emulsion

Once your screen is stretched across the frame and the emulsion is mixed according to the manufacturer's directions, you are ready to coat the screen. Make sure to bring refrigerated emulsion to room temperature. In a dimly lit space, pour the amount needed in a small cup (clean yogurt cups work well). The amount of emulsion depends on the screen size. An ounce of emulsion will cover an 8x10-inch screen. Place the cup in a pan of hot water. Put the cup/pan in a dark cabinet for 5 minutes to warm.

The emulsion is ready to be applied to the screen when it reaches room temperature. In a dimly lit room, pour a little emulsion in the scoop coater or along the edge of the matte board. Hold the coater at an angle at the bottom of the back of the screen. Keep it angled to ensure that the dollop of emulsion stays in contact with the screen during the entire coat (see Figure 3.184).

Working quickly before the emulsion starts to dry, stroke from the bottom to the top until you get a thin, but even coating. While one coating is usually sufficient, multiple coatings will reduce pinholes and areas of unevenness. If only coating the screen once, coat the backside. If coating the screen multiple times, coat both sides, allowing each coat to dry before applying the next. Immediately after coating, place the screen in a dark space and allow to dry completely. Using a fan, a single coating of emulsion should dry in about one hour.

Expose the emulsion

Once the emulsion has dried, affix the film positive, face-up, to the *light table*. Press down and make sure there are no bubbles. Lay the screen front-side up on the table. Weight the screen with blankets. (If using a lamp, affix the positive face-down to the back of the screen covered by a sheet of glass to press the film flat.) Whichever method you use, make sure that when looking through the front of the screen you are viewing the image correctly. Exposure times vary depending on the type and thickness of the emulsion, the number of coatings, and the light source used. On average, a 150-watt bulb takes 9–15 minutes. Do a test to find the correct exposure. Set a timer and expose the sensitized screen to the light source.

Wash out the screen

IMMEDIATELY after completing the exposure, take the screen to a bathtub or sink. Lean the screen against the wall and wash the screen with a strong jet of water. The areas of emulsion that were not exposed to light will wash away; areas that received exposure have hardened and will remain to "block" the screen. Continue washing until the emulsion in all the printable areas has washed away. If the emulsion in the image area will not wash out, the exposure time was too long;

if emulsion in the non-image areas has washed away, the exposure time was too short.

Fix pinholes and tape the screen

Pinholes are small openings in the screen that should have blocked up but did not. They are common, and can be located by holding the screen up to the light. Use a small brush to fill the holes with a little sensitized emulsion (it's best to save the leftover emulsion from the initial coating for this purpose).

Dry the screen for approximately 20 minutes (with a fan).

Since it's nearly impossible to coat the emulsion on the screen right up to the frame, the gap between the frame and the screen should be taped along the inside of the frame with duct tape or a strong plastic-coated tape before printing. This will prevent ink from leaking out at the sides during printing.

Print the screen

Secure the frame to a table, front-side up, using the hinge clamps. If you are printing on material that may wrinkle when printing, stretch it out. For example, insert cardboard inside pillowcases or t-shirts to keep them taut. Keep the material you will print on close by and work quickly, as the ink dries quickly and can block the screen.

Place a test sheet of paper underneath the screen. Spread the ink evenly along the top end of the screen with a spoon or a piece of matte board. Lift the screen slightly off the base. Pull the squeegee in a single sweeping stroke toward you to spread a smooth, even layer of ink across the screen. This is called "flooding" the screen and will fill all open areas with ink. Lay the screen back onto the paper and repeat the stroke, pulling the squeegee toward you at a 45° angle and applying firm pressure. This second stroke pushes all the ink from the flood-stroke through the screen and onto the paper. Lift the screen, remove the paper you just printed on, position a new test sheet (still with the screen slightly lifted) and repeat the process of flooding and printing. Once you see that all open areas are printing well, repeat the entire process on the "good" paper or other printing material.

After printing, wash the ink off the screen with warm water.

If you have printed onto fabric that will be washed, you must heat-set the ink. Allow the ink to dry, then heat-set by placing a towel over the image and ironing the image at the highest setting possible.

Remove the emulsion

To remove the emulsion, spread a diluted solution of emulsion remover on both sides of the screen with a sponge. Let it sit for a few minutes, then wash away with warm water.

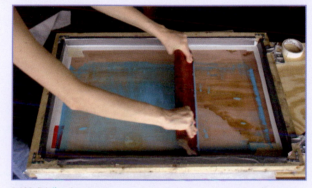

3.186 Printing the screen

PROCESSING DIGITAL IMAGES: DIGITAL WORKFLOW

In order to streamline the process from image capture to print, consider implementing a "digital workflow," a suggested process for capturing, copying, and processing digital images. An effective digital workflow helps you to organize files by name and keyword, embed metadata and color profiles, archive and copy files, protect against loss of files and changes applied to them, and apply digital alterations in non-destructive ways.

This list provides a recommended order of digital processing operations.

1 Image capture on camera (set file type, color space, quality, ISO).
2 Open Adobe Bridge or Adobe Lightroom.
3 Import images (through Bridge or Lightroom).
4 Save backup copies to DVD and external hard drive (can be done during download).
5 Save DNG (Digital Negative Format: an Adobe file format for archiving) versions of images (can be done during download).
6 Batch rename (can be done during download).
7 Sort, color code, and rate images with stars.
8 Add metadata and keywords to images.
9 Make global and local image adjustments in the *Develop* module of Adobe Lightroom, or open and apply changes to images in Adobe Camera Raw.
10 Open images in Photoshop to make more global adjustments, local adjustments, apply layers, and make composited images.
11 Save processed images with layers as PSD or TIFF files and back up these processed images on an external hard drive or DVD.
12 Flatten image layers.
13 Sharpen image.
14 Save flattened, sharpened image.
15 Output images to print or web.

Using Adobe Bridge or Adobe Lightroom to name, organize, and process digital images

While digital files may not take up the physical space of film and slide archives, maintaining hundreds or thousands of files can be challenging. Creating a cataloging system with keywords to locate images, metadata to identify file and author information, and file formats that preserve data will help store, sort, and retrieve digital files. Saving backups of all unchanged files will protect images as they looked when photographed. A photograph that seemed redundant or insignificant at the moment could be valuable in the future and, if preserved in an archive,

will continue to be available. You may want to create an organizational system with both a permanent archive for backed-up *originals* and a storage structure for *derivative* files (in-process or changed copies of the originals). An effective digital workflow will help you to rename files, move files into appropriate folders, manage image color spaces and profiles, organize images by subject or date or process/unprocessed, rank images within categories, save images as different file types, and save backup copies.

Adobe Bridge and Adobe Lightroom compared

Adobe Bridge (in conjunction with Adobe Camera Raw) and Adobe Lightroom each help to create an efficient digital imaging workflow. These two programs differ in the way they store information. Lightroom is catalog-driven, meaning that it stores information about your files so that you can open, view, and organize them even when they are contained in an external hard drive that is offline. Bridge, on the other hand, is a file browser, so it is designed for file navigation and the display of items readily available on your computer or actively connected to it. Unlike Lightroom, Bridge provides a way to browse and search for other media types (graphic design, website design, animation, and videography). It is useful for artists and designers who need to "bridge" between other Adobe Creative Suite products, such as InDesign, Illustrator, Premier, and Flash. Lightroom was designed specifically for photographers, so it provides more photographically driven capabilities, such as a printing module, some automatic preset options for printing and saving files, the ability to save "virtual" copies of images that do not take up more space on your computer, and more image-adjustment capabilities. It also has more options for customizing web galleries. Adobe Bridge is packaged with Photoshop, while Adobe Lightroom must be purchased separately.

If you're especially interested in learning to manage files, Peter Krogh's book, *DAM: Digital Asset Management*, is an excellent reference. He describes most features of Adobe Bridge and Lightroom, and other cataloging software.

The following sections describe recommended procedures for processing digital images in Bridge and the Library Module of Lightroom, and the features available as you manage your files. In the diagrams, numbers indicate corresponding items listed below the image.

ADOBE BRIDGE

Open Adobe Bridge

Open Adobe Bridge to browse, download, and organize images. Launch Bridge by clicking on the icon in the dock or by finding the application button in your computer's application folder.

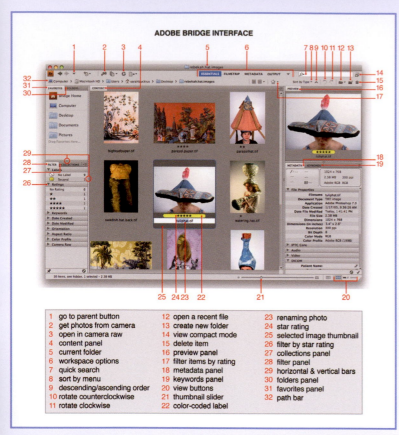

ADOBE BRIDGE INTERFACE

1 go to parent button	12 open a recent file	23 renaming photo
2 get photos from camera	13 create new folder	24 star rating
3 open in camera raw	14 view compact mode	25 selected image thumbnail
4 content panel	15 delete item	26 filter by star rating
5 current folder	16 preview panel	27 collections panel
6 workspace options	17 filter items by rating	28 filter panel
7 quick search	18 metadata panel	29 horizontal & vertical bars
8 sort by menu	19 keywords panel	30 folders panel
9 descending/ascending order	20 view buttons	31 favorites panel
10 rotate counterclockwise	21 thumbnail slider	32 path bar
11 rotate clockwise	22 color-coded label	

3.187 Adobe Bridge

The Bridge workspace
Panels and panes
The Bridge interface contains three panes (left, right, and center). The numbers in the text below correspond to the numbers in red on the diagram. Each pane can display one or more panels, including *Folders, Favorites, Filter, Collections, Content, Preview, Metadata,* and *Keywords.* You can toggle back and forth between the Metadata and Keyword panels, and the Favorites and Folders panels. You can move, hide, or resize any of the panels. To resize the panels, drag their *horizontal bars* (29) up or down, or the *vertical bars* (29) right or left. Double-click the panel tab to minimize or maximize the panel(s).

The **Folders panel** (30) allows you to browse through any folder on the computer to see full-color thumbnails of the images, documents, and subfolders within, including storage devices (CD, flash drive, memory card). Click on a folder and the contents will appear in the thumbnail viewing area.

If you work on one or more folders of images regularly, add them to the **Favorites panel** (31) to save yourself the trouble of hunting the folder down through *Folders* (30). You can add a folder to *Favorites* by selecting the folder in the Folders panel or viewing area and choosing *File > Add to Favorites.*

The **Filter panel** (28) helps with sorting files in the Content panel.

The **Collections panel** (27) lets you create, find, and open the groups of files you combine to form collections.

The **Content panel** (4) shows image thumbnails located in the *current folder* (5). Within the Content panel, you can use the *view buttons* (20) at the bottom right of the interface to view images as thumbnails, as a list, or with details. You can reorder files or thumbnails within the Content panel by clicking on the *descending/ ascending* order button (9) on the top right of the interface. You can make the thumbnails smaller or larger by sliding the *thumbnail slider* (21) to the left or right.

The **Preview panel** (16) provides a larger preview of thumbnails selected in the Content panel.

The **Metadata panel** (18) shows information (file properties such as date of creation, keywords, camera settings, copyright information, etc.) about the selected image.

The **Keywords panel** (19) shows assigned tags (keywords) that help you sort and organize files.

Workspace interfaces
Upon launching, Bridge will open to show a default layout (the workspace) that contains several windows. If you want to minimize the Bridge workspace, click on the *view compact mode icon* (14) on the top right of the window.

At the top of the interface, Bridge offers eight *workspace options* (6) (or you can select *Window > Workspace*). They are: *Essentials, Keywords, Output, Filmstrip,*

Metadata, Preview, Light Table, and *Folders.* The following workspaces may be especially useful:

- *Filmstrip workspace* (shows thumbnails in a row, with a larger preview area above).
- *Essentials workspace* (shows all panels, with a wide center pane for viewing thumbnails).
- *Light Table workspace* (hides all of the panels area to increase the size of the thumbnail viewing area).
- *Metadata workspace* (hides panels on the right to show a list of metadata linked to image files).

Import files and open images

Import image files from your camera by selecting *File > Get Photos From Camera* or by selecting the *get photos from camera* button (2) at the top left of the interface. When downloading images from your camera, the Adobe Bridge CS4 Photo Downloader provides such options as converting Camera Raw files to DNG, renaming files, and attaching metadata (information about images, including keywords).

Open files by double-clicking on folders or images in the *Folders* (30) or *Favorites* (31) panels. Open a recently viewed or favorite file by selecting the *go to parent button* (1) on the top left of the interface. To open a file recently viewed in an Adobe program, select the *open a recent file* button (12) on the top right of the interface.

The top bar of the interface identifies the *current folder* (5). The *path bar* (32) shows you the path of the folder you are viewing. Click on any folder in this path to select it and view its contents.

Naming and renaming images

You can rename an image by clicking on the image name (under the thumbnail). When the name is highlighted, type in the new title as shown in the diagram – see Figure 3.187. You can also perform a *Batch Rename* to rename, copy, and move groups of selected files by choosing *Tools > Batch Rename.*

Moving, deleting, and grouping files

To move a photograph from one folder to another, click on the thumbnail and drag the image to the new folder in the *Folders panel* (30). To drag a duplicate copy of the photograph (instead of the original), press and hold Alt (Mac: Option) as you drag. Rearrange the thumbnails by clicking and dragging one to another location. As you drag, a vertical bar indicates where the image will be placed. To

delete a file, select the thumbnail and then click on the *delete item* (15) icon. To create a new folder, click on the *create new folder* button (13) on the top right of the interface. You can use the *Collections panel* (27) to create, find, and open the groups of files you combine to form collections (which are groups that do not actually relocate the files but help for organization). Create *stacks*, to group thumbnails into personalized categories, by selecting *Stacks > Group as Stacks*.

Rotating images

Rotate thumbnails by selecting the image in the viewing area, then clicking on one of the two *rotate* icons (10 and 11) at the top of the window. Rotating only affects the thumbnail, not the actual image. To apply the rotation to the image, double-click on the photo (the image will open in Camera Raw or Photoshop, with the rotation effect applied), and save the file.

Labeling files

When you record a digital image, the camera embeds information in the file, such as the creation date, file size, and bit depth. When you set a color space or edit an image in Photoshop, Photoshop stores this information as metadata. The Metadata panel (18) provides the information embedded by the camera (*Camera Data*), by Photoshop (*File Properties*), and by yourself (*IPTC Core*). In our example, Figure 3.187, the selected image has a color profile of Adobe RGB (1998), a file size of 2.3MB, a bit depth of 8, and a resolution of 300ppi.

Another way to classify images is to tag them with keywords. Keywords are words and topics that help you to identify specifics about the images, such as the content of the image, capture location, assignment number, client, date created, and subjects in the photographs. Unlike image names, keywords are invisible, and are embedded in the image data. You can apply keywords through the *Keywords* panel (19) and then locate these images by typing in the keywords in the box at the bottom of the Keywords panel.

Ranking, sorting, and searching for images

When you select a thumbnail, five dots appear under the image (in the diagram, the selected image has a five-star rating). Click on the first dot and a star will appear, designating the image with a one-star ranking. Click on the second dot and two stars appear, making it a two-star photo—and so on. Once the photographs are rated, you can group and sort them according to this star-system by clicking on the *filter items by rating* menu (17) in the top of the window and telling Bridge how to present the images: for example, *Show 3 or More Stars*. You can also filter the images to find star ratings using the *Filter panel* (28). Bridge allows for additional ratings: for example, you can *color-code* images (22); you can sort images by different criteria, such as

filename, type, date created, date modified, or star rating, by selecting *View > Sort* or by clicking on the *Sort by menu* (8) from the application bar. Search for images by choosing *Edit > Find*, or use the *quick search* (7) at the top right of the interface.

Open images in Camera Raw or Photoshop

Open a RAW, JPEG, or TIFF file in Adobe Camera Raw by clicking on the thumbnail and doing any of the following: pressing Control+R (Mac: Command+R); clicking on the *open in camera raw* button (3) on the top left of the interface; or by selecting *File > Open in Camera Raw*.

To open a photograph in Photoshop, go to *File > Open With > Adobe Photoshop CS4*. To open multiple images, select one image, then hold down the Command key and click on additional images. Then, go to *File > Open With > Adobe Photoshop CS4*.

ADOBE LIGHTROOM

Adobe Lightroom consists of five modules, each of which involves a different portion of the digital workflow. *Library* (importing, organizing, comparing, and selecting), *Develop* (editing color and tone), and *Slideshow*, *Print*, and *Web* for presentation and output. You can toggle between these modules in the *Module Picker* (7) at the top right of the interface. The following discussion and the illustration in Figure 3.188 mainly address the *Library module*.

Open Adobe Lightroom

Launch Lightroom by clicking on the icon in the dock or finding the application button in your computer's application folder.

The Lightroom workspace
Panels and panes

The interface of the *Library module* consists of an *image display area* (31) in the center, and panels on the left and right. The numbers in the text correspond to the numbers in red on the diagram. A *toolbar* (15) shows viewing, sorting, flagging, rating, and navigating tools. The *filmstrip* (25) is a row of small thumbnails of the photos in the folder, collection, or keyword set on which you are currently working. The left pane displays organizational panels: *Catalog* (30), *Folders* (29), and *Collections* (28). The right pane displays the following panels: *Histogram* (9), *Quick Develop* (10) (for making minor image adjustments), *Keywording* (11), *Keyword List* (12), and *Metadata* (13). To move the panels up and down, drag their *horizontal bars* (14) up or down. To resize the panels' width, drag the vertical bars (14) right or left. Click the *show/hide panel group icon* (8) (at the top of each panel) to minimize or maximize the panels.

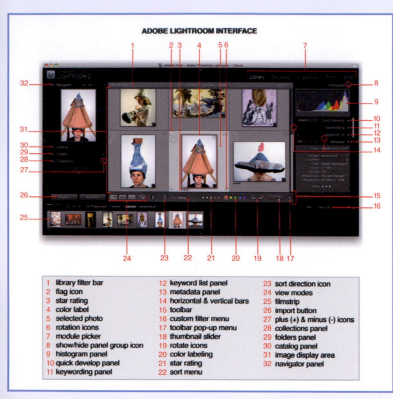

ADOBE LIGHTROOM INTERFACE

1 library filter bar	12 keyword list panel	23 sort direction icon
2 flag icon	13 metadata panel	24 view modes
3 star rating	14 horizontal & vertical bars	25 filmstrip
4 color label	15 toolbar	26 import button
5 selected photo	16 custom filter menu	27 plus (+) & minus (-) icons
6 rotation icons	17 toolbar pop-up menu	28 collections panel
7 module picker	18 thumbnail slider	29 folders panel
8 show/hide panel group icon	19 rotate icons	30 catalog panel
9 histogram panel	20 color labeling	31 image display area
10 quick develop panel	21 star rating	32 navigator panel
11 keywording panel	22 sort menu	

3.188 Adobe Lightroom

Catalogs, folders, and collections panels

Lightroom is catalog-driven, so you must import images into *catalogs* (databases of information about the image) for Lightroom to access them. The catalogs do not contain the image files, which are located on your computer or external hard drive. Rather, the catalogs retain information that Lightroom uses to locate or process the images. When you import images to a catalog, the database houses information, including: a JPEG preview; metadata, including camera type, lens type and ISO; picture data; a link to locate the images on your computer or external drive; image organization, such as keywords and ranking within collections; and editing instructions applied in the *Develop module*. As a result, one major difference between Lightroom and Bridge is that images must be directly imported into Lightroom to be viewed, while Bridge browses the contents of your computer and peripheral devices.

Upon opening Lightroom and importing images, a default catalog will be created. Every time you import images, you can either import them to this catalog or choose to import them to a new catalog that you create. Open an existing catalog by choosing *File > Open Catalog*. To create a new catalog, select *File > New Catalog* and then import photos into that catalog. The *Catalog panel* (30) provides different ways of viewing images: *All Photographs* (all photos in the current open catalog), *Quick Collection* (a temporary group of photos you may have created), and *Previous Import* (recently imported images). If you want to find out the location of the actual image file or the folder containing that file, select that image or folder, Control-click and choose *Show in Finder*.

The *Folders panel* (29) takes you to folders of images. Once you're in a catalog, the Folders panel allows you to browse through folders that contain images to see where they are located on your computer or external device. Click on a folder to see its contents. In this panel, you can add new folders, subfolders, move folders, rename folders, and delete folders by selecting the *plus* (+) or *minus* (–) *icons* (27) on the top of the panel.

To group images, create *collections* by selecting the images and then choosing *Library > New Collection*. To view a list of collections in the catalog, use the *Collections panel* (28). To add new images to this collection, select them in the *image display area* (31) and drag them to the collection in the *Collections panel*. To remove them from the collection, Control-click on the image while viewing the collection and select *Remove from Collection* from the drop down menu that appears, or choose *Photo > Remove from Collection*.

The **image display area** (31) shows image thumbnails located in the current catalog and/or collection you are viewing. You can view this area in four ways. The four *view modes* (24) are, from left to right: grid view (overview of small thumbnails); loupe view (blown-up view of single images); compare view (places two images

side by side); and survey view (you pick several images to view at the same time). The thumbnail that is currently selected (5) will have a light gray background, rather than a dark gray one. You can make all the thumbnails smaller or larger by sliding the *thumbnail slider* (18).

Click on the image in the *Navigator panel* (32) to zoom and move around within a close-up view of the image.

Import files and open images

You must import images into *catalogs* for Lightroom to reference them. To make a new catalog, select *File > New Catalog*. To import files into this catalog, select *File > Import Photos From Disk* or select the *import button* (26) on the left side of the interface. You can also import images into any catalog while it is open by selecting this option. To open an existing catalog, select *File > Open Catalog or File > Open Recent*.

Renaming images

When importing images into Lightroom, you can rename files in the import dialog box if you elect to copy or move them (instead of keeping them in the same location). You can rename a single image or a set of images in a catalog or collection in the *Library module* by selecting the image and choosing *Library > Rename Photo(s)*. Lightroom will not give you this option if it cannot link to the actual image file.

Moving and deleting files

While in the *Library module*, you can move an image from one collection to another by selecting the image and dragging it over the desired collection icon in the Collections panel. You can rearrange the thumbnails within a collection by clicking and dragging one to another location (you cannot rearrange them when you are viewing a full catalog, only when you open a collection). As you drag, a black vertical bar indicates where the image will be placed. To delete an image from a catalog, select *Photo > Delete Photo*. To delete an image from a collection, choose *Photo > Remove from Collection*. To create virtual copies of images (not actual images, just thumbnails with different adjustments applied), Control-click on the image and choose *Create Virtual Copy* from the drop-down menu that appears.

Rotating images

Rotate thumbnails by selecting the image in the viewing area, then clicking on one of the two *rotation icons* (6). You can also Control-click on the thumbnail and select *Rotate Left* or *Rotate Right* from the drop-down menu. Another way to rotate thumbnails is to click on one of the *rotation icons* (19) in the toolbar. If the

arrows are not visible in the toolbar, click on the *toolbar pop-up menu* (17) and select *Rotate*.

Labeling files: The Metadata and Keywords panels

When you record a digital image, the camera embeds information in the file, such as the creation date, the file size, and the bit depth. This information is called *metadata*. The *Metadata panel* (13) provides this information for a selected image, including image-capture information (file size, file type, aperture and shutter speed, date, camera type, etc.), and post-capture applied information (ratings, titles, captions, copyright, creator name, etc.). You can add post-capture information in this panel by typing in words and phrases that would be useful for searching and locating the files at a later date.

Another way to classify images is to tag them with *keyword(s)*. Keywords are words and topics that help you to identify specifics about the images, such as content of the image, capture location, assignment number, client, date created, or subjects in the photographs. Unlike image names, keywords are invisible and are embedded in the image data. You can apply keywords by selecting one or more images and then, through the *Keywording panel* (11), select from previously created words or type in new ones. Use the *Keyword List panel* (12) to view all keyword tags and a tally of how many images use those tags.

Ranking, sorting, and searching for images

When you select a thumbnail, five *star rating* icons (3) appear under the image. Click on the first dot and a dark star will appear designating that image with a one-star ranking. Click on the second dot and two dark stars appear, making it a two-star photo—and so on. You can also select a thumbnail and give it a star rating by clicking on the desired number of stars on the toolbar *star rating* option (21). You can flag or color-code your images by selecting the *flag icon* (2) or one of the *color labeling icons* (20). Once you've color-coded a photo, a *color label* (4) will appear around the thumbnail. Color-coding, and flagging images as rejects or keepers, help to group, sort, and filter your photographs.

You can reorder files or thumbnails in your *image display area* (31) by clicking on the *sort menu* (22) and choosing a criteria that determines how images should be shown (e.g. prioritizing a particular label color, file name, or rating). You can also change the direction of the order (ascending or descending) via the *sort direction icon* (23) on the toolbar.

You can search for images using the *custom filter menu* (16) or the *library filter bar* (1). If you select the *custom filter menu*, pick from different filter options, such as *Rated*, *Flagged*, or *Unrated*. To make filtered searches, select one of the *library filter* options, including *Text* (file name, keywords), *Attribute* (ratings, flags, color-

coding), or *Metadata* (date, camera, lens, location). When you have selected the items to help you narrow your search, the corresponding images will appear in the *image display area* (31).

Opening Lightroom images into Photoshop

You can open a RAW, JPEG, TIFF, or PSD file from the *Library* or *Develop module* into Photoshop by selecting *Photo > Edit In > Edit In Adobe Photoshop*. Lightroom will not give you this option if it cannot link to the actual image file.

File formats: Saving and formatting files

Saving backup copies

Before editing your images, you may want to preserve the original exposures by burning them onto a CD or a DVD, or saving them to an external hard drive. Once stored, the images will be safely archived and available should you require the original unedited version. The advantage of using a CD (CD-R for recordable CD) or a DVD is that they won't take up hard drive space and can be quickly accessed and uploaded. The disadvantage is that they are not archival—they may be scratched, the dye layer may disappear, and may become obsolete in the future. If using a CD or a DVD, label the disk to help identify the images or the photoshoot; a contact sheet cover will allow you to see images contained within (see index for *contact sheet*, digital). If you have shot RAW files, you may want to process them first in Adobe Bridge or Adobe Lightroom (renaming, sorting, entering metadata, and applying keywords), make RAW adjustments, and *then* convert the backup file to DNG format. If you have shot JPEG files, process the files in Bridge or Lightroom and save the backups in their original format.

Saving files: Formats

There are at least three times you should save a file:

1 To save a backup in your permanent archive.
2 To save changes while working on a derivative version.
3 To save a completed derivative version before printing, presenting (via projection or Internet), or delivering or transferring to a second party.

Software saves image files in various ways, referred to as file formats. The file format you choose will affect image quality, preservation of layers, and size, and will determine whether you will be able to open the file in the future. Each format has a particular three-letter file extension (for example, TIFF's is .tif), which, when placed at the end of the file name, helps an application to recognize the format.

Saving a file while editing will not involve changes in file format. You can simply choose *File > Save* and Photoshop will replace the previously saved file with the current version. To preserve the original file and save the edited version as a new file, choose *File > Save As*. Saving backup images or completed versions may involve *changing the format*.

File formats

There are two main characteristics of a file format that may determine how you choose to save the file:

1 Whether or not the format is *universal*. Universal formats allow the file to easily be exchanged and opened with other pixel-based image-editing and graphic software, and across multiple platforms (e.g. Mac, Windows, Unix).
2 Whether the format uses *lossless* or *lossy* compression. Formats that use lossless compression save all data, without damaging the file or losing quality. Lossless formats can be saved over and over without any reduction to image quality. Lossy formats compress the file by permanently eliminating information not particularly significant in the human eye's effort to distinguish content. In other words, lossy compression is based on a series of studies that have determined that the number of colors in an image can be reduced from, say, millions of colors to 256 colors, and the human eye will still discern the same degree of brightness or hue. Lossy formats apply the compression each time the image is saved. Saving the image once may not visibly degrade the image, but multiple saves will reduce image quality and the data cannot be restored.

JPEG (Joint Photographic Experts Group; file extension: .jpg)

JPEG is a lossy format, which compresses the image every time you save it. When saving the file, Photoshop will give options for the amount of compression/quality of the image. Higher compression yields a smaller size file, at lower quality. We recommend using the JPEG format (at maximum quality) when presenting photographic images in screen-based or Internet presentations, or to email images to someone whose computer or server cannot handle large files.

GIF (Graphics Interchange Format; file extension: .gif)

The GIF format is designed for screen and Internet viewing of images with sharp edges (including borders and text) and a few, distinct colors. While photographs are too detailed for gif format, cartoons, line drawings, and digitally rendered images are appropriate. Use *File > Save for Web & Devices* or *File > Save As*, and choose GIF as the file format.

When choosing an inkjet printer, consider the following specifications:

resolution	Printer resolution is indicated with a two-number figure (ex: 4800 x 2400 dpi). The higher the resolution, the more detailed the image.
type of ink	Inks are dye- or pigment-based. Read more about the differences in *Digital Printing*.
ink palette	Describes which colors are used in printing, from the basic four (cyan, magenta, yellow, and black [CMYK]) to palettes with additional tones of color and black. The number and type of inks determine the width of the palette's gamut.
ink cartridge configuration	Indicates whether the cartridges are combined in one package or if each ink can be purchased separately. Combined packages are less efficient because the whole package must be discarded when one ink runs out.
print speed	Printer specifications will list the fastest printing speed possible. This varies from seconds to minutes according to the printer and print settings.
longevity	Printer longevity specifications describe the permanence of the manufacturer's paper/ink set, though longevity is also determined by light, temperature, humidity and exposure to air or contaminants.
maximum paper width	The maximum paper width that will fit in the printer.
maximum printable area	Describes whether the paper can be printed from edge to edge or within particular borders.
paper sizes	Describes the sizes of papers that can be run through the printer.
paper types	Describes the types of paper surfaces and textures that can be printed with the printer/ink combination.
maximum paper thickness	The maximum paper thickness that will pass through the printer.
connectivity	Describes the ways that an image can be sent to the printer, (ex: firewire, wireless, direct print port, USB cord, ...)

3.191 Inkjet printer features (see pp. 296–305)

Selecting a printer, paper, and inks

Printers

A digital printer sprays fine droplets onto various media, such as paper, in the form of dots. While the resolution of digital images (in the camera or a digital file) is measured in pixels per inch (ppi), dots per inch (dpi) is the resolution of a printer when laying down dots. The following types of digital printer are available for home use. For additional printing options, see "Commercial Printing," pp. 308–314.

Inkjet printers spray fine droplets of pigments or dyes to produce the illusion of continuous tone. This means that, although the image is made up of discrete dots, they are so small and compressed that they seem to blend into each other. For several reasons, pigment-based inks are often preferred over dye-based inks when making fine-art prints, so some artists differentiate between inkjet printers based on the type of ink used. For more information about dyes and pigments, see "Inks."

There are essentially two types of inkjet printers, *desktop* and *photo*. *Desktop printers* are small printers that accept letter-size paper. They usually print with four inks, though sometimes more. Desktop printers are somewhat inexpensive, though their inks are pricey. *Multifunction* or *All-in-One* types are inexpensive inkjet printers that also function as scanners, copiers, and sometimes as fax machines. *Photo printers* range in price and size, and accept slightly larger sheets of paper than desktop printers. They usually use six or more inks. *Large Format* printers are large high-resolution inkjet printers that print up to 44 inches in width.

Connecting to the printer

If printing from a computer, send images from the computer to a printer through a USB or Firewire cord, or by wireless technology. Some printers can read a camera's memory card. Others have a dock that connects directly to the camera. A few cameras on the market are capable of sending images by wireless directly to the printer.

Printer maintenance

Install the printer software and follow the manufacturer's instructions. These will walk you through the setup of the software, installation of the inks, and alignment of the printheads. After the initial setup, the printer utilities will provide ways to continue maintaining the printer by cleaning and aligning the printheads. These may begin automatically when you start up the printer or when the ink cartridges are changed, and you can access them if you experience printing problems such as banding, gaps, and graininess.

range and subtlety of the colors we see with our eyes. Furthermore, each medium operates within its own gamut, or range of colors, and therefore converts the numbers differently.

To assist with translation difficulties, digital media (monitors, printers, and software) use color profiles. Color profiles hold information about the available colors embedded in an image file. Standard profiles are created and supplied by paper, printer, ink, software, and equipment manufacturers. These are referred to as ICC (International Color Consortium) profiles. Standard profiles can be downloaded from the manufacturers' websites; you can also create your own custom profiles. Profile specifications tell the color management system how to interpret color data.

The following general guidelines can be used as a starting point to produce accurate color prints of scanned and digitized images. These involve:

- Understanding the digital printer/paper/ink system.
- Selecting a printer, paper, and inks.
- Adjusting and regulating monitor viewing conditions.
- Calibrating the monitor.
- Setting the color working space and color management policies in Photoshop.
- Soft proofing the image in Photoshop.
- Editing the image in Photoshop.
- Using a print profile for a specific printer/paper/ink combination.
- Making the final print.

Understanding the digital printer/paper/ink system

The printer is just one part of a larger system, involving the printer, inks, and print media. Each printer/paper/ink system has its own characteristics. For example, a manufacturer might coat one paper with an additive that extends the permanence of its yellow inks. A print's color gamut, tonal range, surface quality, and longevity are determined by the printer/paper/ink set. For this reason, manufacturers recommend working with inks and papers designed for a particular printer. However, third-party papers and inks, made by other manufacturers, are increasingly common, because they can be less expensive and claim to have compensated for the problems of third-party inks, namely clogged printer nozzles and lack of ICC profiles.

You may want to select a digital printer by determining your output needs first. For example, if you want to print a panoramic image, you may want a printer that accepts rolls of paper. If you want a certain resolution, you will need a printer capable of achieving that dotsize. The following section describes the types of specification to consider when printing.

destination for the saved file, a file name, the file extension, and indicate whether you want to use lossless compression, then click *Save*.

Converting files in Photoshop

In Adobe Photoshop choose *File > Save As* to change a file's name and/or format when saving. In the Save As dialog box, rename the file, choose a destination for the file, indicate the format and other options, such as the color profile, then click Save.

PRINTING IMAGES: DIGITAL PRINTING

Digital printing comes at the end of a longer process in which:

1 A digital camera or scanner captures a color scene.
2 The captured image is viewed and edited on a glowing light box, the color monitor.
3 The data is sent to a color printer to be reproduced with inks and pigments on paper or film.

In this process, each type of equipment translates color differently. Accurate reproduction of the original color scene depends upon effective communication between these different digital devices. If your image will ultimately be seen as a paper print, there are several factors to consider, from making sure that the image seen on the computer monitor has the same color and tonal value as the printed image, to choices of paper, ink, and printer. This section describes the tools, materials, equipment, and processes involved in digital printing.

COLOR MANAGEMENT

Color management is the process of translating digital color data from one piece of equipment to the next while ensuring that the image on the monitor resembles the scene photographed and that the print resembles the image on the monitor. This consistency is tricky, because there are so many agents involved in digital imagery: the camera or scanner, the image-editing software, the monitor, and the printer. Initially, the camera records the subject electronically. That digital information exists as a series of numbers, which are interpreted by a display device as a light-backed image on the monitor, then interpreted again by a printer as an ink-based image on paper. It is not possible for these media to replicate the

3.190 Converting files in Adobe Photoshop

TIFF (Tagged Image File Format; file extension: .tif)
TIFF was created for exchanging pixel-based images between image-editing software and graphic programs and across multiple platforms (e.g. Mac, Windows, Unix). TIFF files can be in any mode (Grayscale, RGB, CMYK, etc.) and the format will preserve clipping paths, content layers, adjustment layers, and vector data. (Note that not all graphic applications can read this information.) TIFF is a lossless format, though Photoshop will offer options for some JPEG (lossy) compression when saving the file. TIFF files saved without compression may be quite large. Because the TIFF format preserves layers and other data, the format is recommended for files that may require additional modification. Additionally, because the TIFF format preserves image quality and is universal, it is the best choice for images that will be printed or used in page-layout programs, and a good choice for formatting when saving a backup file.

PSD (Photoshop Document; file extension: .psd)
PSD is the native format of Photoshop and, as the format preserves layers, channels, clipping paths, and other data, it was at one time widely used to save in-progress images. Now that the TIFF format preserves the same information, PSD is not the only option for saving layers.

PDF (Portable Document Format; file extension: .pdf)
PDF is a good format for documents with a lot of text or for sending proofs or samples through email. Convert single images to PDF with *File > Save As*; Save multiple images as one PDF file in the Output Module of Adobe Bridge. To open a PDF document, you need Adobe Reader or Acrobat.

DNG (Digital Negative; file extension: .dng)
DNG is a format that can contain RAW image data. Adobe created DNG as an open file format that would be suitable for archiving. Converting RAW files to DNG format (and saving the files in a permanent archive) may ensure that the files can be read in the future. However, as each camera model uses a different RAW format, not all formats can be read by the DNG format, and not all will be decoded by software in the future. It may become impossible to open these files within a decade or more. You can convert a RAW file to DNG in Photoshop's Camera Raw by clicking on the *Save Image* button.

Reformatting files
Converting files in Camera Raw
To convert a RAW or other file to another format, such as DNG or TIFF, in Camera Raw, click on the *Save Image*. In the Save Options dialog box, choose a

3.189 Saving in Adobe Camera Raw

Paper: selecting, storing, and handling

The ability to get the right saturation and color depends upon choosing a paper with profiles that match the ink and printer combination. Most papers are made to be used with a particular manufacturer's ink. Store the paper in its original package and do not expose the material to extremes of temperature or humidity.

All papers share the following qualities, though options may be expansive or limited depending upon the printer type:

- Paper color or *tone*. Common tones are: cold-tone papers with a bright white paper base; neutral papers; and warm-tone papers with a cream or yellow paper base. White papers are measured in terms of *whiteness/brightness*. The degree of whiteness of a paper will affect the brightness and saturation of the print colors. The greater the whiteness, the brighter and more saturated the color. Paper color also affects contrast.
- Paper *surface* or finish is a personal choice. With glossy papers, the ink sits on the surface and the image appears to have higher contrast and color saturation. Matte finishes absorb the ink and so seem to have less contrast and vibrancy. Matte surfaces can lose detail in shadow areas of the print. Luster surfaces have a slight sheen, and tend to have the vibrancy of glossy, without the glare. One manufacturer, Crane & Company, produces a cotton pulp paper called Museo Silver Rag, which is meant to produce inkjet prints that resemble chemically developed darkroom glossy prints.
- Papers come in varying *weights* and *opacities*, from heavy canvas to opaque and transparent films. Papers that are too thick will have a hard time going through your printer. Papers that are too thin will be more susceptible to ink bleeding into other areas of the image. Opacity refers to the amount of light that can pass through the paper. Transparencies (clear, smooth films) can be printed on, and then used in overhead projection, on lightboxes, or as digital negatives for alternative chemical print processes. Display film (white opaque film) is a good surface for digital prints that will be shown in a light box.

Inks

The type of ink a printer uses will affect color saturation, gamut, and permanence. *Pigment-based inks* tend to be more lightfast and less sensitive to humidity than dye-based inks. Unfortunately, the way pigments reflect light may make some colors (particularly reds) look muted or dull, and colors may seem to shift under different lighting. *Dye-based inks* produce strong, accurate, saturated colors, but tend to be less stable, fading over time or in less desirable storage and exhibition conditions. *Third-party inks* are cartridges sold by businesses other than your printer's manufacturer. These cartridges are sold at significant discounts.

Manufacturers warn that, for best quality, it is essential to use their inks with their printers, that third-party inks may clog the inkjet printheads, and that using a third-party ink will void the printer warranty. Non-partisan reviews vary in advice, some claiming that the quality will be equal though the permanence of third-party inks cannot be guaranteed.

Paper/ink permanence

Depending upon how you will use the print, permanence may be an issue. Paper and ink manufacturers have made large strides in the area of image longevity. With the combination of archival inks and papers, many images can last for many decades with little to no image degradation. The longevity of a print may depend upon the particular combination of paper and ink, as these materials are often manufactured to work together. The website for Wilhelm Imaging Research (www. wilhelm-research.com) contains charts for the longevity of the latest paper/ink combinations. Archival papers will be clearly marked as such on the packaging. Color shifts and yellowing are common problems with papers of low quality. The permanence of dye-based prints is at risk if exposed to UV light, contact with air, humidity, and pollutants.

Obtain print profiles for a specific printer/ink combination

When selecting options in the print dialog box, you will choose your ink, printer, and paper profile. Each brand/model of ink and paper has specific *color profiles*. A printer's software will load the profiles for that machine's recommended inks and papers. If you use inks or papers from one manufacturer in a printer from another, you can usually locate and download the profiles from the ink or paper manufacturer's website. Even if you are using third-party inks, they usually supply you with profiles to common papers and printers. Install downloaded profiles on your harddrive in *Library > ColorSync > Profiles*.

Adjust and regulate monitor viewing conditions

To achieve reliable results when working on the monitor, it is important to maintain consistent working conditions. Lights should not shine directly on the monitor and the monitor should be brighter than the ambient light. Turn off household tungsten bulbs when working on the monitor or viewing prints. At a minimum, work in a space with consistent lighting that does not vary based on time of day or outside weather conditions. Make sure that there are no colors in your environment that cast colors on the screen. If possible, paint your work area a neutral color (gray). If not, at least make your desktop screen neutral gray. If you know how the prints will

be lit when shown, use the same light temperature to view prints while printing. If you do not know the lighting conditions, use a 5000°K lamp, or daylight.

Calibrate the monitor

The monitor is the crucial piece of equipment in digital photography, as its size, quality, and color affect the appearance of your image while you are working. A color monitor display uses a red, green, and blue (RGB) color space. Monitor calibration refers to eliminating color casts, verifying that grays displayed are neutral, and adjusting basic controls such as contrast, brightness, color temperature, and depth of color to predefined standards.

To calibrate, you assess contrast, brightness, color temperature, and depth of color by using a hardware calibration device or by looking at the monitor itself. There are two types of calibration package. The type you use will depend on your budget and the demands of your work.

- Monitor profiling packages consist of software and a measurement device. The devices are either a colorimeter (a "puck"), or a spectrophotometer that attaches to the monitor to assess the color performance and generate an ICC profile for the monitor. GretagMacbeth, Color Vision, and Monaco Systems provide the user with an easy interface and measurement device to calibrate and profile your monitor. These are the most accurate and expensive means of calibration.
- Calibration utilities such as Apple Display Calibrator Assistant and Adobe Gamma are supplied when you purchase your computer or Photoshop. They can be found in the control panel, and will calibrate and profile the monitor by asking you to visually evaluate a neutral image and background. To calibrate the monitor using one of these utilities in Mac, choose *System Preferences* > *Displays* and select *Color*. Because they rely upon the imperfect human eye to measure color, these utilities are not as accurate as the hardware calibration devices.

Before beginning calibration

- Ensure that the monitor is producing consistent output. Make sure it is warmed up and has been turned on for at least a half hour before calibration.
- Set the monitor background to display neutral gray rather than a colorful or busy pattern that could impede your ability to perceive color.
- Set your screen resolution. Not all monitors will be the same size. LCD monitors should be operated at their native resolutions. The native resolution is the

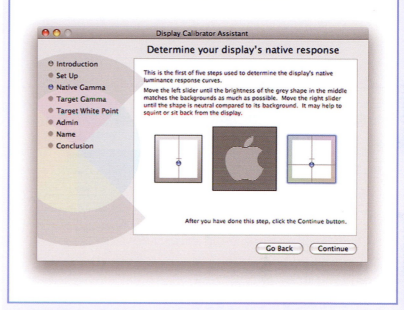

3.192 Monitor calibration

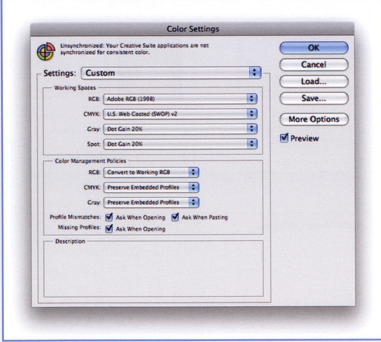

default setting for the monitor. This information will also come with the monitor when purchased. When operated at their native resolution, the image is not rewritten; no pixels are added or subtracted (interpolated).

To calibrate, follow the basic guidelines

- Adjust the display's native luminance response curves—i.e. the brightness—by evaluating a series of neutral objects set against a background.
- Set a target gamma. This adjusts the brightness of the midtone values and the overall contrast of the display. Some photographers recommend the native gamma (1.8 for Mac, and 2.2 for PC). Increasingly, digital artists claim that 2.2 for Mac provides richer contrast.
- Set the monitor white point. This will adjust the overall tint of the display. Select D65 (6500K).
- Name and date your profile. We recommend naming the profile with a date in order to keep track of calibrations.
- Because the monitor brightness will drift over time, recalibrate frequently. Begin each calibration from a supplied profile (such as Apple RGB), rather than your previous calibration profile.

Set the color working space and color management policies in Photoshop

Once you have calibrated the monitor, the next step in color management is to identify the color working space and management policies for this space within Photoshop.

The color working space

The color working space or RGB working space has an ICC profile associated with it. This profile numerically describes all the colors that can be created and read. Each color space has its own gamut, or range, of possible colors. A color space with a "wider" gamut will have more available colors. Your choice of color space will determine the color of the image being displayed. By defining the working space, you determine how the next connecting device will interpret your data.

In Photoshop, choose *Edit > Color Settings*. You can make changes within the dialog box by making selections from the blue drop-down menus. Set your color space in Photoshop under *Working Spaces*. Set the RGB working space profile to *Adobe RGB (1998),* which has a large gamut, or range of colors. When working with images that will only be viewed on the web, work in sRGB color space.

3.193 Color settings

Color management policies

In the bottom half of the dialog box, *Color Management Policies* help guide you in making selections regarding color space. There may be times when you receive a file that either does not have an embedded profile or has an embedded profile that is different from your working space. The choices you make in this box indicate how you would like to color manage new and imported documents in Photoshop.

- Off, if you do not want to color manage new or imported color documents.
- *Preserve Embedded Profiles*, if you anticipate working with a range of documents with different profiles and want to preserve their preferences.
- *Convert to Working Space*, if you want to force all documents to use your current working space.

The color space determines how the pixel values in the file will be interpreted. Colors will shift if the color space of the imported document does not match your color (working) space. Therefore, we recommend setting the RGB policy to *Convert to Working RGB* to force all documents to use your current working space.

If you check the three boxes at the bottom, Photoshop will notify you if there are missing or mismatched profiles. A dialog box (see Figure 3.194) will open up if the file you open has a different working space from the working space (color space) in your color settings. This dialog box will not appear if the files are embedded with the same profile as your color space.

Soft proofing the image in Photoshop

A printing profile contains information about the particular color characteristics for the combination of paper/ink/printer you are using. A soft proof is a proof simulating the characteristics of this combination. It is viewed only on screen, not as a hard copy. Photoshop's soft proofing option allows you to preview the effects of using a printing profile in order to get an accurate representation of how the final print will appear *before* making the actual print. This procedure is referred to as *Soft Proofing*.

Note the image title before you turn on the effects of the printer profile (see title of Figure 3.195).

This is because the image is not yet associated with a printer profile.

With the image open in Photoshop, go to *View > Proof Setup > Custom*. The dialog box shown in Figure 3.196 will open.

Check *Preview* to view the color shifts in your image. Under *Device to Simulate*, select the printer profile for your printer or the profile that you have found to give

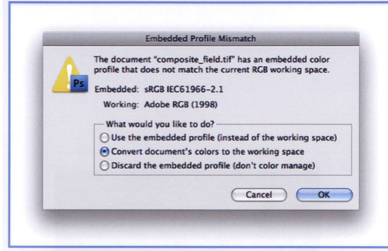

3.194 Color space mismatch

3.195 Soft proofing in Adobe Photoshop

3.196 Soft proofing in Adobe Photoshop

the best results. The printer profile should offer various profiles that have been created for each combination of printer/paper/ink. Select the profile for the type of printer/ink set/paper type you will be using to make the final print.

For *Rendering Intent*, there are several conversion options. We recommend one of the following two:

- *Perceptual:* reproduces colors by scaling down the color working space to fit the destination space gamut. All colors of the source color will be mapped to the nearest in-gamut color of the destination color space.
- *Relative Colorimetric:* changes only the source colors that fall outside the gamut of the destination color space; the in-gamut colors are unchanged. Colors are scaled relative to the destination white point.

Here, we choose Relative Colorimetric, but encourage you to experiment with both.

Leave *Black Point Compensation* checked. Click *OK*.

Now that you have turned on the effects of the printer profile, note the change in the image title (see Figure 3.197):

Additionally, you may note a difference in the value or hue of your image color. This feature provides you with a better sense of how that particular printer/ink/paper combination will reproduce the colors of your image.

Edit the image in Photoshop

If you find that the colors of your image in the soft proof need to be adjusted, you can now make changes to the color and tone in Photoshop. Always make changes using an adjustment layer. Once you are satisfied with the image, and the document size and resolution are correct, save a copy with flattened layers. It is best to print with flattened layers in order to save time and to eliminate the risk of layers being altered. You are now ready to make the final print.

Using a print profile for a specific printer/paper/ink combination

To achieve the best results with your chosen printer, it is important to choose the right settings in your printer software. With the image open in Photoshop, go to *File > Print*. A Print dialog box will open. In the Printer menu, choose your printer. Click on the *Page Setup* button.

A Page Setup dialog box will open. In the Format For menu, select the inkjet printer. In the Paper Size menu, choose your printing paper's size. Many paper sizes offer several options within a drop-down menu. For example, if you would

3.197 Soft proofing in Adobe Photoshop

3.198 Printing in Adobe Photoshop

like to print on US Letter size without white borders, choose the "Borderless" option from the US Letter drop-down menu. Under Orientation, select the portrait or landscape icon. Leave the Scale value at 100%. Click *OK*.

After you've clicked *OK*, you'll return to the Print dialog box. Select *Center Image* to print the image in the middle of the page. Choose *Scale to Fit Media* to downsize your image to fit the paper size. If your image is SMALLER than the page size, choosing Scale to Fit Media will upsample your image and may result in a pixelated print.

Select *Color Management* in the menu in the top right corner. Click *Document* and notice that *Profile: Adobe RGB (1998)* appears below. If this does not appear, you are in a color space other than the one we recommend. Under Color Handling, choose *Photoshop Manages Color*. This uses Photoshop's color engine rather than the printer driver or operating system. Under Printer Profile, select the printer/paper/ink combination for your setup. Under Rendering Intent, choose *Relative Colorimetric*. Make sure that the Black Point Compensation is checked. Now click on *Print*.

Another Print dialog box will open. Under Printer, select your printer profile. In the drop-down menu under Copies and Pages, choose *Printer Settings*.

Choose the following options under Printer Settings. Under Page Setup, choose *Paper Tray* for standard paper sizes. Under Media Type, choose the type of paper you will be using. Under Print Mode, select *Color* for color images. Under Color Mode, select *Off (No Color Management)*. For Output Resolution, you might experiment with different dpi's to produce a satisfactory print. While the printer is optimized for best prints at the highest dpi, many artists find that lower dpi settings are satisfactory. Alternately, you could try starting with the lowest possible dpi and, if necessary, increasing. If your print shows evidence of banding (light lines), your dpi may be too low or your printer nozzles are clogged.

Deselect *High Speed* for higher-quality printing. High-speed printing is bi-directional; to increase printing speed, the printer head lays down ink on both its back and forth movements. Although the quality may be satisfactory with High Speed selected, printers are designed for best printing with this deselected. Keep in mind that printing with High Speed unchecked will cause the printer to lay down more ink and will increase printing time.

Making the final print

Make sure that the computer is connected to the printer. Place the paper in the printer with the appropriate side of the paper facing up or down. Press *Print*. Give the print time to dry properly and then evaluate the digital print in the same lighting conditions as those in which they will be viewed.

3.199 Printing in Adobe Photoshop

3.200 Printing in Adobe Photoshop

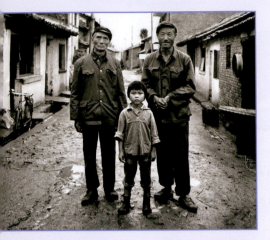

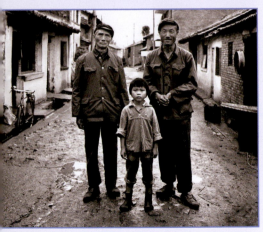

3.201 and 3.202 John Palmer, *Villagers, Yunnan 1986,* 2006.
Digital prints, scanned from 4 × 5in. negative
Note the difference between the greenish cast of Figure 3.201,
made on a color inkjet printer, and Figure 3.202, made on a
printer with Piezo WarmTone inks

DIGITAL PRINTING: PRINTING BLACK AND WHITE ON A COLOR PRINTER

Color printers usually provide an option to print as color or black and white. If printing on a printer with only one black and no gray cartridges, printing in *black and white* is not recommended, because the black ink cartridge by itself is incapable of reproducing fine gradations of tone in the grayscale. Printing in *color* will yield better results because the printer uses cyan, magenta, yellow, and black to create the photo. Most black and white prints made on a color printer have a slight color cast (for example, a warm yellow tone). If you want this cast, you can tweak the color balance of an image to control the direction the cast takes. If you prefer more neutral black and grays, you have a few options.

Some users change the color mode from RGB to Grayscale (*Image > Mode > Grayscale*). However, a better alternative is to keep the image in RGB mode and to change the color image to black and white using the Black and White Adjustment Layer (*Layer > New Adjustment Layer > Black and White*). This image adjustment tool allows you to convert the image to monochrome and to adjust the values according to Red, Green, Blue, Cyan, Magenta, and Yellow color channels. All changes are made on a layer, which can be revised or discarded.

Using grayscale inks on a color printer

Higher-end photo-quality inkjet printers with individual cartridges usually have several shades of black ink (in conjunction with color inks) that facilitate printing in black and white. Some printers can also be adapted to full black and white printing by replacing the color cartridges with pigmented inks of various shades of gray. The best known of these are made by Piezography, which produces archival pigment-based ink sets that can be sprayed through the printheads of the desktop inkjet printer. An *ink set* is a collection of inks with a particular tone, such as warm neutral, selenium, carbon sepia, or cool neutral. Accompanying software determines which head sprays which tone and the size and frequency of the ink dots, and uses ICC profiles for Epson printers. Piezography claims that its system inks are neutral to the human eye and do not fade or shift color.

THE DIGITAL CONTACT SHEET

Adobe Bridge provides an easy way to place your images in a contact sheet format. The image browsing software uses the term *contact sheet* from traditional photography wherein many negatives are printed directly onto a single sheet of paper for evaluation and reference. The digital process also places many images

together on a single sheet, but with a few differences. Since digital files can easily be previewed on the computer, the advantage of the contact sheet is not that the images are easier to view, but the ability to print out a hard copy of thumbnail images for storage, reference, cataloging, and submission purposes.

STEP 1: Locate files in Adobe Bridge
Open Adobe Bridge. If the files you wish to use for the contact sheet are not already in one folder, locate all the images and place them in a folder in Bridge, on the computer's hard drive, or on a connected storage device such as an external hard drive.

STEP 2: Arrange and select images in the Content panel
Choose *Window > Workspace > Output* or select the *Output to Web or PDF* option from the *Output* menu at the top of the Bridge interface. The *Preview panel* will move above the *Content panel* and an *Output panel* will appear at the right of the interface. You can now look at your images and decide if you would like to reorder them. Arrange images in the desired order by clicking and dragging the thumbnails to a new location. If the Content panel area is too small, drag the horizontal bar up to enlarge that panel.

In the Content panel, select the images you want to print on the contact sheet by holding down Shift and clicking on the first and last image in consecutive order. To select non-consecutive images, hold down Command and click.

STEP 3: Format the contact sheet
Within the Output panel, select the PDF option. The *Template* menu provides two choices for contact sheet formatting. You can select either 4*5 *Contact Sheet* (which creates a layout of 4 across and 5 down) or 5*8 *Contact Sheet* (which creates a layout of 5 across and 8 down). The 5*8 option squeezes more images on a page and, therefore, will produce smaller thumbnails. The 4*5 option produces larger images on each sheet, for better viewing, but might require more contact sheet pages to accommodate a large number of selected images.

At any time, if you want to see a preview of your images in your chosen layout, press the *Refresh Preview* button. Your contact sheet will appear in the *Preview panel* (if your contact sheet requires several pages, only one will actually appear as a preview). If you wish to make changes to your contact sheet, move to the next step. If you wish to save this version, move to STEP 6.

STEP 4: Customize the contact sheet
You can customize your contact sheet in the Output panel via the *Document*, *Layout*, *Overlays*, *Playback*, and *Watermark* areas.

3.203 Digital contact sheet in Adobe Photoshop

3.204 The contact sheet in our example allowed the artists Zack Denfeld and Brent Fogt to make comparisons among multiple images. Their photographs document hand-painted signs for the Frimangron Neighborhood Project. The Frimangron neighborhood, built by born-free and bought-free slaves, is one of the oldest districts in the center of Paramaribo, Suriname

Under *Document*, select the page size, image quality, and background color. We chose the *Page Preset*, *US Paper*, to make an 8.5×11-inch sheet, but you can select from other preset sizes or enter customized values for the height and width. Select the *Quality*. We chose *High Quality* to produce a higher resolution file, which also means that our file size will be larger. Under *Background*, you can select White, Black, or Custom. To choose your custom color, click on the *Custom Color Swatch*.

The *Layout* area allows you to order images through *Image Placement*. From the Image Placement drop-down menu, determine whether images are placed horizontally (*Across First*) or vertically (*Down First*). Enter values for the number of *Columns* and *Rows*. More columns and rows yield smaller images. We selected *Use Auto-Spacing* to allow Photoshop to determine the space between images. If you deselect this option, type in customized margin values. To allow Photoshop to rotate images to fit them on the page, select *Rotate for Best Fit*. The last option, *Repeat One Photo per Page*, will create a layout of multiple copies of each image on each page (12 copies of image #1 on the first page; 12 copies of image #2 on the second page, and so on).

The *Overlays* area allows you to include image titles and extensions (e.g. .tif, .jpeg, .psd) below each image. Choose a *Font*, *Size*, and *Color*.

The *Playback* area allows you to customize the PDF file for presentation as a slideshow. For contact sheets, we recommend deselecting all options in this menu.

Watermarks protect images from unauthorized use. In the *Watermark* area, you can overlay information, such as your name, copyright, or logo, on the center of each page. Choose the *Font*, *Size*, *Color*, and *Opacity*. Larger text will cover more of the page.

STEP 5: Preview the layout
Make sure the desired images are selected in the Content panel and press the *Refresh Preview* button to see a thumbnail of the contact sheet layout.

STEP 6: Save the file as a PDF
Once you are satisfied with the contact sheet preview, save the file as a PDF. Scroll to the bottom of the Output panel and check *View PDF After Save* and then click on *Save*. In the prompt that appears, select a location for the file to be saved. Bridge will create and automatically open the contact sheet PDF.

OTHER PRINTING OPTIONS

Commercial photographic printing
For artists who have neither the equipment nor the time to make photographic prints, commercial labs offer a growing array of photographic services. Certain

processes, such as color photographic printing, are difficult to perform by hand and require facilities that are expensive to maintain; commercial labs offer the most affordable alternative. Further, many custom photo labs can make large prints on a variety of materials, a process requiring specialized digital equipment that few individuals are able to purchase. Although it may cost more to have prints made by a service, commercial labs provide more access to facilities and expertise.

📖 **3.5**

Drugstore photo processing

The most common and economical places to print digital files are the standardized labs at drugstores and retail outlets. Most retail stores with photo facilities offer digital printing. They use either dye-sublimation printers, that use a heat process to vaporize dyes that permeate the surface of paper, or inkjet printers that spray tiny dots of colored ink onto the paper, row by row, over the entire picture surface. Each process produces prints immediately. The dye sublimation process produces more fade-resistant prints and better continuous tone than inkjet printing, though this depends on the quality of the printers. Chemical processing (in which the images are transferred digitally to a chemical processor for printing) may be available. This process usually takes an hour, but will more accurately reproduce your images. The only individual choices allowed at drugstores and superstores may be editing options at a kiosk (see index for *photo kiosks*).

Mail-order photo processing

Many companies allow you to order prints online to be mailed directly to your home. Each company provides online web browsers or free, downloadable programs that let you select images from your computer, make simple alterations to the images, and then place your order. Due to upload speed, some companies only accept JPEG files because uploading can be time-intensive. After the company receives your uploaded files, they print the images and mail them to you. These labs produce a larger number of images at a cheaper cost than you might spend on ink and paper on a home inkjet photo printer, and are capable of printing larger images than many home printers.

Professional lab photo processing

Professional labs print digital files using chemical RA-4 color processes, high-end inkjet printers, or digital printers that combine these processes, such as Lightjet printers that use lasers to plot the digital image onto light-sensitive photographic paper, which is then chemically processed using silver halide. Custom photography labs are able to make color corrections, adjust contrast, and improve print quality beyond the constraints of standard print services. Professional labs offer

these printing services at prices that are comparable to or higher than the standardized outlets.

Traditional services, where prints are made by photographically enlarging an image from film, may sometimes be available, but are increasingly expensive and difficult to locate locally. Thus, most labs digitize film in order to print it, and most custom labs scan 35mm, medium-, and large-format film, at an additional cost to making the print.

Commercial presses

If printing large or short runs of posters, postcards, or other publications, you may want to consider a commercial printer that specializes in high-end digital and offset printing. *Offset printing* refers to the process of offset lithography. The image is exposed onto lithographic film. The film image is then "burnt" onto a plate made of paper, metal, or plastic. The printing process begins by placing the plate on the plate cylinder and using CMYK inks and water to create the image. The image is built up by a color separation technique, which adds the colors in succession. Offset printing produces sharp, clean images. Many printers now offer digital offset printing, which bypasses the film stage by using lasers to burn the image directly onto the plate. Although offset printing does not have the continuous tone available with photographic prints, projects with multiple pages, text and images, and bulk runs may necessitate offset printing.

Digital direct-to-press (DTP) printers transfer digital files directly to the printing press. This process provides images with offset printing quality, at less setup cost and time, making smaller runs more affordable.

Some printshops also provide *laser printing* for projects such as this. Although laser printing has a much lower setup cost (no need for plate creation) and produces continuous tone (no dot pattern), it cannot color match like photographic and offset printing and may result in colors that are different from your original file.

Size

The standard output for popular photography remains 4×6-inch prints. Most photo labs can print enlargements up to 8×10 inches; larger photographs are generally available only at custom labs and specialty print services. Digital printing technologies have made large-scale and banner-sized photographs more affordable. Custom labs offer various sizes for printed photographs, some up to 48×96 inches. Beyond that, custom labs and specialty print services offer banner-sized printing on various materials, including matte and glossy photographic paper, adhesive decals, plastic banners, and signs.

Formatting

Make sure all layers are flattened, so that the file size is smaller and to eliminate the risk of layers being altered. Make sure the images are the correct print dimensions for the final print so that no cropping occurs. Commercial labs may or may not accept particular file formats (e.g. TIFF or JPEG) or color spaces (e.g. Adobe RGB or sRGB). Contact the commercial lab to confirm acceptable file and color space formats. Place your files on a flashdrive or a CD, depending upon the media accepted at that venue.

When contacting a commercial press, make sure to ask about the required resolution, bleed margin, color mode, and file format. For example, one printshop may require 300dpi files at the final print dimensions, a ⅛-inch bleed margin, either CMYK, Spot Color, or Grayscale modes (depending upon how many colors will be used to print the artwork), and PDF format.

Quality

Regardless of the lab or print material, the quality of the printed image depends primarily on the quality of the provided file. Low-resolution files produce pixelated images. High-speed or grainy film results in grainy images, even when scanned at a high resolution. For these reasons, it is important to understand how a photograph will be translated into print before placing the order.

The photo kiosk

The benefit of the photo kiosk is the do-it-yourself access that they encourage. Artists without access to a computer, digital editing software, or a good printer can use a kiosk to edit and print images quickly and inexpensively. Kiosks can be found in drugstores, photo-processing stores, shopping malls, maternity wards, and on cruise ships. You start most kiosks by pressing a button to awaken the machine.

Media/storage format

Current kiosk models have slots for various storage formats: CD, flashdrive, and different kinds of memory cards.

Interface of photo imaging software

Navigate the kiosk software through the interface, which offers a range of choices depending upon the particular manufacturer. Interfaces vary, with some software granting the basic choices of print size and quantity, and others allowing editing options, such as the ability to zoom, crop, rotate, correct red eye, auto adjust color and contrast, and turn a color image into black and white or sepia. Most software gives the user the ability to add borders and text.

3.205 Kiosk and photocopier in front of silver-halide processing machines at Ritz Camera, Ann Arbor, MI

3.206 Sticker printing machine, Pinball Pete's, Ann Arbor, MI

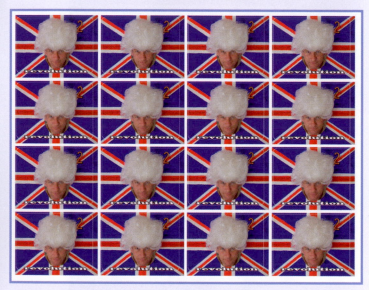

3.207 Nick Tobier, *Mascot for the Revolution*, 2005. Sticker-back photos
Nick Tobier (www.everydayplaces.com) brought his own backdrop to the photobooth to create stamps of his Wigman character. Tobier invented the character in order to revive and honor Sag Harbor's revolutionary and whaling histories. Tobier's Wigman sports both historical costuming (powdered wig, musket, and whaler's vest) and contemporary updates (polo shirt, loafers, and cellphone) to reflect the new Sag Harbor/Hamptons society. Tobier's British flag and postal rate transform the photobooth into a stamp machine that produces illicit federal memorabilia

Software interfaces also determine the amount of time it will take to manipulate and download the prints. A common problem is a delay between when the user pushes the button on the interface and when the software recognizes the command.

Printing
There are two printing options. Either the kiosk is networked to a photo lab's chemical silver-halide processor, or the kiosk is attached to an instant printer, which usually uses a quick dye-sublimation process. The silver halide and dye-sublimation processes are said by manufacturers to be of equal quality, but the silver-halide process seems to produce more accurate colors.

Cost and payment
Photo lab prints have an economical advantage over home printing. At the time of this writing, the average print made at home with high-quality ink and paper costs around $1 while the average price of a 4×6 photo lab print is 29 cents. Speed is expensive. At the kiosk, the faster instant printer usually costs more. The silver-halide process takes about one hour and, therefore, is less expensive. Discounts may be available for printing multiple copies. Many photo labs do not post prices by the kiosk. The interface will give a selection of print sizes, without listing corresponding prices. After editing the images, choosing size and quantity, and confirming the purchase, the kiosk sends the images to the printer and spits out a receipt or an invoice.

The photobooth
Photobooths provide an inexpensive, fast, fun, and immediate way to obtain images. Initially, attendants accompanied booths. They were eliminated in the 1930s in favor of the curtain and booth that offer an isolated space for posers to lose their inhibitions. Babbette Hines, who shows her collection of old photobooth pictures in her book *Photobooth*, describes the feeling of being both the subject and the photographer of a photo: "Alone in the booth, you forgo the behaviors and attitudes expected when a camera is forced upon you … You can be sexy or goofy or tough. You can even pretend to be happier than you are, and you get eight (or at least four) chances to do it." Artists with an interest in portraiture, series, and the mechanical generation of images often use photobooth stills. For example, Andy Warhol used the photo-strip as a source that could be silkscreened and turned into paintings, or used as multiple image portraits, and Tomoko Sawada uses photobooth images to take pictures of herself dressed up as various stock Japanese personalities.

Photobooth prints

Commercial photobooths imprint the image directly onto the paper using either a chemical or an inkjet process. They produce no physical negatives. The positive prints received by the sitter are the only records of his or her activities. Until the mid-1990s, the only variables in the standard photobooth were curtain color, the machine's ability to produce black and white or color, and the individual being shot. Many of these booths still exist.

Contemporary photobooths come equipped with more options: fantastic or cartoonish backgrounds, decorative borders, charcoal renderings, and text, to be printed on paper, cardstock, or as stickers. Marketed toward the arcade crowd, software systems are updated monthly to respond to the latest trends.

Keetra Dixon: the photobooth and second sight

Photobooth sitters play a game of chance as they attempt to present and re-present themselves for a rapid sequence of flash exposures. Keetra Dixon (www.fromktoj.com/photobooth) capitalizes on this sport by repositioning

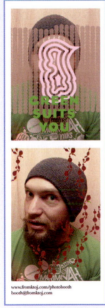

3.209 Keetra Dixon, *Photo Strip #1145654804978*, 2006. Digital print, 2 × 6in

3.210 Keetra Dixon, *Photo Strip #114703635506*, 2006. Digital print, 2 × 6in

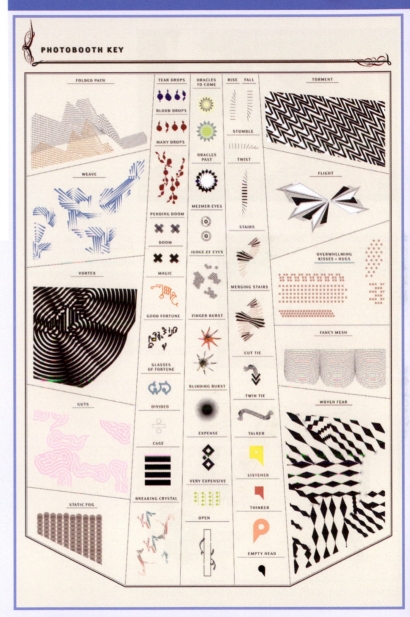

3.208 Keetra Dixon, *Photobooth Key*, 2006. Print, 11 × 17in

the photobooth as a fortune-teller's curtained room and transforming the commanding eye of the camera into a clairvoyant. Sitters enter an ordinary 1970s-era booth, draw a red curtain across the door, prepare themselves, and push a button to initiate the exposures. A computerized female voice announces: "Taking Picture 1 … Taking Picture 2." Two minutes later, the photostrip appears in its slot. It turns out that, not only has the camera's eye seen you, it has peered into your soul.

Superimposed over your portrait are symbols a design-savvy psychic might draw forth. A key on the booth lends insight into how these icons predict the future, cast a spell, or reveal your subconscious or character. The experience and images recall the practice of spirit photography in which a psychic used photography as a means to correspond with ghosts who communicated with a picture language. Dixon uses the 2-minute processing time to create this magic. From a remote location, she monitors the sitter's space, takes the exposures with a digital camera, applies the symbols to the images via digital editing, prints the photographs on pre-cut strips, and quietly slips them into the tray.

REPRODUCING PHOTOGRAPHS WITH OTHER MATERIALS

The craft of latch-hooking, popularized in the 1970s, involves tying 2-inch strands of yarn to a gridded canvas. Like pixels of a digital image, the various shades of color make up an image, usually a cartoon character. Rug kits come as a kind of paint-by-number system in which the canvas is colored. To assemble the rug, you attach shades of yarn to corresponding colors on the grid. By breaking down a digital image into blocks of colored pixels, artist Whitney Lee developed a way to translate appropriate photographs from www.playboy.com onto canvas. Her *Soft Porn*, a 5×8-foot rug, reproduces one of the site's nudes reclining in the style of Titian's *Venus of Urbino* (1538). Whitney's translation into latch-hook gives the photo a painterly effect. In the democratic spirit of crafts, Whitney produces "naughty latch hook kits" (for sale at www.madewithsweetlove.com).

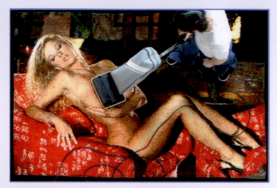

3.211 Whitney Lee, *Soft Porn*, 2002–2003, 5 × 8ft. Latch-hook rug

@ 3.6 Refer to our web resources for information about photographic embroidery, a practice using thread and varying stitches to construct an image.

3.212 Whitney Lee, detail of *Soft Porn*, 2002–2003, 5 × 8ft. Latch-hook rug

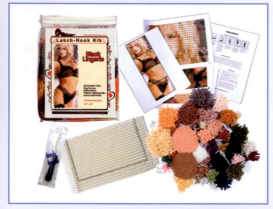

3.213 Whitney Lee, *Black Lingerie Latch-Hook Kit*, 2006, mixed media

SUGGESTED FURTHER READINGS

3.1 RUBBING SUPPLIERS AND RESOURCES

Clare's Celtic Cornucopia. Brass Rubbing. http://www.celticstitchery.com/
New York Central Art Supply. http://www.nycentralartsupply.com/

3.2 LIQUID EMULSION SUPPLIERS AND RESOURCES

Alternative Photography. Articles and technical information about alternative photography processes. http://www.alternativephotography.com/

Bostick & Sullivan. A source for camera equipment, chemistry, books, and other technical information. http://www.bostick-sullivan.com/

Photographers' Formulary. A source for chemistry, non-silver-processing kits, supplies, technical support and workshops. http://www.photoformulary.com/

Rockland Colloid Corp. Rockland Colloid is a source of non-silver-processing kits, liquid emulsions, color toners, digital imaging transfers, and processing information. http://www.rockaloid.com/

3.3 RESOURCES OF HISTORICAL PHOTOGRAPHIC PROCESSES, MATERIALS, AND EQUIPMENT

Books

Jan Arnow, *A Handbook of Alternative Photographic Processes* (New York: Van Nostrand Reinhold, 1982).

John Barnier, *Coming into Focus: A Step-by-Step Guide to Alternative Photographic Printing Processes* (San Francisco, CA: Chronicle Press, 2000).

Christopher James, *The Book of Alternative Photographic Processes* (Clifton Park, NY: Delmar Cengage Learning, 2nd edition, 2009).

Bea Nettles, *Breaking the Rules: A Photo Media Cookbook* (Urbana, IL: Inky Press Productions, 3rd edition, 1992). Includes recipes for cyanotype, Van Dyke Brown printing, gum bichromate, and others.

Lyle Rexer, *Photography's Antiquarian Avant-Garde: The New Wave in Old Processes* (New York: Harry N. Abrams, 2002).

David Scopick, *The Gum Bichromate Book: Non-Silver Methods for Photographic Printmaking* (Boston and London: Focal Press, 2nd edition, 1991).

Mike Ware, *Cyanotype: The History, Science and Art of Photographic Printing in Prussian Blue* (London: Science Museum; Bradford, England: National Museum of Photography, Film & Television, 1999).

Internet

Alternative Photography. Articles, recipes, and technical information about alternative photography processes. http://www.alternativephotography.com/

Bostick & Sullivan. A source for camera equipment, chemistry, books, and other technical information. http://www.bostick-sullivan.com/

Photographers' Formulary. A source for chemistry, non-silver-processing kits, supplies, technical support, and workshops. http://www.photoformulary.com/

Rockland Colloid Corp. A source of non-silver-processing kits. http://www.rockaloid.com/

The World Journal of Post-Factory Photography, Issue #1, Post-Factor Press, 1998. http://www.alternativephotography.com/

3.4 SCREENPRINTING MATERIALS, EQUIPMENT, AND INFORMATION

Suppliers
Dick Blick Art Materials. http://www.dickblick.com/
Nazdar. http://www.nazdar.com/
Standard Screen Supply Corp. http://www.standardscreen.com/

Internet information
Sign Industry (online magazine). http://www.signindustry.com/screen/

Book
Robert Adam and Carol Robertson, *Screenprinting: The Complete Water-Based System* (New York: Thames and Hudson, 2003).

3.5 MAIL-ORDER PHOTO PROCESSING
Adorama. http://www.adorama.com/
Kodak. http://www.kodakgallery.com/
Photo Processing/Printing. http://www.mpix.com/
Shutterfly. http://www.shutterfly.com/
Snapfish. http://www.snapfish.com/
White House Custom Colour (WHCC). http://www.whcc.com/

Commercial printers
Blurb (books). http://www.blurb.com/
Calypso Imaging. http://www.calypsoinc.com/
Inkchaser. http://www.inkchaser.com/
Modern Postcard. http://www.modernpostcard.com/
Pinball Publishing. http://www.pinballpublishing.com/
West Coast Imaging. http://www.westcoastimaging.com/

Digital and film services
Luster Photo & Digital Lab. http://www.lusterphoto.com/

INTRODUCTION

Except in the context of the modernist exhibition, we rarely experience singular or autonomous photographs as artworks in and of themselves. More often, photographs appear in the context of other photographs or images, or couched in text. Additionally, we rarely see an unedited image. Most photographs are put through a range of treatments, such as adjustments of contrast and color. In *Part 4: Editing, Presentation, and Evaluation* we examine strategies for bringing additional meaning to a photograph through manipulation, arrangement, presentation, writing, etc. Most of these methods are employed after a photograph has been produced, such as the addition of text or placement within a book. However, some decisions are made before the image is ever captured. When working in series or sequence, artists often have a guiding concept in mind or a general plan for working. At other times, however, order is imposed only after the fact, by a photo editor or the author of an Internet site. The three chapters of *Part 4: Editing, Presentation, and Evaluation* include two thematic essays—"Series and Sequence" and "Text and Image"—followed by a how-to chapter focused on tools and processes.

The essay "Series and Sequence" investigates how artists use conceptual categories to bring order to groups of images that may or may not have been produced under a general rubric. Some artists have created their own photographic archives or placed their photographs in sequence to suggest physical motion or the passage of time, to produce non-literal, abstract, and poetic arrangements of images, and to describe artistic processes and performance events. Time-based projected slide shows, often accompanied by spoken word or musical performance, fix an amount of time for viewing and for space between viewing. Photobooks compile the work of individual or multiple photographers and bring unity to these collections, creating a cohesive journey for the viewer to explore.

In the essay "Text and Image" we examine the relationship of image and text in historical context, beginning with a discussion of semiotics, or the relationship between a word and the thing that the word represents. Pictures have a direct connection with the thing they depict, while words are arbitrary symbols. However, photographs can be ambiguous representations. For this reason, photographers working in the social documentary tradition often use text to clarify, narrate, and instruct. This essay looks at photography's early connection to print journalism, its use by government agencies, and

influential collaborations between authors and photographers within the photo essays of *LIFE* magazine and other "photo-weeklies." In addition to photo–text collaborations of a public and commercial nature, we also discuss artists who tell personal stories or who use text as a critical frame with which to interrogate the purported truthfulness of the photographic image, as it is used in social documentary, journalism, scientific, and political discourse. Increasingly, artists use photographs accompanied by verbal instructions and spoken word, use text as a formal element in their compositions, and montage photographs as a tool for political critique.

Part 4: Editing, Presentation, and Evaluation concludes with a practical discussion of the Adobe Photoshop Tools panel, and traditional darkroom and digital tools for controlling contrast, color, and blemishes. Additionally, *Editing* (p. 382) describes how to combine and collage imagery through hand-pasted, darkroom, or digital collage, and various ways of integrating type and images. *Presentation* describes various methods of display, from artist books to portfolios, framing, Internet venues, and animation devices. In the final section on *Evaluation*, we describe strategies for critiques and the differences between verbal and written approaches.

Theory: Series and Sequence

Bill Anthes

INTRODUCTION

In our age of global media, images are viewed and consumed in the context of other images—in conceptual groupings that direct and shape our reading and understanding. Images in series and sequence proliferate: professional photographers and corporations create and distribute myriad images; the links of vast computer-generated search pages such as Google Images allow Internet users to access digital image after digital image; individual users author photo-blogs, often with hyperlinked or duplicated images. New technologies for storage and retrieval have created a vast archive of photographic images. Many of these new series are non-linear, or user-defined.

Grouping photographs in series allows for organization and comparison—powerful tools that allow us to grasp a diversity of information. Grouping individual photographs into series makes possible, for example, the entire discipline of Art History, which posits a linkage between objects as diverse as a Cycladic figurine and Bernini's statue of David, or the Great Ziggurat of Ur and Frank Gehry's Guggenheim Museum in Bilbao, Spain. As Walter Benjamin wrote in his influential essay "The Work of Art in the Age of Mechanical Reproduction":

Around 1900 technical reproduction had reached a standard that not only permitted it to reproduce all transmitted works of art and thus to cause the most profound change in their impact upon the public … technical reproduction can put the copy of the original into situations which would be out of reach for the original itself … it enables the original to meet the beholder halfway, be it in the form of a photograph or a phonograph record. The cathedral leaves its locale to be received in the studio of a lover of art.[1]

1 Walter Benjamin, "The Work of Art in the Age of Mechanical Reproduction" (1936), in *Art in Theory, 1900–2000: An Anthology of Changing Ideas*, ed. Charles Harrison and Paul Wood (Malden, MA: Blackwell Publishing, 2003), 520–521.

2 André Malraux, *The Voices of Silence*, trans. Stuart Gilbert (Princeton: Princeton University Press, 1978), 13; quoted in Hal Foster, "The Archive without Museums," *October*, n. 77 (Summer 1996): 100. Malraux's original, *Le museé inimaginable*, was dated 1935–1951. See also Douglas Crimp, "On the Museum's Ruins," in *The Anti-Aesthetic: Essays on Postmodern Culture*, ed. Hal Foster (Seattle: Bay Press, 1983), 43–56.

3 Hollis Frampton, "Eadweard Muybridge: Fragments of a Tesseract," in *Circles of Confusion: Film, Photography, Video, Texts 1968–1980* (Rochester, NY: Visual Studies Workshop Press, 1983), 75.

4 Roland Barthes, *Image, Music, Text*, trans. Stephen Heath (New York: Hill and Wang, 1977), 93.

5 Scott McCloud, *Understanding Comics: The Invisible Art* (New York: Paradox Press, 1999).

André Malraux suggested that all the photographs in the world together functioned as a *musée imaginaire*—a "museum without walls" in which the power of photography gathers and elevates to the status of painting and sculpture a global diversity of functional objects. As Malraux wrote: "A Romanesque crucifix was not regarded by its contemporaries as a work of sculpture; nor Cimabue's Madonna as a picture. Even Phidias's Pallas Athene was not, primarily, a statue."[2] Photographs grouped into series—in a textbook or a digital database—allow students and scholars to make formal, visual comparisons, to posit links, as well as influence and causality across great temporal and geographic distances.

Photographs arranged in deliberate sequences direct the viewer to view each image in a specific pattern, and often have a narrative dimension, even if that narrative is oblique or purely poetic. The first narrative sequential photo series illustrating the Lord's Prayer dated to 1841, and shortly thereafter Henry Peach Robinson produced a four-panel photo-illustration for *Little Red Riding Hood*.[3] A sequence eliminates or compresses the intervals of time or physical distance between exposures. As a viewer, our mind fills in the gap—also known as the gutter—between two images in a sequence. Critic Roland Barthes described a photo sequence as comprising a series of *nuclei*, which "constitute the real hinge points of the narrative." "Catalysers"—clues that will link the images—are "nested" in each image.[4] Or, as comic artist Scott McCloud explains, sequences make time into space, as individual images made at separate times separated by regular or irregular intervals can be viewed in a single instance, as on one page of a book or one wall of a gallery.[5]

PICTURES AT AN EXHIBITION

Sarah Charlesworth (b. 1947) has used photo series to encourage critical thinking about the nature of the photographic image and the power of the mass media to direct and shape the way we understand our world. Each series takes on a different problem and adopts a format accordingly. In the *Modern History* series (1977–1979) Charlesworth explored the ways in which newspaper images inform our perspective on world events. Some of the works track specific events, such as the killing of an American journalist shot in Nicaragua while delivering the news, or an eclipse of the sun seen from the perspective of each town through which it passed. Others show the hierarchies of power from a given perspective, such as *Herald Tribune Sept 1977*, in which she reproduced the newspapers of each day of the month with the text removed. What was revealed was a parade of male authority figures: presidents, generals, kings, and popes dominating the page day after day with various explosions, bombs, and weapons highlighting the day's "events."

4.1 Sarah Charlesworth, *April 21, 1978* (detail, 1 image of 45), from *Modern History*, 1978

The work *April 21, 1978* is one of the best known of the *Modern History* series. One of three works that concern the kidnapping of Italian Prime Minister Aldo Moro by the radical group the Red Brigade, this piece tracks a single photo of Moro holding a newspaper from the day before as it circulates in newspapers around the world. For *April 21, 1978*, Charlesworth reprinted the front pages of 45 newspapers with all the text excised except for the newspapers' masthead and date; the remaining photographs of the day's events floated in white fields. Charlesworth's strategy revealed the choices made by newspaper editors, who decide whether to cover a particular story, how large a photograph to include, and how to contextualize a story in relation to other events. Charlesworth reveals the ways in which the media selects, arranges, and frames current events, thus giving the lie to claims of "objectivity" or "fair and balanced" reporting. As *April 21, 1978* reveals, 41 of 45 newspapers featured the same photograph—a photograph of Moro, posed in front of a Red Brigade banner, holding a copy of the Italian *La Repubblica* dated April 20. Moreover, this photograph demonstrates the Red Brigade's own deliberate use of photographs for political effect: They had earlier claimed to have assassinated Moro, but this new photograph demonstrated that Moro was in fact still alive, and that the Red Brigade was manipulating the flow of information to their advantage. Moro was subsequently murdered on March 16, 1978 by his kidnappers, after Italian government officials refused to release 13 members of the Red Brigade then facing charges.

The effect of seeing a front page within a front page—seeing a newspaper that pictures another newspaper—captures the sense of living in the mass-mediated world of images circulating and reproducing endlessly—a hall of mirrors that French philosopher Jean Baudrillard termed the "precession of simulacra."[6] In each newspaper in which it appeared, the photograph was selectively cropped, enlarged, reduced, and placed in the context of other photographs by each paper. In revealing how "news" is framed, Charlesworth leads us to see how international events are contextualized and prioritized in local contexts: In Rome, Moro's picture alone fills almost the entire page; in London, the same picture, much smaller and more tightly cropped, is placed "below the fold," taking a clearly secondary position to a much larger photograph of the Queen Mum with her new grandson. Moreover, as curator Lisa Phillips notes, by demonstrating graphically which stories are deemed "newsworthy" by major newspapers, *Modern History* makes us aware of the "astonishing scarcity" of representations of women in the news. Engaging in a feminist critique of the role of media representations of women in society, Charlesworth reminds us that the "history" documented by the modern media excludes women.[7]

Photographer and curator Edward Steichen's 1955 exhibition at the Museum of Modern Art in New York, *The Family of Man*, assembled an archive meant to demonstrate the commonality and universality of human experience. Visitors walking into the

6 Jean Baudrillard, *Simulacra and Simulation*, trans., Sheila Faria Glaser (Ann Arbor: University of Michigan Press, 1994).

7 Lisa Phillips, "Sarah Charlesworth: Rite of Passage," in *Sarah Charlesworth: A Retrospective*, ed. Louis Grauchos and Susan Fisher Sterling, (Santa Fe, NM: SITE Santa Fe, 1997), 39–47.

4.2 Steve McQueen, *Once Upon a Time (image 33/116)*, 2002. Sequence of 116 slide-based color images streamed through a PC hard drive and rear-projected onto a screen with integrated soundtrack. 70 minutes

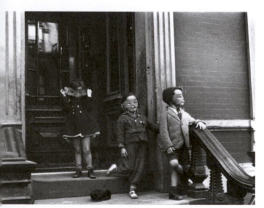

4.3 Helen Levitt, *New York, Children on Stoop Wearing Masks*, 1939. Gelatin silver print

8 Critics have agued that Steichen fulfilled the predictions of Walter Benjamin, Roland Barthes, and others who noted the declining importance of the individual author and the political uses of photography.

9 Edward Steichen, "Introduction," in *The Family of Man* (New York: Simon and Schuster, 1955), 4–5. *The Family of Man* has also been criticized as Cold War propaganda. See: Roland Barthes, "The Great Family of Man," in *Mythologies* (New York: Noonday Press, 1972), 100–102. A more charitable view is offered by Eric Sandeen in *Picturing an Exhibition:* The Family of Man *and 1950s America* (Albuquerque: University of New Mexico Press, 1995). The organization of *The Family of Man* is recounted in John Szarkowski, "The Family of Man," in *The Museum of Modern Art at Mid-Century: At Home and Abroad* (New York: Museum of Modern Art, 1994), 12–37.

10 Carl Sandburg, "Prologue," in *The Family of Man*, 3.

11 Helen Levitt, *Crosstown* (New York: Powerhouse Books, 2001); and *Here and There* (New York: Powerhouse Books, 2003).

exhibition encountered a dizzying installation of more than 500 photographs. (For a similar example of Steichen's exhibition design, see the *Road to Victory* design, Figure 3.8, on page 180.) Images by photographers such as Diane Arbus, August Sander, and Roy DeCarava were included in the exhibition, alongside the work of anonymous photographers, blown up to large scale and splashed across the gallery walls. Selectively cropping, enlarging, and exhibiting the work of more than 270 photographers, Steichen labored to demonstrate his belief in the universality of human experience, as well as the power of photography to reveal the essential fellowship of humanity.[8] *The Family of Man* was "conceived as a mirror of the essential oneness of mankind throughout the world."[9] As Steichen wrote, *The Family of Man* included "Photographs of lovers and marriage and childbearing, of the family-unit with its joys, trials and tribulations … Photographs of the individual and the family unit in its reaction to the beginnings of life and continuing on through death and burial …" The exhibition propounded a universalizing discourse of a common human experience; while the focus was primarily on representations of birth, love, and joy, the exhibition also offered images of war, poverty, and suffering. As poet (and Steichen's brother-in-law) Carl Sandburg wrote in the introduction to the exhibition catalog, there is "only one man in the world and his name is All Men."[10] Continuously in print, the catalog for Steichen's *The Family of Man* is one of the most popular photography books of all time. The exhibition is permanently installed in Clervaux, Luxembourg.

An interesting comparison to Steichen's *Family of Man* is *Once Upon a Time*, an installation made in 2004 by artist Steve McQueen (b. 1969) that self-consciously mimics, updates, and critiques *The Family of Man*. Re-presenting photographs that were sent into space aboard the unmanned Voyager 1 spacecraft in 1977, McQueen explored the ways in which, as in Steichen's famous installation, photography has been used to construct knowledge about humankind. The photographs chosen by the United States National Aeronautics and Space Administration (NASA) to represent life on Earth included newborn babies, bounteous supermarkets, and high-tech skyscrapers. The collection presented a cheerful view of humankind—rosier than Steichen's selection, which did acknowledge poverty and suffering—untroubled by disease, poverty, and war. McQueen's installation included some 116 projected images, and an audio soundtrack of *glossolalia*, or "speaking in tongues"—an undecipherable mystical language spoken by evangelical Christians as well as practitioners of other religious faiths—perhaps to suggest that human difference trumps the universal humanity pictured in the optimistic photographs collected by Steichen and NASA.

Another approach to creating an encyclopedic series was that of Helen Levitt (1913–2009), who spent her entire career photographing the street life of New York City. Her images, meant to be seen together as an ongoing body of work, are inherently more limited in scope than Steichen's or NASA's, but create a powerful sense of place.[11]

As these examples demonstrate, the process of grouping photographs into a series creates a conceptual unit, or an archive—viewed together, a set of photographs become a category—the "Family of Man" as defined by Steichen or the human race as pictured in NASA's photo series. Indeed, as they are separated by great distances, the individuals pictured by Levitt, Steichen, and NASA (and appropriated by McQueen) can exist as conceptual units only in photographs. Indeed, all such groupings are the choice of an individual—defining a group is simultaneously inclusive and exclusive; that is, such categorizations operate by leaving out as much or more than they include.

TYPOLOGY

Bernd Becher (b. 1931) and Hilla Becher (b. 1934) have pursued a collaborative photographic practice since 1959, when they began documenting the industrial landscape around Düsseldorf, Germany. Early in their career, the Bechers were influenced by the work of August Sander, whose 1929 book *The Face of Time* they took as a model for a rigorous and exhaustive photographic survey project. The Bechers' precise photographs of nuclear cooling towers, silos, and steel mill blast-furnaces catalog a category of building that is not "architecture" per se, but what Wend Fischer called "apparatus-like structures."[12] The Bechers photograph their subjects with a standardized shooting process in which individual buildings are centered within the frame; background and context are de-emphasized. Photographing from a standard distance against a uniform light-gray sky suppresses the particularities of scale and color. Because a photographic series eliminates the intervals of time and physical distance between exposures, the subjects of the Bechers' photo series assume their place in a strict, typological grid of formally and conceptually related examples—an evolving archive of related structures.

While the Bechers are interested in the political and economic history of their subjects, theirs is not a documentary project in the standard sense. For the Bechers, the comparisons and conclusions that are drawn in their crisply focused, black and white images are visual; they are interested solely in morphology—the study of physical form and structure (although physical form and structure are often epiphenomena of geographic or historical forces). When arranged in the serial grids that the Bechers refer to as *Typologies*, similarities and comparisons emerge. The Bechers alter and refine the composition and sequence of each **typology** over time; they replace individual photographs with new examples that better fit with, or better develop the series.

Despite some conceptual similarities, the Bechers are different from artists such as Dan Graham or Ed Ruscha, who view photography primarily as a documentary tool. Ruscha's photobooks, for example, often employ simple snapshots or photographs taken by others. In comparison, the Bechers are technical photographers in the

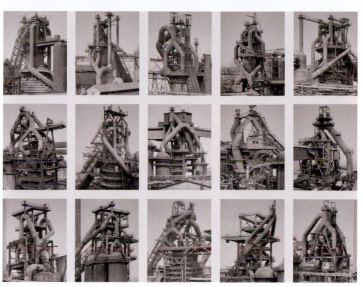

12 Quoted in Armin Zweite, "Bernd and Hilla Becher's 'Suggestions for a Way of Seeing,': Ten Key Ideas," in *Bernd & Hilla Becher: Typologies* (Cambridge, MA: MIT Press, 2004), 10.

4.4 Bernd and Hilla Becher, *Blast Furnaces*, 2003. 15 black and white photographs, 68¼ × 94¼in

typology
The classification or grouping of types that have similar characteristics.

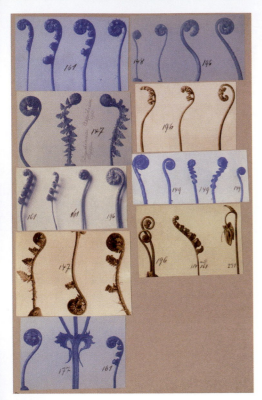

4.5 Karl Blossfeldt, Plate 16 of *Working Collages*, 1915–1925, photogravure

13 Ulrike Meyer Stump, "Karl Blossfeldt's Working Collages – A Photographic Sketchbook," in *Karl Blossfeldt: Working Collages*, ed. Ann and Jürgen Wilde (Cambridge, MA: MIT Press, 2001), 7.

14 Karl Blossfeldt, *Art Forms in Nature: Examples from the Plant World Photographed Direct from Nature* (New York: E. Weyhe, 1929).

15 Stump, "Karl Blossfeldt," 17.

retouch
Altering a photographic print to correct scratches, creases, or other flaws, or to clean up areas of the image.

16 Stump, "Karl Blossfeldt," 12.

tradition of August Sander or Eugene Atget. Their painstakingly deliberate large-format photographs require long exposure times, and the Bechers will often return to a site to rephotograph an image that needs to be improved. As professors at the Düsseldorf Art Academy (where artist Joseph Beuys was also a teacher), the Bechers' dry and precise documentary style influenced a generation of German photographers, including Andreas Gursky, Thomas Ruff, and Thomas Struth.

The typological work of the Bechers bears a similarity to that of the German sculptor Karl Blossfeldt (1865–1932). Blossfeldt's photographs were meant to serve as an archive and resource for future artworks. He referred to them as "Working Collages." He grouped contact prints by subject, isolating individual forms and motifs, and arranged them in sets of between 6 and 20 on gray cardboard sheets. The range of photographic processes that may be seen on any one card—brown gelatin silver bromide, gray gelatin silver chloride, and cyanotype—suggests that they were taken at different times. Blossfeldt is today known for his graphically bold and meticulously detailed photographs of plants; Ulrike Meyer Stump has compared Blossfeldt's photographs to "wrought iron shapes on a neutral ground."[13] Ironically, Blossfeldt never intended his photographs to be exhibited or published. Blossfeldt taught plant modeling in the Berlin *Kunstgewerbemuseum* (Museum of Decorative Art). He saw his photographs as reference and study aids and as patterns for student assignments. Photographer Karl Nierendorf (a champion of the "New Objectivity") appreciated Blossfeldt's modernist aesthetic, and encouraged him to publish the photographs as *Urformen der Kunst* (Art Forms in Nature) in 1928, where they found a wide audience.[14]

Today we see a different Blossfeldt than did his contemporaries. Since the rediscovery of his working collages, Blossfeldt has come to be seen as a forerunner to conceptual art. His use of a typological grid seems to anticipate the work of the Bechers, Ed Ruscha, Douglas Huebler, and Sol Lewitt. Viewing Blossfeldt's collages, rather than the individual images, changes their impact. As Stump writes, the grid format "leads one to compare images with each other rather than simply studying individual pictures in order to detect analogies between art and nature, as Blossfeldt's contemporaries did in the 1920s."[15]

The working collages also document Blossfeldt's working methods as a photographer. Notations indicate that Blossfeldt cropped and **retouched** his photographs for reprinting and publication. As such, Stump writes that, despite their sharp focus, and the apparent similarity to the work of modernist "New Vision" photographers such as Edward Weston, Blossfeldt did not "previsualize" the final photographic image. As she writes, "Blossfeldt, by way of contrast, worked rather like a sculptor, painstakingly coaxing his work from the materials stage by stage."[16] When Blossfeldt's photographs were published in *Art Forms in Nature*, they were printed as individual images—their subjects centered within the frame and detached from context. The working collages

THE
SERENADE
Three Bedrooms, Two Baths, Enclosed Garage, Screened Porch

"The Serenade", Cape Coral unit, Fla.

Homes for America

D. GRAHAM

Belleplain	Garden City
Brooklawn	Garden City Park
Colonia	Greenlawn
Colonia Manor	Island Park
Fair Lawn	Levitown
Greenfields Village	Middleville
Green Village	New City Park
Plainsboro	Pine Lawn
Pleasant Grove	Plainview
Pleasant Plains	Plandome Manor
Sunset Hill Garden	Pleasantside
	Pleasantville

Large-scale 'tract' housing 'developments' constitute the new city. They are located everywhere. They are not particularly bound to existing communities; they fail to develop either regional characteristics or separate identity. These projects date from the end of World War II when in southern California speculators or 'operative' builders adapted mass production techniques to quickly build many homes for the defense workers over-concentrated there. This 'California Method' consisted simply of determining in advance the exact amount and lengths of pieces of lumber and multiplying them by the number of standardized houses to be built. A cutting yard was set up near the site of the project to saw rough lumber into these sizes. By mass buying greater use of machines and factory produced parts, assembly line standardization, multiple units were easily fabricated.

Two Entrance Doorways, Two Home Houses, Jersey City, N.J.

Each house in a development is a lightly constructed 'shell' although this fact is often concealed by fake (half-stone) brick walls. Shells can be added or subtracted easily. The standard unit is a box or a series of boxes, sometimes conceptuously called 'pillboxes'. When the box has a sharply oblique roof it is called a Cape Cod. When it is longer than wide it is a 'ranch'. A two-story house is usually called colonial. If it consists of contiguous boxes with one slightly higher elevation it is a 'split level'. Such stylistic differentiation is advantageous to the basic structure (with the possible exception of the split level whose plan simplifies construction on discontinuous ground levels).

There is a recent trend toward 'two home homes' which are two homes split by adjoining walls and having separate entrances. The left and right hand units are mirror reproductions of each other. Often sold as private units are strings of apartment-like, quasi-discrete cells formed by subdividing laterally an extended rectangular parallelepiped into as many as ten or twelve separate dwellings.

Developers usually build large groups of individual homes sharing similar floor plans and whose overall grouping possesses a discrete flow plan. Regional shopping centers and industrial parks are sometimes integrated as well into the general scheme. Each development is sectioned into blocked-out areas containing a series of identical or sequentially related types of houses all of which have uniform or staggered set-backs and land plots.

Set-backs, Jersey City, New Jersey

The logic relating each sectioned part to the entire plan follows a systematic plan. A development contains a limited set number of house models. For instance, Cape Coral, a Florida project, advertises eight different models:

A The Sonata
B The Concerto
C The Overture
D The Ballet
E The Prelude
F The Serenade
G The Nocturne
H The Rhapsody

Center Court, Rossmoor, Development, Jersey City, N.J.

In addition, there is a choice of eight exterior colors:
1 White
2 Moonstone Grey
3 Nickle

LAWN GREEN

4 Seafoam Green
5 Lawn Green
6 Bamboo
7 Coral Pink
8 Colonial Red

As the color series usually varies independently of the model series, a block of eight houses utilizing four models and four colors might have forty-eight times forty-eight or 2,304 possible arrangements.

Dan Graham

Interior of Model Home, Staten Island, N.Y.

Bedroom of Model Home, S.I., N.Y.

Two Family Units, Staten Island, N.Y.

The 8 color variables were equally distributed among the home exteriors. The first buyers were more likely to have obtained their first choice in color. Family units had to make a choice based on the available colors which also took account of both husband and wife's likes and dislikes. Adult male and female color likes and dislikes were compared in a survey of the homeowners.

Each block of houses is a self-contained sequence — there is no development — selected from the possible acceptable arrangements. As an example, if a section was to contain eight houses of which four model types were to be used, any of these permutational possibilities could be used:

AABBCCDD	ABCDABCD
AABBDDCC	ABDCABDC
AACCBBDD	ACBDACDB
AACCDDBB	ACDBACDB
AADDCCBB	ADBCADBC
AADDBBCC	ADCBADCB
BBAADDCC	BACDBACD
BBCCAADD	BCADBCAD
BBCCDDAA	BCDABCDA
BBDDAACC	BDACBDAC
BBDDCCAA	BDCABDCA
CCAABBDD	CABDCABD
CCAADDBB	CADBCADB
CCBBDDAA	CBADCBAD
CCBBAADD	CBDACBDA
CCDDAABB	CDABCDAB
CCDDBBAA	CDBACDBA
DDAABBCC	DABCDABC
DDBBAACC	DBACDBAC
DDBBCCAA	DBCADBCA
DDCCAABB	DCABDCAB
DDCCBBAA	DCBADCBA

'Like'	
Male	Female
Skyway	Skyway Blue
Colonial Red	Lawn Green
Patio White	Nickle
Yellow Chiffon	Colonial Red
Lawn Green	Yellow Chiffon
Nickle	Patio White
Fawn	Moonstone Grey
Moonstone Grey	Fawn

'Dislike'	
Male	Female
Lawn Green	Patio White
Colonial Red	Fawn
Patio White	Colonial Red
Moonstone Grey	Moonstone Grey
Fawn	Yellow Chiffon
Yellow Chiffon	Lawn Green
Nickle	Skyway blue
Skyway Blue	Nickle

Basement Diner, Home, New Jersey

Car Hop, Jersey City, N.J.

A given development might use, perhaps, four of these possibilities as an arbitrary scheme for different sectors, then select four from another scheme which utilizes the remaining four unused models and colors, then select four from another scheme which utilizes all eight models and eight colors, then four from another scheme which utilizes a single model and all eight colors (in four or two colors), and finally utilize that single scheme for one model and one color. This serial logic might follow consistently until, at the edges, it is abruptly terminated by pre-existent highways, bowling alleys, shopping plazas, car hops, discount houses, lumber yards or factories.

'Split-Level', 'Two Home House', Jersey City, N.J.

'Ground-Level', 'Two Home House', Jersey City, N.J.

Although there is perhaps some aesthetic precedence in the row houses which are indigenous to many older cities along the east coast, and built with uniform facades and set-backs each this century, housing developments as an architectural phenomenon seem peculiarly gratuitous. They exist apart from prior standards of 'good' architecture. They were not built to satisfy individual needs or tastes. The owner is completely tangential to the product's completion. His home isn't really possessable in the old sense; it wasn't designed to 'last for generations'; and outside of its immediate 'here and now' context it is useless, designed to be thrown away. Both architecture and craftsmanship as values are subverted by the dependence on simplified and easily duplicated techniques of fabrication and standardized modular plans. Contingencies such as mass production technology and land use economics make the final decisions, denying the architect his former 'unique' role. Developments stand in an altered relationship to their environment. Designed to fill in 'dead' land areas, the houses needn't adapt to or attempt to withstand Nature. There is no organic unity connecting the land site and the home. Both are without roots — separate parts in a larger, predetermined, synthetic order.

Kitchen Freyer, 'Discount House', New Jersey

ARTS MAGAZINE/December 1966-January 1967

Dan Graham

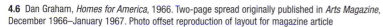

4.6 Dan Graham, *Homes for America*, 1966. Two-page spread originally published in *Arts Magazine*, December 1966–January 1967. Photo offset reproduction of layout for magazine article

17 *August Sander, Karl Blossfeldt, Albert Patzsch, and Bernd and Hilla Becher: Vergleichende Konzeptionen* (Cologne: Photographische Sammlung/SK Stiftung Kultur; and Munich: Schirmer/Mosel Verlag, 1997). Blossfeldt's photographs were also shown alongside the Bechers' at Documenta VI in 1977.

18 Michel Foucault, *The Order of Things: An Archeology of the Human Sciences* (1966), quoted in Stump, "Karl Blossfeldt," 14.

Instamatic camera
Type of point-and-shoot camera first produced in the early 1960s, which used an enclosed film cartridge (126 or 110 format) for easy loading.

were not exhibited until 1997, when they were shown as exhibition objects alongside the photographs of August Sander, Albert Patzsch, and Bernd and Hilla Becher.[17]

In the working collages, Blossfeldt ordered his specimens according to a morphological schema that he called the "Meurer system," after his mentor Moritz Meurer, a painter and designer, under whom Blossfeldt worked. Blossfeldt's process recalls French philosopher Michel Foucault's classic definition of natural history, which seeks to impose upon the world a "timeless rectangle in which organisms, devoid of commentary and all other language, display their visible surfaces, adjacent to one another in virtue of common features, and by that same token virtually analysed."[18] Indeed, Blossfeldt's organizing rubric is similar to that employed by Linnean botany. However Blossfeldt's photographs are not arranged in a way that would be useful to a botanist.

In the late 1960s, conceptual and site-specific artists questioned art's institutional setting and sought to work outside the existing channels of the commercial gallery system. Dan Graham (b. 1942) inserted texts and images into mass-circulation magazines. Graham's photo texts were works of art in themselves; in publishing works such as *Schema (March, 1966)* (a single-page text published in the art journal *Aspen*) and *Homes for America* (a two-page spread published in *Arts Magazine*, December 1966–January 1967), Graham subverted the usual function of publication in the art world, which generally consists of photographs and descriptions of previously completed work in art-critical discussions or as advertisement and promotional materials.

In *Homes for America*, intentionally dull photographs taken by Graham with an **Instamatic point-and-shoot** camera depict the repeating box-like forms of tract housing, tacky interior decoration, and discount store displays in suburban New Jersey. These intentionally bland documentary photographs are interspersed with reproduced developers' floor plans and blocks of text. In his text, Graham writes in a dry, analytical language—a parody of the detached tone of the social sciences—and lodges a subtle critique of post-World War Two suburban development. He describes the developers' strategy of building homes that are mere "shells"—modular boxes that can be rearranged to form any number of erstwhile "styles"—the "Cape Cod," the "Ranch," the "Colonial," and the "Split-Level"—and romantically titled "models"—"The Sonata," "The Rhapsody," "The Serenade," and so forth—and painted in one of a given set of color choices, including "White," "Moonstone Grey," "Seafoam Green," "Lawn Green," and "Coral Pink," according to a scheme designed to minimize the appearance of repetition.

Design and sequence are important in delivering Graham's message. Text and photos are arranged in three uniform columns. The layout reflects the spatial organization of suburban development. Rather than being composed for aesthetic effect, in *Homes for America* Graham arranges images and text in a scheme that mimics the grid of bottom-dollar, suburban development, which maintains straight lines and right angles despite the particularities of the terrain. As Graham explained, "Originally, I wanted the pages to

read like a suburban plan. I was influenced by an article by [French novelist] Michel Butor which focused on street permutations as a series of designs or arrangements, almost like serial repetition in music."[19] As Graham notes, suburban homes are built to exploit economies of scale and designed to maximize land-use and thus profits. Like the objects made by artists for sale in commercial galleries, suburban homes are not site-specific: "the houses needn't adapt to or attempt to withstand Nature. There is no organic unity connecting the land site and the home. Both are without roots—separate parts in the larger, predetermined, synthetic order."

THE BODY IN THE ARCHIVE

Since its invention, photography has been used for surveillance and social control. In the 19th century, Francis Galton, founder of the pseudoscience of Eugenics (and cousin of Charles Darwin), developed a composite photography technique to isolate and recognize so-called racial "types." In a similar vein Alphonse Bertillon developed the standardized frontal and profile photographic convention for ease of use in identifying criminals—a form that has become the "mug shot" used by law enforcement, and a basic unit of the photo-lineup familiar from countless television police dramas. Galton and Bertillon each in their way sought to use the photograph as a scientific tool to analyze and categorize human subjects in a typologically organized archive. As critic Allan Sekula has written, "Bertillon sought to embed the photograph in the archive. Galton sought to embed the archive in the photograph."[20]

The massive archive envisioned by German photographer August Sander (1876–1964) was never completed or published. Sander intended *Menschen des 20 Jahrhunderts* (People of the Twentieth Century) to be a photographic compendium of German society, classified by "type" into seven groupings: the Farmer; the Skilled Tradesman; the Woman; Classes and Professions; the Artists; the City; and the Last People. Sander envisioned a "social inventory" of types—an archive of photographic portraits, comprising 45 separate portfolios.

Sander believed that a catalogue of German social types would demonstrate the "Cycle of Civilization," epitomized by Oswald Spengler's (1880–1936) view of the decadence of contemporary society. Sander's photographs would thematize the transition, from the earthbound farmer, to the educated city-dweller, and "back again to the idiot," as illustrated by Sander's portfolio of photographs of the blind, the feeble, and the dead and dying.[21] In addition to this grandiose scheme, Sander's photographs, in their objective and unsentimental style, were also meant to picture the self-evident "Germanness" of the German people—from the lowly farmer, to the military officer, to the cosmopolitan artist, to the pathetic beggar.

19 Quoted in Mark Francis, "Interview," in *Dan Graham*, by Birgit Pelzer, Mark Francis, and Beatriz Colomina (London: Phaidon, 2001), 10.

20 Allan Sekula, "The Body and the Archive," *October*, v. 39 (Winter 1986): 55.

21 Sander, quoted in Ulrich Keller, "August Sander: A German Biography," in *August Sander: Citizens of the Twentieth Century*, ed. Gunther Sander, trans. Linda Keller (Cambridge, MA: MIT Press, 1986), 23.

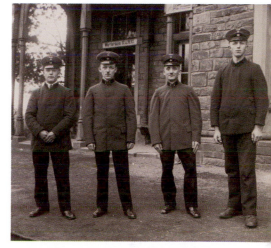

4.7 August Sander, *Railway Officers* (Bahnbeamte), 1910. Gelatin silver print on Agfa-Brovira paper

22 Keller, "August Sander," 19–20.

23 A number of efforts have been mounted, based on surviving prints and Sander's notes, to reconstruct the project. See: Gunther Sander, ed., *August Sander: Citizens of the Twentieth Century*, Linda Keller, trans. (Cambridge: MIT Press, 1986) and Susanne Lange, Gabriele Conrath-Scholl, *August Sander: People of the 20th Century*, seven volumes (New York Abrams, 2002).

Sander's vision of the German people, however, was too inclusive for the times. In 1936, the Nazis, who found Sander's depiction of the German people to be neither homogenous nor racially "pure" and thus unacceptable, seized the original printing plates of Sander's 1929 book, *The Face of Time*. Sander continued to work in secret, creating a portfolio depicting political prisoners (including his son, a member of the Communist Party), and a portfolio of portraits of Jews persecuted by the Nazis.[22] In 1944, Sander's studio was bombed, and his negatives were later destroyed in a fire. However, some 1800 portraits from Sander's photographic corpus survive.[23]

Despite the diversity of his subjects, Sander's signature style unifies the series. Sander favored a short focal length, and all of the subjects, whether they are blind children, pastry chefs, or Hitler youth, engage the camera directly with shoulders

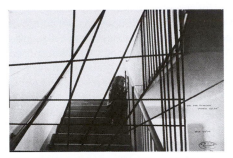

VALIE EXPORT, Body Configuration, *Wir sind Gefangene unserer Selbst, We are Prisoners of our Own Selves*, 1972. Photograph, b/w, 41.3 × 61.7cm

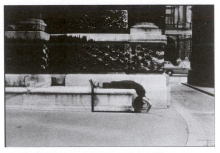

VALIE EXPORT, Body Configuration, *Zustützung, Lean In*, 1976. Photograph, b/w, with black ink drawing, 41.5 × 60.6cm

4.8 VALIE EXPORT. *Körperkonfigurationen in der Architektur* (Body Configurations in Architecture), 1972–1978. Gelatin silver prints

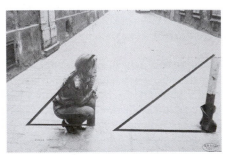

VALIE EXPORT, Body Configuration, *Der Mensch als Ornament, The Human as Ornament*, 1976. Photograph b/w, 42.2 × 61.9cm

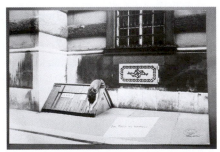

VALIE EXPORT, Body Configuration, *Starre Identität, Rigid Identity*, 1972. Photograph, b/w, 41 × 61cm

squared, looking straight into the camera. Similar to the Bechers' approach, Sander's standardized aesthetic helps the viewer to see this diversity of types as related conceptually—citizens of modern Germany. As art historian Anthony Lee has written, "Photography's mechanical capacity for repeatability and consistency of effect made the farmers and doctors, bakers and painters into a family."[24]

These formal qualities derive from commercial portraiture and define Sander's work as very different from the street photography and documentary images produced by other early 20th-century European photographers, including Brassaï, Henri Cartier-Bresson, and Robert Doisneau. Instead of pursuing the serendipitous "decisive moment," Sander developed a rapport with his sitters, allowing them to compose themselves before the camera. While his portraits emphasize self-presentation, Sander also carefully stage-managed his subjects, eliciting demonstrative gestures. Figures often brandish the tools of their trade, such as the pastry chef who stands at attention with his bowl and whisk, or the railway officers standing at attention, somewhat awkwardly, in their uniforms. These narrative features help to define and identify the sitter's occupation and standing in interwar German society.

Körperkonfigurationen in der Architektur (Body Configurations in Architecture) is a series of 50 black and white photographs produced between 1972 and 1978 by the Austrian VALIE EXPORT (b. Waltraud Lehner, 1940) that depicts the artist pressed into corners, against walls, or in a gutter, forcing her body to conform to the geometry of the architectural spaces she occupies. Critic Roberta Smith suggests that, in the series, EXPORT "haunts" Vienna, "inserting herself into places that are overpowering and by definition male."[25] The common thread linking this diverse oeuvre is EXPORT's focus on the representation of the female body. In an early and provocative **performance**, EXPORT appeared in an art theater wearing a pair of crotchless jeans, and walked up and down the aisles. EXPORT's "Body Configurations" are less confrontational than others of her work, but are no less concerned with issues of representation and sexuality.

Born to an established Jewish literary family in Nantes, France, Claude Cahun (born Lucy Schwob, 1894–1954) is known for series of shape-shifting self-portraits, in which she takes on a range of different personae. We need to see Cahun's entire oeuvre, or at least several of the series, to understand that Cahun is the subject of all the photographs.

In the 1920s and 1930s Cahun, a lesbian, and later an outspoken critic of the Nazis during World War Two and active in the resistance, authored books of philosophy and political theory that influenced André Breton, the founder of the Surrealist movement. Cahun translated into French the writings of sexologist Havelock Ellis, who theorized homosexuality as a "third sex."[26] Cahun was active in the experimental theater of Paris; it is possible that some of her photographs depict characters she played.

performance art
An artwork involving live performance by people or coordinated objects in a particular space at a particular time. Performance art may involve the performing arts (theater, music, dance) or the visual arts, and is often associated with Conceptual Art.

24 Anthony M. Lee, "Noah's Art, Arbus's Album," in *Diane Arbus: Family Albums* by Anthony M. Lee and John Pultz (New Haven: Yale University Press, 2003), 48.

25 Roberta Smith, "Valie Export," *New York Times* (March 3, 2000). See also Roswith Mueller, *Valie Export: Fragments of the Imagination* (Bloomington: Indiana University Press, 1994), 96.

26 Abigail Solomon-Godeau, "The Equivocal 'I': Claude Cahun as Lesbian Subject," in *Inverted Odysseys: Claude Cahun, Maya Deren, Cindy Sherman*, ed. Shelley Rice (Cambridge, MA: MIT Press, 1999), 117.

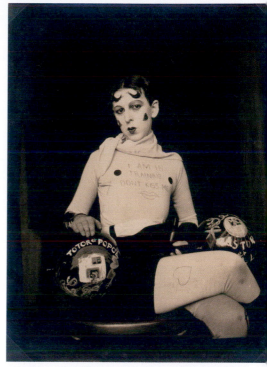

4.9 Claude Cahun, *Self Portrait (as weight-trainer)*, c.1927. Gelatin silver print

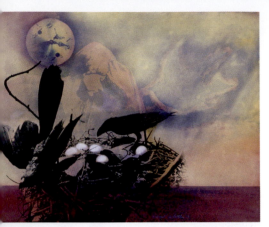

4.10 Bea Nettles, *Birdsnest*, 1977. Kwik Print on vinyl

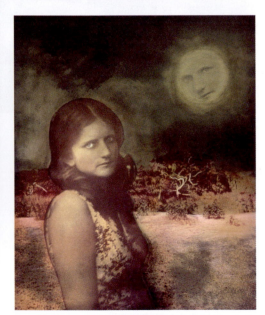

4.11 Bea Nettles, *C in the Moonlight*, 1976. Kwik Print on vinyl

27 Katy Kline, "Claude Cahun and Cindy Sherman," in *Mirror Images: Women, Surrealism, and Self Reproduction*, ed. Whitney Chadwick (Cambridge, MA: MIT Press, 1998), 76.

28 Judith Butler, *Bodies that Matter: On the Discursive Limits of Sex* (New York: Routledge, 1993), 231.

29 Lynn Gumpert, "Introduction," in *Inverted Odysseys: Claude Cahun, Maya Deren, Cindy Sherman*, ed. Shelley Rice (Cambridge, MA: MIT Press, 1999), x. See also Joan Rivière, "Womanliness as a Masquerade," in *Formation of Fantasy*, ed. Victor Burgin, James Donald, and Cora Kaplan (London: Methuen, 1986), 35–44. Originally published in *The International Journal of Psychoanalysis*, v. 10 (1929).

30 Rice, *Inverted Odysseys*, 21.

31 Bea Nettles, *Flamingo in the Dark* (Rochester, NY: Inky Press Productions, 1979), Introduction.

Feminist critics have argued that Cahun's works comprise a rigorous investigation of notions of gender and identity. Indeed many feminist critics have described gender identity as a masquerade—that gender is a kind of copy for which there is no original. As Katy Kline has written, "there is no single original Claude to be found."[27] Judith Butler has argued that gender is fundamentally performative:

First, what is meant by understanding gender as an impersonation? Does this mean that one puts on a mask or persona, that there is a "one" who precedes that "putting on," who is something other than its gender from the start? Or does this miming, this impersonating precede and form the "one," operating as its formative precondition rather than its dispensable artifice?[28]

The notion of a "persona" dates to ancient traditions of masked performance; the term implies theatricality, and was generally used to refer to fictional characters. In its classical use it referred to both the human actor and the masks employed by the actor to perform different roles—in Latin, *per* is "through"; *sonare* is "sound." By speaking through a mask the actor assumed a specific theatrical role. Thus, the term "persona" suggests that an individual may play many roles and may inhabit many selves.[29] Shelley Rice writes that Cahun, as a critic of fixed ideas about identity and sexuality, "used her art to disrupt ideas of gender, social identity, and femininity that were too restrictive. To slip between the social categories that threatened to limit her."[30] We might ask, then, whether Cahun's work is an acknowledgment of the fictional nature of all "selves" or an expression of the ability of the individual to appropriate identities freely.

In 1969, the artist Bea Nettles began combining media in unconventional ways: quilted paintings, etchings printed on fabric, and hand-colored photographs stitched together on a sewing machine. In 1976, she turned her camera's eye inward and began to construct autobiographical images of herself as a "full moon ... sky goddess, and woman in her prime," accompanied by her mother, daughter, and husband. Pregnant during the series, she integrated her physical and emotional experiences into her work. Her "teachers and peers found these processes and the personal content of the imagery hard to understand or accept." Nettles's consideration of her personal experiences as the source of imagery contradicted those modernist philosophies that dictate that photographers may uncover the mystic or spiritual but should not reveal specific personal feelings. In the introduction to *Flamingo in the Dark*, Nettles reveals intimate thoughts, such as her synchronicity with a rainforest: "I felt that if I stayed still for a minute the growth would cover me up. I felt secure, planted in that landscape."[31]

In the artworks of Annette Messager (b. 1943) images are each mounted in an individual frame, encouraging us to view the photographs as discrete elements; hanging en masse, we see them as a single work that has grown accretively. As a group, they become an archive of individual entries. Literally hundreds of individual photographs

depict details of bodies—female and male, young and old. Each image hangs in its own frame from a length of cord. They resemble *ex-votos*—devotional images traditionally left as offerings at pilgrimage sites.

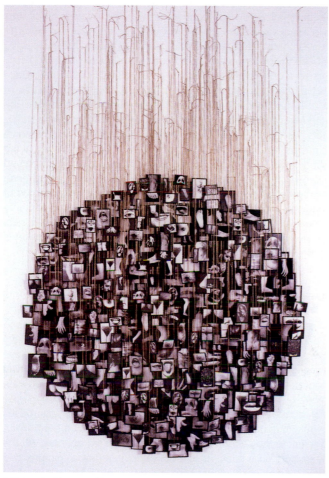

4.12 Annette Messager, *My Vows*, 1988–1991. Photographs, colored graphite on paper, string, black tape, and pushpins over black paper or black synthetic polymer paint. Overall size approximately 356.2 × 200cm

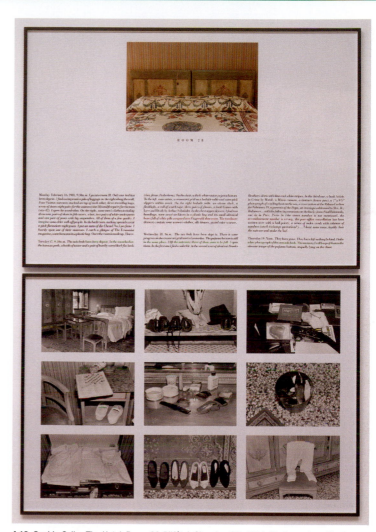

4.13 Sophie Calle, *The Hotel, Room 28 (L'Hôtel, Chambre 28)*, 1981. Photograph and text on paper, displayed: 2140 × 1420mm

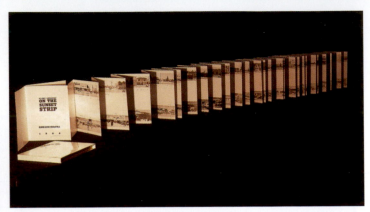

4.14 Ed Ruscha, *Every Building on the Sunset Strip.* Alhambra, CA: Cunningham Press, 1966. Detail showing accordion-folded book

32 Christine Macel, ed., *Sophie Calle, M'as-tu-vue* (Munich: Prestel, 2003), 157.

33 Calle, quoted in Macel, *Sophie Calle*, 161.

French artist Sophie Calle (b. 1953) uses series to explore issues of surveillance, voyeurism, and privacy. For her 1983 work, *The Address Book*, Calle found an address book on the street. She photocopied the book's contents and sent the original back to its owner. Calle then contacted individuals listed in the address book and conducted interviews to get to know the man whom she had never met. *The Address Book* was published as a serial in a Paris newspaper, but the owner of the address book (a documentary filmmaker) threatened to take the artist to court for invasion of privacy. For other artworks, Calle has been trailed by private investigators, and been psychologically profiled based on answers to a questionnaire. For her artwork *The Hotel* (1981), Calle worked for three weeks as a chambermaid in a hotel in Venice, Italy. In the course of cleaning the guestrooms and making the beds, she photographed and described the contents of each room, and imagined the lives of the hotel guests, without ever actually photographing her subjects. As Calle described the project: "I examined the personal belongings of the hotel guests and observed through details lives which remained unknown to me."[32] *The Hotel* was exhibited as a series of photographs accompanied by Calle's written text. A large color photo depicting the pillows and headboard of each neatly made bed was mounted and framed, with a group of black and white photos of the guests' personal belongings and Calle's written description of the room's contents over the course of the time each guest remained. Calle produced journal-like entries: "*Wednesday 18, 9:40 a.m.* He has finished the apples and oranges. The wastebasket is full of peel. He's still on page 198 of Somerset Maugham's book."[33]

IMAGES IN SEQUENCE

In creating photographic sequences, artists control, through deliberate ordering and presentation, the pattern pace by which images are viewed. For his **artist's book** *Every Building on the Sunset Strip* (1966), Ed Ruscha (b. 1937) aimed to produce a comprehensive geographical sequence by mounting a camera on a moving car. Artists also manipulate our experience of time by spacing photographic sequences on separate walls of a gallery installation.

Things are Queer (1973), published as a book by Duane Michals (b. 1932), comprises a sequence of nine silver-gelatin prints. The first image depicts a simple bathroom with a tub, pedestal sink, and toilet. In the second image, a gargantuan leg appears. As the sequence progresses, the camera pulls back, as in a dolly shot in a motion picture, and we see that the bathroom is a small-scale display in a store window. Then we see that the scene we have been viewing is in fact a picture in a book read by a man in a dark corridor. Finally the image of the man in the dark corridor is revealed to be a scene reflected in the mirror above the sink. Uncannily, we have circled back around to where

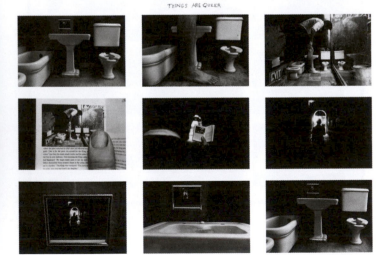

4.15 Duane Michals, *Things are Queer*, 1973. Nine silver-gelatin prints with hand-applied text

the series began, with a picture of what we now know is not a typical bathroom. Nancy Foote describes the series:

Duane Michals reverses photography's usual method of showing an overall view and details in varying closeness, gradually dispensing additional information about his subject by moving farther and farther away. Tableaux which at first appear to contain bizarre discrepancies of scale reveal their true identities as the camera recedes, clarifying by degrees the structure of the scene.[34]

American photographer Minor White (1908–1976) produced some of the best-known photo sequences in the history of photography. White began grouping photographs into sequences initially as an outgrowth of his poetry, and was inspired by the photographic sequences of Alfred Stieglitz made in the 1920s. White's sequences are highly structured, including as many as 30 pictures in the same or similar format. His series develops a related set of compositional motifs, as in *The Sound of One Hand Clapping* (1957–1959), a series built around the formal repetition of circular shapes which provide a pattern of rhythm and repetition as in a song or a poem. Like poetry, White's sequences demand a high degree of concentration and awareness; we must pay careful attention to each image and to its cumulative impact in relation to the images in the sequence.

White described his sequences as a "cinema of stills." He labored to create a narrative structure that was not merely anecdotal; his sequences describe a cycle of visual events cued to what White referred to as "feeling states," but not necessarily storytelling. White wrote:

The time between photographs is filled by the beholder, first of all from himself, then from what he can read in the implications of design, the suggestions springing from treatment, and any symbolism that might grow from within the work itself … The meaning appears in the mood they [the symbols] raise in the beholder; and the flow of the sequence eddies in the river of his associations as he passes from picture to picture.[35]

Early series contained texts which were usually introspective and poetic rather than descriptive. Gradually, White abandoned the use of written texts to focus on the visual. While still rooted in reality (all the photographs are **lens-based**), his images became more abstract. Often the order was not determined, and White considered all his series to be open-ended and unfinished.

White's *Totemic Sequence* (1974) comprises ten images. The sequence begins and ends with the same image—a geometric, X-like form created with two sandwiched negatives of a landscape form. The middle eight images are a series of paired images, which relate to one another through their repetition of an abstract form—a mysterious shape that may resemble a bird or a deer, or, in the case of the fourth and fifth images,

34 Nancy Foote, "The Anti-Photographers," *Artforum*, v. 15 (September 1976): 46–54; reprinted in Douglas Fogel, *The Last Picture Show: Artists using Photography, 1960–1982* (Minneapolis: Walker Art Center, 2003), 24–31.

artist's book
A work of art presented in the form of a book, in which the artist considers and integrates all aspects of the book (structure, contents, and design).

35 Minor White, untitled introductory statement to the *Fourth Sequence*, 1950; quoted in Peter C. Bunnell, *Minor White: The Eye That Shapes* (Princeton: Princeton University Art Museum, 1989), 231.

lens-based photography
Photography that relies upon a lens, depth of field, and monocular perspective.

36 Bunnell, *Minor White*, 232.

Beat Movement
A cultural movement of young Americans in the 1950s, led by artists and writers who rejected traditional social values and sought direction in Eastern philosophies.

two photographs of the same site taken at different times of the day. The final image repeats the first image, turned upside down, bringing the sequence full-circle.[36]

For White, a series depended equally on photography's descriptive as well as its symbolic capacity. The ten photographs in *Totemic Sequence* were made in Schoodic, Maine, in 1969 and 1970. White attached great significance to this particular place on the Maine coast; he considered it a sacred site, and believed it held great power and personal significance. But the sequence also carried deeper associations with the primitive and the mystical—White was known for his spiritual aspirations; he was influenced by Zen philosophy, the American **Beat Movement** writers including Jack Kerouac and Allen Ginsberg, and the teachings of the mystic G.I. Gurdjieff. As White wrote of the series:

4.16 Minor White, *The Totemic Sequence*, 1974. Gelatin silver prints, dimensions variable. The Minor White Archive, Princeton University Art Museum. Bequest of Minor White. Reproduced with permission of the Minor White Archive, Princeton University Art Museum. © Trustees of Princeton University. (*Schoodic Point, Maine*, 1969, individual images, from top to bottom: MWA 69-47, MWA 69-49, MWA 69-281, MWA 69-130, MWA 69-129, MWA 69-71, MWA 69-74, MWA 69-44, MWA 69-274, MWA 69-47)

4.17 William Christenberry, *Hale County Alabama, 1967–2004*

The visual origin was a reproduction of a prehistoric cave painting … seen by chance in a magazine of some sort about 1960. The strange figures moved me then and have been lurking ever since. I am not sure that I understand where this sequence comes from in myself. I am positive of the place but have caught glimpses elsewhere of the same totems and know such exist in other places. But maybe only that place and I in resonance could find the pictures to match the essence … In the present sequence the place was a lone dike on Maine's granite shore … I saw it in 1968 but did not photograph—then three times in 1969 and the last time on a trip to Schoodic in 1970. I visit it whenever I can.[37]

THE PASSING OF TIME

In 1960, while he was a young artist, William Christenberry (b. 1936) discovered Walker Evans's photographs in the book *Let Us Now Praise Famous Men*, which pictured the rural poor of Hale County, Alabama, Christenberry's home. Since then, in paintings, sculptures, **assemblages**, and photographs, he has made a record of the vanishing vernacular architecture of the American South. For Christenberry, the process is a personal ritual. Every year since 1967, he has returned to Alabama to photograph the

37 Minor White, "Totemic Sequence 1974," 1974, n.p.; quoted in Bunnell, *Minor White*, 232.

assemblage
Artworks made by assembling three-dimensional materials, particularly found or discarded objects and scraps of paper or natural materials.

4.18 Atta Kim, *ON-AIR Project, New York Series, 57th Street, 8 Hours*. 2005. C-print

38 Walter Hopps et al., *William Christenberry* (New York: Aperture Foundation, 2006).

same buildings: barns, stores, and bar-b-q joints. Over time, the buildings deteriorate, are transformed, and are rebuilt—sometimes beyond recognition. Other buildings disappear: one series documents a one-chair barbershop that, in photographs from year to year, listed to the right, then the left, and finally collapsed.[38]

Korean photographer Atta Kim (b. 1956) produces large-scale color photographs, with exposure times lasting as long as eight hours, compressing a sequence into a single image. Kim has photographed sporting events and military exercises along the demilitarized zone between North and South Korea. As in 19th-century photographs by Daguerre and others, over the course of an exposure lasting many hours the backgrounds emerge as clear and bright, while moving figures almost disappear. In *ON-AIR Project, New York*

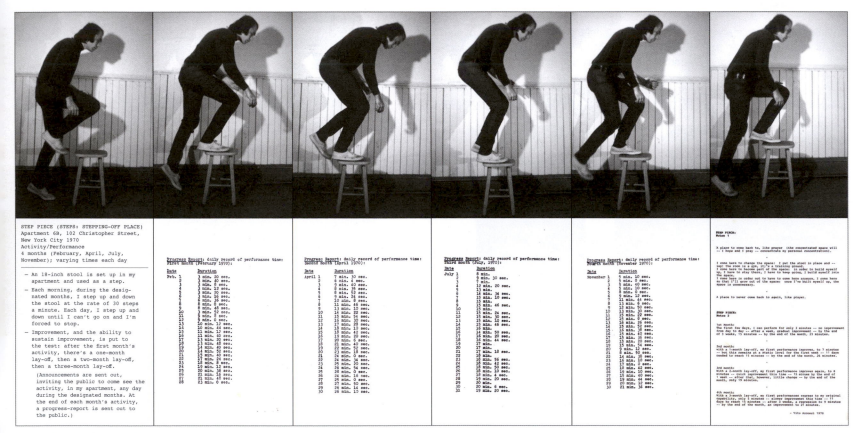

4.19 Vito Acconci, *Step Piece*. 1970

Series, 57th Street, 8 Hours, (2005) a busy intersection seems like a ghost town. Human actors and luminous red vehicle taillights appear as faint blurs; flags waving in the wind are spectral. Rather than depicting time as a sequence of discrete instances, Kim's photographs embody a surprising perception.[39]

DOCUMENTING ARTISTIC PROCESS

Many artists who do not necessarily consider themselves photographers use serial photography to capture and document ephemeral events, temporary performances, and constructions. For *Step Piece*, Vito Acconci (b. 1940) stepped up and down from a stool in his apartment every morning at a rate of 30 steps per minute for as long as he could continue without stopping. Acconci repeated the action until be became fatigued every day for a month. He then waited one month, and repeated the performance. His short-lived performance event was documented in snapshots: Acconci favored an artless "snapshot aesthetic" for his performances. The resulting images were meant to serve as documentation of an event; their "anti-aesthetic" was proof that the event, not the record, was the artwork.

The photographs of Mexican artist Gabriel Orozco (b. 1962) are unusual, because they are linked not by an explicit theme or sense of sequential unfolding, but by a sense of observation, play and the manipulation of found elements, and the repetition of formal elements, such as circles. For example, in *Tortillas y Ladrillos* (Tortillas and Bricks) (1990) and *Turista Maluco* (Crazy Tourist) (1991) (in which Orozco has placed tortillas or oranges in urban spaces), *Ball on Water* (1994), and *Dog Circle* (1995), all four focus on circular forms created or found in the environment. For Orozco, photography is one process among many. Orozco crosses boundaries between media at will. Like other "**post-studio**" artists, Orozco does not follow a traditional artist's practice; his photographs, taken with a simple point-and-shoot camera and processed by a commercial developer, depict the temporary sculptural interventions Orozco makes by rearranging **found objects**, scraps, and other detritus on walks through cities such as New York or Mexico City.

39 Holland Cotter, "In Atta Kim's Long-Exposure Photographs, Real Time Is the Most Surreal of All," *New York Times* (Wednesday, July 12, 2006). http://www.nytimes.com/2006/07/12/arts/design/12atta.html/

post-studio
Refers to a shift that took place in the 1950s. Before this period, most artists made work in a studio isolated from the larger context of the world. The post-studio artist's realm of production is outside of the studio, in both creation and exhibition of the work.

found object
A natural or manufactured object not initially intended as a work of art, which an artist incorporates into an artwork.

4.20 Gabriel Orozco, *Tortillas y Ladrillos* (Tortillas and Bricks), 1990; *Turista Maluco* (Crazy Tourist), 1991; *Ball on Water*, 1994; *Dog Circle*, 1995

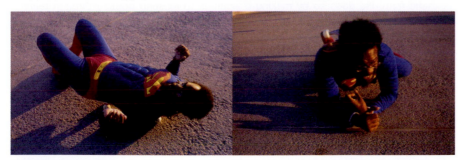

4.21 William Pope.L, "Training Crawl" (for *The Great White Way*: 22 miles, 5 years, 1 street), 2001. Lewiston, Maine. Performance photographs

Performance artist William Pope.L (b. 1955) uses photography to document his grueling performance works. Pope.L has staged over 40 "crawls" since 1978 as an aspect of a larger conceptual project called *eRacism*. Photographs of his 2002 *Great White Way* depict Pope.L dressed in a Superman costume, crawling 22 miles over a period of five years—from the Statue of Liberty, through Manhattan via Broadway (the Great White Way from which the piece took its name), to his mother's home in the Bronx.

As photographs documenting ephemeral performance events have been accepted into galleries and museums, artists have become more deliberate and attentive to aesthetics in creating performance documents; indeed, performance documentation has emerged as a major subgenre of contemporary art. The photographs of Gabriel Orozco, Pope.L, and others are more deliberately aestheticized than the "snapshots" favored by an earlier generation of performance and conceptual artists.

PHOTOBOOKS

Until the acceptance of photography as an artform in galleries and museums in the mid-20th century, books in archives and libraries were the most common place to see a photo. In the 19th century, photographic prints were glued into books, often illustrating texts on natural history, science, geography, and archeology. Printing quality, affordability, and distribution have improved so that many photographers prefer their work to be seen in books. As British photographer Martin Parr explains, "I love the sense of the package, a travelling idea. Someone can pick it up and the idea can explode in their face. The book is a perfect vehicle for photography."[40] Thematic books containing only pictures, or relying primarily on images to convey their point, have emerged as a distinct genre. Books contain images by one photographer or many, professional or amateur, as long as the work is unified by a single theme.[41]

Since 1981, Buzz Spector (b. 1948) has created limited-edition artists' books and installations that address the book as an object of cultural significance as well as an aesthetic form. He does so by making alterations to existing books—through tearing, cutting, or painting. Spector has also produced a series of large-format Polaroid photographs in which he arranges the books in his personal library as still-life subjects. His series *All the Books in My Library* includes the individual photos *By or About Dieter Roth, By or About Ann Hamilton, By or About Christian Boltanski* (all 1999), and *My Ruscha* (2001). Books—which are for many the primary access to the work of art and photography—in Spector's installations and photographs become sculptural forms even as they retain their role as catalogs and records of an artist's work.

40 Quoted in Philip Gefter, "Photography Reveals Itself Between Covers," *New York Times* (Sunday, January 16, 2005), Arts, 29.

41 Martin Parr, *The Photobook: A History, Volume I* (London: Phaidon, 2004) and *The Photobook: A History, Volume II* (London: Phaidon, 2006). Carol Armstrong, *Scenes in a Library: Reading the Photograph in the Book, 1843–1875* (Cambridge, MA: MIT Press, 1998).

4.22 Buzz Spector, *My Ruscha*, 2001. Interior dye diffusion print (Polaroid), 22 × 26in

SLIDE SHOWS

In the 1960s, as artists began to question the boundaries between art and visual culture, and to embrace non-art technologies for image-making, 35mm slides (along with the newly available portable video camera) made their way into galleries and art spaces. Familiar from the dreadful slide shows of family vacations, darkened art history classrooms, corporate sales meetings, and the artist's promotional packet, 35mm slides helped artists to break down boundaries between high and low culture, and challenge the presumed fixity and permanence of the work of art. As curator Darsie Alexander writes in the catalog for *Slide Show: Projected Images in Contemporary Art*, "Rejecting the idea of art as something finite, these artists sought ways to convey the process of making their work, one that included progressive steps as well as digressions and reversals. Slide projection was a perfect medium by which to express these interests."[42] Slide projection emerged as a genre of installation and performance. The first version of Dan Graham's *Homes for America* was a slide projection, comprising 21 images sequenced as a typology of the forms of suburban architecture, and performed in artists' lofts. Artists recognized the importance of sequence and progression in slide projections. As Alexander has written, "The round slide carousel … contains successive slots for images, which are projected *in time* and in sequence, like a film. But by the same token, the different frames capture a past moment that was taken *out of time*, like a photograph."[43] Minor White's *Slow Dance* featured a double-screen, color slide projection that followed a progression of rock formations down a canyon wall, through a streambed, and out into a swirling torrent of ocean spray.

Projection 1 (Herbst, Fall), a 1997 installation by Peter Fischli and David Weiss, includes 324 color slides, projected at large scale and sequenced with an automated **dissolve unit** so that one image fades into the next in an endless chain of images. The result is a dizzying, psychedelic world of close-up views of flowers and plant form—not quite abstractions, but nearly impossible to pin down. Fischli and Weiss allow their projections to be viewed at any size, at the curator's prerogative and as appropriate to the space. Projected onto a gallery wall, comparisons can be made with abstract painting, unfolding over time.[44]

The Ballad of Sexual Dependency by Nan Goldin (b. 1953) was first developed as a slide show. In a series of frank and often explicit images, Goldin documented the intimate details of her circle of poets, musicians, artists, and friends who haunted the nightclubs, bedrooms, and bathrooms of New York's Lower East Side. Goldin's multimedia artwork included a soundtrack of underground music, and chronicled her friends' sexual experimentation, gender transformations, drug addictions, and battles with AIDS, to produce a poignant collective portrait of New York bohemian life in the late 1970s and early 1980s—an extension of Goldin's private life with an open-ended storyline.

42 Darsie Alexander, "Slide Show," in *Slide Show: Projected Images in Contemporary Art*, by Darsie Alexander et al. (University Park, Pennsylvania State University Press, 2005), 5. See also: Chrissie Iles, *Into the Light: The Projected Image in American Art, 1964–1977* (New York: Whitney Museum of American Art, 2002).

43 Alexander, "Slide Show," 5.

44 David Little, "Peter Fischli and David Weiss," in Alexander, "Slide Show," 99–100.

dissolve unit
An interface that connects two or more slide projectors or two or more video projectors, and which makes it possible to fade the lamp in one projector while intensifying the lamp in the other. Rather than moving from image to image abruptly, the unit produces a gradual shift in images.

4.23 Peter Fischli/David Weiss, *Projection 1 (Herbst, Fall)*, 1997. Two sets of 162 slides, two slide projectors, one dissolve machine. Dimensions variable

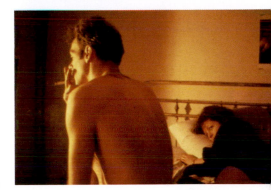

4.24 Nan Goldin, *Nan and Brian in Bed, NYC*, 1983. Cibachrome. 30 × 40in

Goldin's slide show was first presented in nightclubs and bars. Goldin would hold the projector in one arm and loaded the slides with the other. Early performances were mostly attended by Goldin's close friends, many of whom were recurrent characters in the gritty, color-saturated snapshots. *The Ballad of Sexual Dependency* was shown for an art-world audience for the first time in the influential Times Square Show, organized by the artists' group Collaborative Projects in 1980. The slide show eventually developed a narrative structure: beginning with scenes of couples and explorations of gender roles, delving into loneliness, drugs, and drinking, and ending with a series of empty beds and gravesites, marking the impact of AIDS on the downtown art scene. Having defined the look of the bohemian 1970s and 1980s, as well as influencing the "heroin chic" style in fashion and advertising, *The Ballad of Sexual Dependency* was published as a book in 1986.[45]

The Trachtenberg Family Slideshow Players are a popular live musical group based in Brooklyn, New York. Jason Trachtenberg, his wife Tina Pina, and their daughter Rachel Pina perform songs based on collections of vintage 35mm slides they purchase at thrift stores and estate sales. Where once the slide shows were events to be endured at family gatherings and business meetings, the Trachtenberg Family Slideshow Players make them the basis of their pop-music performances. Imagery that was once treasured and important has now become quaint and obscure. The players reinvest the found photographs with meaning through storytelling; the imagery inspires the content of the story. Drawing from themes found in vintage family, corporate, and educational slide shows, Mark Trachtenberg writes the songs, plays most of the instruments, and sings. His daughter Rachel Pina also sings and plays drums, while wife and mother Tina Pina operates the slide projector. The humor and appeal of the Trachtenberg Family Slideshow Players is based on the obsolescence of 35mm slides, now mysterious artifacts from a time capsule.[46]

In 2004 the Kodak Corporation announced that it would no longer produce its slide projectors, and began curtailing production of other traditional photographic supplies. Other manufacturers quickly followed suit. Slides had already largely been supplanted in the boardroom and the classroom by digital imaging and by presentation software such as Microsoft's PowerPoint, introduced in 1987. According to the Microsoft Corporation, some 30 million presentations are made with PowerPoint every day. While anyone who has taken an art history course or attended a corporate board meeting is familiar with the comedy of errors that often accompanied slide presentations—backwards or upside-down slides, jammed projectors, and spent bulbs—PowerPoint has brought its own foibles. Despite, or perhaps because of, its dominance, PowerPoint has been criticized for fostering reductive and programmatic thinking and bad design, engendering the phrase "Death by PowerPoint." As Vint Cerf, one of the inventors of PowerPoint, has mused, "Power corrupts and PowerPoint corrupts absolutely."[47] Nevertheless,

45 Nan Goldin, *The Ballad of Sexual Dependency*, ed. Martin Heiferman, Mark Holborn, and Suzanne Fletcher (New York: Aperture Foundation, 1986). Alexander, "Slide Show," 107–108.

46 http://www.slideshowplayers.com

47 For an interesting critique of the cultural impact of PowerPoint, see Edward Tufte, "PowerPoint is Evil," *Wired*, v. 11, n. 9 (September 2003); http://www.wired.com/wired/archive/11.09/ppt2.html; and Tufte, *The Cognitive Style of PowerPoint* (Cheshire, CT: Graphics Press, 2004).

contemporary artists have embraced PowerPoint much as their 1960s predecessors embraced slides. Artists' lectures are now accompanied by PowerPoint presentations rather than slides. Artist and musician David Byrne's performance *Envisioning Emotional Epistemological Information* (2003) is a send-up of PowerPoint's chart "wizards," bullet points, stock photography, and inane graphics.[48]

MOTION

Photographs arranged in sequence can present the illusion of motion, as in a simple flip book, or in the more complicated thaumatropes, zoetropes, and other early moving picture technologies that preceded the films of Georges Méliès, Thomas Edison, and Edwin S. Porter. The biography of photographer Eadweard Muybridge (1830–1904), popularly known as the "Grandfather of the motion picture," is full of drama—including name changes, murder (Muybridge was acquitted in 1874 for the murder of his wife's lover), and other intrigues (a stormy relationship with patron Leland Stanford, Governor of California, president of the Central Pacific Railroad, and founder of Stanford University, ended in a dispute over the authorship of the motion studies for which Muybridge is famous).[49] Born Edward Muggeridge in Kingston-upon-Thames, near London, the artist emigrated to the United States in the early 1850s. By 1855, he had made his way to San Francisco, where he went into business as a bookseller and publisher. Thrown from a horse-drawn coach while traveling through Texas in 1860, Muybridge suffered possible brain damage—affecting his senses of taste, smell, and vision—which his biographers have cited as an influence on his later career as a photographer. From 1861 to 1866, Muybridge lived in Europe, where he learned the basics of wet-plate collodion photography. By 1866, Muybridge had returned to San Francisco, where he began a photography business.

Muybridge first became known in 1868 for his mammoth photographs and stereo-scope cards of Yosemite, Alaska, San Francisco, and other landscape and architectural subjects, produced under the pseudonym "Helios" (Latin for "Sun") for government and private patrons. The long exposure times required to produce a detailed image caused some problems; for example, human figures appear as smudges against a clear background, or moving bodies of water such as streams and waterfalls appear as a blur. As filmmaker and photographer Hollis Frampton writes, Muybridge embraced these idiosyncrasies of photographic vision:

What is to be seen is not water itself, but the virtual volume it occupies during the whole time-interval of the exposure. It is certain that Muybridge was not the first photographer to make such pictures; my point is that he seems to have been the first to accept the "error," and then systematically, to cherish it.[50]

48 David Byrne, *Envisioning Emotional Epistemological Information* (Göttingen, Germany: Steidl Publishing, 2003). See also http://www.davidbyrne.com/art/eeei/index.php/

49 The reference to Muybridge as the "Grandfather of the motion picture": *Camera Comics* no. 4 (US Camera Publishing Corporation, 1945). Among the most interesting biographies of Muybridge is Rebecca Solnit, *River of Shadows: Eadweard Muybridge and the Technological Wild West* (New York: Penguin, 2003).

50 Frampton, "Eadweard Muybridge," 76.

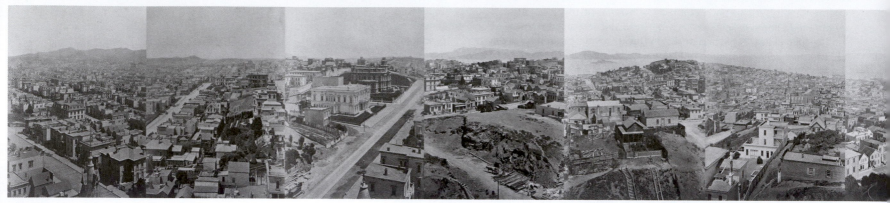

4.25 Eadweard Muybridge, *San Francisco Panorama*, 1878

An adept innovator, Muybridge developed a number of ingenious solutions to the limitations of early photographic processes. Skies, which would burn to bright white over the course of a minutes-long exposure, were collaged from a separate negative in the final print. In 1878 Muybridge created a monumental panoramic photograph of San Francisco, taken from the tower of the unfinished mansion of railroad magnate Mark Hopkins on Nob Hill. The 1878 version was Muybridge's second; the first was produced in 1877. As Frampton wrote of the 1877 version:

> In the great San Francisco panorama [Muybridge] condenses an entire rotation of the seeing eye around the horizon (an action that must take place in time) into a simultaneity that is at once completely plausible and perfectly impossible; it is as if a work of sculpture were to be seen turned inside out.[51]

51 Frampton, "Eadweard Muybridge," 77.

Muybridge's 1878 photograph comprises thirteen 18×22-inch plates, resulting in a panorama measuring more than 17 feet in length, which was published as an album comprising 13 albumen prints. Each individual plate required 15 minutes to prepare and expose, with the help of an assistant. Muybridge's panorama is thus an image of apparent but impossible simultaneity—actually more like a **time-lapse** image, or a motion-picture montage. Moreover, the individual plates are out of sequence chronologically, but not visually or geographically, which creates the illusion of a seamless, 360° view of the city.

Muybridge is best known for his sequential motion-study photographs undertaken at Governor Leland Stanford's ranch at Palo Alto, California, and later at the University of Pennsylvania in Philadelphia. Muybridge's motion studies began when he photographed Occident, a racing horse owned by Stanford, a racing aficionado, to substantiate

time-lapse photography
The process of taking a series of images of a slowly (or imperceptibly) moving object(s) and then playing the images back at a faster rate. For example, to present (in 1 minute) a bowl of fresh fruit as it rots over the duration of a month would speed up the effects of time.

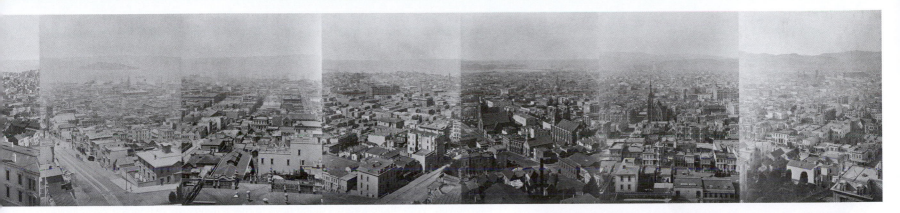

Stanford's theory of "unsupported transport"—the then-controversial idea that all four of a horse's hooves were off the ground at once during a point in the gallop. While none of Muybridge's original photographs of 1872 survive, the original photograph of Occident, taken with new, electrified camera equipment and high-speed photographic plates (which produced little more than a silhouette) proved Stanford's theory to be true, and corrected years of paintings of horses made with the unaided eye.

Muybridge's technically advanced photographs, which literally stopped time in its tracks, point to fundamental changes in human perception in a rapidly industrializing world. As Muybridge's biographer Rebecca Solnit argues, photography and a host of new technologies of the 19th century (e.g. the train with its demand for a standardized schedule) transformed the very experience of time. As Albert Einstein would soon argue, time is a function of the observer's frame of reference; temporality is plastic. The 5th-century BC Greek philosopher Zeno pointed to the paradox of an arrow in flight: If we look at an arrow in flight, at a single instant in time, it appears the same as a motionless arrow. Or, as Frampton has written, "it is possible to view the indivisible flow of time as if it were composed of an infinite succession of discrete and perfectly static instants."[52]

At Stanford's training track at Palo Alto, Muybridge installed a bank of 24 still cameras placed at 21-inch intervals. Each shutter was released by a trip wire. (Later, Muybridge would design a clockwork mechanism to control the shutters.) Subjects were photographed against a white sheet, with regular intervals marked by numbered vertical lines. The 24 images Muybridge produced with this array captured Occident's fluid movement as a series of discrete still images. Muybridge could then reanimate the sequence by projecting the photographs with his **zoopraxiscope**, which would project images of the animals in motion, resynthesizing and projecting uncannily lifelike moving images from Muybridge's painstakingly rationalized still pictures.

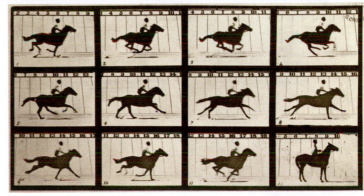

4.26 Eadweard Muybridge, *Galloping Horse*, 1878–1879. Collotype print

52 Frampton, "Eadweard Muybridge," 74.

zoopraxiscope
Invented by Eadweard Muybridge in 1879, this early motion-picture device projected still images from rotating glass disks to create the illusion of movement.

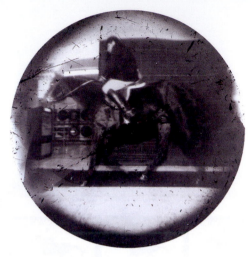

4.27 Steven Pippin, *Laundromat/Locomotion (Horse & Rider)*, 1997. Twelve black and white photographs, 76.2 × 76.2cm

53 Jan Groover, quoted in Susan Kismaric, *Jan Groover* (New York: Museum of Modern Art, 1987), n.p.

4.28 Jan Groover, *Untitled*, 1975. Museum of Modern Art (MoMA), New York. Chromogenic color prints each 23 x 15.3cm; mounted on board; framed

54 Foote, "The Anti-Photographers."

Muybridge's iconic images have been referenced and lovingly parodied by contemporary artists. Steven Pippin made the sequential photographs for *Laundromat/Locomotion* (1997) in a New Jersey laundromat, as an *hommage* to Muybridge. Pippin recreated the famous array of cameras by connecting trip wires to a row of 12 front-loading washing machines, which had been outfitted as rudimentary cameras. Pippin then walked, ran, and rode a horse through the laundromat. When the film had been exposed, Pippin developed the photographs in the wash and rinse cycles of the machines, producing his own versions of Muybridge's famous sequences.

Jan Groover (b. 1943) combines individual photographs in sequential groups that have been carefully selected to produce abstract compositions that remain rooted in everyday experience. Trained as a painter, Groover began her career making minimalist monochrome abstractions, but switched to photography when she decided that she wanted to make artwork that was based on the real world. As she explained to an interviewer, "With photography I didn't have to make things up, everything was already there."[53] For an untitled work from 1975, Groover placed a 35mm camera on a stationary tripod on the side of a road and released the shutter to capture the passing of cars and trucks as well as the empty background. The images she obtained were the result of chance; they were then arranged into groupings of two to four images. The resulting triptych bears some resemblance to Muybridge's motion studies (which Groover collects), except that the high speed of the traffic makes it impossible to track the motion of a single vehicle. Instead, we see a blurred truck nearly filling the frame and aligned next to a smaller passenger car speeding away from the camera.

Reading Groover's art using the Western convention of reading left to right, and assuming that a left to right movement indicates the forward motion of a narrative, we might assume that Groover's composition represents the passage of time. But, as Nancy Foote notes, "In fact, their order is established purely visually within the overall composition, making space [rather than time] their primary concern."[54] As photographs, Groover's images remain rooted firmly in the representation of visible reality. Groover accentuates this fact by surrendering the role of composing the individual images to chance. Groover shares with other artists of her 1960s/1970s generation a desire to de-emphasize the role of the artist as "author" or creative "genius." Rather than inventing a private world, Groover selects and arranges pre-existing ideas and material. But Groover's series are also related to modernist abstract painting; she manipulates the individual panels to produce austere abstract compositions out of the stuff of everyday experience.

One of the best-known works of Eleanor Antin (b. 1935), an artist who has worked in performance, film, and installation, is *100 BOOTS* (1971–1973), conceived as a movie made up of still images. A picaresque road movie of sorts, *100 BOOTS* follows the adventures of 100 black rubber boots, beginning at the Pacific Ocean and ending at the Museum of Modern Art in New York. For the series, Antin traveled across the United

States, stopping to create and photograph temporary installations of the boots: gathered around a pine tree at the rim of a canyon; lined up in pairs at a drive-through movie theater; marching across the arid Southern California landscape; amid the oil fields and factories of middle-America; arriving in New York via the Staten Island Ferry. The photographs were printed as postcards, which, in the spirit of the Fluxus art movement of the 1960s, were mailed to a number of recipients. At the Museum of Modern Art, all 51 postcards were exhibited together for the first time. The boots themselves were displayed in an installation, where they were, as Howard Fox writes,

glimpsed through a beaten-up wood door that opened onto a seedy downtown crash pad. Some of the BOOTS were sacked out on the crummy mattress lying on the floor, others were huddled in a

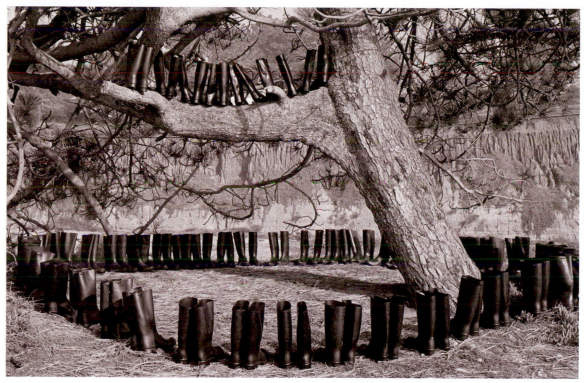

4.29 Eleanor Antin. *100 Boots In a Field, Route 101, California, February 9, 1971, 3:30 p.m. (mailed January 21, 1973)*. From *100 Boots*. 1971–1973. Photographic postcard

small group under the bare lightbulb hanging from a wire, and some just stood around listening to the pop music playing on the radio in the corner.[55]

SCULPTING WITH TIME

La Jetée (1962), a short science-fiction film by director Chris Marker, has a vexing Möbius strip plotline in which time circles back on itself. In a futuristic Paris devastated by nuclear war, a band of survivors experiment with time travel in an attempt to save their ravaged civilization. First, a prisoner is sent back in time to a moment in his childhood in which he witnessed a mysterious and violent event at the main terminal (or *jetée*) at Orly Airport near Paris, an event that has become an obsession. He is then sent to appeal for help from the technologically advanced people of the future. After he returns from the future with a device that will save his fellow survivors, the protagonist is cast aside and left for dead by the experimenters. He is contacted by the people of the future, who offer to help him escape to their time, but he asks to be returned to the mysterious moment in his childhood. He arrives just in time to discover that the violent event he witnessed as a child was his own death as an adult.

Unlike other motion pictures, *La Jetée* is constructed almost entirely of still images, blended with **dissolves**, **wipes**, and **fades** of varying pace, and limited voice-over narration. The film, which unfolds as a flashback, poignantly recalls the fact that memories are often linked to photographs, disconnected from lived experience, as Roland Barthes famously described in his moving essay on a photograph of his mother, who had passed away many years earlier.[56] Marker's protagonist labors to reconstruct a childhood memory of a woman at Orly Airport, but he is unable to put it all together. His memory remains a series of discrete still images as he moves backwards and forwards in time, until the film's final moments. At the film's climax, Marker gives us moving images as the narrative circles around to end at the same airport terminal where it began.

A unique artifact of the post-World War Two period that produced *The Twilight Zone* and other paranoid fantasies, Marker's film has inspired younger artists. Terry Gilliam's 1995 film *Twelve Monkeys* is based on *La Jetée*. And Cindy Sherman has credited a late-night teenage viewing of *La Jetée* on her local public television station as being influential for her evocative series of *Untitled Film Stills*.

The films of Andy Warhol (1928–1987) also make time elastic. Warhol made more than 60 films between 1963 and 1968. *Sleep* (1963) depicts John Giorno, a friend of the artist, sleeping for eight hours. The 35-minute *Blow Job* (1963) comprises one shot of the face of Tom Baker as he received fellatio from Willard Mass.[57] Warhol's endurance-testing, eight-hour-long silent film, *Empire* (1964), consists of just one shot of New York's Empire State Building. *Empire* was filmed from 8:06pm to 2:42am on July 25th and 26th, from

55 Howard N. Fox, "Waiting in the Wings: Desire and Destiny in the Art of Eleanor Antin," in *Eleanor Antin*, by Howard N. Fox (Los Angeles: Los Angeles County Museum of Art, 1999), 48.

> **dissolve**
> In film editing or projection, a gradual shift from one image to the next in which one image fades while the next appears.

56 Roland Barthes, *Camera Lucida*, trans. Richard Howard, (New York: Hill and Wang, 1982).

57 Warhol famously never analyzed or interpreted his own work. For an interesting reading of one of Warhol's films in light of the cultural politics of the 1960s, see Roy Grundmann, *Andy Warhol's Blowjob* (Philadelphia: Temple University Press, 2003).

the 41st floor of the Time-Life Building. The film begins with a washed-out white screen. As the sun sets, the image of the Empire State Building emerges. Floodlights come on as the evening darkens, and for the next several hours the lights of individual office windows flicker on and off. In the last reel, the floodlights are turned off and the remainder of the film passes in near-total darkness.

Each of the 100-foot film reels used to shoot *Empire* was allowed to run out completely before it was replaced; a bright flash of light marks where each roll ends. Each reel marks an interval of time; each flash of white reveals the process of loading and shooting the film. (Warhol's technique also recalls the continuous shot used in motion pictures such as Orson Welles's *Touch of Evil* or Alfred Hitchcock's *Rope*—the technical feat that shifts viewers' attention from the narrative to the otherwise indiscernible and hidden details of the production process.) *Empire* can be seen in relation to the use of serial images in Warhol's silkscreen paintings, in which the printing-screen was allowed to degrade over repeated runs. In *Empire*, imperfections such as reflected light in the window, which at times allows a view of the room from which *Empire* was shot, and Warhol or another figure walking in front of the camera, can be likened to the visual "noise" that Warhol allowed to accumulate on his silkscreen works.

While we are presented with the experience of real time passing—a direct equivalence between time shooting and projecting—this is an illusion. Warhol shot the film at 24 frames per second, and it is screened at 16 frames per second (**fps**), so that six hours and thirty-six minutes of elapsed time is stretched to eight hours and five minutes on the screen. Still, Warhol has made a film with no editing. *Empire* is not *representation* so much as *presentation*—a sequence of excruciatingly long, unmoving images that allow us to view the passing of wordless, soundless time.

Video artist Paul Pfeiffer (b. 1966) creates artwork that compresses time and space, manipulating existing video footage taken from popular films and professional sporting events, including boxing, hockey, and basketball. Pfeiffer alters the footage by erasing figures and altering the rate of time's passage. *John 3:16* (2000) follows a basketball in play. Throughout the video, the ball remains at the center of the screen—an otherworldly hovering sphere—as the game, the players, and the space of the arena move around it. It is the still center in a swirling vortex of light and motion. The ball—oddly reminiscent both of Edward Weston's precisionist photographs of nautilus shells and bell peppers isolated from time and space, and of the floating basketball in Jeff Koons's sculpture, *One Ball Total Equilibrium Tank* (1985)—miraculously levitates, hovers, and rotates, as the background shifts at a dizzying pace. The titles of Pfeiffer's artworks often refer to the history of religious art. This work's title, *John 3:16*, is taken from the biblical passage which is often cited in the banners held by evangelical Christian fans at sporting events and NASCAR races. The passage, chapter and verse, reads: "For God so loved the world that He gave His only begotten Son, that whosoever believeth in Him should not perish,

wipe
A technique in film editing, in which images gradually make a transition from one to another. Unlike a dissolve, where images fade and emerge, a wipe moves across the screen from one side to the other with hard edges.

fade
A technique in film editing, in which an image gradually darkens and vanishes.

fps (frames per second)
In animation, to create the illusion of movement a still image must continue to register in the brain for a short time after it passes from our eyesight. If we see too many frames per second, the images will blend too quickly. Too few fps and the images will appear static or jerky. The standard needed to produce smooth motion is about 30 fps.

58 Dominic Molon, "Corporealities," in *Paul Pfeiffer,* by Dominic Molon et al. (Cambridge, MA, MIT List Visual Arts Center, 2003), 19.

but have everlasting life." Is the basketball, mysteriously floating in mid-air—seemingly eternally—a stand-in for Jesus? Or a reference to the sustained fervor fans feel in the drawn-out final minutes and seconds of overtime?[58]

As this essay has discussed, we rarely experience images in isolation; rather, we encounter them in series and sequences—in collections and databases, exhibitions, presentations, and films. We've explored topics that include the collecting and exhibition of images based on conceptual categories, such as typologies of form, including the human body and issues of identity; sequences that create a sense of movement or that document artistic processes; photobooks; collage; sequential projections; and the notion of "sculpting with time." The next essay explores another way to emphasize context, namely, the relationships that can be created between text and image. This discussion is followed by a practical chapter which addresses editing, presentation, and evaluation for the working artist.

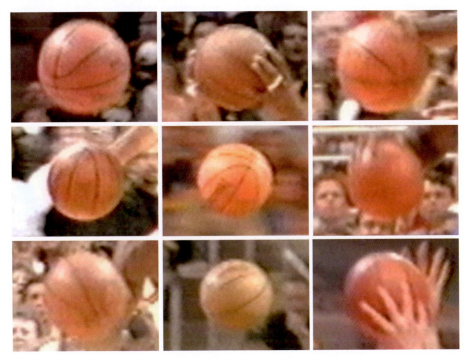

4.30 Paul Pfeiffer, *John 3:16* (2000). Digital video loop, metal armature, LCD monitor, DVD player. Dimensions: 5½ × 6½ × 36in

Theory: Text and Image

Bill Anthes

1 A number of exhibitions and publications explore the relationship between image and text. See: *Word as Image: American Art 1960–1990* (Milwaukee: Milwaukee Art Museum, 1990); Simon Morley, *Writing on the Wall: Word and Image in Modern Art* (Berkeley: University of California Press, 2003). *Word & Image*, an academic journal, publishes essays exploring the relationship between text and image in art history. For an extended theoretical discussion of the relationship between words and pictures, see W.J.T. Mitchell, *Iconology: Image, Text, Ideology* (Chicago: University of Chicago Press, 1986). For another perspective on the varieties of visual communication, see Edward R. Tufte, *Envisioning Information* (Cheshire, CT: Graphics Press, 1990).

2 Roland Barthes, *Image, Music, Text*, trans. Stephen Heath (New York: Hill and Wang, 1977), 38.

INTRODUCTION

The relationship between word and image has a long history; among the earliest books produced in medieval Europe were illuminated manuscripts, which combined text—painstakingly copied by hand—with elaborate illustrations on sheepskin. During the Renaissance, paintings often included painted representations of words spoken by the figures portrayed in the scene. These early examples of the integration of text and image embodied a coherent, Christian worldview; text was understood to represent the "Word of God," and was thus believed to be inherently truthful. In the modern world, we are less confident about absolute truths.

Today, we are likely to encounter words and pictures printed together in magazines, newspapers, or online to shore up the claims to truthfulness. In science textbooks, photographs and diagrams illustrate complex ideas. In children's books and graphic novels, text and images create elaborate fantasy worlds. Billboard advertisements reduce text and images to graphic simplicity so as to deliver their messages with an economical punch. In official documents, text and images are also combined for purposes of bureaucratic record keeping; your passport and driver's license use words and pictures to identify you, and this vital information is increasingly being integrated and uploaded into multimedia databases. In contemporary media, text and images converge to form a seamless package.[1] As the French critic and semiotician Roland Barthes (1915–1980) wrote:

[T]he linguistic message is indeed present in every image: as title, caption, accompanying an article, film dialogue, comic strip balloon. Which shows that it is not very accurate to talk of a civilization of the image—we are still, and more than ever, a civilization of writing.[2]

3 There is much debate on this topic. The critic John Berger would argue that we actually "learn" to see. See his classic *Ways of Seeing* (Reprint, New York: Penguin, 1995). Artist and critic Victor Burgin has argued with the "conventional" notion that word and image are distinct modes of representation, demonstrating that language always intrudes upon the experience of viewing a photograph, or of viewing anything, and that visual and verbal media interact at every level of perception and consciousness: that there is "a complex of exchanges between the verbal and the visual." Victor Burgin, "Seeing Sense," in *The End of Art Theory* (Atlantic Highlands, NJ: Humanities Press International, 1986), 51–58.

4 Maurice Merleau-Ponty, *The Phenomenology of Perception* (1962), trans. Colin Smith (London: Routledge, 1989), 401; quoted in Morley, *Writing on the Wall*, 9–13.

5 The distinction between *icon*, *index*, and *symbol* was first articulated by the American philosopher Charles Sanders Peirce (1839–1914). See "What is a Sign?" (1894), in *Essential Peirce*, vol. II, ed. The Peirce Editorial Project (Bloomington: University of Indiana Press, 1998).

semiotics
The study of signs and symbols as elements of communication.

Text and image are related and complementary—but ultimately irreconcilable—ways of delivering information. Words and pictures offer different kinds of information. While we are taught to read from an early age, we have to learn how to see for ourselves.[3] We scan images for visual information, which we then interpret based on our own, idiosyncratic knowledge and experience; words are visual in nature, but we decipher them according to a strict set of rules, usually from left to right and top to bottom. Words require that we are able to read a language and understand its vocabulary, grammar, and syntax. But as the philosopher Maurice Merleau-Ponty (1908–1961) wrote, written language

promotes its own oblivion … My eyes follow the line on the paper, and from that moment I am caught up in their meaning, I lose sight of them. The paper, the letters on it, my eye and the body are there only as the minimum setting of some invisible operation. Expression fades before what is expressed, and this is why its mediating role may pass unnoticed.[4]

The arbitrary nature of language is explored by the theory of **semiotics**, which is concerned with *signs*, or the linguistic relationship between words (the *signifier*, e.g. "tree") and the things they represent (the *signified*, e.g. a particular woody perennial, deciduous or coniferous, and member of the plant kingdom, or the Biblical "Tree of Life," or alternatively a hierarchical data structure, figure, or graph that branches from a single root, as in a genealogical chart). As linguist Ferdinand de Saussure (1857–1913) noted, the bond between the signifier and signified (this structural unit is known collectively as the "sign") is merely a matter of convention. There is no essential, underlying natural relationship linking our word for tree with the thing itself. Moreover, language is often "coded"—full of idiomatic expressions, clichés, metaphors, and figures-of-speech—so that the words we hear or read often refer to something else entirely, as in when we say that we fail to see the forest for the trees.

Barthes used the terminology of semiotics to explain the difference between words and images; he wrote that images and words are different types of signifiers. As Barthes explained, seeing and understanding a photograph seems to be simple and immediate, because we believe that the experience is not at all like language, which takes time to read or hear, and which often seems to require an advanced degree in linguistics, literature, or a foreign language to fully understand. This is because language, unlike photography, is *symbolic*; words bear only an arbitrary relationship to the things they describe, whereas photographs bear a direct and causal relationship to the things they depict.[5] Pictures (especially photographs) seem more direct, less complicated. Because photographs traditionally have their origin in an optical and chemical process that occurs in the presence of the things represented, we tend to believe, quite logically, that they constitute objective evidence that the person or event represented really does exist, or did exist, or really happened at one time when the photographer and her camera was

present. As such, a photograph is a unique kind of signifier. Whereas a painting or a drawing is an *icon*, which has a resemblance to the object it depicts, a photograph is an *index*, produced during an encounter with the real world, of which it is a trace or remnant, fixed in permanent form by a chemical process. Because the photographic image is produced as a result of a direct encounter with its *referent*, we believe that it is less open to manipulation and duplicity than is language. With photographs, our interpretations seem to take place naturally—almost instinctively. We recognize those people, things, places, or events, or we have seen things like them, or believe that things like them could happen.

Barthes described photographs as "messages without a code." By this, Barthes meant that, in and of itself, a photograph is purely descriptive, a dumb recording of objective, physical facts. Barthes termed this level of representation the photograph's *denotative* meaning; he argued that, at the most basic level, the photograph is a transcription of the physical and optical experience in the presence of which the photographic exposure was made. Ironically, an objective "description of a photograph is literally impossible," according to Barthes, because our descriptions are inevitably interpretations.[6] When we put words together to describe a photograph, we move to the level that Barthes calls *connotation*, in which we describe the photograph using words, which, by definition, cannot be objective. As such, our split-second interpretation of the photograph engages what Barthes terms a *semiological* system, a universe of signs encoded in the photograph, which are decoded by a reader or viewer (that is, they are translated into language) in accord with their own experience.

IS A PICTURE WORTH A THOUSAND WORDS?

In Duane Michals's (b. 1932) photographs and sequences, the text is a diary which places the image in a broader context or story, which may be mundane or fantastical, fiction or non-fiction. Michals adds his handwritten scrawl directly onto the surface of the print in his photographs. The relationship between Michals's words and pictures ranges from purely descriptive, to ironic and disconnected. The text adds a compelling "voice" to the image, although this voice is not always Michals's own.[7]

As an artist concerned with narrative, Michals distinguishes himself from other photographers. "I am a short story writer," he explains. "Most other photographers are reporters. I am an orange. They are apples ... I use photography to help me explain my experiences to myself"[8] And a good story, we know, is not necessarily about telling the truth. Michals criticizes photographers who are overly invested in notions of truthfulness, which he sees as impossible in a photograph. "Most portraits are lies," he writes. "People are rarely what they appear to be, especially in front of a camera. You might know

4.31 Duane Michals, *A Failed Attempt to Photograph Reality*, 1976. Gelatin silver paper with hand-applied text

6 Roland Barthes, "The Photographic Message" (1961), in *A Barthes Reader*, ed. Susan Sontag (New York: Hill and Wang, 1982), 197–198.

7 Indeed, Michals claims that some of his photographs are actually the work of his fictional *alter ego*, Stefan Mihal, who is able to express particularly intense feelings and reveal personal details that Michals is not.

8 Duane Michals, *Real Dreams: Photostories* (Danbury, NH: Addison House, 1976), 1.

9 Michals, *Real Dreams* 2.

10 Michals quoted in Michael Sand, "Duane Michals," *Aperture*, v. 146 (Winter 1997): 53.

11 Elizabeth McCausland, "Documentary Photography," *Photo Notes*, January, 1939. See also William Stott, *Documentary Expression and Thirties America* (London: Oxford University Press, 1973).

me your entire lifetime and never reveal yourself to me."[9] Michals always tugs at the boundaries of what we will believe, poking at our desire to see photographs as "proof" of something that once happened. Explaining that he is "frustrated by the silence of the photograph," Michals turns to writing. "[W]riting, for me," he explains, "is the possibility of being more intimate. I think I can be much more private in language than I can in a photograph."[10]

TELLING A STORY: THE DOCUMENTARY TRADITION

When photography was first developed in the 19th century, it was believed to provide an objective record of the external world. All photographs were believed to be inherently factual, and were considered to be, in essence, "documents." By the 20th century, however, things were considerably more complex. Critic Elizabeth McCausland (1899–1965) first coined the term "documentary photography" in 1939 to distinguish factual or journalistic photography from the new genres of art and commercial photography. Describing the work of Jacob Riis (1849–1914) and his 20th-century heirs, McCausland described documentary style as the "application of photography direct and realistic, dedicated to the profound and sober chronicling of the external world."[11] This belief in photography's ability to present objective facts made it a powerful tool for generations of reformers and social activists who used the camera as a political tool.

For documentary photographers, text often plays a crucial role in reinforcing the clear and unambiguous meanings that the photographers (or their employers) want to send. While they may be powerful and suggestive, photographs are incapable of telling a story on their own. Photographers who seek maximum clarity and hope that their images convey information and impel action often employ text to create a narrative. Text defines the setting and explains how an individual image relates to the larger story, which unfolds beyond the frame of the photograph. The powerful combination of photography and text helps guide and direct interpretation, ensuring that the photo achieves the photographer's (or photo editor's) agenda.

Born in Ribe, Denmark, Riis emigrated to the United States in the 1870s. In 1877, he took a job as a reporter for New York City newspapers. Spending his days and nights working in the city's teeming immigrant ghettos, Riis became appalled at the deplorable conditions endured by new arrivals. His powerful images and descriptions presaged the "muckraking" of journalists such as Ida Tarbell and Upton Sinclair, who worked for political, social, and economic reform in the Progressive Era of the early 20th century. With vivid language, Riis described the squalid conditions of the tenements in his 1890 book, *How the Other Half Lives*. His choice of words is telling; paternalistically, Riis depicted the urban poor as "miserable hordes" that were beyond the pale of his

educated, middle-class readership. In Riis's telling, the poor were susceptible to exploitation by greedy landlords, and in need of guidance in matters of hygiene and morality.[12] Riis wrote:

The necessities of the poor became the opportunity of their wealthier neighbors … large rooms were partitioned into several smaller ones, without regard to light or ventilation, the rate of rent being lower in proportion to space or height from the street; and they soon became filled from cellar to garret with a class of tenantry living from hand to mouth, loose in morals, improvident in habits, degraded, and squalid as beggary itself … the dark bedroom, prolific of untold depravities, came into the world … Rents were fixed high enough to cover damage and abuse from this class, from whom nothing was expected, and the most was made of them while they lasted. Neatness, order, cleanliness, were never dreamed of in connection with the tenant-house system, as it spread its localities from year to year; while reckless slovenliness, discontent, privation, and ignorance were left to work out their invariable results, until the entire premises reached the level of tenant-house dilapidation, containing, but sheltering not, the miserable hordes that crowded beneath smouldering, water-rotted roofs or burrowed among the rats of clammy cellars.[13]

Riis turned to photography to provide visual testimony and objective "witness" to the conditions he encountered and described in his writings. Riis adopted the camera as his primary weapon in the struggle for social change, in order to present a photographic truth, the role of the photograph as evidence, more compelling than mere verbal or literary testimony. As Riis described it,

When the report was submitted to the Health Board the next day, it did not make much of an impression—these things rarely do, put in mere words—until my negatives, still dripping from the darkroom, came to re-enforce them. From them there was no appeal … Neither the landlord's protest nor the tenant's plea "went" in the face of the camera's evidence, and I was satisfied.[14]

Seeking to demonstrate with uncontrovertible proof the horrid conditions in tenement houses, unlicensed saloons, and other dark places, Riis became one of the first photographers to use the flashgun, which made indoor photography possible for the first time. The dazed looks on the faces of Riis's subjects are an effect of his barging into their dark rooms unannounced in the dead of night with his flashgun, as in the photograph, *Five Cents Lodging, Bayard Street*. (Moreover, the volatile chemicals used in Riis's flashgun caused more than one house fire, ironically endangering the very population he was trying to help.) But for all their descriptive power, Riis's photographs mean little without his written report. The text that accompanied his photographs defined the subject matter and directed how and by whom they were to be interpreted. The shortcomings of one medium would be shored up by the other.

12 See Bill Hug, "Walking the Ethnic Tightwire: Ethnicity and Dialectic in Jacob Riis's *How the Other Half Lives*," *Journal of American Culture*, v. 20, n. 4 (Winter 1997): 41.

13 Jacob Riis, *How the Other Half Lives* (New York: Charles Scribner's Sons, 1890), 5.

14 Jacob Riis, *The Making of an American* (New York: Macmillan, 1918), 273. See also: Sally Stein, "Making Connections with the Camera: Photography and Social Mobility in the Career of Jacob Riis," *Afterimage*, v. 10, n. 10 (May 1983): 9–16.

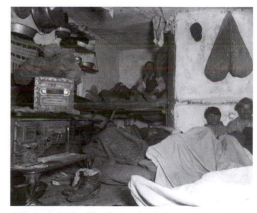

4.32 Jacob A. Riis, *"Five Cents a Spot", Unauthorized Lodgings in Bayard St Tenement, c.* 1890

15 For a sophisticated analysis of the collaboration between artists and writers in photo texts, see W.J.T. Mitchell, "The Ethics of Form in the Photographic Essay," *Afterimage*, v. 16 (January 1989): 8–13.

16 Roy Stryker, "Selected Shooting Scripts," in *In This Proud Land: America 1935–1943 as Seen in the FSA Photographs*, by Roy Stryker and Nancy Wood (Greenwich, CT: New York Graphic Society, 1973), 187–188.

17 Roy Stryker, "The FSA Collection of Photographs," in *In This Proud Land*, 7. A large collection of FSA and OWI (Office of War Information) images can be viewed at the Library of Congress "American Memory" website: http://memory.loc.gov/ammem/fsowhome.html/

During the Great Depression of the 1930s, photographers collaborated with writers to produce documentary projects to dramatize the plight of unemployed workers and displaced farm families. In these hybrid works, word and image support one another, each supplying a different kind and level of information. This division of labor presumed that the visual and verbal were specialized languages. In these now classic collaborations, photographs provided visual evidence of harsh economic conditions, and written text provided the context within which the photographs became meaningful.[15]

Many of these artists and writers were employed by the Farm Securities Administration (FSA), an agency organized under President Franklin D. Roosevelt's New Deal, a massive relief effort aimed at alleviating the effects of the Depression. Between 1935 and 1942, the FSA photo division produced a massive archive of over 270,000 photographs. The photo division was headed by a young social scientist, Roy Stryker. The FSA employed photographers such as Carl Mydans, Walker Evans, Ben Shahn, Dorothea Lange, Arthur Rothstein, Russell Lee, and Jack Delano. Stryker wrote "shooting scripts"—lists of assigned subjects—for his photographers to follow. Stryker directed FSA photographers to document "People on and off the job. How much different people look and act when they are on the job than when they are off? … The effect of the depression in the smaller towns of the United States. To include things such as the growth of small independent shops, stores, and businesses in the small towns; for example, the store opened up on the sun porch, the beauty shop in the living room … Production of foods—fruits, vegetables, meat, poultry, eggs, milk and milk products, miscellaneous products." After the U.S. entry into World War Two, Stryker's scripts included subjects such as "Small town under war conditions … Civilian Defense Activities … Auto and auto tire rationing."[16] Stryker described the impact of the FSA and the documentary ethos thus: "In 1936 photography, which theretofore had been mostly a matter of landscapes and snapshots and family portraits, was fast being discovered as a serious tool of communications, a new way for the thoughtful, creative person to make a statement."[17]

In a sense, the photographs produced by FSA photographers are collaborations. Photographers in the field captured images suggested by Stryker's scripts; the choice and composition were the photographer's prerogative. Once the negatives were submitted to the FSA office in Washington, DC, Stryker selected and edited what was published (e.g. as evidence to present before Congress of the need for federal relief for American farmers and workers during the Depression). As such, the FSA archive reminds us of the collaborative nature of all photographs. As Barthes writes, a photograph is a "message" that comprises three parts: "a source of emission, a channel of transmission and a point of reception." The "source," Barthes writes, is actually a complex entity made up of the actual photographer who snapped the shutter and the photo editor who chose the image from among many on the photographer's contact sheet, and gives the picture its text—a title or caption, or an article, which further couches the photographer's image

in meaning, explaining what it depicts, or, if the image is ambiguous, giving us direction as to how to interpret it. As Barthes writes, whereas the source is a plural group of trained professionals, writers, photographers, business managers, government bureaucrats, etc., the point of reception is always singular: the reader—or the "public"—who receives, interprets, and responds to the message according to their particular cultural baggage. In the case of the FSA photographs, this "public" has been, variously, the select group of United States legislators and bureaucrats who constituted Stryker's immediate audience, and the broader public that has since viewed the photographs in books, museums, and now online. The text that surrounds the image, although it has been carefully selected by the publishers and editors, is ultimately understood and accepted, reinterpreted, or misunderstood based on our own backgrounds: our beliefs, our level of literacy (both verbal and visual), as well as how the picture compares to every other picture we have seen. As Barthes reminds us, the "meaning" of the same photograph can vary widely depending on how and where it is seen and by whom.[18]

While the FSA collection represents by far the greatest number of documentary photographs made during the Great Depression, some of the best-known images resulted from more intimate collaborations between individual photographers and writers. *You Have Seen Their Faces*, by photographer Margaret Bourke-White (1904–1971) and writer Erskine Caldwell (1903–1987), was published in 1937; *Let Us Now Praise Famous Men*, by photographer Walker Evans (1903–1975) and writer James Agee (1909–1955), was published in 1941. Contrasting these two well-known works about the Great Depression in the rural South illuminates two potential relationships between image and word in the documentary style. *You Have Seen Their Faces* features text in the form of short captions to directly comment upon or influence the reader's interpretation of the photograph on the same page; in *Let Us Now Praise Famous Men*, photograph and text are held apart and presented as separate but complementary essays within the same volume.

In *You Have Seen Their Faces*, figures were often shown in isolation, photographed from below or close-up, creating a feeling of monumentality. Caldwell and Bourke-White sought to present their subjects as noble and dignified, to solicit a feeling of common cause between reader and subject. As critic Jefferson Hunter notes, "The expressions on the faces are meant to be human, not southern. *You Have Seen Their Faces*, as a title, implies that Americans should recognize something of their own ordinary satisfaction, courage, or weariness in the photographs of an 'alien' people."[19] Hunter notes that this was a new goal in photojournalism, differentiating Bourke-White's and Caldwell's project from earlier works such as Riis's *How the Other Half Lives*. Hunter writes, "You are seeing faces which might be in a mirror and hearing voices like your own."[20] This powerful effect was achieved through captions, which allowed the subjects to "speak" in their own words, rather than be spoken for by the photographer or the political reformer. Unlike the poor immigrants depicted in Riis's photographs, the subjects of *You Have*

18 Barthes, "The Photographic Message," 194.

19 Jefferson Hunter, *Image and Word: The Interaction of Twentieth-Century Photographs and Text* (Cambridge, MA: Harvard University Press, 1987), 72. See also Margaret Olin, " 'It is Not Going to be Easy to Look into Their Eyes': Privilege of Perception in *Let Us Now Praise Famous Men*," *Art History*, v. 14 (March 1991): 92–115; and Carol Shloss, *In Visible Light: Photography and the American Writer, 1840–1940* (New York: Oxford University Press, 1987).

20 Hunter, *Image and Word*, 72.

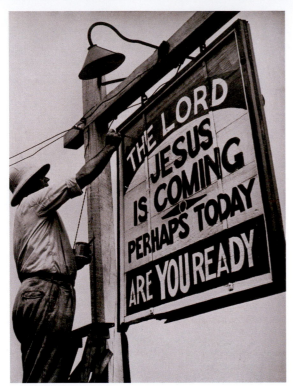

4.33 Margaret Bourke-White. *Untitled (Augusta, Georgia: "It's getting so nowadays …")*

21 Hunter, *Image and Word*, 73.

22 Hunter, *Image and Word*, 73, 74.

23 James Agee and Walker Evans, *Let Us Now Praise Famous Men* (Boston: Houghton Mifflin Company, 1941), xv.

Seen Their Faces do not appear as mute, sociological specimens. Never before had first-person quotations been used exclusively for captioning in photojournalism; this allowed readers to imagine that they heard the Southern sharecroppers and tenant farmers "speak up" on their own behalf.

In one iconic photograph, an African American man is quoted: "Everybody like to fish, but nobody likes to rustle up bait, so I expect that's why I make a sizeable living." A picture of a man in Augusta, Georgia, who is painting a sign for a rural church congregation, is captioned, "It's getting so nowadays people don't ask how good a preacher is at preaching. They want to know how good he is at painting signs." While Hunter notes that the subjects of *You Have Seen Their Faces* are presented as universally "human" rather than "southern," Bourke-White and Caldwell took care to preserve the sound of regional speech in the captions. We get the impression that statements have not been corrected by the authors, which allows readers to imagine that they are in direct communication with the subject who addresses us as an equal. At times, the picture reveals a depth of emotion that seems at odds with the caption. A photo of a couple looking despondent in their cabin in Locket, Georgia, is captioned: "There's probably no man alive who likes to see the sun rise as much as I do, and hates so much to see it set."

The photographs in *You Have Seen Their Faces* are organized into seven sections; each section unfolds as a sequence of eight or nine images. Bourke-White's photographs are intended to be as important as Caldwell's text. Captions are linked to the images, even though this involvement is often non-literal; the relationship between word and image is often evocative rather than illustrative. Longer passages written by Caldwell are printed apart from the pictures in separate sections. Caldwell does not describe specific images, and no specific picture in Bourke-White's photographs is discussed in Caldwell's text, or explicitly identified. Hunter writes: "What counts is that the pictures invite language. Furthermore, the style of the language invited matches the style of what is shown."[21] Hunter argues that Bourke-White's "striking camera angles and dramatic lighting parallel [Caldwell's] sarcasm [and] hyperbole whereby the South becomes the 'dog-town on the other side of the railroad tracks that smells so badly every time the wind changes,' and repetitive, hammered home knowingness."[22]

A very different form of collaboration is seen in *Let Us Now Praise Famous Men* by James Agee and Walker Evans. The relationship between Agee the writer and Evans the photographer makes a strong contrast with the close partnership between word and image formed by Bourke-White and Caldwell (who married one another in 1939). Agee and Evans produced what is arguably the best-known 20th-century American collaboration between a writer and a photographer, but when it was published in 1941 it was poorly received and considered to be a failed experiment.

In his preface, Agee, a journalist and poet who would later write and direct films, wrote: "The photographs are not illustrative. They, and the text, are coequal, mutually independent, and fully collaborative."[23] We might wonder how text and image can

remain independent yet collaborative. Evans's and Agee's collaboration began as an assignment for Henry Luce's *Fortune* magazine in 1936. Evans, who earlier in his life had aspired to be a writer, depicted the humble homes and possessions of three families of white tenant farmers (or sharecroppers) in rural Hale County, Alabama. It took Agee until 1941 to finally put their experience into words. Critic Jonathan Weinberg likens the relationship between Evans and Agee to a sibling rivalry, or a marriage. Indeed, Weinberg and other critics have noted that the tensions of creative collaboration may be more than artistic; they may relate to a sexual rivalry or desire "in which each partner both needs the other and fears that need."[24]

Evans and Agee believed that photography and writing were fundamentally different. For Agee, language, because it is metaphoric, went beyond the capability of the camera. Agee described Evans's camera as "incapable of recording anything but absolute, dry truth."[25] For Agee, the strength of Evans's photographs was their literalism, naturalism, and realism. Evans's photographs are clear and uncluttered. Their sharp focus encourages us to linger on textures and surfaces, shapes and shadows, but they do not purport to offer insight into the inner lives of their subjects. Evans, Hunter writes, "insists on an austere, nonverbal purity."

In contrast to the working relationship between Bourke-White and Caldwell, Evans and Agee segregated image and word completely to ensure that one would not encroach on the other; the photographs are printed in an altogether separate section from Agee's words, which, curiously, take on many of the descriptive qualities of photography, listing the various objects found in the sharecroppers' homes. Agee wrote, "If I could do it, I'd do no writing at all here. It would be photographs; the rest would be fragments of cloth, bits of cotton, lumps of earth, records of speech, pieces of wood and iron, phials of odors, plates of food and of excrement."[26] In the published book, Evans's pictures appeared first, without captions. A reader encounters them before seeing even the title and copyright page. In this way, Evans and Agee ensured that their respective contributions would maintain their integrity. *Let Us Now Praise Famous Men*, then, is not really collaboration at all. It is cohabitation. As Weinberg writes: "We see in the form, or forms, of the collaboration of Agee and Evans a coming together: each artist wants his work to approach the condition of the other; and a breaking apart: the artists keep their mediums separate."[27]

SELLING THE STORY: PICTURE MAGAZINES AND THE PHOTO ESSAY

Prior to the 19th century, printed broadsheets had included woodcut and engraved illustrations printed on the reverse of poems and essays addressing the politics of the day. Since the 1850s, engravings and lithographs had appeared in mass-produced

24 Jonathan Weinberg, "Famous Artists: Agee and Evans, Caldwell and Bourke-White," in *Ambition and Love in Modern American Art* (New Haven: Yale University Press, 2001), 180. See also Wayne Koestenbaum, *Double Talk* (New York: Routledge, 1989), 3.

25 Agee, quoted in Hunter, *Image and Word*, 77

26 Agee and Evans, *Let Us Now Praise*, 13.

27 Weinberg, *Famous Artists*, 187.

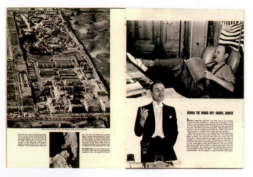

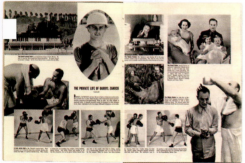

4.34 "Behold The Wahoo Boy: Darryl Zanuck," *LIFE Magazine*, February 15, 1937

28　See Catherine Lutz and Jane Lou Collins, *Reading National Geographic* (Chicago: University of Chicago Press, 1993).

29　Erika Doss, "Introduction: Looking at *LIFE*: Rethinking America's Favorite Magazine, 1936–1972," in *Looking at LIFE Magazine*, ed. Doss (Washington, DC: Smithsonian Institution Press, 2001), 3.

30　Doss, "*LIFE*," 1.

31　The *LIFE* photo archive is available online at http://images. google.com/hosted/life/

32　Doss, "*LIFE*," 16. Intermittent "special issues" were published until 1978; a monthly version of *LIFE* was launched in 1978 and continued publication until 2000.

publications such as daily newspapers and weekly magazines, integrated with the news items. These images were often described as "based on a photograph" to guarantee their truthfulness to an audience not used to seeing pictures in print. Captions identified the subject and instructed the reader in how they should be interpreted. The relationship between caption and image was clear and simple. In the 1890s the introduction of halftone techniques enabled the quick and inexpensive reproduction of photographic images in magazines and newspapers. *National Geographic* magazine, with its pictur-esque photographs of exotic people and places, was first published in 1888.[28] However, the poor image quality possible with newsprint, and the short deadlines, slowed the acceptance of photography in newspapers.

Beginning in the 1930s, new printing processes enabled better printed images to be obtained from photographs, ushering in the golden age of the "picture magazine," including the French *Vu*, the German *Berliner Illustrierte Zeitung*, and the British *Weekly Illustrated*. In the United States, publishers introduced *Collier's*, *Ebony*, *Esquire*, *The Saturday Evening Post*, and *Vanity Fair*, as well as a host of publications whose titles broadcast the visual appeal of the photographs that made up the majority of their contents: *Click*, *Focus*, *Look*, *Mid-Week Pictorial*, *Photo*, *Pic*, *Picture Post*, and *Survey Graphic*. By the 1950s, other magazines such as *Reader's Digest*, *TV Guide*, and Hugh Hefner's *Playboy* had claimed their specialized niches in the marketplace.[29]

Of all of these, *LIFE* magazine, founded in 1936 by Henry Luce, the charismatic publisher who had launched the successful *Time* and *Fortune* magazines, remains the iconic example of the picture weekly. Luce had also produced the radio program and newsreel *The March of Time*, which treated popular movie audiences to short sequences of moving images depicting the events of the day, accompanied by a voice-over. At the height of its popularity, *LIFE* was America's "favorite magazine," boasting a circulation of over 8 million subscribers in 1970; with a "passalong" rate of four or five people, each weekly issue reached an estimated 40 million readers.[30] From the 1930s through the 1970s, *LIFE* amassed an archive of several million photographs and published thousands of photo essays by pre-eminent photographers such as W. Eugene Smith, Margaret Bourke-White, Alfred Eisenstadt, and Gordon Parks.[31] In the late 1960s and early 1970s many picture weeklies shuttered their operations. Higher printing costs, declining revenues, the rise of television, and, most significantly, the collapse of the consensus vision of America that the magazine had so vigorously promoted, finally forced *LIFE* to suspend publication in 1972.[32]

LIFE's success was due in large part to its famous "photo essays." An example is a February 15, 1937 story on Hollywood producer Darryl Zanuck, "the No. 1 asset of Twentieth Century-Fox Film Corp.," which spreads across six pages of the magazine. The written text is subordinate to the pictures, which have been placed to lead the reader

through the piece. The article begins with an aerial photograph of the 110-acre Twentieth Century-Fox lot. The buildings where Zanuck works are marked with numbers that correspond to a written description below; a small picture at the bottom of the page shows a close-up of Zanuck's shoes (next to the head of a lion, purportedly killed by the movie mogul), which, the caption indicates, "carry the most phenomenally successful of movie men around the lot above." On the page opposite, Zanuck's feet (this time in a pair of stylish two-tone shoes) are propped on his desk as the producer, cigar in mouth, reads a script. The caption indicates that Zanuck smokes 20 to 30 cigars a day, the perfect stereotype of the powerful businessman. At the bottom left corner, a photograph of Zanuck in formal wear overlaps the picture above, suggesting that, for Zanuck, business and pleasure also often overlap. The caption informs us that Zanuck's job "takes 14 hours a day with only an occasional night off to tell jokes at a banquet." The final spread of the story pictures the other "chief assets of Twentieth Century-Fox," including child star Shirley Temple, the Dionne Quintuplets, French actress Simone Simon, skater Sonja Henie, and composer Irving Berlin. The strong diagonal of the layout breaks across the pages, leading readers from photo sequences that picture Zanuck at work (cigar in mouth) meeting with another producer, and watching a film in his private projection room, to the final picture of Sonja Henie. The text emphasizes that the photographs (and LIFE's editors) represent the final word on the truth; the caption above the photograph of Henie reads: "Miss Henie does not like the picture below … She told a New York Daily News reporter: 'Took one of those snaps of me in Palm Springs. I was playing tennis. It was awful. I looked like a lady weight-lifter.' Miss Henie erred. She was not playing tennis but badminton."

LIFE was designed to be experienced visually. The reader was encouraged to leaf through the magazine led by the flow of pictures and words; the relationship between word and image is simple and clear, not complicated or challenging. In order to create a seamless flow, photographers were not credited below each image, as is often the custom today. Instead, individual photographers were credited near the back of the magazine. Advertisements often mimicked the look and layout of LIFE's photo essays (even using a similar typeface) and had to be identified by the words "Advertisement" at the top of the page to distinguish them from regular features.

Luce described the photo essay as a powerful new artistic form, which "edit[ed] pictures into a coherent story—to make an effective mosaic out of the fragmentary documents which pictures, past and present, are."[33] Indeed, LIFE's editorial policy employed photography to determine what constituted "news" for its vast readership, and initiated the media-driven "society of the spectacle"—described by the French Situationist writer Guy Debord in the late 1960s.[34] Events must be photographed (and today televised) in order to have "really" happened. The modern citizen becomes a consumer of images.

33 Luce, quoted in Doss, "LIFE," 2.

34 Guy Debord, The Society of the Spectacle (New York: Zone Books, 1994).

4.35 Cover of *Weekly World News*, December 9, 2003

35 http://
weeklyworldnews.com/.
Additionally, an archive
of print editions of the
tabloid can be found
through Google books:
http://books.google.com/
books?id=4PQDAAAAMB
AJ/

36 Moira Roth and
Portia Cobb, "An
Interview with Pat Ward
Williams," *Afterimage*, v.
16 (January 1989): 6.

37 Roth and Cobb,
"Interview," 6.

Contemporary weekly tabloid newspapers, including the *Star* and *National Enquirer*, and magazines such as *People*, have continued *LIFE*'s focus on celebrities and the infamous, publishing articles that are primarily visual—scandalous or shocking photographs with minimal text that confirms what the pictures purport to represent: that a Hollywood actress has ballooned to over 300 pounds, that a handsome young man has brutally murdered his wife and unborn child, or that a miraculous tortilla has been found bearing an image of the face of Jesus. Perhaps the most notorious of these publications is the *Weekly World News*, published from 1979 until 2007 in Palm Coast, Florida. *Weekly World News*, which continues as an Internet site, is known to its readers as "The world's only reliable news," but also for its digitally altered images (initially cut-and-paste) of newsmakers such as the famous "Bat Boy," or Saddam Hussein and Osama Bin-Laden who appear improbably in what the *News* tells us are the pair's recently discovered "Gay Home Movies."[35]

The iconic status of *LIFE* magazine has made it a fitting target for contemporary artists. General Idea produced a parody of *LIFE* entitled *FILE* (an anagram of *LIFE*) in 1972. The design of the magazine looked so much like *LIFE* that the publishers of *LIFE* threatened legal action for copyright infringement. *Accused/Blowtorch/Padlock* (1986), by contemporary African American artist Pat Ward Williams (b. 1948), is based on a photograph Williams spotted in a coffee-table book titled *The Best of LIFE*, containing images by hundreds of photographers throughout the history of the magazine. The photograph Williams found was a grisly image of a young African American man, mutilated and chained to a tree by a mob of Southern racists in the 1930s. Williams explains, "It's a 'before' picture. The photographer must be part of the lynch mob."[36]

For her artwork, Williams rephotographed and enlarged the image three times, to underscore the violence of the image, and framed the pictures in a decrepit window frame, to suggest the context of rural poverty in which racism has flourished. The framed and repeated photograph is mounted against an expanse of black tar paper that recalls a classroom blackboard. Across this surface, Williams has scrawled her emotional reaction to the piece: "WHO took this picture?" "How can this photograph exist?" "Life answers— page 141—no credit." It is important that the text in Williams's work is handwritten and that it is in her own hand. This choice distinguishes Williams's own voice from the voice of detached, editorial authority that she implies is complicit in the crime depicted. Every time that *Accused/Blowtorch/Padlock* is exhibited, Williams rewrites the text and alters the wording. She explains, "My handwriting acts as my voice. By using handwriting instead of print, I hope you can hear a tone and human inflection."[37]

LIFE magazine and the photo essay are parodied in a 1995 artwork by Shawna Dempsey and Lorri Millan. Published in oversize magazine format with grainy black and white photos and the red "*LIFE*" logo on the cover, the artwork presents a photo essay documenting "A Day in the Life of a Bull-Dyke." Adopting the condescending tone of a

sociologist, the photo essay profiles a lesbian, Sally (or Sal). The photo essay follows Sal from when she wakes up "in a strange girl's bed," to breakfast at the Kitty Kat Café, "a notorious gathering place for homosexuals," to the butcher shop where Sal works. The photographs and text are deadpan and darkly humorous, revealing the ways in which Sal lives in a sexist and homophobic society: " 'Working together is no problem,' says Sal's boss Louie. "She's as strong as a man and I can pay her two-thirds the wage.' " After work, Sal is harassed by police and "gangs" of straight boys. Later, Sal dons a man's suit and false goatee to spend the night cruising for straight women "on the other side of the tracks." After a run-in with a jealous male rival, Sal meets Georgia, a curious woman who has never had a homosexual relationship. The photo essay ends with Sal and Georgia embracing and kissing on the steps of a courthouse. But Sal, the essay suggests, is looking for more than an illicit fling: "[O]ur bull-dagger heroine knows how to have a good time," the text concludes. "She's not shy. She's not demure. And she'll continue to rage until she gets what she wants; absolute respect for the lesbian way."

PERSONAL STORIES

The narrative dimensions of photography and text have been explored by many artists who choose to depict stories of a more personal nature than those chronicled by 1930s documentarians or latterday photojournalists. These take the form of fiction, jokes, and autobiographical remembrances. They present a more intimate view of experience than the public narratives of documentary or photojournalism. While personal voices do appear in the documentary work of Bourke-White and Caldwell and other photographers—in the form of quotations from the subjects of the photographs, and in the fact that photographs by their nature are specific rather than general—these personal testimonials are meant to illuminate larger stories: the Depression, war, and corporate malfeasance. While personal narratives by some photographers often resonate with larger issues, allusions to larger events function to bring depth to the experience of the photographer's subjects. Often, as in the blogs of confessional, diaristic, and stream-of-consciousness writings and digital photographs posted by individuals on the Internet, the subject is the author/photographer herself.

California photographer Bill Owens (b. 1938) is an heir to the documentary photo-text tradition of the FSA and *LIFE* photographers. However, Owens's photography steps away from the public narratives of the journalistic tradition to explore more personal stories. Owens, who wrote poetry in college and worked for a newspaper for a number of years as a staff photographer, chose to document his own community, the Northern California suburbs of the 1960s and 1970s, focusing on the strangeness of life in the promised land of the American middle class.[38] The project was based on Owens's own

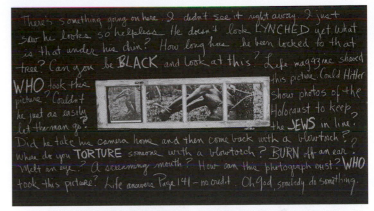

4.36 Pat Ward Williams, *Accused/Blowtorch/Padlock*, 1986

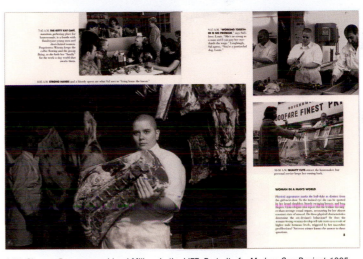

4.37 Shawna Dempsey and Lorri Millan, *In the LIFE: Portrait of a Modern Sex-Deviant*, 1995

38 Bill Owens, *Suburbia*
(San Francisco: Straight
Arrow Books, 1972).

"We lived in our house for a year without any living room furniture. We wanted to furnish the room with things we loved, not early attic or leftovers. Now we have everything but the pictures and the lamps."

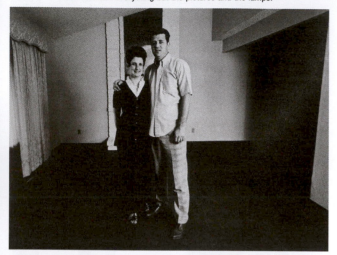

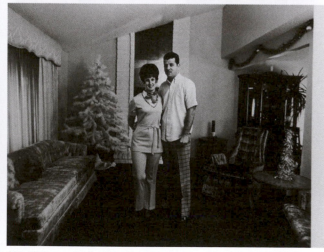

4.38 Bill Owens, *We lived in our house for a year … From Suburbia, 1968–1970*

"shooting script" listing a number of stereotypical activities in his own neighborhood, such as a Tupperware party, a holiday parade, lawn care, and the pleasures of home ownership. Most of Owens's large-format black and white photographs are accompanied by captions, which are placed below or to the side of the photograph. Like his predecessors in the 1930s, Bourke-White and Caldwell, Owens's captions are based on direct quotes from his subjects. As opposed to the work of Bourke-White and Caldwell and Agee and Evans, which highlighted personal stories of survival in the Depression and strength of character amidst great adversity, Owens elicits and chooses statements that reveal the surreal experience of the suburban "good life." One pictured informant tells Owens, "The best way to help your city government and have fun is to come out on Saturday morning and pull weeds in a median strip," as a group of neighbors manicure the small, artificial pocket of nature. Other photographs evoke the nagging guilt and anomie felt by some in suburbia despite their relative comfort, while other Americans were in the streets demonstrating for Civil Rights or protesting against the American war in Vietnam. A woman in curlers holds her child in the kitchen and laments, "How can I worry about the damn dishes when there are children dying in Vietnam." Many images focus on family and the community rituals of eating and celebrating. Meal times are also occasions for revealing how people conform to white, middle-class expectations in suburbia. A photograph of an Asian American family, gathered in their dining room, is captioned: "Because we live in the suburbs we don't eat too much Chinese food. It's not available in the supermarkets so on Saturday we eat hot dogs."

Owens also took portrait photographs of his neighbors, smiling and posing with their boats, cars, recreational vehicles, and furniture suites—their most treasured possessions, suggesting that in the suburbs materialism was supplanting other values. A before-and-after pairing of photographs of a couple in their living room (Figure 4.38) is captioned: "We lived in our house for a year without any living room furniture. We wanted to furnish the room with things we loved, not early attic or leftovers. Now we have everything but the pictures and the lamps."

Tony Mendoza's (b. 1941) diaristic photo-texts recount his personal and family history. They relate his family's flight from Castro-era Cuba; his relationship with his overbearing Cuban father; his decision to drop out of the workaday world to become an artist; his inability as a young man to commit to a serious relationship and a family; his marriage at 45 and his new roles as husband and father. Sometimes Mendoza's images are appropriated from newspapers or other publications. Most often they are old snapshots taken by family members, or photographs that he has taken himself. The texts that accompany his photographs are as revealing as an intimate conversation. These "stories," varying in length from a one-liner to a short paragraph, accompany each photograph and convey a warmth and personality that might not otherwise be apparent in what are otherwise unremarkable still images. Mendoza's autobiographical statement

references the power of the photo and the role of the caption. Rather than identifying or clarifying the subject of the photograph, the caption is a wry joke, using a *double entendre* to comment on Mendoza's self-consciousness about getting older, as well as the mechanics of the photograph image. The phrase "I had Lydia, my first child, at 47. I realize now that I waited too long. When I hold her in my arms, she's out of focus," plays on the declining eyesight of a middle-aged person, as well as on the depth of field of the photograph. Mendoza's careful spacing of the text in relation to the image recalls the timing of a joke delivered in person.[39]

In the diptych *How Do You Like My New Necklace?*, photographer Gay Block (b. 1942) reveals the tensions that defined her relationship with her mother, the subject of an exhibition and book.[40] The pair of photographs depicts Block's mother, Bertha Alyce, posed against a red background. Bertha is topless, and wears an elaborate, artist-designed necklace. Her arms are crossed casually on the back of a chair, over which is draped a sweater. The panel on the left features three paragraphs in a white sans-serif typeface on a red background. The first paragraph tells the story of Bertha's apparent vain and selfish response to Block's first solo museum show, opening in Houston. Block writes, "I expected her to say she liked my new pictures but instead she said, 'How do you like my new necklace?' This became my funniest narcissistic-mother story." In the second paragraph, Block's voice modulates as she takes on a more reflective tone, explaining that, "Twelve years have passed. Mother has been dead for three years and I have all her jewelry." In the third paragraph, Block imagines the story differently, speaking in apostrophe to her dead mother: "You bought [the necklace] especially for my opening … because it was designed by an artist … Why couldn't you tell me you did it for me? Or why couldn't I have known it without your telling me? Why do you have to be dead before I begin to forgive you?" In this final sentence, Bertha is no longer merely the maddening, self-centered mother; Block is no longer the blameless, long-suffering daughter.

As a young girl, Clarissa Sligh (b. 1939) became the keeper of her family's photo-albums. Like the albums and scrapbooks made by many families, Sligh's photo-albums included handwritten labels that identify places and family members and recount family stories. Born in Washington, DC, Sligh was deeply affected by the Civil Rights movement of the 1950s and 1960s. In 1955, she was selected as the lead plaintiff in a key school desegregation case. After earning a degree in mathematics from the Hampton Institute in Virginia and an art degree from Howard University in Washington, DC, Sligh pursued successful professional careers as a programmer for NASA and later as a Wall Street financial analyst. In 1984, Sligh returned to art making. When she began to make her own artwork, her childhood photo-albums became a resource and an influence. Sligh makes use of non-traditional and alternative photographic printing processes, including repho-tographing family snapshots, Van Dyke Brown and cyanotype prints onto watercolor

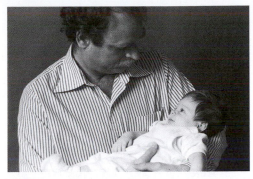

My first child, Lydia, was born when I was 47. I realized then that I had waited too long. When I held her in my arms, she was out of focus.

4.39 Tony Mendoza, *I had Lydia …* (from The Stories series), 2003. Gelatin silver print

39 J. Ronald Green, "Thanks Fidel," in *Tony Mendoza: Photographs, Words, Video* (Columbus, OH: Columbus Museum of Art, 2003), 29–30.

40 Gay Block, *Bertha Alyce: Mother exPosed* (Albuquerque: University of New Mexico Press, 2003).

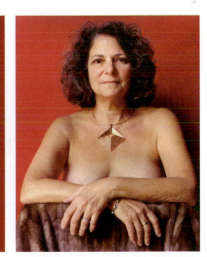

4.40 Gay Block, *How do you like my new necklace?*, 1997/2003. Archival ink jet. © Gay Block

paper, and handwriting. By grafting her own memories and personal history to the core of her art, Sligh tells stories from her own perspective as an African American woman who came of age in the 1940s and 1950s in the segregated South, and who grew up to cross racial barriers. Sligh explains:

[W]e learn to see the photograph as the record of reality. Seeing the photographs with the handwritten words was a way of seeing them become a different record of reality. I was trying to include a handmade record, like scratches, marks, like a footprint or a fingerprint in the photograph, to say that this photograph is not valid without this additional mark, this additional imprint.[41]

In a 1987 Van Dyke Brown print entitled *Waiting for Daddy*, the handwritten explanatory texts have migrated from the labels to the picture itself. Each of the four individuals pictured—Mama, Carl, Junior, and Skookie—are identified by Sligh's handwritten notations on the figures themselves, as is the backdrop: "Grandma's House." Sligh's text (written in simple, uppercase letters) explains the story of the picture, bringing a sense of wonder and nostalgia to a scene that might otherwise seem to document only rural poverty. While the picture represents a scene from Sligh's past, the childlike narrator describes the picture in the present tense:

Here we are waiting for Daddy to take our picture in front of Grandma's back porch. It encloses the well from which we draw our water. The water is always cold, even in summer when the snails come to live inside. An icebox, containing food sits in the far corner. When it gets to be really hot, the iceman brings a big block of ice everyday—some times, we make ice cream. I am a very happy kid. In this house, Grandma is in charge.

QUESTIONING THE STORY

We tend to believe in the authenticity of photographs. Because of this, photography has been used throughout its history as evidence to shore up the authority of science, or to lend credence to the claims of elites. However, some artists seek to remind us that photographs have a rhetorical function—that photographs are carefully constructed cultural texts that need to be read critically. Indeed, the documentary images made by photographers following FSA "shooting scripts" are fictions, in the sense that they were carefully selected—and often staged—to illustrate the story that Roy Stryker wanted to tell. Critical of the belief that photographs offer objective evidence of the truth, many contemporary photographers create fictional stories to encourage skepticism about official versions of the truth, or to deconstruct the authority of science or documentary. Indeed, photographers have been among the most ardent critics of common-sense

41 Sligh, in Laura U. Marks, "Reinscribing the Self: An Interview with Clarissa Sligh," *Afterimage*, v. 17, n. 5 (December 1989): 6.

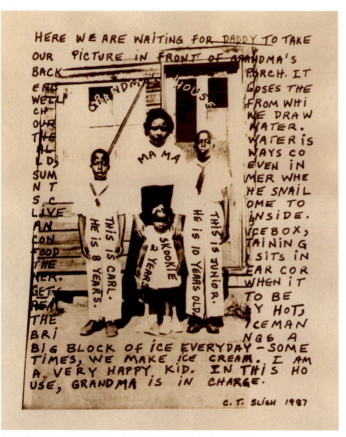

4.41 Clarissa Sligh, *Waiting for Daddy*, 1987. Van Dyke Brown print

notions of the truthfulness of photography. They remind us that "objective" photography has often been a tool of deceit and oppression.

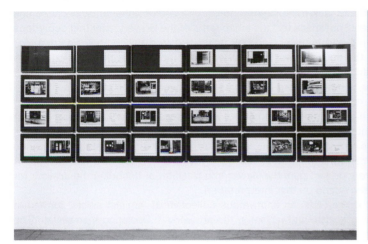

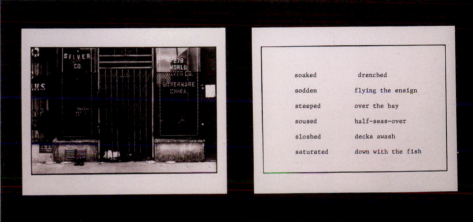

4.42A and B Martha Rosler, installation view and detail from *The Bowery in Two Inadequate Descriptive Systems*, 1974–1975

Martha Rosler (b. 1943) employs text and images to question the authority of the documentary tradition in photography. Her artwork *The Bowery in Two Inadequate Descriptive System*s (1974–1975) consists of 21 identically framed panels, pairing a black and white photograph on the left with a typewritten text with a black border on the right introduced by three panels with only words, no photos. The photographs are intentionally deadpan, mostly frontal views of storefronts, banks, and other dilapidated buildings in the Bowery, the notorious skid row district in Lower Manhattan, previously photographed by documentarians such as Jacob Riis at the turn of the century, and Berenice Abbott and Walker Evans in the 1930s. The typewritten panels on the right present an encyclopedia of slang terms for the body and drunkenness. The photographs are purposely bland, but the language of the text is colorful: "stewed, boiled, potted, fried to the hat … vulcanized, shellacked, varnished." Alexander Alberro suggests that "The two 'descriptive mediums,' one linguistic and one visual, bang up against each other, each emphasizing the other's fundamental inadequacy."[42] As Rosler explained, "I didn't want to use words to underline the truth value of the photographs, but rather words that undermined it."[43]

To Rosler, *The Bowery* is a critical commentary on the tradition of street photography by Weegee and others, as well as the documentary photographers of the FSA, who were being rediscovered and celebrated when Rosler was a young artist in the

[42] Alexander Alberro, "The Dialectics of Everyday Life: Martha Rosler and the Strategy of the Decoy," in Catherine de Zegher, ed., *Martha Rosler: Positions in the Life World* (Cambridge: MIT Press, 1999), 99–100.

[43] Martha Gever, "An Interview with Martha Rosler," *Afterimage* (October 1981): 15.

44 Benjamin Buchloch, "A Conversation with Martha Rosler," in de Zegher, 37.

45 Martha Rosler, "In, around, and afterthoughts (on documentary photography)," in *3 Works* (Halifax: Nova Scotia College of Art and Design, 1981).

46 On the status of women and feminism in the 1980s, see Susan Faludi, *Backlash: The Undeclared War Against American Women* (New York: Anchor, 1991).

early 1970s.[44] Rosler's generation of artists in the 1970s was deeply suspicious of traditional notions of "representation" and of the power of documentary art and photo texts to effect meaningful social change. Accordingly, Rosler's pictures are unimaginatively composed and lack the expected polish of a professional artist because she refuses to "represent" or "speak for" the inhabitants of the Bowery, omitting depictions of the down-and-out and homeless and by using text in a deliberately "inadequate" way. Arguing that the documentary tradition was "decrepit"—that the traditional tools of the documentarian were inadequate for picturing real poverty—Rosler wrote, "If impoverishment is a subject here, it is … the impoverishment of representational strategies."[45] She refused to act disingenuously "as an agent of the system of power that silenced these people in the first place." Rosler's was a new and radical version of social documentary, which sought once and for all to minimize the subjectivity of the artist and leave room for the viewer and the subject to initiate a dialog. Rather than interpreting the image for the viewer—as documentarians since Riis had sought to do—Rosler's *Bowery* project puts the viewer in a position of decoding the artwork for themselves and then acting on that interpretation.

In 1985, the Guerrilla Girls, an anonymous collective of feminist artists, formed in New York to monitor sexism and racism in the art world.[46] Declaring themselves "The conscience of the art world," the group began plastering the city with posters citing statistics on the under-representation of art by women and minority artists in commercial galleries and museums. To protect their identities, they wear gorilla masks for media appearances and adopt the names of historical women artists—Angelica Kauffmann, Rosa Bonheur, Paula Modersohn-Becker, Eva Hesse—as pseudonyms. A poster from 1989 reproduced Ingres's painting of the *Grand Odalisque* (1814); in their version, the odalisque wore a gorilla mask and asked, "Do women have to be naked to get into the Metropolitan Museum? Less than 5% of the artists in the Modern Art sections are women, but 85% of the nudes are female." Other posters demanded, "When racism and sexism are no longer fashionable, what will your art collection be worth?" They cited statistics: "[T]hese galleries show no more than 10% women artists or none at all." The Guerrilla Girls' activist work points to the fundamental inequality of the art world, in which major exhibitions such as *Documenta 7* in Kassel, Germany (1982) featured 28 women and 144 men; The Museum of Modern Art's *International Survey of Painting and Sculpture* (1984) featured 13 women out of 164 artists; and *Documenta 8* (1987) included 47 women out of 409 artists in total. These were grim statistics; the commercial galleries were no better: the Mary Boone Gallery, for example, had an entirely male stable of artists during the 1980s. A 1993 poster reproduced the cover of the *New York Times Magazine* from October 3, 1993, showing a photograph of art dealer Arnold Glimcher of Pace Gallery and his stable of white, male, middle-aged "Art World All-Stars." The Guerrilla Girls appropriated and reprinted the cover without changes, adding only the

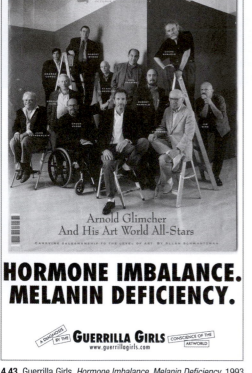

4.43 Guerrilla Girls, *Hormone Imbalance, Melanin Deficiency*, 1993. Poster

phrase, "Hormone Imbalance. Melanin Deficiency," to point to the exclusionary policies of this major gallery.

The art activism of the Guerrilla Girls has been warmly received and supported by many in the art world, especially among women and non-white artists. However, many influential figures, such as art dealer Leo Castelli, have argued that the Guerrilla Girls suffer from a "chip that some women have on their shoulders. There is absolutely no discrimination against good women artists. There are just fewer women artists."[47] However, the Guerrilla Girls' ongoing research demonstrates otherwise. A 2008 poster notes that the holdings of the Broad Foundation (a major collection of contemporary art) represent 194 artists, 96 percent of whom are white, and 83 percent of whom are male.[48]

A number of African American contemporary artists have combined photography with text to challenge the role that visual images have traditionally played in justifying and maintaining racist oppression. African American cultural critic bell hooks (who uses the lowercase version of her great-grandmother's name as her pen name) argues that the new approaches to photographing the black subject, or making use of appropriated existing photographic images, by contemporary black artists is about "critiquing the status quo" and offering a new critical perspective. A number of young African American artists who use text and photography do so with the goal of, as hooks writes, "transforming the image, creating alternatives, asking ourselves questions about what types of

47 Leo Castelli, quoted in Mira Schor, "Backlash and Appropriation," in *The Power of Feminist Art: The American Movement of the 1970s, History and Impact*, ed. Norma Broude and Mary D. Garrard (New York: Harry N. Abrams, 1996), 252.

48 http://www. guerrillagirls.com/ posters/dearestelibroad. shtml/

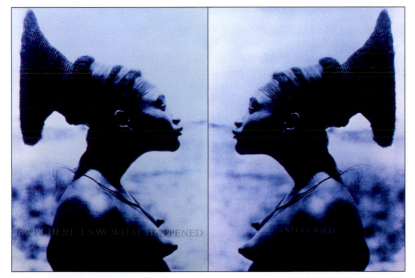

4.44A and B Carrie Mae Weems, *From Here I Saw What Happened* and *And I Cried*. C-prints with sandblasted glass text on glass

49 bell hooks, *Black Looks: Race and Representation* (Boston: Southend Press, 1992), 4; quoted in Phyllis J. Jackson, "(In)forming the Visual: (Re)Presenting Women of African Descent," *International Review of African-American Art*, v. 14, n. 3 (September 1997): 31.

50 Lisa Collins, *The Art of History: African-American Women Artists Engage the Past* (New Brunswick: Rutgers University Press, 2002), 17.

51 Collins, *Art of History*, 19.

52 The Legacy Project, http://www.legacy-project.org/arts/index.html (May 28, 2003).

images subvert, pose critical alternatives, transform our worldviews and move us away from dualistic thinking about good and bad."[49]

Indeed, as Art historian Lisa Collins argues, from its earliest beginnings, "photography and the institution of slavery are closely linked."[50] As Collins writes, "Visual documentation emboldens and lends credence to myth. Similarly, visual corroboration of scientific theory enhances its power and extends its reach. Given this, it is not surprising that those who try to make such meaning have eagerly sought visual evidence that can explain or confirm racialized myths and theories."[51] A famous example is the collection of daguerreotypes commissioned by Louis Agassiz, a renowned Swiss zoologist who conducted a scientific study of the anatomy of African slaves in South Carolina 1847. Agassiz used images made by a local daguerreotypist named J.T. Zealy to illustrate his argument for the existence of eight human "types"—including among others the Caucasian, the Negro, the American Indian, and the Hottentot. The daguerreotypes remained largely unknown for over a century, until the 1970s, when a number of the daguerreotypes were uncovered in the Peabody Museum at Harvard University.

Carrie Mae Weems (b. 1953) combed through this archive—selecting, enlarging, and toning archival photographs for her artwork *From Here I Saw What Happened … And I Cried* (1995–1996). She mounted the photographs behind glass, with a sandblasted inscription: "You became a scientific profile, a Negroid type, an anthropological debate, a photographic subject …" Weems's phrasing simultaneously addresses the viewer and the African American subjects of the photographs. Reprinted in black on a blue background, two larger photographs bracket the installation: a photograph of an African woman and the reverse of this same image. The inscription that hovers over the first image reads in the first person, "From Here I Saw What Happened." The photograph bracketing the installation at the right completes the title: "And I Cried."

Weems explains that her intention is to "describe simply and directly those aspects of American culture in need of deeper illumination."[52] Her goal is to raise consciousness about the role of photography and visual culture in the ongoing perpetuation of racism and discrimination. To make the point that racism is not limited to the past but is an ongoing issue, Weems included photographs by 20th-century photographers, such as Robert Frank, who was represented by a photograph from *The Americans* which depicted a black nanny holding a white child in Charleston, South Carolina, in the 1950s.

Glenn Ligon's (b. 1960) *Notes on the Margin of Robert Mapplethorpe's Black Book* used text to explore themes related to his own African American gay identity. In this installation, Ligon combined rephotographed images from white gay photographer Robert Mapplethorpe's famous photographic series of nude black men (1982 and 1986), photographed in idealized, classical poses, with quotations by historical and contemporary artists, conservative political and Christian leaders, gay authors, and other cultural

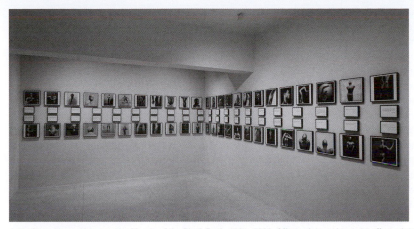

4.45 Glenn Ligon, *Notes on the Margin of the Black Book*, 1991–1993. Offset prints and text. 91 offset prints, framed, 78 text pages, framed

figures.[53] Mapplethorpe's *Black Book* had an allure for Ligon and other gay black men because, as British cultural critic Kobena Mercer writes:

It circulated between us as a kind of illicit object of desire … We were fascinated by the beautiful bodies … [W]e were angered by the aesthetic equation that reduced these black male bodies to abstract visual "things", silenced in their own right as subjects, serving only to enhance the name and reputation of the author in the rarefied world of art photography.[54]

Ligon's "Notes" began as a defacement, in which he literally made notes in the margins of his own copy of Mapplethorpe's book. As he began to refine the project, his research led him to seek sources from a more diverse range of commentators. He collected quotations—many of which were incendiary—on the image and status of the black male body in the dominant white culture. For the installation, Ligon centered two rows of framed and printed texts (the author of each quotation is identified) between upper and lower tiers of black male nudes reproduced from the *Black Book*. Ligon's texts function as elaborate footnotes or annotations. Art historian Richard Meyer describes Ligon's "Notes" as a "wraparound grid of word and image" that "respects, rather than violates, the formal logic of Mapplethorpe's work." As Meyer writes, " 'Notes on the Margin of the *Black Book*' opens a space, at once critical and visual, between Mapplethorpe's nudes and the voices that respond to them."[55] Viewers are allowed to peruse Mapplethorpe's *Black Book* in its original sequence, while reading the collection of quotations that Ligon has appended to it, and, like the viewers of Rosler's *The Bowery*, they are allowed to

53 Robert Mapplethorpe, *Black Males*, Introduction by Edmund White (Amsterdam: Galerie Jurka, 1982), and Mapplethorpe, *The Black Book*, Foreword by Ntozake Shange (New York: St. Martin's Press, 1986).

54 Kobena Mercer, "Skin Head Sex Thing: Racial Difference and the Homoerotic Imaginary," in *Art Matters: How the Culture Wars Changed America*, ed. Brian Wallis, Marianne Weems, and Philip Yenawine (New York and London: New York University Press, 1999). Originally published in Bad Object-Choices, ed., *How Do I Look? Queer Film and Video* (Seattle: Bay Press, 1991), 169–210. See also Mercer, "Imaging the Black Man's Sex," in *Photography/Politics: Two*, ed. Pat Holland, Jo Spence, and Simon Watney (London: Comedia/Methuen, 1987), 61–69.

55 Richard Meyer, "Borrowed Voices: Glenn Ligon and the Force of Language," Queer Cultural Center, The San Francisco for Lesbian, Gay, Bi, Transexual Art and Culture. http://www. queerculturalcenter.org/ Pages/Ligon/LigonEssay. html, July 29, 2009.

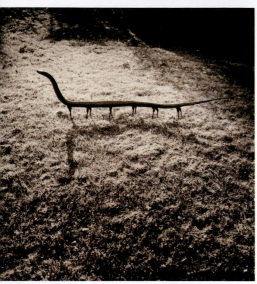

4.46 Joan Fontcuberta, *Solenoglypha Polipodida – Position of Attack*, 1987. Gelatin silver print

56 Diane Neumaier, "An Interview: Reviving the Exquisite Corpse, Joan Fontcuberta and Spanish Photography," *Afterimage*, v. 18 (April 1991): 6.

57 Jean Fisher, "Joan Fontcuberta and Pere Formiguera, The Museum of Modern Art," *Artforum*, v. 27 (October 1988): 141–142. Dana Friis-Hansen, "Joan Fontcuberta and the Creative Quest for a Photographic Reality," Polaroid featured artist. http://www.polaroid. com/studio/artists/ fontcuberta/index.jsp/

place themselves in relation to the dialog between Mapplethorpe's photographs and Ligon's commentary. Ligon's use of text in relation to Mapplethorpe's already famous and controversial photographs brings a new level of complexity to our experience of these images.

Trained in the world of journalism and advertising, Spanish photographer Joan Fontcuberta (b. 1955) came to understand photography as a tool of communication. Fontcuberta explained, "[M]y main concerns were not aesthetics but information theory: semiotics, sociology, history of media. The issues of how messages reach an audience, theoretical concerns about advertising, were very familiar to me." His artwork utilizes the same techniques he used in the projects he completed for corporate clients, but to radically different ends. "In advertising," Fontcuberta explained, "there were precise techniques of visual communication such as the rule that an ad should have a unique selling proposition—a USP. I just transferred all these communication methods to my work, subversively … I tried to show that any photograph was also alive as a cultural construction."[56]

Fontcuberta began *Fauna*, a multimedia collaboration with Spanish writer Pere Formiguera, in 1985. They based the project on the research of Professor Peter Ameisenhaufen, a fictional character invented by the two artists. According to the story developed by Fontcuberta and Formiguera, Ameisenhaufen was an obscure German zoologist who disappeared off the North Coast of Scotland in 1955 (the year of Fontcuberta's birth), leaving only fragments from his archives of arcane scientific data, research notes, maps, audio recordings, and photographs of undiscovered species, including, according to critic Dana Friis-Hansen, "a one-horned monkey that flies, a two-legged, turtle-headed mammal, and a predatory clam that hops on one leg to stalk its prey."[57]

The installation, *Fauna Secreta*, was designed to simulate a natural history museum, including making counterfeit maps, sound recordings, data on sexual reproduction, footprints, x-rays, and field notes. The installation presented fantastical hybrid animals created by a taxidermist from the carcasses of animals donated by zoos. These specimens melded mammal and reptile, tortoise and bird, fish and mammal, made convincing by scientific language and nomenclature as well as by photographs showing the animals in their natural habitats, which were stained to appear aged as if salvaged from Ameisenhaufen's archive. The installation included a videotape of a television news report on the death of the scientist and the discovery of his research archives, a fake documentary film about Ameisenhaufen, as well as fabricated diaries, childhood photographs, and letters.

While the project has been installed in art galleries and museums, Fontcuberta believes that the installation is most successful when it appears in scientific institutions. Fontcuberta sees his project as a "tool to make people think" and be skeptical of

information that they receive from authority figures. Thirty percent of the visitors to an installation of the project at a science museum in Barcelona believed that Fontcuberta's fauna could have existed. In the museum, Fontcuberta explains, "we can challenge the authority of the institution. You have a disposition to believe that a museum will provide a specific content, a specific aura to the objects on display. In a museum of natural history you expect to see natural representations of something from the natural world."[58] While science provides information, it remains our responsibility as consumers of information to determine truth.

INSTRUCTIONS

In our everyday lives, we often encounter photography and text used in combination with instructions (e.g. in the manual that teaches us how to connect our computer to the printer, or where to check if our car is running low on oil). Often a diagrammatic image will clarify what in written language is obscure or complicated. A number of contemporary artists combine photography and text as a means of directing the viewer. Instructions function as a means of getting the audience or reader to perform an action, or to complete the work of art, as in Sol Lewitt's wall drawings, which are completed by a professional installation crew. Instructions can also serve to compel viewers into a state of reflection and heightened critical awareness.

Austrian artist Erwin Wurm (b. 1954) explores the performative dimensions of text and photography in his *One Minute Sculptures*. Following the example of Lewitt, who wrote "The idea itself, even if it is not made visual, is as much a work of art as any finished product," Wurm produced a series of photographs entitled *One Minute Sculptures*.[59] In these, text takes the form of a series of brief instructions: fold and hang a sweater; wear all of one's clothes at once; stand in a bucket with another on one's head for a period of 5 minutes; crouch on hands and knees and act like a dog; sit on the ground and hold one's breath while thinking about the philosopher Spinoza. Subjects who answered a classified ad were photographed acting out the mundane activities of Wurm's instructions. Each individual became, temporarily, Wurm's sculptural material. The resulting photographs are simultaneously humorous and uncanny, as the participants who take on the qualities of inanimate objects become immobilized and corpse-like.

Wurm's work is irreverent and challenging because it encourages viewers to reconsider the potential of everyday objects and their relationship to inanimate things, imagining that they might be used in ways other than those for which they were intended. Moreover, the text which inspires the event also serves to describe it, explaining the bizarre events captured in the photographs. Most radical, however, is the fact that Wurm's work redefines the nature of art as interactive, rather than static.

58 Fisher, "Joan Fontcuberta."

 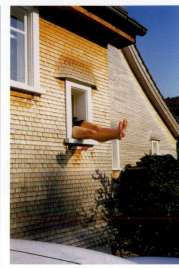

59 Sol Lewitt, "Paragraphs on Conceptual Art" (1967), quoted in Élizabeth Wetterwald, "Erwin Wurm: The Art of Doubting," *Parachute 105*, n. 1–3 (2002): 72.

4.47A and B Erwin Wurm, *Instruction Drawing* (1 minute, 8 a.m.), 1998. Felt pen on paper, 29.7 × 21.0cm. and *Appenzell*, outdoor sculpture, 1998. C-print, 120 × 80cm

Conceptual Art
An art movement that emerged in the 1960s, that emphasized the artist's ability to convey an idea or a concept to the viewer, and rejected the creation or appreciation of a traditional art object such as a painting or a sculpture as a precious commodity.

In the tradition of **Conceptual Art**, or the Dada and Fluxus movements, Wurm does not conform to common preconceptions of an artist as a maker of objects, or an artwork as a discrete, precious object. The performances and their photographic documentation can be reproduced indefinitely, if they are carried out at all; the artwork can be said to exist simultaneously as written instruction, temporal performance, and photographic documentation, with no one instance privileged above any other as the "real thing."

SPEECH

In pre-literate societies, language was transmitted through spoken word. Linguists note that "oral" cultures relied on individuals who could remember and individually convey important information about events and beliefs. By necessity, societies that did not possess written languages were small, intimate groups.[60] Marshall McLuhan has written that the emergence of written language and the development of the printing press enabled communication on a massive scale, changing the size of communities, from the small and intimate groups of pre-literate societies, to expansive and abstract notions of national and global communities of the modern world.[61] The contemporary world of the Internet and instant global communication has created a new paradigm, in which text and image can be geared toward the individual user rather than a mass audience; each reader can configure a text by changing their computer's preferences, or approach it in different ways by following hypertext links according to their own desires. "Spyware" and "cookie" files conspire to create an audience of one, or the ultimate niche-market for advertisers, creating unique combinations of text for each individual reader according to their individual data history.

But even as instant communication, the Internet, and the growth of global markets have transformed the way that we receive and interpret language, many artists use text to create a unique voice. They remind us of the continuing importance of individual experience and expression. British artist Gillian Wearing's (b. 1963) photographic series, *Signs that say what you want them to say and not Signs that say what someone else wants you to say*, plays with the tradition of captioning. For these photographs, Wearing, who also works in Video and **Neo-Conceptual Art**, gave her subjects a card and a marker with which to print whatever they chose to reveal about themselves. The results allowed the subjects to articulate what might otherwise be hidden behind the happy faces that we instinctively present to the camera.

Other artists have combined projected video images with text in the form of a recorded soundtrack. Video artist Tony Oursler (b. 1957) was raised in a family of writers and artists. His grandfather wrote a best-selling, popular version of the Bible, entitled, *The Greatest Story Ever Told*, and his father worked for the *Reader's Digest* and the

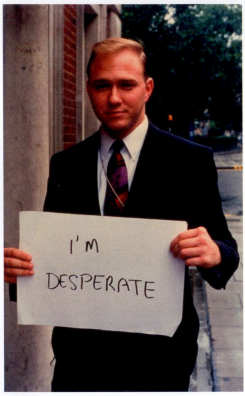

4.48 Gillian Wearing, *Signs that say what you want them to say and not Signs that say what someone else wants you to say (I'm Desperate!)*, 1992–1993. C-print. 48 × 36⅛in

60 Walter J. Ong, *Orality and Literacy* (London: Routledge, 2002).

61 Marshall McLuhan, *Understanding Media: The Extensions of Man* (New York: McGraw Hill, 1964). See also Benedict Anderson, *Imagined Communities: Reflections on the Origin and Spread of Nationalism* (London: Verso, 1991).

Neo-Conceptual Art
Art practices that are influenced by the Conceptual Art movement of the 1960s and 1970s in its desire to communicate ideas, in its rejection of art as a commodity, and in its social and/or political critique.

Christian magazines *Guideposts* and *Angels on Earth*. His mother's side of the family were visual artists. In Oursler's artwork, the spoken word and the audible voice appear in conjunction with moving video images or still photographs. Miniature video projectors create an illusion of life by projecting faces onto heads fashioned from muslin pillows or simple rounded shapes that look like light bulbs. An audio soundtrack features sounds or a monologue by the characters projected on the piece. Many of Oursler's artworks depict abject figures who are immobilized or trapped, and only able to communicate through speech and facial expressions. In *Getaway #2* (1994) a female doll appears to be trapped, or hiding, under a mattress. Her giant pillow head yells "Hey, you! Get outta here!" and hurls a string of obscenities and epithets at the viewer. In creating figures that seem to be only active above the neck, or exist only as heads or giant eyeballs, Oursler highlights the psychological component of his art, creating situations that confront and engage the viewer in ways that the still, silent image cannot.

PICTURES OF WORDS: A FOREST OF SIGNS

As Barthes noted, contemporary culture is mediated by language. Advertisements, instructions, and warnings overpower the landscape, not just in dense urban settings such as Times Square in New York City, but even in wide-open rural spaces. Not surprisingly, a number of 20th-century photographers have turned their attention to the forest of signs we navigate daily. These photographers incorporate text as a design element for its abstract, formal properties, as evidence of human occupation and development, or as a critique of the commercialization of public spaces.

American photographer Berenice Abbott (1898–1991) worked as an assistant to the surrealist photographer Man Ray, and as a successful portrait photographer in Paris during the 1920s. Returning to New York in 1929, Abbott was struck by the rapid pace with which the old Manhattan of 19th-century townhouses and tenements (photographed a generation earlier by Riis) was disappearing. After working as a photographer for Henry Luce's *Fortune* magazine and other commercial clients, and inspired by Eugène Atget's famous photographs of Paris, Abbott proposed *Changing New York*, a project documenting the dramatic transformation of the city's built environment, to the **Federal Art Project** (FAP), an agency of President Franklin Roosevelt's New Deal. Abbott began work on *Changing New York* in 1935 and pursued the project for three years; she amassed more than 300 large-format (8×10-inch) negatives. *Changing New York* was published as a book in 1939 with an introduction and commentary by Abbott's close friend and art critic, Elizabeth McCausland (who had first described and defined the "documentary" style in photography). Abbott's photograph of the *Blossom Restaurant; 103 Bowery. Oct. 3, 1935* captures the old New York that was being rapidly

4.49 Tony Oursler, *Getaway #2*, 1994. Video projector, VCR, videotape, mattress, cloth. Performance by Tracy Leipold. Irregular dimensions (overall approx. 14 × 76 × 124½in.)

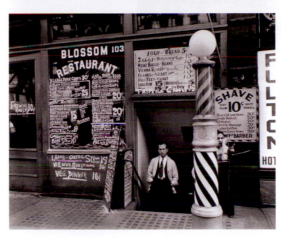

4.50 Berenice Abbott, *Blossom Restaurant; 103 Bowery. Oct. 3, 1935.* 1935. Silver-gelatin print

Federal Art Project (FAP)
A division of the Works Progress Administration (WPA), which was part of President Franklin D. Roosevelt's New Deal initiative to provide economic relief to Americans during the Great Depression. The FAP was a government-funded art program from 1935 until 1943. The program educated artists in community art centers, created an historical pictorial record of Americans, and employed artists to create posters, murals, and paintings in public places, such as government buildings, schools, and libraries.

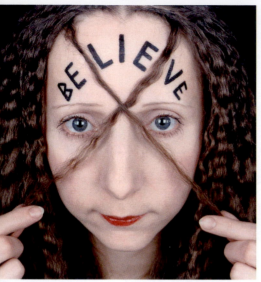

4.51 Rimma Gerlovina and Valeriy Gerlovin, *Be-lie-ve*, 1990. C-print

62 Howard Risatti, "Rimma and Valeriy Gerlovin, Robert Brown Contemporary Art," *Artforum*, v. 29 (February 1991): 131.

63 Risatti, "Rimma and Valeriy," 131–132.

cleared to make way for the massive skyscrapers, heralding New York's emerging status as global metropolis. The photograph documents the prevalence of text in the urban landscape. Here, in the hand-painted sign for the barbershop and the restaurant's menu on the storefront window (with last-minute additions scrawled below), Abbott calls our attention to the vibrant vernacular culture that she saw being swept away in the interest of progress.

WORD AS IMAGE

While some artists photograph text found in the environment, other artists introduce text into the world to create images. In bringing together two apparently contradictory modes of communication (verbal and visual), artists who introduce text into the visual world impose human, rational codes onto nonverbal experience. While text in these images functions as an object, it also serves to remind us that written language is a human creation, an abstraction that does not exist in nature.

Rimma Gerlovina (b. 1951) and Valeriy Gerlovin (b. 1945) use their own bodies as "both prop and canvas" to make sophisticated statements about how language constructs our perceptions of reality.[62] Gerlovina and Gerlovin emigrated from the Soviet Union to the United States in 1979. In the U.S.S.R. they had been at the forefront of the underground Samizdat "self-publishing" movement. **Samizdat** artists produced innovative books, performances, and installations. Their work was considered "political" less for its content than for its underground status, when the official Soviet art was **Socialist Realism**. Artists who made experimental, unorthodox art were in a dangerous—and often illegal—position.[63]

In the United States, Gerlovina and Gerlovin began a series of artworks which they titled *Photems*—combining the words "photograph" and "totem"—and *Photoglyphs*—combining "photograph" with "glyph," a root word meaning "writing." Works combine a number of different written languages: cuneiform, Hebrew, Chinese, Arabic, Sanskrit, Greek, Roman, modern Russian (Cyrillic), and English. In these artworks, text is painted directly on the artists' faces, hands, and bodies; the marked body is then photographed in color and printed in large format. The resulting images are a combination of portraiture and pantomime—Gerlovina and Gerlovin refer to them as "still performances"—and bring together preverbal (bodily) and verbal communication.

In most works, the artists appear in a rigid, frontal view, to de-emphasize what might otherwise be charged psychological portraits. Gerlovina and Gerlovin reveal a love of subversive puns and wordplay that has its origin in the art of Samizdat. For example, *Be-lie-ve* presents Rimma Gerlovina with the word "Believe" painted on her face. With each hand, she pulls a strand of hair across her forehead, isolating the word "Lie." The

texts form clever rebuses and present conundrums for the viewer, wherein visual and verbal codes create puzzles for the viewer to decipher.

Lesley Dill (b. 1950), who was an English major before she earned a masters degree in painting, takes another approach to incorporating text and image. Dill credits her interest in the aesthetic experience of language to a year she spent in India in 1992, where she did not speak Hindi: "This language, with its surface sense removed, I started to hear as an incantation. As I had a studio and was working there, I wanted to make a visual equivalent of this melodic unintelligibility I was hearing everyday. As if you could actually see the sound of talking—a talking where the presence of it was as tangible as the sense unattainable."[64] Much of Dill's art incorporates the writings of 19th-century American poet Emily Dickinson (1830–1886), whose writing, Dill explains, "hit me like a bullet … I feel her words are basically blood to me."[65] Dill began by fashioning the words of Dickinson's poems from wire, fabric, and paper for her sculptures of iconic human and clothing forms, then exploring other techniques—first printmaking, then photography.

For a collaborative project with students at the Art Museum of the University of Memphis (AMUM) in 1996–1997, Dill worked with museum staff and students to develop ideas for images based on poems by Dickinson and Rainer Maria Rilke. Students built props and tableaus and painted words on the faces and bodies of student models. David Horan photographed the results, which were printed in large format on photo-linen, and further embellished with embroidery, by adding text from Dickinson's and Rilke's poems, by stamping and drawing with charcoal and oil stick, scraping away the photographic emulsion with sandpaper and razor blades, distressing the surface, and making holes in the linen. The resulting series of artworks incorporated a range of media to embody the meaning of Dickinson's and Rilke's poetry. The phrase "Oh shooting star that fell into my eyes … and through my body" accompanied an image in which a female figure was transformed into shooting star, inverted and flying though the air, with her hair trailing like the tail of a comet.

In *I Am Its Secret*, a photograph from Shirin Neshat's (b. 1957) "Women of Allah" series, the artist applied Arabic text by hand with pen and ink over the surface of a black and white silver-gelatin print. Excerpted from a feminist poem in Farsi by Iranian poet Furough Farokhzad, the text metaphorically compares women under fundamentalist Islam to a neglected garden.[66] As a young student, Neshat left her home and family in Tehran in 1974 to study art in the United States. After the Islamic revolution that toppled the Shah in 1979, Neshat's family was forced into exile for 11 years. She was not able to return to Iran until 1990, when she found a transformed country. The traditional Persian culture Neshat remembered from her childhood—from street names to women's dress— had been replaced by fundamentalist Islam. Neshat began to make work that addressed her sense of loss and displacement, and that investigated the role and status of women in Islamic countries. While Neshat's text mimics the traditional henna body tattoos worn

64 Mary Sherman, "Points of Departure," *Art New England* (June/ July 1994): 34; quoted in Sue Scott, *Leslie Dill: The Poetic Body* (Orlando: Orlando Museum of Art, 1996), n.p.

65 Sherman, "Points of Departure."

66 Morley, *Writing on the Wall*, 190.

4.52 Lesley Dill, *Falling Girl*, 1997. Thread, oil, charcoal, and photography, 68¾ × 52in

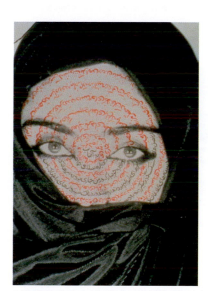

4.53 Shirin Neshat, *I Am Its Secret*, 1993. RC print and ink, 49½ × 33¾in

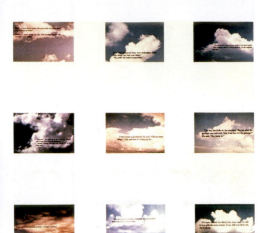

4.54 Richard Prince, *Tell Me Everything,* 1986. Acrylic and silkscreen on canvas

Detail from above

67 Susan Horsburgh, "No Place Like Home," *Time Europe* (August 18, 2000). http:// www.time.com/time/ europe/webonly/

crop
To trim. To crop a negative means to eliminate edges of the image when printing. To crop digitally means to do the same in editing software.

68 On the question of originality and the role of the author, see Roland Barthes, "The Death of the Author" (1968), in *Image, Music, Text,* ed. and trans. Stephen Heath (New York: Hill, 1977), 142–148; Michel Foucault, "What is an Author?," trans. Donald F. Bouchard and Sherry Simon, in *Language, Counter-Memory, Practice,* ed. Donald F. Bouchard (Ithaca: Cornell University Press, 1977), 124–127; Rosalind Krauss, *The Originality of the Avant-Garde and Other Modernist Myths* (Cambridge, MA: MIT Press, 1986).

by Muslim women in the Middle East and Central Asia, the images are anything but traditional. Though the women in these photographs wear the traditional black chador, their bodies are partly exposed, suggesting a feminist challenge to patriarchal Islamic law. Neshat explains:

I'm an artist so I'm not an activist. I don't have an agenda. I'm creating work simply to entice a dialog and that's all. I do tend to show the stereotype head on and then break it down. There's the stereotype about the women—they're all victims and submissive—and they're not. Slowly I subvert that image by showing in the most subtle and candid way how strong these women are.[67]

PHOTOMONTAGE

Many artists have worked with a collage technique known as **photomontage**; they cut and paste images and words from pre-existing sources. When text and image are copied or removed from one context and placed in another, it often produces a change in meaning from the original. Often the new composition is a critical commentary on the original source. Alternatively, rephotographing, **cropping**, or otherwise altering an existing photograph or text can emphasize its constructed, rhetorical nature, and reveal the hidden ideological operations of the original source.

As a child born in 1954 in the heyday of American pop culture, Richard Prince was raised on television and popular music—Zorro and Elvis Presley were early heroes for the young artist. After moving to New York in the 1970s, Prince worked the night shift in the *Time-Life* Building, culling clippings of articles from magazines, or "tear sheets." Prince became fascinating by the leftovers, which were mostly the advertising sections. The pictures were painstakingly produced to be familiar, compelling, or comforting, as required by the needs of the product for which they were originally produced; they were artistic and appealing in their way, but not produced by "artists" per se. Prince began rephotographing these images, creating his famous series of Marlboro men and women in stock situations. Prince does not consider himself a technician; all of his processing and printing is done by a photo lab. Prince refers to this practice as "stealing," or "operating without a license," but this technique is more often referred to as "appropriation," and was widely used by other artists in the art scene that emerged in New York in the late 1970s, including Sherrie Levine and Robert Longo. Artists who appropriated pre-existing images intentionally raised issues of ownership and copyright, but also of the authorship and originality of the artwork.[68]

Many of Prince's works make ironic use of text, such as the 1986 Ektracolor photograph *Tell Me Everything.* This work is produced with a technique that Prince calls "ganging." Prince selected and rephotographed nine appropriated 35mm slide images

of clouds against a blue sky. He then taped these slides together, still in their mounts, and had them transferred as a group to an 8×10-inch negative, which was enlarged and printed, producing a seamless image. The spacing between pictures was dictated by the width and height of the slide mounts. The finished work is a seamless montage of found images and texts: nine photographs of clouds, some overexposed, others printed in poor color. Over each image is superimposed a short joke in a simple serif typeface. The jokes are as familiar and banal as the photographs. They are tired, often funny, but the sort of thing we have heard before from cheesy comedians on late-night television for years. Sometimes they are off-color (like the photographs). Often they hint at the depths of despair or the misogyny of a low-rent comedian warming up the crowd at a strip club: "I went to see a psychiatrist. He said, 'Tell me everything.' I did, and now he's doing my act." Or "The ideal wife would be a beautiful, sex-starved deaf mute who owns a liquor store." Or "I've been married for 34 years and I'm still in love with the same woman. If my wife ever finds out, she'll kill me." Such jokes function like the dark side of the sunny mass-culture images Prince appropriates.

Photomontage has been a preferred technique for radical artists, from the Dada and Surrealist artists of the early 20th century to the postmodern artists of the 1980s. Photomontage had its origins in the cut-and-paste collages of Surrealists such as Max Ernst, which created unexpected and jarring combinations of scale and imagery to produce disorienting effects. The radical German Dadaist John Heartfield (1891–1968) created photomontages he considered to be "engineered photographs." In Heartfield's hands, photomontage was transformed from a Surrealist practice aimed at shocking middle-class viewers out of their bourgeois complacency into a tool for indoctrinating a working-class audience in the radical political ideologies of the anti-fascist communist left.[69] Heartfield was born Helmut Herzfeld, but Anglicized his name in the 1930s to protest against German nationalism and the rise of the fascists under Adolf Hitler. Drawing on his background as a typesetter, Heartfield cleverly cut and pasted existing images to create shocking new compositions. His use of image and text was bitterly ironic. *Hurray, the Butter is Finished!*—a **rotogravure** print that has been rephotographed from Heartfield's text and photographs collage—depicts a German family eating a meal of steel and iron implements. The text at the bottom of the composition refers to a speech made by Hermann Goering, a leader in the Nazi party, commander of Hitler's Stormtroopers (the S.A., *Sturmabteilung*) and president of the *Reichstag*. Translated from the German it reads "Goering in his Hamburg speech: 'Iron ore has always made an empire strong, butter and lard have at most made people fat.'" In works like this, Heartfield lodged a powerful critique of Germany's obsession with industry and the military at the expense of its citizens' general welfare. Heartfield mass-produced his photomontages as political posters and published them in the left-wing magazine

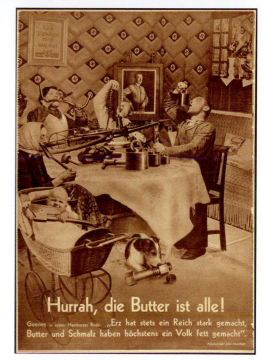

4.55 John Heartfield, *Hurrah, die Butter ist alle!* 1935. Rotogravure print, rephotographed montage with typography

69 See David Evans and Sylvia Gohl, *Photomontage: A Political Weapon* (London: Gordon Fraser, 1986).

rotogravure
A type of intaglio printing process that involves engraving an image onto an image carrier for printing.

Arbeiter Illustrierte Zeitung ("Workers Illustrated Weekly"), published in Germany from 1925 to 1932, when Adolf Hitler's Nazi party forced it to close.

The radical tradition of photomontage continues in the work of American feminist artist Barbara Kruger (b. 1945). In the early 1970s, Kruger was frustrated by her traditional art school education, which emphasized issues of form over those of content and communication. She left art school to be a graphic designer, and designed book covers and magazine layouts; Kruger worked for ten years as a picture editor for the publishing company Condé Nast. Her experience in the world of mass media transformed her art. In an interview with critic Jeanne Siegel, Kruger explained: "I started writing and performing narrative and verse while I was still painting and found that the entry of words into my work soon brought my painting to a grinding halt. By 1978 I was working with photographs and words."[70] Kruger developed an interest in the way that mass media, especially television, have altered our patterns of reading and our relationship to verbal as well as pictorial information. She explained that, as a designer, she "learned how to think about a kind of quickened effectivity, an accelerated seeing and reading which reaches a near apotheosis in television."[71] With her use of a signature typeface (Futura Bold) over vintage black and white photographs, Kruger's artwork duplicates the look and feel of contemporary advertising and media, mimicking a corporation that has created a recognizable "brand image." Kruger's art plays to the "accelerated seeing and reading" that Walter J. Ong describes as "secondary orality"—the advent of television and electronic mass media—which is currently taking the place of the culture of literacy that has dominated Western culture since the appearance of written script over 6000 years ago.[72] Ong argues that secondary literacy combines aspects of traditional oral culture with written communication, and fosters a powerful sense of belonging to a large group, such as a nation or class, which contains more members than any one individual could ever know or experience in a direct, one-on-one relationship.

Kruger is deliberate in her use of language; her use of the pronouns "I" and "your" has the effect of hailing viewers, who are directly addressed, as they are by advertisements. Viewers are thus implicated in the politics of the artworks; it becomes difficult to enjoy them from a purely aesthetic standpoint. Kruger writes: "I think that the use of the pronoun really cuts through the grease on a certain level. It's a very economic and forthright invitation to a spectator to enter the discursive space of that object."[73]

Much of Kruger's work takes the form of public artworks, as billboards and signs for bus shelters, as well as a design for a train station in Strasbourg, France. Aimed to reach large audiences, Kruger adopts the techniques used by advertising, often collaborating with progressive political organizations. She has produced posters for political rallies such as the 1989 March on Washington in support of legal abortion, birth control, and women's rights.

The desire to involve audiences more fully in her art led to Kruger's interest in instal-

70 Jeanne Siegel, "Pictures and Words," *Arts Magazine*, v. 61 (June 1987): 17.

71 Siegel, "Pictures and Words," 19.

72 Ong, "Print, Space and Closure," Chapter Five in *Orality and Literacy*, 115–135.

73 Ong, "Print, Space," 21.

lation, creating total environments, as in her 1994 installation at the Mary Boone Gallery. These were Kruger's first artworks to use a recorded audio track, featuring sounds of crowds and speakers at large political rallies. Kruger became interested in adding sound after she had produced radio spots, public service announcements for radio, promoting the Liz Claiborne Corporation-sponsored anti-domestic-violence campaign, and television spots for MTV.

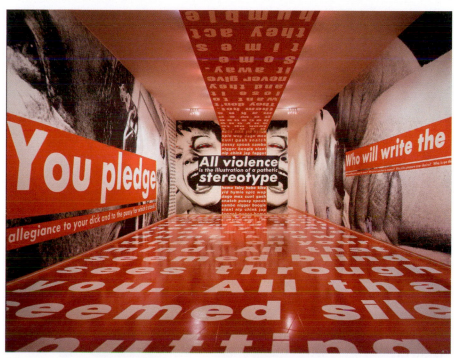

4.56 Barbara Kruger. *Untitled,* Installation at Mary Boone Gallery, New York, January 1991

Photomontage is also the preferred technique of "culture jammers" such as the Adbusters Media Foundation, a global not-for-profit network of activist artists and writers based in Vancouver, which publishes *Adbusters*, a bi-monthly magazine and website.[74] In a guerrilla mode, The Billboard Liberation Front (BLF), formed in San Francisco in 1977, illicitly reworks billboards to introduce critical messages into the public sphere.

74 http://www. adbusters.org/

75 http://www.
billboardliberation.com/

Targets of BLF campaigns have included fast-food corporations, banks, and cigarette manufacturers.[75]

BLF's activist art is a powerful demonstration of the possibilities for combining text and image for an effect that is greater than the sum of the parts. In this essay we have explored topics including the theory of semiotics; the role of text in the documentary tradition; picture magazines and the photo essay; artists' use of texts to create personal stories or to question the presumed truthfulness of the photographic image; instructions; speech; the use of text as a formal visual element; and photomontage. "Editing, Presentation, and Evaluation: Tools, Materials, and Processes," the chapter which comes next, describes practical considerations of type and layout, as well as ways of integrating type with imagery using handmade, darkroom, or digital methods. In addition, the chapter describes a wide range of tools that can be used to alter image size, color, contrast, presentation methods such as book formats, online artworks, traditional framing, and animation techniques, and tools for evaluating one's work.

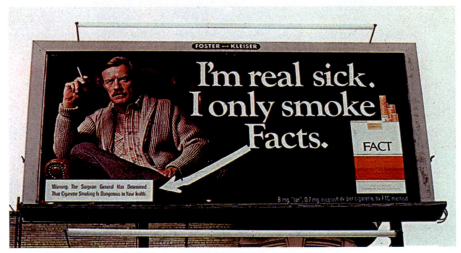

4.57 *I'm Real Sick.* BLF liberates a cigarette billboard. Paper, rubber cement

Editing, Presentation, and Evaluation
Tools, Materials, and Processes

Rebekah Modrak

If you've ever sat through a film and watched the credits scroll, you will be familiar with the term post-production: that is, everything that happens after the action captured by the camera. As though you've just completed recording your images (and called out: "*cut!*"), this chapter responds by proposing multiple possibilities of how to affect your images through the post-production realm of editing, manipulating, and presenting.

Editing describes modifications of scale, contrast, exposure, and color. Scale relates to how image dimensions can be enlarged or reduced. You will learn how to change image tone and contrast in the darkroom or digitally, to digitally correct color casts, and to retouch photos to correct for flaws. In the editing sections, you have the opportunity to consider captured data as raw material. By seeing your image as malleable in form and meaning, you can change the content by selecting parts of the image, through reconstructions of collage with the tools of the darkroom, the Xacto knife, digital cut and paste, and by incorporating type with imagery.

Ultimately, each individual image is meant for a particular context—whether it be an explicit sequence, a narrative, or a body of work. "Presentation" describes different options for displaying work, from some of the earliest forms (books and portfolios) to the most recent (web-based artworks and Internet sharing and portfolios). In addition, we'll describe techniques for matting or framing prints and stitching sequential images together in animations via a flip book, zoetrope, or thaumatrope. For artists interested in developing the ideas and form of their work, "Evaluation" describes various critique strategies to encourage reflection and constructive discussion.

ONLINE @ RESOURCES **4.1** On our website, we describe the following traditional processes and ways to digitally simulate the effect of them:

- The photographic technique, brulée, French for burning, involves intentionally setting a negative on fire to dissolve and warp the film.
- Solarization, also known as the sabatier effect, reverses portions of a print's tones.
- Double exposure or combination printing combines two exposures on top of one another.

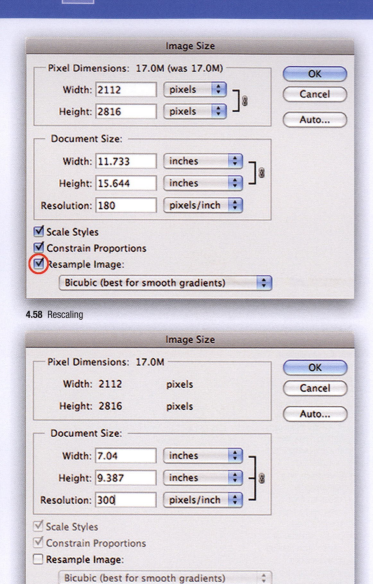

4.58 Rescaling

4.59 Rescaling

EDITING: RESIZING DIGITAL IMAGES

If you scan an image, you can designate the resolution (for example, 300 ppi) and scale while scanning. If you create digital images with a camera, the camera may create images with a resolution or dimensions (for example, 11×17 inches at 240 ppi) that exceed or fall short of your desired size. There are several ways to change resolution and rescale images.

Rescaling: Increase resolution by decreasing physical dimensions

If you want to increase ppi (pixels-per-inch) to a higher resolution and decrease the physical dimensions, you can simply rescale the data without adding or subtracting information.

Open *Image > Image Size*. In our sample dialog box, under Document Size, notice that the Resolution is 180 ppi. The resolution is determined by either the camera or the scanner resolution and the way that any given file is originally converted or captured. The amount of resolution needed depends upon the final use of the file. Final use refers to the type of output: for example, posting the photo on the Internet or printing it out as a poster. On average, 72 ppi is a reasonable resolution for images that will be viewed on the Internet or computer; 150 to 300 ppi is average for images to be printed; 300 ppi is the preferred resolution for high-quality, continuous tone images.

Notice that Resample Image is checked. This means that the resolution setting is not connected (with brackets) to the image dimensions. You can see this indicated in the Document Size box—the width and height are connected by the bracket lines, but the resolution is separate. If we were to change the resolution to 300 by replacing the 180 with 300, Photoshop would add the additional pixels by *upsampling*.

When you upsample, the computer makes up pixel data to achieve the size you have requested. For example, if we change the 180 ppi to 300 ppi, the program will create (also called interpolate) data to fill in the extra space. Upsampling is usually not a good idea because the colors or information created by the computer may be inaccurate.

Deselect the Resample Image checkbox. Notice now that the resolution setting is connected to the image dimensions. When we increase the resolution to 300 ppi, Photoshop automatically adjusts the image dimensions to rescale the image to a smaller size (width and height values) by packing more pixels into a given area. The Pixel Dimensions (top section of the dialog box) stay the same because no pixels were added or deleted. The pixels were just rescaled. Click *OK* to apply the adjustment.

Downsampling: Reducing physical dimensions without affecting pixel resolution

What if you've used this process to increase resolution and the image dimensions are still not small enough? In our example, what if we want an image closer to 4×6 inches at 300 ppi? In that instance, you could check Resample Image and fill in the desired dimensions. Because Photoshop is throwing out pixels (called *downsampling*), the image may soften slightly (making it necessary to use a Sharpen filter in a later stage of your image processing workflow).

Resampling and interpolation

Whenever you resample, upsample or downsample, the pixels in the image are changed. In order to change pixels, Photoshop examines surrounding pixels to determine their color and tone in order to create new ones. Photoshop offers you the following options for performing these changes. They can be found by selecting *Image > Image Size*, checking Resample Image, and then clicking on the drop-down menu at the bottom of the dialog box. Choose an option that fits your image/processing needs. We recommend one of the Bicubic options:

- *Bicubic* (best for smooth gradients): More detailed examination of color value of surrounding pixels than Nearest Neighbor and Bilinear. Slower process, but with more smooth and precise results.
- *Bicubic Smoother* (best for enlargement): More refined examination of surrounding pixels than Bicubic. Good for creating smooth, upsampled images.
- *Bicubic Sharper* (best for reduction): More refined examination of surrounding pixels than Bicubic. Good for downsampling, to maintain detail and sharpness.

Using resampling to make poster-sized images

If you have a small image that you want to print large and no opportunity to reshoot or rescan at higher megapixels or file size, we recommend either of the following:

1 The Bicubic Smoother interpolation method described above.
2 A percentage-based upsampling technique described by Scott Kelby in the second edition of his book *The Photoshop Book for Digital Photographers*. To perform this process on an open image, open *Image > Image Size*. In the pull-down menu by Width and Height, set the unit of measurement to percent. Make sure that *Constrain Proportions* and *Resample Image* are both checked. Increase the image by 10% by entering 110 in the Width. Photoshop will automatically adjust the Height of the image up in the same proportion.

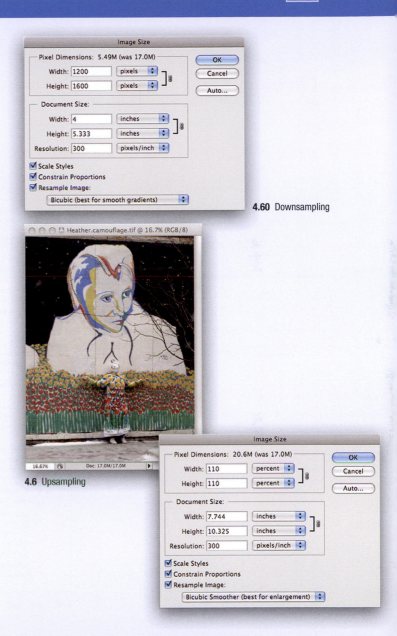

4.60 Downsampling

4.6 Upsampling

Click *OK*. Repeat these incremental upsample steps until your image is the necessary size. If you need to repeat this process many times, make the process automatic by recording the series of steps as an *action*.

DIGITAL TOOLS: ADOBE PHOTOSHOP TOOLS PANEL

Upon opening Photoshop, the Tools panel will appear at the left side of the screen. You can hide the panel by clicking on the dot at the top of the panel, and can show or hide the Tools panel by choosing *Window > Tools*. The panel can display tools in a single column or in two columns. Choose your preferred display by clicking on the double arrow at the top of the panel.

4.62 Digital tools

Icons (such as a brush or a rubber stamp) indicate the nature of the tool; you can also position the cursor over any icon to bring up a tag identifying the name of the tool. Select a tool by clicking on its icon in the Tools panel or by typing the tool's single letter shortcut key. For example, the Move tool's shortcut key is V. All shortcut keys are identified on our diagram, to the right of the tool's name. A small black triangle in the lower right-hand corner of a tool icon indicates the presence of additional tools within that source. Click on the triangle to bring up a flyout panel to select a hidden tool.

The options bar

Most tools have additional features that appear in the options bar when the tool is selected. For example, the Rectangle tool's options bar allows you to switch to other shapes, pick a style and color, and add, subtract, or intersect a path. The options bar for the Brush tool provides brush hardness and diameter, painting modes, a way to adjust the opacity and flow of the paint, and an airbrush option. If the options bar is not visible, choose *Window > Options* or select a tool in the Tools panel and press Return.

Categories of tool

Photoshop CS4 separates the tools into types of actions. Understanding these categories will help you to recall which tools are available for a particular job. In the following sections, we describe key tools for Selecting and Cropping. Additional tools are discussed in other parts of this section on editing. (See the index.)

Selection tools

Selection tools allow you to draw an outline around any area of the image. The selection is indicated with a marquee, a black and white dashed line that forms a completely closed shape. Pixels within this boundary line can be blurred, transformed, painted, or otherwise modified.

The selection tool you choose will depend on the nature of the image. For example, the Magic Wand tool is good for selecting pixels of a single color or a particular range of colors. If you need to select a complicated area of the image, it is sometimes easier to select the background and then choose *Select > Inverse*. For example, if the image shows a hand against a white background, it may be easier to select the white background and then invert the selection so that the hand is selected. If the area you are selecting is particularly detailed, use a zoom key command to zoom in (Command + +) or out (Command + –) of the image to better guide the selection cursor through the image.

4.63 Options bar

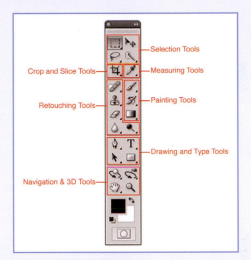

4.64 Digital tools categories

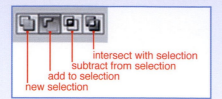

intersect with selection
subtract from selection
add to selection
new selection

4.65 Digital tools selections

To select a complicated area, it is often necessary to use different selection tools together. Photoshop allows you to make a selection one way (with a tool from the Tools panel or menu), and then switch to another tool to subtract from or add to that selection. You can always edit the shape and properties of a selection in Quick Mask mode.

Adding to, subtracting from, and intersecting selections

You can use the same selection tool or a different one, to add, subtract from, or intersect selections.

- *To add additional areas to the selection*, hold down the Shift key while creating the new selection, or choose the *add to selection* icon on the left side of the selection options bar.
- *To remove part of a selection*, hold down the Option key and select the area you want to take away, or choose the *subtract from selection* icon on the left side of the options bar.

Refining selection edges

Some of the above options are also available by using the Refine Edge option. The Refine Edge command allows you to adjust and improve your selection edges and to view the selection against various background colors. To access this dialog box, create a selection and click on the Refine Edge button in the options bar or choose *Select > Refine Edge*. The preview buttons along the bottom provide you with different background colors against which to view your selection. The description at the bottom provides a short note about the option you have selected and a thumbnail that shows the effect of that option.

4.66 Refining selection edges

- *Radius:* refines the selection edge and specifies the selection boundary where refinement takes place. Increase this number for selections with soft transitions or fine detail, such as hair or fur, or blurred boundaries.
- *Contrast:* produces a crisper selection edge by sharpening and removing fuzziness.
- *Smooth*: decreases jagged selection bumps to create a smoother selection outline.
- *Feather*: softens the transition from the selection to surrounding pixels.
- *Contract/Expand*: shrinks or expands the selection edge.

Selection tools in the tools panel

Marquee tools

The marquee tools let you create basic, geometrically shaped selections: rectangles, squares, circles, ellipses, and single rows of pixels. The Rectangular Marquee is

especially efficient for selecting (and then cutting or filling) thin borders around images. The Style feature in the options bar allows you to determine whether the shape adheres to a certain proportion, exact dimensions, or is drawn freeform. To use a marquee tool, select the tool, click on the screen to create a starting point and drag the cursor to make a selection shape. To make a perfect square or circle selection, hold down the Shift key while dragging with the rectangle or circular selection tools. To make a selection expand from the center instead of its starting point, hold down the Option key while dragging with the selection tool.

TIP: Snap

Photoshop's automatic snapping feature directs lines and marquee boxes toward a guide. This can help with exact placement. However, if you find that this feature is preventing you from accurately placing a selection edge, path, or cropping marquee, you can turn off the feature by choosing *View > Snap*.

Lasso tools

Each of the lasso tools allows you to make freehand-drawn selections. In each case, you use the tool to draw a line. The line must form a closed shape in order to become a selection. To close the line, you can—eventually: click on the first point you created; let go of the mouse; or double-click and allow Photoshop to close the selection with a straight line.

Use the *Lasso* to draw freehand selections. Click within the image, draw the selection path and let go of the mouse when finished. To use the tool to draw straight lines, hold down the Option key while dragging and release the mouse button. As long as you continue to hold down the Option key, the tool will work like the Polygonal Lasso.

The *Polygonal Lasso* is essentially a straight-line Lasso tool. Click the mouse button to create an anchor point. Release and drag the mouse to another location. Click again and the tool will create a straight line between the two points. Draw until the selection is a closed selection or double-click to close the selection. To delete the last point you created, press the *Delete* key. If you hold down the Option key while working, the Polygonal Lasso shifts to the Lasso tool.

The *Magnetic Lasso* selects well-defined edges where the contrast between an object and neighboring pixels is very distinct. Click the tool along the edge of the object you want to select to place a starting anchor point. Release and drag the cursor along the object's edge. The lasso will throw out a line that (should) cling to the edge of the object and place anchor points along the path. Whether it does or not is a question of edge contrast. The Edge Contrast, controllable in the options bar, informs the tool of the amount of contrast between the object and the background. When the image contrast is great, raise the Edge Contrast value.

When the image contrast is minimal, lower the value. The options bar also allows you to indicate the Frequency, which tells the tool whether to create more points as you drag or less. For rougher edges, use higher values. You can also click with the mouse to manually place an anchor point. To delete the last point you created, press the *Delete* key.

The Quick Selection tool

Using a round brush, this tool finds and selects areas in the image within well-defined edges. It works best when selecting areas with easily distinguishable edges. Change the diameter to align with the size of the area you wish to select.

The Magic Wand

When you click the Magic Wand tool on a pixel area of a particular value or color, Photoshop selects the other pixels that are the same value or color. You'll find several helpful features in the options bar. *Tolerance* adjusts the range of pixels the tool will capture between values 0 and 255. For example, if Tolerance is set to 5, and you click on a pixel with a value of 160, the tool will select pixels with values between 155 and 165. A smaller number tells the tool to be more selective; a larger number tells the tool to be less choosy. When the Contiguous button is checked, the wand will select only pixels touching the clicked spot. If unselected, the tool will select pixels of a similar value or tone throughout the entire image. *Sample All Layers* tells the tool to select companion colors from every visible layer in the file or, when not checked, from just the active layer. Getting the right selection often involves setting the tolerance value low and then pressing Shift (and click cursor) to add more parts, or Option (and click cursor) to remove other parts.

The Move tool

The Move tool lets you move selected pixels to new positions within the layer. To use, select the Move tool, then click the cursor inside the selection and drag to move, or press the arrow keys (to move the selection in the smallest increment possible). To constrain a move to 45° angles, press Shift while you drag the selected pixels. To copy a selection, select the Move tool, press the Option key and drag the selection to duplicate.

The Pen tool

Though considered a drawing tool, the Pen tool (in Path mode) allows you to draw precise paths that combine straight and curved lines, a good tool for complicated areas with varying textures and details. The path or outline can be turned into a selection, saved, and reloaded. The Pen tool is a good choice when other selection tools have a hard time finding edges.

The Crop tool

The Crop tool allows you to drag out a cropping marquee. You can drag the marquee freeform or crop to particular dimensions or resolution by setting these measurements in the options bar. Once you have created the selection (and if Shield is selected in the options bar), Photoshop darkens the area outside the marquee to make it easier to preview the cropped image. Adjust the marquee by dragging a handle to widen or contract the selection. Move the selection by clicking *inside* the selection and dragging or rotate by clicking *outside* the marquee and dragging. If you are happy with the selection and ready to crop, press Return or click the Commit button (the checkmark) in the options bar. If you want to cancel the crop, press Escape or click the Cancel button.

Hide or Delete: Two choices for cropped information

When working on any image layer that is not the Background layer, you can instruct Photoshop to either delete or hide the cropped area. Check *Delete*, in the options bar, to throw out the cropped information. Check *Hide* to preserve the cropped area. You can access this concealed area by moving the image with the Move tool.

Using the Crop tool to increase the Canvas Size

The Crop tool can also be used to add additional space around the image. First, set your background color to white or to whichever color you'd like the additional canvas area to be. Open the image, zoom out (*View > Zoom Out* or Command + –) so that you see your entire image and, preferably, some gray area around the outer image dimensions. Choose the Crop tool and drag it to create a crop rectangle (any size). Click and drag on the handles to expand the marquee into the gray area beyond the image. You can use the rulers (*View > Rulers*) for more precise additions. Gray areas included in the crop border will become canvas space, colored in the background color. Press Return to add this canvas space.

Cropping to a specific Aspect Ratio, Size, and Resolution

Use this method if you want to crop an image, while retaining a specified aspect ratio (width: height; e.g. 1:4 inches). In the options bar, enter Width and Height. Click on the *Swaps height and width button* if you mistakenly switched the two. You can even specify a resolution for your final image at this cropped size by entering a resolution value in the area next to width and height.

Quick masks

Use quick masks in order to apply tools other than selection tools to create and edit your selections. You can create a selection and then switch to Quick Mask Mode, use a filter or paintbrush to refine your selection, and then click on the

Quick Mask Mode button again to switch back to Standard Mode and view your selection. In Quick Mask Mode, the unselected areas are visible as a "rubylith" overlay. To add to the selection with a paintbrush tool, paint with white. To subtract from the selection, paint with black. Painting with gray will create feathered selections or semi-selected areas. Apply filters to create additional changes to the selection, such as *Filter > Blur > Gaussian Blur* to blur selection edges. Quick Mask Mode is very useful to refine selection edges by hand-painting in or out areas of the selection. You can also use this mode to apply selections using the Gradient tool, which provides a smooth transition from selected to unselected areas.

The Color Range command

Color Range (*Select > Color Range*) selects a particular color or range of colors within the whole image or within a selection, and offers a preview image to assess the outcome. You can use the Eyedropper tool to choose a color from your image or you can choose a preset color group, such as Red. If you use the eyedropper, click inside the image to choose the color. The Fuzziness scale controls the range of associated colors included in the selection. When set to 0, Photoshop selects only pixels of that exact color. Increasing the Fuzziness value increases the range of related colors selected. Choose from some preview options in the Selection Preview dropdown menu at the bottom of the dialog box.

CONTRAST AND TONE

Contrast refers to the range of tones—from the brightest to the darkest—in an image or a subject. A print or scene with dark and light tones but few gradations in between is referred to as *contrasty* or having *high contrast*. A tonal range with few differences and no extremes of light or dark is called *flat* or of *low contrast*. Contrast is usually described in reference to black and white imagery, but the concept applies to color as well. Colors seem more intense and saturated when set against complementary colors. (Complementary colors are opposite one another on a color wheel.)

Several factors determine contrast when selecting a subject and surrounding conditions:

- The tonal makeup of the *subject* itself: whether the object is comprised of strongly contrasting areas or more subtle gradations of tone, and how these values relate to one another. An image whose white and black values are next to each other will appear more contrasty than an image with the same whites and blacks separated by grays.
- The *light* source being used and how it falls on the subject or image: hard, angular light (afternoon sun on a clear day) creates reflection, shadow, and emphasizes texture, while diffuse lighting (cloudy sky) forms flat surfaces.

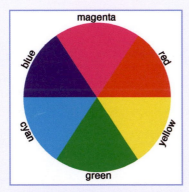

4.67 Additive/subtractive colors on the color wheel. Complementary colors (e.g. magenta and green) are opposite one another

4.68 High contrast

4.69 Low contrast

ADJUSTING IMAGE CONTRAST IN THE DARKROOM

Before your processed film reaches the darkroom, you have already made many choices that affect image contrast: (1) the subject; (2) the lighting; (3) the film—each film reproduces subject contrast differently; (4) filters used during exposure; (5) the film's development—overdeveloping increases image contrast. These factors are discussed elsewhere in the book.

In the darkroom, contrast is determined by several factors including the type of enlarger, the developer, and agitation during development. The greatest degree of contrast control is from the photographic printing paper and the filtration used during printing. (For a basic description of printing papers, see "Black and white photographic papers," p. 263.) The surface of all photographic papers (color or black and white) yields different degrees of contrast. Glossy papers heighten the richness of blacks, giving the appearance of higher contrast.

More significantly, the paper's emulsion determines image contrast. Packages of black and white paper come either as *graded papers* (the whole pack is a designated contrast grade on a scale from #0 (low contrast) to #5 (high contrast)) or as *variable contrast* (able to yield any grade when paired with a variable contrast filter).

Variable contrast papers and filters

As you increase contrast, you will brighten highlight areas and darken shadow areas (possibly until they lose detail and go black). Decreasing contrast will lighten dark areas to reveal details in the shadows. Before beginning, identify areas that should be lightened or darkened, but keep an eye on areas of detail that should be retained.

In black and white printing, contrast exists on a scale from #0 to #5, with low contrast at #0 and #1, average contrast at #2 and #3, and high contrast at #4 and #5. Each number is referred to as a grade. Graded paper comes as a set grade. The idea is that you balance a negative of a certain contrast, say high, with paper of a different contrast (in this case, low). If this doesn't work out, you must change contrast by switching to a new pack of paper with a higher or lower grade. Graded papers are, therefore, somewhat difficult to work with. For that reason, we focus here on using variable contrast papers.

Variable contrast (aka Polycontrast or Multigrade) papers can yield any grade of contrast when paired with the right *variable contrast filter*. These filters can be found in two forms. They come as a set of individual colored sheets (Figure 4.70) from #0 to #5, including half-grades. A sheet is placed under the enlarger's lens or in a filter drawer above the negative carrier. They also come as filters within the colorhead of an enlarger (Figure 4.71) that can be adjusted with dials. In either case, they alter the light source and thereby the image contrast. Magenta light increases contrast; yellow light flattens contrast.

4.70 Variable contrast filters

4.71 Contrast filters in enlarger colorhead

4.72 #0 filter

4.73 #2 filter

4.74 #5 filter

4.75 Split filtering

ONLINE RESOURCES **4.2** Refer to our web resources to learn how to control exposure with split filtration.

Printing on variable contrast paper with no filters is the equivalent of printing with a #2 filter. If you know that #2 is the correct grade for your image, don't bother using a filter. If, however, you may need to experiment with contrast, place a #2 filter under the lens before beginning. This is because filters increase exposure times (it is harder for light to pass through the filters). Once you have started printing without a filter, adding one throws off the exposure time. Even when starting out with a #2 filter, changing to higher (and denser) filter grades will usually require longer exposures, and changing to lower (and thinner) filter grades will usually shorten the exposure time.

Split filtration

Printing with multiple filters is a remedy for images that require a lot of burning or dodging. *Split filtering*, also called *split printing*, involves printing part of the exposure with a #0 filter and the rest with a #5. The #0 filter exposes for the highlights and the #5 for the shadow areas. See our website for more description of this process.

DIGITAL TONAL ADJUSTMENTS

This section describes basic digital tools and techniques for tonal corrections (altering the exposure—the lightness or darkness—and the contrast of a photograph). Bear in mind that the best defense against exposure problems is making an accurate exposure in the first place. If the image is slightly over- or underexposed or has excessive or poor contrast, use one or several of the following tools to adjust the entire image or a selected area. (For correcting localized exposure problems, see the descriptions of the digital burn and dodge methods that lighten or darken areas of an image using masks.) When tackling these problems, always try to improve the problems that affect the greatest image area first.

In a digital file, image detail is the amount of value difference between adjacent pixels. Often, tonal adjustments eliminate these differences, making two previously dissimilar pixels the same. To retain as much image detail as possible, create and work from high-bit depth files, make tonal adjustments in small steps rather than grand moves, use adjustment layers that can be revised, and use the Histogram and Info panels to help analyze your images before and after you edit them.

Bit depth and tonal corrections

The bit depth, or number of bits per pixel, refers to how many tones or colors each pixel can contain. The higher the bit depth, the more tonal values and information

the image contains. As you apply tonal corrections, your file loses data. Working with a high bit file provides you with more data from the start so you can apply larger corrections without fear of ending up with little tonal detail.

You can set most scanners and some cameras to capture high bit data (RAW image files usually have higher than 8 bit depth). To determine the bit depth of your image, go to *Image > Mode* to see which number of Bits/Channel has a check next to it (8 Bits/Channel, 16 Bits/Channel, or 32 Bits/Channel). (Note that changing existing 8-bit files to 16-bit will not increase image information.) Unfortunately, with the increased data of a high bit file comes a greater file size and longer processing time. In addition, some Photoshop tools cannot be applied to higher bit depth images (artistic, pixelate, and texture filters). You will have to go to *Image > Mode > 8 Bits/Channel* to convert the image to 8 Bits/Channel to apply them.

Evaluating image tonal range and contrast

When recording the image, insufficient amounts of light will create an *underexposed* photograph. In this case, the image will appear too dark, will lack contrast, look muddy and flat, and have little detail in the shadow areas. If your image received too much light during exposure, it will be *overexposed*. Overall, the photograph may be too light, lack contrast, and have little detail in the highlight areas. Images with *low contrast* consist mostly of midtone values, lacking pure white and pure black tones. *High contrast* images contain mostly pure white and pure black pixel information and lack midtone values. Evaluate your image's tonal range and determine the distribution of shadow, midtone, and highlight information.

If you have a hard time visually assessing whether your image is under- or overexposed or high or low contrast, especially when working with faded images or those without clear darks and lights, try using the Histogram, as described next.

The Histogram panel

The Histogram (*Window > Histogram*) is a good tool for assessing the tonal range of an image. If your image is RGB or CMYK, select *Luminosity* from the Channel menu to display a histogram that shows the intensity values of the combined channels. The Histogram panel shows a bar graph of the variation in tonal levels throughout the image. Along the horizontal axis, the chart plots tonal levels from 0, on the left, to 255, on the right (0 representing pure black, 128 middle gray, and 255 pure white). The vertical axis (the height of each bar) indicates how many pixels have that brightness or color value within the overall image. There is not one ideal histogram for all images because, as image content and artistic goals differ, so should the tonal character for each photograph.

4.76 Image (top) shows an 8-bits-per-channel image after a single tonal adjustment; image (bottom) shows the identical scene, photographed as a 16-bits-per-channel image, after the same tonal correction

4.77 Example of a histogram showing a full dynamic range

4.78 Example of clipped highlight and shadow areas

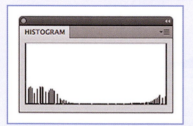

4.79 Example of a histogram with combing

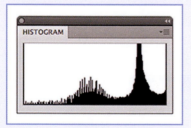

4.80 Example of a histogram with posterization (bump on the left)

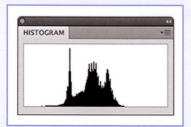

4.81 Histogram showing a concentration of data in the center, indicating a flat, low-contrast image

The histogram will help you to evaluate:

- Whether the image uses the entire *dynamic range*—all 255 tones. A full tonal range will produce a graph with a range of data that includes shadow, midtone, and highlight values (Figure 4.77). While peaks and valleys in the chart may reflect image content, large areas of empty space on either side of the histogram usually indicate a limited dynamic range (Figure 4.81). (Note: this can be a desired result if you want an image with low contrast.)
- Whether the highlight or shadow areas have been *clipped* (Figure 4.78). A histogram showing a spike of pixels at either endpoint of the graph indicates the presence of a large number of pure white or pure black pixels. Such a spike reveals both that the image is over- and/or underexposed and that some of the highlight or shadow data was clipped, converted to pure white or black without details during exposure or during adjustment application in Photoshop.
- Whether the image is *missing data*. While peaks and troughs in the histogram may be a reflection of image content, obvious spikes and gaps may indicate problems. Gaps of several tonal values indicate that either the camera or scanner did not capture the full tonal range or these levels were eliminated in editing. Comb-like histograms (Figure 4.79), with gaps of three or four levels, may be a sign that editing was destructive to the point of causing posterization. Posterization (Figure 4.80), wherein tonal gradations in the image are obvious, shows up as stair-like visual jumps from one tone to the next (as opposed to smooth graduations). This results from having eliminated the transitions, or smooth differences, from one pixel to the next.
- Whether the image is *over-* or *underexposed*. The bars of bright or high-key histograms are crowded together at the right side of the histogram, which may indicate too many lighter pixels and overexposure. The bars of dark or low-key histograms are clustered at the left side of the histogram, which may be a sign of too many darker pixels and underexposure. The bars of medium-key histograms will be bunched up in the middle of the graph (see Figure 4.81).

If, after making tonal adjustments to the image, the histogram does not reflect the document's current state, a warning triangle will appear in the upper-right-hand corner (Figure 4.77). To see an up-to-date histogram, you can click on this warning icon.

The Info panel

Another tool to access the tonal qualities of an image is the Info panel (*Window > Info*). While the Histogram provides a general overview of an image's tonal values,

the Info panel lets you analyze the tone and color of specific pixels in the image. As your cursor hovers over a pixel in the image, the Info panel displays the color value of that pixel. Additionally, you can use the Eyedropper tool to take average measurements of small areas. To do so, make the Eyedropper tool active in the Tools panel and set the *Sample Size* in the options bar. Point Sample reads the value of a single pixel, while other options sample from larger pixel areas.

You can also place color samplers in the image by Shift-clicking on that part of the image with the Eyedropper tool or by clicking with the Color Sampler tool. The RGB values for this point sample in the image will appear in the Info panel and a circular icon will appear in the image with a number that corresponds to the number in the Info panel (you can place up to four point samples in one image). When making tonal or color adjustment layers, such as Levels and Curves, the Info panel will display the values for the color samplers before and after the adjustment. Samplers will remain in an image until you delete them by selecting the Color Sampler tool from the Tools panel and clicking on Clear.

The Info panel is helpful when you need to locate the brightest area of the image (one with all RGB values near 255), the darkest area (where all values are nearest to 0), or a middle gray (with all three values near 128). In addition, this tool can be useful in determining if you have detail in your shadows and highlights. To do so, drag the cursor around within the darkest or lightest areas to see if the tool picks up differences in tone. The numbers also tell you whether you have too much or too little of Red, Green, or Blue, information that is beneficial when making color adjustments.

4.82 Info panel for an image that has four color samplers

LEVELS AND CURVES

To make tonal adjustments, we recommend using Levels and/or Curves, which apply nonlinear transformations. Nonlinear transformations allow you to adjust values in one area of the tonal range, without discarding data in another. For example, you can adjust the midtones, while preserving shadow and highlight values. Nonlinear transformations preserve more image data than linear transformations (such as those applied by Brightness/Contrast), which change all pixels equally, thereby losing some information. Levels and Curves are also available as *adjustment layers*, which allow you to apply the tonal corrections without directly changing the pixels. To access an adjustment layer, choose *Layer > New Adjustment Layer > Levels* or *Curves*, or click on the Levels or Curves icon in the Adjustments panel, or go to the *Create new fill or adjustment layer* icon at the bottom of the Layers panel and click on an adjustment in the drop-down menu.

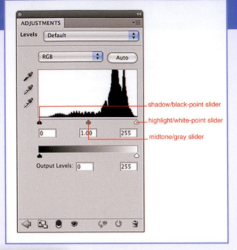

4.83 Levels sliders

4.84 Image before levels adjustment

4.85 Image after the white- and black-point sliders have been moved inward

Levels

The Levels panel (*Layer > New Adjustment Layer > Levels*) displays a histogram of the tonal variations throughout the image and provides the means to alter the shadows, midtones, and highlights of this tonal range. Like the histogram discussed earlier, the Levels graph identifies the shadow and highlight ending points and shows different bar heights that correspond to the number of pixels at a particular brightness throughout the image. The Levels panel offers several tools for adjusting tonal range: the Input Levels sliders, Output Levels sliders and the Eyedropper tools for setting the black, gray, and white points. This section deals solely with the Input sliders.

Input sliders

The Input Levels sliders let you expand or compress values in the image by altering the black point, white point, and midtone of the photograph. Drag the sliders left and right (or, to make small adjustments, click on a slider and press an arrow key). As you move a slider, the numbers in the Input Levels fields and the image on screen change to reflect the adjustment. Make adjustments with the black and white sliders before adjusting the midtone slider.

Moving the black slider away from pure black (0) toward the center makes all pixels to the left of the new slider position black (0) and extends all levels to the right of the new slider position to fill the entire tonal range from 0 to 255. Moving the white slider away from pure white (255) toward the center, makes all pixels to the right of the new slider position white (255) and extends all levels to the left of the new slider position to fill the entire tonal range from 0 to 255. When you move the gray slider, you are repositioning middle gray (50% gray or level 128). If you move the gray slider to the left, the image becomes lighter because you have directed Photoshop to take pixels darker than a 128 value and make them 128. The shadows will stretch to fill up that part of the tonal range and the highlights compress. Moving the gray slider to the right has the opposite effect.

Be aware that dragging the black or white sliders may clip shadow or highlight information. Clipping is not always a problem. At times, you may want to discard distracting details or you may prefer the darkness or lightness of the adjustment at the expense of lost detail. You can see which pixels are being clipped in the image by holding down the *Option* key while dragging a slider. As you move the slider, watch for big clumps of pixels in important areas in the image. In most cases, we don't recommend eliminating these with the slider adjustment.

Curves

Curves (*Layer > New Adjustment Layer > Curves*) allows you to adjust the tonal range of an image. Whereas Levels provides three points of control (the shadow,

highlight, and midtones), Curves allows you to manipulate up to 14 different tonal points.

The default Curves adjustment panel displays a graph with a straight diagonal line, representing the current distribution of tonal values in the image. The horizontal axis of the graph shows the Input levels and the vertical axis represents the Output levels. Like Levels, the default settings for Curves display the intensity values for RGB images in a range from 0 to 255. The black-point (level 0) is at the bottom left corner and the white-point (level 255) at the upper right.

Using Curves to evaluate your image

Curves allows you to quickly determine the values of any pixel area within the image. With the Curves adjustment panel open, click on the on-image adjustment tool and hover the cursor over the image. The cursor will switch to an eyedropper. You will see that the intensity values of the pixel under the pointer will be displayed in the Input and Output levels in the Curves panel. Use this method to identify shadow and highlight areas of your photograph.

Using Curves to make tonal adjustments

In general, Curves works by allowing you to place and adjust anchor points along the line. You can place an anchor point by either selecting the *edit points to modify the curve* icon and clicking directly on the curve, or selecting the on-image adjustment tool and clicking within the image. If hovering with the on-image adjustment tool in the image, watch as a white point shows up on the curve. This point corresponds to a tonal value on the curve. Click to add an anchor point to the curve. If you click and drag an anchor point, you can adjust the curve as well. This method is ideal for locating and modifying particular tones or colors in the image. Be aware that Photoshop will apply the adjustment to all pixels of that value throughout the image.

Dragging a point either down or to the right darkens the image (Figure 4.87). Dragging a point either up or to the left lightens the image (Figure 4.88). To darken highlights, lower a point near the top of the curve. To lighten the shadows, raise a point near the bottom of the curve. Moving the black and white endpoints horizontally toward the center of the graph clips the highlights or shadows. This movement allows you to brighten or darken highlights or shadows respectively. You can drag points in any direction or use the arrow keys to move them in small increments. Though the endpoints on the curve cannot be removed, you can delete any other anchor point by dragging it off the graph or selecting the point and pressing *Delete*.

The input sliders act like the sliders in Levels. Drag them horizontally toward the center of the graph to adjust the white and black points. If you would like to draw freehand curves, select the *draw to modify the curve* icon and draw within

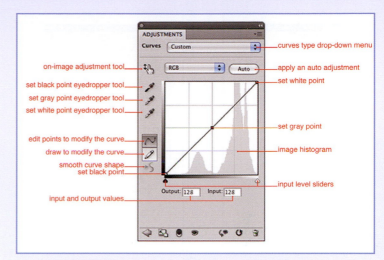

4.86 Curves adjustment panel

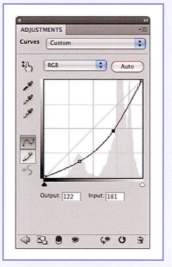

4.87 Darken an image that is too bright by dragging the curve down

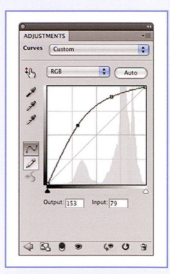

4.88 Lighten an image that is too dark by dragging the curve up

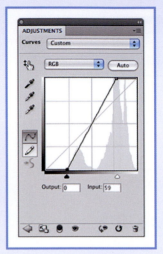

4.89 Angle curve steeply to increase contrast

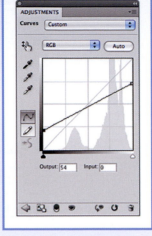

4.90 Lessen curve angle to reduce contrast

4.91 A classic S-curve increases contrast in the midtone areas without blowing out highlights or blocking up shadows

4.92 An opposite S-curve reduces contrast by brightening darker areas and darkening bright pixels

the Curves adjustment panel. You can smooth disjointed jaggedness in the hand-drawn curve by clicking on the *smooth the curve values* icon.

Curves and contrast

The steepness of the curve corresponds to the image contrast; thus, a steeper curve will produce more contrast in the image. A classic S-curve (Figure 4.91) *increases* contrast in the midtone areas without blowing out the highlights or blocking up the shadows. You might consider adjusting the curve to deepen the shadows and lighten the highlights before working on the midtones. To *reduce* contrast, try applying the opposite S-curve (Figure 4.92) to brighten darker areas and darken bright pixels.

Adjusting tones using curve points

The following demonstration shows how to increase the contrast of a flat image, step by step. In this process, we will identify particular tonal areas along the curve that should be lightened or darkened, find those points along the curve, and then modify the curve at those points to lighten or darken the values.

STEP 1: Select image areas that need an adjustment

Open the image you want to adjust. Determine areas that should provide key information, compositional structure, or significant symbolism, but are not currently at an appropriate or distinctive tone. In our example (see Figure 4.93), we want the chairs to be lighter, and all areas of the background (walls, floor, shadow) to be darker so that the pile of chairs will stand out.

STEP 2: Open a Curves adjustment layer

Open a Curves adjustment layer (*Layer > New Adjustment Layer > Curves*) and notice that the default diagonal curve has only two points, each located on one end of the line.

STEP 3: Drag the endpoints in to increase contrast

To heighten contrast in the image, drag the black endpoint (the bottom-left point) horizontally toward the center of the graph to darken the shadow areas and drag the white endpoint (the top-right point) horizontally toward the center to lighten the highlight areas. Some clipping may occur, but trust your visual assessment of the adjustment.

STEP 4: Add points to the curve and adjust them

Select the on-image adjustment tool in the Curves adjustment panel. Find important points in the image that need adjustment. Hover the eyedropper over the points and click to create a corresponding point on the curve. To make large changes in the points on the curve, drag the anchor points. To make small changes, use the arrow keys to nudge them. For example, in our image, we dragged down points 1, 3, 5, and 6 to darken the walls and floor in relation to the chair sculpture. We dragged up points 2 and 4 to increase the brightness of the floating chair sculpture. In the final image, the chairs stand out from the darkened background. (See Figure 4.94.)

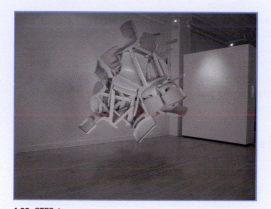

4.93 STEP 1

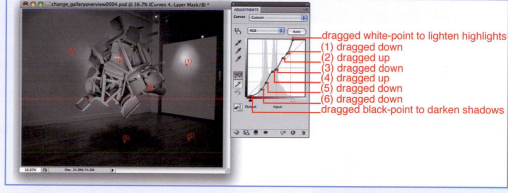

dragged white-point to lighten highlights
(1) dragged down
(2) dragged up
(3) dragged down
(4) dragged up
(5) dragged down
(6) dragged down
dragged black-point to darken shadows

4.94 STEP 4

Making a gradual tonal adjustment

Various conditions, such as photographing with a single light source, can cause uneven exposure throughout the image. While Photoshop's Levels and Curves let you adjust highlight, midtone, and shadow values separately, what if some of your highlights are well exposed and others are under- or overexposed? Correcting the entire photograph will fix one portion of the image, while simultaneously throwing off the rest of the image. Attempting to select and alter a portion of the image (even if feathering the selection) usually creates abrupt shifts in tone.

The Gradient tool is the perfect answer for such situations. Below, we give instructions for making a gradual tonal adjustment. In our mountain landscape, we don't want to lighten the sky, but do want to brighten the mountain and water so that their details are visible.

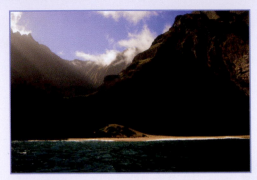

4.95 STEP 1

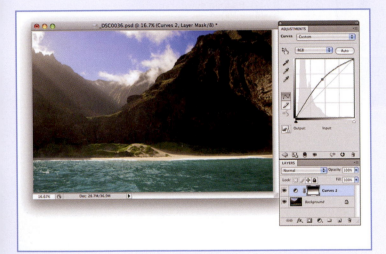

4.96 STEP 3

@ **4.3** Refer to our web resources for information about evaluating and color correcting a darkroom color print.

STEP 1: Lighten the image

Open the image. Choose *Layer > New Adjustment Layer > Curves*. Make a point in the center of the linear curve. Drag this point up quite considerably (you'll be able to modify the degree of lightness later).

STEP 2: Choose the Gradient tool in black and white

In your Layers panel, select the mask icon on the Curves layer you just created. Select the Gradient tool from the toolbox. Press Return and double-click on the third gradient from the left (the Black to White).

STEP 3: Apply a gradient to the adjustment

Begin by clicking the Gradient tool in the image area with *correct* exposure and drag the cursor into the area that you want to fix. In this example, we clicked in the sky and dragged down into the water and mountain. If the adjustment was too light or dark, you can go back and adjust the anchor point on the curve. Simply click on the Curves adjustment layer in the Layers panel and drag or nudge the anchor point in the Curves adjustment panel.

ADJUSTING BRIGHTNESS LOCALLY: BURNING AND DODGING

Most prints are not *straight* prints, images made from a single exposure. Usually particular areas need more or less exposure in order to accentuate or diminish details. Exposure can be added locally by *burning-in* or subtracted locally by *dodging*. To determine whether part of an image should be darkened or lightened, evaluate that area based on how it contributes to or detracts from the subject. There are no rules dictating the tonal range of prints. Whether you have solid shadows, highlight details or glaring, white highlights are all relative to your intentions. As an alternative to dodging and burning, consider split filtration.

Darkroom burning-in and dodging

The techniques of burning and dodging began with darkroom printing. The basic technique: after printing the whole image at one exposure, give more or less exposure to a particular area. *Burning-in* is used to add more exposure to highlight details or to blacken dark gray areas. Conversely, exposure can be withheld from an area by *dodging*, which prevents an area, usually a shadow, from becoming so dark that it loses details. Because the exposure produces a latent image, which

must be processed, you cannot see the effects of burning and dodging until after processing. For this reason, it takes several attempts to get the right amount of exposure.

Darkroom dodging

Make a dodging tool by taping a round piece of heavy cardboard (a 2-inch circle) to the end of a stiff wire (coat-hanger wire works well). The wire allows you to selectively insert the cardboard into the beam of light. If the dodged area is large or on the edge of the print, you can also use your hand as the dodging tool.

To lighten an area of a print, block the light using the dodging tool. During exposure, insert the dodging tool between the lens and the paper, above the area you wish to dodge. Avoid getting a hard edge between the dodged area and the surrounding field by constantly moving the tool (a controlled shake) for the duration.

Darkroom burning

Make a burning tool by cutting a 1–2-inch jagged hole slightly off-center in a board whose dimensions are larger than the paper's. Ideally, use matte board that is black on one side and white on the other. The white side faces up and allows you to see the image while you are burning; the black side faces down so that no light is reflected onto the print.

To darken an area of a print, add extra exposure to a particular area using the burning tool. First, make your initial exposure to the whole sheet of paper. Insert the cardboard between the lens and the paper so that the hole is above the area that needs additional density. Re-expose, moving the tool constantly so that the burned area will not have hard edges.

Burning-in and dodging in practice

To make the final image here, we burned in the background wall in order to make the sink/mirror stand out from the background. We darkened the middle blocks so they would look like a shadowy path winding back toward the dark corner. We burned in the white foreground blocks so their glaring tone wasn't so distracting. Dodging the top of the television monitor made it seem weightier and of comparable value to the other objects.

Digital burning and dodging

Photoshop's Dodge and Burn tools, located in the Tools panel, create the same effects as darkroom burning and dodging tools—they lighten or darken areas of an image. However, the digital versions are brushes that paint in more or less exposure. Settings in the options bar allow you to adjust their opacity and to direct

4.97 Dodging

4.98 Burning

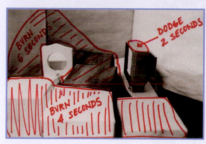
4.99 Burning and dodging

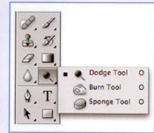
4.102 Digital burning and dodging tools

4.100 Straight print, with #3 filter

4.101 Printed with #3 filter, and dodged and burned

4.103
STEP 1

4.104
STEP 2

midtone/gray slider
highlight/white-point slider
shadow/black-point slider

4.105 STEP 3

4.106 STEP 4

the exposure adjustment at highlights, midtones, or shadows. However, because these tools just darken or lighten the existing tone, their effect often muddies the exposure, rather than revealing or darkening details. The Clone Stamp tool is sometimes a better choice. You can use it at a low opacity (10–20) to take details from well-exposed areas and place them in the over- or underexposed sections. The problem with the Dodge, Burn, and Clone tools is that each permanently alters pixels, making it impossible to reverse the action (once you have saved the changes). As an alternative, the dodging/burning technique described next uses a Levels adjustment layer so that the original image is never altered.

STEP 1: Create a Levels Adjustment layer (for dodging)
Open the image. Here, we demonstrate this technique with Sven Kahns's image *A Study of Scale: Sand Landscape*. Add a Levels adjustment layer by selecting *Layer > New Adjustment Layer > Levels*. Name the layer for the type of adjustment you are making (dodging or burning). Here, we start by dodging, or lightening, the image. Click *OK*.

STEP 2: Use the Levels sliders to lighten the image
The Levels dialog box that opens displays a histogram showing the tonal range of your image. Lighten the image by dragging the highlight and/or midtone Input Levels sliders to the left. The tonal change will be applied to the whole image for now—you will localize the effect later. Lighten more than you ultimately want to, as you will be able to make the effect more subtle later on.

STEP 3: Open the Layers panel
If your Layers panel is not already open, open it through *Window > Layers*. Adjustment layers come with an adjustment layer mask (here represented by the white rectangle next to the Levels rectangle in the adjustment layer). This mask determines what part of the layer is hidden or visible and at what opacity. When the mask is white, the adjustment affects the entire image. Since we want to apply the adjustment to particular areas, we want to begin with a black mask (in which all portions of the layer are hidden) and paint in the adjustment gradually.

STEP 4: Invert the mask
Change the white mask to black (*Image > Adjustments > Invert*). As soon as you do this, the lightening effect will be hidden in your image.

STEP 5: Use the Paintbrush to lighten image areas

In the Tools panel, click on the Paintbrush tool. Adjust the brush settings in the options bar. Choose a soft-edged brush. Select the brush's diameter based on the size of the area you will be painting. Here, we selected size 911. Set the Blend Mode to Normal, the Opacity to 70%, and the Flow to 100%. In the Tools panel, make sure that the foreground color is white. Once the brush is set up, use it to dodge (lighten) areas that are too dark. If the effects are too intense, change the brush opacity to 50% or lower. In this image, we dodged the central sand pile.

STEP 6: Create a Levels Adjustment layer (for burning)

Once you are satisfied with the dodging, you can use the same technique to burn in particular areas of an image. For example, after we dodged the central structure, we created a second adjustment layer, which we named *"burn_darken."* To darken the image, we moved the shadow and midtone Input Levels sliders to the right until the background peaks were barely visible.

STEP 7: Invert the mask and use the Paintbrush to darken image areas

Next, we inverted (*Image > Adjustments > Invert*) the *burn_darken* adjustment layer mask and used the Paintbrush to burn in the distant towers that were too light and distracted attention from the central stalagmite. Compare the original image (Figure 4.109) with the burned and dodged image (Figure 4.110).

4.107 STEP 5

4.108 STEP 6

4.109 Original image

4.110 Burned and dodged image

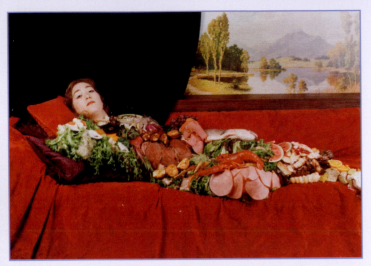

4.111 k r buxey, *My Dinner Party*, 1998. Color photographic print, 3 × 2ft approx

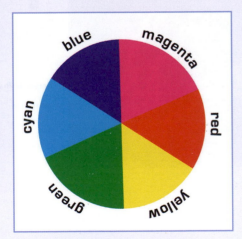

4.112 Additive/subtractive colors on the color wheel. Complementary colors (e.g. magenta and green) are opposite one another

@ **4.3** Refer to our web resources for information about evaluating and color correcting a darkroom color print.

COLOR

Using either handcoloring and toning, or chemical color processes, artists have had access to color photography since the invention of the medium. However, early color processes were tedious and unstable, and by the time more reliable methods were invented in the 1930s, artists had embraced the more abstract, poetic qualities of a black and white tonal range. Commercial photography adopted color as a means to seduce consumers. Popular photography saw a full-color spectrum as a way to create more naturalistic images. Gradually, color became associated with advertising and snapshot photos, and most art photographers dismissed color as an artificial, superfluous detail, preferring the elegance and integrity of a black and white print. In the late 1960s, Pop Art's incorporation of everyday and consumer imagery, documentary photography's new interest in the descriptive possibilities of color, and the emergence of simpler color technologies, created a new acceptance and interest in the expressive possibilities of color. Today, color is one choice among many. Depending upon how it is used, color can refer to certain periods in time that we associate with different hues or casts, and to artistic styles or movements with, say, highly saturated or diffused color; and color can convey a sense of naturalism or abstraction.

The following sections describe three main ways of working with color. These are:

1 *Color correction of digital prints.* Digital images tend to have an excess of one or two hues, and need to be adjusted using digital imaging software. On our website, we describe color correction in the darkroom. In the book, we describe digital color correction processes.
2 *Traditional print toning and digital colorization processes.* In a traditional toning process, the silver of a black and white print is dyed, or replaced with colored compounds. Digital processes replicate this effect.
3 *Handcoloring and digitally simulating the effects of handcoloring.* Handcoloring involves selectively painting black and white photographs with oils or dyes. The detail and texture of the original image may show through or be obscured by the applied color. Digital imaging software offers paint tools that can simulate the effect of handcoloring.

COLOR AND LIGHT

What we see as white light is a blend of different colors of varying wavelengths. The basic primary colors, which can be blended together to form white light, are *red*, *green*, and *blue*. They are called *additive* primaries.

On the color wheel, adjacent additive primaries combine to form *subtractive* primaries: *cyan* (made up of blue and green), *magenta* (made up of red and blue), and *yellow* (made up of green and red). While red, green, and blue can be added together to form white light, the subtractive primaries can be combined to form black.

The subtractive and additive primary opposing one another on the color wheel are complementary colors: cyan is the complement of red; magenta is the complement of green; yellow is the complement of blue.

Subtractive color methods with dyes, pigments, filters, or digital emulation of these principles, use the colors cyan, magenta, and yellow. When acting on white light, each color blocks (absorbs) its complementary color. This is significant because, whether making color corrections digitally or in a traditional darkroom, you can use complementary colors to control one another.

- Cyan and Red can block or neutralize one another.
- Magenta and Green can block or neutralize one another.
- Yellow and Blue can block or neutralize one another.

These are the principles that make color correction and color printing possible in photography. By understanding this relationship between colors, you can choose hues to control a particular color cast.

DIGITAL COLOR CASTS

A color cast is an all-over general color hue that tints most, if not all, objects in a photo. Color casts occur when: a predominant color in the photographed scene reflects upon other objects within the image (e.g. a green wall reflects on a person's skin); when the digital camera's white balance does not match the lighting in the scene (e.g. the white balance is set for tungsten light although you are shooting in daylight); or when shooting in RAW format. At times, a color cast is advantageous, as it can set the scene as warm or cool, imply a time of day, year or season, connect disparate elements, or heighten some aspect of the scene's narrative or ambience. Undesirable casts, however, distract from the artist's objectives with inappropriate colors, or muddy the scene by casting one tinge over the entire image.

Evaluating color balance visually
To evaluate your image's color cast, eliminate color distractions by displaying the image against a gray desktop or by using Photoshop's Full Screen Mode With

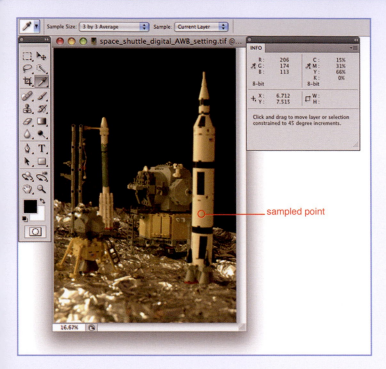

4.113 To numerically identify this image's color cast, we sampled the pixel hues of a white area with details that should be neutral white (the "sampled point"). The Info panel RGB values show us that the Blue value (113) varies greatly from the Red (206) and Green (174) values. We can now choose from various tools (such as Photoshop's Variations, Curves, or Color Balance, or the White Balance Tool in Camera Raw) to adjust the color balance and level out the values. For example, we could add Blue and subtract Red until each value is 174. See the following pages for descriptions of the Variations, Auto Color, and Curves tools

Menu Bar display to place the image on a gray background. Turn on Full Screen Mode With Menu Bar by choosing *View > Screen Mode > Full Screen Mode With Menu Bar*. Look for color casts in the image by evaluating neutral areas; areas that should be white or gray and also contain detail. For example, if you notice a slight red hue in the white or gray image areas and can see that tinge throughout the image, you probably have a red cast. Identifying the cast as cyan, blue, green, red, yellow, or magenta will help when making corrections. You will need to be able to discern the difference between similar hues—for example, between cyan and blue.

Using numbers to identify a cast: The Info panel

If you find it hard to visually determine which hues are causing the cast, you can sample a pixel or area of the image that should be neutral and use the Info panel (*Window > Info*) to determine the values. When working with RGB images, equal values of R (red), G (green), and B (blue) will always produce a neutral color. If the RGB values in the Info panel vary greatly from one another when sampling an area that should be neutral white or gray, you may have a color cast. For example, you may have more blue and green than red, indicating a cyan cast. To sample a single pixel, make the Eyedropper tool active in the Tools panel and choose Point Sample for the Sample Size in the options bar. Place the cursor over a neutral white or gray area (with details) to display a tonal reading in the panel. To take an average tonal reading of a small area, set the Sample Size to 3-by-3 Average or 5-by-5 Average.

DIGITAL COLOR CORRECTIONS

Once you determine that your image has an excess color cast, you can choose from a variety of Photoshop's tools to remove the offending hue. Here, we discuss some of the possible tools—Variations, Auto Color, and Curves. Photo Filters is discussed elsewhere in the book. Many other commands, such as Levels, Hue/Saturation, and Color Balance, can also be used to modify color.

Variations

The Variations command (*Image > Adjustments > Variations*) allows you to see, identify, and adjust the color balance, contrast, and saturation. The eight thumbnail images show the original picture with variations of hue and brightness. The tool can be helpful when you are learning to recognize different color casts or for global image corrections. Unfortunately, the thumbnails are very small, the tool can only be used on 8-bit-per-channel images, and any changes made in Variations affect image pixels directly (rather than on a separate layer).

You can add additional amounts of the six primary colors by clicking on one of the six thumbnails in the bottom left. Subtract a color by clicking on its comple-

mentary color: Cyan / Red; Blue / Yellow; Green / Magenta. The right side of the dialog box contains Lighter and Darker thumbnails that you can click to adjust tonal values. If you are unhappy with your adjustments at any time, revert to your original settings by pressing the Original thumbnail.

Auto Color Correct

The Auto Color Correction function in either the Levels or the Curves Adjustment panel allows you to set values to calculate changes to adjust color. To use the Levels Adjustment panel, open *Layers > New Adjustment Layer > Levels.* When the panel opens, select *Auto Options* from the Adjustments panel menu. In the Auto Color Correction Options box, click on the *Find Dark & Light Colors* and turn on *Snap Neutral Midtones*. In Target Colors & Clipping, set the highlight and shadow points to between 0.00% and 0.05%. Watch the effects in the highlights and shadows. If necessary, click on the Midtone swatch to adjust the midtone target value.

Using Curves to correct color

The Curves command allows you to modify color and tone on an adjustment layer. The following method neutralizes the shadows, highlights, and midtones to remove a color cast. (Note: This method is a modification of techniques Scott Kelby has described in his *Photoshop for Digital Photographers* books.)

STEP 1: Open the image

Open the image that you want to color correct. Open the Info panel (*Window > Info*) so that you can read the RGB pixel values when making corrections.

STEP 2: Locate the deepest shadow area

In order to correct the image, you'll need to locate the shadow and highlight areas and mark them with the Color Sampler tool. Let's start with the shadow area. If you cannot visually locate the blackest or darkest area of the image, use the Threshold tool to help you find it. Select *Layer > New Adjustment Layer > Threshold.* Click *OK.* In the Threshold Adjustments panel, drag the slider under the histogram all the way to the left. The image will turn white. Any black pixels indicate the darkest part of the photograph. If no black appears at the furthermost left point, slowly drag the slider back to the right until a readable area of black appears.

STEP 3: Place a color sampler point

Under the Eyedropper tool in the toolbox, select the Color Sampler tool. In the options bar, select the Sample Size. We find that Point Sample works best for

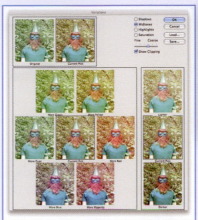

4.115 Auto Color Correction dialog box

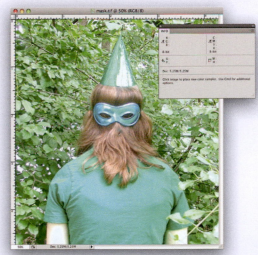

4.114 The Variations dialog box shows 12 thumbnail images. In order to distinguish between the different color casts, we set the Fine/Coarse slider to a coarser setting than we would usually select when adjusting color

4.116 STEP 1

selecting such particular tones. With the Color Sampler tool, click on the area you determined to be the darkest. Use the Info panel to help you locate the darkest pixel area (the area closest to R-0, G-0, B-0). Clicking will leave a target cursor (and a #1) to mark the spot.

Once you have located the darkest point, go on to identify the lightest. In the Threshold Adjustment panel, locate the lightest area of the image by dragging the slider all the way to the right. The first white area that appears is the whitest part of the photo. If no white appears at the furthermost right point, slowly move the slider back to the left until you see a readable area of white.

Use the Info panel to help you identify the lightest pixel area (the area closest to R-255, G-255, B-255). Use the Color Sampler tool to place a second target cursor on the highlight area. Clicking will leave a target cursor (and a #2) to mark the spot. Once you have located these two points, you can discard the Threshold layer by dragging it to the Trash button in the Layers panel.

STEP 4: Set preferences in Curves

Now that you have identified the darkest and lightest points, create a Curves Adjustment layer by choosing *Layer > New Adjustment Layer > Curves* or by clicking on the Curves icon in the Adjustments panel. First, we will set up our preferences for the *shadow color*. Double-click on the Set Black Point Eyedropper tool.

STEP 5: Set the RGB values for each eyedropper

The RGB figures you'll enter for the target shadow and highlight colors will be equally balanced (each of the RGB values the same) so that the black and white areas of your image won't lean toward one particular color (which would cause a cast). Additionally, the numbers will help to prevent clipping by preserving shadow and highlight detail.

In the *select target shadow color box* dialog box, enter the following RGB values: R: 7, G: 7, B: 7. Click *OK* to set those values as your target shadow color.

Double-click on the Set White Point Eyedropper tool. Enter the following: R: 244, G: 244, B: 244. Click *OK* to set those values as your target highlight color.

STEP 6: Assign the target shadow color

Now the Eyedropper tools are ready to correct the image color. Select the Set Black Point Eyedropper tool. Click it on the darkest pixel of the image (inside the #1 target cursor that you made with the Color Sampler tool). You have just shifted the shadow areas to the neutral shadow color.

4.117 STEP 3

set black point eyedropper tool

set gray point eyedropper tool

set white point eyedropper tool

4.118 STEP 4

STEP 7: Assign the target highlight color

Select the Set White Point Eyedropper tool. Click it on the lightest pixel of the image (inside the #2 target cursor that you made with the Color Sampler tool). You have just shifted the highlight areas to the neutral highlight color.

STEP 8: Brighten or darken the image

Evaluate the image. If it seems slightly dark, brighten the image by clicking on the center of the curve and dragging upwards slightly until the midtone values are bright enough. Drag down to darken the midtones.

STEP 9: Remove the sampler points

With the Color Sampler tool selected in the Tools panel, remove the color samplers by clicking on the *Clear* button in the Color Sampler options bar.

See the image before color correction (Figure 4.121) and after (Figure 4.122).

COLOR CONVERSIONS: TONING AND HANDCOLORING EFFECTS

Traditional print toning

Toning involves treating a finished print in a chemical solution that replaces the metallic silver with another color. *Sepia* toners change the silver image into silver sulfide, a brown-colored chemical salt. *Selenium* toner changes the image into a silver selenide salt (a cooler brown-purple, depending upon the strength of the toner and length of time in the solution). *Blue* toner creates a blue image. These are the most common commercially available photographic toners, but others are available in other colors. In addition, various other products, plants, and coloring agents can be used to tone. For example, Kool-Aid or a strong brew of tea or coffee can be used to tint prints.

Toning is usually a treatment for fiber-based papers, though some toners may work with RC papers. The strength and tint of the toning color differs from paper to paper, according to each particular toner and printing paper. Some toners have little or no effect on some papers, no matter how strong the toner solution. You may find that one toner will tone only the silver of a print, while another also stains the paper (the white highlight areas and the border). Toners can also reduce or increase density and contrast. For example, the bleaching process of sepia tends to lighten tonal values, while selenium toner tends to darken values. In addition to coloring the image, some toners, such as selenium, will protect the silver image against the effects of oxidation (exposure to air over time).

4.119 STEP 5

4.120 STEP 8

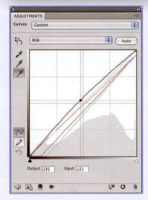

4.121 Original image

4.122 Final image

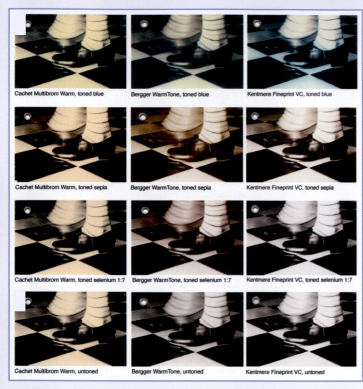

Cachet Multibrom Warm, toned blue | Bergger WarmTone, toned blue | Kentmere Fineprint VC, toned blue

Cachet Multibrom Warm, toned sepia | Bergger WarmTone, toned sepia | Kentmere Fineprint VC, toned sepia

Cachet Multibrom Warm, toned selenium 1:7 | Bergger WarmTone, toned selenium 1:7 | Kentmere Fineprint VC, toned selenium 1:7

Cachet Multibrom Warm, untoned | Bergger WarmTone, untoned | Kentmere Fineprint VC, untoned

4.123 Charlotte Ording, *Shuffle*, toned silver-gelatin prints, each print is 3 × 4½in, 2000

Pre-tone procedures

Paper may be toned immediately after washing in the print development process, or it can be dried, stored indefinitely, and then toned. Make sure that all fixer has been removed from the print before drying, as any traces of chemistry may cause uneven toning. You can tone the entire print or mask portions by painting over these areas with rubber cement. The masked portion will remain un-toned, and the rubber cement can be peeled off after the print has dried. *Split-toning* involves masking part of the image, toning, washing and drying the print, then masking the inverse portions and toning the image with a different toner color.

If you are starting with dried prints, soak them for a minimum of 3 minutes in fresh water. Mix the toner according to the manufacturer's instructions. These will provide a proportion, directing you to mix a certain measurement of water with a certain measurement of toner solution. For example, 1:7 indicates 1 part solution for every 7 parts water (in this case, 8oz of solution would be mixed with 56oz of water).

Toning, washing, and drying

Transfer the wet print to the toning bath. Agitate constantly. Tone for the amount of time recommended by the manufacturer, or experiment with times. Remember that, as prints are toned, the toner bath is weakened and more time will be required to get the same results with additional prints. After toning, wash prints for the amount of time recommended, or for 20–30 minutes. Be sure there is sufficient space and agitation in the wash. Dry prints.

Toned photographic prints—making comparisons

In the series shown in Figure 4.123, you see the results of Charlotte Ording's experiment with toning photographic printing papers. She printed the same negative four times on a Kentmere paper, four times on Bergger paper, and four times on Cachet paper. She left one of the four prints untoned and toned each of the remaining three prints in a different color toner, in order to understand how the solution responded differently to each paper. You'll notice dramatic differences in, for example, the intense blue of the blue-toned Kentmere paper, compared with the golden color of the blue-toned Cachet and the subtle cold glow of the Bergger when toned in blue. *Shuffle* was one of a series of portraits of her daughter, seen through activities central to her life.

Converting digital images from color to black and white using the Black & White adjustment layer

There are several ways to convert a color image to black and white. We do not recommend simply converting the RGB image to Grayscale in *Image > Mode >*

Grayscale, as this method will discard the color information and fail to provide you with the control of the other options. The best technique is to use a Black & White adjustment layer to adjust how each color in the image is converted to black, white, and gray. This technique makes the adjustment as a layer, thereby preserving color data. If, at some point in the future, you decide you want the image to be color again, simply drag this layer to the trash. If you want to edit the effect in the future, just click on the Black & White adjustment layer to open up the adjustment panel. You can also apply a tint, such as a sepia tone, to the image using this tool.

STEP 1: Choose the Black & White adjustment layer

Open the color RGB image in Photoshop. Select *Layer > New Adjustment Layer > Black & White.* Rename the layer if necessary. Click *OK.*

STEP 2: Convert colors to grayscale by adjusting sliders

When the Black & White Adjustments panel opens, drag each slider to customize the conversion of reds, yellows, greens, cyans, blues, and magentas to grayscale tones. Drag left to darken and right to lighten each color channel. There is a drop-down menu at the top of the panel that gives you the ability to select from presets, such as darker, infrared, high contrast blue filter, etc.

Coloring a digital black and white image: Tints and duotones

In the digital world, a photo that uses two colors is referred to as a duotone. A true duotone allows you to play with the tonal range of the image while adding color. On our website, we show you how to do this by converting the photo to Grayscale Mode and then to the Duotone Mode. The advantage of this method is that color can be added selectively to the shadow, midtone, or highlight areas of the image. Another approach to creating duotones is simply to tint the black and white image using the Tint option in the Black & White Adjustment layer.

The method described here applies a color tint equally to the entire image.

STEP 1: Add a color tint using a Black & White Adjustment layer

Colorize the black and white image by applying a tint. Click on the checkbox next to the word Tint in the Black & White Adjustment layer and a color swatch will turn from gray to color. The default color is a sepia-like tan. Click on this swatch

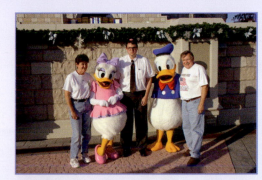

4.124 STEP 1

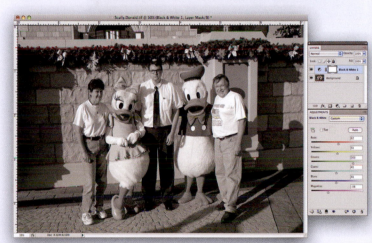

4.125 STEP 2

 4.4 Refer to our web resources for a method of creating a digital duotone that allows you to play with the tonal range of the image while adding color.

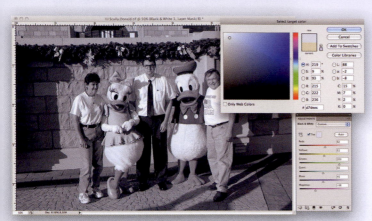

4.126 STEP 1: adding a tint

 4.1

to choose another color and a *select target color* dialog box will open. Select a desired color.

Traditional handcoloring

Handcoloring is the process of applying color to a black and white or toned photographic print. Print details can show through or can be obscured. Some of the earliest photographic prints were handcolored. As early as 1842, technicians developed somewhat elaborate ways to color the two earliest photographic processes, the daguerreotype and the calotype, in order to give the image a greater sense of realism. With the emergence of gelatin-based printing papers in the 1880s, photographs could more easily be colored; photographic businesses offered handcoloring services wherein portraits, usually from weddings, were sent to the colorist with a note indicating the color of the dresses, the flowers, the shoes, etc. By the late 1930s, the Kodachrome process replaced the need for handcolored commercial prints. In the late 1960s, handcoloring reemerged and was adopted by artists as a way to incorporate drawing with photography or to create color effects that could not be created in the actual scene. Today, artists color prints traditionally with photo oils, pencils, retouching dyes, chalk, neon markers, pastels, crayons, and acrylic paints (such as Pierre and Gilles's airbrushed portraits of saints, the dreamlike canvases by Holly Roberts, and Arnulf Rainer's dynamic altered self-portraits) or digitally with image-editing software.

Coloring media

The most common media for coloring are photo oils and pencils. While retouching dyes can also be used to color a print, they tend to soak into the paper and are therefore difficult, if not impossible, to remove. Photo pencils are a better alternative as they can be applied and if necessary erased with greater precision. However, pencil colors cannot be mixed together to produce as wide a range of hues as oils, and photographic papers must be pretreated with Prepared Medium Solution (PMS) to accept pencil colors (the oil of the PMS softens the pencil lead). Photo oils (different to painter's oils) let you choose from or mix the widest assortment of colors. Additionally, you can clean up mistakes. For this reason, we focus on photo oils in this section.

Materials

- *Coloring media*: photo oils and photo pencils.
- *Drafting tape*: to secure the print to the work surface.
- *Cotton balls*: to color, and to lift excess oil from large areas of the print.
- *Cotton swabs*: to color, and to lift oil from small areas of the print.
- *Round toothpicks*: to color fine details.

- *Palette*: for mixing photo oils.
- *Marshall's Prepared Medium Solution (PMS)*: can be used to pretreat photographic paper to make the surface more receptive to coloring media; can be used to remove large areas of color from print; and can be mixed with oil to get lighter tints.
- Faber Castell Peel-Off Magic Rub vinyl eraser: to remove unwanted color.

The image

The contrast and exposure of your print should depend upon whether you want image details to show through the color, or plan to cover the details with paint. If you want the details to show through, print the image at average contrast and avoid too many deep shadows. Print the image with a 1-inch white border, which will provide an edge that can be taped to the work table during coloring. If you are unfamiliar with the handcoloring process, make several extra prints so that you can practice first.

Paper

Oils show up differently depending upon the paper's surface. Glossy papers tend to reveal the color less than matte papers. The color will show up easily on soft papers, such as linen or rag.

Prepare the work area and print

Work on a smooth, clean, stable surface and make sure the print is well lit. This will protect the border from becoming colored and will prevent the print from shifting during the process. If you need to mix colors, squeeze a pea-sized amount of each photo oil onto a palette. If you don't need to mix the color, you can squeeze a smaller amount directly onto the cotton swab to avoid wasting paint (this isn't recommended if using cotton balls). If the print has a border, use drafting tape to secure the paper to the table.

General method of handcoloring and overlapping colors

The general approach to handcoloring is to apply base colors first and details last. Apply base colors loosely, with colors overlapping at their edges. This will help prevent the effect of areas of separate color with thick, heavy oil buildup at the edges. If the first color you applied overlaps into the second color's area, the new color will replace or "lift" the former color. The two exceptions to this are: Extraordinarily strong colors, applied first, may blend rather than being lifted—in this instance, use a fresh swab to lay down more of the second color; and applying yellow over blue will give the yellow a greenish cast. To get a pure yellow, remove the blue overlap first before applying the yellow.

4.127 Shawn Scully, *Hero #17*, 2001, gelatin silver print before handcoloring

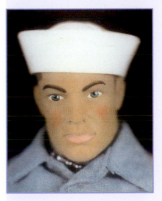

4.128 Shawn Scully, *Hero #17*, 2001, gelatin silver print after handcoloring

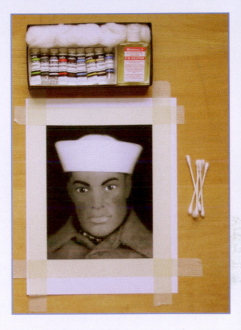

4.129 Handcoloring supplies

Experiment to discover the methods that work for you, according to your aesthetic needs. Test out these techniques on a "bad" print before working on the final print.

Apply the base colors

Begin by applying smooth, light, overall coats of base colors to the print with a cotton ball. In a circular motion, rub an even layer of the oil onto an area of the print. Spread the oil over the area border, into the next color area. Take a fresh cotton ball and lightly wipe over the area just colored in order to even out the color and lift up excess oil. Save these cotton balls in case you need to apply additional color in the detail stage.

Apply the adjacent area color. When applying the second color, go over the borders again; you can fix the overlap when you work on image details. After applying all general base colors, you should be able to see a subtle, even shine when looking at the print from an angle. Bright areas indicate a buildup of oil that should be rubbed off with a cotton ball.

Color the details

Now that you have applied the base colors, you will color the details. Detailing involves controlled rubs that help shape the color and imagery. Apply the oil to a cotton swab, making sure that it penetrates the cotton; this will limit the concentration of oil applied. In this stage, never blend colors using a new swab as it will remove, rather than blend, the hues. Use swabs with some color already rubbed into the cotton.

First, remove any overlaps by applying the desired color to lift the unwanted one. Follow each application by using a clean swab to remove excess oil. Next, address shadow areas, which often need to be lightened slightly, either by lifting up some of the base color or by rubbing gradual amounts of neutral gray and the base color into the area. Then, add color to image highlights that should be more intense than the initial wash. Use the cotton ball to make more gradual shifts in color and the swab for more detailed, intense areas. Finally, remove the color from highlights that should be white by cleaning them with a fresh swab or vinyl eraser so that the color disappears gradually at the outer edges of the highlight and completely in the center. Blow off the eraser particles with your breath or use canned air.

Dry the print

Carefully remove the tape from the border. If there is a buildup of oils along the tape line, gently clean this area by running a cotton swab along the border and then erasing any color with the vinyl eraser. Tape only the corners of the print to the table so that the paper dries flat. Dry in a dust-free location for a few days.

Digital handcoloring effects

There are many ways to digitally color an image. With most methods, you should start with either a black and white or a duotone image in RGB mode. See "Converting digital images from color to black and white," p. 410 to learn this process. Approach digital hand-coloring as you would the traditional process, by working on larger color fields first and then finer details. The main difference is that you can avoid colors accidentally mixing by placing different colors on different layers. By painting different colors on different layers, you can always go back and lower the opacity of the layers to blend the colors together.

Create a color palette

If you are beginning with an RGB file and would like the handcolored version to have a realistic color palette, you can use the original color file as a source of colors. If you are not working from realism, you can still determine a color palette before working. This may come from another color image or by selecting colors from the Color Picker dialog box (double-click on the *foreground color*). To create a palette, select the Eyedropper tool in the Tools panel. Click the cursor on your chosen color in any image. Once the color is set as the foreground color, go to *Window > Swatches* and click on the *Create A New Swatch of Foreground Color* icon at the bottom of the Swatches panel. The color will be added on as the last swatch in the panel. To delete the swatch, drag the square to the Trash button.

Create a new layer in Color blending mode

This technique involves creating a new layer in the blending mode Color. You will apply the handcoloring effect to a layer (separate from the original background layer). As long as you save that layer, you can rework, manipulate or delete your coloring at any time. This technique allows for easy tinkering with the opacity of the applied color, and so it is especially useful for controlling the strength of applied colors.

With the image file open, open the Layers panel (*Window > Layers*). Create a new layer (*Layer > New > Layer*) or click the *Create a New Layer* icon at the bottom of the Layers panel. At the top-left of the Layers panel, set the layer's Blending Mode to *Color*. Make the Paintbrush tool active in the Tools panel and paint. If the intensity of the color is too weak or too strong, change the opacity of the brush and/or the layer. We recommend altering the opacity as you paint, especially in large areas, in order to create the effect of shading and texture. A helpful working method involves creating a new layer for each color applied, or each section that you might want to alter later. By adjusting the opacity of that layer, you can blend the color with other colors on different layers below or above. Make selections of areas to confine your painting strokes to particular sections of the image.

4.130 Creating a new layer

4.131 Before digital coloring

4.132 After digital coloring

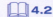 4.2

PRINT RETOUCHING TECHNIQUES

TRADITIONAL PRINT RETOUCHING

Dust or hairs on your negative or photographic paper while printing will show up on your print as white spots or lines. Prints that have been scratched may have narrow white scrapes. You can conceal these blemishes using a technique called spotting. Spotting is the process of applying dye to the spot in order to camouflage it. Make sure to work in a brightly lit environment when mixing dyes and spotting.

Retouching media

The retouching media we focus on here are liquid dyes and watercolors formulated for touching up photographs. The dyes are concentrated, transparent colors with powerful tinting abilities. They can be used to spot or color the print. Dyes come in various warm, cool, and neutral shades of gray, black, and brown. For color prints, these dyes can be purchased in many different colors, including red, magenta, blue, cyan, green, orange, etc. Watercolors are concentrated paints with more transparency than dyes. They come as bottled liquids, tubes of paste, or dried blocks or sheets. Dyes also come in pen form. While pens are convenient, their color may fluctuate over time and the pen tip's size is often too large for small spots.

Other materials
- *White plastic tray* or *palette* to mix and store liquid dyes. We recommend transferring a small amount of the dye to a white tray, which will serve as both palette and storage. A tray should have multiple depressions to separate and store the various hues, a flat area for color mixing, and a lid.
- *Watercolor brush*, size 000, or a larger brush cut down to a very small point. Choose a high-quality brush that does not shed hairs while painting.
- *Water* to dilute the dye (distilled water works best).
- *White cotton gloves* to wear while spotting, or *acid-free paper* to place under your hand in case it rests on the print while holding the spotting brush. The paper will shield the print from skin oil.
- *Paper towel* as a blotter for the brush.

Spotting technique with liquid dyes
Mix liquid dyes to the right color
If spotting a *black and white* print, the liquid dye must match the print's silver (neutral, warm, or cool). Begin with a neutral dye on the tray and add warm or

cool dye, if necessary, until the color of the dye approximates the hue of the silver. Dilute the spotting liquid to be slightly lighter than the value of the print area surrounding the spot. (You will build up layers of dye to match the adjacent area.)

If spotting a *color* print, determine the dominant color of the print area surrounding the spot. Choose the closest color in the color dye kit and place a small amount on the palette. Add one or two other colors (too many colors will just muddy the solution) to get the correct color. For example, for a reddish-brown shade, first place a brown on the palette and then add a red. If the color is too bright, it will stand out on the print. Neutralize the brightness slightly by adding a tiny amount of the complementary color. For example, if you are mixing an orange, add a bit of blue dye to diffuse the brilliance.

Spot the print

The general strategy in spotting is to dilute or mix the dye to be slightly lighter than the print-tone surrounding the spot, and then build up layers of dye to match the adjacent area. Before working on the final print, practice on a test print.

Dampen the brush and then use your fingers to sculpt it to a point.

Dip the brush in water until wet and then lightly in the spotting mixture. If there is too much liquid on the brush when spotting, the small dot you make with the brush will disperse and create a ring *around* the spot, thereby drawing even more attention to the blemish. *Before spotting*, blot the tip of the brush slightly on a piece of paper so that you touch the print with a nearly dry brush. Make sure to keep the brush's tip at a point when spotting.

While spotting, the hand holding the brush usually rests on the print/table. Lay a piece of archival paper beneath your hand to keep skin oil from transferring to the print. Start spotting. Hold the brush perfectly vertical, and slightly dot the blemish with the tip of the brush. Let each dye spot dry before applying another. Patiently build from light to dark to fill in the white spot. Try to create dots that mimic the grain pattern of the print. If you apply too much dye, quickly rinse it away with a damp cloth. Don't throw out the spotting mixture. Let it dry for future use.

DIGITAL PHOTOGRAPHIC RETOUCHING

Digital retouching techniques involve filling in missing visual data, shifting pixels from one location to another, or blending pixels from several locations. While retouching tools can be used to repair (to remove dust and scratches from scanned photographs and negatives and to mend creased or faded images), they can also sharpen or blur pixels, adjust graininess, replace or reconstruct objects

4.133 Spotting tray, dyes, and blotting towel

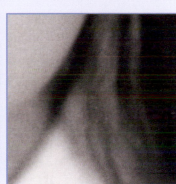

4.134 Gelatin silver print with white dust spot **4.135** Print after spotting

4.136 Digital retouching tools

within an image (for example, you can move a plant from one location to another within an image of a garden).

Make broader types of adjustment (color, contrast, cropping, etc.) before retouching images. Detail work such as repairing, removing, and replacing pixels should usually be done in the final stages of editing. Before retouching, duplicate layers, and always retouch the copy layer so that you can revert to the original at any point OR perform retouching on a new blank layer. While editing, keep the History panel open. This panel keeps a list of the last 20 actions (the number of actions displayed can be changed under *Photoshop > Preferences > Performance*) you have made within the current working session. Attempting to fix the mistake by cloning over a cloning error will excessively diminish image texture. If you go too far with any action, use *Edit > Undo* or simply click on a previous step in the History panel to revert to an earlier stage.

Many of the retouching tools take pixels from one location and place them in another. Because they are duplicating other pixels, the copies can begin to create noticeable patterns if they are not irregular enough. Sampling from different source points and varying the brush size will allow you to avoid creating repeating patterns. When doing this, press the square bracket keys, [and], to increase or decrease the brush size quickly.

The following sections describe some of the digital techniques for basic restoration. Use these tools, sometimes interchangeably, to remove blemishes, correct red-eye, erase pixels, and adjust the sharpness or blur of your images.

Blemishes, dust, and scratches

The easiest way to deal with dust and scratches is to avoid problems in the first place, by cleaning the scanner bed or camera lens, or by brushing or blowing dust off the material that you are scanning. If the dust has been digitally captured and becomes part of the image, a variety of Photoshop tools allow you to retouch these unwanted elements by covering up or blending unwanted specks with neighboring pixels. To remove individual blemishes, such as dust and scratches, you can use retouching tools including the Clone Stamp tool, Healing Brush tool, Spot-Healing Brush tool, or Patch tool. To work with larger areas, the Dust & Scratches Filter and the Blur Filter will minimize blemishes by blurring pixels to decrease the visibility of unwanted noise.

Painting / Brush tools

Retouching brushes allow you to set options such as brush size, hardness, blending mode, paint opacity, flow (clone stamp), and sample layer in their options bar. Use a harder-edged brush when you want to preserve detailed information, such as grain and texture. Use a soft brush when you want to blend your retouched

areas in with the surrounding pixels. You can also soften the effects by lowering the paint *opacity* in the options bar. The *flow* value (clone stamp) refers to how quickly the tool applies copied pixels, so a lower value has a weaker effect than a higher value. Selecting the Airbrush icon (Clone Stamp tool) makes the brush more like an aerosol paint can or spray brush. Retouching brushes allow you to *Sample* layers: *Current Layer* (to sample only from the active layer); *Current & Below* (to sample from the active layer and all layers below that); and *All Layers* (to sample from all visible layers). With the *Aligned* feature checked, the Healing Brush or Clone Stamp tool's source point will be oriented at the same distance/placement from the destination point. With Aligned unchecked, the source will always be the precise original point selected.

As dust can be minuscule, you may need to zoom in on details to work. As you paint, zoom out occasionally to *View > Fit on Screen*, to see how the restoration looks within the entire image. If necessary, increase the brush size and fix any irregularities that may have resulted from being so close.

Clone Stamp tool

The Clone Stamp tool allows you to paint part of an image over another area. You can also sample from one layer to another layer or from one document to another open document that is in the same color mode. The tool is excellent for repairing detailed and high contrast areas, and for filling in missing information. For the brush size, we recommend using a diameter slightly larger than the size of the unwanted spot. To use the tool, select a source point by holding down the Option key and clicking in the location from which you want to sample pixels. Move the mouse and click in the new location. Clicking produces a single clone and dragging produces a series of clones. For most situations, we recommend the clicking method as dragging can produce a more obvious smear.

The Healing Brush

Both the Healing Brush and Clone Stamp tools sample from one area to affect another. However, the Healing Brush tool uses an algorithm to analyze the texture, color, and lighting of the source area. When you paint into a new area, the tool merges the texture of the source area into the color and lighting of the blemished area. Therefore, the brush evenly combines information with new surroundings. The Healing Brush tool often works better for larger areas than the Spot Healing Brush. To use the Healing Brush tool, select the tool from the toolbar and Option-click on an unblemished spot from which you want to copy pixels. Next, paint or click in the area you want to fix. Choose a brush tip slightly larger than the area you want to fix. Healing in tiny strokes or spots allows the algorithm time to calculate and for you to see, and possibly reverse, the results in small stages. When working near edges with a large difference in light and dark contrast, create selections

around the area to be healed. Working within a selection will allow you to avoid abrupt changes in contrast.

The Spot Healing Brush

The Spot Healing Brush repairs small spots well. It works like the Healing Brush but does not ask you to define a source point. This can be an advantage, as it speeds up the process of removing small blemished areas, such as dust spots. To use, select the tool in the Tools panel and click the cursor on top of the blemish. The brush will sample texture, color, and light around the area and use this information to repair the spot. The *Type* options in the options bar allow you to determine whether the sample comes from the area around the edge of the selection (*Proximity Match*) or from all pixels in the selection (*Create Texture*). This tool works best when there is good and adequate information nearby, so consider working with small areas with a brush that is slightly larger than the spot.

Patch tool

The Patch tool allows you to replace large blemished areas with good information from another section of the image. Use this tool when you want to preserve texture and luminosity, and when you have an area of the picture that is similar to or exactly like the area to be fixed. For example, you may use this tool if your image of the sky has one part with dust spots and another section that is dust-free.

With the Patch tool active, draw a selection around specified pixels as you would with the Lasso tool. The Patch tool offers two different operations. If you select Source, draw a selection around the flawed pixels and drag your selection to an area of the image with desirable pixels. If you select *Destination*, draw a selection around the good pixels and drag the selection to the flawed pixels. After making a selection, you can also click *Use Pattern*, which lays down a pattern or repeated image. Use one of the preset patterns in Photoshop's library or create and save a new one.

The advantage of using the *Source* option is that Photoshop previews potential results as you drag the mouse around to find good pixels. When you are happy with the result, let go of the mouse. Unlike some of the other retouching tools, this tool must be used on a layer with pixels (not a blank layer).

In the following demonstration, we will use the Patch tool to correct a blemished image. In Figure 4.137, the white spots that need to be retouched are circled in red.

4.137 Digital retouching

STEP 1: Select the blemished pixels with the patch tool

Zoom in (*View > Zoom In*) on the image to get a closer look at the blemished area. Make the Patch tool active in the Tools panel. Select Source in the options bar and draw a selection around the flawed pixels.

STEP 2: Sample from good pixels

Drag the selection to an area with good information.

The Dust & Scratches filter

The Dust & Scratches filter (*Filter > Noise > Dust & Scratches*) can be used to repair large, fairly uniform areas with many small blemishes. While this filter may get rid of tiny dust, it can also inadvertently remove details, including film grain or other image information. Use this filter only when a quick fix is needed at the expense of losing small details, or when you want to smooth out a grainy image. You can apply the filter to an entire layer or to a selected part of a layer. Consider feathering the section (*Select > Modify > Feather*) to soften the edges, allowing them to blend smoothly into the rest of the image. Use as small a *Radius* value as possible to keep from blurring the image. Use as high a *Threshold* value as possible so that pixels are not removed unless they are very dissimilar. Use the filter in combination with other restoration tools.

Erasing / Removing

Sometimes you may want to remove pixels from your image. Photoshop's Eraser tools allow you to make pixels transparent, thereby revealing the layers or background color beneath. The Eraser tools (the Eraser, Background Eraser, and Magic Eraser) function like paintbrushes that can be dragged over unwanted pixels. As the Eraser tools permanently affect pixels, we recommend either working on a duplicate layer, or hiding pixels with a Layer Mask, which will not eliminate pixels.

Sharpening / Softening / Modifying grain

Some Photoshop tools allow you to sharpen your images, soften your images, or change the appearance of film grain.

Sharpening

Digital images should be sharpened for many reasons. The technology used to capture images, either scanned or digital-camera captures, purposefully blurs images to eliminate unwanted artifacts and patterns created by digital capture technology. In addition, all digital images seem sharper on screen than when they

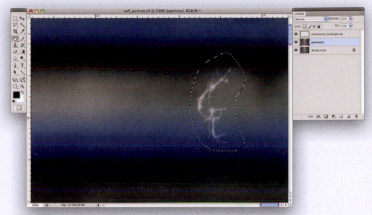

4.138 STEP 1

4.139 STEP 2

are printed because of the way that light emanates from the screen vs. being reflected from paper and printer dot gain (dots are printed larger than they should be). Lastly, different papers reflect light differently, thus making images seem sharper on more glossy paper.

To make images appear to be reasonably focused, you can use one of the Sharpen Filters (Smart Sharpen Filter, Unsharp Mask Filter, Sharpen Edges) or the Sharpen Tool. Be careful, as oversharpening can create glowing edges that become increasingly visible when digital adjustments are applied. To minimize this effect, always perform sharpening immediately before printing and after all image adjustments, in order to view your image at its final state before sharpening. Verify your adjustments in a proof print because viewing the image on the monitor can be deceiving.

For overall sharpening, use filters. For local focus, try selecting areas before applying filters, use masks, or try using the Tools panel's Sharpen tool (but be aware that it might create unwanted artifacts). You can often create more realistic results by using selections and masks to sharpen selected (rather than all) pixels within the image. In addition, you can achieve diverse sharpening effects by sharpening duplicate layers and changing their opacity and blend modes.

The Sharpen filters are located in *Filter > Sharpen*. The Smart Sharpen filter and Unsharp Mask filter are good choices:

The *Smart Sharpen filter* allows you to set the *Amount* of sharpening (intensity of sharpening), *Radius* (size of area to be sharpened), and type of sharpening algorithm (Gaussian Blur [all-purpose], Lens Blur [preferred because it has fewer halo affects], and Motion Blur [corrects blur from camera or subject movement]). The advanced option allows you to adjust the sharpening in the shadow and highlight areas. The filter also allows you to sharpen in iterations with the *More Accurate* option. Smart Sharpen more effectively avoids halo effects, has a larger preview, and allows you to save settings.

Unsharp Mask increases the contrast of neighboring pixels and gives the illusion of sharper edges. Unsharp Mask provides *Amount* and *Radius* options like the Smart Sharpen filter. It also provides a *Threshold* that tells Photoshop which pixels to consider and which to overlook. Larger values tell Photoshop to sharpen only areas with high contrast for subtle sharpening, while lower values will create more intense, overall sharpening. Sharpen images in small doses to avoid oversharpening and halo effects.

Softening

To soften large areas, similar to the effect of using a soft focus lens or diffusing gel, you can use a Blur, Noise, or Diffuse Glow filter. The Blur Filters (*Filter > Blur*) reduce contrast between the edges of objects in images and their surrounding pixels, thereby smoothing out the transition from edge to background. Unlike the

Blur and Blur More filters, the Smart Blur and Gaussian Blur filters make it easy to adjust the amount of haziness by entering a Radius value. The Diffuse Glow filter (*Filter > Distort > Diffuse Glow*) creates a very soft lighting effect over the image. These filters affect all of the pixels on the active layer or selected pixels within a layer. Adjusting the opacity of the layer will increase or decrease the strength of a filter's effect.

To blur locally, apply one of these filters to a selected area (and/or apply a mask) or select the Tools panel's Blur tool, which reduces the color/value contrast between adjacent pixels. The Smudge tool, also in the Tools panel, lets you blur pixels and smooth out colors or textures, an effect like finger painting in that you drag the pixels' color through the image.

Modifying grain

Film or print grain results from high film speeds and particular processing conditions. Digital files show digital noise when the camera's ISO rating is high and often in shadows of images. You can *reduce* the appearance of grain from scanned film images by blurring pixels using one of the softening filters described in the section above. To *create* or *enhance* the appearance of grain or noise, use filters such as (*Filter > Artistic > Film Grain*), which provides a slider to specify the amount of grain, and (*Filter > Noise > Add Noise*).

PHOTO-BASED COLLAGE

The term collage comes from the phrase *papiers collés*, meaning pasted papers, and usually refers to artworks where images or objects are cut and pasted or reassembled. This kind of work is usually based on fragmenting and remixing visual information from various sources. It is difficult to pinpoint the beginning of this tradition, but a logical jumping-off point is the invention of paper in China around 100 BC. In the first 1900 or so years of its production, paper was relatively laborious and expensive to produce. Individuals pasted papers together so that little would be wasted. As paper became less expensive, collage continued and developed into book and text embellishment in the 12th century, leather collage in bookbinding in the 13th century, photo-based collage beginning around the invention of the daguerreotype in 1839, and Victorian-era dried flower and human hair assemblage and wall and furniture decoupage.

A wealth of cut and pasted photographic imagery, darkroom collage, and assemblage (three-dimensional collage) was produced in the 20th century. Cubists looked to collage to establish a new, flatter model of picture space that involved overlapping and juxtaposition in defiance of Renaissance perspective. Dadaists embraced photographic collage as a means of joining commonplace images

4.140 Landworks Studio (Michael Blier, Erik Hanson, Mark Klopfer, Nick Tobier, and Letitia Tormay), *HighLine Frolic*, 2002. Digital collage, 4 × 6in.
The Highline is a 1.5-mile stretch of an elevated railroad track that travels along the far west side of lower Manhattan. Now defunct, the former track is currently an urban wilderness. Landworks Studio, a landscape architecture firm based in Salem, MA, proposed the Highline Frolic as part of an international ideas competition to come up with uses to transform this site. Recognizing the need for a north–south transportation link, they also saw the potential for turning infrastructure and transport into celebration and spectacle, and proposed a combined system linking commuters and roller coaster riders with an interwoven network of pneumatic tubes. Their inspiration for the fantastic part of the creation came from Coney Island, the famous amusement park that was built around the same time as the Highline. Merging the fantastic and the everyday was at this project's core, and the use of Photoshop and digital collage served them conceptually and technically, allowing them to scan images of vintage postcards of Coney Island imagery, and integrate them with Landworks Studio's own digital photos of the Highline today

@ **4.5** Refer to our web resources for instructions on making a darkroom collage or combination print.

4.141 Charles Fairbanks, *Billboard Modification: Eminent Domain (Stop Government from taking your Home, Farm or Business!)*, 2006, billboard advertisement, inkjet print and wheat paste, 8 × 20ft.

Although the billboard shown on the left appears to defend an indisputable ideal – the protection of one's home, livelihood, and sense of security – it literally rests upon questionable grounds. All homes, farms, and businesses in the United States – save those on the parcels allotted to Indian reservations – are built upon land taken from Native Americans. The site of this billboard, in Minneapolis, became home to white settlers only after expelling the Dakota in 1838. To publicly reify this complex history and illustrate the wilful flaws in the logic of eminent domain reform, Fairbanks enhanced the billboard (on the right) with a Dakota-style tepee – emblematic of local homes, livelihoods, and security from before the arrival of Europeans. (Process notes: Fairbanks found an image of a Dakota teepee on the Internet, then made the graphic by selecting the outlines of the structure and door and filling them in using Photoshop's Paintbucket tool. He printed the image on plain white paper using a large-format printer, then wheat-pasted the graphic to the billboard)

4.142 Anne Roecklein, *untitled (small town)*, 2004, postcards on board, 6 × 12in

in unexpected ways. Surrealists saw photographic collage's combination of disparate elements as a means of proving the reality of fantasy. Pop artists interested in consumer culture and postmodern tricksters subverting the dominant culture appropriated imagery from television, magazines, and merchandise as sources of photographic collage. Now, in the 21st century, the fundamental computer commands "copy" and "paste" (terms of traditional collage) illustrate the continuation of collage in digital technology.

Handmade and digital collage are not mutually exclusive. Elements can be cut, scanned, digitally edited, printed, and assembled in infinite combinations. Additionally, thinking of collage as physically and chemically joined imagery is a limited concept as video mash-ups, web-based collage, and digital hybrids bring together pieces of information over time. In this section we describe materials and methods for handmade and digital collage.

CULTURE JAMMING AND COLLAGE

Collage techniques usually entail removing everyday materials from their original contexts. Alternatively, collage can involve a modification or repurposing of ordinary objects or images while leaving them in the same location, in order to question or alter their originally intended meanings. The practice of *culture jamming*—a form of public activism, generally intended to subvert commercial messages—uses collage techniques to transform objects in order to disrupt the advertisements that inundate public space. Any sort of advertising may be targeted for culture-jamming collage: actions range from customizing labeled soup-cans to re-covering oversized billboards (see Figure 4.141).

CONTENT AND FORM

Collage parts can either be invented for the express purpose of being collaged or can be torn from one location and placed in another. The strips in Anne Roecklein's *untitled (small town)*, Figure 4.142, are fragments of postcards celebrating a general 1950s era of pride in small business and local culture. Recontextualizing a fragment of existing imagery—appropriated from art, advertising, or illustrative photography—inherently questions that fragment's original context. By interweaving slices from two "main street" postcards, Roecklein stretches out both streets, thereby emphasizing both the architectural scale of the street and the similar vantage point of the photographers.

The questions that may be asked of any collage, as a maker or viewer, include: What is the source of the original? and: How was it composed, lit, and edited for a particular meaning? Removing the image from its original location involves basic

questions of editing: How much of the image should be appropriated? What are the image's boundaries for these particular purposes? How should the image be scissored, ripped, or digitally selected, before being relocated to a new context? What change in meaning occurs through recontextualization?

Pasting involves combining multiple elements on some sort of ground. The formal arrangement of these parts affects content. Collage elements can blend into new objects and scenes or remain independent elements that sit side by side. When juxtaposing imagery, ask yourself: To what degree should elements seamlessly mix or appear distinct or fragmented? The space around the parts can be as significant as the imagery. Emptiness can allow a pause for reflection, a leap for implied movement, or can convey a sense of delicacy and the illusion of distance. On the other hand, filling all gaps may be necessary when building new forms, completing a scene, or simulating dense energy.

IMAGE APPROPRIATION AND COPYRIGHT CONCERNS

For an artist who wants to remix, alter, and collage images, our society has a wealth of raw material. Enormous stores of photographs are available online, in public archives, and in attics and thrift stores across the country, but the legal restrictions on making art from appropriated images are often difficult to untangle. Here we present the basic guidelines for determining whether the use of appropriated material is legal or not.

Images deemed to be in the public domain can be used in any way, whether for noncommercial, artistic, or even commercial purposes. For copyrighted images, the express permission of the author or copyright holder assures the legality of using the material, but in some circumstances copyrighted material may be used without authorial permission.

The Fair Use Doctrine

The Fair Use Doctrine of the United States Copyright Act allows portions of copyrighted material to be used—without the permission of the author—for purposes of commentary and criticism. This enables copyrighted images to be appropriated for use in new artworks, but only if their use follows certain criteria. Guidelines for the fair use of appropriated imagery in new artworks include:

Parody Is the new work a parody of the original? Unlike other forms of fair use, copyrighted material may be used extensively in a parody in order to "conjure up" the original work. This applies only if the new work—as a parody—is critical of the

copyrighted original, and not if the original material is used as a vehicle to criticize something else.

Transformation Was the original (copyrighted) material transformed by its new usage? Does it create new aesthetics, ideas, or understandings in its new context? If the new work shows the copyrighted material in a parodic or otherwise overtly critical context, or if the new work uses the content of the material to create and present a significantly different set of ideas, it is probably a fair use of the material.

Fact or fiction Is the copyrighted material fiction or nonfiction? Copyright laws in the United States are intended to encourage the dissemination of facts and information while allowing individual creators to reap financial rewards from their creations based on these facts. For this reason, there is generally more leeway to cite copyrighted nonfictional works than fictional ones. For example, the appropriation of journalistic material is more likely to be fair use than the appropriation of theatrical or cinematic works.

Quantity Is only a small portion of the copyrighted work appropriated? The less you take, the more likely your appropriation is a fair use. However, with the exception of parodies, even a small appropriation may be illegal if the portion taken is considered the "heart" of the work.

Market effects Does the new work deprive the copyright owner of potential income from the copyrighted material? If the new work—and the appropriated material it includes—fulfills demand for the original work and usurps its sales, the appropriation probably isn't fair use. When considering this factor, an important aspect is whether the copyright owner would sue based on the market impact of the appropriation.

Judicial taste Although U.S. copyright laws provide a framework for determining whether the appropriation of copyrighted material falls into the "fair use" category, the legal cases that define the issue are all products of subjective decisions by judges and juries. Despite the Supreme Court's indications that offensiveness is not a fair use factor, many courts have ruled against fair use appropriations when they found the new works to be morally offensive.

The Internet and fair use

The Internet is a growing fount of images and other media. Its ease of information sharing has made it the primary battleground in contemporary copyright and fair use struggles. Although corporate interests continue to influence the structure and

distribution of copyrighted media, the Internet has spawned myriad new ways to disseminate, sample, and experience information. In response to this transformed media landscape, the *Creative Commons* organization has assembled a new copyright practice of "some rights reserved," which allows media to be shared and creatively appropriated while certain rights remain for the original creator. In this new media context, Creative Commons (CC) offers a solution for photographers who want to disseminate their work through citation and appropriation without relinquishing the financial and other rewards that may come of it. As such, CC offers a reasonable copyright that radically departs from the traditional full copyright/public domain dichotomy. For information on the variable levels of "some rights reserved," to learn how to distribute your own creations with a CC license, and for a list of Creative Commons media sources, go to http://creative-commons.org/. For more information on copyright, public domain, and fair use, look at the Stanford Libraries website—http://fairuse.stanford.edu/.

HANDMADE COLLAGE

In our culture, there is a nearly endless supply of paper and photo-based collage materials available. If the tactile qualities of the collage are important—the texture of materials, the distinction between edges, the layering of opaque or transparent images, and the depth of the assemblage—hand construction may be a good option. Techniques involving folding, cutting, tearing, pasting, and taping may also be the appropriate choice for artists who want the act of constructing to be visible. Exposing the seams and joints of the work is one way to emphasize the history of the imagery.

Collage tools and materials

Anything that can be affixed to another thing can be used for collage. Paper, parchment, fabric, wallpaper, labels, cardboard, newspapers, magazines, photographic prints, postage stamps, metal, tissue papers, and ticket stubs, among other sources, can be used as source materials.

Cutting and folding tools

Scissors, Xacto knife, bone folder.

Adhesives and fasteners

Liquid and paste adhesives are easily applied with a cheap brush. In addition to glue options, collage elements can be fused by taping, sewing (by hand or machine), tacking, stapling, or other means of fastening. Select the method that works best with your materials and goals.

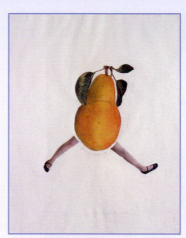

4.143 *Pregnant*

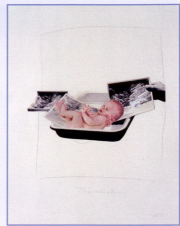

4.144 *Reproduction*

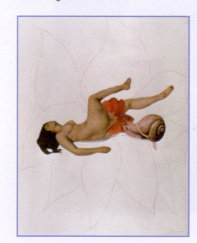

4.145 *Untitled (woman/flower/snail)*

Joanne Leonard, Three pages from *Journal of a Miscarriage*, 1973. Collage and pencil on sketchbook page. Each page is 11 × 14in. When Joanne Leonard became pregnant in 1973, she shifted from darkroom photography to collage with the recognition that, after the birth, collage would be more accessible and conducive to short bursts of studio time, rather than long printing sessions, and that collage would be more conducive to storytelling. The set of 30 collages is a visual journal of pictures about her sexuality, pregnancy, and subsequent miscarriage. Leonard composed the images in *Journal of a Miscarriage* with drawings made with chalk, pastel, paint, and blood from the bleeding; assemblages of imagery found in used magazines and books (including the gift of an obstetrical textbook from the doctor who took Joanne to the hospital); traditional photographs; and layers of transparent paper overlays

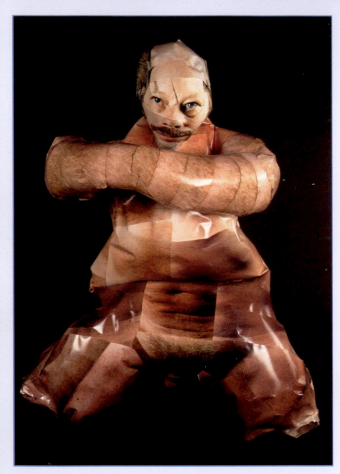

4.146 Rebekah Modrak, *Man with Bent Knees*, 2001. Color photographs, muslin, and polyester filling, 3½ × 3 × 4½ft

Rebekah Modrak experiments with photographic techniques that reveal more complexities than are visible with a single image and the static one-point perspective captured by a lens. After photographing various human anatomies, piece-by-piece, she used those fragmented parts to reconstruct the whole being – a three-dimensional photographic figure internally supported by a muslin form. The resulting photographic work consists of assembled three-dimensional bodies, Frankensteins that utilize sculpture for form and photography as a means of describing surface. Photographic collage allows Modrak to depict the tremendous detail of being a body: hair follicles and pores, moles, freckles, wrinkles, beading sweat, and imprints of watches and socks

Paper adhesives

- *PVA (Polyvinyl acetates)*: archival liquid glues to adhere paper to paper. One of the most common types of paper glues available, PVAs dilute and clean up with water, are often archival or reversible, and work best on porous materials. Because PVA is wet, it can wrinkle collage materials, so applying pressure during drying is recommended. PVA remains flexible after drying.
- *UHU stick*: an archival glue stick for paper on paper.
- *Yes! paste*: a strong, sticky paste used for paper on paper, etc. It is archival and won't stain or color your artworks.
- *Methyl cellulose*: an archival adhesive used for bookbinding and for bonding art papers together. Methyl cellulose is water soluble and thus reversible: even after the paste has dried you can apply water to detach the papers from one another. Usually sold in powder form, we recommend dissolving methyl cellulose in hot water and then adding an equal amount of cold water to form a clear, viscous solution.
- *Wheat paste*: a simple paste consisting primarily of wheat flour and water. Inexpensive and easy to make, wheat paste has been used since the 19th century to paste printed signage on billboards, buildings, and other flat surfaces. Use equal parts of flour and water, mixed to a thick solution. To use, spread paste on the back of the paper. Apply paper to a flat surface and flatten with a roller. If displaying the print outdoors, add a thin coat of paste to the front and edges of the paper to protect it from weather and peeling.
- *PMA (Positional Mounting Adhesive)*: a thin, double-sided sheet of adhesive that comes on a wax paper backing, usually sold in a roll or by the foot.
- *Weldbond*: like superglue, but with the consistency of Elmer's glue. Weldbond can join and seal nearly any material, including paper. Excellent for bonding varied objects and materials.

Other multipurpose adhesives

- *Photo Mount* and *Artist's Adhesive*: manufactured by 3M, these two spray adhesives have minimal acid content. Spray mounts are generally good for porous materials. An advantage of spray adhesives is that they can remain flexible after adherence. Some disadvantages include fast drying times, expense, and high toxicity. Anyone in proximity of the spray should wear a mask. Cover work area with paper or a tarp, as excess spray will make surfaces tacky.
- *Superglue or Crazy Glue*: these glues are good for nonporous materials. A little goes a long way. Acetone can remove excess glue.

- *Hot glues*: come in sticks. A melting gun is required. The adhesive bonds as it cools. Hot glue is especially good for 3D projects and for situations where you need to work quickly.

DIGITAL COLLAGE

Digital capabilities allow artists to mine and combine images from various sources. For example, you could scan and import appropriated found images, hand-drawn or painted text and sketches, and old photographs, magazines, and newspapers. Computers make it easy to manipulate photographs by adding and changing text, and by removing, modifying, camouflaging, and adding elements to pre-existing images. In addition, elements can be textured before being digitized. For example, you could crumple paper and magazines, cut found images, and rearrange them before scanning.

If hand-constructed and darkroom collage showcase the physical nature of materials and images, digital collage encourages more deceptive combinations. Even with overlapping disparate images from blatantly different sources, digital montage can be fairly seamless. This is mostly due to the fact that fragments come together as many pixels within the same file, and are printed as one image on a single ground. Blending elements with digital collage can be a less involved (easier and faster) process than darkroom combination. And, unlike cut-and-paste or darkroom collage, documents are not permanently altered. You can work on a copy of the original file, can make non-destructive edits on layers within a file, and can usually "undo" actions while working.

4.147 Geoff Silverstein, *The Serpent*, 2003. Mixed media, 14¼ × 33in

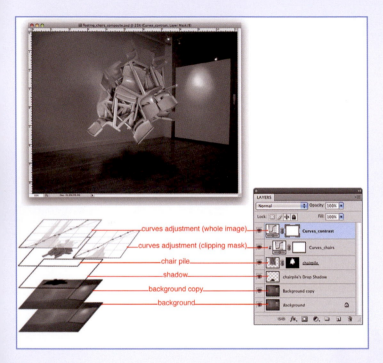

curves adjustment (whole image)
curves adjustment (clipping mask)
chair pile
shadow
background copy
background

4.148 Layer diagram showing final composite image with corresponding layer stack and layer simulation. The curves adjustment layer on the top of the stack affects all layers below. The curves adjustment layer below that affects only the chair image layer because it has been applied as a clipping mask

While hand-constructed images must be recopied to change their scale or opacity, digital editing programs such as Adobe Photoshop offer a range of tools that make it easy to change relative scale by resizing images and objects. Photoshop offers the flexibility to experiment freely by saving elements as a layer. Each layer can be moved, colored, edited, and made semi-transparent without affecting other layers. Digital collage provides ways of blending pictures through adjustments to the opacity of each layer or parts of layers.

Layers

In order to combine images, you must understand the concept of image layers—one of the most powerful features of Photoshop. A layer can be envisioned as a separate image positioned on a clear overlay. Layers are stacked on top of each other like cards in a deck. Transparent areas of the top layer allow you to see the pictures or parts of pictures in the following layers. (Figure 4.148 shows a layer stack and the corresponding composited image. Figure 4.149 shows all of the Layers panel options.) Changes made to one layer do not affect the other layers. In Photoshop, you can have an infinite number of layers. Each time you paste a selection into the image, it automatically becomes its own layer. In addition, layers can be created, copied, reordered, made semi-transparent, turned temporarily off (made invisible), attached to other layers, deleted, or modified in other ways. Layers, especially adjustment layers, increase your file size. As the file size increases, the computer takes longer to process commands. You cannot preserve layers in JPEG format. Images with layers must be saved in Photoshop or TIFF formats. You should always keep a copy of your image with the layers intact. Sometimes you may want to save another copy without layers (for printing, for a smaller-sized copy, or to send through email).

Open the Layers panel through the main menu (*Window > Layers*).

Understanding the Layers panel

- *Displaying and hiding layers*: the *Layer thumbnail* provides a small visual representation of a layer. To its left, the *Visibility icon* indicates that the layer contents are visible. To make the contents of a layer invisible, click on the visibility icon. Click again to make them visible. See Figure 4.149 for examples of hidden and visible layers.
- *Selecting a layer*: to select a layer, click on it. To select multiple layers, click on the first one to make it active and Shift-click on the second (contiguous) layer or Command-click on a second (noncontiguous) layer. In order to edit a layer, it must be *active*. Three indicators reveal which layer is currently active: the

layer will be blue, the layer thumbnail will be outlined, and the layer title will be boldfaced.

- *Moving layers*: layers are ordered in the panel from top to bottom. The top layer is the most visible in the image because opaque pixels on that layer hide pixels in the layers below. Successive layers are visible depending upon the size or opacity of layers that precede them. When you create a new layer, Photoshop places it above the active layer. To move a layer up or down in the stack, click within the layer tile and drag the tile to a new location in the panel.
- *Deleting layers*: to remove a layer, make the layer active and click on the Trash button at the bottom-right of the Layers panel, or drag the layer to the Trash button.

Layer types and characteristics

The following section describes types and characteristics of layers and how to create them. Once layers are created, they can be duplicated through the main menu (*Layer > Duplicate Layer*) or in the Layers panel menu.

Image layers These contain pictures or parts of pictures on a transparent background. (See the *chairpile* layer in Figure 4.148.) When the layer is active, the picture can be repositioned or altered without affecting other layers. Two types of image layer are: regular layers, and background layers (opaque layers that cannot be completely altered). When creating a new file through the main menu (*File > New*), check "transparent," "white," or "background color" in the Background Contents section of the New File dialog box. "Transparent" will make the background layer a regular layer. To make a background editable, convert it into a layer by double-clicking on the Background layer within the Layers panel. You can also reverse this action. Turn a layer into a Background layer through the main menu (*Layer > New > Layer from Background*). Create additional image layers by: pasting a selection into another layer; selecting *Layer > New > Layer*; or clicking on the *Create a New Layer* button in the Layers panel. Immediately when you first open a new image, always make a copy of your background layer (select the background and choose *Layer > Duplicate Layer*) and work from this to ensure that you don't inadvertently make changes to the original pixels.

Type layers Each time you click the Type tool on an image layer, Photoshop automatically creates a new layer for the text. When the layer is active, it can be reopened and edited. Figure 4.149 shows an example of a Type layer. For additional information about how to create and edit text, see "Editing: text," p. 441.

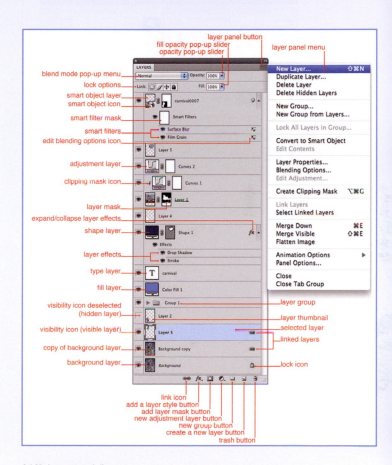

4.149 Layers panel diagram

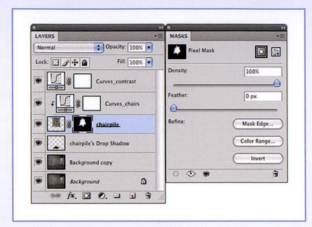

4.150 Layer masks

Layer masks These show and hide selected parts of a layer. For example, a mask can be applied to a sharpened layer so that it shows the sharpness only in the center of the image while allowing the edges to blur. To mask part of a layer, make the layer active (as shown in Figure 4.149, a selected layer becomes blue). (NOTE: a mask cannot be placed on the Background layer; you must first convert the background into a regular layer.) Next, select an area to mask and click the Add Layer Mask button on the bottom of the Layers panel to mask the selected area. In the layer mask thumbnail, black areas are portions that are hidden and white areas are revealed. (See Figure 4.149 for a layer mask.) A layer cannot have more than one image layer mask at a time. You can delete a layer mask (drag it to the Trash button) or edit it by painting with black or white and/or using filters. To bring up the Mask panel, select the Layer Mask thumbnail and choose *Window > Masks*. This panel allows you to adjust the density, feathering, and edge.

Adjustment layers These allow you to alter the color and tone of an image without affecting its pixels. The adjustment layer makes the change as a kind of filter that exists on its own layer without permanently altering the image data. As long as you do not flatten the image (*Layer > Flatten Image*) or merge the adjustment layer with other layers (*Layer > Merge Layers),* the original pixels will be unaffected and preserved. Figure 4.149 shows two curves adjustment layers—Curves 2 and Curves 1. The adjustment layer can be reopened, edited, made invisible, or deleted. Create an adjustment layer through the Adjustments panel, by selecting *Layer > New Adjustment Layer*, or by clicking on the *Create new fill or adjustment layer* icon at the bottom of the Layers panel.

Fill layers These allow you to fill a layer with a solid color, gradient, or pattern. To create a fill layer, choose *Layer > New Fill Layer* and select from Solid Color, Gradient, or Pattern. Figure 4.149 shows a fill layer titled Color Fill 1.

Working with layers
Naming and renaming layers
When you create a new layer through the menu option *Layer > New > Layer,* Photoshop will open a dialog box asking you to name the layer. Sometimes this box offers a default title, which you can keep or change. To rename a layer, double-click on the layer title in the Layers panel.

Grouping layers
You can organize layers by grouping them together. Make a group by either clicking the New Group button in the Layers panel, or choosing *Layer > New >*

Group. Now, move layers into this group by selecting them and dragging them so that your mouse hovers over the Group. Figure 4.149 shows a layer group near the bottom of the layer stack.

Linking layers
If you want the layers to remain connected, even after they are no longer selected, select them, then click the Link icon at the bottom of the Layers panel. Remove a layer from a link by selecting it and clicking the Link icon. Figure 4.149 shows these icons.

Flattening and merging layers
Layer > Flatten Image flattens all layers into one image; they can no longer be altered individually. If you are ready to flatten a few, but not all, layers, the Merge options let you flatten groups of layers. *Layer > Merge Down* combines an active layer with the one directly below in the panel. *Layer > Merge Visible* merges all visible layers (displaying the Visibility icon). *Layer > Merge Layers* merges all selected layers.

Blending layers
In the Layers panel, you can determine how opaque or transparent the layer contents will be, which affects how layers blend with one another. The *Blend Mode* pop-up menu offers a wide range of blending options. When set to *Normal*, the default mode, a layer will not affect other layers. Each of the blend modes in the Blend Mode pop-up menu has a different effect. For example, *Multiply* builds density by multiplying the base color (the color/s on layers below) by the blend color (colors of pixels on the active layer). The *Opacity pop-up sliders* affect the transparency of pixels, including layer styles. *Fill opacity* allows you to affect the opacity of pixels painted in a layer or shapes drawn on a layer without affecting the opacity of layer effects. (See the top of Figure 4.149 for examples of all of these options.)

Layer style effects
Layer style effects are effects such as shadows, glows, and bevels, which can be applied to a layer. Once you have applied a style to a layer, you can modify the contents of that layer and the style effect will change to correspond with the edit. Access the *Layer Styles* through: the main menu bar (*Layer > Layer Style*); by clicking on the *Add a Layer style* icon in the Layers panel (see Figure 4.149); or by double-clicking on the layer.

Smart Objects

Smart Objects are layers that allow for nondestructive editing by preserving the original raster or vector content of the imagery. You can import Photoshop and Illustrator files into Photoshop as Smart Objects to preserve the data without destruction. In addition, converting a layer to a Smart Object allows you to apply filters to the layer without altering pixels. You can endlessly reselect the filter and edit or delete it. To convert a layer to a Smart Object, choose *Layer > Smart Object > Convert to Smart Object*. The Smart Object Mask allows you to show and hide the smart filters applied to the layer. You cannot perform pixel-altering tasks, such as painting, cloning, dodging and burning, on a Smart Object Layer. In such cases, you must convert your layer back into a regular layer. To do so, rasterize the layer by choosing *Layer > Smart Objects > Rasterize*. Figure 4.149 shows a Smart Object Layer, Smart Object Mask, and Smart Filters (surface blur and film grain). Notice the Smart Object icon that indicates a Smart Object layer.

Clipping masks

Any layer, including fill, shape, image, type, and adjustment layers, affects the layers below it in the layer stack. Sometimes, you will find that you want to apply an adjustment only to a single layer. To make these adjustments affect the chosen image layer ONLY and not the layers below, create a *clipping mask*. To do so, create the adjustment first (although it affects all layers below it, don't worry, you will change that in a second). Then, select the adjustment layer and choose *Layer > Create Clipping Mask* OR hold down the Option key and hover your mouse over the line dividing the two layers—the adjustment layer and the image layer to be changed. When the pointer changes to two overlapping circles, click to create a clipping mask.

Making a digital collage

Here we demonstrate how to combine multiple digital images into a single image. Combining images often involves a choice between collaging separate images so that the parts are still visibly distinct and compositing images into a single composition so that the whole image appears completely or relatively seamless. In our demonstration, we bring together multiple images to create the illusion of a seamless composite. In the process, we demonstrate many tools and techniques that may be useful as you join images yourself.

STEP 1: Open image files and set image resolution and color profiles

- *The main image*: Pick an image that will be the main image for your collage OR make a new image by choosing *File > New* and entering an image size, 300

4.151 STEP 1

ppi resolution, and image background color. Under the Advanced option, set your Color Profile to Adobe RGB (1998). Make sure to make a copy of your background layer. In our example, we started with a main image of an empty gallery.

- *The supplementary images*: Change the image size of all additional images to 300 ppi. Although pasted images can be rescaled using *Edit > Transform*, it is easier to work with multiple images if they have a common image resolution. If your images are too small, rescale them (*Image > Image Size*), but be aware that too much upscaling may cause pixelation. To avoid this, begin with high-resolution images or use one of the upsampling techniques described previously in the book.

STEP 2: Place supplementary images in the main image

Bring other images into your main image. With both images open, select the Move tool and click on the incoming image and drag it into your main image. You can also choose *File > Place.* Click the Commit button to place the image.

STEP 3: Organize layers

As you import images, you will begin to accumulate many layers in your main photograph's Layers panel. To keep yourself organized, name all layers and create groups of layers.

If you want a supplementary image to appear spatially located behind some imagery and in front of other images and the background image, select areas of the images and copy and paste elements of the background to be in front. For example, if you want some grass to cover the foot of a woman who was not standing on grass in the original image, you could select and paste grass on a layer OVER the woman's foot.

STEP 4: Make a selection

You can select areas of images before bringing them into the main image, but we suggest doing this after you bring them in and using masks in lieu of removing pixels. The collage/composite process relies on experimentation and is very organic; masks allow the flexibility to change the parts of the image you show and hide as you see how the images overlay and integrate. Over the next two steps, we will show how to apply a mask using a selection.

Getting a good selection is imperative so that the image edges are not distracting in the final composition. Select part of an image with a selection tool. Choose Refine Edge in the selection options bar and adjust the Feather value, the

4.15 STEP 2

4.153 STEP 4

4.154 STEP 5

4.155 STEP 7

smooth value, and expand or contract. From the view mode options at the bottom of the dialog box, select either black or white, depending on the lightness of the other images behind this one. Black will place your selected area against an all-black background. White will place it against an all-white background. Save this selection to be used later if need be. Choose *Select > Save Selection*. To reload this selection later, choose *Select > Load Selection*. In this step, we made a selection of the chair pile using a combination of selection tools.

STEP 5: Apply a mask to hide parts of the original image

Now that you have selected the area of the image that should remain visible in the final composition, click on the *Add Layer Mask* button at the bottom of the Layers panel. Doing so specifies that your selection will remain visible and all of the rest of the image will be hidden with a layer mask.

Once you create the mask, you may notice that the edges of your masked image are too noticeable, too sharp, or too soft. If so, alter the layer mask by painting with black or white or the blur tool on the edges. Alternatively, delete your layer mask (drag the mask to the Trash button); reload your selection (choose *Select > Load Selection*); or adjust this selection to try again (change feather value, contract or expand, or redraw). Once you have a new selection, make a new mask by clicking on the Add Layer Mask button at the bottom of the Layers panel.

STEP 6: Edit images: scale, distort perspective, and warp

Images brought into the main photograph may have an incorrect perspective in relation to the main image. For example, our chair pile was too large for the scene, so we used *Edit > Transform > Scale* to shrink the image. You can also adjust the perspective using the other Transform functions. Choose *Edit > Transform > Skew* and pull on the marquee boxes to correct the image perspective. To stretch the image, select *Edit > Transform > Distort*. Use other options in the *Transform* command to help images fit in with their new surroundings: Scale, Rotate, Skew, Distort, Perspective, Warp, Flip Horizontal and Vertical all alter the spatial orientation of the image. Free Transform allows you to manipulate the image by dragging its corners. Each transformation can be applied to a selection or to an entire layer.

STEP 7: Edit images: lighten, darken, reduce contrast, and alter color with clipping masks

Once images are brought into the main composition, you may notice that they seem lighter, darker, have more or less contrast, or have a different color cast than

the main image. Use adjustment layers such as Curves, Levels, Color Balance, or Hue/Saturation to edit color and tone. To make these adjustments affect the chosen image layer ONLY, and not the layers below it as well, we will create a *clipping mask*.

First, create the adjustment (although it affects all layers below it, don't worry, you will change that in a second). Then, select the adjustment layer and choose *Layer > Create Clipping Mask* OR hold down the Option key and hover your mouse over the line dividing the two layers—the adjustment layer and the image layer to be changed. When the pointer changes to two overlapping circles, click to create a clipping mask. In our example, we applied a Curves adjustment layer (*Curves_chairs*) to the chair-pile layer and converted it to a clipping mask so that it only affected that layer. We applied a second Curves adjustment layer (*Curves_contrast*) to the overall image.

4.156 STEP 8

STEP 8: Create or remove shadows

To *remove* shadows, you can use retouching tools such as the Patch tool and Healing Brush tool to meld pixels of un-shadowed areas onto the shadow. To *create* simple shadows you can paint with a soft black brush on a new layer, then switch the blend mode of the layer to Multiply (to allow the texture from the layers below to come through), and then lower the opacity of that layer to make the shadows less pronounced.

To make more elaborate shadows with more complicated silhouettes, create a drop shadow and warp it. First, select the layer for which you want to create a shadow. For example, when making a shadow for the chairs, we chose the *chairpile* layer. Click on the *Add a Layer Style* icon at the bottom of the Layers panel and select Drop Shadow from the pop-up menu OR choose *Layer > Layer Style > Drop Shadow*. Leave all default options as they are (you can change them later) and click *OK*.

STEP 9: Move drop shadow to a new layer

You will notice that, below your layer, you now have a Layer style effect listed as "Drop Shadow." Unfortunately, this drop shadow can only simulate shadows falling against a back wall, and the light in our image is falling down toward the floor. We must edit (move, warp, distort, and color adjust) the drop shadow further to make it consistent with our direction of light. To do this, we will separate the drop shadow from the chair pile by detaching it from the layer so that it becomes its own layer. To detach it from the layer, Control-click on the Drop Shadow style effect tile and choose Create Layer from the drop-down menu that appears. Click *OK*.

4.157 STEP 9

4.158 STEP 10. Sarah Buckius, *Impossible Sculpture*, 2009. Digital photograph composite, 8 × 10in

 4.3

STEP 10: Adjust shadow shape and tone

Your drop shadow now resides on a new layer below your original layer and has the default blend mode of Multiply and fill of 75%. Adjust the opacity of the layer to make the shadow lighter. You will now (most likely) need to warp the shadow to fit with the direction of the light in your main image. Choose an appropriate transformation tool under *Edit > Transform*. Apply blur to this layer (*Filter > Blur > Gaussian Blur*) to make the shadow edges softer and more realistic.

USING TEXT WITH PHOTOGRAPHS

As Bill Anthes describes in his essay *Text and Image*, words and graphic elements can be efficient tools in conjunction with photographic imagery. Words play a crucial role in shaping the meanings that image-makers want to send. Testimony, in the form of type, can personalize, alter, or confirm the story behind an image. Words can reinforce the truthfulness of the imagery, intentionally point out contradiction, or introduce a new theme that brings unexpected ideas to the piece. Furthermore, artists may use words as imagery to emphasize the formal properties of communication. When working with text and pictures, think through the goals of your language, type, and imagery, and how they work together to communicate as a whole. Create forms of typography by scanning, photographing, and collaging diverse and appropriate sources. Experimentation is the key to discovering what works.

TYPE

Type may include hand lettering, or movable type in printed or electronic form. Typefaces are classified into two forms: *Humanist* letterforms modeled on calligraphy and script; and the more abstract and mechanized *Transitional* or *Modern* forms. The typeface used (whether handwritten or typographic) indicates much about the message and the author of those words. Even before a reader digests the meaning of words, they use the typeface to identify the voice of the text, the projected author of the work, and the tone with which they speak.

When strung together, letters create words or sentences that elicit meanings for viewers and readers. The hierarchy of those letters and words, based on graphic cues or spatial indicators, helps to support and emphasize varying degrees of importance within the content. A character may be deemed more or less significant through choices of font, height, width, boldface, scale, and color. A series of letters can be distinguished through the use of proportion, spacing, indention, and

alignment. These tools help to ensure that a reader notices particular details. When working with type, take into account:

- *legibility*, i.e. whether your text should be legible as words with meaning or not.
- *kerning*, the amount of space between each individual character.
- *tracking,* the amount of uniform space between characters in a block or range of text (as in an entire word or paragraph).
- *leading*, the amount of vertical space between lines of text.

Consider whether rows of text line up vertically or horizontally with one another and think about the effect of using uppercase or lowercase letters for added weight or de-emphasis.

Integrating type and imagery

The way the type is integrated within or outside of the image indicates the significance of that information. For example, captions are often seen as less important than the photograph, while images surrounded by a lot of text may seem ornamental. When working with text and images simultaneously, consider what job each has in telling a complete story. Do the text and images express similar or conflicting ideas and do they compete for attention when juxtaposed? Consider the size, color, location, and weight of the text in relation to photographic elements, in order to emphasize or de-emphasize one meaning over the other. Do the type, graphic elements, and imagery share any visual properties? How does the composition imply movement and/or inertia in order to give dynamism or weight to a given idea?

The following sections describe different materials and tools for working with type, from ways of applying text to imagery (handwriting, stenciling, rub-on, or adhesive-back type), to printing type with imagery in the darkroom, to combining type and pictures using image-editing software.

HANDMADE AND ALTERNATIVE TYPESETTING

If you want to apply text directly to an image, consider analog processes such as handwriting, rub-on text, vinyl letters, and stenciling. These types of text have their own built-in idiosyncrasies that can become virtues in your artwork.

Handwriting

Handwriting is one of the most direct ways to apply text. Depending upon the type of lettering, handwriting can have the character of an intimate diary (cursive

4.159 Ben Van Dyke, *GEO*, 2005. Digital photograph, 8½ × 5½in

writing), an angry outburst (a scrawl), a bureaucratic label (all-caps block text), or many other personalities. The media used (ink, pencil, paint, etc.) help to determine the character of the writing. Glossy or plastic papers may only accept ink, and sometimes only particular types of ink, such as Sharpie markers.

Stenciling and stamping

Create *stenciled* text by cutting a letter or series of letters out of cardboard or laminate. Paint through the negative space left behind onto another surface. The generic, anonymous look of stencils gives little information about the author. Stenciled text often conveys a mark of authority. Graffiti artists make use of these connotations and the reproductive ease of stenciling by making their own stencils in order to reproduce the same image in many locations. As a result, stencils are now equally associated with acts of rebellion. You can purchase stencils at office supply stores, or make your own by printing or drawing the letter(s) on paper and then reinforcing the paper by gluing it on heavier board or by laminating the image. Traditionally, spray paint is a quick and inexpensive means of stenciling, though chalk, ink, marker, and pastels may be used. When applying your stencil to the image, make sure it is as flat against the surface as possible to keep paint from leaking under the edges and to keep lines crisp.

Stamps are carvings of letters that can be pressed into ink or paint and then stamped onto paper or other materials. You can purchase rubber or foam stamp sets in a variety of fonts and sizes at hobby, craft, and office supply stores, or make your own by carving foam, potatoes, or other materials.

Transfer or rub-on letters

Transfer letters, aka *rub-on* letters, are printed on sheets of adhesive-backed transparency. All the letters of the alphabet (plus multiples of some letters) in a single font and size will be printed on one sheet of film. Apply a letter by pressing the inked side of the film to the new surface/material and burnishing the top (non-inked side) of the letter until it transfers from the film to the paper underneath. Use a hard, blunt burnisher such as a spoon to rub the text onto the material. The advantage of rub-on text is the ability to directly apply text to surfaces and materials that cannot be run through a digital printer. The disadvantage is that a range of fonts can only be purchased online and that you could run out of frequently used letters. You can find a wide variety of rub-on fonts online, and basic fonts, such as Helvetica, at office supply stores.

Vinyl letters

Vinyl letters have an adhesive back. They peel off their wax paper and can be pressed onto any surface. They are available in a wider variety of sizes, fonts, and

4.160 Transfer or rub-on letters

4.161 To make this image, the artist placed black stick-on letters onto a transparency to create a mask for the words "pretend it's fun." She exposed the negative of the woman's forehead for 3 seconds, then placed the mask over the paper and exposed the image for another 10 seconds

colors than the rub-on type, but can be harder to apply because they are relatively sticky. You can purchase vinyl letters at most office supply stores.

CREATING TEXT IN THE DARKROOM

When printing in the darkroom, you can print text as a caption in the margins of the image or within the picture (as opposed to applying it to the paper after printing). There are many ways to print type in the darkroom, from photographing the letters and sandwiching that frame with the image negative, to scratching the letters into a negative. You can also create a mask that blocks out areas of light to create the words.

Working with a mask

A mask is a piece of thick cardboard or transparency placed between the projected image and the photographic paper to allow only controlled areas of light to pass through to the paper. The opaque areas of a mask prevent light from reaching the paper. Clear areas of the mask allow light to pass through and expose the print. These areas of the final print will be exposed, gray or black, depending upon the amount of exposure and the density of the mask. A mask can be made through a reductive process, i.e., beginning with thick cardboard and cutting letters out of the board. Or it can be additive, i.e., a transparent base that is painted, printed, or covered with hand-cut, vinyl, or stenciled letters.

INTEGRATING TEXT AND IMAGES DIGITALLY

Working with words and images digitally provides endless opportunities for altering, morphing, resizing, varying color, layering, and copying type. While Photoshop offers a wide variety of fonts, styles, special effects, and type-formatting options, consider integrating and manipulating handmade text (drawings, paintings, etc.), found print sources (newspapers, magazines, posters, etc.), scanned artifacts (wooden letter blocks, signage, ceramic tiled letters), and photographs of type, with digital type or effects. Type found in hardware or grocery stores, in toy bins, or on the back of an historical postcard, etc., or constructed from materials such as grass or gum drops, can be scanned or photographed. Recognizing the potential of type and imagery from multiple sources will yield a more individual voice. Imagine how to integrate text and image before beginning the work, and then use the tools to serve your needs.

Once sources are digitized, digital editing techniques can be used to vary size and spacing, to wrap words around images, to create characters out of photographs, and to add filters, effects, and drop shadows. Working digitally with text

4.162 Ben Van Dyke, *Penny Stamps Distinguished Visitors Series*, 2005. Digital print, 16 × 24in.

To create this poster, Van Dyke assembled several sources, including scanned paper letters ("University of Michigan School of Art & Design") that produced idiosyncratic shadows during the scanning process, a friend's handwriting that Van Dyke collected in all characters, photographs, scanned postage stamps, and even a rake (whose fan directs us to the list of speakers). In yellowish-green on the left, Van Dyke uses a photograph of the lecture theater's "Aisle" sign to form an arch that balances the right-side swing of the rake. The postage and rubber stamps within this dynamic machine play upon the sponsor's name, "Stamps," while the overall form communicates the hum and buzz of many guests within one stimulating system

offers incredible flexibility and opportunity for invention; creating type as a layer allows for endless manipulations without changing other elements of the image.

Type layers

The Horizontal Type tool and Vertical Type tool in the Tools panel allow you to create text on a type layer. When either of these tools is selected, you can create text by clicking on the image and typing, or by clicking within the image and dragging out a text frame (which you can then type within). Clicking creates *Point Type*, in which each line of text is independent. Dragging creates *Paragraph Type*, in which the characters wrap to fit the frame or bounding box. Reshape the box by dragging the corner or edge handles. Convert from Point to Paragraph (or vice versa) through *Layer > Type > Convert to Paragraph Text / Point Text*. Once you have created a text layer, you can reopen the text frame for revision by double-clicking on the type layer's thumbnail icon in the Layer panel or by clicking on top of the text itself with the Type tool. You can also make changes within the Character panel, such as font or type size, without opening the text frame. Just make sure the Type tool is active, the type layer highlighted, and make any desired changes.

Text formatting

Formatting involves making changes to one or more characters or to rows of text. You will find settings (font, font style, alignment, and color) in the options bar, the Character panel (*Window > Character*), and the Paragraph panel (*Window > Paragraph*). Additionally, as the type exists as a layer, you can use any of the features in the Layer Styles (*Layer > Layer Style*). These are some of the features offered in the Type options bar, Character panel, and Paragraph panel:

- *alignment*: aligns text against the top, bottom, sides, or middle of the page.
- *anti-aliasing*: partly fills the edge pixels to create smoother edges.
- *baseline shift*: raises or lowers type from its baseline to create superscripts or subscripts.
- *change text orientation*: changes orientation of selected text from horizontal to vertical (or vice versa).
- *color*: controls type color.
- *create warped text*: warps text with choice of style, type of orientation, and degree of distortion.
- *faux styles*: offers the option of making a font italic if this style does not exist in the style menu.
- *font family*: each font name is displayed as a sample of that typeface.

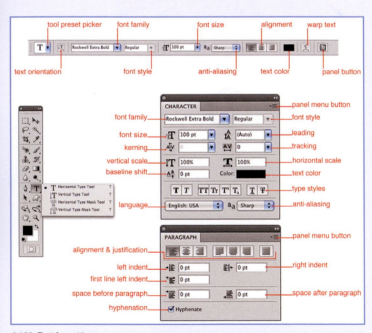

4.163 Text formatting

- *horizontal scale*: compresses or expands characters in width (unscaled characters have a value of 100%).
- *justification*: aligns text up with both the left and right edges of a page.
- *kerning*: the amount of space between each individual character.
- *leading*: the amount of vertical space between lines of text.
- *left, right, and first-line indents*: the amount of space between type and the frame that contains the type.
- *tracking*: the amount of uniform space between characters in a block or range of text (as in an entire word or paragraph).
- *vertical scale*: compresses or expands characters in height (unscaled characters have a value of 100%).

SPECIAL TECHNIQUES FOR WORKING DIGITALLY WITH TYPE AND IMAGE

Working with words and pictures inventively involves knowing how to manipulate text and images. Two helpful tools are clipping masks, which can be used to fill text with images, and the warp command. In the following example, we warp the text "CHICKEN BBQ" to fit around the chickens and then fill the type with a scanned flowery fabric.

In Photoshop, text layers are vector graphics, meaning that they are composed of vectors, or geometric shapes, such as lines and curves, defined by mathematical equations. Digital images that are made up of pixels (digital photographs) are raster graphics. In order to warp text as we do in this demonstration, you must first create the text, and then convert the vector-based text to raster-based pixels, a process called rasterization.

Manipulating type: Creating type to fit around or within imagery

STEP 1: Add text to your image

Open the image that will house the final text and the image that will fill the text. If you are working with two different images, remember that if the two images are not the same resolution size, there will be scale shifts when you paste the text. In our demonstration here, we will be creating text from the scanned fabric (on the right in Figure 4.165).

In your main image, select the Horizontal or Vertical Type tool. Choose the font, style, size, and other character attributes in the options bar or Character panel. Place the type cursor in the image in the approximate location the type will be.

4.164 Sarah Buckius, poster, 2009, 20 × 25 in

4.165 STEP 1

Click and begin typing your first word or letter. In this example, we made each individual letter a separate type layer so that we could warp them individually. Once you have typed all characters, make any necessary changes to your words by selecting the text and then adjusting the options in the Character panel. If you want to shift the words on the image, select the Move tool and drag the text to the correct location.

STEP 2: Apply automated warping options to the text

To warp the text in prescribed ways, make sure the type layer is selected, and choose *Layer > Type > Warp Text*. A dialog box will open giving you several options for warping. Text warped in this manner does not provide the ability to squeeze and contort to fit perfectly around other shapes. For us, we need to be able to maneuver the type to fit into a more particular space, so we are going to use a different method, shown in Step 3.

STEP 3: Use customized text warping

This method involves rasterizing and warping the type. To convert the type layer into a standard raster layer, select the layer and then choose *Layer > Rasterize > Type*.

To warp the letter or word on a layer, select the layer and then choose *Edit > Transform > Warp*, and a mesh will appear over your text. The mesh has control point handles that can be dragged in order to warp the letter or word. Drag the control points to warp each letter or word. When the letter is sufficiently warped, press Return or click Commit in the options bar. Repeat the steps above for each new letter or word that you add.

STEP 4: Merge letter layers

Merge the layers of all letters that will be used to place the image within. To merge layers, hold down the Command key and select all the layers with letters you want to include. The layers will become blue when they are selected.

Then choose *Layer > Merge Layers*.

Using a clipping mask to fill type with photographs

STEP 5: Import the photograph that will fill the text

We will now bring the scanned image (the flowery fabric) into the main image (the text with chicken). Select the Move tool. Click inside the image that will be placed

4.166 STEP 2

4.167 STEP 3

4.168 STEP 4: After merging layers

4.169

inside the type (in our case, this is the fabric). Drag your mouse onto the main image (the chicken image). The image will be transferred onto a new layer in the main image.

Activate the layer you just dragged in. In the Layers panel, drag this new layer so that it is ABOVE the text layer in the layer stack.

STEP 6: Apply a clipping mask

Press the Option key and hover your mouse between the two layers (the text layer and the image layer). When you line the mouse up with the line dividing the two layers, an icon with two intersecting circles will appear. When it does, click your mouse and release the Option key. (Or select the new layer, and choose *Layer > Create Clipping Mask*.) This will create a clipping mask that dictates that the image on this layer only affects the pixels on the layer below. Because the only pixels on this bottom layer are the text shapes, they are the only ones filled with the image. The clipping mask is marked in the layer stack with a little downward arrow that points from the image layer to the text layer below.

4.170 STEP 5

PRESENTATION

THE BOOK

A book is an intimate way of viewing images. An *artist book* is created as a work of art in its own right (rather than as a way to display pre-existing works). All aspects of an artist's book—form, content, and layout—are considered simultaneously and in support of one another. A *monograph*, or portfolio book, is a means of presenting pre-existing works and can be approached as a kind of exhibition. All books are time-based, and some are sequential, offering artists an opportunity to create a narrative or excursion for their readers to explore. Familiarity with various book-binding techniques enables an artist to determine the form along with the content, a distinct difference from purchasing a blank book and trying to adapt one's work to that vessel. "Print on demand" offers the opportunity to create side-sewn and perfect-bound books as artworks, or for presentation or documentation purposes. In this section, we describe the basic parts of a book, two simple types of binding, and print on demand options.

4.171 STEP 6

Artist's books

In *The Century of Artists' Books*, Johanna Drucker proposes that there is no single definition of an artist book. A deck of cards, a zine (a photocopied magazine), illustrated books, and high-quality printed monographs are all part of the genre.

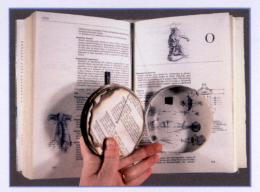

@ 4.6 Refer to our web resources to learn to bind using the pamphlet stitch, a simple way of binding folded pages (often as an alternative to stapling), and for instructions for building a portfolio for presenting and protecting photographs.

📖 **4.4**

4.172 Wendy Shaw Arslan, *Altered Book*, 2000

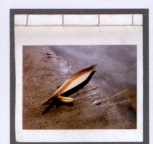
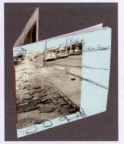

4.173 Julia Farina, *Puddle Crossing*, 2005, side-stitch book

4.174 Julia Farina, *Streetlevel Surname*, 2005, pamphlet stitch book

4.175 Julia Farina, *In Gitta's Head*, 2005, accordion book

Artist books can be produced as multiples, constructed and sold for little or no money. They can serve as an alternative to a gallery exhibition. The artist book in this sense proliferated in the 1960s as part of a larger initiative to make art accessible to a broader and larger audience. Not all artist books, however, are made for such democratic purposes. For example, Wendy Shaw Arslan started with a mass-produced book, but transformed it with image transfers and carvings, into a one-of-a-kind work (Figure 4.172).

Styles of book

The binding of a book determines how the book will be read. A booklet of pages sewn down the side (side-stitched) is usually read from front to back. This flow emphasizes a linear narrative. Conversely, the accordion bind allows all images and pages to be seen at once. Each of the binding techniques described here—the side-stitch and accordion binding—can be modified or adapted to suit varying needs.

Our recommended sources for bookbinding describe variations of these techniques. Whichever form you choose, figure out the layout, placement of pages and holes, and the stitching using a practice version.

Parts of a book and bookbinding terms

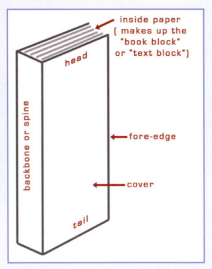

inside paper [makes up the "book block" or "text block"]

head

backbone or spine

fore-edge

cover

tail

4.176 Book parts

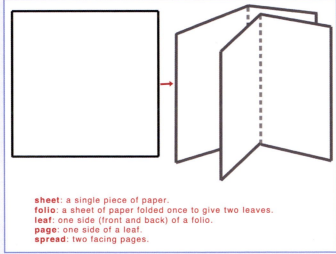

sheet: a single piece of paper.
folio: a sheet of paper folded once to give two leaves.
leaf: one side (front and back) of a folio.
page: one side of a leaf.
spread: two facing pages.

4.177 Internal description

Bookbinding tools and materials

- *cutting tools:* scissors, Xacto knife.
- *measuring tools:* ruler or straight-edge.
- *drawing tools:* pencil and eraser.
- *creasing tool:* a single stroke with a *bone folder* gives a fold a permanent crease. In lieu of a bone folder, you can use a stainless-steel table knife with a non-serrated edge, a popsicle stick, or a ruler.
- *piercing tool:* a *binder's awl* is a tool that can be used to pierce holes for sewn bindings. Any needle that has a shaft with a constant diameter (the shaft does not widen farther away from the point) can be used. The shaft should also be slightly smaller than the diameter of the needle used for sewing. Other sources of piercing instruments are *nails* or a small *electric drill bit* (which works well for piercing large stacks of paper).
- *needle:* a bookbinder's needle, or any needle with an eye large enough to take thread or floss. The diameter of the needle should be slightly larger than the diameter of the piercing tool.
- *binding thread:* waxed linen thread, embroidery floss, or dental floss.
- *paste:* archival PVA bookbinding glue will not yellow or age paper and board.

Constructing a side-stitch book

The side-stitch is a general name for a bookform that is also referred to as side-sewn or Japanese 4-hole binding. The book consists of single or several folded sheets inside a front and back cover, bound together by sewing in and around the book so that the simple, elegant lines of thread are visible. The spine is uncovered.

The form was originally used in China and Japan, as a way to bind paper whose ink drawings had soaked through the page. In order to hide the ink-stained back of the paper, it was folded and bound with the crease on the outside so the inside of the fold was not accessible. The form is also a good way to bind single leaves and can be a good presentation solution for a series of images made before binding was considered as an option. The main considerations will be paper weight (with this binding, lighter is better), the number of sheets (the thicker the book, the better the binding thread looks), and image layout (you will lose approximately ¾ inch of paper on the side that is bound).

Tools, materials, and equipment

Paper (light- or medium-weight flexible paper is fine, and can be single sheets or folded); cover (must be of flexible material—could be single sheets of medium-weight paper, cloth, or wallpaper, or light-weight paper folded in half); needle; medium-weight thread (three times the length of the spine); knife; scissors; piercing tool; straight-edge or ruler; creasing tool; pencil.

4.178 Bone folder

4.179 A binder's awl

4.180 Needle

4.181 Thread

4.182 Glue

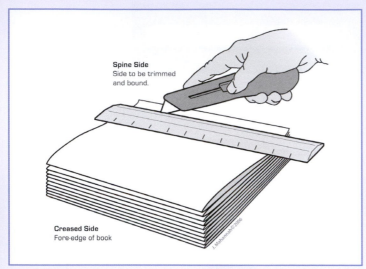

4.183 Trim the stack of folded pages on the spine-side edge

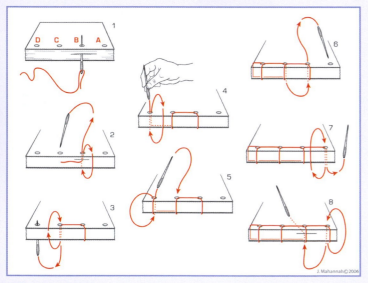

4.184 Side-stitch steps

Assemble pages

Make sure all pages are the same size. If using folded paper, crease the fold with the creasing tool. Stack all pages in order. If pages are folded, the creased side should be on the fore-edge (not the spine) of the book. If necessary, trim the stack on the spine-side edge. Cut two cover sheets to the same size as the paper and place one on the top and one on bottom of the stack. The papers and cover must be clamped in place to prevent the stack from moving when holes are drilled for binding. If the stack shifts, the holes will not line up properly. To prevent shifting, clamp the stack with hardware clamps or bulldog or paper clips.

Binding

In our example, we used linen thread to bind the pages, but embroidery thread, ribbon, or bookbinding screws could be used as well. Along the spine of the book, ⅜ inch from the edge, place two pencil dots—one of them ½ inch from the head of the book and the other ½ inch from the tail. Measure the distance between those two dots and divide that number by three. Place the remaining two dots at equal thirds from one another between these two holes. Each dot will be a *stitching hole* or *sewing station*. Using the piercing tool, punch holes through each of the marked dots. (The holes shown in Figure 4.184 are much bigger than they should be, for illustration purposes.)

Thread the needle with a single thickness (no knot). The first stitch is unusual in that it begins by pushing the needle into the *middle* of the stack of pages by station **B**, and up out of hole **B**. Push the needle through station **B**, leaving a 2-inch tail of thread tucked *inside* the book. Now bring the needle around the outside of the spine and back up through station **B**, then take the needle over to station **C**. Continue the stitches using the diagram (Figure 4.184). Upon reaching station **B** again at the end, open the book to the middle page with the loose tail. Bring the needle through station **B** to the middle page and tie a knot.

Constructing an accordion book

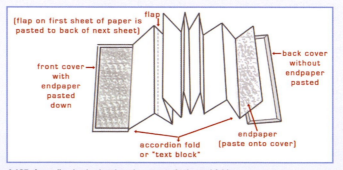

4.185 Accordion book, showing placement of tabs and folds

An accordion book is a long scroll, folded back and forth like the bellows of an accordion. There are many variations of accordion binding. For example, the first and last sheets can be attached to separate boards or to a cover that wraps around the compact folded scroll (called a *flutter book*). The binding determines whether the pages can be read in two directions, front and back, and whether they can be extended to be seen as one long scroll and contracted to be seen as discrete units, or seen *only* as separate sections. The variation described here is the *orihon* structure, accordion-folded paper bound between two separate covers.

The ability to open up the accordion and read the front and back as two panoramic images makes this binding unique. Extending the book to its full length gives the object a sculptural quality and invites juxtaposition. For example, the book *In Gitta's Head* (see Figure 4.189) is compiled from a Dutch photographic comic book. One storyline is on the front side of the book and a second is on the back.

Tools, materials, and equipment

Paper (can be light- to medium-weight, and can be one long strip folded many times or several strips pasted together); cover (medium-weight paper or heavy board—here, we use chipboard); paper to wrap around cover board (heavy board covers can be wrapped first with lightweight paper); Xacto knife; scissors; straight-edge or ruler; creasing tool; paste; pencil.

Assemble pages

Page assembly will depend upon whether you use one long piece of paper or several small pages. In both instances, the first consideration is the number of pages. If using an even number of pages, the book will have a definite front and back; if using an odd number of pages, the book will have no distinguishable front and back (aside from text, cover page, or any other indications you may choose to give).

If using one sheet of paper, it should be cut to the desired height. The length should be one page width times the number of pages in total (including two pages to serve as endpapers that will be attached to the covers). An example: if each book page will be 8 inches wide and there will be 7 pages in the text block and 2 endpapers, the total length of the paper should be 8 × 9 = 72 inches long. Folding the paper is the most difficult step because each fold must line up with the others. Fold the entire sheet of paper in half horizontally. Use a creasing tool to crease the edges. Open the paper and fold each end into the center crease. If you want smaller pages, continue to fold into the creases until the entire sheet is evenly folded. Open the paper and fold back and forth along the creases accordion-style.

If using many sheets of paper, paste them together to achieve the same length. The earliest accordion books were joined without concern for where the joints fell.

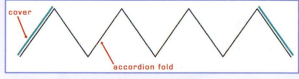

4.186 Single sheet of paper accordion fold, with first and last pages attached to cover boards

4.187 Cover paper wrapped around cover board, viewed from the back

4.188 Endpaper covering back of cover board

4.189 Open accordion book. Julia Farina, *In Gitta's Head*, 2005

📖 **4.5**

More recent techniques place the joints at the page folds so as not to interrupt the contents. To join pages, include a ½-inch flap on one end of each sheet of paper. If the book is very long, alternate joints (on the fore- and spine-edges) so that one side of the book is not fatter than the other. The first and last pages will need a flap or a full sheet of paper to attach to the cover. Fold all flaps and use a creasing tool to crease the edges. Place the folded pages on top of one another so that they fold back and forth, and use the paste to adhere each flap to the back of the next page.

Attaching the pages to the cover

The cover board can be the same size as a folded inner page, or slightly larger. In our example it is ¼ inch higher and wider. The first and last pages of the accordion book can be attached as endpapers to the cover. Prepare the cover board by wrapping it with paper. Then, attach the text block to the back of the cover. If using flaps, paste endpapers (here, white paper) the same size as the inner pages over the back of the board. These endpapers cover the folded edges of the cover paper and the flaps of the inner paper.

Print on demand (making and printing a book using online services)

Print on demand (POD), also known as publish on demand, is a book production technology that allows users to create and print one or more copies of a book that is professionally bound (usually perfect-binding or side-stitch). With print on demand, you have complete control over the design. Create the book, upload the digital file to the self-publishing site, and order as many copies as you want. While you hold copyright to the book, most sites offer the choice of keeping the book private (only you can order it) or public (others can order it, with you potentially earning a profit).

Designing a book on Blurb.com

Many print on demand businesses, such as Lulu.com or Qoop.com, leave the work of designing the book to you. You create the book, save it in a particular format (e.g. a PDF or Word document) and upload the file to the site.

Blurb.com excels at high design and print quality. To create a book with Blurb, download their BookSmart software, which contains professionally designed page layouts. Once in the software, choose the size, format (landscape or portrait), softcover or hardcover. Indicate whether you want to create the book from scratch or use one of the layout options, such as portfolio or photobook. Even in the pre-existing layouts, you will still have the opportunity to edit image containers and

text boxes. The left panel of the BookSmart interface offers various layout options. For example, there are over a dozen options for the Cover Layout alone (some with the title located horizontally or vertically, some with photos, some without); Title Layouts provide options for the title pages; Picture Layouts provide over 90 ways of formatting the page. Alter an existing layout by selecting Edit Layout from the options bar.

The best way to size images to precisely fit a BookSmart image frame (without cropping the image) is to use their recommendations for optimal photo size for a given image container. To do this, choose a page layout. Hover your cursor over an image container to see the pop-up tool noting the "optimal photo size" for that frame. In Photoshop, adjust your image to these preferred pixel dimensions (we plug the pixel dimensions into the Crop tool, but you could also use Image > *Image Size*). Make sure your images are between 150 and 300 dpi, and JPG or PNG format. Then, upload your image files and drag and drop the photos into the image containers.

MOUNTING, MATTING, AND FRAMING

Photographic prints that will be hung on a wall or placed in a portfolio can be shown in a variety of ways. Prints can be trimmed and then tacked to the wall, or placed in a box or portfolio. This direct style of presentation places emphasis on the print as a piece of paper and an image to be communicated rather than as a Work of Art. Mounting, matting, or framing the print asks the viewer to consider the image more as an object and as a substantial artwork. A backing board, window border, or sheet of glass gives the image weight, importance (in that it needs to be protected from buckling and exposure to light and dirt) and defined edges. The use of archival, acid-free materials (i.e. mounting and mat boards, tapes, and adhesives) protects the artworks from exposure to contaminants that would cause staining or deterioration. This is referred to as conservation framing.

The artist who wants to create or order a custom frame is faced with myriad choices of molding (the frame material; sometimes spelled *moulding*), glazing (the glass or plexiglas), and board and frame color and size. The following section describes the different processes involved in mounting, matting, glazing, and framing, and the distinct connotations each defines for the image and artwork. These techniques can all be accomplished yourself, with the right tools and a little practice.

For a price, commercial framing is available. If you require the expertise of a frame shop but have a small budget, do most of the framing yourself but pay to have professionals cut the window mat or dry-mount a large print.

4.190 Spread of the book *Enter, have a good idea of what you want and where it's located: shopdrop this book!*, 2009. Made using Blurb BookSmart software. The photograph on the right is Rebecca Straub's *Still Life in Kroger*, 2008

4.191 Spread of Kim Beck's artist book, *The Grass is Greener*, 2008–2009, shown here within the interface of Blurb's BookSmart software

4.7 Refer to our web resources for more information about materials for matting, mounting and framing, and for instructions on dry-mounting, mounting with photo corners, hinge mounting, window matting, laminates, and front mounts.

4.192 Bleed mount

4.193 Border mount

Mounting

To protect your photograph from bending or wrinkling, to prepare it for framing, or to keep it stiff while hanging on the wall, it is necessary to mount your photograph on a rigid backing. *Mounting* implies adhering a print to a backboard. There are three main techniques:

1 The print is completely adhered to the board using the *dry-mount* process.
2 The print is held in place on the board with *photo corners*.
3 The print is held in place at points with *hinge mounts*.

If you choose to mount the photograph to a backboard without a window mat, then the print should be attached in such a way that the adhesive does not show (e.g. with dry-mount tissue or folded hinge mounts).

The *dry-mount* process remains a common method of adhering photographs to backing because it is inexpensive, easy, and elegant. The process uses heat-activated adhesive tissue sandwiched between the photograph and a stiff backing board. A dry-mounted photograph can be bleed-mounted, that is, it can extend to the board's edges, or it may rest within the spatial border of a larger board. This adhesive technique works well for fiber, RC, and digital prints, regardless of whether the photograph is to be matted or framed, or to stand alone with the backing.

Unless specially noted, however, dry-mounting materials are not considered archival: after several decades, acid from standard materials may cause visible damage to your prints. Although it contains acid, the lifespan of the most common dry-mount material—Color Mount—is long enough for many artists. For archival purposes, use an acid-free dry-mount tissue like Buffer Mount.

Although certain dry-mount tissues, including Buffer Mount, can be removed from an artwork, this is a difficult process: dry-mounting is considered an irreversible mounting technique. The most common mounting alternative—which does not require trimming, adhering, or otherwise altering the photo—is to use a set of *photo corners*. These are triangular pockets, adhered to a backing board, each of which holds the corner of a rectangular photograph. The advantage of photo corners is that photographs can be easily inserted and removed: corners make it easy to switch photographs in and out of mats and frames. Since photo corners cradle and cover the corners of the photograph, they are not ideal for borderless pictures, but work wonderfully for holding a photograph behind a window mat.

Prints can also be attached to a board with a *hinge mount*; the methods we recommend involve taping the print into place with T-hinges (aka pendant or tab hinges) or *folded hinges*. A folded hinge is tucked out of sight under the print: a

good option if you want to *float the print* (to show the edges of the paper within the window mat). For archival purposes, conservators use either linen tape or hinges made of Japanese paper with 100% kozo fibers and cooked starch paste. When archival materials are used to make T- or folded hinges, the hinge (and print) can be easily removed from the board if necessary. Other types of tapes and adhesives (such as cellophane or masking tape, rubber cement, and glue sticks, etc.) will lose their adhesive powers over time and will leave a residue that stains the artwork.

Matting

A *front* or *window mat* is a piece of board with a cutout window, through which the photograph is viewed. The print is mounted to the backboard and the window and backboard are hinged together with paper tape.

The mat's border around the image, often white, separates the image from its surrounding environment, providing a clean viewing field, free from distraction. A window mat can selectively display the photograph: the window can open onto only part of the photo, thus cropping the image while leaving the photograph whole. Alternatively, you can display portions of a photograph's printed borders under a window mat or float the photograph by exposing the print's edges within the window of the mat using a hinge mount.

When used in a frame, the mat keeps the photograph from touching—and adhering to—the frame's glass. Unlike other presentation techniques, matting can be done entirely with archival materials and it is easily reversed (i.e. matted photographs can be removed leaving their presentation materials untarnished). Another advantage of the window mat is that, in case a photograph is handled frequently—as with a portfolio for private viewing—viewers touch the mat rather than the photograph.

Glazing and framing

Once a print is mounted and/or matted, you can place it in a portfolio, hang it on the wall (with or without glass), or frame and hang the work. If you are particular about the type of wood or frame design, you can build your own. Wooden, plastic, or metal commercial frames are available through art supply and home furnishing stores and frame shops.

CONSTRUCTING A LIGHT BOX

A light box is a box with a light inside and a pane of frosted glass over the light. Initially, these boxes were used for viewing and organizing slides or negatives, but they are now commonly used to display commercial or artistic photographs

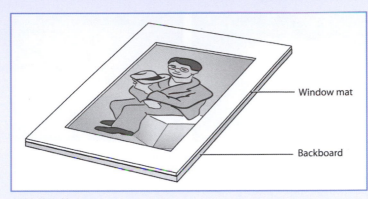

4.194 Matted image

 4.6

4.195, 4.196, and 4.197 Mary Kate Heisler, *Beach Finds Catalog 2006*, 2006. Light box with slides, 8½ × 6¾ × 7 in. Views of drawer, slide, and light in drawer (covered with plexiglas with frosted vellum)

4.198 and 4.199 Step 1: Test to see what box depth works best for your particular piece of plexiglas. Plug in the light fixtures and hold the plexiglas over them. By raising and lowering the glass you can measure the point at which the bars of light disappear and become evenly dispersed light. With our piece of plexiglas the light began to diffuse at 4 inches, so we chose a 6-inch overall box depth

4.200 and 4.201 Step 2: Whether you choose to glue, nail, or screw the corners of the box together, use two clamps long enough to hold the pieces together while you work. This makes proper alignment of the corners easier, and allows you to drill pilot holes accurately for the nails or screws

4.202 and 4.203 Step 3: Attach the boards with screws. Once the fasteners are in, cover the heads with wood putty now, so that the putty is dry and sandable when it is time to paint

printed on transparency, as with works by Jeff Wall and Kota Ezawa. Backlighting the photograph by mounting it on a light box makes the image glow (like seeing an image on a computer monitor) and accentuates rich color and detail. The following instructions describe how to build a light box from scratch. You can also turn an existing box into a light box.

Materials
- *Plexiglas*: One piece of ¼-inch white plexiglas (semi-transparent). The outside dimensions of the plexiglas should be an ⅛ inch smaller than the inside dimensions of your box.
- *Fluorescent light fixtures*: In the demonstration below, two 16-inch tubes were used, which ran along the 21-inch side of the box. You need enough tubes to ensure that the light reaches all surfaces of the plexiglas evenly. If the light box is very big, you may need more than two tubes; if smaller, you may need only one.
- *Wood or board for sides of box*: In this example, the light box will be painted, so we use medium density fiberboard (MDF) for its smooth, paintable surface. Particle board would also work. If you wish to finish the box with stain or clear sealer, choose wood. Lumber yards carry standard dimensions of wood that will probably fit your needs. For example, an 8-foot length of 1 × 6-inch wood would work well, as a good size for a light box is about 18 × 24 inches—you can cut each of the four pieces you would need for these sides from the 8-foot length. Keep in mind that the lumber is kiln dried (no need to use green or pressure treated lumber) and that, in the US, 1 × 6-inch stock typically measures about ¾ × 5¾-inch when you get it.
- *Other wood*: ¾-inch plywood for the back of the box; four ⅜-inch wood strips for the front inside edge of the box.
- *Other materials*: nails, glue or screws, wood putty, primer and paint or stain, adhesive caulk, and pencil.
- *Tools*: Electric drill, saw to cut planks and strips to length, two clamps, and a measuring device.

PHOTOGRAPHY ON THE INTERNET

The Internet, with its capacity to reach a global audience, has become a common place to show or use photography as an artform. Artists manage and share photographs online, display their work in web portfolios and home pages, and use images in interactive web projects. The following section discusses these three online processes: How to use a photo-sharing site to store, organize, and publicly present your photographs; How to create a web portfolio on a home page as a

means of presenting images of artworks; and How to create web-based artworks using photographs. The distinction here is that, in the first two cases, you will be uploading images of pre-existing artworks for display on the Internet. In the third demonstration, we will explore how images can be created for web-based projects that are meant to be seen via a monitor and navigated by an online browser. In this case, the monitor is not a secondary viewing setting, but the primary medium.

4.204 Step 4: Inset four strips of wood near the front edge of the box. Almost any size strip will do, and in this case we nailed ⅜ × ⅜-inch pieces about ¼ inch from the top edge. These are the *stop strips*. The plexiglas will be installed from behind and will press against these strips after the box is painted

4.205 and 4.206 Step 5: After measuring the box's interior dimensions, cut a piece of ¾-inch plywood for the back – just slightly under your measurements. The back panel should slide into the box snugly but without much fuss. This back will keep the box square and will accept the mounting screws for the light fixtures. Secure the lights to the backboard. Drill a hole in the back of the box with a spade bit large enough to pass the cord end through

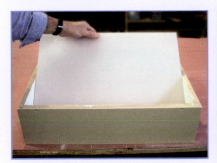

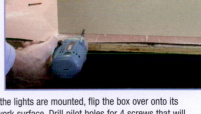

4.207 and 4.208 Step 6: Prime and paint, sanding lightly between coats. Since wood primer is usually white, coat the inside and the back of the box as well, to help bounce and diffuse the light. Allow to dry. With the face of the box down, put the plexiglas in with a weight of some kind placed in the center. This will keep it tightly pressed against the stop strips while the adhesive caulk sets and secures it in place. An alternative to caulk would be to nail or glue small blocks up against the backside of the glass

4.209 and 4.210 Step 7: Once the caulk is cured and the lights are mounted, flip the box over onto its plywood back so that everything is resting flat on the work surface. Drill pilot holes for 4 screws that will attach the box to its back. These screws will remain visible since they may need to be removed later for bulb replacement

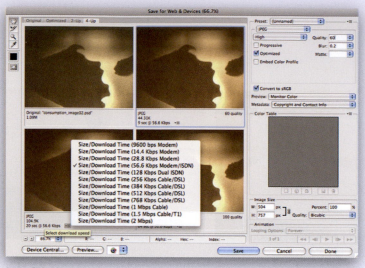

4.211 Sizing for the Internet

Preparing images for the web

In order to display images online, they should be resaved as copies made for online purposes. In the process, you will be able to compress the image, convert the file to the appropriate format, and convert the color space from the Adobe RGB (1998) to sRGB. If you want the image to load quickly online, compression will reduce the file size for easy webpage viewing. Saving images to a different file format compresses the file size. GIF (Graphic Interchange Format) is good for graphics, not as good for photographs. PNG (Portable Network Graphics) is a newer file format option that is good for web imagery. JPEG (Joint Photographic Experts Group) is the most popular choice for online photographs.

To save images for the web in Photoshop, choose *File > Save for Web & Devices*. In the dialog box that opens, select the 2-Up or 4-Up tab to compare the original file with one (2-Up) or three (4-Up) options for the new image. In the Preset menu, choose one of the JPEG options OR customize by choosing JPEG in the Optimized File Format menu. Pick a quality level (e.g. High) from the Compression Quality menu. Uncheck Progressive and Embed Color Profile. Change the Blur value to decrease the visibility of artifacts from compression. Check Convert to sRGB. You can select metadata to append to the file, such as Copyright and Contact Info. Check Optimized.

Look at the difference between the optimized images and the original image. Click on the optimized image that you prefer. Click *Save*. Photoshop will create a copy of the image at the smaller file size.

 4.7

Photo sharing and online photo albums

Since the invention of photography, artists have documented their lives and surroundings and shared these photographs with others. Now, with the Internet, photo sharing reaches a wider audience—a global one. Artists can share their images simultaneously with friends and strangers living around the world. Photo-sharing sites allow artists to showcase work to a large audience, without having to develop a personal website.

Photo-sharing sites allow image-makers to connect with others to form groups and communities of users with common interests. For example, users may share image creation techniques ("how to change a Holga camera into a pinhole camera"), and form groups related to common subject matter and interests (such as "hdr" or "festival" or "photojournalism"). There are forums for discussion, links to groups you can join, and filters to find popular or recent photos and highly visited members.

With the global proliferation of images, you might be worried about protecting the rights and visibility of your images. Sites allow you to determine who sees your photos, and who can post comments or add notes and tags. They may also

provide settings to control licensing of your images for others' use. If you are particularly concerned about others downloading and using your images in ways other than online viewing, only upload images with a low resolution.

When choosing a photo-sharing site, consider options such as:

1 Price (some are free, others charge a fee).
2 Capacity (number of images that can be uploaded and/or viewed).
3 Design (layout and graphics, size of image display, clutter of interface, ability to zoom in and out of images).
4 Community (comment sections, ability to tag photos, user groups, discussion forums).
5 Upload process (from camera phone, from hard drive, from iPhoto, from Lightroom, batch photo uploading).
6 Sharing capabilities (send emails, post on Facebook).
7 Photo printing services (ordering prints and other merchandise online).

Creating a personalized webpage to showcase work

A personalized webpage is a great opportunity to control how your work is viewed, to easily (and inexpensively) present your work to others, and to have your work discovered by new audiences. A variety of programs are available to set up webpages. Some allow you to select from pre-designed templates, including Adobe Photoshop/Bridge, Adobe Lightroom, and Apple's iWeb. Other programs, such as Dreamweaver and Flash, require you to design the website entirely from scratch.

In order to publish your site on the Internet, you will need a web address. A web address is supplied by a hosting company (at a monthly/yearly fee) or, if you are a student, your educational institution may provide you with a free server address and directory. To find a hosting provider, search online for "web hosting services."

In the following steps, we describe the process of creating a webpage using iWeb '09. Our demonstration features artist Heidi Kumao's *Cinema Machines*, which she made out of film, motor, mirrors, record, fan, light, bulb, and recycled furniture between 1991 and 1999.

STEP 1: Choose an iWeb template and page style

Save the images for your web portfolio (convert the images to JPEGs in sRGB color mode at 72 ppi). Place these files in a folder.

Open iWeb. When iWeb opens, the interface presents various template options (black, white, watercolor, modern, etc.) and page styles (photos, about me, blog,

4.212 Screen capture of a page from John Baird's flickr profile

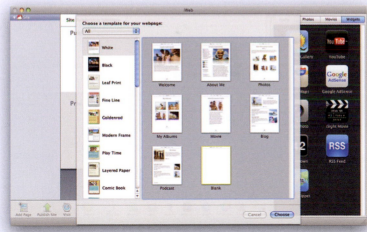

4.213 STEP 1

4.214 STEP 2

4.215 STEP 2

4.216 STEP 3

my albums, blank, etc.). We want to make our own design, so we choose the White template with a Blank page style option.

STEP 2: Navigating iWeb

iWeb now displays a default template with a text box. If you had chosen a different layout style, there might be image placeholders as well. A navigation menu runs along the top of our blank canvas. It currently shows one navigation button (titled Blank), which is the link to one page in this site. As we add pages (*File > New Page*), they will show up as buttons along that navigation bar. Browsers may click on any one of those text buttons to go to that page (for example, the "home" page, the "biography" page, and so on). We want browsers to navigate by clicking on thumbnails along the bottom, so we hide the navigation menu by unchecking *Display navigation menu* in the Page tab of the Inspector (a dialog box for adjusting design and formatting).

The sidebar runs along the left of the dialog box and lists any websites you have created and their internal pages. At any point, you can rename a site by selecting the word "site" in the left sidebar and typing in a new name. We renamed our "blank" page. (In future steps, you will see it called "home" in the sidebar.) An options bar at the bottom of the blank canvas provides options for adding text boxes, drawing shapes, changing the theme, adjusting images, altering fonts and colors, and accessing the Inspector. You can delete any text or image boxes by selecting them and pressing the Delete key on the keyboard.

Open the Inspector by clicking on this button in the options bar. Here, you can rename the site and make it password protected, rename the page, choose from image options such as slideshow and download size, edit the type's font and size and the page's background color, edit shapes that you draw in iWeb (such as rectangles, lines, circles, etc.), and turn a word or an image into a hyperlink that links to another website or another page on this site.

In our example, the default layout size was 700 × 480 pixels. While the default measurements are recommended because all browsers can view the page in this size, we want a slightly wider page, so we change the width (that determines how much space the layout will encompass) to 900 × 480 pixels in the Layout tab of the Inspector.

STEP 3: Enter text and draw shapes

Next, we'll modify the text within this page from "Text" to "HEIDI KUMAO." To do so, click on the text on the template page and type in new words. Now we want to move the text, so we click and drag that text box to the left side of the page. In the Text tab of the Inspector, we change the color of the text to dark gray. In the Fonts option in the options bar, we change the font and size.

We are now ready to place our images. We could do this right away, but first we want to create a frame or border to outline the main image space. In the Shapes option in the options bar, we choose a rectangle. We use it to draw a rectangle in the space, then open up the Graphic tab in the Inspector and choose none for *Fill* and gray in the *Stroke* menu. We set the line width for 0.75 pt. Once you've made a shape, you can move it by clicking and dragging.

STEP 4: Import images

To import your images, open the folder with those files on your desktop, select the images, and drag them onto the page in iWeb. Move the images anywhere on the page by clicking and dragging. Rescale them by selecting the image and dragging the handles (although keep in mind that up-scaling them might cause some pixelation). In our site, we imported an image into our main frame. We also imported several images and scaled them down to become thumbnails at the bottom of the page.

STEP 5: Add text boxes and adjust text size and spacing

Insert text boxes by choosing Text Box from the options bar. Click on the page and drag to make a text box. Type into the box, or copy (Command-C) and paste (Command-V) text, as we did in this example where we copied and pasted Kumao's artist statement text into a text box. Make the font size larger by visually assessing the size, selecting the text box and pressing Command + + (or smaller: Command + –). Change the font style, color, or the numerical size of the font through the Fonts option in the options bar.

STEP 6: Make new pages

Most websites have several pages that link to a main page, or home page. The page that we have created thus far will be our home page and we will create separate pages that link to this one to showcase each of Kumao's individual works. The thumbnails along the bottom will become hyperlinks. We must make separate pages so that when a viewer clicks on the thumbnail a new page will open up. As all of the pages will have the same design, we can select the title "HEIDI KUMAO" and the gray rectangle and copy and paste them to each new page.

To create a new page, choose *File > New Page*. Choose a template. In our site, all pages should look the same, so we choose a White Blank layout. Rename the page. We uncheck *Display navigation menu* in the Page tab of the Inspector. Next, we delete the default text box and paste in the title HEIDI KUMAO and the gray rectangle. Into the main frame we import the image of her work that should

4.217 STEP 5

4.218 STEP 6

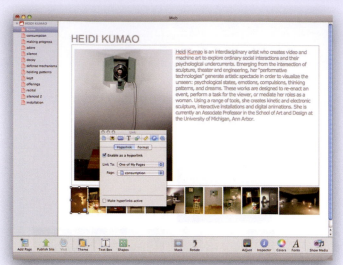

4.219 STEP 7

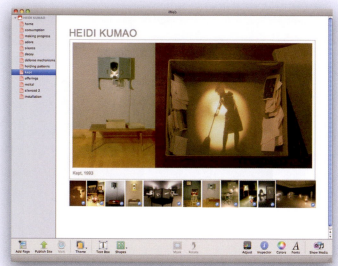

4.220 STEP 7

appear larger in that page and add a title below the image. We don't yet paste the thumbnails below. We repeat these steps for all pages; our site now has several new pages listed in the sidebar.

STEP 7: Link thumbnails to pages
Now, we will link each thumbnail to the new page. Select "home" in the sidebar to open the home page. Click on the thumbnail that corresponds to the page you are about to link. We start with the first thumbnail on the left. In the Hyperlink tab of the Inspector, click on *Enable as a hyperlink*. For Link To, choose *One of My Pages* (you could choose to link to another website, in which case you would choose *An External Page* in this drop-down box). For Page, choose the appropriate page name. Now, when a user clicks on this thumbnail, the corresponding page will open. Repeat these steps to create hyperlinks for all the thumbnails.

Now copy and paste all the thumbnails (with the links applied) to all the pages so that viewers can navigate from one page to any other page.

STEP 8: Link all titles to the home page
Now, we will link each title ("HEIDI KUMAO") to the home page, so that, for example, if someone is viewing image #5 and wants to return to the home page, they can click on HEIDI KUMAO. Select the first page after the home page. Click on the text box with your title. In the Hyperlink tab of the Inspector, click on *Enable as a hyperlink*. For Link To, choose *One of My Pages*. For Page, choose the home page. Repeat these steps for all pages.

STEP 9: Publish your site
Once you have set up your site, you must publish the page to make it visible on the Internet. Click the Publish button at the bottom of the interface. iWeb allows you to publish to a local folder (for viewing on your computer or later upload to your web server) or through an FTP server. After being published, your site is stored on your computer. To access the website files that iWeb creates when it publishes, go to your desktop's menu bar. Choose *Go > iDisk > My iDisk > Web > Sites > YOURSITENAME*. The files inside the YOURSITENAME folder are the files that you must upload to your web server (often done using an FTP program). If you want to edit your site in the future, simply open iWeb and your site will be listed on the sidebar. You must republish and re-upload your site each time you make a change to it.

Creating web-based artworks using photographs
Some artists make images expressly for web-based projects that are meant to be seen via a monitor and, usually, navigated by an online browser. In this case, the

monitor is not a secondary viewing setting, but the ideal exhibition venue. Digitized for the web, photographs join other forms of media, such as sound, animation, hypertext, graphics, and video. In many cases, the works are interactive. Rather than presenting a series of still images that can be scrolled through or animated to appear as a movie, Internet artists build photographic images into complex, participatory systems that change the relationship between artist, artwork, and audience. The formerly passive viewer is now asked to make decisions about content, or to create and alter the work.

Artists such as Mark Amerika and Yael Kanarek have created web projects that are major works. Mark Amerika is known for his new-media works on the web as well as in galleries and museums. Amerika carries the concept of hypertext through his work to connect images, text, and video. Works such as *Filmtext 2.0* (www.markamerika.com/filmtext) are often related to network technology and how it changes the human individual. Yael Kanarek is well known for her ongoing online project *World of Awe*. *World of Awe* is presented through the false interface of a semi-functional laptop, which contains computer-generated image albums and diary entries from a forsaken, sandy planet (http://www.worldofawe.net).

Truth and fiction on the Internet

On the Internet, information and imagery sometimes offer precarious truths. In some cases, these manipulations present ethical problems. For example, the Reuters news service published Lebanese freelance photographer Adnan Hajj's doctored images of the 2006 Israel–Lebanon conflict on their news websites. Bloggers who inspected the photograph discovered that Hajj had added an additional plume of smoke to the burning ruins from an Israeli air attack on Beirut. Digital software had enabled Hajj to replicate existing data so that the destruction in the image appeared more devastating and dramatic. By presenting altered photographs as objective journalistic documentation of actual events, Hajj violated the ethical tenants of the press (http://news.bbc.co.uk/2/hi/middle_east/5254838.stm). In contrast, artist websites may invent whatever fiction they deem necessary to pose certain questions or to challenge particular authorities.

Artist projects that use the Internet to create a context for images often take advantage of the fact that photographs can be faked, and that there is no way to monitor or authenticate information on the web. This serves as a rich conceptual territory for artists to examine the line between fiction and fact in today's visual culture. For example, *The Museum of Jurassic Technology* (http://www.mjt.org), the creation of David and Diana Wilson, has an online component that presents pseudo-historical information in the form of text and images. Each online exhibit tells a unique story, such as the account of an African ant compelled to climb heavenward after breathing in a spore of a particular fungus. Like the actual

4.221 Screen shot of page 13 of Chris Landau's web-based work, *The Flocking Party*, 2005, Flash and Photoshop. http://www.theflockingparty.com/

 4.8

 4.9

museum, located in Los Angeles, California, each exhibit causes the viewer to question their perception of "real" artifacts through the lens of museum presentation.

Artist Chris Landau describes his online story, *The Flocking Party*, as "a multilinear, online story. Set in the future, a researcher's findings about infected birds are revealed to us through a fictitious electronic journal. The birds' heightened cognitive ability (due to their infection) reminds us of our own capacity for cultural evolution and alters our perception of the relationship between nature and technology" (http://www.theflockingparty.com).

ANIMATING PHOTOGRAPHS

While several computer programs turn still photographic images into animated films, the process is also possible through simple handheld devices. The following sections describe how to create animations by constructing basic optical toys, popular in the 19th century. The thaumatrope, flip book, and zoetrope depend on the persistence of vision to blend individual images, thereby creating the illusion of continuous motion.

The thaumatrope

The thaumatrope or "wonder turner" is considered to be the first form of animation. The optical device consists of two images, one on each side of a card. By rotating the card with string, the viewer superimposes the two images into a single picture. First made popular in 1825 by Dr. John Paris in London, the device applies the principle of persistence of vision: the eye retains an image for roughly 1/20 of a second after the object is not in sight. With the thaumatrope, the eye continues to see both images simultaneously as they spin back and forth.

Originally, thaumatropes revealed visual puns, gags, or silly surprises. One of the first thaumatropes shows a bird on one side of the disc and an empty birdcage on the other. When rotated, the bird appears to be in the cage. Most images combined in this way complete one another.

Materials

You can construct a thaumatrope with two photographic or drawn images (which will be placed back to back). In addition to the images, you will need:

- Heavyweight photo paper or cardstock for printing the photos.
- A hole punch and (optionally) grommets to protect the holes.
- Fishing line, rubber bands, yarn, or string (the string must be round, not flat, for smooth rotation between your fingers).

Image shape and size

Circular or elliptical cards rotate more easily, but squares or rectangles work too. Smaller thaumatropes, less than 4 inches wide, produce smoother rotations. However, they also make it harder to see details. If the image is more detailed, use a larger image and card size.

Image design

Thaumatropes from the past were simple drawings with crisp, distinct lines or silhouettes against a sparsely detailed background. For the illusion to work, well defined, high contrast images with blocks of color and thick lines work best. If your picture has a lot of detail, surround the flip-side image with white space, as in our example (Figure 4.222). Cut out or digitally remove background areas that only distract from the illusion. Pairings that encircle one another, such as the bird in a cage, or that fit together, such as a man riding a horse, work best. Images that should superimpose should be placed close to the rotation axis, where the illusion is the strongest.

Construction

Print or collage each of the two images on a separate piece of heavyweight paper or cardstock. Cut the cardstock into the shape of the thaumatrope card. Attach the images to each other using tape or glue so that they are back to back. *One image should be right-side up and the other upside down*. Make sure that the images are well lined up, or the illusion will not succeed.

To ensure that the axis of rotation is centered, punch holes on both ends of the thaumatrope on the central horizontal axis. You may add grommets to the holes to strengthen them and to resist wear and tear. Tie the string through the holes to create the handles. To operate, spin the thaumatrope by holding the string between your thumb and first finger and twirl the disk rapidly.

The zoetrope

A *zoetrope* is a drum with sequential animation stills facing inward around the circumference. The viewer peers through equally spaced viewing slots toward the images on the opposite wall. An open top allows light to enter and illuminate the images. As the drum spins, the slits provide broken views of the drawings or photographs, creating a strobe effect and the illusion of a moving image.

The Chinese inventor Ting Huan invented the device in AD 180. His version hung over a lamp and would turn from the hot-air currents that the lamp produced. In the Western world, the zoetrope was reinvented in 1834 by the British mathematician William George Horner (1786–1837). He called his invention the "daedalum" or "Wheel of the Devil." Forgotten for 30 years, the animation machine was finally

4.222 Zenobie Cornille, New Zealand, *Post no bills*, 2009. Front and back of thaumatrope. Drawings and digital photographs printed on photo paper, 2 × 4in

4.223 Chris Landau, *Flap-Trope*, 2006. Zoetrope and animation sequence

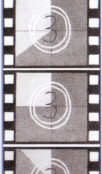

4.8 Refer to our web resources for detailed instructions on building a zoetrope drum and animation strips.

4.224 Betsy Peters, detail of *Kiss*, 2009, photographic flip book

4.225 Betsy Peters, *Kiss*, 2009, photographic flip book

patented in England by M. Bradley and in America by William F. Lincoln and dubbed the "zoetrope," Greek for "turning zoo" or "wheel of life," similar to the thaumatrope.

In 1980, independent filmmaker Bill Brand created a *linear zoetrope* in a subway platform in Brooklyn, New York. When the train passed through the station, viewers inside the cars would see a moving image through the window of the train. Capitalizing on this idea in 2001, entrepreneur and astrophysicist Joshua Spodek turned Brand's linear zoetrope into an advertising scheme for subways all over the world. These advertisements are approximately 500 meters long and 30 seconds in duration. They use illuminated transparencies with a photographic quality that, when animated, looks just like high-definition video.

Artist Chris Landau created the image sequence *Flap-Trope*, in which "the bird forces herself in and out of the animated scene in an impossible, never-ending loop." In our web resources, we follow Chris's methods for creating the zoetrope and animation stills.

These instructions can be altered for your own purposes.

The flip book

A flip book is a simple way to animate images. Also referred to as flick books or folioscopes, flip books can be approached as small films, with similar considerations of direction, scenery, and lighting. The sound of the fluttering pages mimics the sound of a film reel turning, and the rectangular format is similar to a film screen. Unlike video or film animations, the flip book turns the viewer into the animator. The viewer brings the still images to life, controls the speed (by shuffling through slowly or quickly), and the orientation (by viewing the action forwards and backwards).

Flip books have often been used as a kind of artist book, producible in multiples that can be cheaply distributed in venues beyond the gallery. The Dutch artist Jan Voss draws upon Dutch economy and the harnessing of windpower in his *Frischer Wind*. The flipping animates an image of an electric fan, while also creating the breeze and a sound reminiscent of rotating blades. Conrad Gleber's *Raising a Family* begins with a blank page and, as you flip the book, the group portrait of an average family slowly rises from the bottom. Betsy Peters's *Kiss* uses photography to create the illusion that a kiss empowers a girl to levitate and, once airborne, spin around her paramour.

You can make your own flip book by taking pictures with a film or digital camera, printing the images in a darkroom or on a digital printer, and binding the stills into a book.

Before shooting

Choose your subject and the action. Stop animation, the process of taking a photograph, moving the subject or camera, and taking another picture, enables the impossible. You can produce the illusion that objects have moved on their own or that they have moved in ways not possible with limitations of gravity and inertia. Actions can become excruciatingly slow, or faster than normally possible. Consider what can be achieved through a flip book that would not be possible with video.

Once you have chosen the players and the action, make choices of composition and vantage point. How does the action begin, move, and end in relation to the viewer? Will the image be horizontal or vertical? How is the page composed and how does the composition shift along with the action? Bear in mind that imagery closer to the binding may be harder to view, while elements by the edge of the page will be most visible. Consider how lighting frames or hides the subject and affects the mood of the scene throughout the sequence. How do colors, shadows, highlights, and tones direct our attention?

Shooting

On average, flip books contain anywhere from 40 to 80 pages. The three most important choices in shooting are vantage point, focus/depth of field, and speed of motion.

Vantage refers to the camera's proximity to the subject and the angle of view. This can be stable or change throughout the process of shooting. Remember that the camera lens represents the eyes of the viewer, so movement or stability on the part of the lens will affect the viewer's own passage through the animation. Whatever you choose, be consistent when composing shots so that one action (whether on the part of the camera or the subject) leads smoothly into the next. You may want to mark the scene with chalk or tape before or during shooting to keep track of movement, especially if shooting over several days. If using a digital camera, you can use the LCD screen Playback to confirm the composition of different elements in the scene.

When thinking about the camera/subject relationship, consider these options:

- The camera position stays the same while the subject moves. In the final flip book animation, this gives the viewer the impression of watching the action.
- The subject stays in place while the camera rotates or moves around. In the final flip book animation, this gives the viewer the impression of making the action by moving around the subject.
- Both camera and subject move.

4.226 Betsy Peters, detail of *Kiss*, 2009, photographic flip book

How much you move the camera or subject between shots will affect the *speed of motion*. By playing with speed, you can extend or reduce time. A slow buildup of shots stretches out the action, allowing the viewer to examine the movement. For example, while in real life it takes only a fraction of a second to turn your head 90°, a flip book can extend that movement to 2 seconds. In contrast, it may take 10 minutes to braid hair, but a flip book can condense the action down to several seconds. More important parts of a sequence may require more shots with less movement between each, while less significant scenes may need fewer shots and more movement between each frame. Whatever you choose, keep track of how much the subject or camera moves between shots.

Pay attention to the point of focus in each frame. Many digital-camera "continuous shoot" features do not work well because the lens does not refocus on a moving subject between frames. You can preview and verify the success of the animation by quickly scrolling through the digital LCD screen playback.

Once you have processed the film or downloaded the digital files to your computer, you are ready to prepare the images for printing.

Printing film images in the darkroom

In the darkroom, several negatives can be printed at once by using a 4x5-inch negative carrier to enlarge two strips at once. Make sure to give each image a margin of at least 2 inches on one side for binding. We recommend printing on a single-weight semi-gloss paper.

Editing and arranging digital images for printing

Digital animation stills can be manipulated to remove distracting elements of the scene or to create shallow depth of field. At the minimum, the images will need to be resized. In Photoshop, you can open each image separately and resize it to the necessary dimensions for printing. Fortunately, Photoshop's *Actions* allows you to record the steps necessary for a given task and then apply this as an Action to other images with one simple click. Even easier, use *Batch Processing* to apply the Action to a folder of images.

To begin, we recommend duplicating the folder of images. Work with the duplicates so that you preserve the original files. It is preferable to work from the computer's hard drive since you will be dealing with multiple files.

Recording and playing actions

STEP 1: Create a new action
Open the image that you want to resize. Open the Actions panel *(Windows > Actions)*. Click on the *Create New Action* button on the bottom of the panel.

STEP 2: Name your action

In the New Action dialog box, name the action you are creating. If you want to be able to access this action with the function keys, assign a key in the Function Key menu and commands. Click *Record* and Photoshop will begin recording your actions. Note that the Record button is now lit (red) in the Actions panel. Every action you make from this point will be recorded until you click the square *Stop Playing/Recording* button (bottom left in the panel).

STEP 3: Resize the image

Choose *Image > Image Size*. Resize the image. We recommend resizing by deselecting Resample Image, choosing a resolution that will meet your printer needs (300 ppi for most inkjet printers) and then checking *Resample Image* and specifying the document width and height. For our document size, we chose the width (2 inches) and then let the height be assigned proportionally.

Once you have resized the image, click the *OK* button. Then, in the Actions panel, click the Stop button to end the recording process. Under the name of your action (here, "resize flipbook"), you can see all of the details of the steps you have recorded.

STEP 4: Play the action

Open the next flip book image to be resized. Play your action by selecting that action in the Actions panel and clicking on the *Play Selection* button at the bottom of the panel. Photoshop immediately resizes the image to the flip book size.

Photoshop will automate the process further. Instead of applying the action to each image individually, you can subject a folder of images to the Action using Batch Processing. Photoshop will open, resize, save and close each photo separately.

Batch processing

STEP 1: Open Batch dialog box

Choose *File > Automate > Batch*. In the Batch dialog box, choose the Action title in the Action pop-up menu. (Here, we've chosen "resize flipbook".) This Action will be applied to an entire folder of images. Under Source, choose *Folder*. Then click *Choose* to find the folder containing your images. Once the folder is highlighted, click *Choose* in the Source pop-up menu.

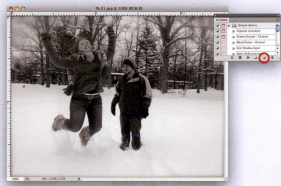

4.227 STEP 1

4.228 STEP 2

4.229 STEP 3

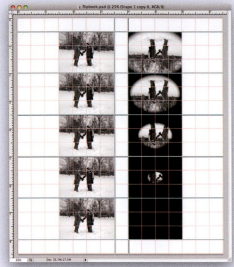

4.230 Betsy Peters, flip book layout

4.231 Betsy Peters, detail of *Kiss*, 2009

STEP 2: Set Batch preferences

Notice that that folder's name now appears in the Source portion of the dialog box. Now, under Destination, tell Batch Processing what to do with the images once they've been altered. Since we are not working from original files, we choose Save and Close. If working from original files, you can have the images saved, renamed, and placed in a completely different folder. When you're done, click *OK* at the top of the dialog box and Photoshop will automatically open, resize, close, and save all images.

Image layout

Once you have resized the images, align them for printing on an 8½ x 11-inch page within Photoshop. The resolution of the layout document must match the resolution of your individual images (in our example, 300 ppi) so that you do not need to resize the images again as you place them in the document. When laying out the 80 or more different shots, consider duplicating frames in order to extend or repeat an action. When flipping, the thumb tends to skip over the final pages in a book. Consider adding duplicate frames of the final images.

Before placing images in your Photoshop document, set up a grid in *Photoshop > Preferences > Guides, Grids & Slices*. We created a grid with red lines every ½ inch. Choose *View > Show > Grid* to make the grid visible. Then, drag Guides from the Ruler to help images snap into place (*View > Show > Guides*). When placing images, leave a 2-inch margin for binding on the edge of the layout. The margin is usually to the left of the image, but this will vary depending on composition and orientation. You may want to add thin, light lines over the gridlines so you have visible lines in the print for easy and exact trimming.

Printing

Print the flip book on white paper. The paper weight will affect the speed of the flip, with heavier papers flipping slow and lightweight papers flipping faster. Sixty-pound paper is recommended. The paper surface will affect both the color and the saturation of the image and the flip quality. Sometimes glossy papers tend to stick together.

Cutting and binding the images

Trim the prints so that each is exactly the same size with a 2-inch margin on one side. Bind the flip book using rubber bands, bulldog clips, glue, or professional binding. We recommend the clips as an easy way to secure the stack. The wire part of the clip can be removed once the metal is secure, though this makes it more difficult to redo the binding if necessary.

Stack the prints and tap the flip-edge on a table to even those edges into one smooth surface. Shift slightly at an angle to create a slightly slanted edge for easier flipping. Holding this edge in place, secure the clip on the binding edge.

EVALUATION

Critique strategies

You have just completed an image (or a series of images):

- Are they good?
- Who can answer that?
- Is that the question?

Giving and receiving functional and productive critiques is a skill set that extends far beyond facile evaluation. Critiques have myriad forms and formats and uses—several of these are discussed in this section. Ideally, a solid critique offers critical feedback sufficient to continue a project/practice actively. Reassurance, praise, condemnation, comparison are only useful as part of substantive feedback that allows remarks and insights to have specific impact on comprehension and growth.

This section considers a number of different scenarios for the critique from an individual looking at their own in-progress work, or presenting that work to a group of peers or a group of strangers.

Critique methods

A critique is an exchange of ideas, questions, observations, and impressions generated by creative work, which may address form, concepts, production, theory, and iconography. This process may take place between two or more people or can be an internal questioning dialog between artwork and artist. A continual practice of critical appraisal refines form and ideas. Keeping this seemingly simple definition in mind, the forms and specifics of critiques vary considerably, based on the questions inherent to the work, the ability of those present to look and listen, and the tangential concerns that arise in the course of the conversation.

To make a clear distinction between a critique and a casual conversation, critiques often use a rigorous formal language to carefully inspect the work being discussed. Terry Barrett has written extensively on the critique form. In his books *Criticizing Art* and *Criticizing Photographs*, he considers several aspects of the critique process, including description, interpretation, and evaluation/judgment. Discussion of the following steps (description, interpretation, and evaluation)

is derived from many of his writings, which are listed in our Critique Strategies resources.

Description should be a conscious and necessary stage. Go through an inventory of naming what you are looking at. Nothing is too obvious to skip over in this stage—from size, to color, to identification of forms. Description allows us to pause and register all of the components of a work. These are facts and proper nouns, elements that exist visibly in the work. Description helps us to pay attention to detail. Be rigorous with your definitions of description—those elements that are visual, technical, and verifiable can be described at this stage, but be wary of creeping qualifiers that amplify description—terms such as *strong* lines, *beautiful* forms, or *harmonious* tone prematurely transform description into evaluation.

Often our tendencies, with our own work or with that of others, prompt us to leap past description to analysis and judgment. In part, this is because we assume that the visual is obvious to all and that restating these details is not necessary and, in part, because we underestimate the potency of the facts. As a useful experiment, try an inventory of an image with a group of peers. Invariably, individual observations will overlap, yet the exercise will also reveal items noted only by one person. Considering all visible elements as part of the work holds the artist to a high standard of decision-making.

Interpretation (What is it *about*?) follows this careful process of description. While interpretation seems to be a somewhat subjective response, after describing the work you should be informed enough to comment on the significance of the choices made. How can the denoted (described) be connoted (convey meaning)? A truly responsive interpretation will be based on the description or facts of the artworks. What are some of the meanings to be discovered from the work? We each approach a work of art with our own particular areas of knowledge. If I am conscious of art history, or of environmental issues, or of literary theory, I might read the work from such a point of view. It can be helpful and fun to identify or play with the basis for an interpretation. For example, a critic could approach the work consciously using the language and perspective of an art critic, or a psychologist, or an athlete. At the same time, Terry Barrett reminds us that valuable interpretations should reveal more about the artwork than the critic: "critics should show the reader that her or his interpretation applies to what we all can perceive in and about the art object." (See Terry Barrett, *Criticizing Art: Understanding the Contemporary* (New York: McGraw-Hill, 2nd edition, 2000), p. 115.)

The final stage of this process, *evaluation* or *judgment*, must utilize the previous steps. Evaluation must be based on the facts of the description and the significance of the meanings or the impact of the work. Judgment reveals a lot about what the viewer values in a work of art. For example, I might applaud a work of art that is unsettling and demands some re-valuation of the world, while another

critic might value a particular kind of craftsmanship. Openly acknowledge these criteria. In a conversational critique with the artist, it is often beneficial (to the artist) to allow them to determine the criteria for judgment. What are their aspirations for the work? Ensuing judgments can be based on the efficacy of the work in terms of these stated goals.

Approaching a critical discussion with this sequence in mind helps make artists more aware of the details of a work and the implications of those elements. Vary your approach to discussing work by considering a critique strategy explicitly for the work in question. We present several approaches in this section.

 4.10

Initiating a conversation: Verbal critiques

A verbal critique can be appropriate for certain works, or it may sit at odds with the visual work. An open discussion will help the artist to learn how your experience of the artwork compares with their own intentions. Your sincere, honest, and individual perspective on your work or on that of others is crucial to a creative and constructive conversation, and thus it is critical that you do not censor or become someone else's voice. As no single interpretation can be exhaustive, the wider the sampling the better. As the words become more directed and the energy level or debate more intense, make sure to direct questions at the work rather than at the artist in order to maintain a substantive critique. A good facilitator, whether an individual's self-assessment or a group moderator, helps detect key responses or tones and pursues these lines of thought.

However the discussion begins, allow time to build an understanding (of your work or someone else's). All conversations are experiments. Dead ends and wrong turns are part of a conversational process.

Beginning with a question

Like a greeting, a question has the ability to frame or direct the flow of conversation. When the artist begins by posing a question she wants answered, the critique is transformed into a conversation she has begun, rather than having the artist or the work be the silent subjects of an outside appraisal. If you do not have a question you are interested in exploring through formal conversation, critique can be an empty experience. Likewise, a specific question—e.g., Does the imagery remind you of the 1970s?—may lead interpretations of the work into too narrow an agenda.

Providing time for the audience to compose a question allows viewers the silence and space to reflect upon the work at leisure, rather than in the midst of an active discussion. This exercise may be fruitful in and of itself, with generated questions being allowed to surface during an organic conversation, or you may

choose to begin the critique with everyone reading their questions as written. This helps to give more introverted members of the group an opportunity to voice their thoughts and provides the artist with a reserve of approaches and impressions from which they can draw throughout the discussion.

Even a query that turns out to be a surface probe, the so-called "straw-man" (a construction that appears as the focus of attention that is in actuality preventing careful inspection of more central concerns), will present an entry into the critique process.

Beginning with a statement

Artist's statements, like leading questions, are in part willful language. Poorly articulated or misleading statements can just as easily shield major questions lurking within the work as expose them. If the desire for your work to achieve a certain intent is anything more than an aspiration, it needs to be received by a critical audience. If you are reviewing work, assume that written or spoken statements are aspirations more so than facts. Where does the work fall short of the stated goals? Often, having a statement to use as a guide is helpful in subverting tendencies (on the part of the audience) to project one's own aspirations onto the work, rather than being willing to consider the work itself (for example, the peer who suggests the work should radically change to suit their interests). In the best of all possible worlds, conversations about art are forums for curiosity rather than a series of suggestions that try to remake work.

Beginning the critique of your work by reading an artist statement will help you to develop concise, well-articulated, and honest descriptions of your interests. Structuring the discussion so that the artist reads the statement and then sits back and listens to the ensuing conversation places extra emphasis on the efficacy of this statement because presenting an inaccurate or vague introduction will only initiate a futile conversation. Not speaking during a critique often helps the artist to be a better listener and, if she has a tendency to respond to every comment, will help her to overcome defensive reactions. Artist statements can also be used at the tail end of the three-stage buildup (description, interpretation, evaluation) to measure against the ideas that arose during that conversation.

A verbal critique can be an intense experience, with so many thoughts to take in at once. Assigning someone to take notes about the conversation will free you up to listen and allow you to read through recorded observations more carefully in the future.

Written critiques

A written critique, in which viewers provide written comments, does not allow for the flow of ideas and juxtaposition of ideas that arise during group discussion. However, the opportunity to write observations and analysis gives the viewer time to think through aspects of the work and to figure out how to communicate these thoughts effectively. Written critiques are most beneficial when they are guided by a series of questions or some other structure. The writer needs to know the scope of their assessment and how to direct it in particular ways, i.e., in light of the project goals, in consideration of prior work by this artist, etc.

SUGGESTED FURTHER READINGS

4.1 TRADITIONAL HANDCOLORING RESOURCES

Books

Cheryl Machat Dorskind, *The Art of Handpainting Photographs* (New York: Amphoto Books, Imprint of Watson-Guptill Publications, 1998).

Heinz K. Henisch, *The Painted Photograph, 1839–1914* (University Park: Pennsylvania State University Press, 1996).

Laurie Klein, *Hand Coloring Black & White Photography* (Gloucester, MA: Quarry Books, 1999).

James A. McKinnis, *Handcoloring Photographs* (New York: Amphoto, 1994).

Tony Worobiec and Ray Spence, *PhotoArt: Darkroom, Digital, Handcoloring, Montage* (New York: Amphoto Books, 2003).

Barry Huggins, *Photoshop Retouching Cookbook for Digital Photographers* (Sebastopol, CA: O'Reilly, 2005).

Suppliers

B&H Photo. http://www.bhphotovideo.com/
Dick Blick. http://www.dickblick.com/

4.2 TRADITIONAL RETOUCHING RESOURCES

Books

John R. Podracky, *Photographic Retouching and Air-Brush Techniques* (Englewood Cliffs, NJ: Prentice-Hall, 1980).

Veronica Cass Weiss, *Retouching from Start to Finish* (Hudson, FL: VC Publishing, 1986). Includes in-depth details on removing facial blemishes, airbrushing, retouching negatives.

Katrin Eismann, *Photoshop Restoration & Retouching* (Berkeley, CA: New Riders, 3rd edition, 2006).

Conrad Chavez and David Blatner, *Real World Adobe Photoshop CS4 for Photographers* (Berkeley, CA: Peachpit Press, 2008).

Barry Huggins, *Photoshop Retouching Cookbook for Digital Photographers:* (Sebastapol, CA: O'Reilly, 2005).

Suppliers

B&H Photo. Sells oils, dyes, pencils, watercolors, markers & pens. http://www.bhphotovideo.com/
Adorama. http://www.adorama.com/
OmegaSatter. http://www.omegasatter.com/
Calumet Photo. http://www.calumetphoto.com/

4.3 TEXT MATERIALS, EQUIPMENT, AND INFORMATION

Books

Ellen Lupton, *Thinking with Type: A Critical Guide for Designers, Writers, Editors, & Students* (New Jersey: Princeton Architectural Press, CA: 2004).

Erik Spiekermann and E.M. Ginger, *Stop Stealing Sheep & Find Out How Type Works* (Mountain View, CA: Adobe Press, 2nd edition, 2002).

Philip Meggs, *Type and Image: The Language of Graphic Design* (New York: Wiley, 1992).

Suppliers

Stencil Ease. Sells custom stencils, paints and materials. http://www.stencilease.com/

Letraset. Manufactures and sells transfer/rub-on letters and symbols. http://www.letraset.com/

Electron Microscopy Services. Manufactures and sells transfer/rub-on letters and symbols. http://www.emsdiasum.com/microscopy/products/photographic/graphics.aspx/

Internet information

Stencil Revolution. Offers resources, tutorials, and artists' profiles for stenciling images in the street, though many tips apply to other types of stencil work. http://www.stencilrevolution.com/

4.4 BOOKBINDING RESOURCES AND SUPPLIERS

Books about technique

Kojiro Ikegami, *Japanese Bookbinding* (New York: Weatherhill, 2000).

Keith A. Smith and Fred A. Jordan, *Bookbinding for Book Artists* (Rochester, NY: Keith Smith Books, 1998).

Aldren Watson, *Hand Bookbinding: A Manual of Instruction* (Newton, MA: Focal Press, 1994).

Books about the history or theory of artists' books

Johanna Drucker, *The Century of Artists' Books* (New York: Granary Books, 1995).

Joan Lyons, ed., *Artists' Books: A Critical Anthology and Sourcebook* (Rochester, NY: Visual Studies Workshop Press, 1993).

Jerome Rothenberg and Steven Clay, eds, *A Book of the Book* (New York: Granary Books, 2000).

Bookbinding supplies

University Products. Manufactures and sells archival-quality materials including Japanese papers, matting and mounting boards, tapes and adhesives. http://www.universityproducts.com/

Gaylord Brothers. A great source of archival supplies, including conservation tools and materials such as adhesives (carries pre-cooked and uncooked wheat starch paste), boards, fabric, and paper. http://www.gaylord.com/

Talas. Sells bookbinding tools and supplies and museum-quality materials including tissues, papers, boards, fabrics, and frames. http://www.talasonline.com/

ANW Crestwood. Imports Asian and European art papers, including Japanese kozo paper. http://www.anwcrestwood.com/

Hiromi Paper International, Inc. Sells fine-art papers, including Japanese kozo paper. http://www.hiromipaper.com/

4.5 PRINT ON DEMAND SERVICES

Blurb. http://www.blurb.com/

Lulu. http://www.lulu.com/

Shutterfly. http://www.shutterfly.com/

QooP. http://www.qoop.com/

4.6 MATTING/MOUNTING RESOURCES AND SUPPLIES

Mounting/matting suppliers

Light Impressions. Sells matting equipment and materials, including mat cutters, archival boards and tapes, and dry-mount supplies. http://www.lightimpressionsdirect.com/

Archivart. Sells products for matting and framing, including museum-quality boards, tissues, papers, and storage boxes. http://www.archivart.com/

University Products. Manufactures and sells archival-quality materials, including Japanese papers, matting and mounting boards, tapes, and adhesives. http://www.universityproducts.com/

Gaylord Brothers. A great source of archival supplies, including conservation tools and materials such as adhesives (carries pre-cooked and uncooked wheat starch paste), boards, fabric, and paper. http://www.gaylord.com/

Talas. Carries bookbinding tools and supplies and museum-quality materials including tissues, papers, boards, fabrics, and frames. http://www.talasonline.com/

ANW Crestwood. Imports Asian and European art papers, including Japanese kozo paper. http://www.anwcrestwood.com/

Hiromi Paper International, Inc. Sells fine-art papers used for printing and conservation, including Japanese kozo paper. http://www.hiromipaper.com/

Harbor. Sells heavy-duty signage materials, such as foam boards, metal-faced panels (including Dibond), and plastic sheets (such as Sintra). http://www.harborsales.net/

Framing suppliers

Utrecht Art Supplies. Sells framing materials, such as boards, tapes, and wooden, plastic, and metal frames. http://www.utrechtart.com/

Pearl Paint. Sells framing materials, such as boards, tapes, and wooden, plastic, and metal frames. http://www.pearlpaint.com/

American Frame. A great resource for framing ideas and materials; the company sells pre-cut frames and makes custom frames. http://www.americanframe.com/

4.7 PHOTO-SHARING SITES

Webshots. http://www.webshots.com
Kodak Gallery. http://www.kodakgallery.com
Photobucket. http://www.photobucket.com
Flickr. http://www.flickr.com
Pbase. http://www.pbase.com
Photobird. http://www.photobird.com
Photobox. http://www.photobox.com
Shutterfly. http://www.shutterfly.com
Smugmug. http://www.smugmug.com
Buzznet. http://www.buzznet.com

Many users have created separate websites that connect to and interact with (via written computer code) Flickr. Suggested sites:

Spell with Flickr. Type in a word and the program will locate images of those letters on Flickr. http://metaatem.net/words/

Airtight Interactive. When you type in a word and an algorithm, the website's code searches Flickr and then displays numerous images related to that concept, with links to their owners' Flickr pages. http://www.airtightinteractive.com/projects/related_tag_browser/app/

4.8 SUGGESTED INTERNET ARTWORKS
Natalie Bookchin. *The Intruder* http://bookchin.net/intruder/index.html/
Victoria Vesna. http://www.bodiesinc.ucla.edu/
Giselle Beiguelman. http://www.desvirtual.com/suite-4-mobile-tags-the-dissonant-place/
Digital Art Museum. http://dam.org/dox/2315.aBbgc.H.1.De.php/

4.9 OPTICAL DEVICES AND ANIMATION RESOURCES
Film before Film [videorecording]; produced and directed by Werner Nekes, (New York, NY : Kino Video, 1989, c1986). Documentary about early cinematic and animation devices. http://www.youtube.com/watch?v=SO27DVdlg5M/
Early Cinema. Information about motion pictures and early cinematic devices. http://www.earlycinema.com/technology/zoetrope.html/
Early Visual Media. Online museum of early visual media. http://www.visual-media.eu/
Jack & Beverly's Optical Toys. Collection of zoetropes and other early animation devices. http://www.brightbytes.com/collection/zoetrope.html/
Getty's Devices of Wonder. Online exhibition. http://www.getty.edu/art/exhibitions/devices/flash/
FLIPBOOK.info. A French website dedicated to the flip book, with over 3000 examples, some of which involve video documentation. http://www.flipbook.info/
The North Carolina School of Science and Mathematics. A great online exhibit of optical toys. "An Introduction to Early Cinema" has descriptions of many early optical toys. http://courses.ncssm.edu/gallery/collections/toys/opticaltoys.htm/
Julia Featheringill. Artist's webpage showing her flip books and other artworks. http://www.uncertainty-principle.com/julia/index.html/
Flipclips. Service that turns video clips into a flip book. http://www.flipclips.com/

4.10 CRITIQUE STRATEGIES RESOURCES
Books
Terry Barrett, *Criticizing Photographs: An Introduction to Understanding Images* (New York: McGraw Hill, 4th edition, 2005).
Terry Barrett, *Criticizing Art: Understanding the Contemporary* (New York: McGraw-Hill, 2nd edition, 1999).
Terry Barrett, *Interpreting Art: Reflecting, Wondering, and Responding* (New York: McGraw-Hill, 2002).
Henry M. Sayre, *Writing About Art* (New Jersey: Prentice Hall, 6th edition, 2008).
Marita Sturken, *Practices of Looking: An Introduction to Visual Culture* (Oxford; New York: Oxford University Press, 2nd edition, 2009).

Internet
Scott Berkun, September 2004, "#35—How to give and receive criticism." http://www.scottberkun.com/essays/35-how-to-give-and-receive-criticism/
Terry Barrett articles. http://www.terrybarrettosu.com/articles.html/
Bruce Mau Design, "An Incomplete Manifesto for Growth." http://www.brucemaudesign.com/manifesto.html/

Glossary

6x6cm: A common image size for medium-format cameras. 6×6 yields a square negative. Medium-format cameras are also available in the smaller, rectangular size of 6×4.5 and the larger sizes of 6×7, 6×8, and 6×9cm.

35mm: A small-format film; each frame (single image) is 24×36mm in size (about 1×1½in.).

Abstract Expressionism: A New York school of painting characterized by freely created abstractions; the first important school of American painting to develop independently of European styles.

abstraction: Removing or simplifying visual information; abstraction can be minor, with the reduced form still resembling that which it initially represented (e.g. a chair that becomes less detailed, but still chair-like), or can be completely abstract, with no connection with the world of recognizable objects.

action painting: A style of abstract painting in which artists splashed or dribbled paint to create the effect of spontaneity.

anamorphic art: A distorted image that is unrecognizable until viewed at a particular angle or in a mirrored surface. In photography, distorted photographs are often corrected by viewing their reflection in a cylindrical mirror.

aperture: An opening in a device or structure; may be fixed or adjustable. In a camera, the aperture is the adjustable diaphragm that widens or contracts to let in more or less light.

appropriate: To adopt another's material, often without permission, reusing it in a context that differs from its original context.

armature: A framework that supports other materials.

artist's book: A work of art presented in the form of a book, in which the artist considers and integrates all aspects of the book (structure, contents, and design).

assemblage: Artworks made by assembling three-dimensional materials, particularly found or discarded objects and scraps of paper or natural materials.

avant-garde: An individual or group with ideas that seek innovation, often with the goal of advancing or challenging mainstream artistic and societal practice. Avant-garde comes from the French term "avant" (fore) and "garde" (guard), referring to the soldiers who went first in battle.

Bauhaus: A school of art and design in Germany, in operation from 1919 to 1933. The school was progressive in breaking down distinctions between practical crafts and the fine arts, and in its endorsement that art should respond to everyday life and society.

Beat Movement: A cultural movement of young Americans in the 1950s, led by artists and writers who rejected traditional social values and sought direction in Eastern philosophies.

bellows: A collapsible, usually accordion-folded, tube on a view camera. The bellows moves the lens board closer to or farther from the film plane.

binaural recording: Sound recording using two microphones that are placed at a distance from one another to simulate human hearing. The resulting recording fully uses the capabilities of the human ears in that the sound seems to be 360°, coming from behind, ahead, above, or from other directions.

blooming, buzzing confusion: Phrase coined by American philosopher-psychologist William James (1842–1910), in his essay "Percept and Concept: The Import of Concepts." The term describes the inner world of babies.

calotype: An early photographic process, made public by William Henry Fox Talbot in 1841. The process was the first negative–positive one in which endless reproductions could be made from an original negative.

carte-de-visite: (aka CDV) A small photograph mounted on heavy cardstock the size of a calling card.

Cartesian model of vision: French philosopher René Descartes's (1596–1650) assertion that the body and mind were separate, and the body had no part in perception. Rather, vision was a result of the mind's detached appraisal of representations as they passed before a kind of Inner Eye.

chiaroscuro: Using light and shadow in a drawing or picture to give two-dimensional objects the illusion of shape.

Cibachrome: A process for printing vivid color prints from transparencies.

cinematography: The art of making lighting and camera choices when filming a movie.

collage: An image made from combinations of photographs, graphics, type, and/or other two-dimensional materials, often pasted onto a backing sheet. Digital collage involves using computer tools to combine imagery from varying sources.

Conceptual Art: An art movement that emerged in the 1960s, that emphasized the artist's ability to convey an idea or a concept to the viewer, and rejected the creation or appreciation of a traditional art object such as a painting or a sculpture as a precious commodity.

Constructivism: An art movement that began in Russia around 1913 and that was influenced by Cubism and Futurism. It is characterized by an interest in the modern, in machines, and in geometric forms determined by industrial materials, such as metals, wood, and glass.

contact print: Process of placing a negative against sensitized material, usually paper, and passing light through the negative onto the material. The resulting image is the same size as the negative.

contact sheet: In traditional photography, a contact sheet is a contact print made from an entire roll of exposed and processed film. This provides an intermediate step, enabling the photographer to determine which pictures should be enlarged. Digital photography continues the practice of making a contact sheet; for example, Adobe Bridge provides a way to place thumbnails in contact sheet format.

crop: To trim. To crop a negative means to eliminate edges of the image when printing. To crop digitally means to do the same in editing software.

Cubism: An art movement of the early 20th century whose artists reduced objects to geometric forms and rejected traditional techniques of perspective in favor of multiple vantage points.

cyanotype: A low-cost permanent print made by exposing a matrix in contact with paper impregnated with iron salts and potassium ferricyanide, which

darkens when exposed to light. The image is usually white on a blue ground.

Dada: An artistic movement following World War One. Dada artists blamed rational institutions of science and government for the destruction caused by the war. They advocated art that was irrational, absurd, and provocative, and which used unconventional forms and methods.

Daguerre, Louis Jacques Mandé (1787–1851): Inventor of one of the earliest photographic processes, the daguerreotype.

daguerreotype: One of the first processes of fixing a photographic image. Invented by Louis J.M. Daguerre in 1839, the process produced a one-of-a-kind (non-reproducible) positive image formed by mercury vapor on a light-sensitized copper plate. The delicate daguerreotype images, most of which were portraits, were often set inside ornate cases and required viewing from a certain angle because of their highly polished surface.

decisive moment: Phrase coined by photographer Henri Cartier-Bresson in 1952 to describe the photographer's goal of catching the fragment of a second in which the elements of a scene—the significance/meaning of the event and the formal, geometrical forms—come together.

depth of field: In a photographic print, the depth of field is the distance between the nearest and farthest points that appear to be in sharp focus.

dissolve: In film editing or projection, a gradual shift from one image to the next in which one image fades while the next appears.

dissolve unit: An interface that connects two or more slide projectors or two or more video projectors, and which makes it possible to fade the lamp in one projector while intensifying the lamp in the other. Rather than moving from image to image abruptly, the unit produces a gradual shift in images.

documentary: In the mid-to-late 20th century, this term would be defined as the act of photographing the world in an objective, truthful manner. However, more recently, writers acknowledge that the photographer's opinion and/or agenda is, at minimum, conveyed through use of framing, and sometimes even through the act of causing people or objects to be positioned or to respond in particular ways. Even so, documentary can still be understood as an attempt to reveal or communicate something about the real world.

Earthworks/earth art: Earthworks refers to a movement that originated in the late 1960s, of artists who created works in nature, using stones, water, leaves, and other natural elements as sculptural materials. Many earthworks are made with the goal of understanding a natural site or phenomenon. Other works reveal the inherent differences between nature and culture, often exposing the human propensity to conquer and manage natural processes.

emulsion: Any light-sensitive coating applied to films, papers, printmaking plates, or other materials to record an image. Traditional emulsions consist of silver-halide crystals and other chemicals suspended in gelatin. Slow emulsions require more light than fast emulsions. Therefore, with slow emulsions, the shutter must be open longer or the aperture must be wider.

Euclidean geometry: A mathematical system attributed to the Greek mathematician Euclid.

exposure: The total amount of light that falls on the film or sensor in the camera to produce a latent or digital image; in darkroom printing, the exposure is the total amount of light exposed on photographic printing paper. Exposure time is the amount of time that light is permitted to fall onto the digital sensor or light-sensitive film or paper.

Expressionism: An art movement of the early 20th century in which many European artists became interested in portraying emotions rather than realistic observations.

fade: A technique in film editing, in which an image gradually darkens and vanishes.

Federal Art Project (FAP): A division of the Works Progress Administration (WPA), which was part of President Franklin D. Roosevelt's New Deal initiative to provide economic relief to Americans during the Great Depression. The FAP was a government-funded art program from 1935 until 1943. The program educated artists in community art centers, created an historical pictorial record of Americans, and employed artists to create posters, murals, and paintings in public places, such as government buildings, schools, and libraries.

femme fatale: A seductive female who lures men into dangerous situations.

film noir: A genre of American films made in the aftermath of World War Two, which reflected the anxieties of the postwar and dawning Cold War period through crime stories cast with desperate characters, and set in shadowy, low-key lighting.

fine-art photography: Photography with art or creative expression as its purpose. This term is often used to distinguish the work from imagery that is in the service of business or public interests, such as commercial or documentary photography.

flashgun: A lamp that emits a brief flash so that a camera has enough light to make an exposure. When first invented, the device resembled a gun.

flatbed scanner: An optical scanner in which the scanning head/camera moves across a stationary bed.

flip book: A book with a series of pictures that change slightly from one page to the next. When flipped, the pictures appear to be animated.

Fluxus: An avant-garde art movement that emerged in the early 1960s. Practitioners celebrated anti-art (much in the spirit of Dada) in defiance of an established gallery system that emphasized and controlled how and which artworks were valued. Fluxus works involved a range of media, including performance, music, correspondence, and visual arts.

folk art: Usually refers to art made by someone who is self-taught as an artist; may also refer to art that is created by (and which often reflects the traditions of) people of a particular culture or region.

foreshortening: A way of representing a subject or an object so that it conveys the illusion of depth—so that it seems to go back into space. Foreshortening's success often depends upon a point of view or perspective in which the sizes of the near and far parts of a subject contrast greatly.

formal: Relating to the form and structure of the work of art, i.e. visual elements such as shapes, lines, color, and texture.

found object: A natural or manufactured object not initially intended as a work of art, which an artist incorporates into an artwork.

found photograph: A photographic image made by another person for another purpose. Examples could be a school portrait, family snapshot, or a police record.

fps (frames per second): In animation, to create the illusion of movement a still image must continue to register in the brain for a short time after it passes from our eyesight. If we see too many frames per second, the images will blend too quickly. Too few fps and the images will appear static or jerky. The standard needed to produce smooth motion is about 30 fps.

f-stop or f-number: A numerical designation (f/2, f/2.8, etc.) indicating the size of the camera's aperture.

Futurism: An art movement founded in Italy in 1909

that revered the new traits of industrial and mechanized life—speed, pollution, noise, and machinery—and that exalted the merits of war and fascism.

gaze: The idea of the gaze is a formal term within film theory and feminist film theory. It involves more than just looking. People always look in films, but the "gaze" refers to looks with specific meanings: usually the act of consumption, appropriation, control; and often the desire for a woman by a man who is looking at her. Jacques Lacan's use of the word "gaze" is more abstract and psychological, describing the fact that individuals are caught up in the scopic field of others.

genre painting: A style of painting that depicts scenes from everyday life.

German Expressionism: Around 1905, many European artists became interested in portraying emotions rather than realistic observations. German Expressionism was part of this larger movement, though tended toward the portrayal of more ominous aspects of the human consciousness. Imagery tended toward distorted lines, dramatic lighting, vibrant color, and flattened perspective. German Expressionist films also emphasized sinister emotional content, with tilted camera angles, strong shadows, and harsh contrasts between dark and light.

Gothic: A literary style that emerged at the end of the 18th century and featured romantic and mysterious occurrences set in gloomy or bleak settings. Gothic dramas took their influence from medieval Gothic architecture's towering structures with gables, arches, and ornamentation.

grain: Silver particles that make up a photographic print.

Group f/64: A group of West Coast American photographers, including Edward Weston, Imogen Cunningham, and Ansel Adams, founded Group f/64 in 1932. The group advocated particular qualities of photography: clearness and definition. They achieved these with the use of small apertures (such as f/64) to obtain a wide depth of field, and large-format view cameras whose substantial negatives created sharp, small-grain images.

Guggenheim Fellowship: A prestigious annual award from the Guggenheim Foundation to artists who are judged to have produced exceptional creative works.

gum bichromate: An early photographic process in which an image is formed by exposing a negative to a surface coated with an emulsion of gum arabic, potassium bichromate, and pigment. The emulsion hardens in relation to the amount of light it receives through the negative. Unexposed emulsion is washed away.

halftone: A process that enables continuous tone images to be printed in ink on paper. When projected onto a printing plate, the image is broken into a regular array of microscopic dots that vary in size according to how dark the image is at that point. The larger dots transfer more ink to the paper, the smaller dots less, reproducing the tones of the original image.

Hasselblad: Medium-format Swedish camera design, originally modeled on a German surveillance camera from World War Two.

high-speed photography: The act of photographing fast-moving subjects with a camera capable of capturing multiple frames per second.

Hudson River School: Style of painting that originated in the area along the Hudson River north of New York City to Albany. Artists were interested in landscape and the quality of light given off by the river.

Impressionism: A movement within painting of the mid-to-late 19th century whose artists used short brushstrokes and pure, unmixed colors in order to reveal fluctuations in light and color.

installation: A work of art that integrates indoor or

outdoor architecture with objects/constructions made specifically for that space.

Instamatic camera: Type of point-and-shoot camera first produced in the early 1960s, which used an enclosed film cartridge (126 or 110 format) for easy loading.

ISO: A numerical scale that measures the film or digital sensor's sensitivity to light. The higher the ISO number or speed, the more sensitive the photographic emulsion or digital sensor is to light. Lower ISOs are less sensitive. (ISO stands for International Standards Organization.)

keystoning: A distortion resulting when a rectangular plane is photographed at an angle not perpendicular to the axis of the lens. The result is that the rectangle appears to have the shape of the keystone of an arch.

kinetoscope: An early cinematic device produced at the end of the 19th century in which an 18mm film ran around a series of spools. As each frame ran under the lens, a flash of light allowed the individual viewer, peering through a peephole, to see what appeared to be a moving image.

Lacan, Jacques (1901–1981): French psychoanalyst who supported the idea of the unconscious mind as espoused by Sigmund Freud, and whose ideas influenced linguistics, film, and literary theory.

large-format camera: A camera which uses 4×5-inch or 8×10-inch sheets of film. Typically the camera's lens forms an image directly on a ground-glass viewing screen to enable composition.

lens: One or more pieces of optical glass used to focus light rays to form an image. There are several types of camera lenses: a normal lens approximates human vision; a wide-angle lens shows a wider angle of view; a telephoto lens captures a smaller field of view and makes the object/scene appear to be closer.

lens-based photography: Photography that relies upon a lens, depth of field, and monocular perspective.

lithography: A printing method in which a drawing is applied to and printed from a stone, metal, or plastic plate.

long exposure: Allowing photosensitive material to receive light for an extended period of time.

machine aesthetic: Popular aesthetic that came about during the industrialization of the early 20th century. Art and design celebrated the appearance of machines, i.e. the look of shiny metals, mirrored glass, etc.

magic lantern: A type of slide projector used for entertainment from the end of the 17th century to the early 19th century. Traveling lanternists would project light through images hand-painted on glass slides. "Magic" refers to the tendency of the imagery to be of creepy, supernatural subjects.

Manichaean: Adjective derived from a religion that originated in Persia in the 3rd century with the basic doctrine of a division between light, which was good, and dark, which was evil.

middle tones: Values midway between light and dark or highlights and shadows.

minimalism: A 20th-century art movement and style stressing the idea of reducing a work of art to the minimum number of colors, values, shapes, lines, and textures.

Modernism: An art movement that embraced innovative media and forms of visual expression, and which rejected traditional forms of representation. In photography, Modernism refers to a period from the end of World War One to the early 1950s.

motion picture: A movie.

narrative: A coherent story or chain of events related in a linear fashion.

negative: An image in which the tones are the opposite of those of the subject. In traditional photography, the image is on film. Light passes through the negative onto photographic printing paper to produce a positive print.

Neo-Conceptual Art: Art practices that are influenced by the Conceptual Art movement of the 1960s and 1970s in its desire to communicate ideas, in its rejection of art as a commodity, and in its social and/or political critique.

New Vision: Phrase coined by László Moholy-Nagy (1895–1946) to describe photography's ability to exceed human vision with radical points of view achieved by cameras, and with experimental processes using light and photographic chemistry.

noise: Random speckles of color in a digital image.

panorama: A 360° unbroken view. Created in the late 18th century, the panorama was a popular tourist attraction; audiences viewed panoramas of pastoral, urban, and exotic landscapes and historic scenes painted on large cylinders that surrounded the viewers.

pantograph: An arm-like instrument for copying drawings or pictures.

parallax: A discrepancy in the field of coverage between two views of a subject seen from different viewpoints. In binocular parallax, the difference comes from the separation between the two eyes. In photography, the difference comes from the slight shift in vantage between the viewfinder and the lens.

The Pencil of Nature: The title of William Henry Fox Talbot's book, published in 1844 and the first to be illustrated with photographic prints tacked in place. Talbot published the book in order to publicize the advantages of the calotype process and to inspire and instruct photographic hobbyists and budding professionals with a range of compositions and subjects. The term "the Pencil of Nature" references Talbot's belief in the objective nature of photography, in which the sun produced the images, not the artist.

performance art: An artwork involving live performance by people or coordinated objects in a particular space at a particular time. Performance art may involve the performing arts (theater, music, dance) or the visual arts, and is often associated with Conceptual Art.

persistence of vision: The brain's ability to retain an image for a short time after the image is no longer in front of the eye. This principle creates the illusion of movement, which makes animation possible.

photo: From the Greek *photos* meaning light.

photocollage: A composite image formed by printing or joining together portions (or all) of more than one photograph and, possibly, other graphic imagery.

photo essay: A series of photographs that tell a story, usually printed in a periodical or book.

photogram: An image formed by placing material directly onto a sheet of sensitized film or paper and then exposing the sheet to light.

photogravure: A photomechanical process in which a photographic image is transferred to a printing plate. When etched, the plate is capable of reproducing the continuous tones of the photograph on paper.

photojournalism: Journalism that uses images to tell a story.

photomontage: See collage.

Pictorialism: Photographers working in the Pictorialist tradition, from 1890 to 1917, wanted to establish photography as an artform. Composition, subject matter, and soft-focus aesthetic were typically used to make the photo look painterly.

picture magazine: A type of print magazine that emerged in the 1930s. The picture magazine (examples are *LIFE*, *Look*, and *Picture Post*) presented news and entertainment in mainly photographic form, and with dynamic layouts and captions.

pinhole camera: A basic camera with no lens or viewfinder, whose aperture is a tiny opening directly in the camera body.

point-and-shoot camera: Small, lightweight film or digital camera with auto-focus and exposure; also referred to as a compact camera.

Polaroid 600: A type of instant film used with a Polaroid camera; the film produces positive images within a few seconds of taking the picture.

Pop Art: Short for "popular art." An art movement that emerged in England in the 1950s and then spread to the United States, characterized by an interest in and use of objects and imagery of everyday, and often mass-produced, items. Pop artists responded to the post-World War Two increase in consumer goods and advertising and created work with imagery recognizable to the general public.

postmodernism: A cultural and artistic movement that questioned the assertions of modern arts and conventions, such as medium specificity and formal purity. Postmodernism is characterized by the juxtaposition of multiple styles, the rejection of assertions of truth or originality, and the blending of high and low culture.

post-studio: Refers to a shift that took place in the 1950s. Before this period, most artists made work in a studio isolated from the larger context of the world. The post-studio artist's realm of production is outside of the studio, in both creation and exhibition of the work.

purism: The idea that a medium has essential qualities. In photography, purism reached its height in the 1920s and was defined as the image's ability to achieve clarity and definition.

readymade: Something that is already manufactured. Marcel Duchamp used this term to refer to commonplace objects that he selected and deemed artworks, such as a urinal. The object became a work of art as a result of his selection, which also involved displaying, titling, and signing the item.

realism: Any form of representation that attempts to show the physical world as accurately as possible, without distortion or emotion.

reenactment: To act or perform again. A historical reenactment is an event or performance in which participants attempt to recreate a historical event, such as a battle.

Renaissance perspective: A method (aka one-point perspective or linear perspective) of creating the illusion of distance in a picture based on mathematical calculations. Developed in the early 15th century, Renaissance perspective shows depth by converging all lines on a central point in the distance.

retinal afterimage: An optical illusion that occurs when a person stares at an image or color for several seconds. After looking away, he/she will continue to see the image/color. Afterimages can be positive (the person sees the original color in the afterimage) or negative (the afterimage is the complementary color).

retouch: Altering a photographic print to correct scratches, creases, or other flaws, or to clean up areas of the image.

rods and cones: The two types of photoreceptors in the eye's retina. The rods are more numerous and more sensitive than the cones, though only the cones are color sensitive.

rotogravure: A type of intaglio printing process that

involves engraving an image onto an image carrier for printing.

Samizdat: From the Russian for *sam* (self) and *izdat* (to publish), the Samizdat movement was a grassroots effort in post-Stalin U.S.S.R. (1950s to 1980s) to evade censorship by writing, reproducing, and distributing forbidden literature by hand, from one individual to another.

semiotics: The study of signs and symbols as elements of communication.

sequence: A linear arrangement in which one image must be read after the next in a particular order.

series: A group of images that are meant to be seen collectively, though not necessarily in a particular order.

shutter: A mechanism in a camera that opens and closes to allow light to pass from the aperture to the film or digital sensor.

shutter release: The button that you press on the camera to take the picture.

signs (theory of): According to semiotician C.S. Peirce, a "sign" is something that stands for something else. For example, red lights at intersections indicate a social convention of movement; the word "tree" stands for a physical object; for James Dean, blue jeans may have been a "sign" of rebellion.

silkscreen: A method of printmaking using stencils to make screen prints. In this process, a design is placed on a woven mesh material. The positive areas of the design allow ink to penetrate onto the printing substrate.

single-lens reflex (SLR) camera: A camera with a mirror inside. The mirror bounces light coming through the lens into the viewfinder. The image seen in the viewfinder is approximately what the camera sees through its lens.

social documentary: A sub-genre of documentary photography, in which the emphasis is placed on people as they live, work, etc., often with the goal of effecting reform.

Socialist Realism: A government-sanctioned style of realist painting in the Soviet Union from the 1930s through the 1980s. A form of propaganda, the figurative, narrative imagery was meant to forward state policy and honor leaders and the working class.

stereoscopy: The technique (aka stereography) of capturing two images of the same scene, from slightly different positions. When viewed in a stereoviewer (aka a stereoscope), the scene appears three-dimensional. The card with the two pictures may be referred to as a stereocard, a stereocarte, a stereogram, or stereoscope.

stock photography: Pre-existing, professional photographs of objects, places, or people that can be used for commercial purposes. Collections of such photographs are available in image banks, where buyers can purchase a license to use the image once or multiple times.

straight photograph: A photograph made with a camera, without any post-exposure manipulation (i.e. cropping the image or compositing images).

street photography: A genre practiced by photographers who make their primary subject modern urban life.

studio lighting: The use of artificial light sources to illuminate a scene or people. The lights and their housings are used in a controlled environment (usually a room) that is shielded from natural light. The lights can be manipulated (to intensify, diffuse, focus the beam of light, etc.).

Surrealism: A movement that began in the early 1920s, which placed importance on gaining access to

understandings outside of rational thought, for example dreams and the subconscious mind. Artists, musicians, and writers attempted to cultivate repressed thoughts or visual imagery. Though many of the visual works seem dreamlike or absurd, they often have some basis in each artist's personal experiences, and in the devastation of World War One.

tableau: An artistic arrangement, often of still objects.

thaumatrope: An optical toy, invented in 1825, which consists of a paper disk with an image on either side; when the card is flipped, the images appear to merge.

time-lapse photography: The process of taking a series of images of a slowly (or imperceptibly) moving object(s) and then playing the images back at a faster rate. For example, to present (in 1 minute) a bowl of fresh fruit as it rots over the duration of a month would speed up the effects of time.

tripod: A three-legged stand used to steady a camera that is too heavy to be handheld or to prevent movement during a long exposure. The three legs are hinged to a plate; the camera attaches to this plate.

tween: A term used in animation to refer to frames interpolated between the key frames; these in-between frames help to morph one shape into another.

typology: The classification or grouping of types that have similar characteristics.

Van Dyke Brown printing: A photographic process that originated around 1840. The process involves a ferric ammonium citrate sensitizer mixed with a silver nitrate solution. When the two chemicals are coated on paper and exposed to sunlight under a negative, the ferric compound turns ferrous, producing a quite visible image in iron. In brown printing, water is used not only to develop the brown print image but also to fix it and wash away the non-image-forming chemicals.

view camera: A camera in which the lens projects an image directly onto a ground-glass viewing-screen, for the purpose of composition. The front and back of the camera can be set at various angles to change focus and perspective. Typically, view camera sizes accept 4×5-inch or 8×10-inch sheets of film.

viewfinder: The window in a camera. This frame shows an approximation of the picture the camera will photograph.

Weimar period: Period in Germany from 1919 to 1933, which began with the Treaty of Versailles that ended World War One, and which ended when Adolf Hitler came to power. The arts and sciences thrived during these years of the Weimar Republic.

Weston, Edward (1886–1958): Photographer working in the early 20th century who strived to reveal the essence of objects by using the "inherent qualities of photography", i.e. maximum detail from foreground to background, and precise lighting.

wet-plate collodion: Wet-plate collodion, aka "wet collodion," "collodion," and "wet plate process," is a photographic process invented in 1851 that uses light-sensitive silver nitrate as an emulsion on glass plates to produce a negative. The emulsion was much faster than its precursor, the calotype, and shortened exposure times considerably.

wipe: A technique in film editing, in which images gradually make a transition from one to another. Unlike a dissolve, where images fade and emerge, a wipe moves across the screen from one side to the other with hard edges.

zoetrope: An optical toy first popularized in the 1860s, which presents a series of images along a strip; images show a figure at various stages of motion. The strip is placed within a cylinder which is then spun. The viewer watches through slots in the cylinder as the

images speed past, giving the illusion of a single figure in motion.

Zone System: A technique to plan negative exposure and development to achieve precise control of the darkness or lightness of various areas in a print. Developed by the American Ansel Adams (1902–1984).

zoom lens: A lens adjustable to a range of focal lengths, from wide to normal to telephoto.

zoopraxiscope: Invented by Eadweard Muybridge in 1879, this early motion picture device projected still images from rotating glass disks to create the illusion of movement.

Index

Only illustrations of works by artists and photographers are highlighted in the index, using italic page numbers. Other subjects may have illustrations on the same page as the text reference or on a nearby page. Numbers in headings are filed as words, e.g. 35mm film is in the T sequence.

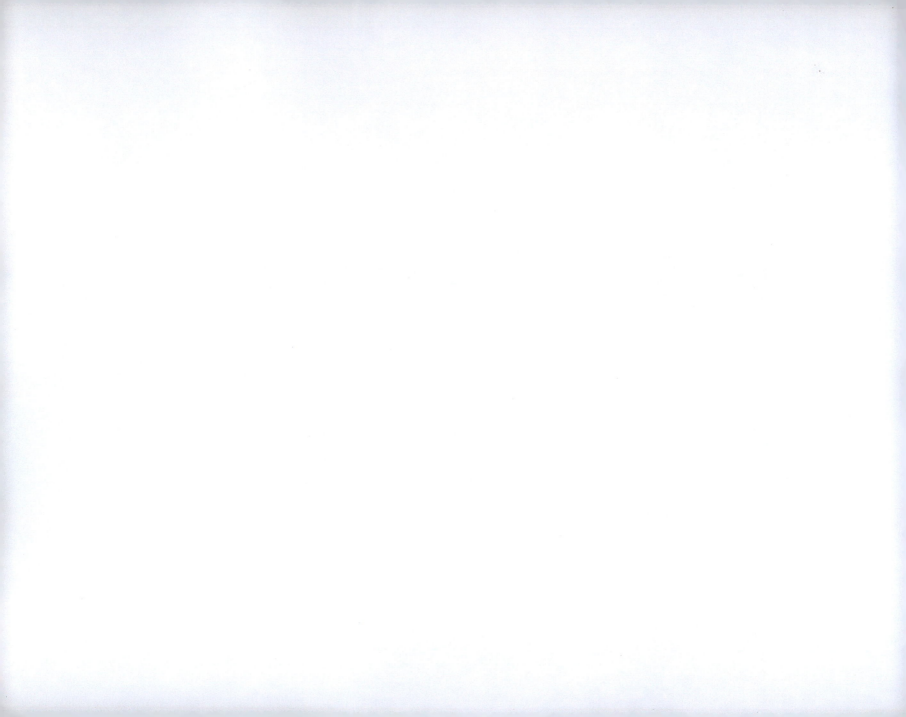

Related titles:

Photography: A Critical Introduction

Edited by: Liz Wells

978-0-415-46087-3

The Photography Reader

Liz Wells

978-0-415-24661-3

Photography

Stephen Bull (RIMC series)

978-0-415-42894-1

Photography: Theoretical Snapshots

J.J. Long, Andrea Noble and Edward Welch

978-0-415-47707-9

Photography Theory

Edited by James Elkins

978-0-415-97783-8

An Introduction to Visual Culture

Nicholas Mirzoeff

978-0-415-32759-6

Cover images:

Row 1:

1. © JESSICA FRELINGHUYSEN, 2005, 2009
2. © MARC TASMAN, 2000-2009
3. © SARAH BUCKIUS, 2006
4. © SARAH V. COCINA, 2002
5. © JOHN BAIRD, 2010

Row 2:

6. © BETSY PETERS, 2009
7. © CHARLES FAIRBANKS 2006
8. © WENDY SHAW ARSLAN 2000
9. © CHRIS TAYLOR 2009
10. © MARY KATE HEISLER, 2006
11. © JULIA FARINA, 2005

Row 3:

12. © SARAH BUCKIUS, 2006
13. © SARAH BUCKIUS, 2006
14. © GARTH AMUNDSON, 2000-09
15. © BAPAK GOGON MARGONO, SANGGAR WAYANG GOGON, 2008. PHOTO © SARAH BUCKIUS
16. © K. R. BUXEY, 1998
17. © SHAWN SCULLY, 2001

"*Reframing Photography* is a wonderful accomplishment with its seamless treatments of theory and a liberated sense of photographs, how they can be made, and how they can look. It will end the senseless separation of photography and art, and technique from idea, right from the beginning. It reframes photography education."

Terry Barrett, *University of North Texas, USA*

"The essays effortlessly link photography to a history of ideas, not simply a history of cameras and chemical processes. The book does not separate historical work from contemporary work, nor does it separate technique from theory. Past and present are in constant communication with the reader who becomes aware of inter-generational, historical, technological, cultural and transdisciplinary influences in photographic practice. This is how the best teachers understand the world and relate information to their students. A contemporary education in photographic practice has come of age with this book."

Barbara DeGenevieve, *School of the Art Institute of Chicago, USA*

"This is a timely book which will be of enormous help to photography and arts students. It combines photography history, useful descriptions of artist's practices and ideas, and technical information and tips, and encourages experimentation. The volume and website demystify a lot of aspects of practice that are not covered in more conventional books, and make it clear how enjoyable fine art photography can be."

Michelle Henning, *University of the West of England, UK*

"*Reframing Photography* is excellent – very well-written, beautifully designed, clear and innovative in its structure – an ideal introduction to the current debates about theory and practice in photography."

Louise Milne, *Edinburgh Napier University, UK*

PHOTOGRAPHY / MEDIA & CULTURAL STUDIES

ISBN 978-0-415-77920-3

9 780415 779203

Routledge
Taylor & Francis Group

www.routledge.com

an **informa** business

To fully understand photography, it is essential to study both the theoretical and the technical.

In an accessible yet complex way, Rebekah Modrak and Bill Anthes explore photographic theory, history, and technique to bring photographic education up to date with contemporary photographic practice.

Reframing Photography is a broad and inclusive rethinking of photography that will inspire students to think about the medium across time periods, across traditional themes, and through varied materials. Intended for both beginning and advanced students, for art and non-art majors, and for practicing artists, *Reframing Photography* compellingly represents four concerns common to all photographic practice:

* Vision
* Light/Shadow
* Reproductive Processes
* Editing/Presentation/Evaluation

Each part includes an extensive and thoughtful essay, providing a broad cultural context for each topic, alongside discussion of photographic examples. Essays introduce the work of artists who use a diverse range of subject matter and a variety of processes (straight photography, social documentary, digital, mixed media, conceptual work, etc.), examine artists' conceptual and technical choices, describe cultural implications and artistic influences, and analyze how these concerns interrelate. Following each essay, the part continues with a "how-to" chapter that describes a fascinating range of related photographic equipment, materials, and methods through concise explanations and clear diagrams.

Key features:

* Case studies featuring profiles of contemporary and historical artists.
* Glossary definitions of critical and technical vocabulary.
* "How-to" chapters provide illustrated guides to different photographic methods, alongside theory.
* Fully up to date, with both high- and low-tech suggestions for activities.
* Online resources at **www.routledge.com/textbooks/reframingphotography** will update information on equipment and provide further activities, information, and links to related sites.
* Lavishly illustrated, with over 750 images, including artists' work and photographic processes.

Rebekah Modrak is a studio artist whose work has been shown at The Sculpture Center, Carnegie Museum of Art, and Kenyon College. She is an Associate Professor in the School of Art & Design at the University of Michigan where she teaches courses involving photography, animation, mixed media, and photographic history.

Bill Anthes is Associate Professor of Art History at Pitzer College. He has received awards from the Georgia O'Keeffe Museum Research Center, the Center for the Arts in Society at Carnegie Mellon University, the Smithsonian Center for Folklife and Cultural Heritage, and the Creative Capital/Warhol Foundation Art Writers Grant Program.